Outlaw Representation

Outlaw Representation

CENSORSHIP & HOMOSEXUALITY IN
TWENTIETH-CENTURY AMERICAN ART

Richard Meyer

OXFORD
UNIVERSITY PRESS

2002

OXFORD
UNIVERSITY PRESS

Oxford New York

Athens Auckland Bangkok Bogotá Buenos Aires Cape Town
Chennai Dar es Salaam Delhi Florence Hong Kong Istanbul Karachi
Kolkata Kuala Lumpur Madrid Melbourne Mexico City Mumbai
Nairobi Paris São Paulo Shanghai Singapore Taipei Tokyo Toronto Warsaw

and associated companies in
Berlin Ibadan

Published by Oxford University Press, Inc.
198 Madison Avenue, New York, New York 10016

Oxford is a registered trademark of Oxford University Press.

Library of Congress Cataloging-in-Publication Data
Meyer, Richard, 1966–
Outlaw representation : censorship and homosexuality in
twentieth-century American art / Richard Meyer.
p. cm. — (Ideologies of desire)
Includes index.
ISBN 0-19-510760-8
1. Homosexuality in art. 2. Art, Modern—20th century—
United States. 3. Censorship—United States. I. Title. II. Series
N8217.H67 M49 2002
704'.0664'09730904—dc21 00-058903

Publication of this book has been aided by a grant from the
Millard Meiss Publication Fund of the College Art Association.

MM

9 8 7 6 5 4 3 2

Printed in Hong Kong
on acid-free paper

FOR DAVID ROMÁN

AND FOR SHERRY MEYER

Acknowledgments

In the course of writing this book, I have received an extraordinary degree of support. It is a pleasure to acknowledge the following institutions and individuals, each of whom helped this work to find a place in the world.

Outlaw Representation expands upon my doctoral dissertation of the same title, the research and writing of which were supported by grants from the Department of History of Art at the University of California at Berkeley, the Jacob Javits Fellowship for the Humanities, the Chester Dale Dissertation Fellowship at the Metropolitan Museum of Art, and the American Council of Learned Societies/Henry Luce Foundation Fellowship for American Art. The process of revising the dissertation into a book was supported by a postdoctoral fellowship at the Getty Research Institute for the History of Art and the Humanities and by a Zumberge Faculty Research and Innovation Grant from the University of Southern California. Funding for color illustrations, coated paper, and reproduction rights has been provided by the Millard Meiss Publication Fund of the College Art Association, the Deans of the College of Letters, Arts, and Sciences at USC, and the Peter Norton Family Foundation. To all of these sponsors, I am most grateful.

In writing this book, I have relied on the critical engagement and support of fellow scholars, especially that offered by David Brody, George Chauncey, Lee Edelman, Philip Eliasoph, Jim Herbert, David Joselit, Juliet Koss, Josh Kun, Pamela Lee, Michael Lobel, Joseph Litvak, David Miller, Paul Morrison, Esther Newton, Andrew Perchuk, Mysoon Rizk, Michael Roth, Gayle Rubin, Jennifer Shaw, Abigail Solomon-Godeau, Debora Silverman, Lesley Stern, David Summers, and Cécile Whiting. An ongoing intellectual dialogue with Douglas Crimp has shaped my thinking and writing throughout the last decade. My thanks to Douglas for many feisty hours of debate and discussion.

A far-flung group of archivists, librarians, curators, gallerists, and foundation staffers facilitated my research by sharing their time, expertise, and access to materials. My thanks to Margery King, John Smith, Lisa Miriello, and, especially, Matt Wrbican of the Andy Warhol Museum; Launa Beuhler, Marisa Cardinale, Anise Richey, and Michael Stout of the Robert Mapplethorpe Foundation; Martin Taylor of the Fales Library and Special Collections, New York University; Adam Weinberg of the Addison Gallery of American Art; Beth Venn and Anita Duquette of the Whitney Museum of American Art; Kay Bearman and Julie Zeftel of the Metropolitan Museum of Art; Lowery Sims of the Studio Museum in Harlem; John McIntyre of the International Center of Photography; Gale

Munro of the Navy Art Collection; Bridget Moore, Edward de Luca, Sandra Paci, and Heidi Lange of the D.C. Moore Gallery; Scott Catto, Sarah Murkett, Penny Pilkington, and Wendy Olsoff of the PPOW Gallery; Michelle Reyes and Andrea Rosen of the Andrea Rosen Gallery; Martin Meeker, Susan Stryker, and especially, Willie Walker of the Gay, Lesbian, Bisexual, Transgender Historical Society of Northern California; Richard Wandel of the National Gay and Lesbian Museum; Jennifer Pearson Yamashiro of the Kinsey Institute for Research in Sex, Gender, and Reproduction. I am especially grateful to Susan Cahan and Peter Norton of the Peter Norton Family Foundation for their commitment to this book and to the artistic freedom with which it is concerned.

Among the many USC colleagues who have welcomed and sustained me since my arrival in Los Angeles in 1996, I am particularly grateful to Gordon Berger, Joseph Boone, Leo Braudy, Robert Flick, Judith Jackson Fossett, Selma Holo, Eunice Howe, Karen Lang, Teresa McKenna, Tania Modleski, Christiane Robbins, and Ruth Weisberg. I would also like to thank the Deans of the College of Letters, Arts, and Sciences, particularly Joseph Aoun, Beth Meyerowitz, and Sarah Pratt, as well as the Vice-Provost for Research, Cornelius W. Sullivan. Nancy Troy, the chair of the Department of Art History at USC, has been a wonderful colleague, friend, and advisor. Her professional energy and vision have transformed the collective life of our department. My USC students provided the first audience for various parts of this book and their responses helped determine its final form. Of special note are the students who participated in graduate seminars on "Sexuality and Visual Culture," "Public Memory and Museum Exhibition," and "Contemporary Art and Identity Politics." One of those students, Sarah Stifler, served as my research assistant throughout the later stages of this project and I thank her for many hours of thoughtful work.

David Halperin, the editor of the series in which this book appears, has been a mentor both intellectually and professionally. Throughout my years as a graduate student, David encouraged and engaged with my work, and this despite the fact of our different institutional homes and disciplinary backgrounds. He has performed much the same role for queer students across the country and, indeed, across the globe. I thank David not only for his extensive editorial work on this book but also for his professional courage and commitment to the field of gay and lesbian studies. At Oxford University Press, I have worked with three different acquisitions editors: Elizabeth Maguire, T. Susan Chang, and Elissa Morris. My thanks go to each of them, and especially to Elissa, who shepherded the manuscript through a delicate editorial process. I would also like to thank Christi Stanforth for copyediting the book, Suzanne Holt for designing it, and Cynthia Crippen for creating the index. I am grateful to my production editor, Jessica Ryan, for the care and efficiency with which she treated my work.

Parts of this book have been presented at the annual meetings of the College Art Association, the American Studies Association, the Society for Photographic Education, the Semiotic Society of America, and the Popular Culture Association, as well as at the International Congress of the History of Art in Amsterdam, the Center for Literary and Cultural Studies at Harvard University, the Institute of Fine Arts at New York University, the University of British Columbia, Stanford University, Yale University, Cornell University, the University of Notre Dame, Northwestern University, the University of California at Berkeley, Los

Angeles, Riverside, and Santa Barbara, the University of Rochester, the University of Colorado, the Institute of Contemporary Art in Philadelphia, the Santa Monica Museum of Art, the Whitney Museum of American Art, the Solomon R. Guggenheim Museum, and Southern Exposure at Project Artaud in San Francisco. I thank all of these institutions, as well as the individuals who invited me to speak at them.

Three women at the forefront of a new generation of modernist art historians, Leah Dickerman, Brigid Doherty, and Christina Kiaer, have been longtime respondents and faithful allies. I am proud to work alongside them. Connie Wolf talked me through some of the most difficult moments in this project and, no less heroically, hired me at the Whitney when I really needed a job. Page duBois provided her magical blend of intelligence, warmth, and humor. Ira Sachs always believed in the value of my work, even when I did not. Other friends who furnished moral support and welcome distraction during the long life of the project include Anthony Aziz, Sammy Cucher, Paul Mele, Douglas Melton, Bill Clegg, Anthony Rapp, David Roussève, Conor McTeague, Cameron Sanders, and Sarah Williams.

Among the sweetest rewards of my research process was the chance to meet and come to know Paul Cadmus. Paul shared his art, his archives, his vivid memories, and his great good humor with me. Although he died in 1999 at the age of 94, Paul's life and work continue to inspire my own. Like Paul, several of the other artists discussed in this book shared insights about their work and access to their archives. I am grateful for the engagement of Felix Gonzalez-Torres, Glenn Ligon, Holly Hughes, and Loring McAlpin. This book is indebted to the scholars who have cleared a space for gay and lesbian studies within art history, including Deborah Bright, Emmanuel Cooper, Whitney Davis, Harmony Hammond, Jonathan Katz, Catherine Lord, James Saslow, Kenneth Silver, and Jonathan Weinberg. Without their scholarship, my own would have been, quite literally, unthinkable.

Throughout my life, I have been blessed with wonderful teachers, none moreso than the professors who introduced me to the field of art history at Yale University—Ann Gibson, Celeste Brusati, Robert Herbert, and Craig Owens—and those under whom I pursued advanced study at the University of California at Berkeley, including Svetlana Alpers, Carol Armstrong, Michael Baxandall, and Carol Clover. The three teachers with whom I worked most closely at Berkeley, Kaja Silverman, T. J. Clark, and Anne Wagner, each provided crucial intellectual gifts. With marvelous clarity, Kaja taught me about the interpretive power of psychoanalysis. Tim offered bold, bracing criticism and moved me with the craft of his writing. Anne, a superb advisor, invested equal parts rigor and generosity in our work together.

Aileen Meyer provided both sisterly and photographic support to this project. My brother Bruce advised me on legal and financial matters. My sister Robin offered kind words and interest. To them, as well as to my sister Sara, my sister-in-law Sharon, and my late father, Herb Meyer, I offer thanks and affection. I thank my extended family, Gladys and Betty Eisenstadt, for their warmth and support. And I honor the memory and love of Betty, Joseph, and Morris Kaplan.

My mother, Sherry Meyer, shaped my intellectual life from the first by stressing the power of learning and by presenting the world as a space of possibility.

Her originality and independence inspire my work; her kindness and devotion enrich my life.

For the last seven years, David Román has been my partner in every sense of the word—companion and confidant, co-conspirator and best friend. He saved this project several times over—helping me to write and re-write chapters, to clarify key ideas, and, sometimes, to just get on with it. His thinking and insights lie at the core of this book. Beyond his intellectual gifts, David has offered me his generosity of spirit, his joy in the everyday, and his open-hearted love. Sharing my world with him has made all the difference.

Contents

Outlaw Representation

I

The Red Envelope

On Censorship and Homosexuality

Dear————,

The enclosed red envelope contains graphic descriptions of homosexual
erotic photographs that were funded by your tax dollars. I'd never send you
the photos, but I did want you to know about the vile contents of your tax
funded material. You'll be as outraged as I am when you open the envelope.

You have just read the opening lines of a direct mail letter signed by the Rev-
erend Pat Robertson and dated October 25, 1989. The letter was printed and
distributed by the Christian Coalition, a conservative political organization that
Robertson had founded the week before.[1] Accompanying the letter was a sealed
red envelope (figure 1.1) that contained a list of descriptions of photographic
images crowned by the words "TAX-PAYER FUNDED" and "Photographs Too Vulgar
to Print." Here is the list:

1. A photo of a man with a bull-whip inserted in his rectum. This piece of
 "art" is listed as a self-portrait of the photographer.
2. A close-up of a man with his "pinkie" finger inserted in his penis.
3. A photo of a man urinating in another man's mouth.
4. A photo showing one man holding another man's genitals.
5. A photo of a man's arm (up to the forearm) in another man's rectum.
6. A photo of young pre-school girl with her genitals exposed.
7. A photo of naked children in bed with a naked man.
8. A photo of a man in a suit exposing himself.
9. A photo of a man with his genitals laying on a table.

FACING PAGE: Figure 1.1. Red envelope sent by the Christian Coalition, direct mail
letter, October 25, 1989. Courtesy People for the American Way, Washington, D.C.

Although it fails to provide the name of the photographer who created these pictures, the Christian Coalition's list focuses exclusively on the work of Robert Mapplethorpe. By October 1989, Mapplethorpe's photographs were at the center of a national controversy over federal funding to the arts, homoeroticism, and the limits of creative freedom.[2] The conflict over Mapplethorpe's work had begun the preceding June, when the Corcoran Gallery of Art canceled a full-scale retrospective of the photographer's work entitled *The Perfect Moment*. Several of the entries on the Christian Coalition's printed list of "Photographs Too Vulgar To Print" would have sounded familiar to anyone following the Corcoran controversy.[3]

The Christian Coalition's mailing fueled the public attacks on Mapplethorpe's work and on the National Endowment for the Arts (NEA). In so doing, however, the Christian Coalition enacted its own extravagant staging of homosexuality: the sealed red envelope; the warning (or promise) of "graphic descriptions" of "homosexual erotic photographs" within that envelope; and the numbered list of scenes featuring sadomasochism, naked children, and the repeated exposure and penetration of the male body. In its address to the reader, the mailing shifts between sexual salaciousness and censoring control, between a solicitation of the desire to see these "photos" and an enforced frustration of that desire in the name of righteous outrage. Here, for example, is the advice offered by the Reverend Robertson at the end of the letter: "IMPORTANT—I encourage you to exercise your freedom immediately by destroying the vulgar information about the photographs." Yet the "information" that Robertson urges us to destroy has been prepared, printed, and distributed by his organization. Whatever "vulgarity" that information carries in the context of this mailing is of (and by) the Christian Coalition's own design.

Each of the nine entries on this list means to describe a Mapplethorpe photograph, but, in fact, only eight of them do so. The exception is number 7, "a photo of naked children in bed with a naked man." No such photograph by Robert Mapplethorpe—or by any other federally funded artist—exists. A Mapple-thorpe portrait entitled *Jesse McBride* shows a naked boy sitting alone; another, entitled *Rosie*, portrays a semi-naked girl sitting alone (it is number 6 on the Coalition's list); and many Mapplethorpe photographs depict naked men, either alone or in pairs, though rarely are these men shown in bed. The picture described as entry number 7 has been created by the Christian Coalition, by the force of *its* fantasy of "a naked man" (Mapplethorpe himself?) consorting with "naked children."

Fantasy has been defined within a psychoanalytic context as a "purely illusory production" or, again, as "an imaginary scene . . . representing the fulfillment of a wish."[4] Yet, as philosopher Judith Butler argues, fantasy often functions by bracketing its status as illusory, by "postur[ing] as the real."[5] The Christian Coalition's list clarifies Butler's point. A fantasy of "naked children in bed with a naked man" is offered as though it were a description of the real, which is to say, an actual photograph by Robert Mapplethorpe.[6] The Coalition's list, with its numerical sequencing and seemingly objective language of description, constitutes each entry as equally real in the mind of the reader, with the real here functioning, paradoxically enough, as that which must be imagined by the reader, since the photographs themselves have been removed from visibility.

Why should it matter that "photo" number 7 never existed in the first place? It matters because behind the fabrication of nonexistent photographs lies an attempt to regulate and suppress actual works of art. It matters because the invented image of "naked children in bed with a naked man" exploits long-standing stereotypes of homosexual men as child molesters in order to dramatize the supposed indecency of federally funded art. And it matters because phantom images such as "photo" number 7 reveal how the Christian Coalition creates the forms of obscenity which it then adduces as proof of the "moral decadence that has invaded the heart of America."[7] The Christian Coalition's letter exemplifies a contradiction that recurs throughout the modern history of censorship: attempts to restrict or regulate sexually explicit images produce their own theater of sexual acts and imagery, their own fantasies of erotic exchange and transgression.

Outlaw Representation looks at the ways that particular artists have negotiated censorship, exploited it as a means of visibility, incorporated it into their work, or otherwise shaped their professional careers in response to it. In the case of Mapplethorpe (who died three months prior to the cancellation of *The Perfect Moment*), it would be left to others—including other artists—to respond to the public attacks on his work. In 1993, the painter and mixed-media artist Glenn Ligon created *Red Portfolio*, an installation of nine seemingly identical photographs arranged in a row along a gallery wall (figure 1.2). Each of the photographs bears a white text centered within a larger, monochromatic field of black. The texts are so small that they cannot be read from a distance. But as the viewer approaches the photographs, the texts resolve into a series of one-line phrases, each citing a different entry from the Christian Coalition's list (figure 1.3). Ligon returns to this list not to defend or reclaim Mapplethorpe's photographs but to underscore the terms of their distortion and attempted censorship by the Christian Right. All that can be seen (or, rather, read) in *Red Portfolio* are the small textual phrases—the puny traces of fear and fantasy—that the Christian Coalition has put in the place of Mapplethorpe's work. By printing photographs of each entry from the list of "Photographs Too Vulgar to Print," Ligon reveals the contradiction through which censorship incites our desire to see the very pictures that it simultaneously insists must not be shown.

Pleasures of Condemnation

The Christian Coalition's paradoxical investment in Mapplethorpe might best be understood in light of what anthropologist Carol S. Vance has called "the pleasures of condemnation." In a frequently reprinted essay, Vance describes the ways in such pleasures pervaded the 1985–86 hearings of the U.S. Attorney General's Commission on Pornography, also known as the Meese Commission:

> The atmosphere throughout the hearings was one of excited repression: witnesses alternated between chronicling the negative effects of pornography and making sensationalized presentations of "it." Taking a lead from feminist anti-pornography groups, everyone had a slide show: the FBI, the U.S. Customs Services, the U.S. Postal Service, and sundry

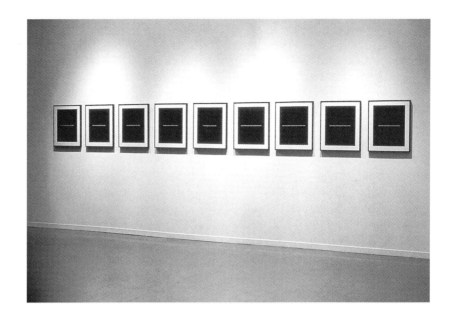

Figure 1.2.
Glenn Ligon, *Red
Portfolio*, 1993.
Photographic
installation, nine
gelatin silver
prints, each 16" ×
20". Courtesy
Glenn Ligon.

vice squads. At every "lights out," spectators would rush to one side of the room to see the screen, which was angled toward the commissioners. Were the hearing room a ship, we would have capsized many times.

Alan Sears, the executive director, told the commissioners with a grin that he hoped to include some "good stuff" in their final report, and its two volumes and 1,960 pages faithfully reflect the censors' fascination with the thing they love to hate.[8]

While the hearings sound almost comical in their resemblance to the peep shows and porn theaters they seek to close down, Vance makes clear that the commission's final report, with its ninety-two recommendations for legislation and law enforcement against the sale of sexually explicit images, was anything but laughable.[9] The contradictions, even the hypocrisy, that structured the Meese Commission hardly invalidated its regulatory power. Indeed, Vance argues that one measure of the commission's success lay in its ability to redirect sexual pleasure into moral and legal censure: "The large amount of pornography shown, ostensibly to educate and repel, was nevertheless arousing. . . . Unacknowledged sexual feelings . . . developed into a whirlwind of mute, repressed emotion that the Meese Commission channeled toward its own purpose."[10] The arousal produced by the screening of sexually explicit material could not be acknowledged within the context of the Meese Commission hearings. Yet, as Vance argues, sexual pleasure energized the proceedings in unspoken ways, "exciting" the disciplinary operations of restriction and regulation. Because "there was nothing but silence"[11] on the subject of sexual pleasure, the Meese Commission could exploit the contradiction between its declared aims (the condemnation of pornography) and its theatrical means (the incessant reproduction of pornography) without being called on to explain or address that contradiction.

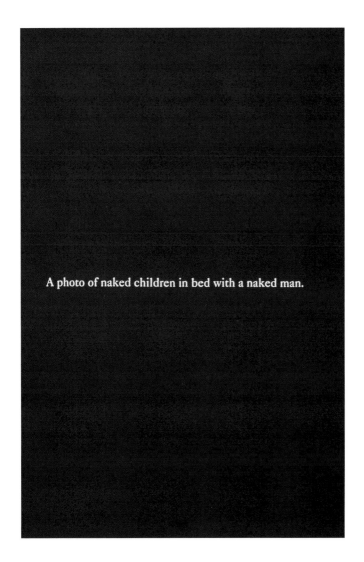

A photo of naked children in bed with a naked man.

Throughout her analysis of the hearings, Vance emphasizes the specifically visual force of the proceedings:

> Visual images dominated the hearings at all times. During screenings, pornographic images consistently captured the audience's attention with a reliability that eluded the more long-winded witnesses. . . . A rustle of excitement swept through the audience at the announcement of each showing. The chance to see forbidden material had obvious appeal. In between slide shows, the images of sex still loomed large, as witnesses testified under a blank projection screen whose unblinking, steady eye served as a reminder of the pornography whose nature had been characterized with seemingly documentary precision.[12]

The blank film screen recalls the contraband images that have just been projected on it. The empty screen functions as a site for the imaginary projection *of*

Figure 1.3. Glenn Ligon, *Red Portfolio*, 1993. Photographic installation (detail), one gelatin silver print, 16" × 20". Courtesy Glenn Ligon.

pornography in the absence of its material representation, as a site for the remembrance (and anticipation) of sexually explicit scenes by the commissioners and their audience. Vance's insights into the workings of the Meese Commission are crucial for understanding the broader relationship between censorship and sexuality in twentieth-century American culture. Like the regulation of pornography, the censorship of visual art functions by masking its constitutive dependence on—and pleasure in—the images it seeks to suppress. Like the Meese Commission, the censorship of visual art helps to create and sustain a symbolic space (or screen) of obscenity onto which any number of different pictures may be projected.

Outlaw Representation

Outlaw Representation approaches the censorship of visual art by studying quite particular examples of its operation, examples that all concern the representation of homoerotic desire by artists who identified themselves, with varying degrees of explicitness, as homosexual. The work of Paul Cadmus; Andy Warhol; Robert Mapplethorpe; David Wojnarowicz; the collective Gran Fury; and Holly Hughes constitute the case studies around which this book is organized.[13] These artists pursued different professional ambitions and stylistic commitments and labored under distinct historical conditions and constraints. Yet, in each case, their work was subjected to an act of censorship that marked a wider moment of anxiety concerning homosexuality. What range of responses did these acts of censorship provoke? How was the "problem" of homosexuality acknowledged—or avoided—in those responses? How did the circumstances of censorship serve both to suppress and to recirculate the art at issue?

Although it proceeds in a chronological fashion, *Outlaw Representation* does not propose a progressive history in which homosexual artists become ever more adept at negotiating the circumstances of censorship and overcoming the terms of stigma and invisibility. Nor do the artworks discussed in this book move toward increasingly affirmative representations of homosexual dignity and equality. For, as I shall argue, the "negative" image of homosexuality—the image of crime or sin, of sickness or stereotype—has constituted an essential part of the pictorial language on which artists from Paul Cadmus to Holly Hughes have drawn. To utilize the negative terms of homosexuality is not necessarily to endorse or accept those terms. It may also be to restage one's own outlaw status within a different register of representation and thereby to reopen the question of homosexuality for further inquiry.

This argument has been made most famously by philosopher and historian Michel Foucault in *The History of Sexuality: An Introduction*. According to Foucault, the invention of homosexuality as a perversion offered the building blocks through which a "reverse discourse" could be forged:

> There is no question that the appearance in nineteenth-century psychiatry, jurisprudence, and literature of a whole series of discourses on the species and subspecies of homosexuality made possible a strong advance of social controls into this area of "perversity"; but it also made possible the

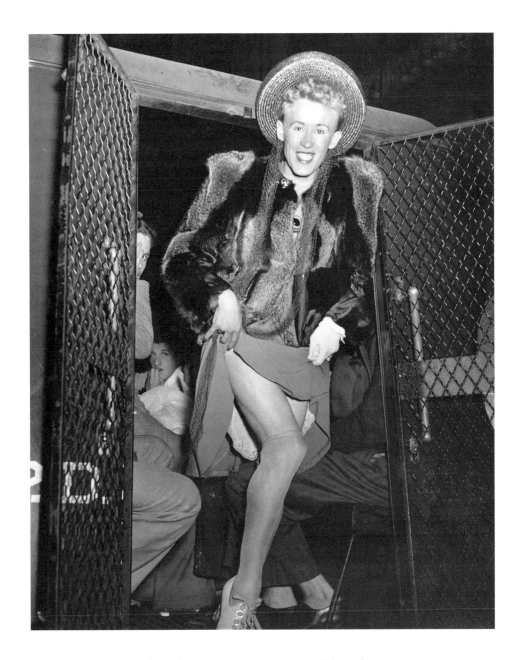

Figure 1.4. Weegee (Arthur Fellig), *The Gay Deceiver*, c. 1939. Gelatin silver print.
© Weegee 1998/International Center of Photography/Liaison Agency.

formation of a "reverse" discourse: homosexuality began to speak in its own behalf, to demand that its legitimacy or "naturality" be acknowledged, often in the same vocabulary, using the same categories by which it was medically disqualified.[14]

Foucault's concept of reverse discourse structures the central claim of this book: namely, that the regulation of homosexuality has provoked unanticipated responses and counterrepresentations, unforeseen pictures of difference and self-conscious stagings of deviance.[15]

I want to clarify this claim by turning to a visual image that both records and troubles the criminalization of homosexuality. In 1939, the tabloid photographer Weegee (a.k.a. Arthur Fellig) captured a drag queen—or "gay deceiver," as the picture's title put it—emerging from a paddy wagon (figure 1.4). Rather than submitting to the disciplinary force of the police by, say, hiding his face in shame, the "gay deceiver" makes the most of his appearance before the camera. He lifts his skirt high above the knee, smiles broadly, and steps daintily out of the wagon. The "gay deceiver" showcases his own theatrical flair and drag glamour even, and indeed especially, at the scene of his public arrest. Throughout the 1930s and early 1940s, Weegee shot many photographs of people (usually but not always men) in paddy wagons and police stations, of people being detained or arrested by the police (figures 1.5, 1.6). In most of these photographs, the subjects shield their face from the camera, as if to frustrate Weegee's attempt to render them visible in their moment of police detention. Weegee would himself complain, in his 1945 book *Naked City*, about men who, in the midst of being arrested, covered their faces or otherwise "gave me a lot of trouble as I tried to photograph them."[16] Far from giving Weegee any such "trouble," the subject of *The Gay Deceiver* appears to welcome the attentions of the camera. The drag queen stages his emergence from the paddy wagon as an occasion for self-display rather than public disgrace, as a moment of posing rather than punishment.

The Gay Deceiver portrays a homosexual subject, but it was not created by one. Indeed, the picture might be said to insist on the difference between the man in front of the camera (i.e., the transvestite, the "deceiver") and the man behind it (the photographer, the truth-teller). Throughout much of his professional career, Weegee sought to capture moments of social distress, urban disaster, and criminal deviance. He did so, in part, by following the police to crime scenes, vice raids, and public emergencies and by using infrared film, which could record even the most nocturnal of activities. In the case of *The Gay Deceiver*, however, the negative cast of Weegee's project has been reversed from within the frame of the photograph by a subject who openly embraces, even performs, his deviant visibility for the camera.[17]

With *The Gay Deceiver* in mind, I would like to return to the concept of reverse discourse as formulated by Foucault in relation to the modern history of homosexuality:

Take the case of homosexuality. Psychiatrists began a medical analysis of it around the 1870s—a point of departure for a whole series of new interventions and controls. . . . But [we see homosexuals] taking such discourses literally, and thereby turning them about; we see responses

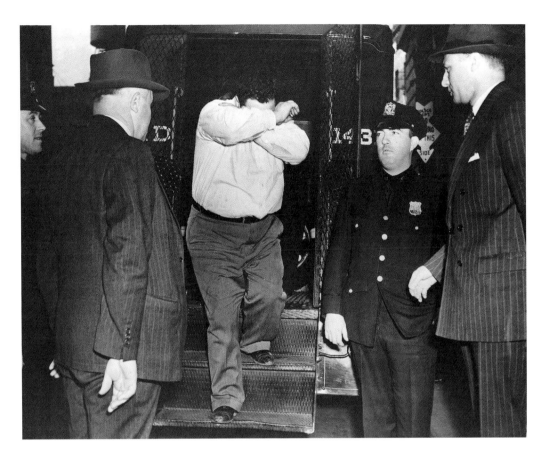

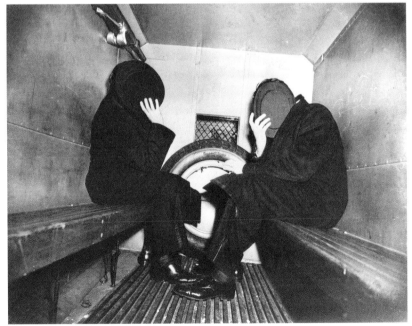

Figure 1.5. TOP
Weegee (Arthur Fellig),
*Barber Confesses to Murder of
Einer Sporrer, March 21,
1937.* ©Weegee 1998/
International Center of
Photography/Liaison
Agency.

Figure 1.6. BOTTOM
Weegee (Arthur Fellig),
*Charles Sodokoff and Arthur
Webber Use Their Top Hats to
Hide Their Faces, January 27,
1942.* ©Weegee 1998/
International Center of
Photography/Liaison
Agency.

arising in the form of defiance: "All right, we are what you say we are—by nature, disease, or perversion, as you like. Well if that's what we are, let's be it, and if you want to know what we are, we can tell you ourselves better than you can."[18]

The subject of *The Gay Deceiver* answers Weegee's camera in much the way Foucault describes homosexuals responding to the pathologizing discourse of late-nineteenth-century psychiatry. "All right," says the drag queen to the camera (and, by extension, to the viewer), "I'll be the deviant you say I am, but I won't be shamed by it. In fact, I will wear my deviance like a skirt, to be twirled and flaunted." *The Gay Deceiver* stands as part of a modern history in which homosexual subjects have restaged the criminal status to which they have been assigned so as to mark a visible difference and distance from it. The title of this book, *Outlaw Representation*, means to name that history. *Outlaw Representation* pictures the possibility that the law (whether the criminal code or compulsory heterosexuality) may be made to crack or buckle, that the punitive regulation of homosexuality may be forced to give way to other visions of social and sexual life.[19]

To counter the terms of one's own subjugation via the use of visual images is not, however, to overturn that subjugation or to change the social and material conditions that underwrite it. Each time I look at *The Gay Deceiver*, I am struck not only by this man's fabulous vamping but also by the fact that he is being led off to a police station to be booked on charges. However charismatic this figure may appear to us today, we should remember that he was treated as a criminal in 1939 and that it was only under the circumstances of police arrest that this (or any other) "gay deceiver" would have been photographed by Weegee.

Rather than focusing on the historical persecution of homosexual people (on, for example, the public arrest of drag queens in New York City circa 1939), this book attends to the ways in which homosexual visibility has itself been policed within the sphere of twentieth-century American art. It looks both at the suppression of work by gay artists and at how those artists resisted, reacted to, or represented that suppression. Andy Warhol, for example, responded to the criminalization of homosexuality by exploiting the gritty appeal of the police mug shot at the 1964 World's Fair. And Robert Mapplethorpe defied the historical censorship of homosexual imagery by insisting upon the aesthetic value of gay pornography. This is not to say that Warhol himself saw homosexuality as a criminal act or that Mapplethorpe conceived of gay culture as essentially pornographic. Rather, it is to suggest that Warhol and Mapplethorpe took the outlaw status of homosexuality and made it over into visual form. They reworked the phobic construction of homosexuality so as to counter that construction within the space of their art.

The nearly two hundred pictures reproduced in this book do not confirm or conform to any one theoretical model, although I summon various theoretical concepts (e.g., Foucault's reverse discourse) and interpretive methods to help me understand them. Nor do these images survey the social history of homosexual life in the United States, although particular moments in that history (e.g., early 1970s gay liberation) are discussed in some detail. Rather, I approach the pictures in this book as historical and theoretical objects in their own right, as

images that generate questions of interpretation as much as they resolve or explain them. In each chapter, artworks that once provoked censorship now provoke close visual analysis, archival investigation, and a return to the historical moment and artistic context of their production. The attention lavished on the visual images in *Outlaw Representation* responds to, and means to frustrate, the avowed mission of censorship, the mission of making these images disappear.

Having introduced the concept of "outlaw representation," I turn now to the three categories whose intersection this book seeks to map: "censorship," "homosexuality," and "twentieth-century American art." What follows is less a strict definition of these terms than a discussion of the ways in which they will be understood in the chapters that follow.

Censorship

Although this book does not mount a legal study of censorship, the symbolic force and repercussions of the law are discussed throughout. It seems appropriate, therefore, to consult the definition of "censorship" provided by *Black's Law Dictionary*: "The review of publications, movies, plays, and the like for the purposes of prohibiting the publication, distribution, or production of material deemed objectionable as obscene, indecent, or immoral."[20] Given that the language of the law strives for maximal clarity, this definition of censorship seems surprisingly ambiguous. What counts, for example, as a procedure of review? And is there a difference between reviewing materials "for the purposes" of prohibition and actually prohibiting their display or distribution? These questions are linked, in turn, to the problem of temporality. When, within the history of a work's production and display, may an act of censorship be said to occur? In defining censorship as a form of review, *Black's Law Dictionary* suggests that the work in question has been censored sometime after its completion. Yet the dictionary also includes the possibility of prohibiting "the production of material deemed objectionable," thereby implying an intervention prior to the work's completion, a preemptive strike or preview rather than a review. Given this range of temporal possibilities, how are we to map the relation between the production and censorship of works of art?

In the introduction to an anthology entitled *Suspended License: Censorship and the Visual Arts*, Elizabeth Childs suggests that "we may begin by defining censorship narrowly as a 'regulative' operation—that is, as a process by which works of art that have entered the public sphere are controlled, repressed, or even destroyed by the representatives of political, moral, or religious authority."[21] This definition helpfully locates censorship within a clear sequence of events: a work of art must first be created and then introduced into the public sphere before it can be censored. Yet, as we shall see, the act of censorship often prevents works of art from reaching the public stage for which they are intended. Paul Cadmus's 1934 painting *The Fleet's In!*, for example, was censored on the basis of its *reproduction* in the popular press, a reproduction that occurred three weeks prior to the painting's scheduled display at a museum in Washington, D.C. As in the case of *The Fleet's In!*, censorship sometimes flows not from the direct examination of an

artwork but from that work's reproduction in the press or from written or verbal descriptions by someone who has (or even, in some cases, has not) seen the work firsthand.

The most overt cases of censorship—the official suppression and material destruction of works of art—share a continuum with other, less conspicuous forms of regulation and restriction. The censorship of artistic expression may, in fact, be most effective when it is least perceptible, when virtually no one realizes that it has even occurred. As art historian Leo Steinberg has argued, "Censorship does not necessarily take the form of a direct assault or removal. Its cunning consists in denying its own operation and leaving no scars."[22] Such relatively invisible forms of censorship may be imposed on artists from without (by museums, galleries, or granting institutions operating "behind closed doors") or from within. In the latter case, artists may themselves decide to withhold or destroy works of art as a preemptive strike against external acts of censorship.

The phenomenon of self-censorship shifts our focus from the public to the private sphere, from the realm of institutional control to that of individual self-regulation. Yet these spheres cannot always be clearly distinguished or disentangled from each other. Tom Kalin, a member of the AIDS activist collective Gran Fury, has insisted on the link between internal and external modes of regulation: "To speak of censorship in the arts without first situating it within an elaborate series of permissions and withholdings which threaten to control every movement of our collective and individual bodies—would be a dangerous omission. Censorship proceeds from inside our lives and is imposed from the outside as well: a process which mirrors . . . the complex formation of our identities."[23] When Kalin speaks in the first-person plural of "our collective and individual bodies" or of "our identities," he is referring to those of lesbians and gay men. In the course of everyday life, gay people confront a range of psychic, social, and institutional prohibitions against homosexuality, from subtle forms of silencing to acts of open hostility and harassment. The censorship of homoerotic art, Kalin argues, reinforces and extends these prohibitions.

Outlaw Representation locates the suppression of art within an expanded field of "permissions and withholdings." Public acts of censorship will here be linked to private acts of self-regulation and instances of individual self-censorship tied to institutional forms of restriction. The history this book traces, and the works of art it examines, have been shaped by both psychic and social constraints, by both private and public forms of regulation. Coming to terms with that history means attending to censorship at the level of subjectivity and everyday life no less than to censorship at the level of museum policy or government programs.

In attempting to understand censorship as a force that "proceeds from inside our lives and is imposed from the outside as well," I have found Sigmund Freud's formulation of psychic censorship especially useful. In *The Interpretation of Dreams*, first published in 1900, Freud describes the process by which the unconscious wish at the core of the dream is concealed and reformulated into the dream's manifest content. By way of clarifying this process of reformulation (which he calls the "dream distortion"), Freud promises "to seek a social parallel to this internal event in the mind. Where can we find a similar distortion of a psychical act in social life?"[24] The parallel Freud finds is that of a writer who must camouflage the "difficult truths he has to tell" so as to avoid official reprisals:

A writer must beware of the censorship, and on its account he must soften and distort the expression of his opinion. According to the strength and sensitiveness of the censorship he finds himself compelled either merely to refrain from certain forms of attack, or to speak in allusions in place of direct references, or he must conceal his objectionable pronouncement beneath some apparently innocent disguise: for instance, he may describe a dispute between two Mandarins in the Middle Kingdom, when the people he really has in mind are officials in his own country. The stricter the censorship, the more far-reaching will be the disguise and the more ingenious too may be the means employed for putting the reader on the scent of the true meaning.[25]

What Freud describes in this passage is less the act of censorship than its effects. The threat of censorship compels indirection and "ingenious disguise" on the part of the writer. Censorship produces as well as prohibits writing; it consigns the writer not to silence but to the strategic use of suggestion and metaphor, of submerged meanings and encoded messages.

Freud repeatedly likens the distortion of the dream to an act of censorship in *The Interpretation of Dreams*.[26] He writes, for example, that "dreams are given their shape in individual human beings by the operation of two psychical forces. . . . One of these constructs the wish which is expressed by the dream, while the other exercises a censorship upon this dream-wish and, by the use of that censorship, forcibly brings about a distortion in the expression of the wish."[27] Censorship is here enacted by "individual human beings" (rather than by the State) on the expression of their own dreams (rather than on published writing or other forms of public expression). As he did in the case of the writer with "difficult truths to tell," Freud once again emphasizes the effects of censorship as both repressive and productive. Censorship demands the displacements, disguises, and distortions that conceal the unconscious wish at the core of the dream. But through that very process of concealment, censorship shapes the manifest content of the dream.

Throughout this book, I argue for a similarly dialectical concept of censorship. Like the censorship of dreams, the censorship of visual art functions not simply to erase but also to enable representation; it generates limits but also reactions to those limits; it imposes silence even as it provokes responses to that silence. Although I draw upon Freud's theory of psychic censorship in discussing the censorship of visual art, my interpretive method is quite distinct from that of dream interpretation. In *The Interpretation of Dreams*, Freud aims to decipher the distorting effects of censorship so as to reveal the hidden meaning (i.e., the unconscious wish) at the dream's core.[28] This book argues, by contrast, that the censored work of art can never be fully dissociated from the social and psychic conditions of its suppression. Rather than trying to retrieve the essence of the artwork as it may have existed prior to the effects of censorship, I chart the dynamic relationship between the two, between the regulation of art and the responses called forth by that regulation.

In this sense, my interpretive method resembles recent feminist studies of censorship rather more closely than it does Freudian psychoanalysis. In a 1988 book entitled *Cinema, Censorship, and Sexuality, 1909–1925*, Annette Kuhn argues

that censorship should not be conceived simply as an "act of prohibition, excision, or 'cutting-out'—a practice through which certain subjects are forbidden expression in representations."[29] Instead, she proposes that censorship be placed within an "ensemble of power relations"[30] marked by "unevenness, resistance, conflict and ongoing transformation."[31] By way of implementing such an approach, Kuhn employs a "case study" model in which she analyzes several early twentieth-century British films concerning sexuality in relation to the censorship controversies they aroused at the time of their initial release. Kuhn approaches these films not as random targets of censorship but as works created in response to the regulating gaze of the censor. Drawing upon her case studies as evidence, Kuhn argues that "censorship incites resistances, which in turn may provoke further gestures of censorship directed at maintaining the boundaries under challenge. Censorship, then, is an ongoing activity of definition and boundary-maintenance, produced and re-produced in challenges to, and transgressions of, the very limits it seeks to fix."[32] Kuhn describes what might be called a circuit of censorship. The censor sets limits and, by so doing, creates a class of materials (e.g., the indecent, the obscene) that have transgressed those limits or that threaten do so in the future. Conversely, materials defined as explicitly or potentially transgressive call forth the need for a censor to regulate them. Yet, as Kuhn demonstrates, censorship involves not just a regulator and an object to be regulated but also a wider set of ideological constraints and possibilities, of social, sexual, and creative limits and the ongoing process through which those limits are tested and redrawn.

Judith Butler has similarly argued that the censorship of language must be understood as a "productive form of power." Butler is careful to specify, however, that "by 'productive' I don't mean positive or beneficial, but rather, power as formative and constitutive, that is, not conceived exclusively as an external exertion of control or the deprivation of liberties. According to this view, censorship is not merely restrictive or privative, active in depriving subjects of the freedom to express themselves in certain ways, but it is also formative of subjects and the legitimate boundaries of speech."[33] Although in this passage Butler is discussing the censorship of spoken language, her claim is equally applicable to the suppression of art. Far from a solely restrictive force, the censorship of art functions as a powerful (if unwitting) generator of visual expression.[34]

In their approach to censorship as simultaneously prohibitive and productive, Butler and Kuhn draw upon Foucault's formulation of disciplinary power. "What gives power its hold," Foucault would observe in 1979, "what makes it accepted, is quite simply the fact that it does not simply weigh like a force which says no, but that it runs through, and produces things, it induces pleasure, it forms knowledge, it produces discourse; it must be considered as a productive network which runs through the entire social body much more than a negative instance whose function is repression."[35] Like Butler and Kuhn, I am indebted to Foucault for my understanding of censorship as a generative form of power. Far from "simply weigh[ing] like a force which says no," the censorship of art "forms knowledge," "produces discourse," even "induces pleasure." I depart from Foucault, however, by emphasizing the agency of individual subjects, and especially of individual artists, to create new visions of social and political possibility, to wield power as well as resist or react to it.[36] The artists discussed in this book

did not simply respond to the prohibitions visited upon their work. They also used their art to portray social and sexual worlds that could never be fully controlled by the force of censorship.

Homosexuality

As has been much discussed, the English word "homosexuality" is a medical invention of the late nineteenth century.[37] This is not to say that homosexuality was unknown or unregulated prior to its clinical designation as such but, rather, that individuals were not generally categorized according to sexual object choice.[38] The relatively recent coinage of the term "homosexuality" underscores its construction as a kind of identity (rather than an act or sin that anyone might potentially commit) and the rootedness of that identity in historically specific practices of language, medical science, and culture.

The conceptual shift from homosexuality as a set of proscribed acts to "the homosexual" as a distinct kind of person was never a smooth or seamless transition. Preexisting notions of homosexuality as a sin or crime continued, and still continue, to jostle alongside more modern constructions of homosexual identity.[39] As a result of this slippage between acts and identities, homosexuality has remained a peculiarly unstable category, even and perhaps especially at its moments of greatest visibility. According to literary critic Jonathan Dollimore, "The more homosexuality emerges as culturally central the less sure become the majority as to what, exactly, it is: a sensibility, an abnormality, a sexual act, a clandestine subculture, an overt subculture, the enemy within, the enemy without?"[40] The definitional problem of homosexuality here issues in a kind of paratactical proliferation: insofar as it might surface anywhere, homosexuality must be everywhere policed. The threatening instability of homosexuality would seem to oppose the legitimacy of heterosexuality and the traditional social forms (e.g., marriage, biological reproduction, child-rearing) that underwrite it. Yet by including "the enemy within" on his list of descriptive possibilities, Dollimore suggests the power of homosexuality to breach the boundaries and very constitution of the heterosexual majority.

"Homosexuality," writes critical theorist Diana Fuss, "is produced inside the dominant discourse of sexual difference as its necessary outside, but this is not to say that the homo exerts no pressure on the hetero nor that this outside stands in any simple relation of exteriority to the inside."[41] Rather, heterosexuality carries homosexuality within it—as a fantasy of transgression, as an image of alterity, as a possibility at once desired and disavowed. The doubleness of homosexuality is nicely encapsulated by a gay liberation slogan from the early 1970s: "I am your worst fear," gay men and lesbians declared to onlookers, "I am your best fantasy" (figures 1.7, 1.8).[42] Condensed within this slogan is an understanding of homosexuality as a site of both anxiety and fascination for the dominant culture. Part of the slogan's flamboyance lies in the way it foists homosexuality onto every non-gay-identified listener, including closeted homosexuals. The slogan reverses the inside/outside relation of normative heterosexuality and marginalized homosexuality such that it is now the self-declared homosexual who claims knowledge of, and even inhabits, the psyche of the "straight" listener. Even as the

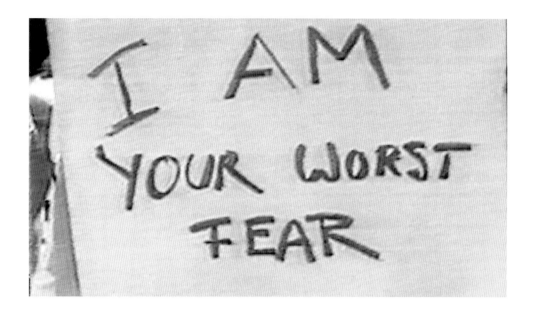

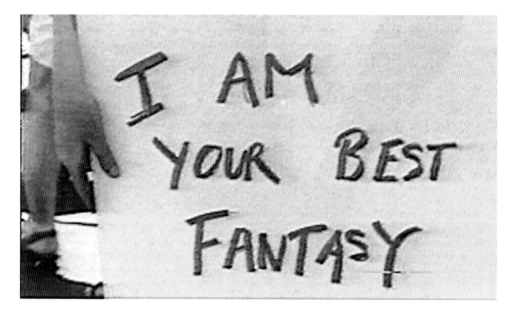

Figure 1.7. TOP
"I Am Your Worst Fear," c. 1970. Gay liberation placard (detail), archival footage featured in *A Question of Equality: Part 1* (film documentary, 1994), Testing the Limits Collective.

Figure 1.8. BOTTOM
"I Am Your Best Fantasy," c. 1970. Gay liberation placard (detail), archival footage featured in *A Question of Equality: Part 1* (film documentary, 1994), Testing the Limits Collective.

slogan identifies its speaker as gay or lesbian, it simultaneously positions homosexual desire deep inside the imaginary of the dominant culture. Homosexuality is thus conceived not simply as an identity that is "owned" by gay people but as a site of sexual and symbolic power that is under continual dispute, both by those who identity themselves as gay or lesbian and by those who do not.

In his 1972 book *Homosexual Desire*, the French writer and gay liberation activist Guy Hocquenghem offers an especially vivid account of this dispute:

> If the homosexual image contains a complex knot of dread and desire, if the homosexual fantasy is more obscene than any other and at the same time more exciting, if it is impossible to appear anywhere as a self-confessed homosexual without upsetting families . . . then the reason must be that for us twentieth-century westerners there is a close connection between desire and homosexuality. Homosexuality expresses something—some aspect of desire—which appears nowhere else, and that something is not merely the accomplishment of the sexual act with a person of the same sex.[43]

The "homosexual image" that opens this passage is less the material representation of homosexuality than the imaginary picture it summons in the mind of "twentieth-century westerners." Hocquenghem understands homosexuality not as a simple positivity, nor even as an oppositional identity, but as a place-marker for "something—some aspect of desire" that cannot be assimilated by the larger culture.

Outlaw Representation likewise approaches homosexuality not simply as the "accomplishment of the sexual act with a person of the same sex" but also as a symbolic image, "a complex knot of dread and desire" that may be set to any number of different tasks, including explicitly homophobic ones. That the "homosexual image" continues to arouse both dread and desire in American culture may be demonstrated not only by the recent controversies over federal funding to the arts but also by political conflicts that would, on the face of it, seem quite removed from questions of visual representation. Recall, in this context, Bill Clinton's ill-fated plan to end the federal policy of dismissing lesbians and gay men from the armed services. Television news stories on the "gays in the military" debate in late 1992 and early 1993 often featured images of military men in showers, toilets, and multiple-berth barracks. Such images were meant to dramatize the close quarters and intimate physical conditions of military life and to suggest the problems that would arise (i.e., the desires that would be aroused) should self-identified homosexuals gain access to these spaces. The January 25, 1993, edition of the *NBC Nightly News*, for example, featured a story on the military ban entitled "Will It Work?" The story opened with the title question superimposed upon a shot of two showerheads spewing water (figure 1.9). Following this shot, the camera panned down to reveal the shaven heads and upper torsos of two men (presumably members of the armed forces) as they showered in close proximity to each other. The camera then pulled back to reveal several more men (and several more showerheads) within the same communal space. Finally, the camera cut back to the original two men, now framed from behind, as they emerged from the shower and, their bodies still glistening with water, proceeded toward a row of toilet stalls (figure 1.10).

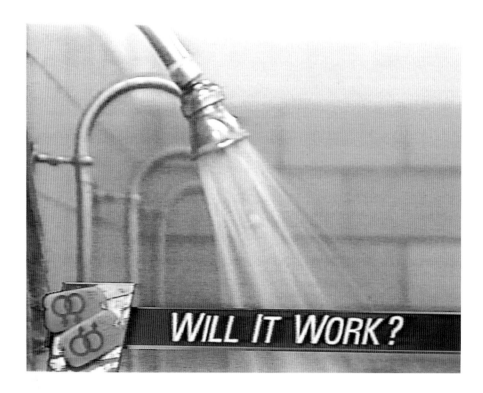

WILL IT WORK?

Figure 1.9.
"Will It Work?"
NBC Nightly News,
January 25, 1993,
photo by the
author.

Intrigued by this remarkable televisual image, I phoned the NBC studios in
New York City to find out more about the footage (e.g., where and how did they
get it? who shot it and why?). According to the line producer of the "Will It
Work?" segment, the footage was originally shot as part of a 1988 story on
American marines undergoing P.O.W. training in the Panamanian jungle.[44] A
camera crew had accompanied the marines throughout a week of strategic exer-
cises. It was not until the end of that week that the marines were permitted
access to showers and running water. By this time, according to the line pro-
ducer, the marines were so desensitized to the presence of the camera crew and
so focused on their long-deferred showers that they didn't care who was watch-
ing (or filming) them.

Within the original logic of the 1988 story, then, the image of showering
marines signified the successful completion of a grueling training procedure.
Within the terms of the 1993 story, however, that same image signaled the naked
vulnerability of the male body within the close confines of military life.[45] In this
context, it should be noted that the image of lesbians in the military was rarely (if
ever) sexualized in the same way within the press coverage of the ban, even
though women in the armed services face a greater likelihood of dismissal on
grounds of homosexuality than do their male counterparts.[46] Given that homo-
phobia is directed against both women and men in the U.S. military, it seems par-
ticularly telling that the *image* of men in showers and barracks should have been
so anxiety-producing for American popular and political culture in late 1992 and
early 1993. Why would the image of naked women in showers not have "worked"
within the representational economy of news stories such as "Will It Work?"

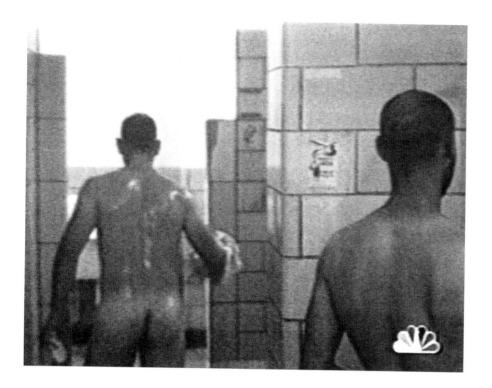

This question opens onto a larger discontinuity in the historical representation of male and female homosexuality, a history in which the latter has far more often been rendered invisible (or unthinkable) than the former. When female homoeroticism has been represented within twentieth-century American art and visual culture, it has often been on terms that imply or manifestly include a male viewer. In such cases, lesbianism is at once denied and deflected into a heterosexual scenario of leering male pleasure.[47] One need only to consider the conventions of "straight" pornography (in which men have sex with women, and women have sex with women, but men never have sex with men) to confirm the continuing force of this asymmetry.[48] While heterosexual pornography lays bare the disparity between male and female homoeroticism most explicitly, that same disparity shapes mass-cultural images such as the shower sequence in "Will It Work?" Although the U.S. military discriminates even more harshly against lesbians than against gay men, the image, and perceived menace, of male homosexuality are typically summoned to justify that discrimination. The naked men in "Will It Work?" reveal how the phobic, if secretly fascinated, staging of male homoeroticism may be directed not only against gay men but against lesbians as well.

Outlaw Representation does not deal in detail with the censorship of lesbian artists, a topic that raises a discrete set of questions about the historical terms of lesbian visibility and merits its own full-length study. The formation of lesbian and gay male subcultures in the United States is marked less by parallelism than by deep asymmetries in terms of social history, material resources, and modes of self-representation. While significant alliances have sometimes been forged

Figure 1.10. "Will It Work?" *NBC Nightly News*, January 25, 1993, photo by the author.

between lesbian and gay male subcultures (as, for example, in the early gay liberation movement of the 1970s and in the AIDS activist movement of the late 1980s and early 1990s), those alliances are, regrettably, more the exception than the rule.[49]

For a work of art to arouse a public controversy, it must cross a certain threshold of visibility—whether through museum or gallery exhibition, visual reproduction in the press, or public attacks by would-be censors. Until quite recently, visual art by and about lesbians has been restricted from reaching this threshold of visibility within American culture.[50] In this sense, lesbian artists have been subjected to a prior—and more profound—form of censorship than that visited upon the gay male artists discussed in *Outlaw Representation*.[51] That lesbian art did provoke public controversy in the United States in the early 1990s is a phenomenon I discuss in the afterword to this book. The afterword, which focuses on the work (and federal defunding) of the performance artist Holly Hughes, does not claim to compensate for the preceding absence of lesbian art in this book. It does suggest, however, that the relative invisibility of lesbian art—and of public conflicts concerning lesbian art—constitutes a "structuring absence" within twentieth-century American culture, an absence imposed not by chance but by historically specific exclusions and inequities.[52]

This book's focus on male homosexuality is intended not as yet another erasure of women's history and experience but as a contribution to the field of lesbian and gay studies, a field that, at its best, attends to the distinctness of lesbian and gay male histories without construing the two as simple parallels or pendants. It is my hope that the specificity of *Outlaw Representation*, its insistence on asking the same set of questions (about art, censorship, and homosexuality) about several different moments in twentieth-century American culture, will make it useful to those who are asking similar questions about other artists, other histories, and other forms of social and material constraint.

BEFORE CONCLUDING this section, I want to add a few words of clarification about the concept of "homosexuality in art." Works of art do not, of course, possess sexual orientations. To speak of homosexuality "in" art might therefore seem semantically imprecise, if not outright illogical. Nevertheless, the term has gained currency in scholarly work (including my own) that links the history of art to questions of homosexual experience and desire.[53] One problem with the concept of "homosexuality in art" is that it tends to collapse the sexual identity of an artist with the content of his or her work. Art history needs to move beyond an interpretive model that locates homosexuality as an effect of biography on the one hand and iconography on the other, as a theme (or scene) that marks the life and work of particular artists. It is not that the questions now put by art historians to, say, the early-twentieth-century painter Marsden Hartley ("What were Hartley's relationships with women? Was he exclusively homosexual?")[54] should be placed out of bounds. It is, rather, that the relevance of such questions to this (or any) artist's work must be argued for rather than assumed.

The place of homosexuality within modern art cannot be confined to biographical facts or pictorial subtexts, to private messages or secret codes that need

only to be cracked by the attentive art historian. Rather, the relation between homosexuality and modern art must be charted as a dialectic between historical possibility and constraint, between public discourse and private knowledge, between the visual image and that which lies beyond the boundaries of the imaginable at a given moment.

For just this reason, however, the concept of "homosexuality in art" remains crucial. The history of homosexuality in the United States has both shaped and been shaped by visual images, including but not limited to works of art.[55] The homoerotic drawings of Tom of Finland from the 1950s, 1960s, and 1970s (figure 1.11), for example, are often credited with popularizing the frankly macho style of post-Stonewall (i.e., post-1969) gay culture. In 1982, *The Advocate*, a nationally distributed gay magazine, described Tom of Finland as "the Scandinavian folk artist whose drawings have probably done more to shape the leather image than any other single force."[56] The magazine then quoted a San Francisco gallery owner named Peter Hartman who claimed that "it is the first time in the history of art, that an actual imagery has produced a subculture."[57] Hartman's claim, while overblown, suggests the indebtedness of post-Stonewall gay culture to prior images of homosexual fantasy and embodiment. In this context, it is worth noting that Tom of Finland drew upon the example of Paul Cadmus (an artist of a slightly older generation) as a source for his muscular, bulgingly erotic figurations of the male body.[58] Insofar as we can speak of artists such as Cadmus or Tom of Finland as helping to produce (rather than simply record) a public imagery of gay desire and identity, then the concept of "homosexuality in art" becomes more viable.

In order to map the complex relations between art and homosexuality, we must allow for what the psychoanalytic critic Jacqueline Rose describes as an "idea of sexuality which goes beyond the issue of content to take in the parameters of visual form (not just what we see but how we see—visual space as more than a domain of simple recognition)."[59] *Outlaw Representation* attempts to understand how both homosexuality and its prohibition have structured the visual field at particular art-historical moments, drawing attention to certain images and interpretive possibilities and away from others. The book foregrounds a history in which absence matters as much as presence, a history shaped no less by the suppression of art than by its expression. Even as it focuses on specific artworks and the artists who made them, *Outlaw Representation* also looks at what does not appear within—at what has been made to disappear from—the history of twentieth-century American art.

Twentieth-Century American Art

Art historians typically divide twentieth-century American art into two distinct eras: an isolationist, pre–World War II period dominated by realism, and a post–World War II period dominated by modernist painting in which abstract expressionism emerges as the leading light of the international avant-garde.[60] This split between prewar realism and postwar modernism continues to structure the professional divide between "Americanists" and "modernists" within the

field of art history.[61] The former usually teach American art from the colonial period through the middle of the twentieth century, while the latter cover nineteenth- and early-twentieth-century European art as well as postwar American and, to a somewhat lesser extent, postwar European art.

In addition to the split between realism and modernism, the issue of aesthetic quality also divides the history of twentieth-century American art. As Jules Prown, a prominent historian of American art, pointed out in 1984, "Pre–World War II American art is still considered by the art historical establishment . . . as below the aesthetic level of other schools."[62] Wanda Corn, another leading Americanist, has similarly observed that "critics and historians of [prewar] American art have pursued their work knowing that the objects they study are considered inferior by others. This has often led them to be overly apologetic."[63] Both Prown and Corn go on to point out the unexpected benefits of working on "inferior" art: namely, a less hierarchical approach to the history of art and a willingness to engage a wider range of visual materials. Corn, writing in 1998, put the issue this way:

> There . . . seems to be an increased tendency, barely perceptible a decade ago, for art historians to take their skills as visual analysts into new domains. It is now an everyday occasion to find scholars who once confined themselves to art in museums looking at Hollywood films, advertisements, [and] popular illustrations. . . . Although it is too early to assess whether this move will unhinge the hold that the fine arts have traditionally had on historians of the visual, it is noteworthy—and quite understandable—that art historians dealing with American culture have shown greater flexibility and curiosity about the circulation of popular images than scholars dealing with other nations and cultures.[64]

Already accustomed to dealing with noncanonical art, Americanists are, as Corn sees it, more open to the study of popular images and material culture than their counterparts in other art-historical fields.[65] Corn's argument, while appealingly anti-elitist, is not entirely sufficient or persuasive for the purposes of this book. In my case, it was the study of feminist art history, rather than of prewar American art, that forced a rethinking of what might count as an "appropriate" object of art-historical study and of why objects of scholarly study were categorized as "appropriate" or "inappropriate" in the first place. I think in particular of the work of Linda Nochlin, Lisa Tickner, and Anne Wagner and of the confidence with which these (and other) feminist art historians have retooled the study of modern art to address issues of gender, power, and the exclusions imposed by history.[66] These scholars have traced the relation between art and female identity without rendering either category into a transparency or essence of the other.[67] Their work has inspired my own questioning of disciplinary conventions and art-historical methods in *Outlaw Representation*.[68]

Like feminist art history, the study of art and homosexuality must confront the question of how to make historical constraints visible. "One of the problems in tracing the history of homosexuality," writes the Americanist art historian Jonathan Weinberg, "is that it is a history that was never meant to be written."[69]

Figure 1.11. *Physique Pictorial* (April 1961), cover by Tom of Finland. Courtesy Gay, Lesbian, Bisexual, Transgender Historical Society of Northern California, San Francisco.

In order to trace—or write—such a history, we must be willing to look in places (and at pictures) that are not "properly" within the domain of traditional art-historical scholarship. To this end, *Outlaw Representation* situates works of art alongside advertisements, activist posters, publicity images, news photographs, law-enforcement manuals, popular cartoons, physique magazines, and commercial pornography. The visual objects I have already highlighted in this chapter—a red envelope, an installation by Glenn Ligon, three Weegee photographs, an activist placard, and two stills from a network news story—indicate the range of images considered in *Outlaw Representation*. That this book attends no less to Christian Coalition mailings and gay liberation posters than to oil paintings and art photographs does not mean that the visual and material differences among these objects will be ignored. To look with a certain intensity at, say, a red envelope is not to argue for the aesthetic value or formal complexity of such an object. Rather, it is to insist on the significance of that object within the public history and contested politics of both homosexuality and modern art.

This book does not seek to elevate vernacular materials to the status of high art. Nor does it conform to what the modernist art historian Carol Armstrong has disparagingly called a "cyberspace model of visual studies," in which all pictorial objects, including canonical artworks, are stripped of their material specificity and reduced to so many bits (or bytes) of information.[70] Instead, *Outlaw Representation* argues that the censorship of twentieth-century art necessarily opens onto wider fields of visual culture and social history. The book follows particular works of art as they move, or are forced, out of the gallery and the museum and into the pages of the popular press, the chambers of the Senate, the arenas of public protest, the transcripts of legal proceedings, and the printed matter of censorship campaigns.

While *Outlaw Representation* is intended as a contribution to the study of twentieth-century American art, it is concerned neither with modernist narratives of stylistic innovation nor with Americanist questions of national tradition. Instead, it traces an alternative—and admittedly selective—history of modern American art in which questions of homosexuality and artistic freedom come into contact, and often into conflict. These moments of contact are not simply waiting, fully formed but heretofore ignored, to be retrieved by scholars equipped with the right tools and techniques. Rather, these moments are themselves marked by erasures and ellipses, by secrets and structuring absences. By writing such moments into art history, I mean to illuminate the social, psychic, and institutional constraints that have shaped the visibility, but also the invisibility, of homosexuality within twentieth-century American art.[71]

Case Studies

This book begins, chronologically speaking, with the work of Paul Cadmus in the early 1930s because that work marks the first moment (to my knowledge) in which American art depicting homosexuality was not only produced but also exhibited, reviewed, reproduced, and publicly censored. A complex interplay of social and artistic factors permitted Cadmus to depict homosexuality at this early moment. Broadly speaking, these factors include the realist tendencies of

American painting during the 1930s, especially the emphasis on urban leisure and erotic diversion favored by such artists as Reginald Marsh; the availability of an artistic circle that included fellow writers and artists who identified themselves, if in necessarily limited ways, as homosexual; the formation and increased visibility of gay male subcultures throughout the 1920s and early 1930s; and the circulation of a stereotypical image of effeminate male homosexuality in contemporary popular culture.[72] From an interpretive standpoint, the most salient problem is how to describe the relationship between Cadmus's art and the larger culture on which it drew. How, in other words, do we connect what is represented within Cadmus's pictures to what occurred in the social world beyond them without collapsing the two? How do we determine the relation between visual "text" and historical "context" without having the latter serve as merely the backdrop against which the former unfolds?

Such questions arise not just in the case of Cadmus but in that of every artist treated in *Outlaw Representation*. In attempting to address them, I have organized this book as a series of case studies.[73] Each of the next four chapters (and, more briefly, the afterword) focuses on a different artist or art collective and the terms under which their work was produced, displayed, reproduced, criticized, suppressed, or censored outright.[74] My decision to "zoom in" on a limited number of artists allows for a certain depth of historical detail and visual description. That decision carries its own problems and potential pitfalls, however, not least those of overemphasis (of the selected artists) and exclusion (of everyone else). "A common danger in case studies," cautions historian Donna Penn, "is the tendency to claim too much significance for a local site. At its best, the case study reveals the features distinctive to a particular site while analyzing how those particulars illuminate, challenge, contribute to, or alter our general theories and assumptions."[75] *Outlaw Representation* knowingly courts the danger of overvaluing its local sites, of spending too much time on specific images, artists, and historical episodes and not enough on "general theories and assumptions." Given the core concerns of this book, however, such a danger may be all but unavoidable. However carefully we chart the terrain on which censorship and homosexuality intersect within twentieth-century art, that terrain shifts and slides beneath our feet, not least because of the various constraints that continue to restrict our view of it. The best we can do is to measure the terrain inch by inch, image by image, and case by case, knowing all the while that it will never look quite the same way again. Here, then, are the case studies that comprise the rest of this book.

Chapter 2, "A Different American Scene: Paul Cadmus and the Satire of Sexuality," considers the early career of a realist painter whose work was exposed to public condemnation and censorship. In 1934, Cadmus's oil painting of sailors on shore leave was confiscated by the United States Navy shortly before its intended display at the Corcoran Gallery in Washington, D.C. Taking that episode as a point of departure, the chapter discusses how Cadmus alternately defied and accommodated the prohibitions imposed on his work in the 1930s.

Chapter 3, "Most Wanted Men: Homoeroticism and the Secret of Censorship in Early Warhol," places Andy Warhol's work of the 1950s and early 1960s within a dialectic of professional constraint and creative reinvention. It considers the various restrictions that shaped Warhol's early work, from the rejection of his

"boy" drawings in the late 1950s to the censorship of his mural *Thirteen Most Wanted Men* at the 1964 World's Fair.

Chapter 4, "Barring Desire: Robert Mapplethorpe and the Discipline of Photography," focuses on Mapplethorpe's representation of censorship within his little-known collages of the early 1970s and on the erotics of discipline within his famous s/m photographs of the late 1970s. The chapter concludes by examining how Mapplethorpe's portrayal of both censorship and sadomasochism was reframed by the conflicts over *The Perfect Moment* in 1989–90.

Chapter 5, "Vanishing Points: Art, AIDS, and the Problem of Visibility," looks at the censorship of AIDS-related art in the wake of Mapplethorpe's death. It argues that the threat of censorship was compounded by the cultural anxieties surrounding homosexuality within the context of the AIDS epidemic. Public controversies provoked by the work of Gran Fury, an AIDS activist art collective, and David Wojnarowicz, a mixed-media artist and writer, provide the chapter's case studies.

The afterword, "Unrespectable," discusses the symbolic force of the NEA's so-called decency clause, as well as Holly Hughes's response to, and creative reworking of, the legislative demand for decent art.

Each of the chapters described above begins with an idiosyncratic detail: an unexpected juxtaposition of paintings, a discrepancy in the telling of an anecdote, a hidden link between art and politics, a public moment of rhetorical excess. These details provide an entrance, however narrow, into the historical field of constraint and possibility within which the artists at issue operated. Given this book's reliance on overlooked details and repressed knowledges, it seems appropriate to end the introduction by returning to Freud and his theory of dream censorship.

The Best Bit

In a footnote added to *The Interpretation of Dreams* in 1919, Freud recounts the dream of the "love services" (*Liebesdienste*), in which a female patient dreams that her offer to attend to wounded soldiers on the front is mistaken as an offer to perform sexual "services" on the troops. Throughout the course of the dream, the patient replaces the word "service" with what Freud calls "an incomprehensible mumble." When, early in the dream, the woman mentions her desire to volunteer to a group of male military officials, Freud reports that

> the actual wording of her speech in the dream was: "I and many other women and girls in Vienna are ready to . . ." at this point in the dream her words turned into a mumble ". . . for the troops—officers and other ranks without distinction." She could tell from the expressions on the officers' faces, partly embarrassed and partly sly, that everyone had understood her meaning correctly. . . . There followed an awkward silence of some minutes. The staff surgeon then put his arm round her waist and said: "Suppose, madam, it actually came to . . . (mumble)."[76]

The female patient could not admit the image of "servicing" the soldiers—or, indeed, the very word "service"—into consciousness, even within the relatively relaxed zone of the dream.[77] In commenting on this case of dream censorship, Freud addresses his reader in the following manner:

> You will, I hope, think it plausible to suppose that it was precisely the objectionable nature of these passages that was the motive for their suppression. Where shall we find a parallel to such an event? You need not look far these days. Take up any political newspaper and you will find that here and there the text is absent and in its place nothing except the white paper is to be seen. This, as you know, is the work of the press censorship. In these empty places there was something that displeased the higher censorship authorities and for that reason it was removed—a pity, you feel, since no doubt it was the most interesting thing in the paper—the "best bit."[78]

The passages that provoke press censorship are, for Freud, "no doubt the most interesting thing in the paper." But is it the act of censorship that retroactively imbues these lost passages with their status as "the best bit"? Is it the visible trace of absence, the "nothing" of the white paper where print once appeared, which renders that which remains legible less "interesting" in Freud's eyes?

Freud does not pursue these questions in *The Interpretation of Dreams*. So as to think further about these issues within the context of homosexuality and American visual culture, let us turn from the example of Freud's political newspaper to that of a photograph that similarly registers the "empty place" of censorship. Several years ago, I purchased a beefcake picture for three dollars from a shop called Gay Treasures in Greenwich Village (figure 1.12).[79] Along with two or three hundred other physique photographs, the picture was housed in a cardboard box labeled "1950s." On the back of this particular photograph, the name "Ben Montgomery" had been penciled in, a reference, so the clerk at Gay Treasures told me, to the name of the model portrayed (rather than, as in some cases, the name of the photographer). The most striking aspect of the photograph, and indeed the reason I purchased it, is the large white band that cuts diagonally across Ben Montgomery, bisecting his body into upper and lower zones while blocking out his genitals and upper thighs altogether. Rather than a piece of tape affixed to the photograph (and thereby removable from it), the white band is coincident with the surface of the image. It constitutes the photographic image no less than does Montgomery's carefully if slightly awkwardly posed body, the rectangular pedestal on which he rests, the diamond-patterned carpet beneath his feet, and the pleated screen behind him.

The white band both arouses and frustrates our desire to see what lies beneath it, to see "the best bit" of Ben Montgomery's portrait. As viewers of this photograph, we may try to imagine it prior to the imposition of the diagonal white band. Yet the partially blocked picture is all that survives. Indeed, the partially blocked picture may well be the only version of this photograph ever printed or circulated. Given these conditions, I would suggest that we see the portrait of

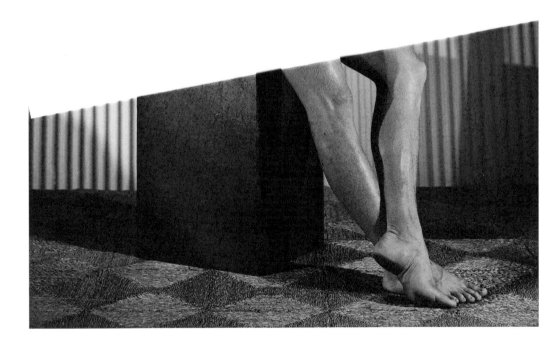

Figure 1.12. Anonymous, *Ben Montgomery*, 1950s physique photograph. Author's collection.

Ben Montgomery as a record of both desire and its suppression, of both homo-erotic display and its clumsy yet insistent refusal. We cannot simply remove, read through, or otherwise dismiss the mark of censorship, however much we might wish to do so. It demands to be reckoned with as part of the picture and as part of the historical past. This book is one attempt at that reckoning.

FAMOUS PAINTINGS BY MODERN AMERICAN ARTISTS

1. "Daughters of the Revolution," by Grant Wood (1892–) (1889–)
2. "Lighthouse at Two Lights," by Edward Hopper (1882–) 4. "Baptism in Kansas," by John Steuart Curry (1897–)
3. "Jealous Lover of Lone Green Valley," by Thomas Hart Benton 5. "Gilding the Acrobats," by Paul Cadmus (1904–)

A Different American Scene

Paul Cadmus and the Satire of Sexuality

The entry under "painting" in the 1941 *Encyclopaedia Britannica* includes a full-page spread showcasing five "Famous Paintings by Modern American Artists" (figure 2.1).[1] Appearing in the left-hand column of the spread are Grant Wood's *Daughters of Revolution*, a portrait of three tea-sipping spinsters seated before a framed reproduction of *Washington Crossing the Delaware*; Thomas Hart Benton's *The Jealous Lover of Lone Green Valley*, a picture based on a Ozark folk song in which a woman, wrongly accused of infidelity, is stabbed to death by her lover; and John Steuart Curry's *Baptism in Kansas*, a scene of the Christian ritual as witnessed by a small-town congregation on the flatlands. These three paintings are commonly said to typify Regionalism, the loosely yoked artistic movement that focused on the life and lore of small-town America.[2] The upper-right-hand painting, Edward Hopper's *Lighthouse at Two Lights*, though not associated with Regionalism, offers an austerely idyllic view of a rural American locale, the coast of Maine near Cape Elizabeth, and the larger series of lighthouse paintings from which it derives remains one of the artist's most admired.

The last and largest reproduction in the layout is of Paul Cadmus's *Gilding the Acrobats*, an oil and tempera painting from 1935. Unlike the other "modern American artists" featured in the spread, unlike virtually *every* other American artist of the 1930s, Cadmus focuses quite insistently on the male nude. As the 1937 *Life* magazine pointed out, Cadmus typically emphasized "the play of muscles and the stretch of skin above them."[3] Yet the "play of muscles" in a picture such as *Gilding the Acrobats* does not celebrate the well-built male body so much as it exaggerates that body nearly to the point of contortion. For all their bulging physicality, Cadmus's male nudes rarely seem comfortable in their own skin.[4]

FACING PAGE: Figure 2.1. "Famous Paintings by Modern American Artists," *Encyclopaedia Britannica*, vol. 17 (1941), plate 24. Courtesy Encyclopaedia Britannica.

Consider, for example, the snarling expression of the central acrobat as he encounters his own forearm and flexing muscles. Nothing else in the *Britannica* spread—not Wood's mordant spinsters, not Benton's folksy, pop-out figures—prepares us for Cadmus's "queer" combination of the carnal and the carnivalesque. (Throughout this chapter, I will use the term "queer" in a double sense: to suggest a dramatic departure from the norm and, more particularly, to describe a subversion of heterosexuality by way of same-sex desire and activity. Both senses of "queer"—i.e., as peculiar and as homosexual—would have been available to Cadmus in the 1930s. At that time, however, "queer" was virtually always a term of denigration when applied to homosexuality. It was not until the early 1990s that "queer" came to connote a proud defiance of heterosexuality and, more broadly, of normativity itself. My own use of the term in this chapter exploits its recent revival to suggest both the pictorial eccentricity and the defiant homoeroticism of Cadmus's early work.)[5]

Throughout the 1930s, Cadmus held artistic allegiances both to the satire of American life and to the erotic idealization of the male body. When those allegiances came into conflict, the resulting pictures (and *Gilding the Acrobats* is one) spun off in unpredictable, even unprecedented, directions.[6] Satire, as a form that "diminishes a subject by making it ridiculous and [by] evoking toward it attitudes of amusement, contempt, indignation, or scorn," would seem singularly ill suited to the work of eroticization.[7] Yet it was Cadmus's surprising combination of satire and the ideal—of denigration and delectation—that enabled him to depict homoerotic relations among men as well as overtly homosexual characters at a moment when virtually no other American painter was doing so.[8]

As his inclusion in the *Encyclopaedia Britannica* might suggest, Cadmus was considered an important, if still emerging, talent within the American art world of the 1930s. His first one-man show, at New York's Midtown Gallery in 1937, attracted some seven thousand visitors, breaking attendance records at the venue and selling out all of the works on display (figure 2.2).[9] In reviewing the exhibition, the *New York Times* praised "this very gifted young American [for his] splendid draftsmanship, so lusty and firm yet so full of unforced subtlety, and his quite as splendid sense of design,"[10] while a notice in the *Art Digest* celebrated "the rare ability of this thirty-two year old who promises to play a dominant role in the growing art of this country."[11] By the end of the decade, *Life* would showcase Cadmus in a series on five prominent American painters, and *Newsweek* would confidently count him "in the top bracket of that . . . generation of young American painters who will someday inherit the togas of Benton, Wood, and Curry."[12]

This prophesy would remain unfulfilled: Cadmus's career, even more than those of the Regionalist painters, declined sharply after the Second World War. Marginalized to the point of near eclipse by the rise of abstract expressionist painting and the corresponding preeminence of modernist art criticism, Cadmus's work came increasingly to be regarded as kitsch, the category Clement Greenberg opposed to avant-garde production and famously described in 1939 as "pre-digested art . . . vicarious experience and faked sensations . . . the debased and academicized simulacra of genuine culture."[13] There is more than a little irony, then, in the timing of the 1941 *Britannica* spread. At the very moment when Cadmus is said to exemplify modern American art, he stands on

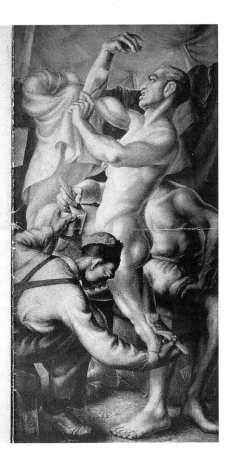

PAINTINGS . . .

1. Aspects of Suburban Life: Main Street (1937)
2. Aspects of Suburban Life: Polo (1936)
3. Aspects of Suburban Life: Golf (1936)
4. Aspects of Suburban Life: Public Dock (1936)
5. Aspects of Suburban Life: Golf — small version (1936)
 Paintings 1 to 5 lent by Treasury Department Art Projects.
6. Venus and Adonis (1936)
7. Two Boys on a Beach (1936)
 Lent by a private collector.
8. Gilding the Acrobats (1935)
9. Self Portrait (1935)
10. Coney Island (1934)
11. Miguel (1934)
12. Greenwich Village Cafeteria (1934)
 Lent by Public Works of Art Project.
13. Y. M. C. A. Locker Room (1933)
14. Shore Leave (1933)
15. Bicyclists (1933)
16. Juan (1933)
 Lent by Miss Ilse Bischoff.
17. Majorcan Fishermen (1932)
18. Puerto de Andraitx (1932)
 Lent by Dr. H. Justin Ross.

WATERCOLORS, DRAWINGS and ETCHINGS

•

PRICES ON APPLICATION

PORTRAIT COMMISSIONS ARRANGED

the brink of a protracted decline into obscurity, a decline that would ultimately lead modernist critics such as Dore Ashton to declare the artist "not a historical figure at all, [but] an also-ran."[14]

Over the last several decades, however, interest in Cadmus has undergone a gradual renaissance, one that has seen the completion of Philip Eliasoph's doctoral dissertation on the artist in 1979; the mounting (again by Eliasoph) of a 1981 retrospective; the publication and subsequent reprinting of a popular monograph on Cadmus by Lincoln Kirstein; the production of a documentary film on the artist; a cover story in *Art in America*; and one-person exhibitions at the National Museum of American Art, the Metropolitan Museum of Art, the National Academy of Design, the Whitney Museum of American Art, and the Yale University Art Gallery.[15] In 1998, Cadmus received the Distinguished Artist Award for Lifetime Achievement from the College Art Association, the leading professional organization of artists and art historians in the United States.[16] The revival of interest in Cadmus's work stems, in part, from a wider art-historical reclamation of American scene painting and muralism of the 1930s, a reclamation that signals the willingness of a growing number of scholars to consider works of art falling outside prevailing canons of modernism and "significant" avant-garde production.[17]

Figure 2.2.
"Paul Cadmus,"
1937 exhibition
checklist. Midtown
Galleries, New
York, N.Y. Cour-
tesy Paul Cadmus.

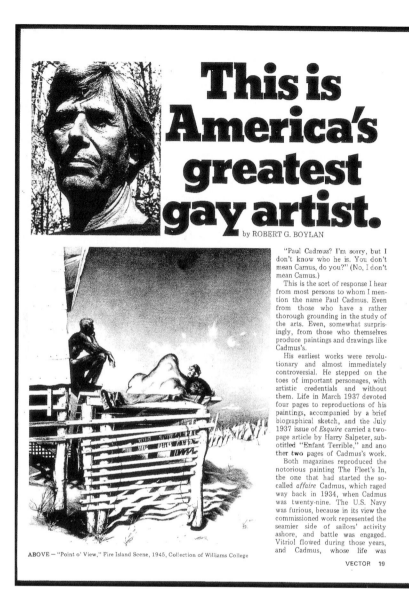

This is America's greatest gay artist.

by ROBERT G. BOYLAN

"Paul Cadmus? I'm sorry, but I don't know who he is. You don't mean Camus, do you?" (No, I don't mean Camus.)

This is the sort of response I hear from most persons to whom I mention the name Paul Cadmus. Even from those who have a rather thorough grounding in the study of the arts. Even, somewhat surprisingly, from those who themselves produce paintings and drawings like Cadmus's.

His earliest works were revolutionary and almost immediately controversial. He stepped on the toes of important personages, with artistic credentials and without them. Life in March 1937 devoted four pages to reproductions of his paintings, accompanied by a brief biographical sketch, and the July 1937 issue of *Esquire* carried a two-page article by Harry Salpeter, subtitled "Enfant Terrible," and another two pages of Cadmus's work.

Both magazines reproduced the notorious painting The Fleet's In, the one that had started the so-called *affaire* Cadmus, which raged way back in 1934, when Cadmus was twenty-nine. The U.S. Navy was furious, because in its view the commissioned work represented the seamier side of sailors' activity ashore, and battle was engaged. Vitriol flowed during those years, and Cadmus, whose life was

ABOVE — "Point o' View," Fire Island Scene, 1945, Collection of Williams College

Figure 2.3.
Robert Boylan,
"This Is America's
Greatest Gay Artist,"
Vector, January/
February 1976.
Courtesy Gay,
Lesbian, Bisexual,
Transgender Historical Association of
Northern California, San Francisco.

Even before art historians completed the initial scholarship on Cadmus, however, the gay male community had begun to reclaim the artist as a significant figure within its own, largely unwritten history.[18] As early as 1976, gay newspapers and magazines were casting Cadmus as an artistic pioneer whose homoerotic work had laid the foundation for that of later gay painters and photographers such as David Hockney, Robert Mapplethorpe, and Tom of Finland. The celebratory tone of features such as "This Is America's Greatest Gay Artist" in the 1976 *Vector* (figure 2.3) typifies this early coverage.[19] Such articles were part of a broader, post-Stonewall effort on the part of community-based historians and journalists to retrieve forgotten gay and lesbian lives from the historical record, to reclaim the "hidden history" of homosexuality. The emergence of lesbian and gay studies as an increasingly visible field of scholarly endeavor in the late 1980s

and 1990s further invigorated interest in Cadmus's career.[20] Some half-century after their creation, Cadmus's early paintings, prints, and drawings came to be seen as a signal achievement within the history of gay culture.[21]

How, though, did Cadmus secure such an achievement? How did he picture homosexuality at a moment when it was virtually unrepresentable within the sphere of painting and all but unspeakable within that of art criticism?[22] This chapter addresses these questions by analyzing selected episodes in Cadmus's artistic production and critical reception in the 1930s, the opening decade of his professional career. It looks in particular detail at the defining moment of that career, the 1934 censorship of *The Fleet's In!*. The terms of this censorship were complex and often contradictory, issuing as they did in both official censure and national celebrity, as well as in more subtle forms of artistic constraint and publicity. We shall look at how Cadmus negotiated these circumstances, sometimes manipulating them to strategic effect and sometimes being manipulated by them. The controversy surrounding *The Fleet's In!* was complicated by the fact that Cadmus's depiction of male homosexuality, while manifest within the painting, was acknowledged neither by those who denounced the picture in 1934 nor by those who sought to defend it.[23] The navy's attack on the painting, Cadmus's response to that attack, and the press coverage of the entire episode were shaped in part by this structuring absence, this refusal to name what was there, stereotypically, for all to see.[24]

My analysis of *The Fleet's In!* will occasion discussion of two other paintings of the period in which Cadmus enlisted satire to address issues of sexuality and difference: *Self-Portrait Mallorca* (1932) and *Gilding the Acrobats* (1935), a painting briefly introduced above. Taken together, these three pictures offer a map of the different means through which Cadmus harnessed homoeroticism to satire in his early work. They also demonstrate how a range of social and artistic constraints—from the most overt act of censorship to the subtlest form of suppression—shaped Cadmus's first decade of professional production.

"Carousing in Queer Postures"

In 1933, an unemployed, as yet unknown Paul Cadmus was hired by the Public Works of Art Project (PWAP), a federal arts program organized under the auspices of the Civil Works Administration (CWA).[25] Like every artist on the project, Cadmus "was employed to paint without any restrictions except that his painting must be an easel picture and on an American subject."[26] Just back from an extended trip abroad and now living in Greenwich Village, the artist opted to paint satires of contemporary New York City life.[27] During his three months on salary, for the "not bad" sum, as Cadmus remembers it, of thirty-four dollars a week, he completed two large oil paintings: *The Fleet's In!*, a raucous scene of sailors on leave in Riverside Park (figure 2.4), and *Greenwich Village Cafeteria*, a no less rowdy account of Stewart's Cafeteria on Christopher Street near Seventh Avenue South (figure 2.5). Shortly after finishing the second painting, Cadmus was invited to display both works in a show honoring the contribution of the PWAP to the cultural life of the nation.[28] The institutional sponsor for the exhibit was the Corcoran Gallery of Art in Washington, D.C.

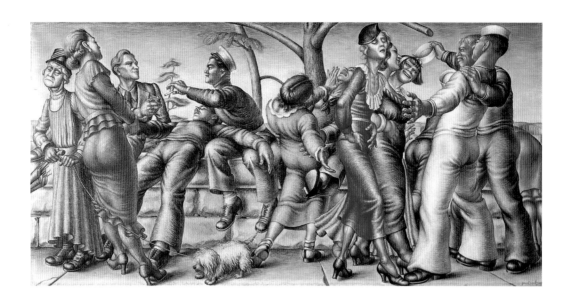

Figure 2.4. Paul Cadmus, *The Fleet's In!*, 1934. Oil on canvas, 30" × 60", Naval Historical Center, Washington, D.C. Courtesy D. C. Moore Gallery, New York, N.Y.

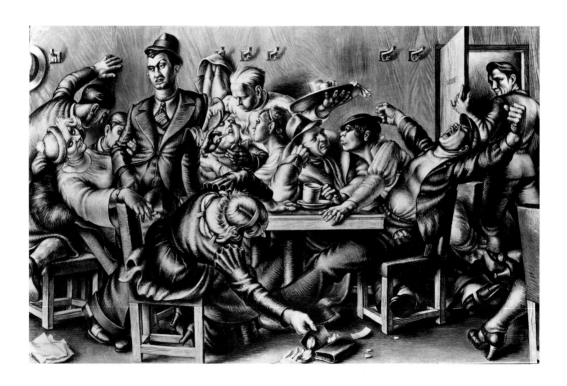

Figure 2.5. Paul Cadmus, *Greenwich Village Cafeteria*, 1934. Oil on canvas, 25½" × 39½", Museum of Modern Art, New York, N.Y. Extended loan from United States Public Works of Art Project. Photo courtesy D. C. Moore Gallery, New York, N.Y.

The April 3 edition of the *Washington Evening Star* ran a preview article on the exhibit, accompanied by a reproduction of *The Fleet's In!*. Incensed by the picture, retired navy admiral Hugh Rodman sought to have it removed not only from the Corcoran exhibit but also from any future possibility of public display.[29] At Rodman's behest, the assistant secretary of the navy, Henry Latrobe Roosevelt (President Roosevelt's second cousin), personally confiscated the canvas and took it to his home.[30] Upon his death in 1936, Henry Roosevelt "bequeathed" the painting to the Alibi Club, a private men's association whose membership included a number of high-ranking government officials.[31] Although the club never acquired legal title to *The Fleet's In!*, the painting would hang above its fireplace for more than four decades.

The censorship of Cadmus's painting in 1934 provoked a media sensation, with scores of newspapers and several national magazines running articles and editorials on the episode, many accompanied by reproductions of the work.[32] While naval officials had successfully removed *The Fleet's In!* from the Corcoran show ("It's out of sight and will remain out of sight," vowed Roosevelt), they had unwittingly insinuated the picture into the far more powerful flow of mass culture.[33] As the July 1937 *Esquire* put it, "For every individual who might have seen the original at the Corcoran, at least one thousand saw it in black and white reproduction."[34] Cadmus underscored the paradox of the government's action when he noted that "by attacking my painting, naval officials have only called attention to it, whereas if they had said nothing about it, it probably would have been noticed only by the art critics."[35] Bounced out of the art museum and onto the front pages of the national press, *The Fleet's In!* emerged as a succès de scandale.[36] Much of the public and critical attention enjoyed by Cadmus later in the decade stemmed from this inaugural moment of notoriety. As the artist himself would recall, "I owe the start of my career, really, to the Admiral who tried to suppress it."[37]

Contemporary press accounts of the censorship episode sometimes criticized, and occasionally openly ridiculed, the navy for its action. The New York tabloids covered the story with an irony verging on camp and a fairly stinging suggestion of official prudery and possible misconduct: "Horrors! Not Our Sailors!—So CWA Painting Is Banned" mocked the headline for the *New York Daily News* (figure 2.6), while a no less derisive *New York Post* proclaimed, "Did You Say 'Anchors Aweigh,' Admiral? No, Take It Away! Take That Thing Away" (figure 2.7). As these tabloid lay-outs might suggest, *The Fleet's In!* was widely recirculated as a result of the navy's attempt to remove it from visibility. Far from a successful act of suppression, the confiscation of the painting provoked (and, in a sense, produced) a series of articles, cartoons, editorials, letters to the editor, and published interviews that drew ever more attention to the issues the navy sought to cover up. The censorship of *The Fleet's In!* generated a public, and often heated, debate over the social and sexual behavior of sailors on shore liberty.[38] Why should the activities of the sailor on leave in the city prove such a contested site of meaning in 1934, and what anxieties were fueled by Cadmus's representation of those activities in *The Fleet's In!*?

The Fleet's In! stacks fourteen figures (five sailors, a marine, and one male and seven female civilians) along a narrow, horizontal axis. The characters are pressed flush up against the surface of the picture plane. A low wall marking the

boundary of Riverside Park pins the bodies to the foreground while banding off access to any deeper recession. Cadmus's shallow, emphatically horizontal field of figures recalls the processional of a frieze or bas-relief. The left-to-right "scanning" encouraged by the painting and the exaggerated expressions of its characters might also be said to mimic a popular press cartoon, a significant reference point, if not a direct source, for Cadmus's rude satire.[39] Even the exclamation point of the title seems to assert the painting's status as outrageous caricature rather than realist representation.

The Fleet's In! compresses its figures into an uncomfortably shallow space while emphasizing the cling of their clothing and the torsion of their postures. These are bodies that do not behave, figures who seem to pop out from beneath overly tight uniforms and dresses. We meet the characters not at eye level but at that of groin and midriff.[40] Like the sleeping sailor on the left-hand side of the composition, the viewer "slides down" the vertical register of the painting. Cadmus directs our attention away from the faces of the figures (all those grimaces and guffaws) and toward their insistent bodies. We are made aware of buttocks and hips even when we don't see faces, as on the far-right margin of the painting. Part of the self-conscious vulgarity of *The Fleet's In!*, then, is the way it constructs a virtually continuous "crotch and buttocks shot" of its characters.

The pictorial logic of *The Fleet's In!* revises the conventional representation of the American sailor on shore leave. Rather than simply coupling the sailor with a female civilian (as did such contemporary artists as Reginald Marsh), Cadmus introduces him into a larger field of competing social and erotic interests, a field in which both male and female civilians—as well as other military men—vie for the sailor's attention. Cadmus's revision of shore leave is accomplished through a pictorial satire decidedly more arch, and certainly more grotesque, than that of his contemporaries. As the 1937 *Art Digest* put it, Cadmus's paintings "are harsh caricatures that make the work of Reginald Marsh and Kenneth Hayes Miller seem almost gentle."[41]

One of the better period accounts of Cadmus's work, a 1935 feature in the *Minneapolis Journal*, described *The Fleet's In!* as an occasion in which the painter "gave full vent to his feelings and depicted men and women as he saw them, not as graceful beings, but as robustious [*sic*] creatures carousing in queer postures."[42] The postures are "queer" in the distance they draw from either upright propriety or convincing relaxation, in the way they contort bodies and turn them at oblique angles to the picture plane. And the postures are "queer" in their insistence on anality, both male and female, an insistence that seems to gather momentum as the eye scans to the right, until the composition concludes with a group of four figures articulated largely from behind (figure 2.8). Notice how the organization of the group's three sailors not only showcases their protruding buttocks and crotches but also follows an anal-erotic logic of insertion and reception. The bodies of the military men, in alternating white and blue uniforms, are angled toward one another in a loose mime of homosexual exchange.[43] The group's lone female figure, though also pictured from behind, is largely excluded from the erotics of the scene. She is, in fact, nearly edged out of the composition altogether by the blond sailor on one side and the crop of the frame on the other.

HORRORS! NOT OUR SAILORS!—SO CWA PAINTING IS BANNED

(By Associated Press, reprinted from yesterday's late editions of The News)

THIS IS THE WAY our sailor boys act when on shore leave, according to Paul Cadmus, CWA artist, who painted it. He called it "The Fleet's In." It hung on the walls of the Navy Department at Washington until Admiral Hugh Rodman, Ret., complained to Secretary of the Navy Swanson. The work of art was taken down and Henry Roosevelt, Assistant Secretary, sent it to his home. Admiral Rodman said a whole lot of mean things about the picture. (See Editorial, opposite page, and story on page 10.)

Did You Say 'Anchors Aweigh,' Admiral? No, Take It Away! Take That Thing Away

Associated Press Photo

Painting of group of sailors on shore leave, done by Paul Cadmus, CWA artist of New York, which Secretary Swanson barred from Navy Department after Admiral Rodman objected to it as an insult.

Figure 2.6. TOP: "Horrors! Not Our Sailors . . ." *New York Daily News*, April 20, 1934. Courtesy Paul Cadmus.

Figure 2.7. BOTTOM: "Did You Say 'Anchors Aweigh' . . ." *New York Post*, April 19, 1934. Courtesy Paul Cadmus.

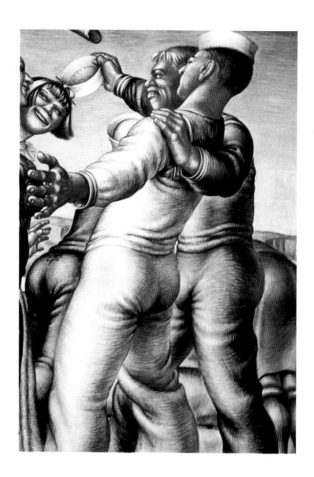

Figure 2.8.
Paul Cadmus,
The Fleet's In!, 1934.
Detail. Courtesy
D. C. Moore
Gallery, New York,
N.Y.

The exclusion of the female figure from the sexually charged buddy-ism of the sailors typifies the larger logic of *The Fleet's In!*. Within the governing terms of this painting, the proximity of female civilians to military men coincides with the frustration, rather than the furthering, of heterosexual exchange. Consider, for example, the futile attempt of the back-turned woman on the left side of the composition to rouse a sleeping sailor into consciousness.[44] The sailor sprawls, in drunken intimacy, across the lap of his military buddy (a marine) while leaning away from both the female and male civilians. This episode constructs a complex knot of desire in which three separate kinds of investment—homosocial, homosexual, and heterosexual—swirl around the figure of the sleeping sailor.

Another subversion of heterosexual pairing occurs in the center of the composition, where a sailor's aggressive come-on is met with the powerful resistance of a woman framed from behind (figure 2.9). Even as she smacks away the attentions of the sailor, this woman also bends back toward, and cups the buttocks of, a female figure to her right. In her resistance to the groping gob, the woman seems almost to be reaching out for an alternative form of physical contact. Throughout *The Fleet's In!*, heterosexual pairing seems to drive figures apart, while same-sex touching binds them together. It is almost as though the characters had been introduced into a reverse magnetic field where opposites

repulse and likes attract. The painting's insistence on anality thus constitutes but one aspect of its inversion of "normative" sexual coupling.

In addition to undoing heterosexuality, *The Fleet's In!* includes one episode that explicitly figures a homosexual encounter. A blond male civilian on the left side of the scene extends a Lucky Strike cigarette to a marine, who, reaching over the body of his buddy, accepts the offer. The physical and sartorial appearance of the male civilian, as well as his (interested) presence at the scene of the sailors' carousing, plainly constitutes a queer characterization. Indeed, Cadmus's treatment of the male civilian features a virtual catalog of period signs of the so-called pansy or fairy: pursed lips, rouged cheeks, ringed fingers, red tie, slicked-down blond hair, even the sinister cast of shaded eyes and brow (figure 2.10).[45] In suggesting a hoped-for homosexual pickup, the pansy embodies that which the military men are not, namely the initiating subject, rather than the desired object, of a same-sex transaction. The potential availability of the military men to the pansy is predicated on a set of contingencies (e.g., shore leave, intoxication, financial compensation, etc.), while the sexual identity of the pansy is immutable and has been stereotypically marked as such by the picture. Like several popular cartoons, novelty songs, and pre–Hays Code Hollywood movies of the late 1920s and early 1930s, *The Fleet's In!* portrays the fairy as both a rival to, and a

Figure 2.9.
Paul Cadmus,
The Fleet's In!, 1934.
Detail. Courtesy
D. C. Moore
Gallery, New York,
N.Y.

near equivalent of, the heterosexual woman.[46] Within the logic of these representations, the fairy was inscribed within the sphere of ersatz womanliness. As George Chauncey argues in *Gay New York: Gender, Urban Culture, and the Making of the Gay Male World, 1890–1940*,

> It was only the men who assumed the sexual and other cultural roles ascribed to women who identified themselves—and were identified by others—as fairies. The fairies' sexual desire for men was not regarded as the singular characteristic that distinguished them from other men, as is generally the case for gay men today. That desire was simply one aspect of a much more comprehensive gender role inversion (or reversal), which they were also expected to manifest through the adoption of effeminate dress and mannerisms; they were thus often called inverts (who had "inverted" their gender) rather than homosexuals in technical language. . . . Sexual desire for men was held to be inescapably a woman's desire, and the invert's desire for men was not seen as an indication of their "homosexuality" but as simply one more manifestation of their fundamentally womanlike character. The fundamental division of male sexual actors . . . was not between "heterosexual" and "homosexual" men, but between conventionally masculine males, who were regarded as men, and effeminate males, known as fairies or pansies, who were regarded as virtual women, or more precisely, as members of a "third sex" that combined elements of the male and female.[47]

As Chauncey observes, the fairy's status as a "virtual woman" (or "third-sexer") typically entailed competition with "actual" women for the attentions of men—and, especially, of sailors—who might "swing" either way. A 1933 cartoon from *Broadway Brevities*, a New York scandal sheet popular during the late 1920s and 1930s, vividly exemplifies this formulation: a fairy strolling through a park with a husky, if stupefied, sailor on his arm taunts a heavily made-up woman seated on a nearby bench (figure 2.11). The cartoon's title, "Pickled Corned Beef," refers to the inebriated ("pickled") state of the stocky sailor ("corned beef," an early variant of "beefcake").[48] The one-word caption, "Rivalry," summarizes the structure of the scene and the nasty logic of its humor. Any woman who would engage the fairy as a rival was inevitably framed as a "floosie" whose femininity was no less strenuously produced than the foppishness of her homosexual competitor.[49] The motif of a contest between—and an equivalent denigration of—the floosie and the fairy pervades popular representations of male homosexuality in the 1930s.[50] Femininity, whether housed in the body of a man or a woman, was both punished and parodied within this system of sexual definition.[51]

Both *The Fleet's In!*, painted early in 1934, and "Pickled Corned Beef," published in October 1933, unfold along a promenade bounded on one side by a low stone wall marking the perimeter of a park. We know that the former is set on the edge of Riverside Park, not far from the navy's anchorage on the Hudson River at Ninety-sixth Street.[52] The *Broadway Brevities* cartoonist almost certainly selected the same site for "Pickled Corned Beef." This shared choice of venue stemmed from the notoriety of Riverside Park as a destination for sailors in search of sexual companionship (whether male or female) during the 1930s.[53]

PICKLED CORNED BEEF

"Rivalry!"

Figure 2.10. TOP: Paul Cadmus, *The Fleet's In!*, 1934. Detail. Courtesy D. C. Moore Gallery, New York, N.Y.

Figure 2.11. BOTTOM: "Pickled Corned Beef," *Broadway Brevities*, October 11, 1933. Courtesy Gay and Lesbian Historical Society of Northern California, San Francisco.

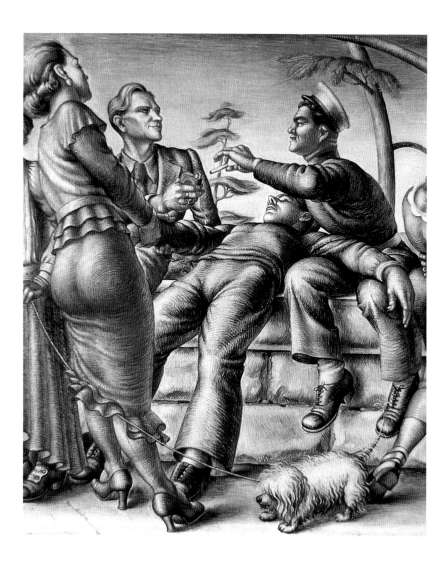

Figure 2.12.
Paul Cadmus,
The Fleet's In!, 1934.
Detail. Courtesy
D. C. Moore
Gallery, New York,
N.Y.

Beyond the similarities of their depicted locale and period caricatures, however, "Pickled Corned Beef" and *The Fleet's In!* organize their comic narratives quite differently. In contrast to the simple triangle of desire and competition that structures "Pickled Corned Beef," *The Fleet's In!* sets its homosexual character within a complex, multifigure field of erotic attraction and repulsion (figure 2.12). The male civilian's approach to the marine (via the offer of a cigarette) seems rather tame when compared to the rough-and-tumble action occurring elsewhere in the scene.[54] As if to reinforce the fairy's difference from the other figures in *The Fleet's In!*, his lower body is entirely obstructed by the (back-turned) woman in front of him. A composition rife with anal eroticism and magnetized by same-sex contact thus denies its one openly homosexual figure any below-the-belt presence within the picture. Such a denial reinstates the fairy's status as the subject—rather than object—of sexual desire. Along with the female figure in front of him and the elderly woman on the left margin of the painting, the male homosexual is forcibly distanced from the intoxicated intima-

cies of the military men. That distance renders him as much an onlooker to the sailors' carousing as an active participant in it.

Same-sex relations are not, however, as marginal to *The Fleet's In!* as the fairy's placement within the composition might suggest. While homosexuality has been expressly depicted through a single, stereotypical character, its dispersed energies press hard on every figure in the visual field. Those energies create a kind of whirlwind force, pushing and pulling these bodies out of conventional pairings and upright comportment.[55] The "queer postures" that structure *The Fleet's In!* cannot be confined to any one character or narrative episode within the painting. Rather, they shape the most basic terms of the composition: its over-ripe palette and comic grotesque faces, its bulging bodies and clinging clothing, its figures who resist the protocols of heterosexual pairing while reaching out (sometimes literally) for other alternatives.[56]

"Not Our Sailors"

Within forty-eight hours of the removal of *The Fleet's In!* from the Corcoran, a letter by Admiral Rodman was released to the press and cited as the official justification for the navy's action. In it, Rodman denounced Cadmus's painting as "a disgraceful, sordid, disreputable, drunken brawl, wherein apparently a number of enlisted men are consorting with a party of streetwalkers and denizens of the red-light district. This is an unwarranted insult to the enlisted personnel of our Navy, is utterly without foundation in fact and evidently originated in the sordid, depraved imagination of someone who has no conception of actual conditions in our service."[57] We might note the admiral's overproduction of adjectives ("disgraceful, sordid, disreputable") in characterizing *The Fleet's In!* and his slight step back, via that "apparently," from its depicted figures. In the course of this passage, Rodman moves from attacking the painting to denouncing its creator as someone whose "depraved imagination" bespeaks his ignorance of the "actual conditions" of navy life. Later in the letter, Rodman's attack on the artist gives way to an extended series of claims as to the virtues of the American sailor ("Our men are self-respecting, self-reliant, they are trustworthy, well-behaved . . .").[58] According to Rodman, sailors on shore leave were far more gentlemanly in their public behavior than students from Harvard, Yale, or Columbia on semester break and that, "owing to our policy of enlistment, no one who is not physically, mentally, and morally fit would be selected. There are dozens of applications where one is chosen. In this way, we get the very best."[59] For all his outrage over *The Fleet's In!*, the admiral refuses to describe the picture in any detail. Each time he touches upon the painting, Rodman condemns it in general terms ("a disgusting picture," "a disgraceful orgy") and then promptly returns to his account of the courteous and self-restrained men in "our Navy."[60]

Cadmus responded to the admiral's letter with his own set of truth claims: "What I painted was a true picture of a part of Navy life. That's what the shouting is all about. If the picture didn't hit home with the truth, the Navy wouldn't find it so objectionable."[61] In defending the accuracy of his account of sailors and civilians on Riverside Drive, Cadmus would insist that "when the fleet's in, Riverside Drive is no place for a respectable person. Especially in the park. The

ships moor in the Hudson River and the women come hanging around . . . waiting for the men to come ashore."[62]

In different ways, both the artist and his military censors emphasized the subject matter of *The Fleet's In!* (as mimetic truth and misleading lie, respectively) while eliding its visual form. The picture's keyed-up palette, cartoonish figures, and grotesque expressions—in short, its avowed perversion of realism—dropped out of the public discourse on *The Fleet's In!*. A kind of "reality effect" accrued to the painting in the aftermath of its censorship. Consider, for example, the "challenge" laid down by the magazine *Our Navy* ("The Standard Publication of the United States Navy"), whose editor dared Cadmus "to accompany me on a tour of inspection of Riverside Drive at any hour of the day or night while the United States Fleet is anchored in the North River. I will take along the ladies of my family and you may take along yours. I will guarantee that they will receive the utmost of courtesy from every Bluejacket ashore and that they will not be insulted or molested in any way."[63] Although he declined this offer, Cadmus vowed to the press that, with camera in hand, he would "stroll up Riverside Drive and try to snap unretouched proof that what [I] painted really happens— Admirals or no Admirals."[64] Cadmus and the navy both proposed to test *The Fleet's In!* against eyewitness accounts or photographs of Riverside Drive, but not against, say, other paintings of sailors on shore leave. The status of Cadmus's picture as a satirical and willfully stylized work of art was framed as largely irrelevant to the terms of its censorship. When asked, for example, about his motivation for ordering the removal of *The Fleet's In!* from the Corcoran, the secretary of the navy asserted, "I simply didn't want it. It was right artistic but it was not true to the Navy."[65] To which Cadmus, in a characteristic inversion of official logic, responded, "The Secretary has it just backward. . . . It was not artistic— but it was true."[66]

The discourse surrounding *The Fleet's In!* turned, then, on an almost legalistic concept of truth whereby "evidence" could be brought forward to substantiate or refute Cadmus's view of the sailor. In one memorable instance, the Young Men's Christian Association (YMCA) rose to the navy's defense by producing photographs of well-behaved sailors on shore leave: "a gob reading a good book" (figure 2.13) and a pair of "Bluejackets" playing bridge with bespectacled "girl secretaries" (figure 2.14). These pictures, which were published by the *Boston Daily Record* to accompany a 1934 article on the Cadmus controversy, sought to restage shore leave as a sedentary scene of indoor leisure and sober study. Compare the four-square alignment of sailors and secretaries around the bridge table (and the sense of upright propriety and physical distance it imposes) with the figures in *The Fleet's In!*, who constantly defy verticality and threaten, in their swerving intoxication, to collapse over (and into) one another.

The *Boston Daily Record* cites John R. Conahay, the physical director of the YMCA in Charlestown, Massachusetts, as to the virtues of sailors on shore leave: "Most of the boys from the ships make a beeline for the Y when shore leave comes. They read good books, they play cards, and they play pool."[67] Absent from Conahay's description is the possibility that the "boys" who "make a beeline for the Y" might pursue any additional forms of pleasure (whether with women, with male civilians, or with each other) while on shore liberty. In a revealing

Here's a gob reading a good book at the Y. M. C. A. yesterday.

Bluejackets from the U. S. S. Dupont, now in at the Charlestown Navy Yard, in a bridge game at the Y M. C. A., with girl "Y" secretaries. L. to r., A. M. Phipps, back to camera, Ruth Simpson, J L. Lapacek and Dorothy Blaikie. All this refutes Paul Cadmus' mural depicting Navy life ashore.

Y. M. C. A. DEFENDS SAILORS

Figure 2.13. TOP: "Here's a gob reading a good book . . ." Photograph from *Boston Daily Record*, c. May 1934. Courtesy Paul Cadmus.

Figure 2.14. BOTTOM: "Bluejackets from the U.S.S. Dupont . . ." Photograph from *Boston Daily Record*, c. May 1934. Courtesy Paul Cadmus.

moment later in the same article, however, two sailors on leave at the Charles-town YMCA are asked for their response to *The Fleet's In!*:

> Gus Layes of the U.S.S. Cayuga could only shake his head and mutter imprecations. "It's a shame, a shame," he said. "And me who never drank anything but milk."
> "That's the trouble," chimed in A. M. Phipps . . . of the [U.S.S.] Dupont, "these [artist] guys read a few books or catch a glimpse of a sailor's private life and they want to tell all the world about the navy."[68]

Although the *Boston Daily Record* presents these comments under a section enti-tled "Sailors Are Indignant" and reports that the bluejackets at the Charlestown YMCA "considered themselves maligned" by *The Fleet's In!*, the cited remarks of those sailors suggest a quite different response. Gus Layes's declaration that Cadmus's painting has violated his purity ("And me who never drank anything but milk") is clearly facetious. And while A. M. Phipps does seem sincerely trou-bled by *The Fleet's In!*, his worry is not that the painting misrepresents shore leave but rather that the picture reveals uncomfortable truths about "a sailor's private life." By producing photographs of sailors playing bridge and reading books, the YMCA sought to counter Cadmus's rowdy, intoxicated scene of shore leave. The caption to the bridge photograph states the point plainly: "All this refutes Paul Cadmus' mural depicting Navy life ashore."[69] Yet the remarks of the two sailors actually on shore leave at the YMCA contradict such a claim.

Far from "refuting" the truth of Cadmus's painting, the image of docile and bookish sailors quickly became a target for cartoonists and satirical commenta-tors of the day. In "The Fleet's In, According to Admiral Rodman," a *New York Daily News* cartoon from May 1934 (figure 2.15), two sailors spend their shore leave cozily reading Scripture beneath a tree in Riverside Park (a venue denoted by the military memorial in the background).[70] That the sailors pursue not booze or women but Bible study while on liberty marks their comic deviation from the manly norm. Other cartoons lampooned the sailor's supposed self-restraint by picturing him as completely oblivious to the sexual attentions of female civilians. "The Fleet's In (With Apologies to Cadmus)," a cartoon from the *Newark Evening News*, portrays three bluejackets, their eyes firmly closed, striding in perfect lockstep down a promenade in Riverside Park (figure 2.16). Three nearby women, each in lipstick and bonnet, wink in a flirtatious—if futile—attempt to solicit interest from the men. The sailors are so uninterested in female companionship that they literally "blind" themselves to the very sight of it.

In a similar, if more suggestive, cartoon in the *New York Daily News* (figure 2.17), a woman drops her handkerchief in an attempt to garner attention from a passing sailor.[71] The gob—all flowing bell-bottoms and swinging neck-apron—ignores the woman's gesture outright. Instead, he blithely blows smoke circles into the air. That gesture, together with his curving profile and delicately held cigarette, serves both to feminize the sailor and to explain his lack of interest in the opposite sex. The woman's punning response to this slight—"WHAT TH[E], WHAT IS THIS, A NEW DEAL IN THE NAVY?"—further marks the sailor's behavior as a departure from normative masculinity.

"THE FLEET'S IN"

ACCORDING TO ADMIRAL RODMAN

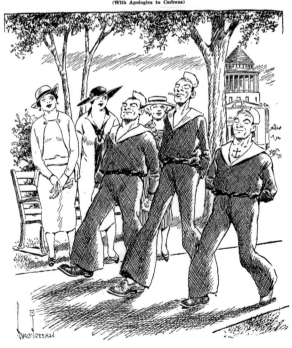

NEWARK EVENING NEWS, THURSDAY, MAY 31, 1934

The Fleet's In

(With Apologies to Cadmus)

Figure 2.15. TOP
"The Fleet's In, According to Admiral Rodman." Cartoon from *New York Daily News*, May 31, 1934. Courtesy Paul Cadmus.

Figure 2.16. BOTTOM
"The Fleet's In (With Apologies to Cadmus)." Cartoon from *Newark Evening News*, May 31, 1934. Courtesy Paul Cadmus.

As these cartoons suggest, the navy's defense of its "well-behaved" sailors during *The Fleet's In!* controversy was frequently ridiculed by the popular press. Drinking to excess and carousing with women were the commonly accepted pursuits of the sailor on shore leave; such activities were, in fact, celebrated as salty proof of his virility.[72] The navy could not dissociate the sailor from these pursuits without simultaneously unmanning him. An editorial in the *New York Daily News* entitled "Should Sailors Be Sissies?" stated the problem plainly:

> If most of our sailors have come to the point where they hurry alone to the Public Library or the museums on shore leave, instead of finding themselves some girlfriends and doing a little drinking, dancing and the rest of the things that he-men do when they want to relax, then it's too bad for us and for our Navy. The shore-leave activities so vividly pictured by Mr. Cadmus go with the fighting man's trade. . . . You can't prettify th[at] trade and still attract fighting men into it.[73]

The greatest irony: Cadmus's broadly satirical painting is defended as a scene of normative masculinity, while both the admiral responsible for its censorship and his "prettified" image of the sailor are ridiculed as effeminate. Notice how the editorial aligns the spaces of the museum and library with emasculation and a corresponding absence of female companionship (the sailors "hurry alone" to these venues) while associating Cadmus and his painting with "healthy" heterosexual leisure ("finding themselves some girlfriends," "doing a little drinking," and the rest).[74]

Even as the popular press parodied the navy's bowdlerized account of sailors on shore leave, so too—and perhaps more surprisingly—did Cadmus himself. In a quip that enjoyed wide circulation, the artist told *Newsweek* that were he to paint "Rodman's idea of sailors on leave," the picture would show "ladies rowing

on a lake or picking posies from the flowering mead."[75] By deploying accusations of effeminacy which, with just a slight turn of the screw, might have been leveled against him, Cadmus activated a kind of "reverse discourse" during the controversy over *The Fleet's In!*.[76] He took the language of his own potential debasement as a homosexual artist and wielded it against his military censors.

But why was that language not turned against Cadmus? Why was it Rodman and his "prettified" sailors, rather than the painter of *The Fleet's In!*, who were parodied as effeminate, if not incipiently homosexual? In order to answer this question, we must listen to the play of silence and suggestion within *The Fleet's In!* controversy. We must hear what is not said (as well as what is) by Cadmus, Rodman, and the popular press. We must attend, in short, to the workings of the closet. As Eve Kosofsky Sedgwick has analyzed it, the homosexual closet is less a space of totalizing secrecy—an epistemological blackout—than a series of silences situated in magnetic relation to other kinds of speech acts and information.[77] Beyond merely suppressing information, the closet also produces specific forms of sexual meaning and knowledge (e.g., homosexuality as unspeakable, homosexuality as scandal). That silence may produce or even incite discourse is one of Foucault's central insights in *The History of Sexuality*:

> Silence itself—the things one declines to say, or is forbidden to name, the discretion that is required between different speakers—is less the absolute limit of discourse, the other side from which it is separated by a strict boundary, than an element that functions alongside the things said, with them and in relation to them within over-all strategies. There is no binary division to be made between what one says and what one does not say; we must try to determine the different ways of not saying such things. . . . There is not one but many silences, and they are an integral part of the strategies that underlie and permeate discourses.[78]

The "closet" must therefore be understood in relation both to that which it refuses to reveal and to that which surrounds (or provokes) its silence. Silence and specification are not a binary pair but counterpoints on a continuum that includes a range of qualified speech acts (suggestion, veiled reference, half-acknowledgment, partial admission) that dip into the registers of both ignorance and knowledge.

In responding to the censorship of his work, Cadmus frequently employed ellipses, allusions, and other means of verbal indirection. The painter would, for example, tell the *New York World Telegram*, "I'd like to take those Pollyanna admirals for a walk. . . . Don't they know what goes on in their Navy? Why, any casual observer can see more in one hour than I've put in my paintings. I've seen sailors doing lots of things I don't dare paint. On Riverside Drive especially. It's always impressed me as a—well, a very sordid place."[79] In a variation on the same remark, Cadmus declared to the *New York Daily News*, "I'd like to take those Pollyanna Admirals for a walk along the Drive. . . . I used to live out there and if I had painted what I actually saw, they would have hung me instead of the canvas."[80] Even as Cadmus defends *The Fleet's In!* with reference to his firsthand knowledge of sailors on shore leave, he leaves the content of that knowledge largely unspoken. The artist's refusal to name that which he had witnessed "on

Riverside Drive especially" echoes the navy's supposed ignorance of those same activities ("Don't they know what goes on in their Navy?"). Because he knew the press would never ask him to specify the "things" he didn't "dare paint," Cadmus could exploit a double discourse of vagueness and provocation, of implied sexual meaning and its occlusion.

As late as 1937, three years after the censorship of *The Fleet's In!*, the double discourse surrounding the painting would remain in play. A profile of Cadmus published that year in the *Brooklyn Daily Eagle* reported that "Paul wonders what is 'true' of the navy. He lived on Riverside Drive and he ought to know. He said he didn't tell half the story [in *The Fleet's In!*]."[81] The *Brooklyn Daily Eagle* suggests a gap between the behavior depicted in *The Fleet's In!* and that which Cadmus himself had witnessed along Riverside Drive. This gap, this other "half of the story," consisted in large measure of a homosexuality far more explicit than anything that Cadmus could portray in paint in the 1930s.

A dialectic between specification and silence also surfaced in characterizations of Cadmus published in the popular press. Although the artist's homosexuality was occasionally alluded to by journalists, such references remained strictly within the register of connotation. Cadmus was variously described as a "muscular young man with a cocoa tan," a "glossy-haired, Greenwich Village artist," and a "tall, blond bachelor mild-mannered and extremely shy."[82] During an interview with a reporter from the *New York World Telegram*, Cadmus was said to be "lolling on the couch and propping his face on a pillow."[83] Art historian Jonathan Weinberg has deciphered a rather more specific suggestion of homosexuality in the period coverage of *The Fleet's In!*:

> One article mentions a call Cadmus got from a stranger who asked, "if he had ever been to Sands Street, near the Brooklyn Navy Yard." The significance of this question is not explained in the article, but it is mysteriously repeated in *Newsweek*'s coverage of the incident, again without explanation. Sands Street was a notorious homosexual cruising ground (it is the location of Charles Demuth's *On "That" Street*, which shows a gentleman picking up two sailors). Such a peculiar phone conversation inserted in a short article without explanation was a tip to the reader.[84]

Such "tips" embedded homosexual meaning within references to which readers would have varying degrees of access. Without the proper knowledge of the code words ("glossy-haired," "Greenwich Village artist," "Sands Street"), the details offered would have seemed merely descriptive. And even with the requisite knowledge, the references were oblique enough so as to remain deniable.[85] Indeed, the suggestion of male effeminacy—and, with it, that of homosexuality—was more palpable in the lampoons of Admiral Rodman and the prettified sailor than in press accounts of Cadmus. The relative unspeakability of homosexuality in 1934 enabled Cadmus to attack the navy via a discourse of normative masculinity while remaining largely immune to such an attack himself. It also permitted the artist to depict an openly homosexual figure without having to defend, or even acknowledge, that depiction in print.

Though it was never mentioned in 1934, the inclusion of the fairy in *The Fleet's In!* was almost certainly a factor in the picture's censorship. This is suggested by

SAILOR, SAY IT ISN'T SO

THE FLEET'S
ALL IN

PAINTED
BY
ADMIRAL
RODMAN

period cartoons that link the stereotypical representation of male effeminacy to the suppression of the painting. In "Sailor, Say It Isn't So," a *New York Daily News* cartoon from April 1934, Admiral Rodman, now laboring before a canvas, is forced to assume Cadmus's position as creator of *The Fleet's In!* (figure 2.18). Rather than a rowdy scene of shore leave, however, the admiral paints an angelically simpering sailor complete with halo, blond curls, full wings, pursed lips, and piously crossed hands. The sailor's supposed virtue is exaggerated to the point of emasculation; he emerges, almost literally, as a kind of fairy. By condensing sailor and fairy into a single effeminate figure, the cartoon combines two distinct social roles (the military man and the male homosexual). In effect, "Sailor, Say It Isn't So" compels Rodman to paint not only his impossibly angelic view of the sailor but also a hint of the queer content of *The Fleet's In!*.

"The Fleet's In, According to Admiral Rodman" (figure 2.15) alludes to homosexuality even more forcefully than does "Sailor, Say It Isn't So." Rather than "finding themselves some girlfriends" or "doing a little drinking," two sailors travel together to Riverside Park. They enjoy their liberty in the absence of either male or female civilians. While the sailors now consult the Gideon Bible, they may presently engage in one of those activities Cadmus "witnessed on Riverside Drive" but "didn't dare paint." Such a forward-looking interpretation would explain both the glance of the right-hand sailor at his studious companion and the drooping flower—a period sign of the pansy—held in his hand.[86] In its

Figure 2.18. "Sailor, Say It Isn't So." Cartoon from *New York Daily News*, April 20, 1934. Courtesy Paul Cadmus.

coupling of two sailors deep inside Riverside Park, the cartoon responds both to the homosexual content of *The Fleet's In!* and to the willful misrecognition of that content by the navy.

If, as I argued above, Cadmus disperses the force of homosexuality throughout the visual field of *The Fleet's In!*, a parallel procedure might be said to occur in the public discourse surrounding the picture in 1934. Though never acknowledged in print, the stereotypical figure of the fairy resurfaced in cartoons ("Sailor, Say It Isn't So") and editorials ("Should Sailors Be Sissies?") on the painting's censorship. In effect, the navy's removal of *The Fleet's In!* from public display activated a series of satires that reproduced the (unspoken) issue that had provoked the censorship in the first place. The representation of male homosexuality was not destroyed so much as displaced to other sites of depiction. Because the navy could not persuasively name the "problem" with *The Fleet's In!*, it was destined to inspire ever more instances of the imagery it professed not to see.

This paradox would resurface with a vengeance several decades after the censorship of *The Fleet's In!* In 1980, at the urging of art historian Philip Eliasoph, the U.S. government sought to retrieve Cadmus's painting from the Alibi Club, the private men's association that had retained possession of the picture, though not its legal title, since 1936. Faced with the threat of both a civil lawsuit and the summoning of federal marshals to seize the painting by force, the Alibi Club reluctantly agreed to relinquish the painting to governmental control.[87] After retrieving *The Fleet's In!*, the federal agency in charge of public works of art (the General Services Administration) awarded legal title of the painting to, of all places, the Department of the Navy.[88]

The Department of the Navy sent the picture, now in poor condition after decades of hanging above the Alibi Club's fireplace, to be professionally restored. Following its restoration, the painting appeared in a 1981 retrospective of Cadmus's career organized by Eliasoph. After traveling with the retrospective to each of its five venues, *The Fleet's In!* was placed in storage by the navy. Several years later, the painting was transferred from storage and installed in the public galleries of the Naval Historical Center in the Washington Navy Yard in Washington, D.C.,[89] where it remains on view to this day.[90]

The military branch of the government that censored the picture in 1934 has thus become its legal custodian and public exhibitor. This is not to say, however, that *The Fleet's In!* has been assimilated to the mission of the Naval Historical Center, which, according to its official Web site, is "to enhance the Navy's effectiveness by preserving, analyzing and interpreting its hard-earned experience and history for the Navy and the American people."[91] Cadmus's raucous account of shore leave opposes the heroic pictures of military service and sacrifice elsewhere on view at the Naval Historical Center, pictures with titles such as *Flight Deck at Dawn*, *Bullets and Barbed Wire*, and *A Warrior Homeward Bound*.[92] *The Fleet's In!* satirizes and sexualizes "the hard-earned experience" of navy life that the Naval Historical Center seeks to enshrine. From within the halls of official military history, Cadmus's sailors and civilians continue to "carouse in queer postures." This queer difference may help to explain why, according to Gale Munro, the curator of art at the Naval Historical Center, *The Fleet's In!* has become "by far the most popular painting in our collection."[93]

Stereotype and Self-Portraiture

The subject of sailors on shore leave captured Cadmus's attention with particular force throughout the 1930s. Of his eight major paintings on New York City life during that decade, three are devoted to the sailor theme.[94] Of his recurrent attraction to this theme, Cadmus, who grew up on Riverside Drive, would later recall: "I always enjoyed watching them [sailors] when I was young. I somewhat envied the freedom of their lives and their lack of inhibitions. And I observed. I was always watching them. I didn't know them personally, I was not going after them or expecting any relationship with them, but they were fun to watch, and I watched them a great deal."[95]

The sailors enjoy a sense of physical freedom and social license that Cadmus envies but does not embody. Throughout the passage, the artist insists on his role as witness to, rather than participant in, the boisterous activities of the sailors. He stresses, above all, that the appeal of the sailor was one he appreciated from a visual distance ("I always enjoyed watching them," "I observed," "I was not going after them," "they were fun to watch," "I watched them a great deal"). By emphasizing his physical distance from the sailors, Cadmus means to distinguish himself from the kind of man who might "expect a relationship" with them, the kind of man represented by the fairy in *The Fleet's In!* as well as by the male civilian in the left midground of Cadmus's 1933 *Shore Leave* (figures 2.19, 2.20). Like Cadmus, the homosexual figures in *The Fleet's In!* and *Shore Leave* seem to savor the spectacle of sailors on shore leave. Unlike Cadmus, however, these men do "go after" the sailors, as least insofar as the offer of a cigarette or a conversation seems to prefigure other, more intimate forms of exchange.

Variations on this same character appear in several of Cadmus's paintings from the 1930s, including *Greenwich Village Cafeteria*, where a fairy with slicked hair and delicate hands turns around to give us one last look before he slips stealthily into the men's room (figure 2.21). Such figures, stationed on the margins or in the background of Cadmus's early paintings, embody a view of the male homosexual as predatory, preening, and perversely effeminate. The other figures in those same paintings hardly escape cartoonish derision or distortion, however, as is clear from the bearish yawn (or belch) of the male diner at the right end of the table in *Greenwich Village Cafeteria*. But it is the fairy who interests me here, in part because it is he who might be said to parallel the position of Cadmus in the 1930s: a young homosexual man who fixes his gaze on other men (especially sailors) or who, as in *Greenwich Village Cafeteria*, is linked to an all-male space (a "men's room") just beyond the descriptive bounds of visibility.

Several period photographs seem to play, albeit subtly, on the correspondence between Cadmus and the homosexual characters he painted. For example a 1937 photograph from *Life* magazine shows the artist standing before *Greenwich Village Cafeteria* in his (Greenwich Village) studio (figure 2.22). With his neatly combed hair, high cheekbones, and slender, long-limbed body, Cadmus visually echoes the homosexual figure on the far-right side of the painting. Cadmus's frontal and slightly diagonal stance neatly reverses the fairy's back-turned bodily orientation. Within the visual logic of the *Life* photograph, the fairy's over-the-shoulder glance now seems directed no less at Cadmus himself than at the viewer.

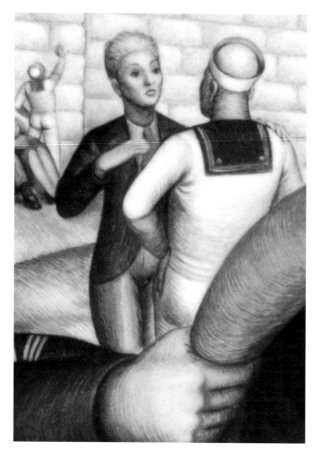

Figure 2.19. TOP
Paul Cadmus, *Shore
Leave*, 1933. Oil on
canvas, 33" × 36",
Whitney Museum of
American Art. Photo-
graph courtesy D. C.
Moore Gallery,
New York, N.Y.

Figure 2.20. BOTTOM
Paul Cadmus, *Shore
Leave*, 1933. Oil on
canvas (detail). Photo-
graph courtesy D. C.
Moore Gallery,
New York, N.Y.

If Cadmus was sometimes aligned with the homosexual characters he painted, this does not mean that he necessarily saw himself as such a character. How else, though, might the artist have portrayed his identity in the 1930s, given that the predominant image of male homosexuality was that of the emasculated fairy? Would Cadmus's sexuality simply be erased from the visual terms of his self-portraiture? Or would he allow certain comparisons to be drawn between himself and the fairy, as in the *Life* photograph? In what follows, I will argue that in *Self-Portrait Mallorca* (figure 2.23), completed in 1932, Cadmus found a pictorial means of signaling his sexual preference without recourse to homosexual stereotype. *Self-Portrait Mallorca* was never censored or suppressed in the manner of *The Fleet's In!*. This is not to say, however, that the painting was free from the constraints placed upon homosexual visibility in the 1930s. To the contrary, *Self-Portrait Mallorca* reveals how Cadmus negotiated—and, to some extent, pictured—these constraints within the space of his early work. By returning to *Self-Portrait Mallorca*, I mean to suggest that public acts of censorship (e.g., the navy's confiscation of *The Fleet's In!*) are tied to far more private forms of restriction and artistic response.

Figure 2.21.
Paul Cadmus,
Greenwich Village Cafeteria, 1934.
Detail. Photograph courtesy D. C. Moore Gallery, New York, N.Y.

Figure 2.22.
Photograph of Paul
Cadmus from "Paul
Cadmus of Navy
Fame Has His First
Art Show," *Life*,
March 29, 1937:
44. ©Time Inc.

Self-Portrait Mallorca offers the artist in the reflection of a foreground mirror set on a ledge overlooking a veranda.[96] The only other figure in the composition is that of a naked woman who seems surprised, though not overly distressed, by Cadmus's presence on the scene. She has just dropped her towel, presumably in the confused excitement of the moment, though whether her disrobing is by accident or by design remains unclear. As she looks over to the artist at his mirror, Cadmus continues to look at himself, preferring (it would seem) his facial reflection to her full-figure exposure. Cadmus's careful and completed appearance, what we might even call his carefully completed appearance, underscores the immodesty and carelessness of the female figure in the background (figure 2.24). The woman's flesh is so loosely painted, especially in the area of the upper torso, that it suggests an almost cursory treatment by the artist. That Cadmus seems to have "rushed" through his description of the female figure adds to the comic effect of her unexpected appearance on the scene. It also dramatizes, by way of contrast, the precisely wrought image of the self in the foreground: the delicate bone structure of the artist's face, the fine texture and blond highlights of his hair, the carefully delineated stubble of his mustache, the casual, Continental elegance of his clothing, the filigree patterns on his mirror's silver frame.

Cadmus's shaving mirror is, of course, a tool for facial grooming and the daily maintenance of personal appearance. Several of the ancillary objects laid out next to it (white towel, razor, shaving brush) underscore this function. Within the larger fiction of the painting, however, Cadmus would seem to have little use for the mirror at this moment: he is already groomed and fully dressed for the day. As if to reinforce this point, the artist sports several layers of clothing—a

Figure 2.23. Paul Cadmus, *Self-Portrait, Mallorca*, 1932. Oil on canvas, 22 × 18".
The Forbes Magazine Collection, New York, N.Y. Courtesy D. C. Moore Gallery,
New York, N.Y.

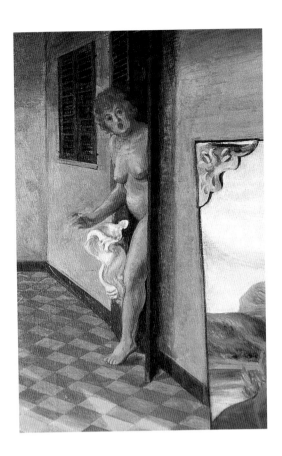

Figure 2.24.
Paul Cadmus, *Self-Portrait, Mallorca*,
1932. Oil on canvas, detail. Courtesy D. C. Moore Gallery, New York, N.Y.

striped T-shirt, a collar shirt, and a cardigan—as well as a precisely shorn mustache and a self-possessed expression. If Cadmus is not shaving or dressing at this moment, neither does he seem to be momentarily checking his appearance prior to exiting the apartment. The resolution of his reflected image (again, in contrast to the more "cursory" image of the female nude) suggests a sustained self-scrutiny rather than a passing glance. Why, then, should Cadmus be looking at himself in this manner? Perhaps because the mirror, in giving the artist back to himself as a two-dimensional image, facilitates not only shaving but also self-portraiture.

The production of a self-portrait entails both visual self-apprehension (as, most typically, in a mirror) and pictorial self-representation. As T. J. Clark has argued, self-portraiture often moves between these two moments or registers, between an image of the artist looking at his or her own appearance and an image of the artist painting that same look: "[It is] not just that the object of a self-portrait is supposedly the subject who made it, but that that making is part of what is portrayed. The self is to be shown representing itself; and there is the rub; for 'shown' cannot possibly be meant literally here—or can it? What does it mean, after all, to 'show' representation?"[97] Cadmus attempts to "show representation" in *Self-Portrait Mallorca* not only by offering his mirror image as the focal point of the painting but also by framing that image as an oil portrait. The shaving mirror in *Self-Portrait Mallorca* serves as a sort of switch-point between

the procedures of looking and making, between the acts of reflection and representation. It bounces us out of the fiction of the self-portrait (male figure glancing at himself in mirror, naked female neighbor witnessing him) and into the technique and materials of its making, a making that ultimately folds back into the terms of the painting's fiction.

The conventionalized relation of the Mallorcan landscape to the foreground, bust-length figure of the artist signals that Cadmus sees himself in *Self-Portrait Mallorca* not merely through the optic of mirror reflection but also through that of Italian Renaissance portraiture. Let Biagio di Antonio's *Portrait of a Young Man* (c. 1480) mark the quattrocento convention of presenting the sitter as a half-length figure set against an expansive, if minutely detailed, landscape (figure 2.25). When viewed through the lens of the Biagio portrait, Cadmus's depicted mirror image resolves all the more insistently into a painting within the larger picture that is *Self-Portrait Mallorca*. As Cadmus's shaving mirror doubles as an Italianate portrait, so the instruments of his personal grooming (figure 2.26) correspond to those of high art, with the shaving brush standing as a metaphoric equivalent to a paintbrush, and the handle of the razor as a stick of charcoal or crayon. Because brush and razor are the tools, rather than the visual focus, of shaving-become-painting, they sit nearby the framed image but are not reflected on its surface. The orange, by contrast, is fully reflected in the mirror, perhaps because it stands in for the category of still life, a category that, like the artist's own face and figure, constitutes a "proper" subject for oil painting.

The metaphor of the mirror as a painted self-portrait is extended by the oversized scale of the shaving mirror, a scale far more appropriate to an oil painting than to a travel accessory.[98] The enlargement of the foreground mirror in *Self-*

Figure 2.25. Biagio di Antonio, *Portrait of a Young Man*, c. 1480. Tempera on wood, 21½" × 15⅜". Metropolitan Museum of Art, New York, N.Y.

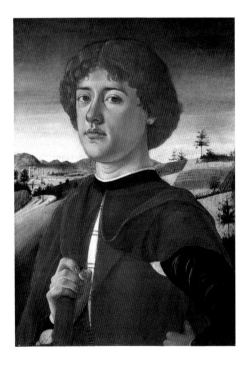

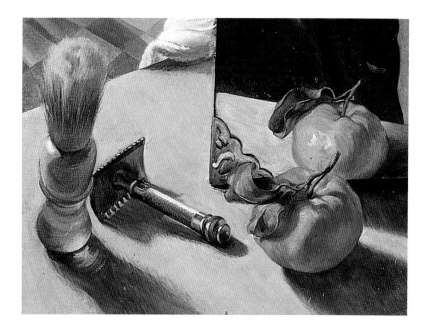

Portrait Mallorca counters the miniaturization of the female figure in the back-
ground. The force and scale of Cadmus's self-display seems to have produced a
corresponding belittlement—both literal and symbolic—of the woman on the
veranda. It is as though the artist's self-absorption has distorted the spatial rela-
tions of the larger painting. While Cadmus's reflection is aligned with the colors
and curving lines of nature (the sky and verdant landscape, the orange and its
leafy stem), the female nude is thrown deep within the architectonics of the
interior. Her figure, smaller than traditional perspective would dictate, must
contend with a set of insistent geometries: the checkerboard pattern of the
orange and yellow floor, the slashing angles of sunlight and shadow upon it, the
blue shutters of door and windows, and the outline of the oversized shaving
mirror.

If Cadmus's mirror image links him to the genres of self-portraiture, still life,
and landscape painting, the image of the female figure embodies the "lower" reg-
isters of caricature and comic burlesque. In *Self-Portrait Mallorca*, the male artist
serves as the locus of pictorial attention and desire, as a framed work of art. The
female nude, by contrast, scurries through the background like a bit player in a
bedroom farce. Cadmus could not paint himself as erotically and explicitly
attached to another man in 1932.[99] He could, however, render himself as the
object of his own desiring gaze while, at the same time, sabotaging the viability
of heterosexual coupling.[100]

The self-absorption of the male subject, whether captured by that subject or
by an admiring witness, was a motif that recurred in Cadmus's work and in that
of his artistic circle, especially within the arena of photography. George Platt
Lynes's 1928 portrait of his sometime lover, the surrealist poet René Crevel (fig-
ure 2.27), features the subject absorbed in his own mirror image. Crevel's pro-
file on the left side of the composition is answered by the half-lit reflection of his

full face on the right. In this case, the doubling of the male subject in his mirror might be seen to stand in for the less "properly" representable coupling of photographer and model, of Lynes and Crevel. The implied homoeroticism of the portrait is enhanced by the subtle inscription, via reflection, of Lynes's hand and camera between the twinned faces of Crevel. A 1941 Cadmus photograph of his lover, Jared French, also features the motif of male doubling via reflection, though in this case the reflection is cast on water rather than glass (figure 2.28). Cadmus photographs his wading subject from behind, a favored vantage point of the artist as we saw in *The Fleet's In!*. French's body is thus pictured in a view that he himself cannot access. In Cadmus's portrait of French, as in Lynes's of Crevel, the photographer's investment in his partner is suggested by a doubling of the male body that extends beyond the bounds of simple mirroring or self-reflection. Lynes imposes his own presence, and that of the photographic apparatus, onto his portrait of Crevel. Cadmus's portrait suggests a voyeuristic pleasure in framing French from behind and in catching him at a moment when he seems unaware of the camera's presence.[101] In different ways, then, both portraits stage a thematics of narcissism while breaking open the circuit between the self and its reflection.

A last portrait from the period dramatizes with particular force the play of difference across the doubling of the self. In a 1937 Lynes photograph, a nude male figure is mirrored by his frontal reflection on the surface of a pane of glass (figure 2.29). The figure, arms outstretched in a mime of classical statuary, has been smoothed and silhouetted by studio lighting. A closer inspection of the photograph, however, or a glance at its title, *Charles Nielson with J. Ogle (behind glass)*, reveals that the male subject is doubled not by his own image but by a second man standing behind the glass. The mirroring of the self is thus unveiled as an act of studio mimicry in which two models impersonate a single, reflected figure. The visual codes of self-absorption transfigure, as if before the viewer's eyes, into those of homoeroticism as the seeming identity between the subject and his reflection shades into a subtle difference. *Charles Nielson with J. Ogle (behind glass)* obscures the distinction between self and other to such a degree that narcissism appears as the threshold and very mirror of same-sex desire.

I would like to step back for a moment from particular portraits in which the male body is doubled or mirrored to pursue the larger question these portraits pose: why should narcissism provide a means of depicting male homoeroticism? This question is overdetermined from the first by the fact that narcissism, since Freud, has so often been understood as constitutive of male homosexuality. Although Freud theorized narcissism in multiple ways, one of his most influential formulations (first put forward in 1910) held that homosexuals "take *themselves* as their sexual object. That is to say, they proceed from a narcissistic basis and look for a young man who resembles themselves and whom *they* may love as their mother loved *them*" (Freud's emphasis).[102] According to this model, male homosexual desire is fueled by an imagined similarity between the self and the desired object. Yet that similarity entails not a simple mirroring of the self but a triangulated relation in which the male subject desires other men from the imagined perspective of the mother. While this formulation may be no less problematic (for homosexual men and their mothers, at least) than the popular concept of narcissism as extravagant self-regard, it is certainly distinct from it.

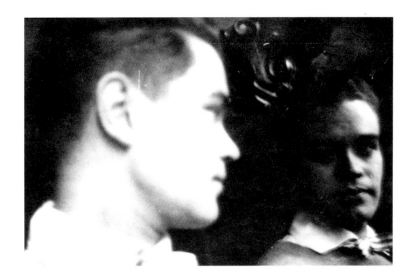

Figure 2.27. TOP
George Platt Lynes,
Portrait of René Crevel,
1928. Vintage silver
print. Courtesy
George Platt Lynes II.

Figure 2.28. BOTTOM
Paul Cadmus, *Jared
French, Clinton, New
Jersey*, 1941. Gelatin
silver print. Courtesy
D. C. Moore Gallery,
New York.

In recent rereadings of Freud, several scholars have contested the perceived equivalence between narcissism and gay male desire.[103] Kaja Silverman, for example, has argued that the psychic relation of male homosexuality to femininity might best be understood as a shifting modality that oscillates between desire and identification. Silverman insists that narcissism, far from a distinctive feature of male homosexuality, must be understood as intrinsic to the very condition of subjectivity. "Receptivity, specularity [serving as a visual object], and narcissism represent constitutive features of *all* subjectivity, even though masculinity is predicated on their denial" (Silverman's emphasis).[104] In this context, "masculinity" refers to those forms of male subjectivity that conform to dominant models of heterosexual desire and entitlement, to what Silverman calls "the straight and narrow path of conventional masculinity."[105] Extrapolating from Silverman's argument, I would suggest that homosexual men, including artists

Figure 2.29. George Platt Lynes, *Charles Nielson with J. Ogle (behind glass)*, 1937. Photograph. Courtesy George Platt Lynes II.

such as Cadmus and Lynes, have sometimes dramatized precisely those psychic features that dominant masculinity disavows. The self-conscious inflation of narcissism in *Self-Portrait Mallorca* or *Charles Nielson with J. Ogle (behind glass)* serves to mark out a space of difference and distance from normative manliness. This is not to say that homosexual men in general or Cadmus and Lynes in particular really were (or are) more narcissistic than their heterosexual counterparts. Rather, it is to claim that the codes of narcissism have been available to homosexual artists for use in ways that heterosexual masculinity could not abide.

I want to argue this point by comparing *Self-Portrait Mallorca* to a slightly earlier work by a Regionalist painter that strongly disavows narcissism. In Thomas Hart Benton's 1925 *Self-Portrait* (figure 2.30), the artist confronts the viewer as though we presented a threat or danger precisely because we are watching him look at himself. Benton locates us where his mirror would be placed during the act of self-portrayal and then regards that observation space with open hostility. Cadmus, by contrast, depicts himself *as* a mirror reflection, thereby situating the viewer where the artist would be while in the act of painting himself. Benton stages the presence of the beholder as an unwanted intrusion into the studio: if we would only leave, he might resume work on the painting at hand, a painting that has been angled away from the viewer such that only the back of the canvas is visible. This denial of pictorial access, this blind spot in the visual field, produces a question—and, to my mind, a tension—as to whether the picture Benton is seen working on in the 1925 *Self-Portrait* is that very self-portrait. Within the fiction of the larger work, is Benton painting himself painting himself? Or is he painting himself painting another subject entirely? Or, one last alternative, is he painting a different picture of the same subject, namely himself? If we could turn that fictive canvas around, what image would we find depicted on its surface? The ferocity with which Benton meets the gaze of the viewer seems to warn us that we cannot resolve this question, that we cannot enter the space of his studio. In an apt description of the 1926 *Self-Portrait*, curator Henry Adams notes that, "Benton wields his paintbrush like a club."[106] Such an aggressive stance betrays the artist's own anxiety over the terms of his self-display. Benton seems to worry that his role as studio model, as specularized object, will undermine his status as the determining subject of vision, which is to say, as the artist before his easel. This worry correlates with the disavowals (of narcissism, specularity, and receptivity) that are, for Silverman, constitutive of traditional masculinity.

I have contrasted Benton to Cadmus in large part because of the former's investment in dominant modes of masculinity and his avowed contempt for male effeminacy and homosexuality.[107] Yet while Benton's self-portrait projects an inflated masculinism congruent with his own discourse on gender and sexuality, it cannot be made to stand in for male heterosexuality *tout court*. Likewise, Cadmus's specific staging of the self in *Self-Portrait Mallorca* cannot be taken to represent male homosexuality circa 1932. Each artist's account of the self was particular to his own practice as a painter, a practice inflected by, but never equivalent or reducible to, his sexual identity. Cadmus *used* the codes of narcissism and satire to suggest his sexual difference at a historical moment when the options for gay self-representation were severely curtailed. This is not to claim, however, that the artist's homosexuality can be directly mapped onto his self-portrait such that, for example, a denigration of the female body is seen to structure (or speak-

Figure 2.30. Thomas Hart Benton, *Self-Portrait*, 1926. Oil on canvas, 37⅜" × 31⅜".
Collection of Jessie Benton Lyman. Photograph © 1988, The Nelson Gallery
Foundation. Courtesy Anthony Benton Gude and the Nelson-Atkins Museum of Art.

Figure 2.31.
Jared French, *Self-
Portrait, Mallorca,*
1932. Watercolor
on paper, approxi-
mately 5" × 7".
Courtesy D. C.
Moore Gallery,
New York.

the truth of) Cadmus's "actual" desire for other men.[108] Nor should Cadmus's self-representation be generalized into a description of other homosexual artists of the day. Several of the artists in Cadmus's immediate circle created self-portraits that reject the terms of male narcissism on which *Self-Portrait Mallorca* depends.

The most relevant example for our purposes is that of Jared French, who also produced a work entitled *Self-Portrait Mallorca* in 1932, the year in which he and Cadmus lived together on the Spanish island (figure 2.31). For all of French's proximity to his lover at the time, his painting mimes not Cadmus-like self-absorption but a palpable Benton-like dismay with the very terms of self-portrayal.[109] French paints himself, bearded and shirtless, against the backdrop of the Mallorcan sea and distant landscape. Rather than gazing out at the viewer or back at himself, French looks sharply off to his right, toward a space that we, as viewers of the painting, cannot see. The artist furrows his brow while narrowing his gaze, as though concentrating on an object that does not meet with his approval.

In describing the conventions of self-portraiture, T. J. Clark observes that self-regard "is not a neutral term in common usage and shades off quickly into *amour propre*. Looking too hard at oneself is embarrassing. . . . Self-portraits are partly made, I think, against this background of suspicion, and the look in them has to signify before all else that the painter cast a cold eye on his subject-matter as opposed to a warm one."[110] In *Self-Portrait Mallorca,* French moves one step beyond casting a cold eye on his subject matter. He refuses to acknowledge the reception of his own look, refuses, as it were, to show himself being seen. Even as French delicately details his physical appearance (the wisps of blond-white hair, the reflection of light off his forehead, lips, and bearded chin), he disowns the visual attention necessary to produce that description. He denies the means

of self-portrayal not only by turning away his head but also by excluding the accouterments of painting (canvas, brush, palette) and of reflection (mirror) from his depiction. In French's *Self-Portrait Mallorca*, the artist looks not so much at a specific object beyond the frame but, more simply, at something—at anything—that is not himself. French's self-portrait recalls Benton's insofar as it deflects attention away from the painter's role as the object of his own, invested look. Following Silverman, I would suggest that such a deflection of specularity aligns the depicted self with the dominant terms of masculinity, whatever the "actual" sexual orientation of the artist producing the depiction.

Where Benton defies and French denies his own self-apprehension, Cadmus invites the viewer into the act of looking at the self. By so doing, Cadmus acknowledges self-absorption as a constitutive element of self-portrayal. Yet, the figure of the female witness in *Self-Portrait Mallorca* complicates the terms of that acknowledgment. The presence of the older woman in the background extends the visual circuit between self and reflection into a triangular relay of looking and looking back, of pictorial presence and absence. The woman looks, after all, not at the artist's mirror image but at the subject who casts it. She looks, in other words, at the undepicted space in which the artist (and now the viewer) stands. *Self-Portrait Mallorca* directs us from Cadmus's reflection in the foreground to the female figure in the background and then, from her surprised look, back to our own position as viewer.[111] But whose gaze is organizing this relay? Whose look is prior and determining, whose subsequent and reactive?

For all the primacy of Cadmus's look at himself in the mirror, the scope and final destination of that look remain ambiguous. The artist eyes his reflection from a slightly oblique angle, an angle that may also allow a view—or at least a glimpse—of his female neighbor.[112] The possibility of such a double look suggests a view of the self that similarly slides between the registers of idealization and satire, between the beautiful young man in the mirror and the naked older woman on the veranda. The neighbor's exaggerated femininity may not, in the end, be wholly extrinsic to the male self reflected in the mirror. As we saw earlier in this chapter, openly homosexual men ("fairies") were typically equated with—while also set in competition against—openly sexual women ("floosies") during the 1930s. Recall Chauncey's observation that "sexual desire for men was held to be inescapably a woman's desire, and the invert's desire for men was not seen as an indication of their 'homosexuality' but as simply one more manifestation of their fundamentally womanlike character."[113] With this period equivalence in mind, might we see the female figure in *Self-Portrait Mallorca* not simply as a comic counterpoint to the artist or as a sign of his failed heterosexuality but also as a supplement to, perhaps even a satirical mirror of, the self? At the very moment when Cadmus would seem most absorbed in his own reflection, a female figure looks at him and, in a sense, mirrors his status as beholder. For all their obvious difference, the figures of the male artist and the female nude answer each other from across the space of the veranda. Their ruddy complexions, honey-colored hair, and white towels create a kind of visual rhyme, especially as the upper folds of the woman's falling towel seem to point (or float) toward the artist, as if reiterating her interest in his presence. Even as the painting enacts a series of oppositions between male subject and female witness (idealization/satirization, nearness/distance, youth/middle age, dress/nudity), it

simultaneously sets these oppositions into a circuit of looking and reflection, of call and response. In *Self-Portrait Mallorca*, Cadmus paints his lips pink and adds a few blond highlights to his hair while projecting onto the veranda an image of what may be his own femininity looking back at him. In so doing, he ingeniously reworks the codes of both self-portraiture and homosexual stereotype.

According to Cadmus, *Self-Portrait Mallorca* was the first work "into which I introduced something not directly painted from nature: the startled woman coming out of the next door apartment. . . . No such woman, as in the picture, existed. Neighbors were bourgeois Mallorcans."[114] Cadmus inagurated his practice of painting from imagination by introducing a naked woman to a scene of his own self-apprehension. The female nude, peering out at the artist from her doorway, marked Cadmus's debut not only as a fantasist but also as a satirist. In his first experiment with the form, Cadmus consigned satire to the background of a painting whose overall form is not satirical. Yet the tension between satire and idealization fuels much of the pictorial and narrative interest of the painting. In *Self-Portrait Mallorca*, this tension turns on gender, with the female figure carrying the force of satire and the male artist enjoying the fruits of idealization.

While Cadmus could not paint himself as an openly gay subject in the 1930s, he could (and did) distance himself from the normative image of heterosexual masculinity. *Self-Portrait Mallorca* suggests Cadmus's homosexual difference neither through the visible coupling of male bodies nor through a stereotype of the effeminate fairy but through an idealization of the male self and a satirization of the female nude. A dialogue (and often a conflict) between satire and the ideal would remain central to the artist's work in the 1930s, especially in those instances where he portrayed the nude. The terms of both satire and idealization shift dramatically, however, when the nude in question is male rather than female.

Revisions of the Nude

When asked in 1988 whether he had been angry that the navy censored his work in 1934, Cadmus responded that "I don't remember being angry at all—no. I suppose I was a little bit indignant. I mean I thought I was being suppressed or censored, but I don't remember being outraged or anything like that. I guess I just took it as a matter of course that people are censored.[115] Cadmus recalls a bit of indignation but no outrage in the face of being censored in 1934. "I just took it as matter of course that people are censored." Taking censorship as a "matter of course" means anticipating the possibility that one's art may be suppressed and making artistic choices in the light of this knowledge. How might Cadmus have internalized the threat of censorship within his own process of pictorial composition and revision? By looking closely at *Gilding the Acrobats*, a picture completed within a year of *The Fleet's In!*, we will see how Cadmus took censorship as "a matter of course" even as he continued to insist on homoerotic displays of the male body.

Gilding the Acrobats offers four male figures preparing for a circus performance in various states of dress and undress (figure 2.32). In contrast to the artist's contemporary paintings of Riverside Drive, Greenwich Village, or the West Side

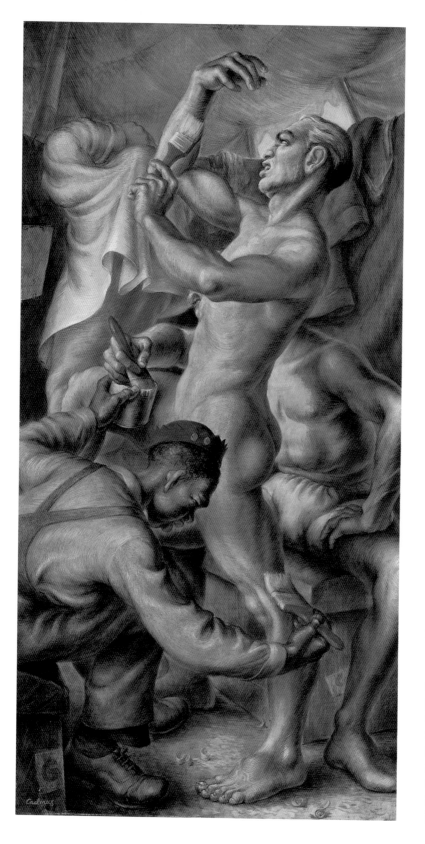

Figure 2.32.
Paul Cadmus,
Gilding the Acrobats,
1935. Mixed tech-
nique (oil and tem-
pera) on pressed
wood panel, 36½"
× 18½". Metropol-
itan Museum of
Art, New York.
Courtesy D. C.
Moore Gallery,
New York.

Figure 2.33.
Paul Cadmus, *Male
Torso*, c. 1937. Pen
and ink on paper,
11⅜" × 8⅛".
Courtesy D. C.
Moore Gallery,
New York.

YMCA, *Gilding the Acrobats* affords no description of a specific New York City locale. Cadmus created the picture in his studio on St. Lukes Place in Greenwich Village and employed no photographs or direct sketches of circus performance as source material. The pictorial presentation of the central figure in *Gilding the Acrobats* exemplifies Cadmus's insistence on what one member of his circle has called "the touchable body"—the body displayed as the sum of its own physical gestures and muscular force, as the reach of an upraised arm, the arc of a pair of buttocks, the bulge of a neck or collarbone, the jut of a chin or Adam's apple.[116]

Cadmus was preoccupied with the subject of the male nude throughout the 1930s; sketching from the live male model constituted his most common artistic activity during that decade.[117] Cadmus's early sketches of the male nude typically aspire to a kind of classical ideal (figure 2.33), an ideal that contrasts sharply with the artist's more occasional drawings of the female nude, in which the body, weighty and pendulous, is marked by fleshly imperfection (figure 2.34). The inclusion of a contemporary garment of clothing, such as the single stocking in the sketch of the seated female nude, only emphasizes the anticlassi-

cal treatment of the subject. Among the most salient contradictions to inhere in Cadmus's early work is a marked asymmetry of approach to male and female figures and a related tendency, as in *Gilding the Acrobats*, to sweep the female body out of the visual field altogether. If, in the memorable phrase of Lewis Mumford, Cadmus's "hand lingers too lovingly on the flesh he would chastise,"[118] that tendency surfaces only when the flesh in question is male. An opposite problem, an excess of chastising, occurs when the figure is female or otherwise feminized, as in the artist's portrayal of openly homosexual figures.[119]

Different pictorial investments, then, structure Cadmus's male and female bodies as well as his heterosexual and homosexual ones. Yet even the preferred terms of identity within Cadmus's pictorial lexicon (i.e., male, heterosexual-identified) do not escape cartoonish distortion and derision. Masculinity is glimpsed within raucously unstable circumstances and liminal spaces: in the far reaches of the circus tent, on shore leave in Riverside Park, in the locker room of the West Side YMCA, in an overcrowded Greenwich Village cafeteria, at a wild party on New Year's Eve. Heterosexual masculinity, far from a stable site of identity, is further unfixed by the powerful force of same-sex attraction. Cadmus's male athletes, sailors, acrobats, and revelers enjoy homosocial contacts that border on, and often shade into, something more insistently erotic.

Figure 2.34. Paul Cadmus, *Female Nude (from Sketch Book #C)*, c. 1936. Pen and brown ink on paper, 11" × 8¼". Courtesy D. C. Moore Gallery, New York.

Gilding the Acrobats not only exemplifies this tendency; it qualifies as something like a metadiscourse on it. A sustained attention to the muscular male body describes both Cadmus's procedure in creating the picture and the fiction he has depicted within its frame. The figures in *Gilding the Acrobats*, some nude or semi-nude, are themselves painting the male nude. Although aware that circus gilding was accomplished with sponges (so as to apply the pigment more quickly to the overall surface of the body), Cadmus opted to show his figures wielding paint-brushes.[120] The pictorial substitution of brushes for sponges allies the proce-dure of acrobatic gilding with the creative craft of painting, thereby suggesting that *Gilding the Acrobats* may itself be an allegory of art or, at least, an allegory of art as practiced by Paul Cadmus. Both the painter and his depicted acrobats share a similar attitude toward the male nude: a combination of investment and pro-fessional distance, of absorption and arch disavowal.

According to Cadmus, Jared French served as the model for all four figures in *Gilding the Acrobats*, including the black youth in the foreground.[121] While Cad-mus often based his male figures (or even multiple figures within the same work) on French, he produced only two full-scale portraits of his lover, neither of which was exhibited during the 1930s. In the first of these portraits, *Jerry* (figure 2.35), from 1931, Cadmus tips the horizontal of the mattress up toward the pic-ture plane so that virtually the entire background of the composition is over-taken by the sheets and pillows of the bed. This perspectival shift suggests a par-ticular intimacy insofar as the artist, if not in bed with Jerry at this very moment, is obviously familiar, and near, enough to have just been so. We might note that Jerry's bedside reading is James Joyce's *Ulysses*, a novel banned at the time on grounds of obscenity.[122] As Cadmus recalls, Luigi Lucioni, an Italian friend and fellow painter, smuggled a contraband copy of the book into the United States as a gift to the couple.[123] Jerry's outlawed practice of reading *Ulysses*, connected as it is to his frankly sensuous gaze and recumbent body, may stand in for other, less easily representable acts of bedtime transgression.

Where Jerry looks directly up to the viewer, acknowledging, even inviting our pleasure in his physical exposure, the figures in *Gilding the Acrobats* seem oblivious to our presence, lost as they are in their own painterly tasks or in the process of disrobing. Although three of the four figures in the painting have stripped or are stripping down, the conceit of circus gilding metaphorically "cloaks" them in a narrative justification. Because such cover is refused in the earlier, more openly homoerotic *Jerry*, that portrait could not be publicly exhib-ited in the 1930s. Cadmus contrived the circus theme of *Gilding the Acrobats* to justify the nakedness of his male figures, a nakedness that, by the artist's own account, constituted the painting's raison d'être.

The use of acrobatic gilding is nevertheless a peculiar choice within the terms of Cadmus's practice in that acrobats did not gild themselves for public perform-ance in the 1930s but wore spangled leotards and tights. A 1930 photograph of Alfredo Codona, the most celebrated acrobat of the day (figure 2.36), typifies the characteristic costume of circus aerialists at the time. In *Gilding the Acrobats*, Cadmus has almost certainly borrowed the motif of body gilding from another circus act, that of the "living statues," performers who were washed with gold (or, less typically, bronze or silver) paint and then assumed a succession of frozen poses, individually or in collective *tableaux vivants* (figure 2.37).[124] The "living

Figure 2.35.
Paul Cadmus, *Jerry*, 1931. Oil
on canvas, 20" × 24". Courtesy
D. C. Moore Gallery, New York.

Figure 2.36.
Harry Atwell, "Alfredo Codona
Sitting on Trapeze Bar," 1930.
Photograph. Courtesy Circus
World Museum, Baraboo, Wis.

statues" (also called the "human statues") highlighted the exposure of the body while elevating it to the level of representation, cloaking the circus performer in a "costume" of painted skin that theatrically simulated cast-metal sculpture. While acrobatic troupes were dominated by male performers, the "living statues" were primarily, though not exclusively, the province of women. The gendered division between the two circus acts also marked a difference of performative mobility: where acrobats entertained through their high-flying activity (e.g., aerial somersaults, flips, and dives), the "living statues" were presented as immobilized objects—the (female) body, frozen and painted, become a carnival mannequin.

In a Ringling Brothers photograph of a "living statue" from 1933, the female performer smiles tightly through her stiff pose, as though trying, against all odds, to convince us of her comfort with this absurd circumstance (figure 2.38). Such a dual sense of exposure and alienation, of eroticism and awkwardness, surfaces as well in *Gilding the Acrobats*. Consider how the standing acrobat confronts his gilded forearm and oversized hand with a mixture of concentration and repulsion (figure 2.39). The acrobat encounters his upraised arm as though it were something external to himself, a painted prosthesis with which he were not completely satisfied. The snarling facial expression of this central figure seems rather at odds with the pictorial attention lavished on the rest of his body. Lincoln Kirstein, noting this contrast, describes *Gilding the Acrobats* as exemplary of the fact that the "faces characterizing many of Cadmus's early nudes are objectively mature and in no way attractive. They are seen not as ideal, but as solid capitals to the twisted baroque plinths of bone and muscle."[125] We could say that the acrobat's grimacing face bears the mark of satire, while the treatment of his body returns us to a more classicizing tradition of the male nude. The central figure in *Gilding the Acrobats* is marked, then, by an internal contradiction: the erotic force of his exposed body pulls against the harshly metallic tone of the larger painting.

If such tensions arise from Cadmus's freezing of the acrobatic body into a living statue, they also stem from other pictorial borrowings. The sense of the nude body as a virtual sculpture attends not only to circus photographs of the "human statues" but also to many commercially produced images of homoerotica from the 1930s, including a series of photographs of the bodybuilder Tony Sansone printed in a 1932 booklet entitled *Modern Classics* (figure 2.40). *Modern Classics* justifies its fixation on the supertoned body of Sansone through a fabulously hyperbolic discourse on art and classicism. The booklet's essay, by one Joseph Nicolosi, proclaims that Sansone "has been for many years by far the most perfect masculine specimen obtainable by sculptors, painters, and illustrators; indeed, his physique is the embodiment of the Greek Gods; the ideal model of Phidias and Michelangelo combined, of elegant proportion and form surpassing even the finest sculptures of the classics. He seems to be the choicest of Athenian youth of the heroic age, incarnating out of time."[126]

Nicolosi legitimates the homoerotic exposure of the naked male body by elevating that body to the status of art. And not just any art but that of Phidias and Michelangelo combined. Once "incarnated out of time," Tony Sansone may be presented as a classical sculpture, a Renaissance nude, a Greek God, an Athenian

youth, as almost anything, it would seem, but a Brooklyn bodybuilder flexing and posing for the camera in 1932. For all its rhetorical fervor, the text cannot disguise the distinctly modern conditions of Sansone's appearance before the camera, conditions that include, of course, the camera itself. A palpable tension between classicism and the contemporary, between homoerotic investment and artistic justification, shapes the text, images, and very title of *Modern Classics*. Visually, this tension produces a palpable awkwardness about the terms of masculine display. It is an awkwardness that *Modern Classics* shares with *Gilding the Acrobats*. Notice, for example, how both the Cadmus painting and the Sansone photograph conceal the male genitals, whether through the strategic placement of another figure's head or through the retouching of the area where the penis would be. Even as they savor the nude male body, both *Modern Classics* and *Gilding the Acrobats* somewhat clumsily deny its full exposure.

In this context, it is worth thinking more closely about the compositional treatment of the figures in *Gilding the Acrobats* and, more specifically, about how the physical proximity of the acrobats to one another occasionally confuses the distinction between discrete bodies. Notice, for example, how the right foot of the seated acrobat can also be "read" as that of the central figure. Perhaps the moment of maximum charge and ambiguity in *Gilding the Acrobats* is the point at which the four figures seem nearly to intertwine: the boy's hand that holds up the can of radiator paint is directly adjacent to the standing acrobat's upper thigh, above which snakes the extended hand of the seated figure, and below

Figure 2.37. Harry Atwell, "Human Statues Posing in Buckingham Fountain," 1933. Photograph. Courtesy Circus World Museum, Baraboo, Wis.

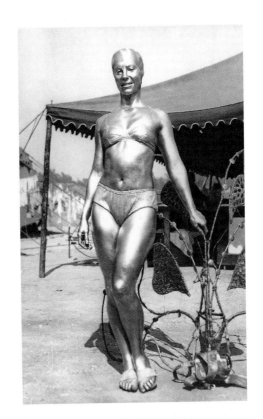

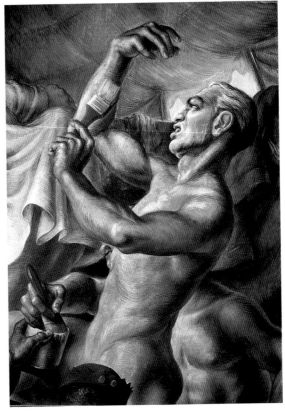

Figure 2.38. TOP
"Lady Statue Ready for
the Human Statue Act;
Posing in Backyard,"
1934. Photograph,
Ringling Bros. and
Barnum & Bailey
Combined Shows.
Courtesy Circus
World Museum,
Baraboo, Wis.

Figure 2.39. BOTTOM
Paul Cadmus, *Gilding
the Acrobats*, 1935.
Detail. Courtesy
D. C. Moore Gallery,
New York, N.Y.

which appear the buttocks of the disrobing acrobat in the background (figure 2.41). One strategy through which Cadmus secures the boundary between male bodies in *Gilding the Acrobats* is by marking off, via race and generation, the black youth in the foreground from the adult acrobats in the rest of the composition.

Cadmus's decision to include a black figure within a picture devoted to the theme of skin painting introduces a charged set of racial issues into the work. What function does racial difference serve within *Gilding the Acrobats*, and how does it relate to the painting's peculiar combination of satire and homoeroticism? In a 1946 reminiscence of the painting, Cadmus recalled, "I was greatly fascinated by the acrobats, trapeze artists and especially by the gilded people. I thought it would be particularly interesting to see them contrasted with real flesh and with the dark flesh of the little negro boy."[127] Cadmus's formulation contrasts so-called real flesh both to the gilded skin of the white performers

Figure 2.40. "Anthony ('Tony') J. Sansone," in *Modern Classics*, 1932. Courtesy Gay and Lesbian Historical Society of Northern California, San Francisco.

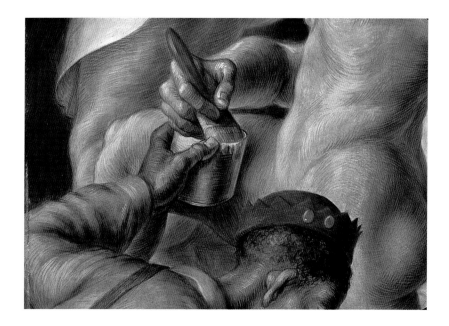

and to the "dark flesh" of the "little negro boy." This remark (and, to a lesser
extent, the painting to which it refers) implies that black skin need not be gilded
because it is already "painted" by pigment. Notice, in *Gilding the Acrobats*, how
Cadmus disperses gold highlights across the surface of the boy's billowing shirt
and, more sparingly, across that of his blue coveralls. In effect, the black figure is
"gilded" on the level of his clothes, while the white acrobats are gilded on the
level of their skin. With his shirt, coveralls, shoes, and beanie, the black youth is
not simply dressed but "overdressed" by comparison to the naked and near-
naked acrobats.

The pictorial difference of the black youth from the adult acrobats marks his
subordinate role within the circus troupe. While the youth helps to prepare the
white acrobats for performance, he will not appear in their circus act: his (black)
body will not be placed on public display. American circus troupes of the 1930s,
unlike European ones of the same period, did not employ black acrobats. In Rin-
gling Brothers and other major U.S. circuses, black employees were occasionally
permitted to work as clowns but were far more often consigned to support staff
positions such as porters and dressers—positions like that of the black youth in
Gilding the Acrobats.[128]

Gilding the Acrobats reiterates the stereotypical equation, widely circulated and
enforced in 1930s America, between black male youth and contented servility. A
commercially produced postcard from the 1930s, for example, shows a black
delivery boy smiling for the camera while holding several boxes of flowers that,
presumably, he has yet to deliver. The postcard's caption reads, "A Familiar Fig-
ure on the 'Campus.' Do you recognize him?" (figure 2.42). Issues of recognition
and misrecognition are central to the logic of this postcard and, more broadly, to
the workings of stereotype. The postcard does not ask us (indeed, does not allow
us) to "recognize" this youth as an individual subject. Instead, it frames him as a

A Familiar Figure
on the "Campus"
Do you recognize him?

"familiar figure" (the happy black servant, the laboring black boy) who could be making his deliveries on the campus of virtually any private college or university in the United States at the time.[129]

Stereotype might be defined as a social and pictorial mechanism in which difference (and here it is racial difference) is first hyperbolized and then frozen. Stereotype constructs a kind of mask that, for all its overt artifice, its terrible theatricality, cannot easily be removed. It is the force of stereotype that labors to freeze the smile and servility of the "familiar figure" of the black delivery boy pictured on the 1930s postcard. Yet, as postcolonial critic Homi K. Bhabha has argued, stereotype is also a psychic procedure whereby an anxiety about difference is not simply displaced but also endlessly reproduced.[130] Stereotypes of racial difference might thus be said to serve as a portrait of the white imaginary, of its (futile) attempts to keep the racialized body at an extreme—and extremely visible—distance.

With this formulation in mind I want to turn back to *Gilding the Acrobats* and to look, more specifically, at the history of its production, a history in which the racial identity and stereotypical role of the foreground figure turn out to be far from stable. In Cadmus's first preparatory sketch (figure 2.43), the figure of the

Figure 2.42.
"A Familiar Figure on the 'Campus,'" 1930s. Commercial postcard. Reproduced in Joseph Boskin, *Sambo: The Rise and Demise of an American Jester* (New York: Oxford University Press, 1988). Courtesy Joseph Boskin and Oxford University Press.

Figure 2.43.
Paul Cadmus, first
preparatory sketch
for *Gilding the Acro-
bats*, c. 1935. Cour-
tesy D. C. Moore
Gallery, New York.

seated boy appears not as a black youth in coveralls and beanie but as a slightly older white adolescent. Compare the languid stance of the white boy in the sketch to the industrious one of the black youth in the painting. Where the black youth concentrates fervently on his painterly task, the white boy seems rather blasé in his application of paint. The black figure must, for example, hold the can of radiator paint up for the acrobat seated behind him, while, in the drawing, the can rests on the foreground floor, near the right arm of the lounging youth. The difference in the boys' race also marks a difference in the degree of their servility.

Cadmus's first preparatory sketch for *Gilding the Acrobats* stages a subtly eroticized encounter between two acrobats and two attendants, at least one of whom is clearly an adolescent. The white boy leans under the standing acrobat, thereby necessitating the (provocative) parting of the older man's legs while the seated youth on the right side of the composition cranes his neck to look up at that same

standing figure. In a rather more overt miming of sexual relation, the foreground boy's head has been placed level with the central acrobat's crotch. The depiction of such a physically intimate encounter is not something that Cadmus would retain in *Gilding the Acrobats*. By the second preparatory sketch (figure 2.44), the figure on the lower left of the composition has been lifted up off the floor, situated on a trunk, garbed in coveralls, and rendered younger in age. His head now bends down and away from the crotch of the standing acrobat, a change that mutes the oral-erotic implications of the original sketch. Meanwhile, the youthful attendant in the right midground has been recast as an adult acrobat. He no longer looks up, wide-eyed, to the man standing above him.

Between the second preparatory sketch and the finished painting, Cadmus would introduce only one substantive change into the composition: the substitution of the black youth for his white counterpart. This change underscores the

Figure 2.44. Paul Cadmus, second preparatory sketch for *Gilding the Acrobats*, c. 1935. Ink with white chalk on paper, 5⅞" × 12". Courtesy D. C. Moore Gallery, New York.

issue of color in multiple ways. The juxtaposition of the black youth and the white acrobats throws the procedure of body gilding into more dramatic relief. While the black youth applies radiator paint to the skin of the acrobats, he is not himself so painted. He serves as the agent, but not the object, of skin painting. In another sense, however, the foreground youth is far more brilliantly "colored" than the acrobats. Where the circus performers are depicted in metallic tones of gold and white, the black figure—with his red beanie, gold shirt, gray-green coveralls, blue socks, and brown shoes—draws together the larger palette of the painting. Even as he holds up the can of paint for the other figures, he also carries color—and color difference—into the painting. If, as suggested above, *Gilding the Acrobats* may be seen as an allegory of Cadmus's art, the foreground figure might be said to mark "color" in the painterly as well as the racial sense, to stand in for the application of pigment and the contrast of hue.

Yet the terms under which the black youth has been asked to symbolize color in *Gilding the Acrobats* are particularly narrow and historically specific. Cadmus presents the figure through (and as) a series of broadly stereotypical traits: the beanie and coveralls, the exaggerated lips, the protruding ears (figure 2.45).[131] This stereotype of black servitude helps to anchor *Gilding the Acrobats* within the vernacular codes of contemporary American culture while distancing the picture from the languid erotics of the first preliminary sketch.[132] Race—or, more specifically, the race of the black youth—allows Cadmus to erase the more suggestive relation between white men and white adolescents that surfaced in the first sketch for the painting. In other words, the black figure symbolizes not only racial difference and painterly color but also a displacement of homoeroticism onto racial difference and painterly color.

In a sense, the labor of this displacement remains visible on the surface of the painting. Look again at the extension of the black figure's neck and the strategic placement of his head and cap. It is as though Cadmus's anxiety about homoeroticism, rather than being relieved by the introduction of racial stereotype, has been reiterated by it. If the black youth seems to strain as he applies paint to the acrobat's leg, perhaps it is because the youth can never quite conceal the homosexual charge of the painting into which he has been introduced.

In a 1994 interview with the author, Cadmus would describe *Gilding the Acrobats* as "an entirely trumped-up affair—I had been to the circus but this [picture] had little to do with that. It was a pretext for the male nude."[133] That Cadmus should require a pretext for the male nude in 1935 is itself worth noting, especially as that requirement would have been magnified by the previous year's controversy over *The Fleet's In!*. Cadmus's fixation on the muscular male body structured his approach to *Gilding the Acrobats*, from the first preliminary sketch to the final composition. It was the combined force of satire and racial stereotype in the finished work that allowed Cadmus to frame his queer fixation on the male body within culturally acceptable terms.[134]

The prohibitions imposed on Cadmus's early work, including the threat and actual force of censorship, were to some extent productive of that work, of its visual interest and historical significance. As we witnessed with the 1934 removal of *The Fleet's In!*, acts of censorship designed to shut down certain subjects of representation (e.g., the homosexual sailor) functioned instead to renew or reroute those very subjects.[135] Censorship worked, however unwittingly, not

Figure 2.45. Paul Cadmus, *Gilding the Acrobats*, 1935. Detail. Courtesy D. C. Moore Gallery, New York, N.Y.

merely to erase but also to produce representation. This paradox attached both to acts of overt or "brute" censorship, such as the confiscation of *The Fleet's In!*, and to more subtle forms of artistic constraint and prohibition. Consider, as an example of the latter phenomenon, the production of *Gilding the Acrobats*. Because Cadmus could not paint the male nude in openly sexual terms in 1935, he offered it as a carnivalesque spectacle, as a "living statue" done up in gold radiator paint. *Gilding the Acrobats* is at once a fixation on, and a satire of, the male nude. And it is just this contradiction that generates the visual power and peculiar erotics of the work. Far from a solely restrictive force, then, the constraints imposed on homosexual visibility functioned for Cadmus as a powerful generator of (or irritant to) pictorial representation. In the 1930s, popular forms of entertainment such as scandal sheets, pre–Hays Code Hollywood movies, and novelty songs were the primary spaces available for the public articulation of male homosexuality. Cadmus borrowed the vocabulary of these popular forms—the vocabulary of cartoonishness, satire, and stereotype—and applied it to his paintings of contemporary social life.

Throughout the 1930s, Cadmus created a series of paintings that both depicted and were partially structured by homoeroticism. Far from a celebration of gay male identity, several of these works (e.g., *The Fleet's In!*, *Greenwich Village Cafeteria*) bluntly ridiculed the figure of the male homosexual. Yet even as Cadmus framed the homosexual as a stereotypical "fairy," he staged the larger public world (of Riverside Drive and Times Square, of the circus tent and the West Side YMCA) as a space of homoerotic relation and possibility.

In 1937, on the occasion of his first one-man show, Cadmus distributed a one-page "credo" detailing his artistic beliefs and commitments. It focused, above all, on his use of satire: "This, then, is my viewpoint—a satirical viewpoint; and I think I'm correct in saying that genuine satire has always been considered supremely moral. But, strangely enough, though the artistic expression is often composed of elements repulsive to the artist, the very efficacy of these repulsive and perhaps immoral elements in strengthening and achieving better social standards is a source of infinite concern and even delight to the satirical artist."[136] Notice how the artist's social "concern" gives way to his "delight" at the close of this passage. Cadmus's early practice as a painter was likewise divided between the moral purpose he claimed for his art and the delight he took in portraying social vice and fleshly display. To some extent such a paradox characterizes the very tradition of satire: "Most satirists . . . claim one purpose for satire, that of high-minded and usually socially-oriented moral and intellectual reform; however, they *engage* in something quite different" (emphasis in the original).[137] The three paintings on which this chapter has focused reveal the contradiction between the stated aims of Cadmus's early work and the "quite different" force of its pictorial and erotic energies. In *The Fleet's In!*, Cadmus set a stereotypical figure of the male homosexual within a more ambitious satire of shore leave, a satire that wreaks havoc on opposite-sex pairing. In *Self-Portrait Mallorca*, the artist subtly equated narcissism with same-sex desire by contrasting an idealized image of the male self with a caricature of the female nude. In *Gilding the Acrobats*, Cadmus called upon racial stereotype to relieve, however incompletely, the backstage erotics of an all-male and largely nude scene. Satire was

simultaneously an enabling and a constraining force in Cadmus's early work, a means of testing the limits of homosexual visibility within the sphere of contemporary art and a moral alibi for doing so.

Out of the Archives

Sometime in 1938, Paul Cadmus was photographed by George Platt Lynes in the latter's New York City studio. In one of the portraits from that session, Cadmus poses on a white painted staircase, wearing a tattered T-shirt and little, if anything, else (figure 2.46). The shirt seems to have been torn in a premeditated fashion, probably for the express purpose of the studio session, and its jagged exposures, along with Cadmus's steady, half-illuminated gaze and spread-legged stance, convey a knowing eroticism.[138] The photograph is one in a larger series of nude and seminude portraits of Cadmus and his lover, Jared French, that Lynes produced in the course of a single sitting. Most of the portraits feature French and Cadmus together. A few show one or the other alone. The series was never publicly exhibited by George Platt Lynes, nor was it reproduced during the course of the photographer's career, which ended with his death in 1955.[139]

It is worth noting, however, that Lynes did exhibit and reproduce several other photographs of Cadmus in the 1930s and early 1940s. A portrait of the painter was, for example, included in Lynes's 1941 exhibit at the Pierre Matisse Gallery in New York, and others were published in popular magazines such as *Life* and *Town and Country*. These public portraits did not, however, offer Cadmus in any stage of undress. The seductive pose and attire of the 1938 portrait were possible only because Cadmus knew that the photograph, once printed, would remain within the confines of a narrow circle of friends and colleagues, of fellow artists, poets, dancers, and museum men who were, as one member of that circle put it in his 1937 diary, "frankly given to the phallic passion."[140]

Lynes's photograph of Cadmus would not be publicly exhibited until 1993, when it was included in *The Artist as Subject*, a show of painted and photographic portraits of Cadmus held at the Midtown Payson Galleries in New York.[141] The cloistering away of Lynes's seminude portrait of Cadmus for over five decades mirrors, and in a sense extends, a prior manipulation of the image by the photographer. Sometime after its initial printing, the portrait was cropped down from a larger image that includes the fragmented, half-nude figure of Jared French, matchingly outfitted in a tattered undershirt (figure 2.47).

The cropped image of Cadmus conforms more closely to the conventions of studio portraiture: it constructs a one-to-one dialogue between camera and sitter; it offers a three-quarter-length view of the sitter while focusing attention on his face; its backdrop extends into a continuous monochrome, smoothly articulating the upper reaches of the visual field. Yet it is the larger, uncropped photograph that more accurately reflects the terms of the 1938 studio session—the terms, that is, under which Lynes portrayed Cadmus and French as a homosexual couple. Look, for example, at the horizontal alignment of Cadmus's eyes with French's genitals, the brush of contact between Cadmus's tattered T-shirt and French's leg, just beneath the knee, and the truncation of Cadmus's lower

Figure 2.46. George Platt Lynes, *Portrait of Paul Cadmus*, 1938. Gelatin silver print. Courtesy D. C. Moore Gallery, New York.

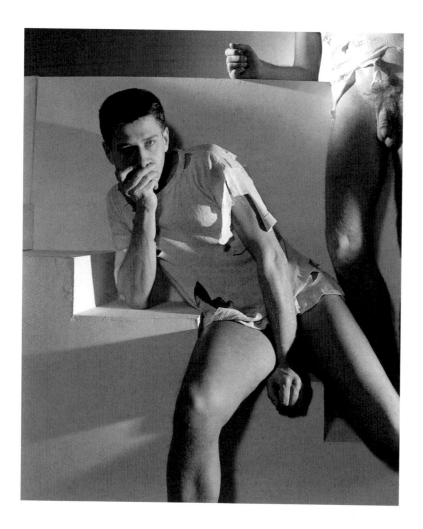

body as it answers the erasure of French's head and shoulders. There is an odd kind of arithmetic governing this double portrait, a way in which the two men both compete with and complete one another, with Cadmus providing (or, better, giving) head to French's headless body. Yet the couple has hardly been divided into equivalent halves of an anatomical whole: there are duplications (three hands, four fragmented legs) and deletions (no feet), skewings and overt asymmetries (Cadmus holding the center of the composition, French consigned to its right margin). The pairing of the two men, at least as it is here recorded, holds neither to the model of the mirror (i.e., the lover as reflection, double, or clone) nor to that of the binary (i.e., the lover as complement, completion, or "other half").

Throughout the series, of which some fourteen photographs survive, both men are shown naked from the waist down.[142] While French often and openly displays his genitals, Cadmus sometimes covers his or turns away from the camera so as to obstruct visual access to them (figures 2.48, 2.49). The pictures construct a complex dialogue between sexual exposure and concealment, between

Figure 2.47. George Platt Lynes, *Paul Cadmus and Jared French*, 1938. Photograph. Courtesy Kinsey Institute for Research in Sex, Gender, and Reproduction, Bloomington, Ind.

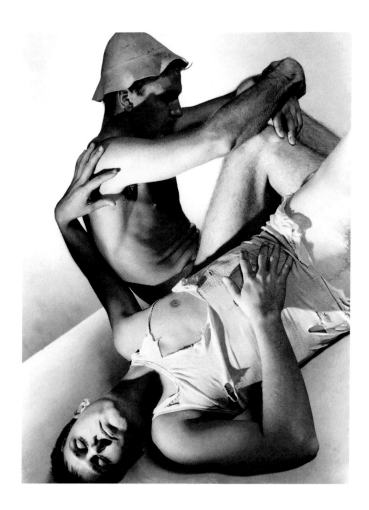

Figure 2.48.
George Platt
Lynes, *Paul Cadmus
and Jared French*,
1938. Photograph.
Courtesy Kinsey
Institute for
Research in Sex,
Gender, and
Reproduction,
Bloomington, Ind.

display and discretion, with Cadmus often, but not always, taking up the latter, less expressly phallic role and French the former, more exhibitionist one. Within this series of same-sex encounters, no easy symmetries (least of all those of sex) obtain. The photographs thus suggest not only the intimacy but also the imbalance and partial erasures of the self that a sustained sexual relationship entails. Lynes's subsequent cropping of the double portrait removes any trace of sexual partnership and reframes the photograph as an individual, if still eroticized, image of Cadmus.

Christian Metz, writing of the cut or crop that all photographs enact on the continuous flow of time and space, argues that "the photograph itself, the 'in-frame,' the abducted part-space, the place of presence and fullness . . . is undermined and haunted by the feeling of its exterior, of its borderliness, which are the past, the left, the lost, the far away even if very close by."[143] The cropped portrait of Cadmus remains haunted by that which it has projected off-frame, not only the figure of Jared French but also the expressly sexual relation he and Cadmus shared, and on this occasion staged, for the camera.[144] This exclusionary move has been mirrored in art-historical writings on Cadmus that present the creative and sexual relationship he enjoyed with French as a creative and platonic

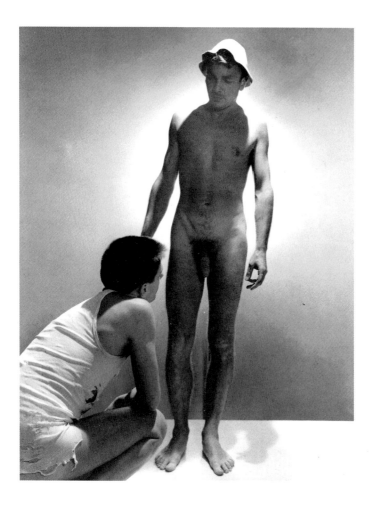

one. French is referred to not as Cadmus's partner or lover but as a "painter-friend" or an "artist/companion."[145]

I have spent a good deal of time on Lynes's 1938 portrait of Cadmus and French because I want it to stand in for the visual representations of male homosexuality that existed but went largely unseen in the 1930s, for the compulsory exclusions and obstructions that removed those images from visibility, and, most especially, for the restricted field of representation within which Cadmus and his contemporaries maneuvered. Like Lynes's 1938 portraits of Cadmus and French, Cadmus's satirical paintings are best understood as a dialogue between that which has been depicted within the frame and that which has been excluded from it. The frame in question is not merely the physical border of *The Fleet's In!* or *Self-Portrait Mallorca* or *Gilding the Acrobats* but the wider frame that governed their production and reception in the 1930s. It is the frame through which a public culture (of critics, reporters, cartoonists, government officials, and, not least, Cadmus himself) saw—but also refused to see—this artist's work.

Figure 2.49. George Platt Lynes, *Paul Cadmus and Jared French*, 1938. Photograph. Courtesy Kinsey Institute for Research in Sex, Gender, and Reproduction, Bloomington, Ind.

3

Most Wanted Men

Homoeroticism and the Secret of Censorship in Early Warhol

Boys

While struggling to establish his career as a fine artist in the late 1950s, Andy Warhol asked his friend and fellow artist Philip Pearlstein to help him land a show at a downtown gallery in New York City. Many years later, Pearlstein would recall the episode as follows:

> Andy wanted to have a show at the Tanager Cooperative Gallery on Tenth Street—at the height of its glory then. I was a member. He submitted a group of boys kissing boys which the other members of the Gallery hated and refused to show. He felt hurt and he didn't understand. I told him I thought the subject matter was treated too . . . too aggressively, too importantly, that it should be sort of matter-of-fact and self-explanatory. That was probably the last time we were in touch. The next thing I knew came the Campbell's Soup can. Andy and I just lost contact altogether.[1]

There are a number of striking things about this recollection, not least of which is Pearlstein's criticism that Warhol has ascribed too much importance to his chosen subject of "boys kissing boys." The problem, as Pearlstein sees it, is not so much the homoerotic theme of the work as Warhol's overly "aggressive" approach to that theme. "Why," Pearlstein seems to ask, "must you make such a big deal out of it?"

FACING PAGE: Figure 3.1. Andy Warhol, *Male Couple*, c. 1950s. Blue ballpoint pen on tan paper, 16¾" × 14". © The Andy Warhol Foundation for the Visual Arts/ARS, New York.

Another notable feature of this anecdote, which is occasionally repeated yet rarely scrutinized in the Warhol literature, is that only one drawing by Warhol of "boys kissing boys" from this period is known to exist (figure 3.1). Pearlstein is perhaps recalling other homoerotically charged pictures produced by Warhol at the time (such as figures 3.2, 3.3, 3.4) and then ascribing to those pictures a level of explicitness that they did not, in fact, possess.[2] The question of which works Warhol actually submitted to the Tanager Gallery remains unresolved, in part because Warhol never mentioned the episode in any interviews or published writings and in part because Pearlstein's account seems to change—sometimes subtly, sometimes dramatically—each time it appears in print.[3]

In a 1987 interview, for example, Pearlstein recalled Warhol's submission to the Tanager Gallery as a series of "small paintings. . .mostly of boys kissing boys with their tongues in each other's mouths" and proceeded to explain that the work was "totally unacceptable, as far as subject goes. . .It was embarrassing. The men in the gallery were all macho—you know, de Kooning was the big dog. . .it was almost the end of the era, but it was still very strong. . .Anyway, I tried to explain to him [Warhol] that it didn't matter what kind of subject matter you used but some subject matters were best to avoid, the more neutral the subject the better."[4] On this telling, Pearlstein specifies the works at issue as "small paintings" and recalls their homoeroticism rather more explicitly. The "boys" not only kiss; they now insert their tongues in each other's mouths. The question of how Warhol might have rendered this visible in a painting is not addressed. Pearlstein does, however, provide a more specific rationale for Warhol's rejection by the gallery. The "macho" sensibilities of the men in the cooperative (including

Figure 3.2. Andy Warhol, *Untitled*, c. 1956–57. Ballpoint pen on paper, 16¾" × 14". © The Andy Warhol Foundation for the Visual Arts / ARS, New York.

Figure 3.3. TOP
Andy Warhol, *Untitled
(Boy Licking His Lips)*,
1956. Ink on paper,
16⅝" × 13⅞". © The
Andy Warhol Founda-
tion for the Visual
Arts/ARS, New York.

Figure 3.4. BOTTOM
Andy Warhol, *Two Men
(Decorative Background)*,
c. 1950s. Oil, spray
paint, and ink on linen,
42" × 47¾". Founding
Collection, Contribu-
tion The Andy Warhol
Foundation for the
Visual Arts, Inc.

Willem de Kooning and Pearlstein himself) could not abide pictures of "boys kissing boys." Given the masculinist ethos of New York School painting in the 1950s, this rationale seems all too believable. Or rather, it would seem believable but for the fact that no painting matching Pearlstein's description is known to exist.

Several months prior to this interview, Pearlstein published a tribute to Warhol in the pages of *Art in America*. The tribute was part of a portfolio of remembrances of Warhol, who died in February 1987. Toward the end of his contribution, Pearlstein once again recounted the Tanager story, albeit with a rather different inflection:

> By then [the late 1950s] I had become a member of a co-op gallery on Tenth Street, the Tanager, that had developed cachet as a good place to show. Andy wanted to show there and I took a group of his works to one of the gallery group's monthly meetings, but the other members weren't in favor of showing his work. I think he felt I had let him down and we were seldom in touch after that. Within a couple of years he was showing with the Allan Stone, Stable, and Castelli galleries.[5]

In this version of the story, no rationale is given for Warhol's rejection by the cooperative, nor is any description of the rejected work offered. The tenor of the rebuff has likewise been softened ("the other members weren't in favor of showing his work") in comparison with Pearlstein's initial account ("the other members of the Gallery hated and refused to show [the work]"). The refusal of Warhol's homoerotic pictures by the Tanager Cooperative in the late 1950s thus gives way, some thirty years later, to an account from which the very mention of homoeroticism has been expunged.[6]

The rejection of Warhol's work by the Tanager Gallery cannot be taken as a fixed historical event. The episode has been reworked by memory and narration, by the retrieval of some details and the removal of others, and by the various contexts and occasions of its retelling. Rather than overlooking the inconsistencies of Pearlstein's story so as to focus on its central event—Warhol's rejection by the Tanager—I would argue that the instability of the story itself constitutes an important part of its narrative. The homoeroticism of Warhol's work seems to *provoke* the slips and elisions that mark Pearlstein's anecdote. These slips contribute, in turn, to factual instabilities within the Warhol literature such that, for example, the date of the Tanager rejection shifts (from 1956 to 1955 to 1957 to 1959–60) in the successive retellings of Pearlstein's anecdote by various scholars.[7] If the image of "boys kissing boys" plays havoc with Pearlstein's memory (and, by extension, with the art-historical accounts that draw upon that memory), perhaps it is because that image is already a misrecognition of Warhol's work. It is as though Pearlstein must exaggerate the homoerotic charge of Warhol's "boys"—must force them to kiss and tongue one another—so as to evince the alleged "aggressiveness" of the images and thereby justify the Tanager's rejection of them.

The instability of the Tanager episode points to the difficulty of recovering those everyday forms of artistic constraint that leave little, if any, trace of having

occurred. No formal explanation for the Tanager's rejection was required, no written letter sent, no official justification provided. Instead, Pearlstein offered Warhol an informal explanation of the gallery's decision within the context of a private conversation. That conversation would enter into the public discourse on Warhol's career some twenty years after the fact, and even then only through the shifting, unstable lens of Pearlstein's memory. The inconsistency of Pearlstein's story does not mean that Warhol's rejection by the Tanager Gallery should be discounted as untrue or historically insignificant. That inconsistency does suggest, however, the need for a more nuanced account of Warhol's pre-Pop art and the range of responses it provoked at the time. It is not simply the rejection of the "boy" pictures that requires further explanation but also the context within which Warhol produced those pictures and the confidence that emboldened his effort to exhibit them publicly.

In the first half of this chapter, I consider the relation between Warhol's artistic and commercial production of the 1950s, between the art he displayed (or tried to display) in galleries and that which he was paid to create for ad campaigns and department store windows. Building on the scholarship of curator Trevor Fairbrother, I argue that Warhol's success as a commercial illustrator and retail designer during this period shaped the contemporaneous response to his fine art. Warhol's association with the "unmanly" world of ladies shoes and department store windows informed the often chilly reception of his art. The significance of Warhol's early or "pre-Pop" art cannot be calibrated, however, strictly in terms of its critical reception. Even as Warhol's early work was dismissed by established art galleries and critics, it was embraced by his colleagues in commercial illustration and retail design, colleagues who were often homosexual men. The New York design world of the 1950s furnished one of the few professional arenas in which gay men could work without closeting their sexual identities. Warhol not only took full advantage of this openness in his day-to-day life, he translated into his visual art by portraying male friends and colleagues as objects of homoerotic desire, as beautiful boys. Even when it was not openly homoerotic, Warhol's pre-Pop art took up the flamboyant tone and exaggerated effects of what was already known by this time as "camp."

In the second half of the chapter, I shift attention from Warhol's art and commercial designs of the 1950s to his far more celebrated Pop paintings of the early 1960s. Several of Warhol's early Pop pictures employ repetition, metaphor, and multiple coding to suggest homosexual difference without making it manifest. Warhol's *Thirteen Most Wanted Men*, a mural of criminal mug shots produced for, and then censored at, the 1964 World's Fair, provides a key example of this phenomenon. Although *Thirteen Most Wanted Men* was created for a venue that could not have been more public, its suppression by Fair officials remained almost entirely secret in 1964. This chapter revisits the restrictions imposed on Warhol's early work, from his rejection by the Tanager Gallery to the censorship of *Thirteen Most Wanted Men* at the World's Fair. These restrictions were not simply obstacles for Warhol to overcome but forces that shaped his creative decisions and artistic output. In returning to Warhol's early work, I attend both to the constraints imposed upon that work and to the alternative pleasures and possibilities it afforded.

WARHOL'S STRUGGLE to achieve recognition as a fine artist in the 1950s is particularly striking given his remarkable success as a commercial illustrator during that same period. During that decade, his professional output included graphic designs for *Glamour*, *Harper's Bazaar*, *Interiors*, *McCall's*, the *New York Times Fashion Special*, and *Vogue*; window displays for Bonwit Teller; Christmas cards for Tiffany and Company; and advertisements for Martini & Rossi, Bourjois Perfume, Fleming Joffe leathers, and the Simplicity Pattern Company, among other clients.[8] It was Warhol's ad campaign for I. Miller Shoes, however, that brought him the greatest degree of professional recognition during this period. From 1955 to 1957, I. Miller ads showcasing Warhol drawings appeared on a weekly basis in the Sunday *New York Times*, almost always in the pages devoted to wedding announcements and engagements (figures 3.5, 3.6, 3.7). The placement of Warhol's ads next to columns reporting that "Dora Grabfield Is Wed in Milton" and "Miss Mary Conroy Becomes Engaged" reinforce their appeal to a female consumer. Warhol's silhouetted pumps and bejeweled shoe buckles seem to complement (even accessorize) the photographs of newlywed white women that share the same pages of the newspaper.

In contrast to the streamlined product designs Warhol would later showcase in his Pop art of the 1960s (Campbell's Soup cans, Coca-Cola bottles, Brillo boxes), the I. Miller ads carry a sense of nostalgia and ornamental wit. Much of

the appeal of Warhol's commercial imagery lay, paradoxically, in its noncommercial, handwrought appearance. In contrast to most other graphic designers of the day, Warhol created a "signature style" of commercial illustration during the 1950s. On occasion, Warhol's I. Miller ads even included his signature or initials, discreetly tucked beside the buckle of a shoe or beneath the petal of a flower.

Warhol's work for I. Miller combined fashionability with faux naïveté. Notice, for example, how a 1957 advertisement for the company showcases the Victorian charm of a single hand-embroidered stocking (figure 3.8). Warhol presents the stocking as a black, slightly nubby silhouette into which swirls of silver thread have been woven. Even as Warhol summons the visual codes of the old-fashioned and the outmoded, however, he does so in order to hawk the new and the now. The copy for the ad reports that "since Grandmother wore hand-embroidered hose, there have been shoes by I. Miller. . . . But stockings by I. Miller is today's newest news. Shoe-planned by us in style, weight, color, and weave, our own stockings are ready now at all the I. Miller Salons." The ad creates a dialogue between novelty and nostalgia, between the "newest news" in stylish hosiery and the traditional, handcrafted appeal of grandmother's stocking.

Warhol's commercial illustrations were extremely well received both by his professional clientele and by his peers in the field of graphic design. He would,

Figure 3.6. Andy Warhol, *Advertisement for I. Miller Shoes*, *New York Times*, September 25, 1955. The Archives of the Andy Warhol Museum, Pittsburgh. Founding Collection, Contribution The Andy Warhol Foundation for the Visual Arts, Inc. ©The New York Times Company.

Figure 3.7.
Andy Warhol,
*Advertisement for I.
Miller Shoes, New
York Times*, November 13, 1955. The
Archives of the
Andy Warhol
Museum, Pittsburgh. Founding
Collection, Contribution The Andy
Warhol Foundation
for the Visual Arts,
Inc. © The New
York Times
Company.

for example, win four awards from the Art Director's Club in the 1950s, three of which recognized the "distinctive merit" of his I. Miller advertisements.[9] According to Jesse Kornbluth, "By the end of 1957, Warhol was as celebrated as a commercial artist could be and was, to his great delight, listed under 'fashion' in a book called *1,000 New York Names and Where to Drop Them*."[10] David Bourdon has similarly characterized Warhol's professional success in the mid- to late 1950s: "Warhol soon became New York's most distinctive and sought-after illustrator of ladies' accessories. His instantly recognizable work appeared in virtually every New York fashion magazine. . . . An endless procession of shoes, gloves, scarves, hats, handbags, belts, and jewelry passed through the apartment [in which Warhol lived and worked]."[11] It is worth noting that Warhol's work as a commercial artist was tied to "an endless procession" of shoes, fashion accessories, and jewelry *for women*. His professional success as a commercial illustrator and designer derived in large part from the witty femininity of his drawings and retail displays.

"Andy had such a good feel for the delicate, the feminine," according to Stephen Frankfurt, an art director at the advertising firm of Young & Rubicam.[12] In 1959 Frankfurt hired Warhol to work on a campaign for Modess, a

Since Grandmother wore hand-embroidered hose,
there have been shoes by I. Miller..... but stockings by
I. Miller is today's newest news! Shoe-planned by us in style, weight,
color and weave, our own stockings are ready now at all the
I. Miller Salons. Until November 30th, they are available at special
introductory savings for each box of three...

I.Miller

New York · Washington · Philadelphia · Baltimore · White Plains · Rochester · Atlantic City

brand of sanitary napkins. One of Warhol's drawings for the campaign featured a school of doves forming into a letter *V*, a reference to the "new 'V' shape" then being trumpeted by Modess (figure 3.9). As in this case, Warhol's commercial work of the 1950s was almost always tailored to and closely associated with the female body. From drawings of hand-embroidered stockings to shop windows showcasing the pleasures of perfume or potpourri, Warhol's commercial work did not simply address the female consumer; it pictured a feminized world.

Warhol's professional association with femininity occasionally shaded into a form of camp identification. In 1952, for example, when he received his first Art Director's Club medal, the handwritten inscription on the envelope read, "Andrew Warhol, her medal" (figure 3.10).[13] Fairbrother, the only scholar who has discussed this inscription in print, identifies it as one made by Warhol himself. An archivist at the Andy Warhol Museum believes, by contrast, that Warhol's mother penned these words.[14] In either case, the author of the inscription would come as something of a surprise given that "Andrew Warhol, her medal" conforms neither to the conventional terms of self-designation nor to those of maternal description. The slightly lopsided handwriting on the 1952 envelope

Figure 3.8. Andy Warhol, *Advertisement for I. Miller Shoes*, c. 1956. The Archives of the Andy Warhol Museum, Pittsburgh. Founding Collection, Contribution The Andy Warhol Foundation for the Visual Arts, Inc.

THE NEW SHAPE: V SHAPE
andy Warhol

Figure 3.9.
Andy Warhol, *The New Shape: V Shape*, c. 1959. For Modess. Ink and gouache on paper, 17" × 10¹¹⁄₁₆". ©
The Andy Warhol Foundation for the Visual Arts / ARS, New York.

does resemble Julia Warhola's penmanship rather more closely than her son's. Mrs. Warhola often provided the lettering and signature for her son's early work, a labor she provided at his behest and to his specifications. If Warhol's mother did inscribe the phrase "Andrew Warhol, her medal," on the envelope to the 1952 Art Director's Club medal, she almost certainly did so at her son's request. In this sense, we might see the inscription as one "produced" by the artist, whether directly or through the cooperating hand of his mother. Whoever wrote it, the notation "Andrew Warhol, her medal" speaks in the parlance of homosexual camp, a parlance in which feminine pronouns may be assigned not only to women but also to gay men. As Michael Bronski has argued, "What is sometimes referred to as 'camp talk'—especially gay men referring to one another with women's names or pronouns—evolved as a coded, protected way of speaking about one's personal or sexual life. If one man were to be overheard at a public dinner table saying to another, 'You'll never guess what Mary said on our date last night,' nothing would be thought of it."[15] If the gay male practice of referring to other homosexuals as "Mary" or "she" originated as a means of self-protection and subtle encoding, it also offered the secret pleasure of defying conventional gender assignments and given names. "Andrew Warhol, her medal" partakes of this pleasure, as does a great deal of the artist's work in the 1950s.

In a 1955 flyer created as a professional calling card, Warhol summoned the figure of a female circus performer to stand as his surrogate (figure 3.11). The performer, who holds an oversized sprig of roses, is literally covered with tattoos. On closer inspection, the tattoos resolve into consumer trademarks and product designs, into Miss Clairol and Chanel No. 5, into Schweppes and Pepso-

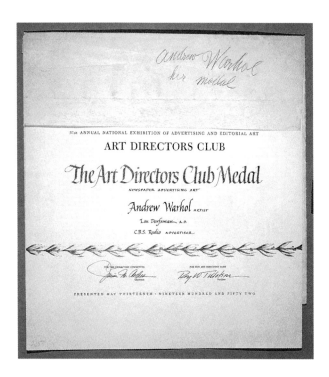

dent. The central and most salient inscription, however, is the artist's name and phone number ("Andy Warhol, Murray Hill 3-0555") across the woman's mid-section. As Fairbrother has argued, Warhol's flyer communicated "the same come-and-see me message as a tattoo on a body. In terms of the persona he was developing, it was a brilliant foray, inviting the challenge of the public eye (circus), espousing openly nonconformist values (tattoo), and taking pride in being something other than a stereotypical white male professional (sassy female)."[16] Warhol inscribed a sense of unconventional femininity onto a flyer whose purpose was to advertise his professional skills and creative sensibility. Like the inscription on his Art Director's Club award, Warhol's flyer linked his identity as a commercial illustrator to a campy sense of his own femininity. Such objects marked Warhol's membership in a world where he might be described—or even describe himself—as "she" or "her."[17]

 With the salient exception of Fairbrother's essay, art-historical scholarship has all but ignored the links between femininity and male homosexuality in Warhol's commercial enterprise of the 1950s. Even the most astute writers on Warhol have detoured around questions of gender and sexuality when addressing his pre-Pop work. Benjamin H. D. Buchloh, for example, argues that Warhol's shoe drawings for I. Miller evince a "real affinity for and unusual familiarity (for a commercial artist) with the avant-garde practices of the mid-fifties."[18] And it is Warhol's "unusual familiarity" with the advanced art of the day that is said to invest his ads with "a risqué stylishness that the average commercial artist would have been unable to conceive."[19] In elaborating on this point, Buchloh reproduces several of Warhol's I. Miller ads from the mid-1950s. Even as he reprints

Figure 3.10. Andy Warhol's 1952 Art Director's Club medal, with envelope inscribed by Julia Warhola: "Andrew Warhol, her medal." The Archives of the Andy Warhol Museum, Pittsburgh. Founding Collection, Contribution The Andy Warhol Foundation for the Visual Arts, Inc.

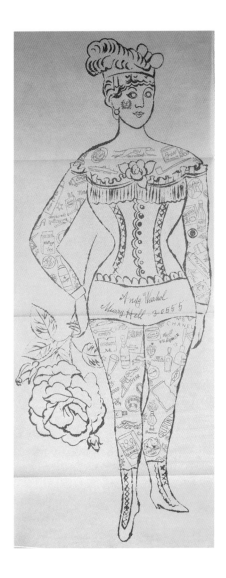

Figure 3.11.
Andy Warhol, *Untitled (Tattooed Lady)*,
1955. Offset lithograph on pale green
tissue paper, 28⅞"
× 11". ©The Andy
Warhol Foundation
for the Visual
Arts/ARS,
NewYork.

these ads, however, Buchloh ignores the "ladies shoes" they hawk, the "pumps, street sandals, and evening slippers" they offer up to the female consumer.[20] Rather against the odds, Buchloh aligns Warhol's I. Miller ads with the artistic sophistication of the NewYork avant-garde while distancing them ever further from the sphere of the "average commercial artist." In doing so, he deflects attention away from the core concerns of Warhol's advertising images, namely femininity, fashion, and the solicitation of consumer desire. Rather than situating Warhol's commercial work in relation to the avant-garde of the 1950s, I aim to place it within the social and professional worlds of advertising, design, and fashion in which the artist moved at the time. And rather than seeing Warhol's ads as a prefiguration of his Pop art of the 1960s, I would like to discuss them in relation to the other creative projects Warhol pursued during the 1950s.[21]

Even as Warhol fulfilled numerous commissions for ad agencies, fashion magazines, and corporate clients in the 1950s, he also created a wide range of other

(noncommercial, noncommissioned) artwork: pen and watercolor portraits, hand-colored prints, drawings of shoes overlaid with imitation gold leaf and silver foil, collaborative books, painted screens, and a few full-scale oil paintings. Beginning in 1952, Warhol periodically exhibited selections of this work at venues on the fringes of the Fifty-seventh Street art world. A selection of his shoe collages, for example, was shown in 1956 at Serendipity, a café patronized largely by people in the fashion, design, and theater worlds, and then, somewhat more formally, at the Bodley Gallery and Bookstore.[22]

In a publicity coup for Warhol, six of the collages were subsequently showcased in a two-page spread entitled "Crazy Golden Slippers" in the January 1957 issue of *Life* magazine (figure 3.12). *Life*'s article, the first to introduce Warhol to a national audience, described his work in the following manner:

> While drawing shoes for advertisements, Andy Warhol, a commercial artist, became fascinated with their design and began to sketch imaginary footwear as a hobby. His work grew more and more ornate until he completed some 40 slippers made entirely of gold leaf ornamented with candy-box decorations. Each was created to symbolize a well-known personality. Recently, Warhol exhibited them at New York's Bodley Gallery, priced at $50 to $225 each. To his astonishment, they were eagerly bought up for decorations, and Warhol is now busy creating a whole new set of crazy golden slippers.[23]

Life sets Warhol's work within the register of charming triviality. The artist, we are told, is "astonished" to find a ready market for the "slippers" he creates as a pastime. What *Life* fails to mention, however, is that the prices listed for Warhol's work are quite consistent with those of other artists exhibiting on Fifty-seventh Street at this moment.[24] Even as *Life* reports that Warhol's collages are exhibited (and sold) in a New York art gallery, it sets those works within the sphere of amateur craft, of "candy-box" decoration. Notice, for example, that "Crazy Golden Slippers" appears not in the magazine's art section but in "Speaking of Pictures," *Life*'s weekly feature on offbeat visual images.[25] In prior issues, "Speaking of Pictures" had variously showcased photographs of a newborn baby porpoise in Florida ("A Birth Under Water"), of fence-jumping at the National Horse Show ("Hurdles from on High"), and of an orchestral concert illuminated by musical instruments fitted with colored lights ("Rhythmic Colors of a Symphony").[25] By their very placement in "Speaking of Pictures," Warhol's collages were presented less as artworks than as charming visual oddities. We should note, however, that *Life* allotted such charming visual oddities two full pages near the front of each week's issue. The magazine's more occasional coverage of contemporary art appeared, by contrast, near the back of the issue and was rarely more than one page in length.

One month before "Crazy Golden Slippers" was published in *Life*, Parker Tyler reviewed Warhol's shoe collages for *Art News*. In his review, Tyler describes not only the works at hand but also the man who made them:

> Andy Warhol is a very young artist who may be said to be addicted rather than dedicated. Currently, he is addicted to shoes—or, rather, hand-drawn

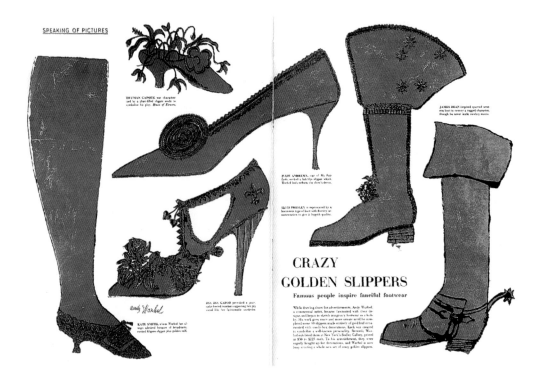

CRAZY
GOLDEN SLIPPERS
Famous people inspire fanciful footwear

Figure 3.12.
Andy Warhol's
celebrity shoe
portraits featured
in "Crazy Golden
Slippers," *Life*,
January 21, 1957.
The Archives of
the Andy Warhol
Museum, Pitts-
burgh. Founding
Collection, Contri-
bution The Andy
Warhol Foundation
for the Visual Arts,
Inc.

images of them; single, never in pairs, and usually large enough to fit circus giants of both sexes. Naively outlined in strict profile and then, as it were, smothered in gold-leaf and decorative commercial-cutouts in gold (tassels, cupids, conventional borders), they have an odd elegance of pure craziness. If one doubted they were fetiches [*sic*], his doubt would be dispelled by noticing that an evening slipper is inscribed to Julie Andrews and a boot to James Dean.[26]

Tyler employs a vocabulary of compulsive excess ("addicted," "smothered," "pure craziness," "fetiches," and even "circus giants of both sexes") to capture the pictorial flamboyance of Warhol's work. Yet for all its descriptive verve, the review leaves the terms of Warhol's "addiction" rather vague: is the artist "addicted" to fetishizing the stars as decorative shoes, to fetishizing the shoes themselves, or to fetishizing the decorative as an end in itself? By slipping between these options—between a fixation on celebrity, on footwear, and on decoration—Tyler frames Warhol's work (and, to a lesser extent, the "very young artist" himself) as both perverse and compelling, as both "crazy" and "elegant." In so doing, Tyler suggests, while never making explicit, the camp appeal of Warhol's collages.

According to historian George Chauncey, the term "camp" has circulated among homosexual men since the 1920s to name "a style of interaction and display that use[s] irony, incongruity, theatricality, and humor to highlight the artifice of social convention."[27] Not the least part of camp's appeal for gay audiences

lies in its championing of the marginal, the trashy, the otherwise degraded.[28] In his study of the emergence of homosexual subcultures in the United States during and after World War II, historian Allan Bérubé argues that camp served an especially important function insofar as it "could simultaneously distance [gay men] from the humiliation they endured as social outcasts while creating an alternative moral order and culture in which gay men were in control. . . . These styles reflected the self-consciousness of some gay men as sexual or gender outsiders and helped them define themselves as 'insiders' of their own secret world."[29] Like the gay men about whom Bérubé writes, Warhol was drawn to the alternative possibilities and pleasures that camp seemed to promise. Within Warhol's social and professional milieu, the "secret world" of camp was shaped less by a sense of fearful privatization than by a shared delight in artifice and marginality, a delight enjoyed especially though not exclusively by homosexual men. "To be camp," as the writer Mark Booth would later observe, "is to present oneself as being committed to the marginal with a commitment greater than the marginal merits."[30] Recall in this context Warhol's reclaiming of the marginal (old shoes and boots, imitation gold leaf, candy-box ornaments) as something gilded and glamorous, something worthy of dedication to a "Judy Garland" or a "James Dean." According to Charles Lisanby, a set designer and close friend of Warhol's in the 1950s, the shoe collages "were the very definition of camp," and "that's exactly what we called them at the time."[31]

Although Warhol's friends may have admired and freely discussed the camp appeal of his collages, the word "camp" was never mentioned in the handful of public notices that work received in the 1950s. *Life*'s 1957 photo-essay did, however, inscribe Warhol's "crazy golden slippers" into a discourse of the decorative closely related to camp.[32] Even *Life*'s insistence on Warhol's work as relatively trivial, the mere hobby of a commercial designer, could be set within camp's larger project of deflating the serious in favor of the marginal and the degraded.[33] While we may thus situate *Life*'s account of Warhol's work within the context of homosexual camp, that relation remains entirely implicit within the terms of the original article.[34]

While the word "camp" did not appear in any of the published reviews of Warhol's work in the 1950s, his art was sometimes described in terms that alluded, however obliquely, to homosexuality. In 1952, the Hugo Gallery mounted a two-person show consisting of drawings by Warhol and by figurative artist Irving Sherman. The exhibit received a short notice by James Fitzsimmons in *Art Digest*. After praising Sherman's drawings for their "wit and excellence of draftsmanship," Fitzsimmons declared that

> Andy Warhol's fragile impressions—15 drawings based on the writings of Truman Capote—are less amusing, less impressive altogether. For various reasons one thinks of Beardsley, Lautrec, Demuth, Balthus, and Cocteau. The work has an air of preciosity, of carefully studied perversity. Boys, tomboys, and butterflies are drawn in pale outline with magenta or violet splashed here and there—rather arbitrarily it seems. At its best it is an art that depends upon the delicate tour de force, the communication of intangibles and ambivalent feelings.[35]

Fitzsimmons seems dismayed by Warhol's work, by its "air of preciosity," its dependence on delicacy, and its fragility of impression. Even more troubling to the reviewer is his sense that Warhol has "carefully studied" these effects, has, in fact, intended to produce them. The artistic lineage invoked by the review—"Beardsley, Lautrec, Demuth, Balthus, and Cocteau"—suggests a dizzying array of sexual and pictorial eccentricity. But what, one wonders, are Fitzsimmons's "various reasons" for summoning these particular artists? And why do those reasons remain so vague? Even as the review describes the "perversity" that pervades Warhol's drawings, it never veers too close to defining the nature of that perversity. Instead, it resorts to the register of the unspoken and the unspecified, to "the communication of intangibles and ambivalent feelings."

Fitzsimmons has surprisingly little to say about the most obvious fact of Warhol's 1952 show—its devotion to the work of Truman Capote. Capote, arguably the most visible male homosexual writer of the day, held extremely significant import for Warhol, both personally and professionally. According to Warhol's own account, he was fixated on Capote in the early 1950s and repeatedly attempted to make contact with him by phone and mail.[36] This fixation is to some extent reflected in Warhol's recurrent portrayal of the author and his work. In addition to the fifteen Capote drawings, now lost, which were displayed at the Hugo Gallery in 1952, Warhol produced two sketches of the author in the early 1950s, the later of which presents Capote as an ethereal young man whose hands playfully frame his closed eyes and eyelashes (figure 3.13).

Even when Capote was not represented by Warhol, the writer's name and work were sometimes invoked to describe Warhol's pictorial style. In 1954, Warhol exhibited a suite of drawings of men (including several of the dancer

Figure 3.13. Andy Warhol, *Truman Capote*, c. 1952. Ink on paper, 16¾" × 13¾". © The Andy Warhol Foundation for the Visual Arts / ARS, New York / Andy Warhol Museum, Pittsburgh.

truman Capote

John Butler) at the Loft Gallery in New York. In a short notice published in *Art-news*, Barbara Guest observed that "Andy Warhol has developed an original style of line drawing and a willingness to obligate himself to a narrow horizon on which appear attractive and demanding young men involved in the business of being as much like Truman Capote or his heroes as possible. His technique has the effect of the reverse side of a negative, although his lines are broken and the spaces not clouded. Prices unquoted."[37] The "attractive and demanding young men" who emulate "Truman Capote or his heroes" perform, for Guest, the rhetorical task of situating Warhol's art within a homosexual milieu. Once again, homosexuality is alluded to rather than named, suggested rather than spoken. In making that allusion, Guest strikes a tone of subtle condescension toward Warhol and the "narrow horizon" of aesthetic possibility within which his work unfolds.

Warhol's association with Capote is most vividly captured in the *Truman Capote* collage, one of the six "Crazy Golden Slippers" reproduced in *Life* magazine. According to *Life*'s caption for the work, "Truman Capote was characterized by a plant-filled slipper made to symbolize his play, *House of Flowers*."[38] Warhol's depiction of Capote as a woman's shoe strewn with flowering vines may well have referred to more than the title of the author's recent play. With its hothouse blossoms and miniature scale, the collage would seem to allude to Capote's own pint-size appearance and puckish charm. In "cross-dressing" Capote as a woman's shoe, Warhol offers a witty paean to male effeminacy, an affectionate portrait of one flamboyantly homosexual (or, as Warhol might have said, "swish") artist as seen by another.[39]

My interpretation of the *Truman Capote* collage begs a broader question concerning Warhol's "crazy golden slippers." Can these works rightly be understood as portraits of the celebrities to whom they are inscribed?[40] What links the visual form of the shoe collages to the famous men and women they name? According to Nathan Gluck, Warhol's commercial assistant from 1955 to 1963, the naming of the shoe collages was an offhand, even haphazard procedure:

> The *names* that were given to these things were, more or less, arbitrary. I mean, the *James Dean* was given to a boot because it was the only male shoe. . . . All the rest of the shoes were ladies' shoes. So, the obvious thing was to name them for the ladies. . . . They were all drawn and were given names afterwards! They were never given names before they were drawn. . . . He did a shoe and then, somebody said, "Let's call this shoe Judy Garland, and let's call this 'A Shoe for Zsa Zsa Gabor.'"[41]

After describing the names of the shoe collages as "more or less, arbitrary," Gluck notes the (nonarbitrary) assignment of the name "James Dean" to "the only male shoe" and the (nonarbitrary) correspondence of the "ladies' shoes" to female stars. According to Gluck, the naming of the collages followed a binary logic of gender difference. Gluck's recollection is belied, however, by the collages themselves. The *Judy Garland* (figure 3.14), for example, features a male cowboy boot with feather and foil crests that looks like a gaudy cousin to the *James Dean* boot in "Crazy Golden Slippers." And the *Truman Capote* collage, as we have seen, showcases a woman's slipper with flowering vines. These works are

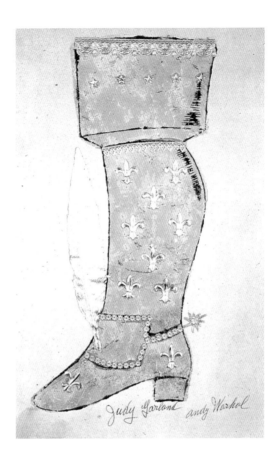

Figure 3.14.
Andy Warhol, *Judy
Garland*, 1956.
Collage of gold
leaf, ink, feather,
mixed media, and
paper. ©The Andy
Warhol Foundation
for the Visual Arts.

among several Warhol collages—including the *Christine Jorgenson* (figure 3.15), a
pair of gilded pumps named for the most famous transsexual of the day—which
challenge the assumption that gender roles necessarily follow from, or align
neatly with, biological sex. I am fixing on the inconsistencies of Gluck's passage
not to dispute his account of the shoe collages so much as to elaborate upon his
central insight. The relation between the celebrity name and pictorial content of
these works was an unpredictable one, even more unpredictable, it seems, than
Gluck's recollection would have it. The logic (or whim or association) that might
have determined the naming of a particular collage could not be known in
advance of the moment of naming, nor could it be made to conform to any strict
division of gender roles.

In a recent interview Charles Lisanby (Warhol's friend and the original owner
of the *Julie Andrews* pump) recalled Warhol's penchant for name-dropping
throughout the 1950s. Warhol's desire, as Lisanby described it, was not only to
meet celebrities such as Truman Capote, Cecil Beaton, and Greta Garbo but also
to talk about them, to invoke their names.[42] The celebrity shoes might be read in
relation to this desire. The insouciance with which Warhol may have dropped the
names "James Dean" and "Julie Andrews" onto this or that collage suggests that
the artist was interested less in the uniqueness of any one star than in the star
system itself, the system through which stardom is named, packaged, and
imitated.[43]

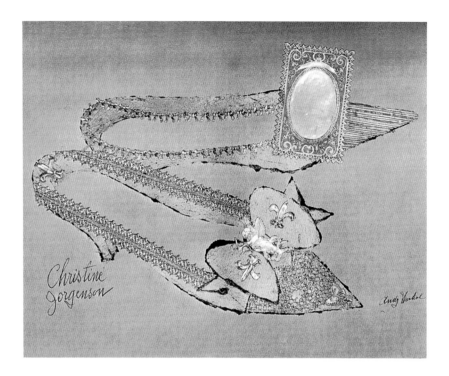

That the particularity of the star mattered less to Warhol than the culture of celebrity is further suggested by the fact that even the unique spelling of the star's name occasionally falters within Warhol's early work—"Elvis Presley," for example, becomes "Elvis Presely" (figure 3.16), while "Zsa Zsa Gabor" is recast as "Za Za Gabor" (figure 3.17). Such misspellings are typically attributed not to Warhol but to his mother, Julia Warhola, with whom he lived throughout much of his adult life.[44] Warhol was so enamored of his mother's penmanship, with its eccentric spelling and imperfect command of English, that (as mentioned above) he often asked her to provide the lettering for his early work, including the signature of his name.[45] According to Nathan Gluck, when Mrs. Warhola tired of signing her son's name, Gluck would "fake" her simulation of Warhol's signature.[46] The artist's signature, traditionally the sign of a work's authenticity and completion, here becomes a task that may be undertaken by at least two different surrogates. With its charming scrawl and slightly lopsided letters, Mrs. Warhola's (or Nathan Gluck's) penmanship paradoxically inscribes a sense of singularity, of a particular hand, on the shoe collages. And the particular hand, as the signature on these works misleadingly tells us, is that of "Andy Warhol." Like the unpredictable selection of celebrity names for the shoe collages, Warhol's signature challenges the security of individual identity, including, and especially, the artist's own.

According to Fairbrother's interpretation of the celebrity shoes, Warhol "had invented a way to appropriate the names of the famous and thus take for himself some of their limelight."[47] I would suggest a slightly different reading. The shoe collages allowed Warhol to mark his own fascination (what Lisanby remembers

Figure 3.15. Andy Warhol, *Christine Jorgenson*, 1956. Collage of gold leaf, ink, mixed media, and paper. ©The Andy Warhol Foundation for the Visual Arts.

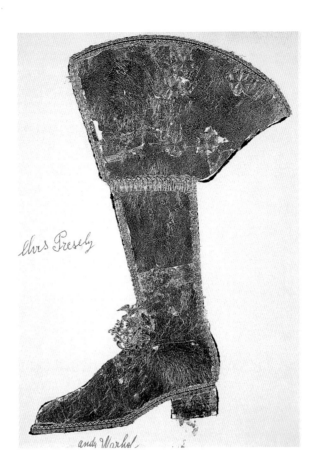

Figure 3.16.
Andy Warhol, *Elvis Presely*, c. 1956.
Collage of gold foil, ink, mixed media, and paper, 20" × 14". © Andy Warhol Foundation for the Visual Arts.

as an "obsession") with the culture of celebrity while simultaneously transcending the constraints imposed by his commercial career. The witty but always appropriate femininity of the I. Miller drawings is transformed, within the space of the shoe collages, into something excessive and flamboyantly effeminate. With their trashy, tin-foil luxury and open embrace of fandom, the celebrity collages defy the decorous logic of the *New York Times* society pages ("Dora Grabfield Is Wed in Milton") in which the I. Miller ads appeared. In paying tribute to a far-flung set of celebrities—from Elvis Presley to Anna Mae Wong, from James Dean to Christine Jorgenson—Warhol reimagines the star system as a camp collection of "crazy golden slippers." With each collage, Warhol portrays not an individual star but the creative power of the fan to remake the image of the star through the act of devoting himself to that image.

I want to return for a moment to Nathan Gluck's recollection of how the shoe collages were named. According to Gluck, Warhol "did a shoe and then, somebody said, 'Let's call this shoe Judy Garland, and let's call this "A Shoe for Zsa Zsa Gabor.""[48] Who were those "somebodies" that named Warhol's celebrity shoes, and how might their presence inflect our understanding of these works? During the mid- to late 1950s, Warhol not only employed assistants such as Gluck to help in the production of his commercial art; he also held informal "coloring

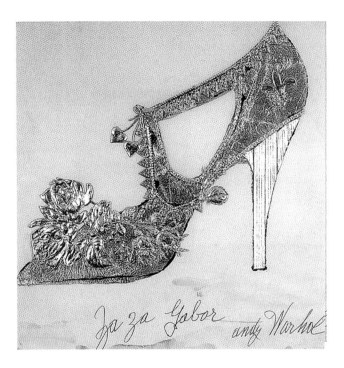

Ja Za Gabor andy Warhol

parties" at Serendipity and at his Lexington Avenue apartment. Stephen Bruce, the co-owner of Serendipity, would later recall Warhol's coloring parties:

> He . . . would have five or six people with him. He would give them work, art work, to finish. Like: he was doing I. Miller ads, and then, weekly he would come in, and, I remember, one time he had a page of butterflies that he had printed or mimeographed, and he had all the people color in all of the butterflies with no direction or anything like that. . . . It was always different people, I think. People who were, you know, people who he was involved with, and a lot of them were very attractive, very nice people.[49]

The "very attractive, very nice people" who attended Warhol's "coloring parties" were most often young homosexual men who worked in the design, retail, and fashion industries: window dressers, jewelry designers, commercial illustrators, set designers, buyers for department stores, interior decorators, fashion photographers. Like Warhol, these men helped produce the idealized image and desirable look of femininity in magazine layouts and department store displays. Their identities and desires as homosexual men, however, remained invisible within the very layouts and shop windows they designed. Even as Warhol and his friends helped set the stage for retail culture in the 1950s, they did not themselves appear upon that stage.

If the world of homosexual decorators and designers was one situated "behind the scenes" of fashion design and retail display in the 1950s, Warhol's art provided a space in which that world might finally take center stage. In 1958, for example, Warhol created a portrait of Kenneth Jay Lane, a costume jewelry

Figure 3.17. Andy Warhol, *Za Za Gabor*, c. 1957. Collage of gold leaf, silver trim, ink, and paper, 9¾" × 9¾". © Andy Warhol Foundation for the Visual Arts.

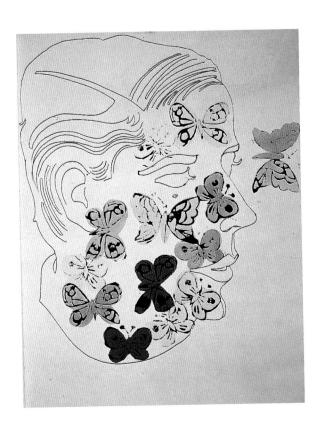

designer (figure 3.18). A veritable school of butterflies, variously washed in pink and red watercolor, are pictorially inscribed—or tattooed—onto Lane's face, while a single butterfly is stationed to the immediate right of his head, in alignment with his field of vision. The portrait of Lane strongly recalls a series of fashion photographs on which Warhol collaborated in 1952. At the request of his friend Otto Fenn, a fashion photographer, Warhol designed a series of butterfly projections that could be cast onto the model's body and clothing. In one memorable picture, the model's face is inscribed with a single lavender and pink butterfly, which then multiplies into an entire field of brilliantly colored butterflies in the background (figure 3.19). Six years later, Warhol would redo the Otto Fenn shoot in his portrait of Kenneth Jay Lane. Now it is the male jewelry designer, rather than the female fashion model, whose face is inscribed with pink butterflies. Lane, who ornamented the female body with jewelry for a living, here becomes an ornamental image in his own right.

In addition to *Portrait of Kenneth Jay Lane with Butterflies*, Warhol produced many other portraits of male designers and decorators in the 1950s. A picture entitled *H.B. Charles Lisanby*, for example, offers the youthful set designer in profile (figure 3.20). The "H.B." stands for "Happy Birthday"—the portrait was Warhol's gift to its subject. As if to reinforce the delicacy of Lisanby's face, Warhol includes a watercolor pear, with slender branch and leaves, in the lower left section of the portrait. Like Lane's butterflies, Lisanby's pear suggests an alternative—and softened—form of masculinity. Here is a man, *H.B. Charles Lisanby*

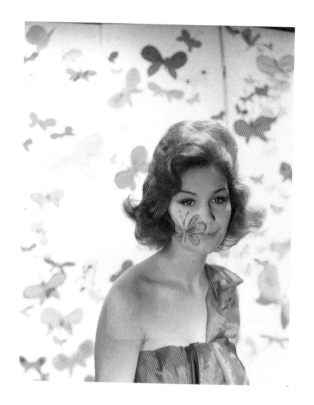

Figure 3.19. Otto Fenn, fashion photograph, c. 1952, with butterfly projections designed by Andy Warhol. Courtesy Archives of the Andy Warhol Museum, Pittsburgh.

proclaims, whose association with a fruit is nothing to be ashamed of. According to Lisanby, the inclusion of a pear punned on Warhol's (unrequited) desire to "pair" with him romantically. Warhol would repeat the pear motif in several other drawings dedicated to Lisanby in the mid-1950s.[50] In portraits such as *H.B. Charles Lisanby* and *Portrait of Kenneth Jay Lane with Butterflies*, Warhol presented his male friends and colleagues as objects of both decoration and desire.

Warhol's career as a commercial illustrator and retail designer sometimes contributed to the dismissal of his art by critics and other commentators. Truman Capote, for example, recalled that even after receiving his namesake shoe collage as a gift, "I never had the idea he [Warhol] wanted to be a painter or an artist. I thought he was one of those people who are 'interested in the arts.' As far as I knew he was a window decorator. . . . Let's say a window-decorator type."[51] Capote's remark suggests his disdain for "window-decorator types" who lack the rigor (or talent or ambition) to become authentic artists. Capote associates Warhol with a stereotype of the fey decorator whose aesthetic interests run primarily to throw pillows and window treatments.

Warhol does not seem to have shared Capote's view of the difference between real artists and those who are merely "interested in the arts," between the value of the avant-garde and the triviality of window dressing. Warhol's artistic enterprise in the 1950s might even be said to contest these oppositions. His shoe collages delight in the marginal, the trashy, and in the dropping of names. And his portraits of male designers are imbued with a delicacy that never shades into disdain or dismissive stereotype.

Figure 3.20.
Andy Warhol,
H.B. Mister Lisanby,
1956. Ink and
watercolor on
paper, 17¾" ×
12⅓". Courtesy
Charles Lisanby,
Los Angeles.

In 1957, Warhol created a work that borrowed elements from both of the pre-Pop series on which I have been focusing—the shoe collages and the portraits of male designers. The work, *Untitled ("To All My Friends")*, features eleven shoes and boots, each of which has been drawn in profile and then overlaid with imitation gold leaf (figure 3.21). Eight of the eleven shoes are labeled with the names of men: Bob C., Nathan, Norman, Clinton H., Gene Moore, Stephan, Patch, Calvin. These names refer to members of Warhol's social and professional world: Gene Moore, for example, was the director of window display at Bonwit Teller, and he occasionally hired Warhol to design windows for the store. "Bob C." refers to Bob Craner, an illustrator who was Moore's boyfriend at the time. "Norman" stands for Norman Sinclair, a graphic designer and acquaintance of Warhol's during the mid-1950s. "Stephan," "Patch," and "Calvin" refer to the three co-owners of Serendipity (Stephen Bruce, Patch Harrington, and Calvin Holt). Not only did these three men exhibit Warhol's art at their boutique/restaurant; they also helped decorate the artist's apartment on Lexington Avenue. "Nathan" stands, of course, for Nathan Gluck, the person who was most involved (apart from Warhol himself) in the production of Warhol's work during the 1950s. And "Clinton H." refers to Clinton Hamilton, Gluck's lover at the time and the window dresser at Bonwit Teller who originally recommended (to Gene Moore) that Warhol be hired by the store.

Untitled ("To All My Friends") is a kind of private remaking of the "Crazy Golden Slippers" spread from *Life* magazine, a paean not to James Dean and Elvis Presley but to the men who worked alongside Warhol in the design professions, who encouraged and enabled his career as a commercial artist, and who, in some

Nathan

Norman

Bob C.

Gene Moore

Clinton H

Stephan

Patch

Calvin

To all my Friends

andy Warhol

cases, assisted in the creation and display of his art. Insofar as such homosexual designers (or "window-decorator types") were dismissed or ignored by the New York avant-garde of the 1950s, Warhol's small but gilded tribute "To all my friends" offers an important counterimage of social and professional community.[52] For Warhol, homosexuality was not simply a matter of individual desire or personal preference but also of social and artistic exchange, of friendship networks and shared creative sensibilities.

A number of photographs of Warhol from this period suggest the flavor and flair of his homosexual milieu. In 1955, a snapshot of Clinton Hamilton, Nathan Gluck, and Warhol was shot by Edward Wallowitch, a photographer who was Warhol's boyfriend at the time (figure 3.22).[53] While the three men in the photograph all wear suits and ties and cross their legs at the knee, each returns the

Figure 3.21. Andy Warhol, *Untitled ("To All My Friends")*, c. 1956. Ink and imitation gold leaf on paper, 9" × 8". © Andy Warhol Foundation for the Visual Arts / ARS, New York.

Figure 3.22.
Edward Wallo-
witch, *Clinton
Hamilton, Nathan
Gluck, and Andy
Warhol*, 1956.
Photograph. ©
John Wallowitch.

look of Wallowitch's camera in a distinct manner. Hamilton smokes a cigarette with his right hand while balling his left one into a fist. Gluck rests his hands on his two companions in a gesture of camaraderie. And Warhol, with his sidelong glance and delicately extended hand, all but vamps for the camera. The photograph was taken in the Greenwich Village apartment of Wallowitch's older brother John, a gay composer and pianist with whom Warhol and Edward frequently socialized. The elder Wallowitch would occasionally throw what he called his *gyvenimas* (a Lithuanian word for "life" or "Here's to life") parties in which guests were invited to celebrate not a national holiday or someone's birthday but simply the fact of being alive and assembled together.[54] According to John Wallowitch, the social circle in which he, his brother, and Warhol participated in the 1950s would find "any excuse for a party," including a festive word retrieved from the Lithuanian lore of the Wallowitch family.

Like *Untitled ("To All My Friends")*, Edward Wallowitch's photograph of Hamilton, Gluck, and Warhol was produced for private purposes, to be shown and shared with a circle of friends. Yet this circle of mostly male, mostly homosexual friends was forged in part through professional association, through the production of art, music, advertising, photography, and retail design. The social and creative world in which Warhol moved in the 1950s, the world of Serendipity and "Here's to life" parties, exceeds any conception of homosexuality as a strictly private or exclusively sexual pursuit.

No account of the relation between Warhol's art and sexuality in the 1950s would be complete without some mention of his so-called cock drawings. According to Nathan Gluck,

> Andy had this great passion for drawing people's cocks, and he had pads and pads and pads of drawings of people's lower regions: they're drawings of the penis, the balls, and everything, and there'd be a little heart on them or tied with a little ribbon. And they're, if he still has them, they're in pads just sitting around. I used to wonder what his mother would do if she saw them. But, I guess, she never saw them or didn't recognize them. But, everytime he got to know somebody, even a friend sometimes, he'd say, "Let me draw your cock."[55]

This passage, from a 1978 interview of Gluck, stresses Warhol's offhand approach to sketching the genitals of other men—his frequent, if not indiscriminate, requests to "let me draw your cock." Such requests, while no doubt audacious for the 1950s, occurred within a social world dominated by gay men, a world in which the male body was already understood as an object of desire and delectation for other men. Warhol's cock drawings issued from (and relied on) the homosexual milieu in which he circulated at the time. And like that milieu, the cock drawings combined sexual possibility and decorative flamboyance.

Consider, for example, an early drawing entitled *Decorated Penis* that offers a male member festooned with hearts and flowers and tied with a ribbon (figure 3.23).[56] The parallel lines that mark the length of the penis stop near the bottom of the page. There is no sense of detachment or disjunction from a continuous male body. In abandoning any relation to testicles or pubic hair, to upper thighs or lower belly, the penis takes on a new set of associations: hearts and flowers, ribbons and bows. Rather than depicting the penis as but one part of the male nude, Warhol presents it, proudly vertical, as a decorative object in its own right. Here is the penis not as a symbol of manly authority or domination but as a sweetly ornamental gift, a phallic valentine.

The playful eroticism of this drawing recurs in many of Warhol's sketches of the male body from the 1950s, as, for example, in a sketch of a male nude in which the figure's penis, lower belly, and upper thighs provide the ground on which several seashells rest (figure 3.24). The seashells seem less a sharp contrast than a harmonious accent to the male body. Like the shells, the outline of the legs and waist, the tufts of public hair, and the contours of the penis are rendered through a series of casually delicate curves and dipping lines. Once again, Warhol presents the male body, and the penis in particular, not as an agent of aggression but as an object of boyish prettiness. Neither the *Decorated Penis* nor the *Male Nude with Seashells* is structured according to any phallic ideal of penetration or manly action.[57] Like nearly all of Warhol's male nudes from the 1950s, they suggest an alternative economy of visual pleasure in which the male body becomes a site for decoration and witty adornment.

How did sketches such as *Decorated Penis* and *Male Nude with Seashells* circulate at the moment of their creation? According to Fairbrother, Warhol produced

Figure 3.23. TOP
Andy Warhol, *Decorated Penis*,
1950s. Black ballpoint on manila
paper, 17" × 14". © 2000 The
Andy Warhol Foundation for the
Visual Arts / ARS, New York.

Figure 3.24. BOTTOM
Andy Warhol, *Male Nude*, 1950s.
Ballpoint pen on paper, 17⅛" ×
14". The Andy Warhol Museum,
Pittsburgh, Founding Collection.
© Andy Warhol Foundation for
the Visual Arts, Inc. Photo by
Richard Stoner.

such "explicit homoerotic works" for "his private sphere in the fifties."[58] Fairbrother's formulation of a discrete private sphere does not acknowledge the complex relation between publicity and privacy that marked Warhol's work and world in the 1950s. Far from a strictly private sphere, the homosexual milieu in which the artist circulated was structured by both his professional career and his personal desires, by both his connection to other designers and decorators and his sexual pursuits and attachments. That Warhol would leave "pads and pads and pads" of cock drawings "just sitting around" the apartment suggests his relatively lax sense of privacy about the pictures. While Warhol never publicly exhibited the drawings in the 1950s, neither did he shy away from displaying other examples of his homoerotic art during that same decade.

On Valentine's Day 1956, for example, Warhol's *Drawings for a Boy Book* opened at the Bodley Gallery and Bookshop. With the same free-flowing lines and simplified silhouettes as *Decorated Penis* or *Male Nude with Seashells*, the *Boy Book* drawings frame the male body as both appealingly decorative and youthfully self-absorbed (figure 3.25). While the Bodley exhibit did not feature frontal nudity in the manner of the cock drawings, it did offer several images in which the male body was inscribed with multiple hearts. Like the February 14 date of the show's opening, these drawings suggest Warhol's romantic attachment to other men. As the title of the show indicates, Warhol conceived the drawings as part of a unifed project, a "Boy Book," the publication of which would never come to pass. The *Drawings for a Boy Book* show received but one review, a short notice in *Art News* by Ronald Vance: "Andy Warhol's 'Drawings for a Boy-Book' comment, inevitably often cruelly, by means of a hard psychological line and such symbolism as strings of inverted hearts on the young men. For example, *Tom*'s head narcissistically is lifted with closed, rather eyeless eyes to an anonymous pair of lips suspended in space. Prices unquoted."[59] Vance's description of the *Boy Book* drawings is noticeably off-target. Warhol's tiny hearts hardly seem "cruelly symbolic," and his decorative line is neither "hard" nor especially "psychological." Vance's clumsy prose and peculiar tone (e.g., "Tom's head narcissistically is lifted with closed, rather eyeless eyes") suggest not only an inaccuracy of description but a refusal, whether conscious or not, to acknowledge the homoerotic playfulness of the drawings on display. Warhol's work has provoked a discomfort in this reviewer, a discomfort that registers in awkward phrases and inaccurate descriptions.

Sometime after the Bodley show (though just how long after is unclear), Warhol would submit a more explicit set of homoerotic pictures to the Tanager Gallery, a submission that, as we know, resulted in rejection. I would like to return, one last time, to Philip Pearlstein's original narration of the "boys kissing boys" story so as to consider its conclusion more closely. After recounting Warhol's rejection by the Tanager, Pearlstein recalls, "The next thing I knew came the Campbell's Soup can. Andy and I just lost contact altogether." How are we to understand Warhol's artistic passage from the "boy" drawings of the late 1950s to the Campbell's Soup Can paintings, which were first exhibited in 1962?[60]

In the early 1960s, Warhol gradually abandoned his professional life as a commercial illustrator so as to concentrate on his career as a gallery artist.[61] In developing what would become his signature style of Pop art (deadpan repetitions of media images and consumer product designs), Warhol increasingly

Figure 3.25. TOP
Andy Warhol, *Studies for a Boy Book*, 1956. Ballpoint pen and ink on paper, 16¾" × 13⅞". © Andy Warhol Foundation for the Visual Arts / ARS, New York.

Figure 3.26. BOTTOM
Andy Warhol, *Seated Male Nude Torso*, c. 1955–56. Black ballpoint on manila paper, 17⅞" × 11⅞". © Andy Warhol Foundation for the Visual Arts / ARS, New York.

moved away from the hand-drawn and flamboyantly decorative pictorial style of his earlier work. In tandem with this shift in his artistic output, Warhol reinvented his personal style of dress and self-presentation. Throughout his years as a commercial artist (1949–c. 1962), Warhol typically wore sports coats or khaki suits, white button-down shirts, and bow or rep ties. Notice the relative consistency of Warhol's sartorial appearance (businesslike, a bit fey, and slightly rumpled) in two photographs taken eleven years apart: a 1950 shot of the young illustrator "making the rounds" in New York City (figure 3.27) and a 1961 picture of Warhol in front of Serendipity café, still the center of his social world at the time (figure 3.28).[62] By 1964, however, Warhol would be sporting mod black sweaters, blue jeans, and black sunglasses (figure 3.29)—a look that he would sustain, sometimes with the addition of a black leather jacket, throughout the remainder of the decade (figure 3.30). The two later photographs portray Warhol in the Factory, the fourth-floor loft in a former hat factory on East 47th Street that served as his studio from 1963–1968. The Factory provided the space not only for the production of Warhol's art and films, the latter of which he started shooting in 1963, but also for an extended social and creative world of artists, poets, musicians, speed freaks, hustlers, hangers-on, and "superstars." Because the Factory has been so richly documented, both photographically and in written recollections, I will not delve deeply into its social scene or key players.[63] Instead, I will simply observe that the silvered space of the Factory provided the arena within which Warhol refashioned both his work and himself in the 1960s.

David Bourdon, a friend of Warhol's at the time, describes this change as part of a broader project in self-transformation. "His metamorphosis into a pop persona was calculated and deliberate. The foppery was left behind and he gradually evolved from a sophisticate, who held subscription tickets to the Metropolitan Opera, into a sort of gum-chewing, seemingly naive teenybopper, addicted to the lowest forms of popular culture."[64] Bourdon's recollection is at once revealing and slightly misleading. While Warhol may have styled himself as a "sophisticate" in the 1950s, he was also and openly devoted to the "lower" forms of popular culture, especially to Hollywood films and fandom, to spotting celebrities and dropping their names onto his "crazy golden slippers." What is more, the simultaneity of Warhol's interests in high and mass culture—in, say, a subscription to the Metropolitan Opera and a subscription to *Photoplay* magazine— would hardly have been seen as incompatible within the artist's social milieu of the 1950s.

Warhol's "metamorphosis into a pop persona" in the early years of the 1960s might better be seen as a self-conscious shift in the artist's presentation of both his public identity and his professional output. Even as Warhol reinvented himself, salient aspects of his identity (e.g., his devotion to popular culture, his homosexuality) remained visible, albeit on different terms. Warhol's fixation on celebrity and popular culture, for example, became ever more central to the methods and subject matter of his early-1960s art. His homosexuality, on the other hand, was displaced from the level of denotation to that of connotation, from the register of the explicit to that of the encoded.[65]

In her justly celebrated "Notes on Camp" of 1964, Susan Sontag draws a contrast between "Camp taste" and "Pop Art" that parallels the shift in Warhol's work

Figure 3.27. TOP
Leila Davies Singelis,
*Andy Warhol "Making the
Rounds,"* 1950. Gelatin
silver print. The
Archives of the Andy
Warhol Museum, gift
of the artist.

Figure 3.28. BOTTOM
John Ardoin, *Andy
Warhol at Serendipity 3*,
1961. Photograph. ©
John Ardoin.

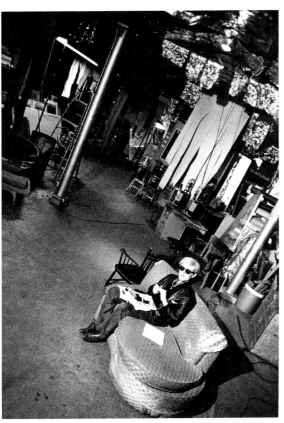

Figure 3.29. TOP
Edward Wallowitch,
Andy Warhol, 1964.
Photograph. Courtesy
John Wallowitch.

Figure 3.30. BOTTOM
Billy Name, *Andy
Warhol*, c. 1966.
Photograph.
© Billy Name/Bruce
Coleman, Inc.

at around the same time: "Camp taste identifies with what it is enjoying. People who share this sensibility are not laughing at the thing they label as "a camp," they're enjoying it. Camp is a tender feeling. (Here, one may compare Camp with much of Pop Art, which—when it is not just Camp—embodies an attitude that is related, but still very different. Pop Art is more flat and more dry, more serious, more detached, ultimately nihilistic.)"[66] Where Warhol's drawings and collages of the 1950s bespeak the affectionate pleasures of camp, his Pop paintings of the early 1960s are "more flat and more dry, more serious, [and] more detached" in their address to the viewer. Where works such as the *Boy Book* drawings openly thematize homosexuality, the Pop paintings avoid any explicit reference to same-sex desire, opting instead for a series of deadpan repetitions of prefabricated images.

In mapping this transition in Warhol's work, I am to some extent following the lead of Caroline Jones, an art historian who has argued that Warhol consciously suppressed the markings of homosexuality in his early Pop art. In the following passage, Jones describes Warhol's shift from a commercial artist (which she designates as "artist" with a small "a") to a Pop "Artist" (with a capital "A") in the early 1960s: "The period during which Warhol was attempting to become an Artist (after having been an artist) was the period in which he effaced and suppressed signs of "homosexuality" in favor of silence and ambiguity; an effacement and suppression which was not attempted before [his production of Pop] Art. . ."[67] Although largely in agreement with this formulation, I would stress the partial nature of Warhol's suppression of homosexuality in his Pop art of the early 1960s. Rather than silencing same-sex desire outright, Warhol "smuggled" it, all but imperceptibly, into selected paintings.

As one part of this process of smuggling, the effete "boy" of the 1950s drawings was supplanted by the manly outlaw of the 1960s silkscreens, by *Silver Marlon* and *Double Elvis*. Warhol's use of the outlaw was most dramatically staged in *Thirteen Most Wanted Men*, his contribution to the 1964 World's Fair. The work capitalized on the gritty appeal of police photography to subvert the otherwise sunny celebration of American culture and technology on offer at the exposition. Or, rather, it would have done so had it not been censored a few days before the fairgrounds opened to the public. The remainder of this chapter looks hard at both *Thirteen Most Wanted Men* and the circumstances of its suppression. It shifts from Warhol's pictorial use of camp in the 1950s to his depiction of criminality in the early 1960s and, thus, from drawings of "boys" to paintings of "men."[68] In making this shift, I will not suggest that paintings such as *Thirteen Most Wanted Men* are more "mature" or artistically developed than Warhol's pre-Pop art and commercial designs. Rather, I will argue that Warhol's work of the early 1960s, and his depiction of male criminality in particular, suppressed the visibility of homosexuality without quite snuffing it out.

Men

In 1964, Warhol was one of ten artists invited by the architect Philip Johnson to decorate the facade of the New York State Pavilion at the World's Fair, a building

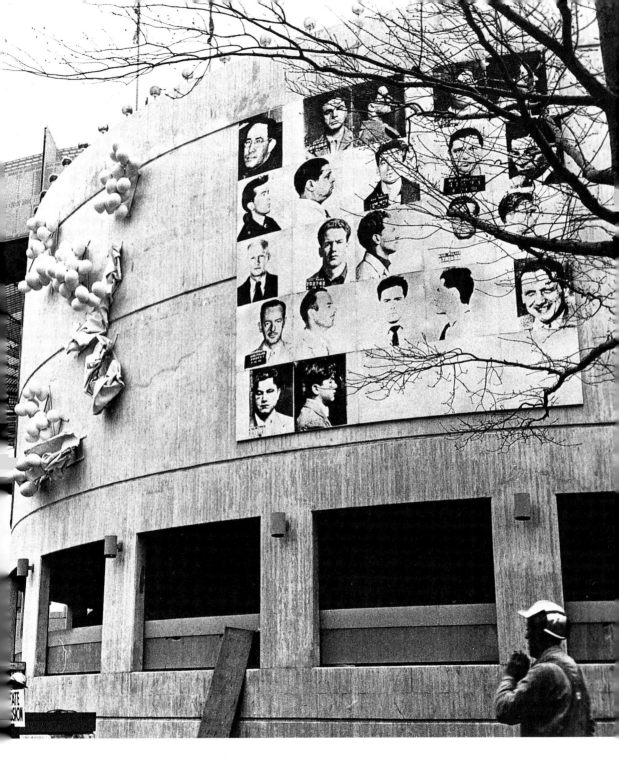

Figure 3.31. Andy Warhol, *Thirteen Most Wanted Men*, 1964. Silkscreen ink on Masonite, New York State Pavilion, New York World's Fair, twenty-five panels, each 48" × 48", overall dimensions 20' × 20'. ©The Andy Warhol Foundation for the Visual Arts/ARS, New York.

Johnson had designed as a showcase for modern art, architecture, and technology. Warhol contributed *Thirteen Most Wanted Men* (figure 3.31), a silkscreened mural of mug shots appropriated from the files of the New York City Police Department. A week before the grand opening of the Fair on April 22, 1964, *Thirteen Most Wanted Men* was installed on the exterior facade of the Pavilion's "Theaterama," a large, cylindrical movie theater. Within forty-eight hours of the mural's installation, a work crew covered *Thirteen Most Wanted Men* with aluminum house paint, thereby muffling it under a monochrome of silver (figure 3.32). Warhol's mural, now a visible absence on the New York State Pavilion, was left to stand in this state throughout the opening festivities of the Fair and for several months thereafter. Years later, Philip Johnson would claim that Governor Nelson Rockefeller had insisted on the mural's removal. Other sources, including Warhol himself, would hold World's Fair president Robert Moses responsible for the mural's censorship.

Although preparations for the 1964 World's Fair received enormous coverage in New York newspapers, the suppression of *Thirteen Most Wanted* Men attracted little attention. The *New York Times* ran a two-sentence mention (on page sixteen) of the mural's demise; Emily Genauer included a few paragraphs about it in her weekly column in the *New York Herald-Tribune*; and the *New York Journal American* carried an article on page four. Apart from a brief mention of the voided mural in the *New York Times* some three months later, there was no other press coverage of this episode.

Such minimal reporting cannot be attributed, however, to any lack of interest in *Thirteen Most Wanted Men* on the part of the New York press. Prior to its overpainting, the mural had been reproduced by both the *New York Times* and the *New York Journal American*, the latter on page one.[69] In the April 17 issue of the *New York Times*, a photograph of *Thirteen Most Wanted Men* accompanied a story previewing the entire range of art that was to go on display the following week at the World's Fair, from "masterpieces by Michelangelo" to "priceless porcelains and pop art."[70] The caption for the photograph announced, "POP ART AT THE FAIR: Faces of the criminals 'most wanted' by Federal Bureau of Investigation decorate exterior of the New York State Pavilion. Andrew Warhol is artist."[71] Given that *Thirteen Most Wanted Men* had already received this kind of publicity, and given that official acts of censorship typically attract both press coverage and public fascination, how are we to explain the scant attention paid to the censorship of Warhol's mural?

The answer is that no external act of suppression, much less of censorship, ever occurred at the World's Fair, at least according to the story reported by the press at the time. The three New York newspapers that covered the incident each informed their readers that *Thirteen Most Wanted Men* had been overpainted at Warhol's own request. According to the *New York Times*, "Andrew Warhol, the artist, . . . asked that his mural, 'The Thirteen Most Wanted Men,' be removed from the Theaterama of the New York State exhibit. Having seen the mural hung, he did not feel that it achieved the intended artistic effect, Philip Johnson, designer of the exhibit, disclosed yesterday."[72]

The *New York Journal American* likewise presented the mural's overpainting as Warhol's decision:

Figure 3.32. Aluminum paint covering *Thirteen Most Wanted Men*, 1964. New York State
Pavilion, New York World's Fair. ©The Andy Warhol Foundation for the Visual
Arts/ARS, New York.

Mr. Warhol yesterday told Philip Johnson, designer of the exhibit, he did not feel his work achieved the effect he had in mind, and asked that it be removed so he could replace it with another painting. . . .

"He thought we hung it wrong," said Mr. Johnson. "He didn't like it the moment he saw it. And since he was willing to do another piece, I didn't think we had a right to hold him to this one." . . .

"Mr. Warhol works very fast and I'm sure he'll have a replacement ready in a few days. There won't be anything up there until he gets another piece done."[73]

Conspicuously missing from these accounts is any direct quotation from Warhol. Instead, Philip Johnson is brought on to explain Warhol's supposed dissatisfaction with *Thirteen Most Wanted Men*. Emily Genauer's column in the *New York Herald-Tribune* presented much the same ventriloquized version of the painting's destruction as had the *Times* and the *Journal American*:

Mr. Warhol claims that the work was not properly installed and felt that it did not do justice to what he had in mind.

Mr. Johnson said yesterday that he was in agreement with the artist and ordered the mural removed from the building. "I've asked him to do another mural for the spot and knowing how quickly Warhol works, I'm sure we'll be able to put it up in time for the opening next Wednesday."

"There is no question," Mr. Johnson continued, "about any official complaints from any of the Fair's authorities—and if there were, we would not do anything about it."

Mr. Warhol's gallery dealer, Eleanor Ward, agreed that the removal was instigated entirely by the artist: "Andy just didn't like the way it looked, and I think it's wonderful of Mr. Johnson to let him make another one on such short notice."[74]

No other mural by Warhol was ever installed on the building. This absence was not, however, reported by the *New York Herald-Tribune* nor, so far as I can tell, by any other newspapers at the time. The censorship of Warhol's mural was thus rendered invisible at the very moment of its commission. Not only was the Fair absolved of any responsibility for the mural's destruction, but Philip Johnson, a key player in the work's removal, was presented as a strong defender of artistic integrity. Eleanor Ward would go so far as to praise Johnson for allowing (that fickle) Warhol the opportunity to redo his mural at the last minute.

Some three months after the opening of the World's Fair, the *New York Times* published an article that briefly discussed the public's response to Warhol's ill-fated work:

Visitors to the New York State Pavilion at the fair, studying the 10 especially commissioned works of art that ring the façade of the circular building designed by Philip Johnson, have recently been inquiring about the fate of two pop art pieces that seem to be out of operation. One, a mural by Andy Warhol, featured front and profile views of men allegedly "wanted" by the police, but has been silvered over with paint.[75]

The other piece of Pop art to "malfunction" (as the *Times* put it) was Robert Indiana's neon mural *EAT*, which, due to a technical glitch, had remained dark for most of the Fair. After mentioning the problem of *EAT*'s electrical illumination, the article returns to *Thirteen Most Wanted Men*: "As for the Warhol mural, said to have been painted out at Mr. Warhol's direction, it is understood that he received legal threats from one of the men whose picture was involved."[76] Following this vague and rather awkwardly phrased explanation of the mural's demise, the article cites Warhol directly: "'One of the men labeled "wanted" had been pardoned, you see,' said Mr. Warhol the other day, 'so the mural wasn't valid anymore. I'm still waiting for another inspiration.'"[77] Warhol mentions no legal threat from any of the "most wanted men," though he does imply the possibility of such a threat when he describes the mural as "invalid." Warhol assigns no agency to the decision to overpaint his mural, nor does he claim (as did Johnson) any problem with the way the mural was hung or with its aesthetic effect. Instead Warhol deadpans that "I'm still waiting for another inspiration," a remark that calls attention to the still-empty space of the voided mural and to the original "inspiration" trapped beneath it.[78] Warhol's brief comments to the *New York Times*, offered some three months after his mural's destruction, marked the artist's first public statement on the episode.

Although more information about the censorship of Warhol's mural would eventually surface, the contradictions at the heart of the episode would never be fully resolved. In a 1970 interview with the German art historian Rainer Crone, Philip Johnson would recall the problem with *Thirteen Most Wanted Men* in the following manner:

> The names [of the most wanted men] got to Governor Rockefeller; [the men] were all Italian. You see, we have a terrible problem in this country which you don't have in Europe. The Mafia is reputedly Italian, you see, and most of these "Thirteen Wanted" were Mafiosi. And the other thing was that they'd already been exonerated—it was an old list, and a lot of them had been proven not guilty. And to label them, we would have been subject to law-suits from here to the end of the world.[79]

In response to this recollection, Crone asks, "So it was not an artistic reason [that provoked the mural's suppression]?" To which Johnson replies, "No, on the contrary. The Governor has used Warhol since to make his own portrait."[80] With these remarks, Johnson flatly contradicts his earlier story, as reported in the New York newspapers, that the mural had been removed at Warhol's request and for strictly aesthetic reasons. Even as Johnson radically alters his account of what happened to *Thirteen Most Wanted Men* at the 1964 World's Fair, he never acknowledges any inconsistency between his original story and his later recollection.

In 1980, Warhol himself would write about the destruction of his mural in a manner that diverged quite dramatically from every previous account of the episode, including the artist's own:

> The World's Fair was out in Flushing Meadow that summer with my mural of the Ten [*sic*] Most Wanted Men on the outside of the building that Philip Johnson designed. Philip gave me the assignment, but because of some

political thing I never understood, the officials had it whitewashed out. A bunch of us went to Flushing Meadow to have a look at it, but by the time we got there, you could only see the images faintly coming through the paint they'd just put over them. In one way I was glad the mural was gone, now I wouldn't have to feel responsible if one of the criminals ever got turned in to the FBI because someone had recognized him from my pictures.[81]

This recollection is telling not only for the mistake Warhol makes about the title of his mural but also for the concern he betrays for the men whose mug shots appeared on it. Rather than worrying about possible lawsuits against him or against the Fair, Warhol worries that the "most wanted men" may be apprehended as a result of his mural. Notice as well that Warhol attributes the Fair's decision to "some political thing I never understood," thereby suggesting that the explanation offered to him at the time was not fully convincing or comprehensible.

The secret nature and discrepant accounts of the overpainting of *Thirteen Most Wanted Men* cannot be sifted down into a stable truth of what "really" happened at the 1964 World's Fair. How, for example, are we to calibrate the degree of Warhol's collusion with the story that *Thirteen Most Wanted Men* was destroyed at his own request? To what extent did Philip Johnson or Eleanor Ward or Warhol himself consciously deceive the press (and, by extension, the public) about the suppression of the mural and to what ends? As I say, these questions will yield no clear answers. Rather than pursuing them, perhaps we should look more closely at the conditions of secrecy and discrepant narration in which these questions are embedded. Instead of trying to uncover the truth of the mural's censorship, perhaps we might take the secrets, half-truths, and conflicting stories about *Thirteen Most Wanted Men* as constitutive of its suppression at the 1964 World's Fair.[82]

According to its publicity literature, the 1964 World's Fair was "dedicated to man's achievements on a shrinking globe in an expanding universe, his inventions, discoveries, art, skills and aspirations," as well as to providing "wholesome entertainment."[83] To this celebration of technological innovation, this "Olympics of Progress" (as the Fair dubbed itself), Warhol introduced the unwelcome figure of the felon. On the most fundamental levels of form (grainy black-and-white photographs) and content (criminal faces), *Thirteen Most Wanted Men* offered a harsh counterpoint to the full-color displays and "futuramas" on offer throughout the Fair.[84] In defying the affirmative program of the World's Fair, Warhol's mug-shot mural functioned as a form of outlaw art at Flushing Meadow.[85]

In one sense, however, *Thirteen Most Wanted Men* answered the mandate of the World's Fair. The mural portrayed individuals at the pinnacle of their chosen careers and showcased a vivid (if entirely deviant) form of American achievement. Sidra Stich has argued that the most wanted men represented "a perverse fulfillment of the American dream"[86] and thus, from Warhol's perspective, a perversely appropriate subject for a State-sponsored mural at an international exposition. Yet the emphasis must remain on the "perversity" of Warhol's gesture within the context of the World's Fair. As Warhol well knew, the "talents" of embezzlers and attempted murderers were not the "achievements, skills, and

aspirations" the organizers of the World's Fair wished to celebrate. In portraying the criminal as an iconic American antihero, Warhol acidly mocked the official ethos of the Fair.

Beyond its specific critique of the World's Fair, *Thirteen Most Wanted Men* was fueled by Warhol's interest in institutionalized discipline, an interest already manifest in the electric chair silkscreens of the previous year and, indeed, in the entire "Disaster" series of which the electric chairs were part (figure 3.33). Like *Thirteen Most Wanted Men*, the electric chair paintings are inscribed by absences within the visual field, literal voids that counter the imagery of social control on display. The blank spaces within both *Thirteen Most Wanted Men* (the lower-right-hand corner) and *Silver Disaster* (the entire right portion of the painting) echo the vacancy of their depicted subjects, whether the blank, affectless gazes of the outlaws or the virtual emptiness of the execution chamber, with its unstrapped electric chair and its sign demanding silence from would-be witnesses.

Art historian Thomas Crow has argued that Warhol's interest in death and disaster in the early 1960s cannot be understood apart from the artist's simultaneous fixation on stardom and celebrity.[87] As Crow points out, the Jackie, Marilyn, and Liz series all constitute part of Warhol's larger "Death in America" project insofar as they were occasioned by the death or near death of these celebrities. Writing on the links between death, celebrity, and mass culture in Warhol's work, Crow describes the early Pop art as "a kind of *peinture noire* in the sense that

Figure 3.33. Andy Warhol, *Silver Disaster*, 1963. Silkscreen ink on metallic polymer paint on canvas, 42" × 60", on extended loan to Baltimore Museum of Art, courtesy of the Sonnabend Collection, New York / Andy Warhol Foundation for the Visual Arts, Inc. / ARS, New York.

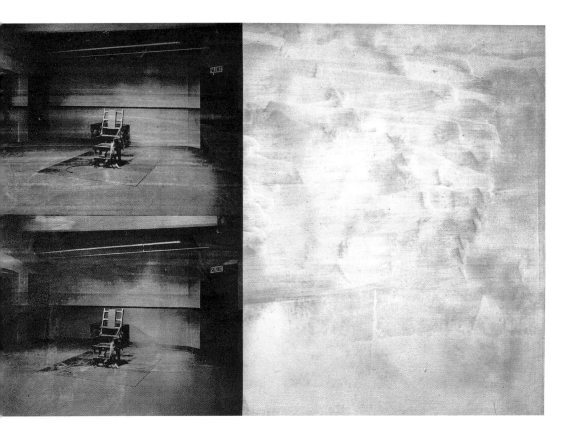

we apply the term to the *film noir* genre of the forties and early fifties—a stark, disabused, pessimistic vision of American life, produced from the knowing rearrangement of pulp materials by an artist who did not opt for the easier paths of irony or condescension."[88] The description of Warhol's early Pop art as *peinture noire* is particularly germane to *Thirteen Most Wanted Men*. More forcefully than any other painting from this period, the World's Fair mural bridges Warhol's interests in celebrity, death, and criminality. Each of the men pictured in the mural was a kind of low-level star, one whose image was reproduced across the nation, albeit in post offices and police stations rather than films and fan magazines. By endowing the mug shot with a grandeur he typically reserved for Elvis Presley or Marilyn Monroe, Warhol insisted on the *Most Wanted Men* as mass-cultural icons and, by implication, as objects of desire for a mass audience.

Warhol himself would later write of the alignment of criminal and "star" within the space of popular culture: "Nowadays if you're a crook you're still considered up there. You can write books, go on TV, give interviews—you're a big celebrity and nobody even looks down on you because you're a crook. You're still really up there. This is because more than anything people just want stars."[89] That Warhol saw the felon as a kind of star is further suggested by the visual similarities that link *Thirteen Most Wanted Men* to Warhol's contemporaneous silkscreens of male and female movie stars. The mural's arrangement of twenty-two close-up photographs in a geometric grid strongly recalls such compositions as 1962's *Marilyn Monroe Twenty Times* (figure 3.34).

In addition to the similarity of their compositional formats, *Marilyn Monroe Twenty Times* and *Thirteen Most Wanted Men* share the use of outdated source photographs. The Marilyn series, which Warhol initiated shortly after the star's death in 1962, was based on a still from the 1953 film *Niagara*.[90] Similarly passé, the mug shots in *Thirteen Most Wanted Men* feature number boards bearing dates as early as 1942. Writing on the Marilyn series, Thomas Crow argues that Warhol's choice of an outdated photograph of Monroe "measured a historical distance between her life and her symbolic function [as sex symbol] while avoiding the signs of aging and mental collapse."[91] *Thirteen Most Wanted Men* similarly opens a space between the original context of the mug shots and their artistic retrieval in a later cultural moment. With its grainy, magnified photographs and empty field of silver paint in the lower-right-hand corner, the mural makes this historical gap over into visual form.[92]

At a World's Fair devoted to the achievements of tomorrow, Warhol chose to look backward by recovering criminal mug shots from the New York City Police Department. Far from celebrating the promise of America's future, *Thirteen Most Wanted Men* stood as a darkly sardonic commentary on its past. The outdated status of the "most wanted men" would later be offered as a defense of the mural's overpainting. Recall Johnson's comment that "it was an old list, and a lot of them had been proven not guilty. And to label them, we would have been subject to law-suits from here to the end of the world."[93] The visible gap between the original context of the "most wanted men" as police photography and Warhol's recycling of them as Pop art here serves to justify the censorship of *Thirteen Most Wanted Men*.

Warhol's use of outmoded mug shots might be seen in a rather different light from that offered by Johnson. In using "backdated" photographs for *Thirteen Most*

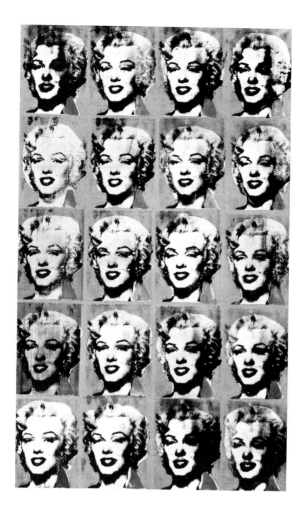

Figure 3.34.
Andy Warhol,
*Marilyn Monroe
Twenty Times*, 1962.
Silkscreen ink on
canvas, 84" × 46".
© Andy Warhol
Foundation for the
Visual Arts, Inc.
™ 1999 Estate of
Marilyn Monroe
licensed by CMG
Worldwide, Indi-
anapolis, Ind.,
46256www.
MarilynMonroe.com

Wanted Men, Warhol implicitly posed the following question to his viewers: "If the police is no longer pursuing the outlaws pictured here, by whom are these men most wanted now?" One answer is, by Warhol himself; another is, by the viewer of the mural; a third is that the men are now wanted by one another. While the subversive status of *Thirteen Most Wanted Men* at the 1964 World's Fair has been duly noted in the scholarly literature on Warhol, the most significant aspect of that subversiveness has been virtually ignored—namely, the way in which the work links criminality to homoeroticism.[94] The title of the World's Fair mural—officially known as *Thirteen Most Wanted Men* but later referred to, more simply, as *Most Wanted Men*[95]—turns on this double entendre. It is not only that these men are wanted by the police but that the very act of "wanting men" may constitute a form of criminality if the wanter is also male, if, say, the wanter is Warhol. The title of Warhol's mural metaphorically "double-codes" its depicted men as objects of both official surveillance and illicit desire.[96]

In *The Burden of Representation*, art historian John Tagg describes the visual codes shared by criminal and clinical photography in the late nineteenth century, codes still operative in the mid-twentieth-century mug shots of *Thirteen Most*

Figure 3.35.
Source image for
Andy Warhol's
*Thirteen Most Wanted
Men* (1964): Louis
Joseph Musto,
Most Wanted Man
No. 10, page 12
from "The Thirteen
Most Wanted,"
New York City
Police Department
booklet, February
1, 1962. The
Archives of the
Andy Warhol
Museum, Pitts-
burgh; Founding
Collection, Contri-
bution The Andy
Warhol Foundation
for the Visual Arts,
Inc.

Wanted Men: "the body isolated, the narrow space, the subjection to an unreturn-able gaze, the scrutiny of gestures, faces and features, the clarity of illumination and sharpness of focus, the names and number boards. These are traces of power, repeated countless times, whenever the photographer prepared an exposure, in police cell, prison, consultation room, asylum."[97] Warhol's gesture of magnify-ing miniature photographs to mural size emphasizes, even spectacularizes, these traces of power. In elevating a compulsory image of identification to the heroic status of a public mural, Warhol transforms the relation between viewer and depicted outlaw. In their original format, the mug shots appear as tiny ($1\frac{1}{2}"$ × $1"$) photographs atop printed information about each criminal (figure 3.35). In this context, the mug shots install the viewer in a position of visual and social dominance—we read the outlaw's list of offenses and view his photograph in order to assist in the larger effort to apprehend and discipline him. But Warhol's architecturally scaled portraits—each panel measures approximately four feet by three feet—command a quite different kind of attention from their viewer, one that has little to do with identification or assistance to the police (figure 3.36). *Thirteen Most Wanted Men* organizes the mug shots into a complex circuit of visual exchange. It sets up a collective relay of looks that pass not only between the outlaws and the viewer but also among the outlaws themselves.

By dispensing with the text that originally accompanied the mug shots, Warhol removes the criminals from the specific history of their crimes while enhancing the visual appeal of their mug shots. The men become associated not with particular transgressions (felonious assault and bail-jumping in the case of

Louis Joseph Musto, murder in the case of Frank "Tanky" Bellone) but with the deviant, defiant status of the outlaw as such. Stripped of their names and pseudonyms, their arrest records and vital statistics, Warhol's most wanted men now embody the visual codes of criminal photography: the deadpan gaze, the subjection to profile and frontal poses, the number boards, and so on.

In their original format, the mug shots were laid out with a right profile on the left side of the page and a full-face photograph on the right. The profile of the criminal thus always turned in toward and, in a sense, "looked at" the face to its right. Warhol disturbs this format in *Thirteen Most Wanted Men* both by separating pendant images of the same criminal, as in the second row of the mural, and by reversing the order of profile and frontal photographs, as in the third row. *Thirteen Most Wanted Men* thus permits the felons to "look" out at the space beyond the frame and, on occasion, at the faces of one another (figure 3.37). Through such pictorial mediations and reversals, Warhol creates visual encounters among the most wanted men that could never have occurred in the original police booklet. In the center of the fourth row, for example, a criminal in shirt and tie is sandwiched between his own profile and that of another felon, who turns as if to look toward him. In choreographing such moments of visual reciprocity between the outlaws, Warhol stages the act of men looking at one another as a monumental scene of criminality.

By diverting police photography from its intended function of criminal detection, Warhol thwarts the law even as he replays its visual codes. *Thirteen Most Wanted Men* constructs a countermodel of visual power in which one sort of social outlaw (the criminal) is watched—and wanted—by another (the homosexual artist). Even as the portraits of *Thirteen Most Wanted Men* always remain recognizable as criminal photographs, they also mobilize other interpretive

Figure 3.36. Andy Warhol, *Thirteen Most Wanted Men*, 1964. Detail, approximately 48" × 40". ©The Andy Warhol Foundation for the Visual Arts.

Figure 3.37.
Andy Warhol,
*Thirteen Most Wanted
Men*, 1964. Detail.
©The Andy Warhol
Foundation for the
Visual Arts.

possibilities, including, but not limited to, an outlawed imagery of gay desire and cruising. Beyond its direct critique of State power, the mural suggests that the prohibition of homosexuality may imbue same-sex desire with all the gritty allure of a mug shot.

Several months after completing *Thirteen Most Wanted Men*, Warhol shot a silent 16mm film entitled *Thirteen Most Beautiful Boys* (figure 3.38), a film that extends, and renders explicit, the homoeroticism of the World's Fair mural. The "most beautiful boys" were in fact young men variously associated with the Factory— Gerard Malanga, Freddie Herko, Dennis Deegan, and Bruce Rudo, among others. Within the terms of this film, the "boys" have no role to play beyond their status as objects of desire, no cause to appear before the camera other than their beauty in Warhol's eyes. Where the mug shots of *Thirteen Most Wanted Men* were appropriated from a prior cultural source and diverted from their original use in the dominant culture (e.g., criminal detection), the footage of the "beautiful boys" plainly signifies sex appeal. In short, where *Thirteen Most Wanted Men* encodes same-sex desire in the register of connotation, *Thirteen Most Beautiful Boys* simply speaks it.[98]

In its World's Fair preview story of April 15, 1964, the *New York Journal American* described the visual appeal of Warhol's mural: "Unabashedly adorning the New York State Pavilion at the World's Fair today—resplendent in all their scars, cauliflower ears, and other appurtenances of their trade—are faces of the city's

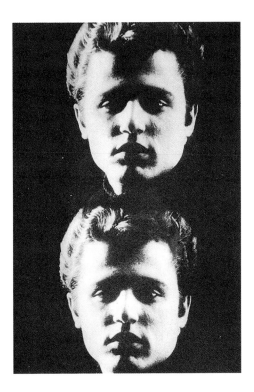

Figure 3.38.
Still of Gerard
Malanga from Andy
Warhol, *Thirteen
Most Beautiful Boys*,
1964. Film. ©
Andy Warhol Foun-
dation for the
Visual Arts.

13 Most Wanted Criminals. . . . If they survive the weather and the expected howls of protest, they will be viewed by the international exhibition's 90 million visitors."[99] This passage is notable both for the reverse glamour it ascribes to the *Most Wanted Men* ("resplendent in all their scars") and for the protest it (accurately) foresees the mural provoking. As we know, that protest occurred "behind the scenes" of the World's Fair and was effectively covered over by a public discourse that assigned to Warhol (and Warhol alone) the decision to destroy the work. Three days after its preview story, the *New York Journal American* ran a shorter report on the demise of Warhol's mural under the headline, "Fair's 'Most Wanted' Mural Becomes Least Desirable." By riffing on "most wanted," the headline sets an irreverent tone that the accompanying article largely follows. At one point, for example, the article refers to "the boys" who "adorn[ed] the exterior of the New York Pavilion of the World's Fair."[100] Albeit with tongue in cheek, the article broaches the issue of the most wanted men as objects of desire. It points to the possibility that Warhol's pun on "wanted men" was not entirely lost on his contemporary audience.

In the earlier of the two *New York Journal American* articles on Warhol's mural, the issue of the work's source material is explicitly raised. The article quotes Warhol as follows: "I got the pictures from a book the police put out. It's called '"The 13 Most Wanted" Men.' It just had something to do with New York and I was paid just enough to have it silk screened. I didn't make any money on it."[101] A booklet entitled "The Thirteen Most Wanted" was indeed printed by the New York City Police Department (figure 3.39) in January 1962.[102] Each page of this booklet is devoted to a single "wanted man" such that the reader flips from one to

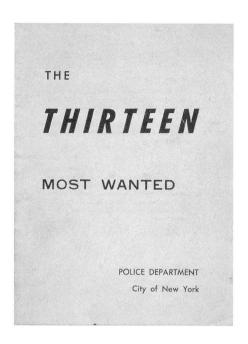

THE

THIRTEEN

MOST WANTED

POLICE DEPARTMENT
City of New York

Figure 3.39.
Front cover of
"The Thirteen Most
Wanted," New York
City Police Depart-
ment booklet, Feb-
ruary 1, 1962. The
Archives of the
Andy Warhol
Museum, Pitts-
burgh. Founding
Collection, Contri-
bution The Andy
Warhol Foundation
for the Visual Arts.

the next, encountering each criminal, and the history of his crimes, individually. Warhol's mural, as I have argued above, sets the criminals into a shared visual space such that they can now "look" at one another.

Given that "The Thirteen Most Wanted" was produced for use by law-enforce-ment officials, how did Warhol come to possess a copy of it?[103] The *New York Jour-nal American* posed just this question to the city's police department in 1964. The department's response is worth quoting directly: "Walter Arm, deputy commissioner of the Police Department's Bureau of Community Relations, said he didn't have any idea how Warhol got hold of the pamphlet used as a working plan for the work of art. 'As far as I know, we did not give the book to him, but he may have gotten it from us,' Mr. Arm said. 'That is all I can tell you.'"[104] Clearly an old hand at officialese, Mr. Arm avoids the question put to him even as he seems to answer it— "we did not give the book to him, but he may have gotten it from us." Although Arm insists that this response is the only one he can provide to the press ("That is all I can tell you"), it begs a follow-up question: How might Warhol have gotten "The Thirteen Most Wanted" from the police if they "did not give the book to him"?

According to John Giorno, a poet and friend of Warhol's at the time, the artist was secretly given a copy of the booklet by a New York City police officer. In an essay recounting his friendship and sometime collaboration with Warhol in the 1960s, Giorno recalls the origins of *Thirteen Most Wanted Men* in detail:

On April 28, 1963 [the painter] Wynn Chamberlain invited Andy, me, and a friend of his named Bobo Keely, to dinner in his loft on the top floor of 222 Bowery. . . .

At dinner we talked about Bob Indiana's new show at the Stable and the current gossip. Andy mentioned he had a problem because he had to do a

piece for the 1964 World's Fair and he didn't have an idea. . . . *"Oh, I don't know what to do!"* said Andy.

We were eating coq-au-vin and drinking white wine. Wynn said, "Andy, I have a great idea for you. The Ten Most Wanted Men! You know, the mug shots the police issue of the ten most wanted men."

"Oh, what a great idea!" said Andy.

"My boyfriend is a cop," said Wynn. "He can get you all the mug shots you want. He brings a briefcase of them home every night. . . . "

"Oh, what a great idea!" said Andy. "But Robert Moses has to approve it or something. . . . I don't care, I'm going to do it!"

Wynn Chamberlain had a lover, Jimmy O'Neill, who was gay and a New York City policeman, half Italian and half Irish, and he was gorgeous. Jimmy was a third-generation cop. His grandfather was a captain. Jimmy was hip. He gave Andy a big manila envelope filled with crime photos, mug shots, archival photographs, and the Ten Most Wanted Men.[105]

Giorno's account turns largely on the coincidence that a "third-generation cop" should also be a "hip" homosexual who brings a "briefcase of mug shots" home to his painter-boyfriend each night. A social and sexual network of gay men links Warhol, however covertly, to a New York City police officer. That connection functions to subvert police protocol so as to enable Warhol's creative process. The link between Warhol and O'Neill marks the presence, within the very space of law enforcement, of outlaw desires and secret commitments.

In an interview with the author, Giorno reiterated the details of this anecdote (down to the menu of Chamberlain's dinner party and the size of O'Neill's manila envelope) and added that Warhol "absolutely loved" the idea of "taking mug shots and making them into art."[106] Substantiating Giorno's account is the fact that the archives of the Warhol Museum include several mug-shot posters that were acquired by Warhol in the early 1960s (presumably from O'Neill) and remained in the artist's possession until his death (e.g., figure 3.40).[107] Giorno's anecdote not only substantiates Warhol's double coding of *Most Wanted Men*, it also literalizes, in the figure of Jimmy O'Neill, the bond between disciplinary power and outlaw desire. Within the logic of Giorno's story, the police officer functions as a kind of double agent, smuggling restricted materials out of the precinct and into Warhol's studio. O'Neill's subversion of official policy could hardly be said, however, to undo the power of the police. Even as O'Neill was passing mug shots on to Warhol, he was also working for a police department that was in the midst of a crackdown on gay culture, one engineered specifically to "clean up" New York City in preparation for the World's Fair.

The poet and curator Frank O'Hara would memorably describe this police crackdown in a letter written to his friend and fellow poet John Ashbery in January 1964:

In preparation for the World Fair New York has been undergoing a horrible cleanup (I wonder what they think people are *really* coming to NYC for, anyway?). All the queer bars except one are already closed, four movie theaters have been closed (small ones) for showing unlicensed films like Jack Smith's *Flaming Creatures* and Genet's *Chant d'amour*. . . . The fair itself,

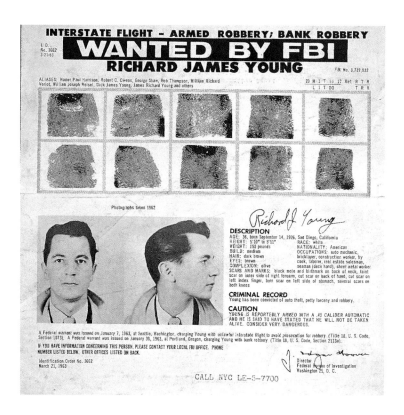

Figure 3.40.
FBI Wanted Man
poster of Richard J.
Young, March 21,
1963, from Andy
Warhol's collec-
tion. The Archives
of the Andy Warhol
Museum, Pitts-
burgh. Founding
Collection, Contri-
bution The Andy
Warhol Foundation
for the Visual Arts,
Inc.

or its preparations are too ridiculous and boring to go into, except for the amusing fact that [Fair president Robert] Moses flies over it in a *helicopter* every day to inspect progress.[108]

As O'Hara makes clear, the police department's "horrible cleanup" of New York was directed with particular force against "queer" people and the venues in which they congregated. As the January date on O'Hara's letter testifies, the cleanup was initiated several months before the Fair opened to the public. The censorship of *Thirteen Most Wanted Men* at the World's Fair might be seen as but one part of a larger project to foreclose the expression of deviant desires and outlaw identities in New York City in 1964. Building on a "cleanup" (or "crack-down") already under way, the censorship of *Thirteen Most Wanted Men* suggests the compulsory and sanitized nature of the world on display at the 1964 World's Fair. Any hint of deviance or criminality was to be swept from Flushing Meadow and, whenever possible, from the larger city of which it was part.[109]

The censorship of *Thirteen Most Wanted Men* was not altogether successful. Because Warhol never replaced his mural, the silver void continued, as Benjamin Buchloh nicely puts it, "to speak of having been silenced into abstract mono-chromy."[110] As a visible absence on the facade of the New York State Pavilion, the overpainted mural recalled the labor of censorship that had preceded and, in a sense, produced it. From the perspective of the World's Fair officials, the voided mural may have spoken all too clearly of its own silencing. Some months after the work was overpainted, Fair organizers further shrouded it with an immense

black cloak (figure 3.41). *Thirteen Most Wanted Men*, a work explicitly concerned with mechanisms of surveillance and social control, was thus twice covered over, doubly closeted at the 1964 World's Fair. Why would the Fair deem it necessary to cover an already blank mural? The closeting of homosexuality, as Eve Kosofsky Sedgwick reminds us, depends upon "the act of a silence—not a particular silence but a silence that accrues particularity by fits and starts, in relation to the discourse that surrounds and differentially constitutes it.[111] The "closeting" of Warhol's mural beneath a field of silver paint accrued particularity in relation to the criminal mug shots that had preceded and, in a sense, "differentially constituted it." Although most visitors to the World's Fair did not know that a set of mug shots lay underneath the silver monochrome, both Warhol and the officials who censored his mural certainly did. Through this knowledge,

Figure 3.41.
Peter M. Warner,
Thirteen Most Wanted Men covered with black tarp on New York State Pavilion, New York World's Fair, 1964–65. Photograph. Courtesy Charles Warner.

the mug shots continued to haunt the scene of representation after their evacuation from it, dismaying Fair officials even when muted under aluminum house paint.

There is one additional aspect to this haunting—one further set of ghost images associated with *Thirteen Most Wanted Men*—that I have yet to address. When told that his mural could not stand, Warhol initially proposed that twenty-five identical portraits of Robert Moses be placed over the mug shots of the *Most Wanted Men*. Warhol even produced a silkscreen portrait of Moses (figure 3.42) as a prototype for the mural (or, more precisely, for one-twenty-fifth of the mural) he hoped to install on the facade of the New York Pavilion. Warhol answered the censorship of his work by attempting to make one of the primary agents of that censorship visible. Drawing on the work of Michel Foucault, literary critic Paul Morrison has argued that "disciplinary power . . . strategically labors not to speak its name, not to be known or acknowledged as such."[112] Warhol's proposal to replace *Thirteen Most Wanted Men* with a multiple portrait of Robert Moses clearly aimed to make "disciplinary power speak its name" so that it might "be known and acknowledged as such."

Philip Johnson rejected Warhol's proposal for a Robert Moses mural. As Johnson would later recall, "I forbade that, because I just don't think it made any sense to thumb our noses. . . . I don't like Mr. Moses, but inviting more lawsuits by taking potshots at the head of the Fair would seem to me very, very bad taste. Andy and I had a little battle at the time, though he is one of my favorite artists."[113] Johnson's response bespeaks a clear, if antipathetic, understanding of Warhol's critique of official power, of the artist's desire to take a "potshot" at Robert Moses by forcing the Fair president to "show his face," again and again, on the facade of the New York Pavilion.

Consider the changes that would have been wrought in the shift from *Most Wanted Men* to World's Fair president. The markings of discipline and defiance inscribed on the mug shots (figure 3.43) are replaced by the grinning self-satisfaction of the executive, by the leisure and luxury of an enfranchised man who is not compelled to answer the camera directly but can instead smile broadly while

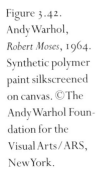

Figure 3.42.
Andy Warhol,
Robert Moses, 1964.
Synthetic polymer
paint silkscreened
on canvas. ©The
Andy Warhol Foundation for the
Visual Arts/ARS,
New York.

orienting his gaze elsewhere. While the outlaws are typically framed in frontal or profile positions, Moses situates himself in a slightly diagonal (if awkwardly overclose) relation to the camera. As mentioned above, Warhol's arrangement of mug shots within *Thirteen Most Wanted Men* enacts a subtle play of difference and repetition as well as a complex circuitry of looking and looking back. If the image of Robert Moses had been repeated twenty-five times on the facade of the New York Pavilion, there would have been no such sense of visual reciprocity or collective exchange. Warhol's proposal for *Robert Moses Twenty-Five Times* signals not a pleasure in repetition but an outright flattening of difference. The monotony of *Robert Moses Twenty-Five Times* suggests that while the Fair president may have possessed the means to censor Warholian desire, he clearly lacked the appeal necessary to serve as its object.

Later in 1964, Warhol would repeat this critique of mainstream masculinity in a portrait, this one commissioned, of yet another company man. In *The American Man (For Watson Powell)*, Warhol took a corporate photograph of Watson Powell, the founder and former CEO of the American Republic Insurance Company in Des Moines, Iowa, duplicated it thirty-two times on a rectangular grid, and saturates it in flat tonalities of tan, cream, and beige (figure 3.44). In addition to the portrait's official title, Warhol dubbed it "Mr. Nobody,"[114] thereby making plain his attitude toward the depicted subject. If the outlaws in the World's Fair mural were among Warhol's most wanted men, then Watson Powell and Robert Moses must surely have ranked among his least.[115]

Warhol's satire of enfranchised masculinity in *The American Man (For Watson Powell)* may be highlighted by comparing that picture to *Ethel Scull Thirty-six Times*, a 1963 portrait of the New York art collector (figure 3.45). Where the precise replication of Watson Powell's face and its strict containment within the family of beige banalizes an already vacant portrait of corporate identity, the diversity of color and stance in Scull's portrait emphasizes the range of her the-

Figure 3.43.
Andy Warhol,
Thirteen Most Wanted Men, 1964. Detail.

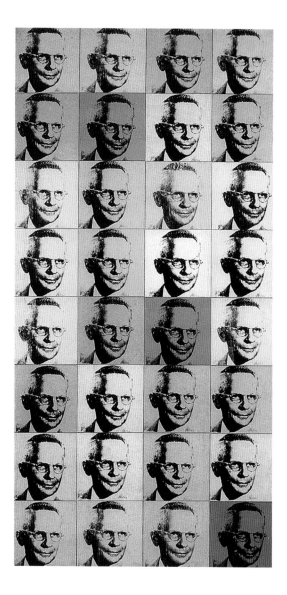

Figure 3.44. Andy Warhol, *The American Man (For Watson Powell)*, 1964. Synthetic polymer paint and silkscreen ink on canvas, 32 panels, each 16" × 16¾". © Andy Warhol Foundation for the Visual Arts/ARS, New York.

atrical femininity, the ways in which, with just a minimum of props, she can project a seemingly infinite number of affects: high glamour, hilarity, hairdo check. The pleasures of repetition in Scull's portrait have to do with the way in which recurrence plays off against difference, the way each image both mimics and differentiates itself from a chain of adjacent shots, as in a filmic sequence of an object in motion. Although there are thirty-six discrete views of Ethel Scull in this work, Warhol used only seventeen different source photographs to make the portrait. So as to suggest a greater diversity of images and poses, Warhol

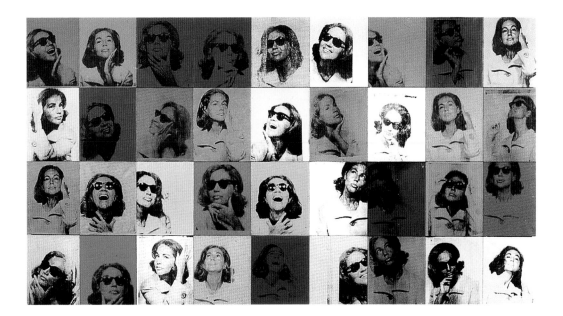

reversed some of the photographs, manipulated their registration on the canvas, or saturated them in brilliantly contrasting colors.[116]

In *Ethel Scull Thirty-six Times*, Warhol employs several representational strategies that recur in the following year's *Thirteen Most Wanted Men*. Both silkscreens generate visual interest by matching a "low" photographic technique (the photobooth snapshot, the criminal mug shot) with a "higher" genre of painting (the patron portrait, the mural for an international exposition). In addition, each work forces the depicted subject out of his or her "appropriate" social space and into unexpected venues: the socialite in a Times Square arcade, the felon at the World's Fair. Finally, both silkscreens employ a gridded format that enforces geometrical order while avoiding predictable replication. Where the visual differences in *Ethel Scull Thirty-six Times* are derived from contrasts of color and pose, those in *Thirteen Most Wanted Men* stem from the multiplicity of subjects, the frequent separation of companion portraits, and the occasional use of a candid photograph in lieu of a mug shot (as in the upper-left-hand corner and the far right end of the fourth row). Warhol further undoes the logic of repetition by leaving a gap on the mural's lower right corner, as though anticipating future inscriptions onto his list of *Most Wanted Men*.

Visual pleasure in Warhol's early silkscreens—and I take *Ethel Scull Thirty-six Times* and *Thirteen Most Wanted Men* to be exemplary here—attaches to a model of repetition that can accommodate difference. To generate subtleties of difference within an overall pattern of repetition, Warhol relied upon high contrast colors, unexpected compositional elements such as blank spaces, and streaky, off-register, or otherwise idiosyncratic silkscreen impressions. When such differences are avoided or outright suppressed, as in *The American Man (For Watson Powell)* or *Robert Moses Twenty-five Times*, their absence suggests that the depicted subject does not merit the full complexities of Warholian repetition.

Figure 3.45. Andy Warhol, *Ethel Scull Thirty-six Times*, 1963. Synthetic polymer paint and silkscreen ink on canvas, 36 panels, each 20" × 16". © Andy Warhol Foundation for the Visual Arts/ARS, New York.

Warhol most clearly draws out the relation among repetition, difference, and homoerotic desire in his work on the male movie star. In his 1963 *Double Elvis* (figure 3.46), for example, Warhol duplicates a publicity still from the 1960 Western *Flaming Star* in which several phallic surrogates (gun, knife, holster, shadow) mark Presley's body. Warhol's doubling, beyond merely reinforcing the phallicism of the source photograph, activates the erotic possibility of man-on-man contact. The pressure points of *Double Elvis*, its moments of maximum charge and ambiguity, are those places at which the two bodies overlap or touch: the cross of upper thighs and the join of outstretched arms. Warhol's alignment of these overlaps gradually permits the left-hand Elvis to pull away from his right-hand partner until the former emerges in a two-fisted gesture of gunslinging. As the left-hand figure becomes a fully engaged outlaw shooting a double-barreled load, his right-hand companion is consigned to a background station of passivity and pictorial fade-out, to the secondary status of a shadow or afterimage. What at first seems a precise duplication of Presley's image thus resolves into a relation between slightly but significantly differentiated male bodies, a relation in which several potentially erotic hierarchies are put into play: top and bottom, extension and recession, activity and passivity, dominance and submission.

Of the early Pop silkscreens, Roland Barthes writes, "Look how Warhol proceeds with his repetitions. . . . he repeats the image so as to suggest that the object trembles before the lens or the gaze, and if it trembles, one might say, it is because it seeks itself."[117] When a film still of Elvis Presley "seeks itself" through repetition, it activates a homoerotic doubling of male bodies which the terms of the original still could never admit. Warhol's repetition of Presley challenges the supposed stability of mass-cultural images of the male body from the 1950s and 1960s. It testifies to the manifold ways in which such images were mimicked, manipulated, and multiplied by viewers, and particularly by gay male viewers such as Andy Warhol.[118] In *Double Elvis*, Warhol draws out the queer appeal of a male star whose very stardom was contingent on the disavowal of any such appeal.[119]

In the same year that he created *Double Elvis*, Warhol would populate the Ferus Gallery in Los Angeles with multiple versions (some doubled or tripled in registration) of his Presley portrait (figure 3.47). Rather than installing the show himself, Warhol mailed the silkscreens on a giant roll of canvas, uncut and unstretched, to Irving Blum, his L.A. dealer, along with instructions that the pictures should be cut down and installed however Blum saw fit so long as they were "hung edge to edge, densely—around the gallery."[120] Where *Double Elvis* activates a fantasy of man-on-man contact, the wraparound installation at the Ferus Gallery multiplies the possibilities and pleasures of homoerotic mirroring. At the Ferus, Warhol offers not just an Elvis pair but a serial progression of Presley clones, a battalion of six-foot-tall Elvises who fan out across the gallery walls in seemingly endless repetition. In considering this proliferation of Presleys, we might consult the following scenario from *The Philosophy of Andy Warhol, from A to B and Back Again*:

> So today if you see a person who looks like your teenage fantasy walking down the street, it's probably not your fantasy but someone who had the

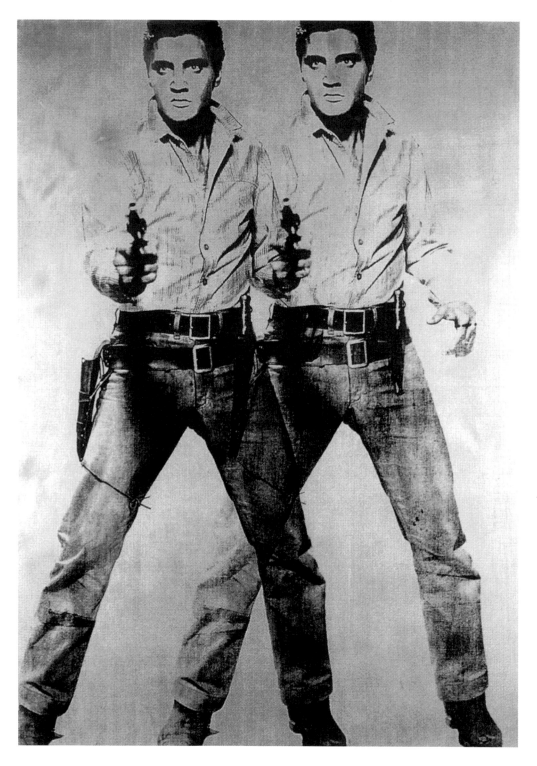

Figure 3.46. Andy Warhol, *Double Elvis*, 1963. Silkscreen ink on aluminum house paint on canvas, 81 1/16" × 58 1/4". © Andy Warhol Foundation for the Visual Arts / ARS, New York. Used with permission of the Estate of Elvis Presley.

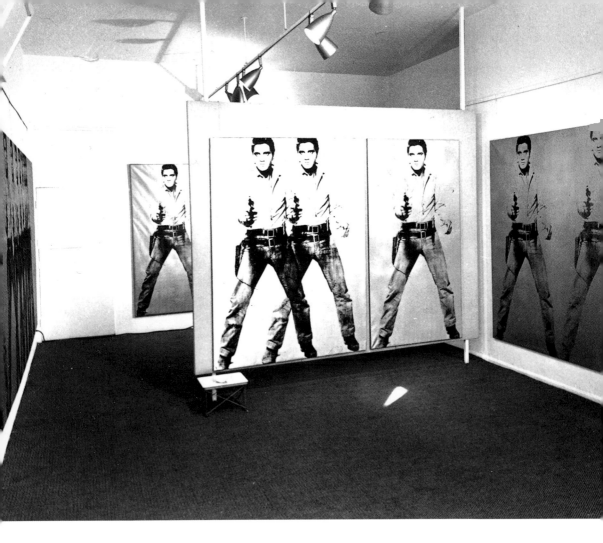

Figure 3.47.
Andy Warhol, *Elvis*
exhibition, September 1963. Ferus
Gallery, Los Angeles. © Andy Warhol
Foundation for the
Visual Arts/ARS,
New York. Used
with permission of
the Estate of Elvis
Presley.

same fantasy as you and decided instead of getting it or being it, to look like
it, and so he went and bought that look you both like. So forget it.

Just think of all the James Deans and what it means.[121]

One does not possess or become James Dean (or Elvis Presley) but purchases his
look and, in doing so, begins to attract other celebrity impersonators as well. A
loosely organized collective ("all the James Deans") is generated through the
communal imitation of an ideal image of desirability, through the mirroring of
parallel fantasies played out across the surface of the body.

Lest this Warholian moment be imagined as a utopian one, we should recall
the artist's advice to the reader: "So forget it." Notice how, in the peculiar syntax
of the larger passage, the impersonal pronoun "it" quickly slides out of specific
reference. By the time we get to that penultimate command, "so forget it," we
cannot be certain whether "it" refers to the real James Dean, the fantasy of James
Dean, the James Dean impersonator, or the idea of possessing (or becoming) any
one of these. This confusion of star and surrogate underscores the ambiguity of
Warhol's advice to the reader and, more broadly, of his practices of celebrity

repetition. Whatever its specific antecedent, "so forget it" would seem to warn against confusing the fantasy on the street with the original object of desire, the "real" James Dean. But in the context of Warhol's broader project on repetition and celebrity, that "so forget it" might also be taken as a directive to abandon the search for authentic fantasy objects and to savor instead superficial imitation, obvious mimicry, and self-conscious simulation.

The pleasures of repetition in *Thirteen Most Wanted Men*, *Double Elvis*, and the Ferus Gallery installation suggest, but never specify, an erotics between men. Recall, by way of contrast, the flamboyantly camp appeal of the Truman Capote pump and the overt, if playful, homoeroticism of the cock drawings. The openly homoerotic content of the pre-Pop art has been rerouted by Warhol into grittier—if less recognizably sexual—representations of male desirability in the silkscreen paintings of the early 1960s.

Warhol and the FBI

Four years after the censorship of *Thirteen Most Wanted Men* at the 1964 World's Fair, the Federal Bureau of Investigation opened a file on Andy Warhol.[122] Heavily expurgated sections from this file were released in 1987 (under the Freedom of Information Act) and later published. As the published version of the file reveals, the FBI's interest in Warhol was aroused not by any of the artist's paintings but rather by his film *Lonesome Cowboys*, a loosely structured Western about a group of cowboys who pose as brothers so that they can sleep together without arousing undue suspicion.[123] After being tipped off as to the potential obscenity of *Lonesome Cowboys*, the FBI dispatched two agents to attend a midnight screening of the movie at a San Francisco film festival in November 1968. In an entry to the FBI file dated from a few days after the screening, the two agents provide an extended (and pricelessly deadpan) synopsis of the film:

All of the males in the cast displayed homosexual tendencies and conducted themselves toward one another in an effeminate manner. . . .

As the movie progressed, one of the actors ran down a hill. The next scene showed a man wearing only an unbuttoned silk cowboy shirt getting up from the ground. His privates were exposed and another cowboy was lying on the ground in a position with his head facing the genitals of the cowboy who had just stood up. A jealous argument ensued between the cowboy who was observed running down the hill and the one wearing the silk shirt. The man in the silk shirt was seen urinating; however, his privates were not exposed due to the camera angle. . . .

. . . The sheriff in one scene was shown dressing in woman's clothing and later being held on the lap of another cowboy. Also, the male nurse was pictured in the arms of the sheriff.

Another scene depicted a cowboy fondling the nipples of another cowboy.

There were suggestive dances done by the male actors with each other. These dances were conducted while they were clothed and suggested lovemaking between two males.

UNITED STATES DEPARTMENT OF JUSTICE
FEDERAL BUREAU OF INVESTIGATION

Copy to: 1 - USA, Phoenix, Arizona
 1 - USA, Atlanta, Georgia
 1 - USA, New York, Southern District of New York

Report of: SA [redacted] Office: PHOENIX
Date: 12/17/69

Field Office File #: PX 145-230 **67C** Bureau File #: 145-4011

Title: ANDY WARHOL;
 ET AL

Character: INTERSTATE TRANSPORTATION OF OBSCENE MATTER

Synopsis: USAs in New York City, New York; Atlanta, Georgia,
 and Phoenix, Arizona declined prosecution.

 -C-

 DETAILS:

Figure 3.48.
U.S. Federal
Bureau of Investi-
gation, memo to
file, "Andy Warhol;
et al," December
17, 1969. Courtesy
Margia Kramer,
New York.

There was no plot to the film and no development of characters throughout. It was rather a remotely-connected series of scenes which depicted situations of sexual relationships of homosexual and heterosexual nature.[124]

After detailing each scene in *Lonesome Cowboys* (and even some of the individual shots and camera angles), the agents finally throw up their hands at the film's lack of character and plot development. Warhol's movie is not only obscene, they complain, it is also poorly paced and underwritten. Within the context of the FBI's file, however, it is the two agents, no less than Warhol himself, who attend to the nipple fondling and mock lovemaking of the cowboys, to the position of one actor's head in relation to another's crotch, and to various scenes of urination, cross-dressing, and same-sex dancing. The FBI's file bespeaks the central contradiction of its own practice of surveillance, a contradiction named by Susan Stewart as "the impossibility of describing desire without generating desire."[125] So as to gather evidence against Warhol, two FBI agents were sent to watch *Lonesome Cowboys* together, at midnight, in a movie theater in San Francisco. And in writing up what they saw that night, the agents set off a spark of the cowboy erotics they claim merely to describe.

The FBI's investigation of Warhol would ultimately fail to result in a criminal indictment. One of the last pages in the file (figure 3.48) documents the fact that

the U.S. Attorney's offices in three different cities (New York, Atlanta, and Phoenix) all "declined prosecution" of Warhol for the "interstate transportation of obscene material" (i.e., for taking prints of *Lonesome Cowboys* across state lines). Yet the very fact that the FBI pursued an investigation of Warhol carries historical significance. Following the Tanager Cooperative in the late 1950s and the New York World's Fair in 1964, the FBI surveyed and sought to restrict the "homosexual tendencies" of Warhol's work.

About a month after the FBI opened its investigation of Warhol in 1968, a one-person exhibition of the artist's work was mounted at the Rowan Gallery in London. The work on display consisted of a suite of Marilyn Monroe prints and a series of silkscreen paintings entitled *Most Wanted Men*. As it turned out, Warhol had saved the original silkscreens for his World's Fair mural such that he could make individual paintings of the mug-shot portraits that comprised the mural. In *Popism: The Warhol 60s*, the artist would recall that "since I had the Ten [*sic*] Most Wanted screens already made up, I decided to go ahead and do paintings of them

Figure 3.49. Billy Name, "Andy Warhol in the Factory with *Most Wanted Men, No. 11, John Joseph H.*" Photograph © Billy Name/Bruce Coleman, Inc.

anyway. (The ten certainly weren't going to get caught from the kind of exposure they'd get at the Factory.)"[126] Once again, Warhol betrays a concern about the potential capture of the outlaws pictured in *Most Wanted Men*. He reasons that the "kind of exposure" the most wanted men will receive at the Factory poses no threat to their continued freedom. Within the space of Warhol's studio, the men would be displayed for the purposes not of criminal detection but of visual pleasure. Equally as important, *Most Wanted Men* would now be seen by an audience who, like Warhol himself, was more likely to identify with the criminal than with the police.

Several photographs taken by Billy Name between 1964 and 1968 show one or another of the *Most Wanted Men* hanging on or leaning against the walls of the Factory. An especially memorable shot from 1964 catches both Warhol and *Most Wanted Men No. 11, John Joseph H.*, in the reflection of a mirror that has itself been enclosed within a gilded frame (figure 3.49). Warhol's reflection, far smaller than that of *John Joseph H.*, remains confined to the lower-right-hand corner of the mirror. For all the disparity in size between Warhol and *Most Wanted Men No. 11*, the two are well matched in pose and attitude. Both figures assume a frontal orientation and meet the camera with a look of dead seriousness, as if to stare it down. Within the space of the Factory, Warhol and the outlaw have come to mirror each other.

I want to close this chapter with another Billy Name photograph. This one, from 1968, shows Warhol's *Most Wanted Men No. 2, John Victor G.* propped up against a wall at the Factory (figure 3.50). Still wrapped in plastic, the painting has either recently returned from the London show or, more likely, awaits its departure for the same. But for the moment it waits and watches, a kind of sentry guarding the entrance to the bathroom whose closed door we see on the right.

While Warhol was under surveillance by the FBI, he continued to display his *Most Wanted Men*, both at the Factory in New York City and at the Rowan Gallery in London. Warhol's recycling of these paintings might almost be taken as a kind of countersurveillance operation, one in which the disciplinary gaze of the law is returned and eroticized by the oulaws it aims to capture. Even as the FBI scrutinized Warhol's work and world in 1968, the artist and his *Most Wanted Men* looked right back.

Figure 3.50.
FACING PAGE
Billy Name, "*Most Wanted Men, No. 2, John Victor G.* in the Factory." Photograph © Billy Name / Bruce Coleman, Inc.

new york's first homosexual newspaper

GAY POWER

volume 1
number 16

75¢

cover: robert mapple thorpe

4

Barring Desire

Robert Mapplethorpe and the Discipline of Photography

My life began in the summer of 1969. Before that I didn't exist.
—Robert Mapplethorpe

In June 1969, the patrons of the Stonewall Inn, a gay bar in Greenwich Village, resisted arrest during a police raid and, in so doing, triggered several days of public rioting and street protest. These riots are generally taken to mark the birth of the gay liberation movement in the United States. Modeling itself on the women's liberation and black power movements, gay liberation sought to link homosexual freedom to a larger vision of revolutionary change in which all hierarchies of social, economic, and sexual power would be leveled.[1]

In June 1969, Robert Mapplethorpe was twenty-two years old and living in a loft on Delancey Street in Lower Manhattan. He had just left his studies at the Pratt Institute of Design in Brooklyn and was seeking to launch his career as a professional artist. The work he was making at the time consisted primarily of collages and mixed-media constructions, many of which incorporated photographs from male physique magazines and commercial pornography. Mapplethorpe was not active in the gay liberation movement, and his proximity to the Stonewall Riots should not, of course, be construed as any sign of political engagement on his part. As I will argue, however, Mapplethorpe's early work was fueled by the increasing confidence of homosexual visibility in the wake of Stonewall and was, on one occasion, explicitly aligned with the politics of gay liberation.

FACING PAGE: Figure 4.1. *Gay Power*, 1, no. 16 (1970). Courtesy Gay, Lesbian, Bisexual, Transgender Historical Society of Northern California, San Francisco.

In the fall of 1970, a Mapplethorpe collage entitled *Bull's Eye* appeared on the cover of *Gay Power* (figure 4.1), a liberation broadside that billed itself as "New York's first Homosexual Newspaper." *Gay Power* carried news of gay liberation politics, both locally and nationally, as well as book reviews, advice columns, personal ads, graphic art, and topical cartoons.[2] The rise of liberation newspapers such as *Gay Power*, *Gay*, *Gay Sunshine*, *Come Out!*, *Fag Rag*, and *Killer Dyke* in the years between 1969 and 1971 provided an unprecedented degree of visibility—and self-generated press coverage—for the gay and lesbian movement.[3]

The appearance of *Bull's Eye* on the cover of *Gay Power* marked the first time one of Mapplethorpe's artworks was reproduced and circulated. Yet there is no mention of the cover in the (now voluminous) literature on the artist. Likewise, the archives of the Robert Mapplethorpe Foundation include no information, beyond a copy of the cover itself, on the specifics of this association.[4] How, then, are we to understand this moment of alliance between Mapplethorpe and *Gay Power*, this unexpected link between the artist's early work and the radical politics of the gay liberation movement?[5]

In pursuing this question, I will look in some detail at the activist ambitions and visual imagery of the gay liberation movement before turning back to *Bull's Eye* and several other examples of Mapplethorpe's early work. I will not, however, attempt to situate the gay liberation movement as the political "real" that Mapplethorpe's early work illustrates or exemplifies. Radical gay politics cannot be stationed as merely the backdrop against which Mapplethorpe's contemporaneous work unfolds. The gay liberation movement produced its own forms of representation (manifestos, graphics, posters) calling for sexual freedom and radical social change. Mapplethorpe's early work alternately engaged with these representations and marked a distance from them. Rather than stressing sexuality as a form of freedom and plenitude, Mapplethorpe incorporated the visible signs of constraint and external regulation into his work. In collages such as *Bull's Eye*, he pictured both homoeroticism and its prohibition, both same-sex desire and its suppression. By so doing, Mapplethorpe took the historical legacy of censorship—of forced invisibility—and made it over into pictorial form.

The eroticization of constraint is central to the other series of Mapplethorpe pictures on which this chapter will focus—the photographs of gay sadomasochism produced from 1977 to 1979. Where the porn collages mimic the external regulation of homoeroticism by the police and the post office, the s/m photographs portray the play of sexual power and powerlessness within the frame of the photograph. After looking closely at the visual terms of the s/m photographs, I will consider a 1978 episode in which the most explicit of the s/m pictures were removed from a commercial gallery in San Francisco. The pictures were later displayed, under the title *Censored*, at an alternative art space in the same city.

Far from simply concluding in a notorious episode of censorship, Mapplethorpe's career was shaped by the force of censorship throughout. Here again, the concept of censorship must be expanded to include not only overt acts of material destruction and suppression but also more subtle forms of restriction and constraint, including those thematized within Mapplethorpe's own

work. Long before his photographs were denounced on the floor of the U.S. Senate or adduced as evidence of obscenity in a Cincinnati courthouse, Mapplethorpe represented the censorship of sexual imagery and the erotics of discipline in his work. In so doing, he gave visual form to the contradiction at the core of *Outlaw Representation*: the prohibition of homoerotic imagery serves not only to suppress but also to provoke and produce that imagery.

"Gay Is Good"

The gay liberation movement of the early 1970s proposed homosexuality as a source of pride and public affirmation rather than private shame or abjection. "Gay Is Good," a slogan loosely modeled on "Black Is Beautiful," encapsulated the gay liberationist critique of various institutions (the medical profession, the State, the Church) that framed homosexuality as "bad" (i.e. pathological, criminal, or sinful).[6] The slogan, imprinted on placards and buttons (figure 4.2), defied the denigration and denial of homosexuality within American culture. In a 1970 manifesto entitled "Gay Is Good," liberation activist Martha Shelley laid down the following challenge to a reader specifically identified as heterosexual:

> Look out straights, here comes the Gay Liberation Front. . . .
> We want something more now, something more than the tolerance you never gave us. But to understand that, you must understand who we are.
> We are the extrusions of your unconscious minds—your worst fears made flesh. From the beautiful boys at Cherry Grove to the aging queens in the uptown bars, the taxi-driving dykes to the lesbian fashion models, the hookers (male and female) on 42nd Street, the leather lovers—and the very ordinary un-lurid gays—we are the sort of people everyone was taught to despise—and now we are shaking off the chains of self-hatred and marching on your citadels of repression.[7]

Shelley configures gay liberation as a force that moves from inside the psyche of the heterosexual subjects ("we are the extrusions of your unconscious minds") to the external spaces and inhabitants of the city ("the aging queens in uptown bars, the taxi-driving dykes") and back again to the consciousness of "straight" subjects ("we are marching on your citadels of repression"). Shelley locates gayness not so much in any specifically homosexual practice but in a larger liberation of psychic and social life, one that gives defiantly corporeal form to the repressed materials and forbidden fantasies of "straight" culture. For gay liberationists of the early 1970s, the term "gay" functioned as a call for political action and social transformation. In his 1971 manifesto "Out of the Closets," Allen Young wrote that "gay, in its most far-reaching sense, means not homosexual, but sexually free. . . . This sexual freedom is not some kind of groovy life style with lots of sex, doing what feels good irrespective of others. It is sexual freedom premised upon the notion of pleasure through equality."[8]

Manifestoes such as "Out of the Closets" and "Gay Is Good" situate gay liberation as a process in flux, a coming to consciousness rather than a stable identity

Figure 4.2.
Gay Is Good, c. 1969.
Button. Courtesy
Gay, Lesbian,
Bisexual, Transgender Historical Society of Northern
California,
San Francisco.

to be achieved or attained. A similar vision of gayness as metamorphosis animates a 1969 subscription advertisement for *Gay Power* (figure 4.3). The ad features a creature who, while endowed with male genitals, also sports full hips, long hair, giant fuschia wings, and a green Day-Glo body. The image enacts a play of light and color such that the winged figure seems to slide back and forth between two and three dimensions, between a posterlike flatness and a slight perspectival depth. The black silhouettes of the face, arms, and legs perform a kind of double duty—suggesting both shadows cast upon the figure's fluorescent body and flattened shapes that rhyme with, and then merge into, its grandiose wings. The wings incorporate both floral and weblike patterns and shift between phallic and vaginal forms. The creature moves, then, between various registers of color, form, and figuration and courts associations at once masculine, feminine, and mythic. In so doing, the figure signals the utopian ambitions of gay power to transcend the categorical divides of sexual and racial definition.

In addition to psychedelic colors and mythic figuration, the gay liberation movement often employed frontal nudity—usually but not exclusively male—to suggest the emancipatory pleasures of sexual freedom. The back cover of the December 1969 issue of the *San Francisco Free Press*, for example, features a naked man, posing near the edge of a cliff with an expanse of ocean and a single, distant beacon in the background (figure 4.4).[9] In his left hand, the man holds a modest plywood-and-cardboard sign stenciled with the words "Gay Liberation Front." The man's right hand, held above his head, forms the peace sign. The man might almost be said to be planting a flag for gay liberation, to be staking a claim, however temporary or tongue-in-cheek, to this spot at land's end as an alternative to the normalizing topographies of everyday life. The man's naked address to the camera signals not seduction or sexual come-on so much as a sense of contentment in casting off the constraints and "hang-ups" of the dominant culture.

There is another and related way that we might interpret this man's appearance before the camera—namely, as a form of "coming out." At the core of the gay liberation movement was the call for gay men and women to come out of their closets of secrecy and denial, to proclaim their sexuality to family, friends, colleagues, and the larger public world. "The key phrase," Jill Johnston proclaimed in a 1970 *Village Voice*, "is COME OUT. Come out of hiding. Identify yourself. Make it clear. Celebrate your sexuality."[10] Coming out was framed by the gay liberation movement not simply as a private act of self-disclosure but as a public demand for visibility. New forms of communal activity such as gay pride parades, "gay-ins" (mass gatherings in city parks or other highly visible venues), and "zaps" (public confrontations with antigay politicians, magazine editors, and public officials) asserted the newly confident presence of gay men and women within the public sphere. The naked man on the back cover of the *San Francisco Free Press*, with his frontal stance, casual nudity, and apparent comfort before the camera, embodies the pleasures "coming out" was meant to provide—the pleasures of personal freedom, self-acceptance, and spiritual as well as sexual satisfaction.

A 1970 poster created in tandem with the first anniversary of Stonewall enacts the process of coming out as a joyously public and collective project (figure 4.5). The poster's demand for gay visibility is made both textually—"Come Out!! Join the Sisters & Brothers of the Gay Liberation Front"—and visually,

Figure 4.3. "Gay Power: Subscribe," from *Gay Power* 1, no. 2 (1969). Courtesy Gay, Lesbian, Bisexual, Transgender Historical Society of Northern California, San Francisco.

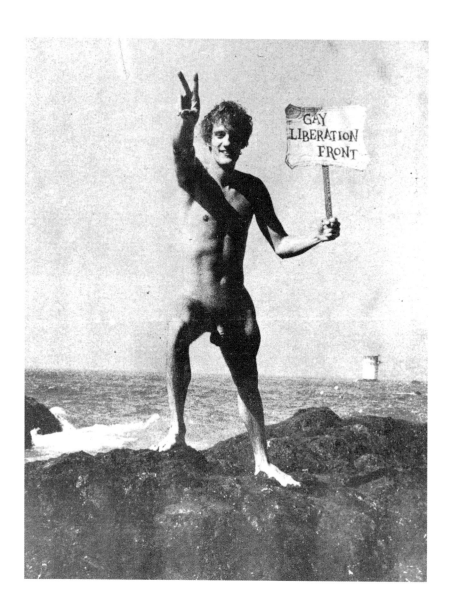

through the image of some seventeen men and women running down an other-
wise empty city street. The poster presents the members of the Gay Liberation
Front (GLF) in a loosely horizontal arrangement—a front, if you will. Yet the
contours of this collective seem marvelously unstable, both because the group is
variously one, two, or three bodies deep and because it overflows the left and
right edges of the frame, as though it cannot quite be contained by the image.
The poster offers the "sisters and brothers" of the GLF as an "army of lovers"
whose insurgent force reverberates throughout the city's streets. The poster
functions as the visual equivalent to one of the most popular of gay liberationist
slogans: "Out of the Closets and Into the Streets." With their jeans and patterned
shirts, their long hair and raised fists, the GLF members enact their defiant iden-
tification as "gay"—as sexually and socially free—rather than simply as homo-

sexual. The poster was shot by Peter Hujar, a photographer who was the boyfriend of GLF member Jim Fouratt at the time. (Fouratt is the figure, second from the right in the front row, with upraised fist, sunglasses, and striped pants.)

The poster *Come Out!!* marks a key difference between the ambitions of the GLF and those of earlier homosexual activist groups. Prior to Stonewall, activist groups such as the Mattachine Society and the Daughters of Bilitis typically presented homosexuality as dignified, nonthreatening, and assimilable to the mainstream. These groups self-identified as "homophile," a term created to desexualize (and therefore render less troubling) homosexuality in the eyes of the dominant culture. The names of these organizations drew on literary or mythological references (e.g., Mattachine, Bilitis) so as similarly to camouflage the sexual nature of homosexuality.[11] Homophile groups of the 1950s and 1960s stressed responsible citizenship while seeking social and legal reforms that would improve the lives of homosexual people. Gay liberationists of the early 1970s, by contrast, sought a full-tilt social and sexual revolution.

Some measure of this difference may be calibrated by comparing *Come Out!!* to a 1965 Associated Press photograph of a homophile picket at the White House (figure 4.6). The homophile group demonstrates at a site of official power so as to signal its respectful disagreement with federal policies such as the dishonorable discharge of homosexuals from the military. The picketers march in geometric formation, almost in lockstep, while remaining within the space allotted by the White House for such events—on the sidewalk, outside the gates. All of the demonstrators are garbed in "gender-appropriate" clothing—the men in jackets, white shirts, and ties, the women in dresses or skirts, cut just beneath the knee.[12] In the left foreground, a police officer with his back to the camera and his hands planted on his waist monitors the picket. To the right, the marchers are framed by the metal gates of the White House lawn. The business attire and orderly formation of the picketers further reinforce this sense of constraint, of staying within the bounds (both spatial and symbolic) of propriety. The White House picket, the model of a dignified, well-organized demonstration, could not seem more distant from the haphazard arrangement, unpredictable gestures, and casual androgyny of the figures in *Come Out!!*.[13] Where the liberationists in *Come Out!!* take to the streets so as to be photographed by a friend and fellow traveller, the homophile picketers present themselves to be seen—and photographed—by others: by the press, the public, and the federal government. The *Come Out!!* poster casts off the constraints to which the homophile picketers submit. In the 1970 photograph, there are no gates, no police officers, no respectable attire, no orderly marching, and no White House lawn. The poster stages gay liberation as a utopian space beyond the reaches of State power and social control.

The opposition between the 1965 photograph and the 1970 poster is not as stark or straightforward as it first appears. The members of the White House picket were brave nonconformists who enacted an image of middle-class propriety for the purposes of official protest. According to historian Martin Duberman, the picketers had decided, after extensive debate within the group, that they should look as respectable as possible at the White House, even if that meant borrowing a tie or buying a dress. "It was important to look ordinary," the march's lead organizer argued, "to get bystanders to hear the message rather

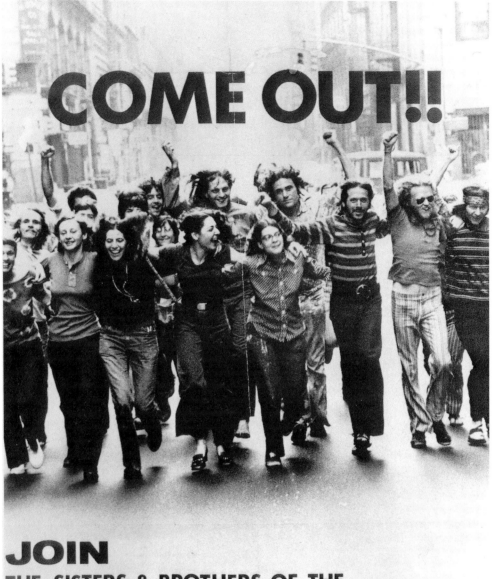

Figure 4.5. *Come Out*, 1970. Gay Liberation Front poster, photo by Peter Hujar. Courtesy Stephen Koch, the Estate of Peter Hujar.

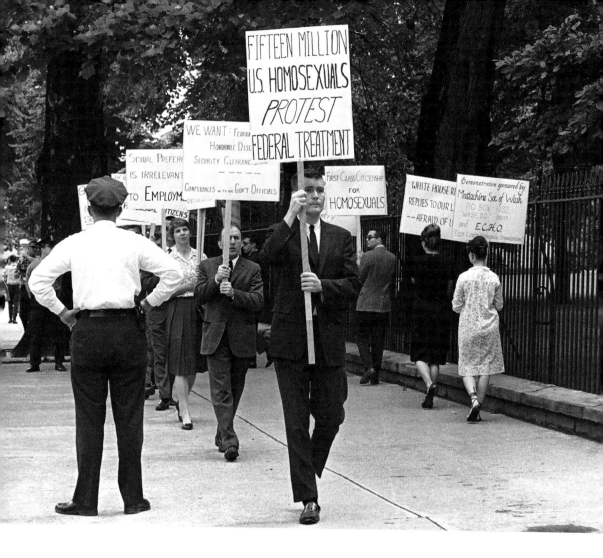

The signs visible in the photograph read:

FIFTEEN MILLION U.S. HOMOSEXUALS PROTEST FEDERAL TREATMENT

WE WANT: FEDERAL Honorable Disc. Security Clearance. — — — — CONFERENCES with our Gov't Officials

SEXUAL PREFERENCE IS IRRELEVANT to EMPLOYMENT... CITIZENS

FIRST-CLASS CITIZENSHIP FOR HOMOSEXUALS

WHITE HOUSE R... REPLIES TO OUR L... --AFRAID OF U...

Demonstration sponsored by Mattachine Soc. of Wash. P.O. BOX 1032 WASH. D.C. 20013 and E.C.H.O. East Coast Homophile Organizations

than be prematurely turned off by appearances."[14] The homophile picketers stage-managed the image of their own acceptability.

If the reassuringly ordinary appearance of the protesters at the White House picket was prepared for cameras and bystanders, so too was the sense of egalitarian community and irrepressible action conveyed by *Come Out!!*. The New York chapter of GLF had put out a call to its entire membership (which included over two-hundred people at the time) to participate in the photo shoot for *Come Out!!*, but only about fifteen people showed up.[15] The poster cleverly masks the disappointingly small number of activists willing to be photographed by densely packing the middle expanse of the visual field and by catching the figures in the midst of seemingly spontaneous motion. The rhetoric of the image thus belies the reality of the terms of the photo shoot. A similar paradox marks *Come Out!!*'s representation of gender parity. Whereas the poster presents a collective in which "sisters and brothers" seem to participate equally, the GLF was, in fact, dominated by men, in terms of both leadership positions and overall membership.[16] The poster disguises the gender inequities that structured the GLF at the

Figure 4.6. "Picketing for gay rights in front of the White House, May 21, 1965." © UPI/Bettman Newsphoto/ Corbis.

time, inequities that would later lead to the departure of a core group of lesbian activists from the organization.

Both the *Come Out!!* poster and the photograph of the White House picket must be understood as highly mediated images of homosexual visibility rather than as snapshots of historical truth. Both pictures reflect the public strategies, rather than the internal realities or ideological contradictions, of the groups they portray. Comparing the *Come Out!!* poster to the photograph of the White House picket reveals some of the differences between homophile and gay liberationist approaches to public visibility in 1965 and 1970, respectively. The homophile movement acknowledged the power of the State and the restrictions it imposed, while gay liberation projected a radical escape from those restrictions. Homophile groups offered themselves as law-abiding citizens, as the dutiful sons and daughters of America, while liberationists figured themselves as social and sexual revolutionaries, as "sisters and brothers" who would no longer submit to the rules of the parent culture.[17] It would be a mistake, however, to generalize this contrast into a historical model of progression in which pre-Stonewall assimilation gives way to post-Stonewall radicality. Homophile activism did not simply disappear with the advent of gay liberation in 1969. Rather, homophile strategies coexisted, if sometimes tensely, with the newer formulations of sexual freedom and revolutionary change proposed by the gay liberation movement.

In her 1990 book *Epistemology of the Closet*, Eve Kosofsky Sedgwick argues against historical narratives of homosexuality in which "one model of same-sex relations is superseded by another . . . [and] the superseded model then drops out of the frame of analysis."[18] Instead, she urges a consideration of "the relations enabled by the unrationalized coexistence of different models during the times where they do exist."[19] Sedgwick's argument helps to describe the complexity of gay culture and politics immediately after Stonewall, especially in terms of the "unrationalized coexistence" of homophile and liberationist activism at the time. With the concept of "unrationalized coexistence" in mind, I return now to Mapplethorpe's *Bull's Eye* so as to argue that it mingles the different models of homosexual visibility which were on offer in 1970.

Bull's Eye

Bull's Eye (figure 4.7) appropriates the pornographic image of a naked man wearing knee-high rubber boots and sets it within a larger field of cutout circles, bars, and rectangles. Two screens of paper mesh have been placed, like sliding doors, on either side of the figure, while a black bar obscures the man's eyes, as though shielding his identity from the viewer, and a square of yellow spray paint covers his midsection. A red circle bounded by a larger white ring, the bull's-eye of the work's title, overlays the figure's genitals.[20] Like the homophile picket of the White House in 1965, *Bull's Eye* is marked by the external codes and constraints of the law. Like the *Come Out!!* poster of 1970, *Bull's Eye* insists on homosexuality as a form of radical difference. Mapplethorpe presents the naked male body as both a target of prohibition and a source of pleasure, as both an object of censorship and a defiance of it.

Figure 4.7. Robert Mapplethorpe, *Bull's Eye*, 1970. Collage. ©The Estate of Robert Mapplethorpe.

In mimicking the disciplinary power of the State, *Bull's Eye* cites the legal constraints that governed the commercial display of the male body in the pre-Stonewall era. Prior to 1966, the publication of photographs featuring frontal male nudity was prohibited in the United States.[21] Notwithstanding this prohibition, an elaborate network of physique magazines developed in the decades following the Second World War. Many of these magazines catered to a homosexual readership. Throughout the 1950s and early to mid-1960s, publications such as *Physique Pictorial*, *Art and Physique*, and *Grecian Guild Pictorial* employed the alibis of art, health, and classicism to picture erotically exposed male bodies while avoiding prosecution on charges of obscenity.[22] The pages of these magazines were populated by male models and bodybuilders naked save for a posing strap, a decorative codpiece (figure 4.8), or a strategically placed prop such as a plumed sword handle, a beach ball, a towel, or, in the case of one Wayne Hunt of Glendale, California, a maritime clock (figure 4.9). A smaller set of imported magazines such as *International Nudist Sun* called upon discourses of nudism and "naturism" to present pictures of naked men posing on sand dunes and grassy knolls (figure 4.10).

Figure 4.8.
Back cover of
Physique Pictorial,
January 1960.
Courtesy Gay,
Lesbian, Bisexual,
Transgender
Historical Society of
Northern California,
San Francisco.

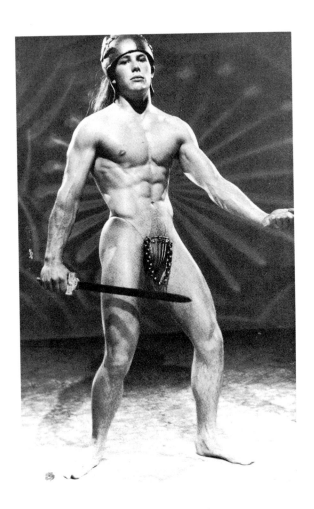

The covering of the genitals, an external imposition on homoerotic desire, was sometimes recoded by physique photographers as an act of irreverent display. In a 1965 photograph of a model named Bob Zimmerman published in *MANual* (figure 4.11), the obstructing bar has become a signboard that declares the possibility of a private session in which Zimmerman will remove the sign altogether. Rather than enforcing a strict sense of prohibition, the signboard welcomes, even solicits, a fantasy of full frontal exposure. A rather more flamboyant form of excess marks a 1958 photograph from *Art and Physique* magazine in which the model, Ron O'Brien, sports a bejeweled codpiece out of which flows an expanse of silken fabric (figure 4.12). As if to compensate for its concealment of O'Brien's penis, the photograph overproduces the means of that concealment, remaking the posing jock into an extravagant object of decorative appeal. Like the sword he holds aloft, O'Brien's codpiece redoubles and hilariously exaggerates his phallic endowment. The ornamental posing strap serves both to cover and to showcase the nearly naked male body. Decorative flourishes extend as well to the background wall of the photograph, upon which dozens of paper daisies have been hung. Even as they embellish the display of O'Brien's body, the daisies also distract us from it, not least because they seem to be "pop-

Figure 4.9. "Wayne Hunt," *Physique Pictorial*, January 1960. Courtesy Gay, Lesbian, Bisexual, Transgender Historical Society of Northern California, San Francisco.

WAYNE HUNT 23, 5'11 160 lbs waist 29 biceps 15, of Glendale California, is an actor. We made a movie once with Wayne and another fellow (Danny Peppler), and the film was to be entitled "Danny and the Muscle Merman". However Eastman Kodak claimed that two reels were lost and since these were just dropped in their receiving slot without getting a receipt, there was nothing we could do about it. But if enough people ask, we might release the incomplete film. For a number of reasons it would be impractical to attempt to finish the film again.
This is AMG photo XN-1-8V. If you are trying to figure out a meaning for it, don't bother. We just happened to have a ship's clock and Wayne stuck it in front of him for the sake of symmetry. If you can figure out some Freudian meaning, please let us know. Incidentally, there are 15 catalog pages of Wayne Hunt at $1.50. Includes many excellent duals.

Figure 4.10. TOP
Advertisement for *Inter-national Nudist Sun*, as
published in the March
1965 edition of *The Big
Boys*, a bimonthly
physique magazine pub-
lished by the Guild Press.
Author's collection.

Figure 4.11. BOTTOM
"Bob Zimmerman,"
MANual, December
1965. Courtesy Gay,
Lesbian, Bisexual,
Transgender Historical
Society of Northern
California, San Francisco.

Figure 4.12. "Ron O"Brien," *Art and Physique*, 1956. Courtesy Gay, Lesbian, Bisexual, Transgender Historical Society of Northern California, San Francisco.

ping up" all over the place. It is as though the flowers covering the background wall are meant to compensate for the one object (the "flower" of O'Brien's manhood) that cannot be shown.

Like the beefcake shots in *MANual* and *Art and Physique*, Mapplethorpe's *Bull's Eye* imbues constraint with compensatory pleasures and decorative appeal. The square covering the figure's midsection, for example, is a brilliant shade of translucent yellow that focuses our attention on the covered genitals even as it reiterates a sense of blockage and pictorial overlay. The white circle marking the bull's-eye is an adhesive sticker, one probably fabricated for use as a reinforcement for the binder holes in notebook paper. Mapplethorpe's precise placement of that sticker marks not only a concealment of but also a careful attention to the male figure's genitals.

Like the beefcake photographs in *MANual* and *Art and Physique*, *Bull's Eye* both obstructs and insists upon the sexual display of the male body. But in contrast to pre-Stonewall physique magazines, Mapplethorpe's collage blocks out not only the genitals but also the eyes of its male figure. In so doing, *Bull's Eye* recalls police photographs in which the face of the criminal would be banded out to protect his or her identity from the public. A photograph from a 1964 pamphlet entitled "Homosexuality and Citizenship in Florida: A Report of the Florida Legislative Investigation Committee" features one such image (figure 4.13). It portrays a man in the midst of patronizing a "glory hole" (a hole drilled through the partition between toilet stalls so as to enable sexual contact between the men on either side). According to its accompanying caption, "This photograph was taken by a Florida law enforcement agency of a homosexual act being performed in a public rest room. Such occurrences take place every day in virtually every city in every state. It is significant that the removal of the toilet stall doors to facilitate photography did not deter these and numerous other practicing homosexuals."[23] The caption highlights the problem of "homosexual acts" in public restrooms in two ways—first, by insisting that the phenomenon is so widespread that it can scarcely be contained ("such occurrences take place every day in virtually every city in every state"), and second, by suggesting that not even the threat of public exposure will discourage the practitioners of such activities.[24] Notice, however, that the toilet stall door has been removed "to facilitate photography," which is to say, to facilitate the photography of men having sex at this glory hole. Were the removal of the door to have deterred the practice of such sexual activity altogether, there would have been nothing for the police to photograph, no picture for the Florida Legislative Investigation Committee to publish. Like the police camera itself, the removal of the toilet stall door anticipates—and helps to produce—the visible image of illicit homosexuality.[25]

Following its statewide distribution by the Florida Legislative Investigation Committee in 1964, "Homosexuality and Citizenship in Florida" was reprinted in 1965 by the Guild Press, a publisher of male physique magazines such as *Grecian Guild Pictorial* as well as gay pulp novels and other homoerotic materials.[26] By way of publicizing "Homosexuality and Citizenship in Florida," the Guild Press printed an advertisement that promised customers "an action photograph of a rest room 'glory hole' scene that is unbelievable," a photograph that, the ad continued, is "the only scene such as this that we have ever seen in print any-

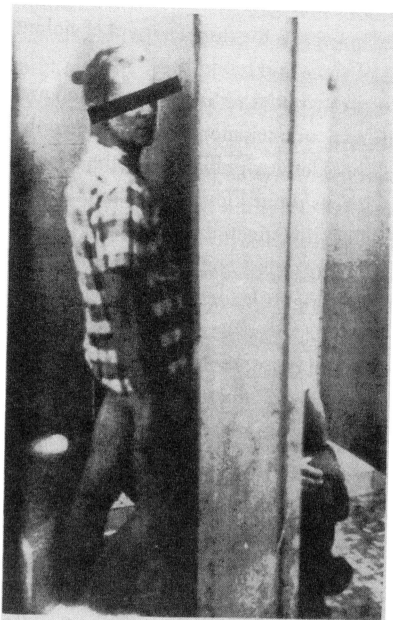

This photograph was taken by a Florida law enforcement agency of a homosexual act being performed in a public rest room. Such occurrences take place every day in virtually every city in every state. It is significant that the removal of the toilet stall doors to facilitate photography did not deter these and numerous other practicing homosexuals.

Figure 4.13. "A Homosexual Act Being Performed in a Public Restroom," *Homosexuality and Citizenship* brochure (Florida Legislative Investigation Committee, 1964). Reprinted by Guild Press, Washington, D.C., 1965. Courtesy Gay, Lesbian, Bisexual, Transgender Historical Society of Northern California, San Francisco.

where."[27] The republication of "Homosexuality and Citizenship in Florida" (or, as the Guild Press advertisement put it, "Florida's Purple Report!") proved a popular item among the Guild's clientele. According to historian Thomas Waugh, the Guild Press took its "facsimile of the noncopyrighted booklet and marketed it broadly to their gay mail-order customers across North America. The glory hole photo became famous. . . . The erotic image [was] too volatile to be constrained from its potential for pleasure and empowerment by the literal and dominating lens of the Law."[28] Rather than opposing the "pleasure and empowerment" of the glory hole photograph to the "dominating lens of the Law," we might consider how that lens helps, however unwittingly, to construct the photograph's appeal for homosexual viewers. Within the context of the Guild Press reprint, the markings of surveillance and discipline imbue the glory-hole image with unintended pleasures. The barring (both literal and figurative) of homosexuality by the Florida State Legislative Committee becomes a means of counteridentification for a gay audience. While the booklet intends to position homosexuality as criminally deviant, the Guild Press invites its customers to recode this "most amazing book" for their own purposes.[29]

Like the Guild Press's reprint of "Homosexuality and Citizenship in Florida," Mapplethorpe's *Bull's Eye* underscores the ways in which the act of prohibition calls forth the images it outlaws. In setting the figure of naked man behind bars, Mapplethorpe mimics the punitive authority of the police. Yet the artist also reimagines that authority by making imprisonment a function of pasted papers and stick-on circles, of yellow spray paint and black plastic netting. In *Bull's Eye*, the male figure's knee-high black rubber boots, especially as set against his otherwise naked body, imply a taste for fetishistic pleasure. The figure's mock imprisonment by Mapplethorpe might be said to extend, rather than contradict, this kinkiness. *Bull's Eye* suggests that disciplinary power itself carries an erotic charge and that the criminalization of homosexuality may thus reveal as much about the jailers as about the inmates. *Bull's Eye* insists that the censorship of homoerotic images, far from an effective act of erasure, produces other effects and images, other pleasures and targets of desire. "Where there is power," Michel Foucault writes in the first volume of *The History of Sexuality*, "there is resistance, and yet, or rather consequently, this resistance is never in a position of exteriority in relation to power."[30] *Bull's Eye* gives visual form to the inextricability of power and resistance, of homoerotic pleasure and its prohibition.

In reflecting on his early work in a 1981 interview, Mapplethorpe would connect his collages both to the image of the outlaw and to the erotic appeal of pre-Stonewall pornography. When asked about the black rectangles covering the eyes of the men in several of his early works, Mapplethorpe affirmed that

> I've always liked that, it's like pictures of gangsters with their eyes blocked out. A friend once gave me a show in his apartment in the Chelsea Hotel [in 1971]. The announcement was a pack of male pornographic cards and each one had their eyes blocked out. The first time I went to 42nd Street and saw those pictures in cellophane, I was straight and didn't even know that those male magazines existed. I was sixteen and not even old enough to buy them. I'd look in the window at those pictures and I'd get a feeling in my

stomach. I was in art school then and I thought, God, if you could get that feeling across in a piece of art . . . It was exciting but definitely forbidden. Because they were always in cellophane you couldn't get at them. Putting things over the pictures came partly from that, it veiled things a little bit and made them more unreachable. But I remember wanting to get that feeling across, which of course you can't, in the context of an art gallery.[31]

It is hardly surprising that a sense of the "unreachable" should have augmented Mapplethorpe's teen-age fascination with pornography. What is surprising, however, is the artist's commitment to "wanting to get that feeling across" in his own work. In the early 1970s, Mapplethorpe situated pornography at the center of his artistic output. In doing so, he attempted to picture not just the sexual immediacy of pornographic images but also their "cellophane" inaccessibility, not just the visual pleasure of eroticized male bodies but also their "unreachability." Mapplethorpe's "42nd Street" anecdote rehearses the dialectic between pleasure and prohibition, between desire and constraint, expressed in the artist's early collages. The anecdote also returns Mapplethorpe to the moment of his first encounter with homoerotic porn magazines—"I was sixteen and not even old enough to buy them." Mapplethorpe would have been sixteen years old in 1962–63. In his porn collages of the early 1970s, he revisits a teenage experience of forbidden desire by reviving the homoerotic imagery (complete with the markings of censorship and blocked access) that provoked that desire almost a decade before.

Even when he did not block out portions of the male body, Mapplethorpe staged the historical suppression and taboo appeal of homoerotic images, especially those published prior to Stonewall. In his 1972 photo-transfer collage *Untitled (Grecian Guild)*, for example, Mapplethorpe warps and elongates the May 1964 cover of *Grecian Guild Pictorial*. He then affixes the cover to a canvas backing and sets it within a wooden frame (figure 4.14).[32] The physique magazine *Grecian Guild Pictorial*, published by the Guild Press from 1956–1968, called upon the alibi of Greek classicism in order to proffer images of nearly nude young men. The covers and pictorial layouts of the magazine, especially those from the 1950s, often thematized classicism quite explicitly (figure 4.15). In the official "Creed of the Grecian Guild" printed in every issue, the magazine's readership was further associated with the ideals of "Grecian civilization":

> The Grecian Guild is a brotherhood of bodybuilders, artists, physique students, and others dedicated to the radiant health of body, mind and spirit which frees man from the vulgar and base and inspires him to noble ideals and endeavors. It is pledged to the perfection of the body as the divinely created temple of the mind and spirit; to the appreciation of all beauty and worthy art; to the accomplishment of the best of which each man is capable; to the love of God, truth, honor, purity, friendship, and native land.
>
> The Guild is universal in its precepts, embracing the best in all nations and cultures, but in its name it honors the high ideals and glorious achievement which characterized Grecian civilization during its Golden Age and which have since enriched the lives of all nations.[33]

Figure 4.14. Robert Mapplethorpe, *Untitled (Grecian Guild)*, 1970. Collage.
©The Estate of Robert Mapplethorpe.

GRECIAN GUILD
PICTORIAL anc

SUMMER, 1956
50c

ART and BODYBUILDING

This creed cannot be taken to reflect the self-understanding of the men who sub-scribed to *Grecian Guild Pictorial*. It can, however, be understood in terms of the justifications and rhetorical framings required of magazines marketed to homo-sexual men in the 1950s and early 1960s.

In this context, Mapplethorpe's warping and distortion of the *Grecian Guild* cover might be said to figure the gap between the homoerotic images the maga-zine published and the official justifications for those images (e.g., love of God and nation, art appreciation, physical and spiritual self-improvement) that it printed in each issue. The process of photo-transfer allowed Mapplethorpe to "lift" the image of a pensive, shirtless boy from the cover of the magazine, warp and elongate it, and then add daubs of paint to its edges. Unlike the original cover image from the 1964 issue, Mapplethorpe's warped version undoes the geometric regularity of the rectangular format. As if to reinforce this newfound irregularity, Mapplethorpe sets the cover within a wooden frame whose edges the cover cannot reach. The mismatch between warped cover and oversized frame in *Untitled (Grecian Guild)* suggests that homoerotic desire can never be made to fit seamlessly into prefabricated frames of cultural acceptability such as classicism, brotherhood, bodybuilding, or artistic study.

Figure 4.15.
*Grecian Guild
Pictorial*, Summer
1956. Courtesy Gay,
Lesbian, Bisexual,
Transgender Histori-
cal Society of North-
ern California,
San Francisco.

The male body in Mapplethorpe's early work is an object not only of homo-erotic display but also of decorative appeal, an image to be cut and pasted and collected, to be set against velveteen fabrics and marbleized papers. In 1970's *Leatherman I* (figure 4.16), for example, Mapplethorpe lays a field of tightly woven black mesh over a sheet of red paper that bears the image of a seminaked leatherman. The red paper has, in turn, been pasted onto an expanse of sky blue wallpaper embossed with white velvet flocking. A single silver star punctuates the upper-right-hand section of the black mesh field. The leatherman, seated on a stool, wears only a biker's cap, leather gloves, and a motorcycle jacket. He holds a large bullwhip, which wraps, snakelike, around his exposed right thigh and knee. A rectangular sliver of silver tape, rather difficult to discern in repro-duction, has been placed over the figure's eyes. The leatherman's gaze is thus subject to a double barring—first by the silver tape and then by the field of black mesh that overlays it.

Leatherman I combines the markings of censorship with those of sado-masochism. And it sets that combination against a backdrop of Victorian wallpa-per with velvet patterning. The collage draws a parallel between sexualized dis-cipline (the leatherman's whip, biker's cap, and jacket) and the "discipline" to which the image of the leatherman is itself subject (the barring and overlay of the figure's body). Already in 1970, then, Mapplethorpe was drawing together the historical legacy of censorship, the props and practices of gay s/m, and the pleas-ures of decoration.

In collages such as *Bull's Eye* and *Leatherman I*, Mapplethorpe drew upon the post-Stonewall confidence of homosexual visibility and the radical politics of gay liberation. Yet where gay liberation offered utopian visions of sexual freedom that sought to transcend the constraints of mainstream culture, Mapplethorpe incorporated the markings of constraint and prohibition into his work. By mak-ing such constraints visible—by blocking out, tearing, and otherwise distressing pornographic images of the male body—he simultaneously exaggerated and eroticized the labors of censorship.

The productive role that censorship plays in relation to homoerotic desire is explored in Mapplethorpe's *Untitled* collage from 1972, which employs silver spray paint to veil a pornographic photograph of a male couple (figure 4.17). The spray paint covers nearly the entire image; only a small rectangle near the top of the page is spared. Rather than restricting our view, as a solid black bar would, the unpainted rectangle provides an access route or window opening onto the surprisingly delicate kiss of the two young men.[34] The collage scram-bles the effect of the censorship it enacts, showcasing the kiss while diverting attention from, and then gradually drawing it back to, the genital display of the right-hand figure. Notice, for example, how the upended rectangle nearly aligns with the exposed penis in the picture's foreground so as to create a strong verti-cal dialogue, a kind of call and response, between the kiss in the upper section of the collage and the penis below.

While Mapplethorpe figured the effects of censorship and constraint in his early work, that work was itself severely constrained in terms of its public visi-bility. Apart from their display in a "friend's hotel room" at the Chelsea Hotel and the reproduction of *Bull's Eye* on the cover of *Gay Power*, Mapplethorpe's porn

collages were never exhibited during the early 1970s, though not for lack of try-
ing on the artist's part.[35] According to Mapplethorpe's biographer, Patricia
Morrisroe, the artist was repeatedly rebuffed by dealers whom he approached
about exhibiting the collages: "Mapplethorpe complained that dealers were
loath to exhibit his work because of its homosexual content, and that several pri-
vately advised him that if he wanted to become successful, he had to soften the
gay themes."[36] Edmund White has similarly traced the rejection of Mapple-
thorpe's early work to the anxiety its subject matter provoked among potential
exhibitors:

> Dealers in the early 1970s might have been enthusiastic about Robert's
> explicitly homosexual art, but they all shrugged and said they couldn't sell
> it. Patti Smith [the rock musician, who was Mapplethorpe's best friend and
> roommate at the time] would show his work to gay dealers who'd reject
> it; as she recalled, "Several of them told me, 'I think the work is really
> interesting, but how can I exhibit it without making a statement about
> who I am?' Robert was really hurt by that."[37]

Figure 4.16.
Robert Mapple-
thorpe, *Leather-
man I,* 1970.
Collage. ©The
Estate of Robert
Mapplethorpe.

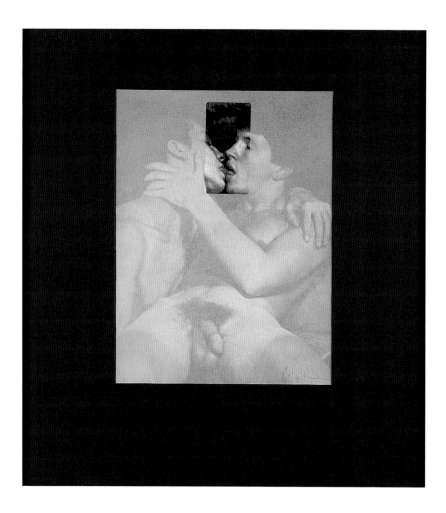

According to this account, would-be dealers of Mapplethorpe's early work wor-
ried about what it might reveal about *them*, as if collages such as *Bull's Eye* and
Leatherman I would expose not just their creator but also his professional spon-
sors as homosexual.[38] Here, the gay dealer's anxiety about "making a statement
about who I am" determines the rejection of Mapplethorpe's work, a rejection
that extends and enforces the restriction of homoeroticism depicted in that
work. The blockage of vision thematized in works such as *Bull's Eye* and *Leather-
man I* anticipates the refusal of art dealers to be seen or identified as homosexual.
And this refusal, in turn, contributed to Mapplethorpe's relative invisibility
within the New York art world of the early 1970s.[39]

Frustrated by the commercial rejection of his art, Mapplethorpe abandoned
the practice of collage in 1972. From that point forward, he shot photographs—
initially Polaroids and then, beginning in 1973, black-and-white prints.[40] It was
as a photographer, of course, that Mapplethorpe achieved professional promi-
nence and financial (if not always critical) success in the late 1970s and 1980s.
Far from "softening the gay themes" of his work, however, Mapplethorpe contin-
ued to focus on the sexualized male body throughout his photographic career. In

the late 1970s, he trained that focus on gay sadomasochism, an interest already manifest in such early works as *Leatherman I*. Like his porn collages, Mapplethorpe's photographs of s/m enact an erotics of constraint. But where the collages obstruct access to certain parts of the male body (e.g., the eyes, the genitals) so as to suggest a prior prohibition or censorship, the s/m pictures showcase the costuming and props of sexualized discipline. In what follows, I discuss Mapplethorpe's s/m project in relation both to the external acts of censorship to which it was subjected and to the internal logic of the pictures themselves, a logic which, like that of the porn collages, understands constraint as a source of pleasure.

Framing Sadomasochism

Mapplethorpe shot photographs of gay sadomasochism in New York and San Francisco in the years between 1977 and 1980, a period in which the leather and s/m scenes became increasingly visible within the gay subcultures of both cities.[41] Rather than entering the various sites of the s/m scene (e.g., the leather bar, the sex club, the private dungeon) with camera in hand, Mapplethorpe typically invited s/m participants into his studio, where he would have them pose with their preferred props and paraphernalia.

From the outset of the s/m project, which he often referred to simply as the "sex pictures," Mapplethorpe framed s/m as but one photographic theme (or specialty) among others. Mapplethorpe's first public exhibition of the s/m photographs, a 1977 show in New York City entitled *Pictures*, provides a case in point.[42] The show was split between two different venues, each of which focused on a different genre of Mapplethorpe's work: the Kitchen, a not-for-profit art space, showed a selection of the s/m pictures, while the Holly Solomon Gallery, a commercial art space, displayed the photographer's society portraits. The clever gallery announcement for the exhibition, designed by Mapplethorpe himself, marked this thematic division in visual terms. The announcement presents two views of a man's hand holding a pen and writing the word "Pictures." The hand on the left wears a leather glove and a studded metal bracelet; the one on the right, a Cartier watch and a striped oxford shirt (figure 4.18). The implication is that the same man alternates between these two "hands," between his roles as businessman (by day) and leatherman (by night). Mapplethorpe stages the difference between dominant culture and leather subculture as merely a stylistic one, a simple exchange of one costume for another.

A visual process of "contrast and compare" structured not only the *Pictures* announcement but also the exhibition itself, at least to judge from the handful of reviews the two-part show received. Here, for example, is how Bob Colacello described the show in the February 1977 issue of *Interview* magazine:

> At first glance, the contrast between the simultaneous shows, between the Archbishop of Canterbury taking tea in a proper English garden and a wild boy of the West Side sneering naked in a leathery loft, is overwhelming. But there are clues that suggest a single, and singular, sensibility is at work here, not the least being the fact that all the pictures in both shows are matted

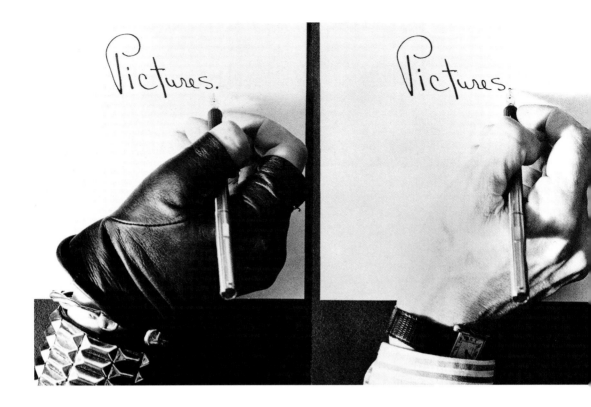

Figure 4.18.
"Pictures," 1977.
Gallery announce-
ment, photographs
and design by
Robert Maple-
thorpe. The
Kitchen / The Holly
Solomon Gallery,
New York. ©The
Estate of Robert
Mapplethorpe.

with silk, elegant pastel silk, white on white silk, black on black silk. They
are all, finally, princesses and penises, very precious objects carefully
composed, meticulously printed, beautifully framed.[43]

For Colacello, the formal elegance of Mapplethorpe's work resolves the other-
wise "overwhelming" contrast of its various subjects. Regardless of their nomi-
nal subject—archbishop or leatherboy, princess or penis—Mapplethorpe's
photographs each manifest the same deluxe materiality. The review's descriptive
listing—"matted with silk, elegant pastel silk, white on white silk, black on
black silk"—mimics Mapplethorpe's attempt to fashion his photographs as
"unique objects" complete with specially selected mats and custom-designed
frames.[44]

The use of such materials was part of an effort on Mapplethorpe's part to
invest his photographic prints with the aesthetic cachet and market value of
"high art." Mapplethorpe's desire to appeal to art collectors, rather than simply
to photography collectors, was a topic about which he could be quite blunt: "You
really have to work at selling photographs to art collectors and that is what I
want to do: to sell to people who collect art, instead of just to people who are in
love with photography only. I want people to see my work first as art, and second
as photography. I guess even part of why I do this framing is that I want it be seen

first as an image, then as a photograph."[45] Because Mapplethorpe wanted viewers, and especially potential collectors, to see his photographs as works of fine art, he stressed the material crafting of his pictures into singular objects. As early as 1977, Mapplethorpe was contriving techniques (e.g., mirrored frames, multiple mats) so as to belie the inherent reproducibility of his photographic prints and thereby position them "first as art." But how did Mapplethorpe's emphasis on what he called "extravagant presentation" inflect the subject matter of his photographs, particularly in the case of the s/m pictures? David Bourdon's April 1977 review of the *Pictures* exhibit in *Arts* magazine focused on just this question:

> The photographs had eye-catching mattes of various colored silks, which resembled a proscenium arch, since they covered only the tops and sides of the prints. At first glance, the frames and mattes seemed obtrusive; with familiarity, they came to look no more kinky than the leather and metal costumes worn by the people in the photographs. The frames are, in a sense, another level of costuming. (All the works displayed were unique art objects in which the frame is an integral part. Mapplethorpe also will print the same images in a limited, unframed edition of five.)[46]

For Bourdon, the highly prepared nature of Mapplethorpe's sex pictures, their aesthetic "costuming," echoes the kinky stagecraft of the s/m scenes they depict. Building on Bourdon's insight, I will pursue the parallel between studio photography and gay sadomasochism in Mapplethorpe's work. To do so, I will briefly describe s/m on its own terms before turning back to Mapplethorpe's pictorial account of it.

Pat Califia, a writer on lesbian and gay s/m since the late 1970s, defines sadomasochism as "sex which involves adopting fantasy roles, using implements to produce stress or erotic pain, and applying various techniques, such as physical restraint, to create a consensual exchange of power between the participants."[47] Califia's definition, with its reference to "fantasy roles, implements, and techniques," underscores the carefully prepared—even theatrical—nature of s/m. Her emphasis on the performative aspects of s/m echoes that of many other writers on the same subject. Historian Jeffrey Weeks, for example, describes sadomasochism as a "theatre of sex, where the consenting partners freely engage in extreme activities,"[48] while the anthropologist Paul Gebhard similarly remarks upon how often "the phenomenon [of s/m] reminds one of a planned ritual or theatrical production."[49] The theatricality of s/m derives in large part from its use of erotic props and paraphernalia, from its reliance on scripted (or partially scripted) roles, and from the often elaborate guidelines, ground rules, and limit points that the participants negotiate in advance of the sexual act.[50]

The practice of studio photography might likewise be said to require props and paraphernalia, preset roles, protocols, and technical preparations. Rather than covering over the staginess and preparations of studio photography, Mapplethorpe tended to emphasize them. A 1978 portrait titled *Helmut*, for example, offers the elegant, if unlikely, display of a squatting leatherman atop a pedestal (figure 4.19). Even as it reveals Helmut's buttocks, boots, and leather harness, the portrait also emphasizes its spare art-studio setting—the pedestal,

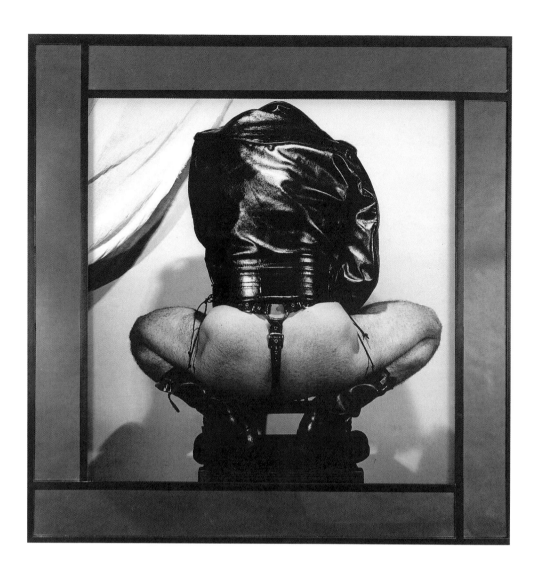

the white wall, the framing sweep of fabric. Mapplethorpe's formalist play with
light and shadow is insistent and unapologetic here, the leather jacket becoming
blackest, for instance, when it overlaps the white muslin fabric behind it. *Helmut*
seems less a portrait of a particular leatherman than a study of the leather para-
phernalia itself and the way it is worn—we might even say modeled—by a prac-
titioner of s/m. The highly presentational style of *Helmut* extends as well to its
unique frame—a rectangular construction of smoky, mirrored glass—which
Mapplethorpe designed expressly for the portrait. The photograph has thus
been "costumed" in a fashion no less extravagant than that of the man it presents.

In his use of such props as a central pedestal and background drapery, Map-
plethorpe recalls the conventions of studio still lifes and photographs of classical
statuary.[51] By 1979, the floral still life had become one of Mapplethorpe's spe-
cialties, and comparisons were frequently drawn between his photographs of
flowers and his portraits of leathermen. Mapplethorpe took particular delight in

presenting wildly different subjects as equally stylized forms of photographic delectation. "I don't think there's that much difference," he told an interviewer in 1979, "between a photograph of a fist up someone's ass and a photograph of carnations in a bowl."[52]

Mapplethorpe's comment echoes the bipartite structure of an advertisement published by the Robert Miller Gallery in 1979 in which *Helmut* is opposed to a still-life of white carnations in a black bowl (figure 4.20). The letter *X* centered beneath *Helmut* refers to Mapplethorpe's "X portfolio," an edition of thirteen s/m photographs that were accompanied by a contrasting "Y portfolio" of floral studies (a "Z portfolio" of black male nudes was later added).[53] Once leather-man and calla lily inhabit the same photographic lexicon, even the most audacious of sadomasochists can be "tamed" into elegant abstraction and the gentlest of floral arrangements freighted with a sexual charge. This, in any case, would seem to be the logic proposed by the coordination of Mapplethorpe's alternate photographic practices into matching portfolios.[54] Throughout his career, Mapplethorpe would insist that the formal power of his work could reconcile even the most dramatic contrasts of subject matter. "I'd have a picture of fruit or flowers next to a picture of sexuality next to a portrait of someone socially prominent. My interest was to open people's eyes, get them to realize anything can be acceptable. It's not what it is, it's the way it's photographed."[55]

For all its affinity to a still life, a photograph such as *Helmut* can never be divorced outright from the specificity of leather sex and subculture. Certain visual details (the spreading of Helmut's legs, the outlining of his buttocks by the leather tie-strings, the suggestion of autoeroticism made by the placement of the right arm) will assert themselves should the viewer become too interested in photographic chiaroscuro or art for art's sake. As spectators of *Helmut*, we are asked to imagine the frontal view that the photograph denies. According to my own such view, Helmut, now in the midst of masturbating, is taking a hit of amyl nitrate, or "poppers" (an inhalant, especially popular among gay men in the 1970s, used to intensify sexual sensation). This would explain the droop of Helmut's head and the crook of his left elbow as he reaches upward to inhale the amyl nitrate. The "poppers" scenario I have just sketched is admittedly the product of (my own) fantasy. Yet *Helmut* solicits the production of such a fantasy by suggesting far more than it actually shows about its subject's sexual activity. In *Camera Lucida*, Roland Barthes memorably describes a Mapplethorpe self-portrait as "launch[ing] desire beyond what it permits us to see."[56] In *Helmut*, Mapplethorpe launches our desire to a space, just past the camera's grasp, of autoerotic practice and kinky pleasure.

Rather than catching his subjects in the midst of sexual activity, Mapplethorpe typically emphasizes the artifice of the studio session. His 1978 portrait *Joe* (figure 4.21), for example, attends to the task of describing Joe's fetishwear: the ridges of the rubber hood, the strap-on breathing tube, the studded collar, the industrial rubber gloves, the sheen of the latex bodysuit. The premeditation of Joe's pose, the fact that he has donned his latex and is stilling his body for Mapplethorpe's camera, is emphasized by the visual evidence of the image. This is no vérité realm of the street or sex club but an acknowledged artistic setup, the studio space of bare floorboards and benches, of strobe lights and reflective back-drops.

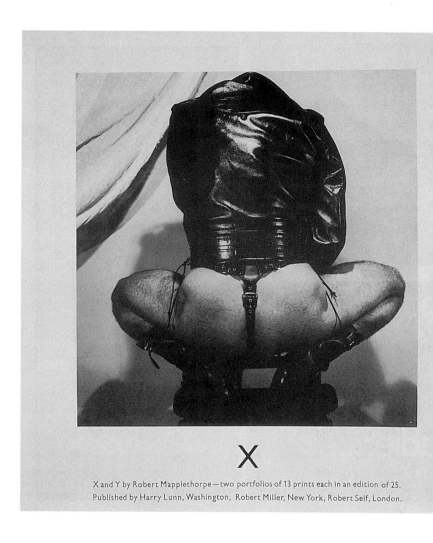

X

X and Y by Robert Mapplethorpe—two portfolios of 13 prints each in an edition of 25.
Published by Harry Lunn, Washington, Robert Miller, New York, Robert Self, London.

Figure 4.20.
Advertisement for
Robert Map-
plethorpe's X and Y
portfolios, 1979.
The Robert Miller
Gallery, New York,
published in *Artfo-
rum* (April 1979).
©The Estate
of Robert
Mapplethorpe.

In Mapplethorpe's most compelling pictures of s/m, he crosses the theatrical appeal of sadomasochism with that of studio photography. *Untitled (Boot Fetish)*, for example, portrays a subject who has placed much of his face inside a leather cowboy boot, as if to inhale its aroma (figure 4.22). The physical identity of the sitter is subordinated to that of his fetish object, white flesh giving way to black leather, brown stitching, silver studs. It is almost as though the man, through the very posturing of his body, attempts to conform to the "demands" of his boot. Notice the rounding over of the shoulders, the loss of the lower part of the face, the way in which the body, however we trace its contours, continually returns our attention to the central boot. Mapplethorpe takes the fetishistic capabilities of photography—the way it can deploy light, texture, and cropping to isolate and eroticize an object—and crosses them with the fetishistic pleasures of the leather scene.[57]

At the heart of Mapplethorpe's s/m project lies a tension between sexual exchange and its simulation, between the space of leather subculture and that of the photographic studio. It mattered to Mapplethorpe, at least to judge from the

Y

An exhibition of new photographs by Robert Mapplethorpe at the Robert Miller Gallery
724 Fifth Avenue, New York, March 21 through April 12.

frequency with which he repeated the claim, that the men portrayed in his s/m photographs should be recognized as authentic participants in gay leather subculture, not as models hired and costumed for a day's shoot. "The people involved in those sexual pictures," Mapplethorpe insisted, "are really involved in them. It's their thing. If there was somebody that happened to be drinking piss in the photograph, he was, in fact, into drinking piss. He wasn't doing it for the picture."[58] For all their overt artifice and premeditation, Mapplethorpe's pictures are not, he tells us, mere pantomimes of sadomasochism. Rather, they are grounded in the "real" (i.e., off-camera) practices of a sexual subculture. Yet this claim is contradictory insofar as Mapplethorpe's subjects, however genuine their membership in the s/m scene, were of course "doing it for the picture," at least on the occasions in which they posed for Mapplethorpe's camera. As Mapplethorpe himself described it, "For the most part, these situations were created with my photographs in mind."[59]

The tension between posing for the camera and engaging in sexual activity is most evident in Mapplethorpe's photographs of s/m couples. In the double por-

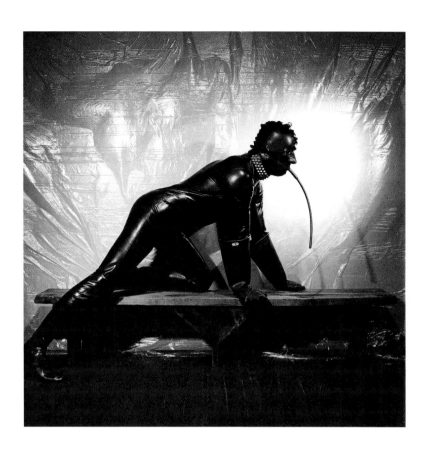

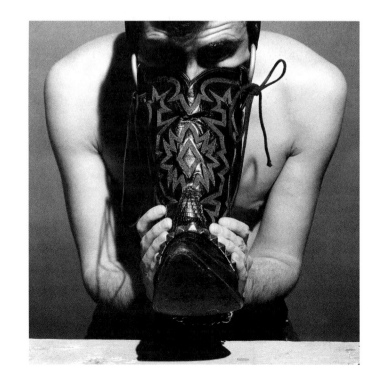

Figure 4.21. TOP
Robert Mapplethorpe,
Joe, 1978. Photograph.
© The Estate of Robert
Mapplethorpe.

Figure 4.22. BOTTOM
Robert Mapplethorpe,
Untitled (Boot Fetish),
1978. Photograph. ©
The Estate of Robert
Mapplethorpe.

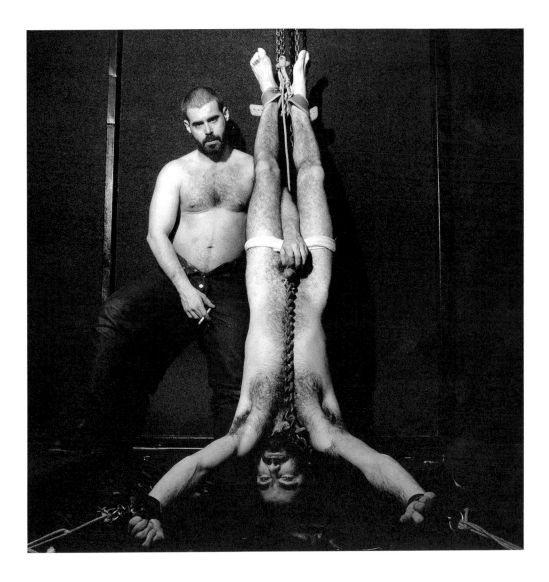

trait *Elliot and Dominick* (figure 4.23), for instance, the subjects display their s/m equipment and respective sexual roles to the camera. Elliot stands next to Dominick, who hangs upside down, like an inverted Christ, from a truss of chains and restraints. But even as this couple demonstrates the machinery of bondage, neither man seems particularly enthralled by that demonstration. It is as though they are waiting, perhaps a bit resentfully, for the camera to absent itself so that their pleasure session might begin or resume. Elliot and Dominick project a resolute awareness of their roles, not only as sexual master and slave but also as confident subjects before the camera's stilling gaze.

To dramatize the distance between *Elliot and Dominick* and a documentary photograph of gay sex culture from roughly the same moment, we might compare Mapplethorpe's double portrait to a 1982 photograph by Mark I. Chester entitled *Slot, Rm. 328* (figure 4.24). Chester's photograph, part of a series entitled "City of Wounded Boys and Sexual Warriors," accompanied an article on San

Figure 4.23. Robert Mapplethorpe, *Elliot and Dominick*, 1979. Photograph. ©The Estate of Robert Mapplethorpe.

Francisco's Folsom Street neighborhood entitled "To the Limits and Beyond" in the magazine *The Advocate*.[60] The couple pictured by Chester are in a private room at the South of the Slot Hotel, a gay bathhouse near Folsom Street. Although the door to their room is open, the men pictured seem unaware of the presence of the photographer. Their sexual activity has been caught in medias res, and the subordinate details of the scene (long shadows, crushed mattress, tangle of chains) appear to have been spontaneously registered by the camera. The visual codes of *Slot, Rm. 328* signal the authenticity of the sexual scene we are witnessing, the photographic capture of gay sex "beyond the limits." Such are the codes that Mapplethorpe's *Elliot and Dominick* avoids at all costs. Rather than allowing a sense of photographic transparency, Elliot and Dominick insist upon the artifice of their pose; they challenge our spectatorial power to see and freeze them by allowing us only a limited view of their sadomasochistic practice. If Elliott and Dominick are willing to allow each other to transgress conventional psychic and sexual boundaries, they do not invite the viewer to do so.

The practice of sadomasochism stages a highly theatrical dialogue between sexualized power and powerlessness, between control and submission. In Mapplethorpe's work, such a dialogue is enacted not only among the practitioners of s/m but between those practitioners and the photographer for whom they pose. Even as they outfit themselves for the most extravagant forms of sexual discipline (torture, bondage, flogging), the men in Mapplethorpe's s/m photographs signal their awareness of the photographic circumstance in which they are engaged. They "perform" the fact of their own posing and thus trouble any sense of the photograph as a spontaneous document of s/m activity. By acknowledging the intrinsic staginess of the studio session, these men convey the theatricality not only of sadomasochism but also of Mapplethorpe's photography.

The self-conscious theatricality of Mapplethorpe's s/m project is perhaps best characterized by his 1979 portrait *Brian Ridley and Lyle Heeter* (figure 4.25). The couple are posed not in the abstracting space of the studio but in the particularizing one of their own living room. Mapplethorpe exploits a mismatch between this couple's sadomasochistic outfits and their domestic interior, between their leather, chains, and master/slave relation, on the one hand, and their wingback chair, oriental rug, grasscloth wall covering, and white-antlers end table, on the other. This spectacular disjunction not only defuses the leather machismo of Ridley and Heeter, it also insists that neither their erotic costume nor their domestic context, neither their chains nor their faux-rococo table clock, can provide a wholly adequate account of their identities. The fabulously normative interior that Ridley and Heeter inhabit (in full leather) calls attention to the theatricality of their various masquerades, both as sexual master and slave and as partners in haute bourgeois domesticity.[61] The contradictions of Mapplethorpe's portrait defeat any essentialist interpretation of Ridley and Heeter in (or as) their sadomasochistic roles.[62]

In terms of the photograph's surprising overlay of sadomasochism and domesticity, consider the couple's simulation of a conventional marriage portrait pose, with the dominant partner standing behind his seated, and apparently submissive, mate.[63] An example of this pose in its more traditional context is furnished by Cecil Beaton's portrait *Queen Elizabeth and Prince Philip*, taken on the occasion of the queen's coronation in 1953 (figure 4.26). Even in the Beaton photograph,

however, the standard positions of male dominance and female docility are revised insofar as the queen's superior authority as monarch is marked by the elaborate regalia that unfurls from her *seated* position and by the marginalized position of the prince within the visual field. Needless to say, *Brian Ridley and Lyle Heeter* provides a far more dramatic revision of conventional gender roles than does *Queen Elizabeth and Prince Philip*, in that the dominant partner is now a leather-daddy who restrains his seated, if strapping, mate with a link of chains in one hand and a riding crop in the other. What is more, the protocols of gay sadomasochism (unlike those of the British monarchy) permit some degree of hierarchical reversibility, some opportunity for top and bottom to switch places.

Although Ridley and Heeter declare their respective positions of sexual dominance and submission, each man appears equally dominant, even defiant, in the face of the camera.[64] While a sexual economy of power and powerlessness may exist between this couple, neither man will readily submit to the gaze of the

Figure 4.24.
Mark I. Chester, *Slot Rm. 328*, 1992. Photograph from the "City of Wounded Boys and Sexual Warriors" series. © 1992 Mark I. Chester.

Figure 4.25.
Robert Mapple-
thorpe, *Brian Ridley
and Lyle Heeter*,
1979. Photograph.
© The Estate of
Robert Map-
plethorpe.

camera. The intensity of the couple's look out at the camera was necessary if the portrait was to avoid condescending to its sitters. We can imagine how easily the contradictions of the scene might otherwise have framed Ridley and Heeter as deluded or pathetic.

Even as he emphasized the theatricality of both s/m and studio photography, Mapplethorpe insisted on his work's connection to an authentic sexual subculture. One of the primary ways he did so was to emphasize his own involvement in the gay leather scene, as a participant first and a photographer second: "I was a part of it, yeah, that's where most of the time people—photographers—who move in that direction have a disadvantage, I think a disadvantage, in that they're not part of it. They're just voyeurs moving in on a scene, and with me it was quite different. Some of those experiences that I later recorded I had experienced firsthand, without a camera."[65] There is no shortage of evidence with which to confirm Mapplethorpe's claim for a firsthand knowledge of s/m, no dearth of accounts describing his patronage of leather bars and sex clubs and his indefati-

gable pursuit of sexual adventure.[66] I am less interested in retrieving the "truth" of Mapplethorpe's sexual experience in the late 1970s (i.e. the activities he preferred, the men he pursued, the backrooms he patronized) than in looking at the public representations he made of that experience, both photographically and in published interviews.

In an unforgettable *Self-Portrait* from 1978, Mapplethorpe poses for the camera while anally penetrating himself with a bull-whip (figure 4.27). Mapplethorpe uses the bull-whip, along with his black leather vest, chaps, and boots, to announce his stake in the subculture he portrays. The *Self-Portrait* asserts that when Mapplethorpe photographs the (other) practitioners of gay s/m, the lens of his camera is not pointed metaphorically downward. In offering his bullwhip and penetrated body to the camera, Mapplethorpe refutes what Susan Sontag has described as the "supertourist" stance of documentary photography in which

Figure 4.26. Cecil Beaton, *Queen Elizabeth and Prince Philip on Coronation Day*, 1953. Photograph. © Camera Press, London.

the photographer becomes "an extension of the anthropologist, visiting natives and bringing back news of their exotic doings and strange gear."[67] Rather than reporting on the "exotic doings" of others, the 1978 *Self-Portrait* presents Mapplethorpe himself as the object of photographic curiosity, as the sadomasochistic "native" in the midst of using his own "strange gear."

The *Self-Portrait* does rather more, however, than confirm Mapplethorpe's firsthand knowledge of s/m. It rewrites the conventions of self-portraiture along manifestly homo- and anal-erotic lines. Within the history of art, one is hard-pressed indeed to recall another self-portrait, whether painted or photographic, which offers its artist in the act of anal penetration. The bravado of Mapplethorpe's 1978 *Self-Portrait* derives in large part from the spectacle of its anality and from the fact that the anus on offer is the photographer's own. As Eve Kosofsky Sedgwick has pointed out, the anus is "the place that is signally not under one's own ocular control."[68] For Sedgwick, the anus symbolizes the larger shames (but also the pleasures) of that which cannot be fully seen or shown. In the 1978 *Self-Portrait*, Mapplethorpe calls upon the apparatus of photography to overcome this "blind spot." The artist penetrates himself with a bullwhip while turning around to confront the camera as it pictures that which he cannot otherwise see.

In *Homosexual Desire*, a book translated into English the same year that Mapplethorpe created this self-portrait, Guy Hocquenghem argues that gay men are perceived as threats to the body politic because of their association with anality. Rather than deny this association, Hocquenghem suggests that gay men might embrace it so as to challenge the terms of "phallic" subjectivity and desire. If, as Hocquenghem suggests, "the anus has no social position except sublimation. . . . [It] expresses privatization itself,"[69] then Mapplethorpe's 1978 *Self-Portrait* might be seen as a radical desublimation of the anus, a publicizing not only of the anus but, by extension, of the sexual and creative possibilities that our culture labors to keep hidden, covered, "behind." "Gay men," writes Richard Dyer in another context, "have been thought of as deviant and disruptive of masculine norms because we assert the pleasure of being fucked and the eroticism of the anus."[70] The visibility of Mapplethorpe's anus, alongside that of his leather chaps, vest, boots, and bullwhip, activates an expressly homosexual form of self-portraiture, one that defies the normative codes of phallic masculinity.

For all its audacity, Mapplethorpe's stance in the 1978 *Self-Portrait* is a paradoxical one. The photographer inhabits both a vulnerable position (penetrated by a bullwhip and fully opened to the scrutiny of the camera) and a domineering one (outfitted in leather chaps and vest, penetrating himself, and audaciously returning the gaze of the camera). The *Self-Portrait* thus complicates the central trope of sadomasochism, the division of sexual labor along a power/powerlessness axis, by simultaneously staging the roles of both mastery and subordination, both active insertion and passive reception. Even as the photograph articulates Mapplethorpe's dual role of dominance and submission, it also reminds us that such an articulation is occurring within the space of the studio, the space of white walls, varnished floorboards, and draped chairs.

In this context, Mapplethorpe's role as both the agent and object of anal penetration (as both "top" and "bottom") might refer to the procedure of creating a self-portrait, to the simultaneity of serving as both the productive agent and the

receptive object of photography. The reflexivity of Mapplethorpe's self-penetration mirrors the reflexivity of his self-portrayal. By way of extending this reading of the image, consider the manner in which Mapplethorpe's bullwhip snakes not only out of his body but out of the visual field, leading from his exposed anus to our own position of gazing. Although it has most often been likened to a tail, the bullwhip also resembles an extension cord or shutter-release cable tying Mapplethorpe's body to the clicking camera off-frame. Notice the photographer's careful fingering of the whip and the way his cupped left hand mimics the action of triggering a shutter-release. The bullwhip, a fetish object of gay s/m, here stands in for the mechanisms of photography, mechanisms implied by the metaphor to be fetishistic. In using photography to depict sadomasochism, Mapplethorpe simultaneously calls upon the props of sadomasochism to depict studio photography.

If the surliness of Mapplethorpe's gaze acknowledges that he is being "caught in the act" of autopenetration, it also signifies a sense of mastery over both the

Figure 4.27. Robert Mapplethorpe, *Self-Portrait*, 1978. Photograph. ©The Estate of Robert Mapplethorpe.

photographic image and the self depicted in it. In the introduction to *Certain People*, a monograph of Mapplethorpe photographs that includes the 1978 *Self-Portrait*, Susan Sontag reports, "I once asked Mapplethorpe what he does with himself when he poses for the camera, and he replied that he tries to find that part of himself that is self-confident."[71] While the registration of self-confidence is central to all of Mapplethorpe's self-portraits, it is particularly significant in cases where the self, as in the 1978 *Self-Portrait*, might otherwise seem to be in a position of submission.

The 1978 *Self-Portrait* insists on the difference between Mapplethorpe's pursuit of sadomasochistic pleasure (at say, the Slot in San Francisco or the Mineshaft in New York City), and his performance of it in the studio. The *Self-Portrait* does not capture the experience of gay s/m so much as it demonstrates, perhaps even simulates, that experience for the camera. It emphasizes Mapplethorpe's confidence in being photographed rather than his pleasure (or pain) in being anally penetrated. In this sense, the photograph glosses a remark Mapplethorpe made during a public discussion of his work in San Francisco in 1978. Someone in the audience asked, "Has the camera become part of the sex," and Mapplethorpe responded, "Sex without the camera is sexier."[72] Like his 1978 *Self-Portrait*, Mapplethorpe's answer stresses the mediation of photography and the effect of that mediation on the sexual scene portrayed. "I would prefer a sexual experience to photographing one," Mapplethorpe asserted in 1979. "The camera gets in the way, although I have always made an effort to use it."[73] Once again, Mapplethorpe articulates a certain tension between sexual immediacy and photographic intervention, a tension that structures the look and logic of his entire s/m project.

Mapplethorpe's s/m pictures thematize two different kinds of constraint— first, the sexualized constraint of bondage and discipline, of bullwhips and wrist shackles, and second, the pictorial constraint imposed by studio photography, by the self-consciousness of pose and gesture, of stylized lighting and controlled composition. We might even say that Mapplethorpe depicted s/m as a dialogue between these two forms of constraint. A third, and quite different, form of constraint that marked Mapplethorpe's s/m photographs in the late 1970s was commercial censorship. In what follows, I consider this "third constraint" as well as the terms of Mapplethorpe's response to it.

Censored

In the spring of 1978, 80 Langton Street, a not-for-profit art space in San Francisco, mounted an exhibition of Mapplethorpe's photography. The show consisted of nineteen black-and-white photographs cataloguing a range of sexual and sadomasochistic practices. Among the featured works were two photographs of "fisting" (manual penetration of the anus), a picture of "baby drag" (a heavyset, middle-aged man in a baby's dress and bonnet, sucking on a bottle), and a portrait of a rubber fetishist (*Joe*). The *Self-Portrait* with bull-whip was the only picture of Mapplethorpe in the show and was, not incidentally, reproduced as the announcement card for the exhibition (figure 4.28).

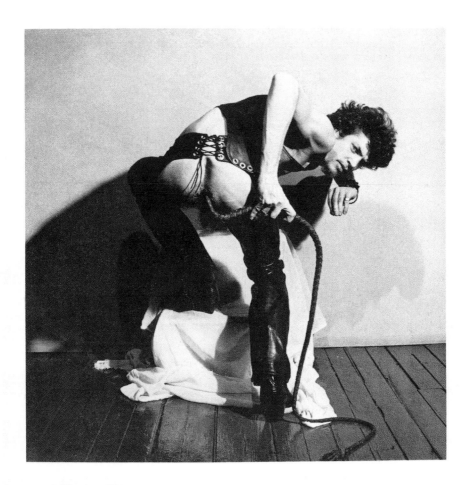

CENSORED

Robert Mapplethorpe

March 21
through April 1, 1978
Reception:
Monday, March 20,
6—8 p.m.

80 Langton Street
San Francisco
(415) 626-5416
Gallery Hours: 1—5 p.m.
Tuesday—Saturday

Figure 4.28. *Censored*, 1978. Gallery announcement (postcard), 80 Langton Street, San Francisco. ©The Estate of Robert Mapplethorpe. Courtesy The Robert Mapplethorpe Foundation, New York, and New Langton Arts, San Francisco.

The exhibit's title, *Censored*, referred to the curatorial circumstances surrounding and suppressing Mapplethorpe's work at the time. In 1977, Mapplethorpe had secured an agreement for a one-man show at the Simon Lowinsky Gallery, a commercial art space in San Francisco. The exhibit, which would mark the photographer's West Coast debut, was to present his sexually explicit and suggestive pictures, some of which had been shot in the Bay Area.[74] Shortly before the slated opening of the show, however, Simon Lowinsky rejected nineteen of Mapplethorpe's s/m pictures, belatedly declaring them unfit for commercial display.[75] Mapplethorpe's response was surprisingly—and strategically—conciliatory: "I said, o.k., why don't we tone it down. I'll take the suggestive ones and put them in your show and then take the explicit ones [out]. . . . Take a third sexual pictures, a third portraits, and a third flowers and we'll put together a show like that, otherwise it was no show."[76] Faced with Lowinsky's resistance to his work, Mapplethorpe opted to "tone it down" by removing the most explicit photographs and then mingling the "suggestive" ones with his pictures of flowers and portraits of socialites. Rather than a showcase of Mapplethorpe's "sex pictures," the Lowinsky exhibit thus became a heterogeneous sampler of the photographer's work.[77] The formula Mapplethorpe devised for the Lowinsky show—"a third sexual pictures, a third portraits, and a third flowers"—would emerge as something of an organizing strategy for his subsequent career.[78]

Even after being rebuffed by Lowinsky, Mapplethorpe did not give up on the idea of showing his hardcore pictures in San Francisco. As the photographer would later remember it, "I got the Curator at Berkeley [Jim Elliot, director of the University Art Museum] interested in my sex pictures and he helped me to find one of these free spaces, Langdon [*sic*] Street, which exist through the National Endowment of the Arts, they don't have restrictions. They don't have to make money. So I had two shows out there at the same time. I like double shows. I like lots of shows."[79] Mapplethorpe's characterization of the NEA ("they don't have restrictions") is particularly striking given the fact that, some ten years later, his photographs would be used to justify the need for content restrictions on federally funded art. It is worth noting, however, that in the late 1970s the NEA could (and did) fund spaces such as 80 Langton Street without imposing content restrictions or decency clauses on artists, curators, or arts administrators.[80]

With the indirect help of the NEA (which funded 80 Langton Street's annual budget rather than the *Censored* exhibition in particular), Mapplethorpe's most explicit photographs were mounted at an alternative art space in San Francisco at the same time that his "softer" work was on display in a commercial gallery. In this way, Mapplethorpe "covered" the San Francisco art scene in the spring of 1978. The Lowinsky Gallery was located at 228 Grant Avenue, in the upscale boutique district adjacent to Union Square. By contrast, 80 Langton Street was located off Folsom Street in the South of Market (SoMa) district, a warehouse neighborhood that functioned as the center of San Francisco's gay leather scene.[81] We might say, then, that the commercial rejection of Mapplethorpe's s/m pictures by Lowinsky resulted in the return of those pictures to the very space of their subculture. The mounting of *Censored* at 80 Langton Street, not far

from the Ramrod, the Slot, and the Stud, imbued the exhibit with a certain glamour of the margin. Listen, for example, to the description of the show's opening-night reception that appeared in the *San Francisco Art Dealer's Associated Newsletter*:

> A fascinating cross-section of San Francisco society, and visitors from elsewhere, drank wine and bottled beer as they congratulated the New York photographer on his exhibition of photographs which explore the world of sado-masochism and its ritualistic trappings. Among those in the crowd, rubbing shoulders with the men in black leather, were popular ceramic artist Anita Mardikian, art collector Byron Meyer, University Art Museum Director James Elliot, male model Peter Berlin . . . San Francisco art dealers Simon Lowinsky, Ursula Gropper [and so on].[82]

The smug clubbiness of this account might give us some pause in celebrating Mapplethorpe's resistance to the commercial censorship of his work in 1978. It is the photographer, after all, who straddles the "world of sado-masochism" and that of the art market, forming the singular join in that "fascinating cross-section." Mapplethorpe, outfitted in motorcycle jacket and studded leather chaps for the opening (figure 4.29), stands as an avatar of the sexual transgressions he photographs, the artist who engages in the wild side of subculture in order to frame—and tame—its image for the gallery crowd. Patrons of the local art circuit may now "rub shoulders" with the "men in black leather" (including Mapplethorpe himself) while safely installed within the chic propriety of a gallery opening.[83] Indeed, the very dealer who "censored" the s/m pictures, Simon Lowinsky, is named on the list of prominent guests at the opening-night reception.

While he was no longer involved in marketing the s/m photographs, Lowinsky knew that their display at 80 Langton Street could not but draw attention to his concurrent Mapplethorpe exhibition of portraits and flowers. Lowinsky could thus benefit from the transgressive frisson of Mapplethorpe's most graphic work on sadomasochism without having to display that work in his Grant Avenue gallery.[84] And it was not only Lowinsky but Mapplethorpe himself who stood to gain from the show at 80 Langton Street. In presenting his work under the title *Censored* at an alternative art space, Mapplethorpe could simultaneously accommodate his commercial dealer and secure his credentials as an artistic renegade.[85] It was Mapplethorpe who came up with the title *Censored* for the 80 Langton Street show and designed its gallery announcement. Like the *Bull's Eye* collage of 1970, the 80 Langton Street announcement figures the force of censorship while simultaneously defying it. According to Lowinsky, Mapplethorpe was "well aware of the p.r. effect that calling it 'Censored' would have. . . . He knew that a controversy would only create more interest in the pictures."[86] Although Lowinsky is hardly a neutral source on the matter, his recollection is consistent with other accounts of the *Censored* show, most notably Mapplethorpe's own. Mapplethorpe acquiesced to the removal of his s/m photographs from the Lowinsky gallery so as not to forfeit altogether the chance to exhibit his work there. Mapplethorpe then presented those same s/m photo-

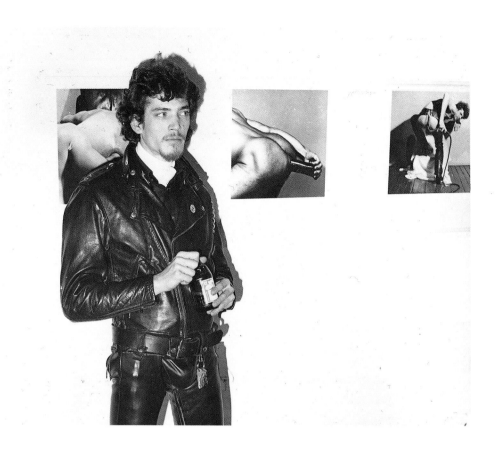

Figure 4.29.
Rink, "Robert
Mapplethorpe at
'Censored' Open-
ing," 1978. Photo-
graph. © Rink Foto
1978.

graphs at an alternative art space under the title *Censored*.[87] He thus put censor-
ship to use, both pictorially and promotionally. Mapplethorpe capitalized on the
commercial rejection of his s/m photographs to imbue those photographs with
a heightened sense of artistic and sexual outlawry.

 In response to the 80 Langton Street exhibit, the porn magazine *Son of Drum-
mer* published a selection of the *Censored* photographs in a layout entitled "The
Robert Mapplethorpe Gallery."[88] The magazine was a special, onetime issue of
Drummer, a gay leather and s/m publication that billed itself as "America's Mag
for the Macho Male." In a commentary accompanying the "Mapplethorpe
Gallery," *Drummer*'s editor, Jack Fritscher, affirmed that "Mapplethorpe is no
'concerned' photographer smug with social significance. He shoots portraits
only of people he likes. He chronicles S/M fetishism from the inside out. He's a
man who knows night territory."[89] *Son of Drummer* invokes Mapplethorpe's
direct involvement with sadomasochism to legitimate his photographic account
of it. Not surprisingly, the layout of "The Robert Mapplethorpe Gallery"
includes the 1978 *Self-Portrait*, the photographer's most graphic credential of
s/m experience. As if to draw out the kinky defiance of the *Self-Portrait*, the cap-
tion beneath it reads, "Portrait of the Artist as a Young Satyr." No less striking
than *Son of Drummer*'s pictorial layout is the manner in which the accompanying
commentary ties Mapplethorpe's "knowledge of night territory" to his high-

toned social and professional life: "He lunches afternoons at One Fifth Avenue. He maneuvers after midnight at the Mineshaft. He photographs princesses like Margaret, bodybuilders like Arnold, rockstars like his best friend Patti Smith, and nighttrippers nameless in leather, rubber, and ropes. He's famous for his photographs of faces, flowers, and fetishes."[90] Mapplethorpe's sophistication is exemplified by the ease with which the photographer moves from one cultural milieu to another, from upscale restaurants to hard-core sex clubs and back again. Fritscher's commentary suggests a certain parallelism between Mapplethorpe's diverse subjects ("faces, flowers, and fetishes") and the various social and sexual spaces in which the photographer circulates. Mapplethorpe's urbanity is marked by his access to aristocracy ("princesses like Margaret"), celebrities ("like his best friend Patti Smith"), expensive meals ("lunches . . . at One Fifth Avenue"), and kinky, anonymous sex ("nighttrippers nameless in leather, rubber, and ropes").[91]

Fritscher has gotten something right about the logic (including the marketing logic) of Mapplethorpe's work. Mapplethorpe's photography, like the rise of glossy gay porn magazines such as *Drummer* and *Son of Drummer*, participated in the larger packaging of male homosexuality as a "lifestyle" in the late 1970s. According to historian John D'Emilio, "Among gay men, the burgeoning of a visible, commercialized, urban sexual subculture of the 1970s virtually buried the gay liberation critique. Gay liberation transmuted into a movement for [gay men's] sexual freedom; exploring new frontiers of sexual pleasure, beyond the boundaries of what middle-class America approved, became a central element of gay male life."[92] In place of the gay liberation movement's emphasis on revolutionary social change, the "gay lifestyle" was structured around commercial sites of pleasure (e.g., bars, bathhouses, discotheques, shops, restaurants) and an erotic ideal of manliness to which leather and s/m paraphernalia (e.g., uniforms, handcuffs) were particularly well suited.

Mapplethorpe's photography not only reflected the commercialized pleasures of gay life in the late 1970s; it also helped to publicize them. Shortly after the publication of "The Robert Mapplethorpe Gallery" in *Son of Drummer*, for example, Mapplethorpe was hired to shoot the cover for an issue of *Drummer* (figure 4.30). "Robert Mapplethorpe's *Authentic* 'Biker-For-Hire' Coverman" suggests the ease with which the photographer's work (and his increasingly famous name) could be set to the task of promoting gay s/m as a "lifestyle." Part of the promise of that lifestyle was that certain fantasies of machismo (e.g. the tattooed, bearded, cigar-smoking biker) would now be embodied, represented, and available "for hire" by gay men. In addition to the cover of *Drummer*, Mapplethorpe would later produce the official poster for the "Black Party," an annual leather, sex, and dance event held at the Saint, one of New York's largest and most popular gay discos. Beneath a photograph of a shirtless, muscular man holding horns to his head, the poster lured potential ticker-buyers to the party with the promise that "Robert Mapplethorpe Will Be Photographing Selected Guests."[93]

In mapping out the process whereby marginal social groups are "discovered" and co-opted by the dominant culture, Thomas Crow writes that subcultural forms "are usually first made salable by the artisan-level entrepreneurs who spring up in and around any active subculture. Through their efforts, a wider cir-

Figure 4.30. *Drummer* 3, no. 24 (1978), with "Robert Mapplethorpe's *Authentic* 'Biker for Hire' Coverman." Courtesy Gay, Lesbian, Bisexual, Transexual Historical Society of Northern California, San Francisco.

cle of consumers gain access to an alluring subcultural pose, but in a more detached and shallow form as the elements of the original style are removed from the context of subtle ritual that had first informed them."[94] Mapplethorpe might well be seen as such an "artisan-level entrepreneur" in relation to the s/m subculture he photographed in the late 1970s. Certainly, the photographer never made any pretense about his professional ambitions ("I like double shows. I like lots of shows") or about his willingness to exhibit his work in formats that would suit the dictates of the contemporary art market.

"There's all this energy now around faggot art," said Mapplethorpe in 1979. "It would be nice to see something legitimate as art come out as well. I don't see why it couldn't."[95] Mapplethorpe's comment, with its distinction between "faggot art" and "something legitimate," signals his own ambition to bridge the gap

between the still emergent gay art scene of the late 1970s and the established art market of uptown galleries, museums, and auction houses.[96] By the end of 1979, Mapplethorpe was already well on his way to realizing this ambition. His photography had been the subject of one-person shows in New York, Los Angeles, Houston, Washington, Amsterdam, and Paris, and he was now represented by the prestigious Robert Miller Gallery in New York City. Virtually alone among the artists of his generation working on explicitly homosexual themes, Mapplethorpe successfully made the passage from alternative art spaces to elite commercial galleries and museums. In doing so, however, Mapplethorpe would abandon s/m as a subject matter for his work.

Mapplethorpe's desire to make "faggot art" into something "legitimate" cannot be understood apart from the broader phenomenon whereby gay culture of the mid- to late 1970s increasingly became structured (and sold) as a set of social, sexual, and consumerist pleasures. The shift from the gay liberationist ethos of the early 1970s, with its critique of capitalism and male supremacy, to the commercialized gay subculture of the late 1970s carried its own contradictions. Even as gay men embraced consumerism and the dominant values of the marketplace, they also insisted on increasingly public forms of sexual visibility, including leather and s/m.[97] And, as D'Emilio points out, it was gay culture's emphasis on multiple pleasures and sexual partners that "middle-class America" could not abide.

A similar paradox obtained to Mapplethorpe's photographs of gay s/m. In their contemporary moment, the sex pictures were rarely accepted as fine art photography, no matter how many portraits of Paloma Picasso or pictures of carnations Mapplethorpe hung next to them. As a 1980 article on the photographer pointed out, most "established galleries refused to exhibit the images resulting from his explorations [of s/m]."[98] In a 1981 interview, Mapplethorpe described his disappointment with the reception of the s/m pictures and with the way those pictures inflected his larger body of work:

> I thought . . . that people could see that here's the flower. It's perfectly composed, perfectly lit, [or here's] a beautiful portrait of a society lady, whatever, you know, a celebrity. Then you see a cock and it's a different subject, same treatment, same vision, which is what it's all about—my eyes as opposed to someone else's. And I thought that it would make people see things differently. But what happened is that they took the cocks and fused them onto the others instead of the other way around. They forgot that the other pictures were even there.[99]

Mapplethorpe here seems to lose faith in the formal power of his photographic technique to overcome differences of subject matter. He laments the failure of viewers to see that his photographs—whether of a flower, a society lady, or a cock—are all products of the "same treatment, same vision—my eyes as opposed to someone else's." After repeatedly positioning the s/m photographs in relation to his other work, Mapplethorpe now complains that his audience refuses to see the "other pictures," the flowers and portraits, apart from the "cocks." Given the degree to which Mapplethorpe called upon the s/m pictures to spice up his society portraits and floral still lifes, this complaint might sound a

bit disingenuous. It is possible, however, that Mapplethorpe had underestimated the effect his sexually explicit pictures would have on the rest of his photographic output. If, as he frequently claimed, Mapplethorpe was seeking a formal equivalence among his various themes, that equivalence seems to have been thrown out of whack by the singular force of the s/m photographs.

Sometime early in 1980, Mapplethorpe stopped shooting pictures of gay s/m. According to the photography critic Ingrid Sischy, Mapplethorpe's s/m pictures thereafter "became the portion of his work which stayed in drawers, only appearing on the rarest of occasions and many of them never again seen. But no one who knew about them forgot those scenes, even if the knowledge was only by rumor. They stayed in the back of the mind, tugging a little every time another Mapplethorpe work went by."[100] Sischy describes the s/m photographs as a remembered disturbance, a set of phantom images that continued to haunt Mapplethorpe's career even after they were stashed away in storage. Writing in 1988, Sischy could scarcely have known that the disturbance provoked by the s/m photographs would return with a vengeance the following year. This time, however, the disturbance would register not only at the level of individual viewing but also at that of museum policy, federal arts funding, and political conflict.

Projections

On June 13, 1989, Christina Orr-Cahall, the director of the Corcoran Gallery of Art, canceled *The Perfect Moment*, a full-scale retrospective of Mapplethorpe's work that was slated to open less than three weeks later. Orr-Cahall's decision was made in response to pressures applied by Republican politicians, including Senator Jesse Helms of North Carolina, who were, in turn, responding to protests against Mapplethorpe by the American Family Association (AFA), a conservative Christian organization based in Tupelo, Mississippi, and led by the Reverend Donald Wildmon.

In a striking rhetorical twist, Orr-Cahall would describe the decision to cancel *The Perfect Moment* as a staunch defense of artistic freedom in the face of an overheated political scene: "We decided to err on the side of the artist who had the right to have his work presented in a non-sensationalized, nonpolitical environment. . . . If you think about this for a long time, as we did, this is not censorship; in fact, this is the full artistic freedom which we all support."[101] Orr-Cahall's argument persuaded virtually no one, including the Corcoran's own staff, which collectively urged the director to resign as a result of the incident.[102] After issuing a statement of "regret" concerning the Mapplethorpe cancellation, Orr-Cahall would, in fact, step down from her position as director of the Corcoran in December 1989.[103]

The cancellation of *The Perfect Moment* exacerbated a conflict over federal arts funding already under way by the summer of 1990. The conflict had begun the previous April, when the AFA sent out 1 million letters denouncing a single work of art, Andres Serrano's *Piss Christ*. The work, a large-scale color photograph of a crucifix submerged in a luminous bath of urine, had been awarded a $15,000 prize by the Southeastern Center for Contemporary Art in Winston-Salem, North Carolina, an institution partially funded by the NEA. Shortly after

receiving the AFA's letter, Senator Alfonse D'Amato of New York ripped up an exhibition catalog featuring a reproduction of *Piss Christ* on the floor of the Senate. In cheering on D'Amato's gesture, Jesse Helms announced, "The Senator from New York is absolutely correct in his indignation. . . . I do not know Mr. Andres Serrano and I hope I never meet him. Because he is not an artist, he is a jerk."[104]

If the worst accusation Helms could muster against Serrano was that of being "a jerk" instead of an artist, the senator and his colleagues would find rather more explicit charges to level against Mapplethorpe a few months later. During congressional hearings on the NEA in September 1989, for example, Representative Robert Dornan of California asserted that Mapplethorpe "was a child pornographer. He lived his homosexual, erotic lifestyle and died horribly of AIDS."[105] One week later, Senator Helms would explain the need for content restrictions on federally funded art in a similar fashion:

> And that is what this is all about. It is an issue of soaking the taxpayer to fund the homosexual pornography of Robert Mapplethorpe, who died of AIDS while spending the last years of his life promoting homosexuality. If any Senator does not know what I am talking about in terms of the art that I have protested, then I will be glad to show him the photographs. Many Senators have seen them, and without exception every one has been sickened by what he saw.[106]

Both Dornan and Helms move freely between attacking Mapplethorpe's life ("his homosexual, erotic lifestyle"), recalling his "horrible" death as a result of AIDS, and denouncing his work as federally funded pornography. Their rhetoric blurs the boundaries between art and life, between representation and reality, and between photographic content and physical sickness.

If the figure of Mapplethorpe as degenerate artist was thrust onto the national stage by Helms, Dornan, and company in 1989, so too was the power of Mapplethorpe's work to inflame Republican lawmakers, Christian fundamentalists, and the Corcoran Gallery of Art. The vilifications to which Mapplethorpe was subjected provoked a counterdiscourse in which his photographs came to symbolize artistic freedom and the struggle against censorship. A protest rally held outside the Corcoran on the evening of June 30, 1989 (the night before *The Perfect Moment* was to have opened), marked a key moment in the political reclamation of Mapplethorpe's work. During the protest, several Mapplethorpe pictures, including a 1979 photograph of a threadbare American flag, a 1980 *Self-Portrait*, and a 1986 nude entitled *Thomas in Circle*, were projected onto the facade of the museum (figures 4.31, 4.32, 4.33).[107] Mapplethorpe's work thus appeared, in radically oversized format, on the exterior of the institution from which it had been denied access. To draw out the irony of this moment, the photographs were projected near the main entrance to the Corcoran, whose stone lintel bears the inscription "DEDICATED TO ART." The projection of Mapplethorpe's work onto the exterior of the museum effectively symbolized its banishment from the interior space of legitimate display. The projection indicted the Corcoran's cancellation of *The Perfect Moment* by ironically simulating the museum's official function—the public display of art.

Figure 4.31. TOP
Frank Herrera, photo-
graph of *The Perfect
Moment* protest, June
30, 1989, Corcoran
Gallery of Art, Wash-
ington, D.C.
© Frank Herrera.

Figure 4.32. BOTTOM
Frank Herrera, photo-
graph of *The Perfect
Moment* protest, June
30, 1989, Corcoran
Gallery of Art,
Washington, D.C.
© Frank Herrera.

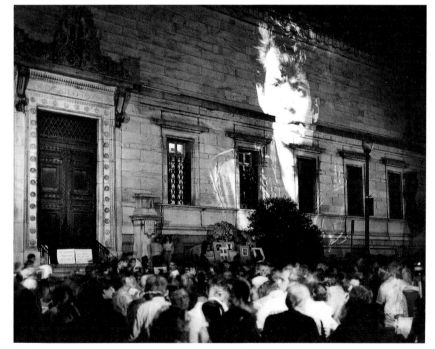

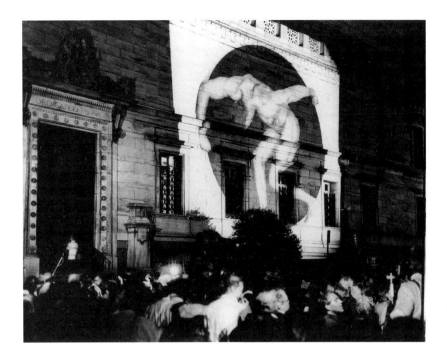

Although ten Mapplethorpe photographs were projected onto the Corcoran during the protest, the *Self-Portrait* was the picture most often reproduced in the press. It was reprinted, for example, in the *New York Times* as well as on the cover of the September 1989 issues of both *Artforum* and *American Theatre* magazines (figures 4.34, 4.35). Censorship, as I have argued throughout this book, generates the publicity and recirculation of the very works it seeks to suppress. In canceling its exhibition of Mapplethorpe's photographs, the Corcoran provoked the recirculation of those photographs in newspapers and magazines, on television broadcasts, on the floor of the U.S. Senate, in a Cincinnati courtroom, and, not least, on its own exterior facade. In this last instance, the reproduction of Mapplethorpe's work by protesters at the Corcoran was itself reported and reproduced in the press.

The projected *Self-Portrait* not only recirculates Mapplethorpe's work; it also revives the figure of the artist himself. Mapplethorpe, who died three months prior to the protest, now reappears, flickering yet monumental, to answer the censorship of his art. With his knit brow and tightly focused gaze, his lit cigarette and leather jacket, Mapplethorpe seems to defy his "cancellation" by the Corcoran. If, as Senator Helms and the Christian Right contended, Mapplethorpe posed a sexualized threat to the sanctity of American culture, the projected *Self-Portrait* offers an image of just how audacious that threat might be. It conjures the photographer in the form of a fifty-foot phantasm that cannot be expelled from the official precincts of art.[108]

As part of its larger attack on the NEA in 1989, the Christian Right projected its own fears and fantasies (of homosexuality, of sadomasochism, of child pornography) onto the figure of Mapplethorpe.[109] The projected *Self-Portrait* might be said to force these "projections" into public view, to summon the

Figure 4.33. Frank Herrera, photograph of *The Perfect Moment* protest, June 30, 1989, Corcoran Gallery of Art, Washington, D.C. © Frank Herrera.

Figure 4.34.
Artforum, September 1989. Courtesy
Artforum.

specter of Mapplethorpe into shimmering visibility. The figure of the artist returns, "like an insistent ghost," to haunt those have denounced his work and demeaned his life.[110] The nocturnal circumstances of the *Self-Portrait*'s appearance (necessary, of course, for an outdoor projection) further reinforce this apparitional effect. As the critic Denis Hollier has noted, large-scale projections onto monuments and museums "give a dreamlike quality to public space . . . [by] leaving, with the lightness of what can be seen only at night, their message on walls they expose without touching."[111] The projected *Self-Portrait* inscribes a dual message on the walls of the Corcoran—a declaration of protest by the activists who organized the rally and, alongside that, an insistence on bringing to light the "bad dream" of Jesse Helms and the Christian Right.[112]

In order to link Mapplethorpe's depiction of gay sadomasochism to his portraits of children, conservative commentators sometimes misconstrued the very content of his photography. In a column for the *Washington Times*, Patrick Buchanan recounted the controversy over *The Perfect Moment* as follows: "At Washington D.C.'s Corcoran Gallery, a photographic exhibit by Robert Mapplethorpe, recently dead of AIDS, featuring men engaging in violent homosexual sex, with nude children thrown in, was canceled."[113] Buchanan's syntax places "nude children" in the immediate proximity of "men engaging in violent homosexual sex," who in turn are associated with AIDS and death. Given this account of *The Perfect Moment*, those unfamiliar with Mapplethorpe's work might well have imagined, however erroneously, that nude children were featured in his photographs of "violent homosexual sex." Both Buchanan and the broader discourse of censorship in which he participated sought to exploit just this confusion. Mapplethorpe's portraits of children were "thrown in" with those of gay sadomasochism in order to activate long-standing stereotypes of the male

homosexual as child molester and thereby to frame Mapplethorpe as criminally deviant.

In this context, I want to consider one of the photographs at the center of *The Perfect Moment* controversy—Mapplethorpe's 1976 portrait *Jesse McBride* (figure 4.36). A press release from the American Family Association dated July 1989 describes this portrait as "a shot of a nude little boy, about eight, proudly displaying his penis" and further claims that the photograph was produced "for homosexual pedophiles."[114] Needless to say, the AFA does not reproduce the photograph at issue. If it did, viewers might notice that Jesse McBride appears absolutely matter-of-fact about his nakedness and no more self-conscious (or proud) of his genitals than any other part of his body. The AFA's press release functions to sexualize this image, to fixate on the boy's penis far more intensely than does either Mapplethorpe or Jesse McBride. The American Family Association distorts and dramatizes the picture it claims simply to describe. In viewing Mapplethorpe's portrait of *Jesse McBride*, we should recall (as the American Family Association clearly did not) that photographs of naked children do not, in and of themselves, constitute child pornography, nor, for that matter, does the act of photographing a naked child necessarily constitute an act of sexual exploitation.[115] Yet these are precisely the slippages that shaped the description of Mapplethorpe's portraits of children during the height of *The Perfect Moment* controversy.[116]

The association of homosexuality with child molestation would also surface in the wording of the 1989 "Helms Amendment," which prohibited the use of NEA

Figure 4.35. *American Theatre*, September 1989. Courtesy *American Theatre*.

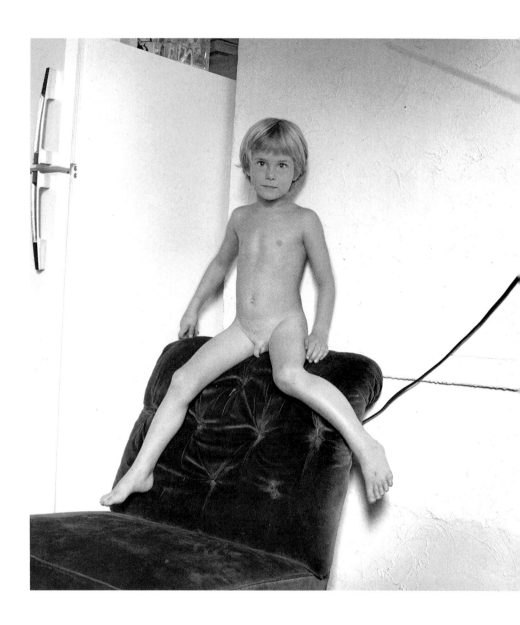

Figure 4.36.
Robert Mapplethorpe, *Jesse McBride*, 1976.
Photograph. ©The Estate of Robert Mapplethorpe.

funds to "promote, disseminate, or produce obscene or indecent materials, including but not limited to depictions of sadomasochism, homoeroticism, the exploitation of children, or individuals engaged in sex acts."[117] As Carole Vance has argued, "The purpose of this sexual laundry list was to provide specific examples of what Sen. Helms and, more generally, conservatives and fundamentalists find indecent."[118] I would push this point further and suggest that Helms's list of indecencies derives from his own view of Mapplethorpe's work, from the "sadomasochism" of the sex pictures, the "homoeroticism" of the s/m photographs and the black male nudes, and the supposed "exploitation of children" recorded in the portraits of *Jesse McBride* and *Rosie*. Mapplethorpe's photography stands, for Helms, as the very picture of that which must be prohibited by Congress, as the catalog of indecencies the federal government must ward against.

The Click of the Shutter

Five weeks after its cancellation by the Corcoran Gallery, *The Perfect Moment* was mounted by the Washington Project for the Arts, an alternative arts space in the same city. Following its run in Washington, D.C. (where the show attracted some forty thousand viewers), *The Perfect Moment* traveled to the University Art Museum in Berkeley, where it was mounted without major incident, and then to the Contemporary Art Center (CAC) in Cincinnati. On April 7, 1990, the opening day of the exhibition in Cincinnati, police temporarily closed *The Perfect Moment* in order to videotape the show as evidence for an obscenity indictment sought by the Hamilton County Prosecutor.[119] That same day, both the CAC and its director, Dennis Barrie, were indicted on charges of pandering obscenity and child pornography. In September 1990, Barrie and the Contemporary Art Center were brought to trial.

The definition of obscenity to which Barrie and the CAC were subject during the trial was drawn from the 1973 Supreme Court decision in *Miller v. California*, which ruled obscene any work which, "taken as a whole, appeals to the prurient interest in sex; portrays in a patently offensive way, sexual conduct specifically defined by the applicable state law; and, taken as a whole, does not have serious literary, artistic, political, or scientific value."[120] Given this definition of obscenity, it is not surprising that both sides in the Barrie trial sought to sever issues of artistic form from those of subject matter, with the prosecution emphasizing the sexual content of particular Mapplethorpe images and the defense insisting on their aesthetic value and formal achievement. The opposing arguments in the Cincinnati trial thus replayed the tension between form and subject matter at the heart of Mapplethorpe's photographic enterprise.

In a pretrial motion, the prosecution argued that only seven of the 175 Mapplethorpe pictures in *The Perfect Moment* should be permitted into evidence— five s/m photographs (including the 1978 *Self-Portrait*) and two portraits of children in partial or complete undress: *Rosie*, from 1975, and *Jesse McBride*, from 1976. Drawing on *Miller v. California*, the defense argued that the alleged obscenity of *The Perfect Moment* could only be judged by considering the exhibition in its totality. The court found in favor of the prosecution. Its reasoning for doing so is worth quoting at length:

> The court finds that each photograph has a separate identity; each photograph has a visual and unique image permanently recorded. The click of the shutter has frozen the dots, colors, shapes, and whatever finishing chemicals necessary, into a manmade instant of time. Never can that "moment" be legitimately changed. . . . Arranging photographs within an exhibition to claim a "privilege of acceptability" is not the test; the "whole" is a single picture, and no amount of manipulation can change its identity.[121]

Notice the court's (modernist) stress on the autonomous "identity" of each photograph, on the power of any one picture to stand, and thus to be judged, alone. To the court, the curatorial arrangement of Mapplethorpe's work within a museum exhibition is just so much "manipulation." What matters is not the breadth of Mapplethorpe's artistic output, the development of his pictorial

style, the dialogue enacted between his various pictures, or the multiple genres and materials with which he worked. What matters is the single "moment" that has been frozen in the "click of the shutter."

The language of the court's ruling in the Cincinnati case echoes the title of *The Perfect Moment* exhibition. The court sees each of Mapplethorpe's photographs as a "manmade instant of time" or, again, as a "moment" that can "never . . . be legitimately changed." Janet Kardon, the curator of the retrospective exhibition, similarly argues in her catalog essay that "the final message of a Mapplethorpe photograph" is its ability to capture "the most seductive instant, the ultimate present that stops time and delivers the perfect moment into history."[122] Both the Cincinnati court and the museum curator stress the "identity" of the individual photograph—the unique (or "perfect") moment captured by the camera— as the defining feature of Mapplethorpe's work. The court does so in order to isolate seven Mapplethorpe pictures from the larger context of the exhibition in which they were presented. Kardon does so in order to situate the photographer as a "committed formalist."[123]

The court's ruling represses the comparative logic of Mapplethorpe's work, the ways that the artist insistently juxtaposed one photographic genre to the next. Whether it was through the use of matching portfolios, concurrent gallery exhibitions, or published interviews, Mapplethorpe almost always emphasized the formal parallels among his various photographs. And, perhaps more to the point, so did *The Perfect Moment*. As organized by Kardon, each gallery of the exhibition included a range of photographic subjects, including portraits, self-portraits, still lifes, nudes (often though not exclusively of black men), and s/m photographs.[124] In addition, *The Perfect Moment* displayed the X, Y, and Z portfolios in a manner that compelled viewers to compare and contrast the pictures to one another. A slanted table offered the complete contents (thirteen photographs each) of the three portfolios set out in a neatly arranged grid (figure 4.37). It was on such a table that all five of the s/m photographs at issue in the Cincinnati trial were displayed.

Within the context of *The Perfect Moment*, then, these five pictures could be seen only in juxtaposition to the other images in the X portfolio, as well as to the flowers in the Y portfolio and the black male nudes in the Z portfolio. Within the context of the Cincinnati trial, however, these five photographs, along with the two portraits of children, were viewed as autonomous pictures. According to the *Los Angeles Times*, the legal effect of the court's pretrial ruling was "that Barrie and the center may be convicted if only one photograph is found to be obscene."[125] By defining Mapplethorpe's work in terms of the "separate identity" of seven photographs, the court distorted both the viewing conditions of *The Perfect Moment* and the structuring logic of Mapplethorpe's photography.

In its pretrial ruling, the court invoked a discourse of formalism to isolate some of Mapplethorpe's most controversial—and, in the prosecution's view, his most patently obscene—photographs from the rest of his output. In the course of the trial, however, defense witnesses would invoke a similar discourse of autonomous form to emphasize the artistic value of Mapplethorpe's photography. Martin Friedman, the director of the Walker Art Center in Minneapolis and an expert witness for the defense, described Mapplethorpe's artistic achievement in the following manner:

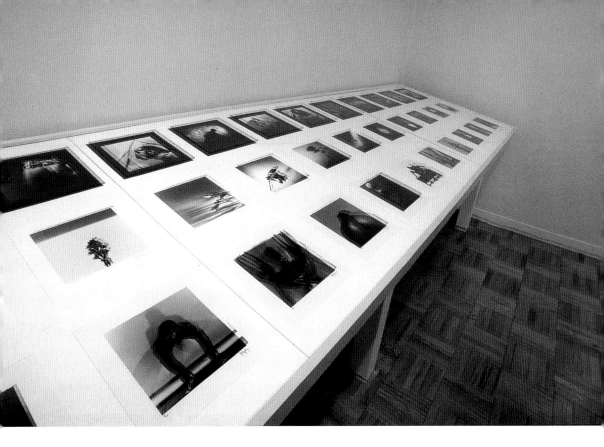

Figure 4.37.
"Robert Mapple-
thorpe: The Perfect
Moment," 1988.
Installation photo-
graph of X, Y, and Z
portfolios, Institute
for Contemporary
Art, University of
Pennsylvania.
Courtesy Institute
for Contemporary
Art, Philadelphia.

There is about Mapplethorpe's work an extraordinary quality of almost a surreal nature. It is reality in a vacuum. And he is able to apply that extremely intense, formal vision to a diversity of topics, whether they be still life, figure groups, landscape. And there is a consistency in his handling of form, light and space.

He is essentially a formalist, in fact, a classicist, in my view. And his roots are very strongly, really almost Nineteenth Century salon photography.[126]

Janet Kardon would similarly testify that Mapplethorpe was "one of the most important photographers working in the 1980s in a formalist mode" and that formalism "has to do less with subject matter and more with light, color, composition, [and] arrangement."[127] Under friendly questioning from the defense lawyer, Kardon proceeded to offer the following account of Mapplethorpe's photographic enterprise: "No matter what the subject matter, he brought a sense of perfection to it. And all the attributes one characterizes a good formal portrait by, that is composition and light and the way the frame is placed around the image, all of those things are brought to bear in every image."[128] In describing the 1978 *Self-Portrait* to the jury, Kardon called it a "figure study" in which "the human figure is centered. The horizon line is two-thirds of the way up, almost the classical two-thirds to one-third proportions. The way the light is cast, so there's light all around the figure, it's very symmetrical, which is very characteristic of his flowers."[129] The glaring absence in Kardon's description of the 1978 *Self-Portrait* is, of course, Mapplethorpe's anus, along with the bullwhip with

which he penetrates it, the leather chaps, vest, and boots he wears, and the defiance of his gaze as he turns to confront the camera and, by extension, the viewer. Kardon strategically ignores the dynamic relation between the elegant form of the *Self-Portrait* and its explicitly sexual subject matter. In so doing, she elides the significance of the 1978 *Self-Portrait* as a document of Mapplethorpe's participation in s/m subculture.

It may be, however, that such a reading of the image was not possible given the circumstances under which Kardon was testifying. Kardon was describing the 1978 *Self-Portrait* in terms she thought (or was advised) would be most helpful to the defense's case. Her formalist discourse was shaped, at least in part, by the legal exigencies of the trial at which she was testifying, not by a scholarly ambition to describe the work in its full complexity or historical context. The logic of the law imposed its own restrictions on Kardon's language. It is worth noting, however, that Kardon's catalog essay for *The Perfect Moment* similarly fixes on the formal qualities of Mapplethorpe's work while largely (though not, as in her trial testimony, entirely) avoiding issues of sexuality and sadomasochism.

The discourse of formalism mobilized by the defense would reach a rhetorical apogee with the testimony of Evan Turner, the director of the Cleveland Museum of Art. In reference to the five s/m photographs, Turner would propose to the jury, "I think with these difficult images, one way of judging their quality . . . is to look at them as abstract, which they are, essentially."[130] Turner overcomes the "difficulty" of Mapplethorpe's s/m photographs by bracketing their subject matter to such an extent that it all but disappears into abstraction.

Robert Sobieszek, a photography curator and expert for the defense, similarly underscored the formal significance of Mapplethorpe's work or, as he put it, "how they are composed, how they are lighted, how they are finished, how they are printed."[131] When discussing the five s/m photographs in particular, however, Sobieszek shifted from a formalist discourse to a biographical one of the tortured artist: "They reveal, in very strong, forceful ways, a major concern of this creative artist; a major part of his life, a major part of his psyche or psychology, his mental make-up and perhaps, they say to me, some troubled portion of his life that he was trying to come to grips with. . . . It's not unlike Van Gogh painting himself with his ear torn off, or cut up."[132] By stationing Mapplethorpe's s/m photography in relation to Van Gogh's self-portraiture, Sobieszek links the former to the latter's undisputed status as high art. But in so doing, he analogizes Mapplethorpe's practice of sadomasochism to Van Gogh's emotional distress and physical self-mutilation. Sobieszek's line of reasoning, as critic Douglas Crimp has pointed out, positions Mapplethorpe's s/m photographs as pathological. "What is disclaimed here," writes Crimp of Sobieszek's testimony, "is Mapplethorpe's willing and active participation in a sexual subculture that we have no reason to believe he found 'troubling' or was 'trying to come to grips with.'"[133] In order to situate Mapplethorpe's s/m photographs as art, defense witnesses either ignored their subject matter altogether or framed it within the terms of psychological suffering and distress.

Somewhat surprisingly, the prosecution called only one expert witness to discredit the artistic value of Mapplethorpe's photography. That witness was Judith Reisman, a paid researcher for the American Family Association and (as the defense would repeatedly remind the jury) a former songwriter for the *Captain*

Kangaroo television series. Responding to the contention of a defense witness that art "expresses human emotion or human feeling," Reisman insisted that the five s/m photographs could not be considered art because four of them excluded or masked the human face while the fifth, the 1978 *Self-Portrait*, "displayed no discernible emotion."[134] Of Mapplethorpe's *Self-Portrait*, Reisman argued, "With the absence of pain, even of joy, the absence of distress, of any human emotion, one then receives information that this is an appropriate activity."[135] Reisman criticizes the 1978 *Self-Portrait* for its emotionlessness while neglecting to describe Mapplethorpe's act of anal penetration; his leather bullwhip, boots, and harness; or the sexual subculture to which all of these related. Like the expert witnesses for the defense, Reisman avoids the topic of gay sadomasochism almost entirely.[136]

Why would the prosecution's one expert witness repress the sexually explicit subject matter of the photographs she sought to define as obscene? Although this question cannot be answered definitively, it seems likely that Reisman's testimony was informed by the prosecution's conviction that the "bottom line is the pictures" and "the pictures will speak for themselves."[137] Perhaps Reisman shied away from the subject matter of Mapplethorpe's pictures because she believed, like the lawyers with whom she would have consulted prior to her testimony, that the visual explicitness of the photographs would provide sufficient evidence of their obscenity. Words failed the prosecution's expert witness when she was faced with Mapplethorpe's s/m photographs. The only argument she was able to articulate regarding these photographs—that they lacked visible emotion—was hardly sufficient as a legal demonstration of obscenity. The defense witnesses, by contrast, mobilized an elaborate verbal discourse of formalism—of composition, lighting, printing, and technical expertise—to establish the artistic merit of Mapplethorpe's work.

On October 5, 1990, after less than two hours of deliberation, the Cincinnati jury acquitted Barrie and the Contemporary Art Center of all charges.[138] After the trial, members of the jury told reporters that, however repulsed they may have been by Mapplethorpe's photographs ("We thought the pictures were lewd, grotesque, disgusting," one juror told the *New York Times*), they felt they should defer to the opinion of experts on the matter since they, the jurors, understood nothing about modern art.[139] The verdict in the Cincinnati trial seems to have been motivated not by the jury's confidence in the artistic value of Mapplethorpe's work but by their self-perceived incomprehension of that work, by their sense of inadequacy in the face of contemporary art and the criteria by which it is to be judged. As one juror put it, "I'm not an expert. I don't understand Picasso's art. But I assume the people who call it art know what they're talking about."[140]

The experts who called Mapplethorpe's work art at the Cincinnati trial did so by describing its formal elegance and technical achievement. Their arguments succeeded, at least in part, because they bracketed the centrality of gay subculture and sexuality to Mapplethorpe's s/m photographs. The trouble with such arguments, as both Carole Vance and Douglas Crimp have suggested, is that they tacitly accept a view of homosexuality as degrading and unspeakable. "If we are afraid to offer a public defense of sexual images," wrote Vance shortly after the Corcoran's cancellation of *The Perfect Moment*, "then even in our rebuttal we have

granted the right wing its most basic premise: sexuality is shameful and discrediting."[141] Within the broader context of the Mapplethorpe controversy (the context of Jesse Helms and the Christian Coalition as well as that of the Cincinnati trial), the "basic premise" of homosexuality as "shameful and discrediting" gathered remarkable force.

I mentioned above that words failed the prosecution's one expert witness, at least insofar as her words were meant to persuade the jury that Mapplethorpe's work was obscene. In a telling moment during the trial, however, Reisman was cross-examined by a defense lawyer concerning an article she had published denouncing the "gay lifestyle." By way of explaining her views about homosexuality, Reisman testified that "anal sodomy is traumatically dysfunctional and is definitely associated with AIDS."[142] Reisman did not explicitly link this statement about AIDS and sodomy to either Mapplethorpe or his photography. Given the trial at which she was testifying, however, Reisman's words could not but reinforce the association (already frequently drawn by this time) between Mapplethorpe's sexually explicit work and his AIDS-related death.[143] In closing this chapter, I want to look more closely at the ways in which Mapplethorpe's sickness was collapsed into the frame of his photography.

Shockers

At the core of *The Perfect Moment* controversy was the claim that Mapplethorpe's photographs constituted a form of obscenity and should not, therefore, be funded by the federal government or displayed by a museum. And underwriting that claim was the insistence, sometimes made explicit, that Mapplethorpe's work was shot through with the dangerous force of his own sexuality. "This Mapplethorpe fellow," Helms told the *New York Times* in July 1989, "was an acknowledged homosexual. He's dead now, but the homosexual theme goes throughout his work."[144] Or again: "Mapplethorpe was a talented photographer. But clearly he was promoting homosexuality. He was a homosexual, acknowledged to be. He died of AIDS. And I'm sorry about that. But the fact remains that he was using this, his talent, to promote his homosexuality."[145] Such repeated invocations of Mapplethorpe's homosexual life and AIDS-related death were meant to evidence the depravity of his work. During congressional hearings on the NEA, Helms would mention Mapplethorpe's "recent death from AIDS" and then describe his photography in the following manner: "There are unspeakable portrayals which I cannot describe on the floor of the Senate. . . . Mr. President, this pornography is sick. But Mapplethorpe's sick art does not seem to be an isolated incident. Yet another artist exhibited some of this sickening obscenity in my own state. . . . I could go on and on, Mr. President, about the sick art that has been displayed around the country."[146] In denouncing Mapplethorpe's art as "sick," Helms suggests that it is not an "isolated incident" but a spreading "obscenity" that must be contained and eradicated. HIV infection is thus displaced from Mapplethorpe's body to the body of his work as his photographs are said to pollute (the neoconservative fantasy of) a "clean" American culture. Helms's attack on Mapplethorpe's photography was quite consistent with the senator's public policies regarding AIDS at the time. In June 1987, Helms appeared on national

television to call for a federal quarantine of people with AIDS, a proposal almost as menacing as the spread of HIV infection it sought to ward against (figure 4.38).[147] Four months later, Helms successfully sought to prohibit the federal funding of AIDS prevention materials that might "promote, encourage, or condone homosexual sexual activities or the intravenous use of illegal drugs."[148] Helms censored the depiction of safer sex and clean needles from the very materials where those representations were most necessary—AIDS prevention posters, brochures, cartoons, and other forms of public information about the crisis. In the course of introducing this amendment on the floor of the Senate, Helms would offer his own theory of HIV transmission: "Every AIDS case," he said flatly, "can be traced back to a homosexual act."[149] For all its terrible ignorance, Helms's (mis)statement bespeaks the symbolic force of the association between gay male sex and epidemic sickness, an association that Helms would later summon in his attacks on Mapplethorpe and the National Endowment for the Arts.

Although employed with particular ferocity by Senator Helms, this rhetorical association was hardly invented by him. Here is how the writer Dominick Dunne described a 1988 Mapplethorpe retrospective to the readers of *Vanity Fair* magazine: "However much you may have heard that this exhibition was not a shocker, believe me, it was a shocker. Robert Mapplethorpe was described by everyone I interviewed as the man who had taken the sexual experience to the limits in his work, a documentarian of the homoerotic life in the 1970's at its most excessive, resulting, possibly, in the very plague that was killing its recorder."[150] Dunne rewrites the express homosexuality of Mapplethorpe's

Figure 4.38. ACT UP, *Let the Record Show...*, 1987. Mixed media, installed in New Museum window, detail. Courtesy New Museum of Contemporary Art, New York.

s/m work as an etiology of disease. Dunne's plague metaphor contaminates both gay sexual culture of the 1970s and its photographic portrayal by Mapplethorpe. In a similar if even more hyperbolic rhetorical move, *Artnews* critic Susan Weiley wrote that, in light of AIDS, the most explicit of Mapplethorpe's s/m images "provoke a shudder similar to the one we feel looking at smiling faces in photographs of the Warsaw ghetto."[151]

Such an escalation of rhetoric (from homosexuality to AIDS to plague to genocide) characterizes not only the reception of Mapplethorpe's work in the late 1980s but also the justifications given for its censorship. Throughout the NEA episode, the relentless invocation of Mapplethorpe's death as a result of AIDS and the frequent representation of his body as conspicuously ailing served as the frame through which his s/m photographs, and sometimes his entire photographic output, were to be viewed. Mapplethorpe, once the most explicitly "gay" of gay male artists, now became the most explicitly diseased of artists with AIDS.

As Carole Vance has argued, the rhetoric of sickness and moral decay employed throughout *The Perfect Moment* controversy was at times "chillingly reminiscent of Nazi cultural metaphors" of degenerate art.[152] Vance cites the following passage from a 1989 editorial by Patrick Buchanan as one such example: "As with our rivers and lakes, we need to clean up our culture: for it is a well from which we must all drink. Just as poisoned land will yield poisonous fruits, so a polluted culture, left to fester and stink, can destroy a nation's soul."[153] Buchanan's imagery of contagion and disease, of poison and pollution, derives a good deal of its rhetorical punch from the fact that Mapplethorpe's work had already been connected, via the artist's homosexuality and AIDS-related death, to danger and degeneracy. As art critic Ingrid Sischy pointed out at the time, "The press coverage of the Corcoran's cancellation made it clear just how glued together Mapplethorpe and AIDS have become. Practically every time his name was mentioned, AIDS was mentioned too, as his I.D. . . . Now the physical sickness that the man endured is being used to confirm ideas that the work itself is sick."[154] In this context, Sischy discusses the fact that Mapplethorpe's late self-portraits were often published in the popular press to signify the "illness" of both the artist and his imagery. Mapplethorpe's 1988 *Self-Portrait* with death's-head cane (figure 4.39) was the photograph most often reproduced to this end.

What is most striking about the 1988 *Self-Portrait* is that, like Mapplethorpe's work on gay sadomasochism, it explicitly refutes the conventions of "victim photography" (i.e., photographic images in which members of marginalized social groups are offered up as victims, freaks, or "specimens" to an implicitly normative viewing audience).[155] As Douglas Crimp has argued, photographic portraits of people with AIDS in the 1980s and early 1990s often exploited the visible signs of disease to solicit both fear and pity from the viewer.[156] In such photographs, "people's difficult personal circumstances are exploited for public spectacle. Yet the portrayal of these circumstances never include . . . the social conditions that made AIDS a crisis and continue to perpetuate it. People with AIDS are kept safely within the bounds of their tragedy."[157]

Consider, in this context, a photograph taken of Mapplethorpe at the opening of his Whitney retrospective that was published, along with Dunne's aforementioned text, in the February 1989 issue of *Vanity Fair* (figure 4.40). Although

Figure 4.39. Robert Mapplethorpe, *Self-Portrait*, 1988. Photograph. ©The Estate of Robert Mapplethorpe.

Figure 4.40. Robert Mapplethorpe photographed by Jonathan Becker at the Whitney
Museum of American Art, July 1998. Originally published in *Vanity Fair*, February 1989.

dressed in a tuxedo and surrounded by well-wishers, Mapplethorpe seems detached and despondent, as though lost in the realm of his own fatigue. The photograph directs our attention to the splotchy discolorations on Mapplethorpe's face and neck, to his bony, prematurely wrinkled hands, and to the walking stick he angles toward himself. Above all, the photograph conveys a sense of the artist's physical defeat at this, his moment of greatest professional triumph. One cannot help but contrast Mapplethorpe's unfocused gaze and ailing body with the alert and fully engaged figures who surround him. Even as it presents Mapplethorpe in the public space of the museum, *Vanity Fair* confines him to the terms of his individual, and now inevitable, tragedy.

Look again at the self-portrait Mapplethorpe created in 1988, less than two months before the opening of his Whitney retrospective. In contrast to the *Vanity Fair* photograph, the 1988 *Self-Portrait* signifies anger as well as illness, confidence in the face of cultural fear. Through its very theatricality (white fist grasping death's-head cane in near space, white face floating in deeper space, all set within a monochrome of black), the *Self-Portrait* asserts Mapplethorpe's authority over his self-representation. While the visual repercussions of AIDS are there to be seen in the face of Robert Mapplethorpe, the force of his photographic style contests the patheticizing operations of victim photography.

"Photography," Crimp observes, "is a very impoverished medium for representing anything so complex as AIDS, as *living* with AIDS."[158] Unlike most portraits of people with AIDS, Mapplethorpe's 1988 *Self-Portrait* admits that impoverishment, even insists upon it. In this image, as in the 1978 *Self-Portrait* with bullwhip, Mapplethorpe simultaneously meets and defies the gaze of his own camera. By so doing, he signals the radical insufficiency of photography to capture the experiences—and vulnerabilities—of his sentient body.

5

Vanishing Points

Art, AIDS, and the Problem of Visibility

In March 1986, the conservative writer William F. Buckley called for the mandatory tattooing of people with AIDS. "Everyone detected with AIDS," he wrote in a widely cited op-ed piece in the *New York Times*, "should be tattooed in the upper forearm, to protect common-needle users, and on the buttocks, to prevent the victimization of other homosexuals."[1] As Buckley saw it, people with AIDS had to be indelibly marked as such, their bodies imprinted with a literal sign of the danger they posed to others. Buckley's tattoo proposal was fueled by the fear that people infected with HIV would not be clearly differentiated from the rest of the public, that their infection would not be *visible enough*.[2]

In November 1987, approximately thirty members of a newly formed activist organization called the AIDS Coalition to Unleash Power (ACT UP) created a site-specific artwork for the window of the New Museum of Contemporary Art in New York.[3] The work, entitled *Let the Record Show . . .*, featured a pink neon sign that declared "Silence = Death," an LED signboard, a photomural of the Nuremberg trials, and a series of six cardboard cutouts representing public figures who had, in the view of ACT UP, aggravated the AIDS crisis (figures 5.1, 5.2). Directly beneath each cardboard silhouette was a concrete slab that was inscribed, headstone-like, with a quote relating to the epidemic. The fifth cardboard cutout bore a likeness of William F. Buckley. The accompanying slab was inscribed with these words: "Everyone detected with AIDS should be tattooed in the upper forearm, to protect common-needle users, and on the buttocks, to prevent the victimization of other homosexuals."

FACING PAGE: Figure 5.1. ACT UP, *Let the Record Show . . .*, 1987. Mixed media, installed in New Museum window, detail. Courtesy New Museum of Contemporary Art, New York.

In one sense, *Let the Record Show* . . . reversed the logic of Buckley's proposal. Rather than rendering the person with AIDS visible as a threat to others, ACT UP portrayed Buckley himself as part of the crisis, the social and political disaster, that AIDS had become by 1987. In setting a cardboard likeness of the columnist against a photomural of the Nuremberg trials, ACT UP drew out the link between Buckley's proposal and the compulsory tattooing of inmates in the Nazi death camps. ACT UP challenged Buckley's regulatory scheme by forcing the regulator—rather than his targets—into visibility.[4]

Although the LED signboard in *Let the Record Show* . . . offered statistics about AIDS fatalities (e.g., "By Thanksgiving 1987, 25,644 known dead"), the work included no image of a person with AIDS. This visual absence was in keeping with ACT UP's refusal to portray the epidemic in terms of individual suffering or private tragedy. *Let the Record Show* . . . countered the prevailing image of the "AIDS victim" at the time—the image of a homosexual man or I.V. drug user confined to a wheelchair or hospital bed, the image of a wasted body at or near the threshold of death.[5] "Since the earliest days of the epidemic," writes David Román in his study of AIDS and performance in the United States, "gay men have been identified nearly irreversibly with AIDS."[6] As we saw in the case of the Mapplethorpe controversy, the "irreversible" association between gay men and AIDS was often used to position homosexuality itself as a form of sickness and public threat.[7] *Let the Record Show* . . . responds to this problem by presenting not a gay man but a senator, a surgeon, a health commissioner, a Christian fundamentalist, a conservative columnist, and the President of the United States as the very pictures of medical and political crisis.

This chapter focuses on artists who insisted on homosexual visibility even as they sought to disrupt what Román calls the "encapsulation of AIDS as 'homo-

sexual.'"[8] It looks at the work of Gran Fury, an AIDS activist art collective active from 1988 to 1992, and David Wojnarowicz, an artist and writer whose work addressed AIDS from 1987 (the year he tested HIV-positive) until his death in 1992. In response to the prevailing representation of the epidemic as the image (and threat) of the infected homosexual, these artists depicted both homoerotic pleasure and political rage. As a result, their work was denounced, defaced, prohibited from public display, and otherwise suppressed. As I have argued throughout this book, attempts to censor or suppress works of art produce contradictory effects: they provoke as well as prohibit artistic expression. In different ways, both Gran Fury and Wojnarowicz responded to the threat of censorship by representing that threat, by picturing the restrictions to which their art was subjected. This chapter traces the various relays of restriction and response, of attack and counterattack, that shaped the work of these artists in the late 1980s and early 1990s.

Activist Erotics

The creation of *Let the Record Show . . .* by ACT UP would lead, early in 1988, to the formation of Gran Fury, a self-described "band of individuals united in anger and dedicated to exploiting the power of art to end the AIDS crisis."[9] The eleven founding members of Gran Fury were all participants in ACT UP, and most of them had collaborated on *Let the Record Show* The collective took the name Gran Fury in reference both to its own anger in the midst of the epidemic and, more ironically, to the model of Chrysler Plymouth sedan that the New York City police used as squad cars. Inscribed within the group's name, then, was a reference to both a subjective experience (rage) and a tool of State power (police squad cars), to both an internal sensation and an external force.

Though organized as an autonomous collective, Gran Fury worked in close alliance with ACT UP, producing posters and agitprop to accompany the larger group's demonstrations, and serving, in the words of Douglas Crimp and Adam Rolston, as ACT UP's "unofficial propaganda ministry and guerrilla graphic designers."[10] As part of its pictorial contribution to the AIDS activist movement, Gran Fury sometimes recycled historical images of homoerotic pleasure. In the spring of 1988, for example, Gran Fury created two posters in conjunction with ACT UP's "day of protest" against homophobia. In the first, the slogan "Read My Lips" extends across a World War II–era picture of two sailors in the midst of a kiss (figure 5.3); in the other, the same slogan sits atop a 1920s photograph of two women gazing, with longing intensity, into each other eyes (figure 5.4). The source image for the latter was a publicity still from a 1926 play entitled *The Captive*, the first Broadway show to focus on the subject of lesbianism and, as a result, the target of a citywide censorship campaign. In February 1927, at the height of the controversy over *The Captive*, New York City police raided the play and arrested its producers and cast, including leading lady Helen Menken (who is seen kneeling on the left in Gran Fury's poster).[11] Menken and company were released the next day after the producers of *The Captive* promised to close the play, which they did within the week.[12] Less than two months after the police raid on *The Captive*, the New York State legislature passed a law prohibiting the

KISS IN

Friday, April 29:
 9:00 pm **March from Christopher & West Sts.**
10:00 pm **Rally at Sheridan Square**
10:30 pm **Kiss In at 6th Avenue & 8th St.**
11:30 pm **Tracks—ACT UP/ACT NOW Fundraiser**

FIGHT HOMOPHOBIA: FIGHT AIDS

SPRING AIDS ACTION '88: Nine days of nationwide AIDS related actions & protests.

Figure 5.3. Gran Fury, *Read My Lips (Boys)*, 1988. Poster (offset lithography), 10¾" × 16¾". Courtesy Gran Fury.

presentation of any theatrical work "depicting or dealing with, the subject of sex degeneracy, or sex perversion," a law that remained on the books until 1967.[13] The female version of *Read My Lips* thus carried a historical reference, however unknown to most viewers of the poster in 1988, to a defiant moment of lesbian visibility and to the police actions and legislative censorship that visibility provoked in 1927.

As several women in ACT UP were quick to point out, however, *Read My Lips* reduced lesbian eroticism to a gaze, a fixed distance, a refined delicateness: while the sailors smooched, the flappers just looked. To these objections, one might add that the publicity still from *The Captive* seems particularly ill suited to the

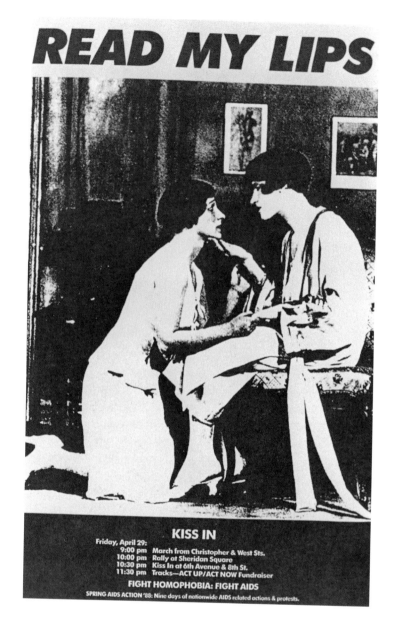

READ MY LIPS

KISS IN

Friday, April 29:
9:00 pm March from Christopher & West Sts.
10:00 pm Rally at Sheridan Square
10:30 pm Kiss In at 6th Avenue & 8th St.
11:30 pm Tracks—ACT UP/ACT NOW Fundraiser

FIGHT HOMOPHOBIA: FIGHT AIDS

SPRING AIDS ACTION '88: Nine days of nationwide AIDS related actions & protests.

slogan "Read My lips," since Menken and her costar are neither speaking nor kissing at this moment. What, then, is the message to be "read" on their lips? The muted eroticism of the image becomes even more conspicuous when juxtaposed with the sailor photograph selected for the male version of *Read My Lips*. When displayed side by side (as they often were in 1988), the two posters imply that lesbianism is somehow less physically expressive, less passionately embodied—in short, less sexually *active*—than male homosexuality. Even as Gran Fury sought to affirm both male and female homoeroticism in *Read My Lips*, the collective also—and unwittingly—desexualized lesbianism. When Gran Fury subsequently revived the poster as a T-shirt, however, the image from *The Captive* was replaced with a Victorian photograph of two women in the midst of a kiss

Figure 5.4.
Gran Fury, *Read My Lips (Girls)*, 1988.
Poster (offset lithography),
10⅛" × 16½".
Courtesy Gran Fury.

(figure 5.5). Such a revision was characteristic of Gran Fury's working method: its graphics, placed in service to a wider community of AIDS activists, were open to the criticism and creative input of that community.[14]

Within the original context for which *Read My Lips* was created—a "day of protest" against homophobia in April 1988—the poster announced a series of events organized by ACT UP, including a "kiss-in" at the corner of Sixth Avenue and Eighth Street in Manhattan.[15] Loosely modeled on the love-ins and be-ins of the late 1960s, kiss-ins were designed as public demonstrations of gay and lesbian presence. At an allotted moment, ACT UP members would kiss each other in same-sex pairings. While public displays of affection between heterosexual couples are routine, even banal, those between same-sex couples remain relatively rare, largely because of the verbal harassment and physical violence to which people engaging in such acts are vulnerable. According to ACT UP, its kiss-ins were held as "an aggressive demonstration of affection" that would "challenge repressive conventions that prohibit displays of love between persons of the same sex."[16]

Because it represents a transgression of social norms, the public enactment of a same-sex kiss can never be understood as the mere equivalent of a heterosexual one. Cultural critic Philip Brian Harper has argued that

> what is different . . . about the same-sex kiss versus its counterpart in the heterosexual narrative is that the former potentially functions to reveal a secret, not only about the nature of the *relationship* between the persons who kiss, but also about those persons themselves. In other words, due precisely to our culture's governing presumption that everyone is heterosexual unless proven otherwise, the same-sex kiss speaks to *identity* in a much more highly charged way than does a kiss between a woman and a man.[17] (Harper's emphasis)

Harper's point—that a same-sex kiss enacted in public reveals sexual identity in a more dramatic (and often a more dangerous) fashion than does an opposite-sex kiss—is both confirmed and complicated by the example of the AIDS activist kiss-in. Within the context of an ACT UP kiss-in, men were encouraged to kiss other men and women other women regardless of the "actual" relationship between the kissers (e.g., friends, lovers, acquaintances, virtual strangers). The collective act of kissing was here intended to serve as a public defiance of homosexual invisibility, not (or at least not necessarily) as a declaration of romantic love or sustained union between the kissing participants. At a kiss-in, same-sex kissing could be performed by anyone in ACT UP, including the straight and bisexual members of the group. "We kiss," says ACT UP's fact sheet, "so that all who see us will be forced to confront their own homophobia." Kissing is here enacted not as an expression of romantic intimacy but as a public performance of same-sex visibility, a performance directed toward an audience of onlookers who are not themselves part of the action.[18]

Both the male and (revised) female versions of *Read My Lips* might be said to fulfill a similar performative function to ACT UP's kiss-in, although with an added historical resonance. The recovery of homoerotic imagery from the first half of the century ties same-sex kissing to the legacy of gay and lesbian culture

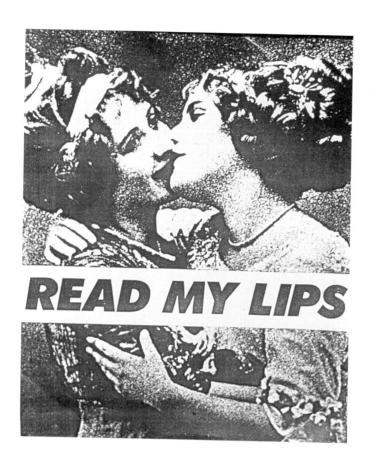

before Stonewall. The male version of *Read My Lips*, for example, revives the long-standing pictorial tradition of the sailor as an object of homoerotic attention, a tradition that, as we saw in chapter 2, strongly shaped Paul Cadmus's paintings of the 1930s. To create *Read My Lips*, Gran Fury reproduced an underground porn photograph from 1940–45, a print of which is now housed in the archives of the Kinsey Institute for Research in Sex, Gender, and Reproduction (figure 5.6). In contrast to the cropped version that appears in *Read My Lips*, the original photograph extends well below waist level to include both sailor's semi-erect penises, one of which rests, in almost perfect perpendicular, upon the other. Within the terms of the original photograph, the sailors' kiss was one part of a more extensive act of sexual exchange and exposure. For *Read My Lips*, Gran Fury shifted attention from below the belt of the sailors to above, from a scene of genital display and pornographic exposure to an erotic (if no longer explicitly sexual) image of kissing.

I have returned to the source photograph for the male version of *Read My Lips* so as to demonstrate that the poster's homoeroticism is marked by a prior pictorial absence. The cropping out of the lower portion of the sailor image might be said to reenact the censorship to which photographs of homosexual exchange have historically been subjected. Although the cropping of the sailor porn renders it less explicitly sexual, Gran Fury's distribution of *Read My Lips* forces the

Figure 5.5.
Gran Fury, *Read My Lips (Girls)*, revised version, 1988.
Poster (offset lithography),
10" × 16½".
Courtesy Gran Fury.

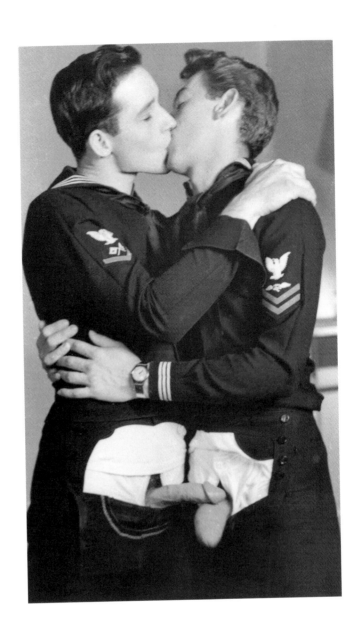

Figure 5.6.
Anonymous photo-
graph, c. 1940–45.
Courtesy Kinsey
Institute for
Research in Sex,
Gender, and
Reproduction,
Bloomington, Ind.

image into an unprecedented degree of public visibility. In the 1940s, the sailor
photograph would have circulated as a contraband image among a small and
secret circle of male viewers. As revived by Gran Fury in the late 1980s, the
(cropped) picture was pasted onto utility poles, bus shelters, and city buildings
and then printed on T-shirts worn by ACT UP members and their supporters
(figure 5.7).[19]

In a March 1989 demonstration, hundreds of ACT UP members gathered at
New York City Hall to demand city housing for homeless people with AIDS and
treatment programs for infected IV drug users. Scores of ACT UP members
were arrested for civil disobedience during the demonstration, including at least
one wearing a *Read My Lips* T-shirt (figure 5.8). Even as he is being dragged off

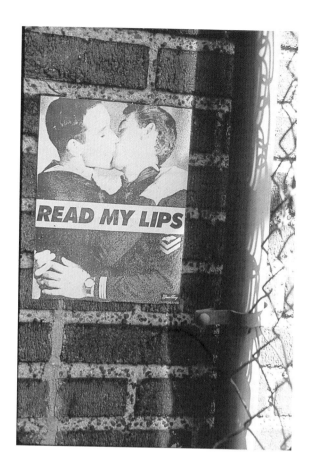

Figure 5.7. TOP
Gran Fury, *Read My
Lips (Boys)*, 1988. Poster
(offset lithography).
Courtesy Gran Fury.

Figure 5.8. BOTTOM
Fred W. McDarrah,
"ACT UP demonstrator
being carried off by
police in front of New
York City Hall," March
28, 1989. Photograph.
© Fred W. McDarrah.

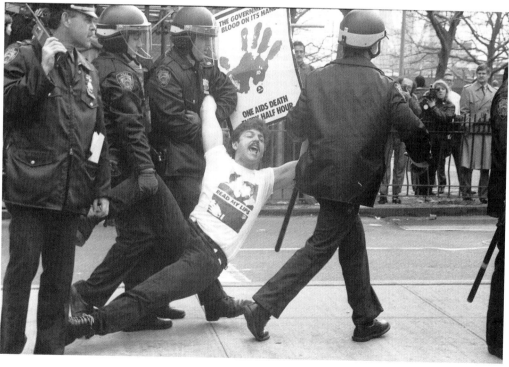

into custody, this ACT UP member continues to get his message across. His *Read My Lips* T-shirt counters the riot gear and billy clubs of the police with the visible, nonviolent power of homoeroticism. It mouths defiance as well as desire.

Kissing Doesn't Kill

Less than a year after the debut of *Read My Lips*, Gran Fury produced another graphic showcasing the same-sex kiss as a response to the AIDS crisis (figure 5.9). Initially produced as a busboard (an advertisement affixed to the side of a city bus), the 1989 graphic offers three interracial couples dressed in high-contrast colors and posed against an expanse of white monochrome. Each of the couples is kissing. Both the brightly patterned clothing worn by the figures and the overall visual style of the image simulate Benetton's well-known "Colors of the World" ad campaign (figure 5.10). Indeed, at a quick first glance, we may think we have encountered yet another in that would-be provocative (if ultimately vacant) series of advertisements. It only takes another moment, however, to notice the differences Gran Fury has propelled into the space of advertising and to recognize that its agenda has nothing to do with boosting retail sales of Italian sportswear. Two of the three couples are of the same sex, and a banner caption extending above the entire image declares, "Kissing Doesn't Kill: Greed and Indifference Do." In smaller type, a rejoinder text beneath the image reads, "Corporate Greed, Government Inaction, and Public Indifference Make AIDS a Political Crisis."

Kissing Doesn't Kill mimics the codes of consumerist pleasure and visual seduction to capture the viewer's attention and direct it to the AIDS crisis. It affirms homoerotic desire and physical affection in the face of an ongoing epidemic, insisting that lesbians and gay men fight the efforts of the larger culture to position their sexuality as deviant or dangerous. In response to the dominant image of white gay men and poor people of color as the "guilty victims" of AIDS, *Kissing Doesn't Kill* celebrates cross-racial kissing (between men, between women,

Figure 5.9. Gran Fury, *Kissing Doesn't Kill*, 1989–90. Bus panel, 136" × 28". Courtesy Creative Time.

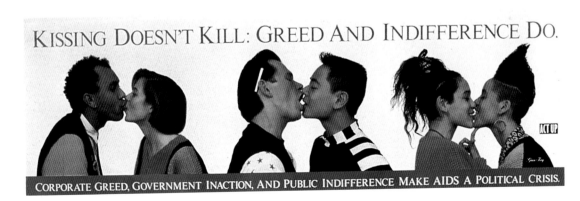

between a man and a woman) as pleasurable. Finally, *Kissing Doesn't Kill* challenges misinformation about AIDS, rejecting early accounts (and rumors) that erroneously named kissing as a risk behavior and saliva as a likely fluid of HIV transmission. The most notorious scandal concerning kissing and AIDS transmission occurred in the summer of 1985, when Rock Hudson publicly revealed that he had AIDS. Television stills of Hudson's kiss of Linda Evans on the previous season's *Dynasty* (on which Hudson was a guest star and Evans a cast member) were reproduced in tabloid newspapers and popular magazines (figure 5.11), and the issue of potential transmission via that kiss was repeatedly raised. The photographs and sensational headlines of this press coverage—"Fear and AIDS in Hollywood," "Has Linda Anything to Fear?," "Linda Evans and *Dynasty* Cast Terrified—He Kissed Her on Show"—invest Hudson's kiss with the threat of AIDS contagion and, more especially, with the threat posed to "innocent" heterosexuals (e.g., "Linda") by diseased and deceitful homosexuals (e.g., "Rock").

In contrast to the representation of the homosexual's kiss as potentially deadly, Gran Fury's busboard reclaims kissing as an affirmative—and safe—display of mutual affection and desire. In *Kissing Doesn't Kill*, as in *Read My Lips*, Gran Fury insisted on the centrality of eroticism to its practice of AIDS activism and on the ideal of sexual freedom in the midst of the crisis. As early as 1985, AIDS activist writers such as Cindy Patton were arguing that "AIDS must not be viewed as proof that sexual exploration and the elaboration of sexual community were mistakes. . . . Lesbians and gay men . . . must maintain that vision of

Figure 5.10.
"United Colors of Benetton," spring/ summer 1989.
Advertisement.
Photo by Oliviero Toscano. Courtesy Benetton Inc.

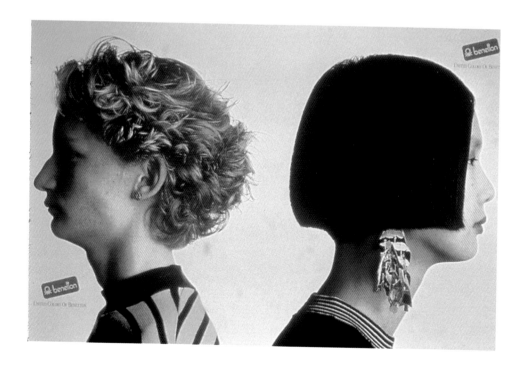

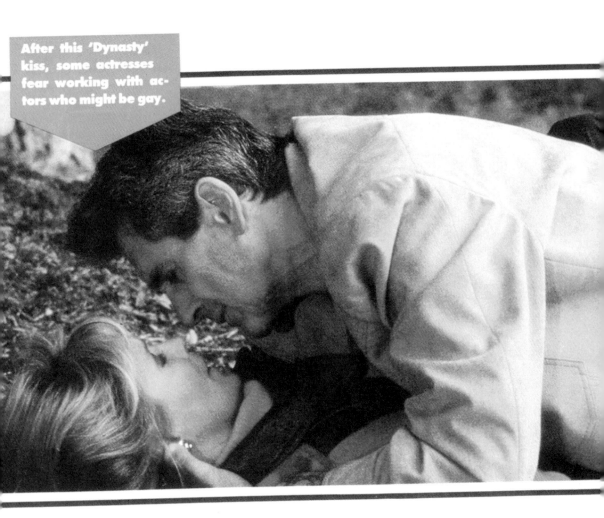

After this 'Dynasty' kiss, some actresses fear working with actors who might be gay.

sexual liberation that defines the last fifteen years of [our] activism."[20] In its defiantly joyous homoeroticism, *Kissing Doesn't Kill* offers just such a liberationist vision, now resituated within the context of the AIDS epidemic.[21]

When affixed to the side of a city bus, *Kissing Doesn't Kill* functions as a mobile advertisement, traveling through various neighborhoods of the city rather than remaining within the bounds of any one community or subculture. It courts as wide a consumer audience as possible, jockeying alongside other advertisements and mass-produced images within the public sphere. "We are trying to fight for attention as hard as Coca-Cola fights for attention,"[22] observed Gran Fury member Loring McAlpin of the group's mass-market ambitions. In *Kissing Doesn't Kill*, as in almost all of its activist production, Gran Fury simulated the glossy look and pithy language of mass-market advertising to seduce the public into dealing with issues of AIDS transmission, research, funding, and government response, issues that might otherwise be avoided or rejected out of hand. In catching viewers off-guard, Gran Fury sought to bring them into a heightened awareness of the AIDS crisis. Collective member Avram Finkelstein described

the success of Gran Fury's work, and of *Kissing Doesn't Kill* in particular, as deriving from the fact that it puts "political information into environments where people are unaccustomed to finding it. . . . It's very different from being handed a leaflet where you automatically know someone's trying to tell you something and you may not be receptive to hearing it. But when you're walking down the street and you're gazing at advertising—who knows what goes through [your] mind?"[23]

Kissing Doesn't Kill was commissioned by "Art against AIDS on the Road," a public art project organized in conjunction with several auctions of contemporary art that benefited the American Foundation for AIDS Research (AmFAR).[24] The invitation for Gran Fury to participate in the project, alongside such well-known contemporary artists as Barbara Kruger, Cindy Sherman, and the late Robert Mapplethorpe, was indicative of the art-world attention the collective was receiving at the time. Invitations to exhibit at the Whitney Museum and the Venice Biennale, among other prestigious venues, would follow within the next two years. By exploiting such attention and the financing and public access that accompanied it, Gran Fury was able to stage its graphics in ever-more-ambitious formats. The group's output—initially inexpensively produced posters and agit-prop (such as the *Read My Lips* posters)—soon evolved into full-color billboards, busboards, subway placards, and street signs.

The support of external funding agencies also carried with it particular forms of constraint. "Art against AIDS on the Road," for example, was organized by a group (AmFAR) reliant on corporate donations and other forms of financial support from the private sector. After Gran Fury submitted its design for *Kissing Doesn't Kill* to "Art against AIDS on the Road," AmFAR refused to run the rejoinder text of the piece: "Corporate Greed, Government Inaction, and Public Indifference Make AIDS a Political Crisis." Although it offered no justification for this decision, AmFAR likely considered the slogan to be uncomfortably explicit in its indictment of corporate motives and government practices.[25] Gran Fury was thus faced with the decision of eliminating the rejoinder text from *Kissing Doesn't Kill* or dropping the project altogether. The collective decided in favor of the former, believing that the visual power of the kissing couples together with the force of the primary slogan were strong enough to stand on their own.[26]

In San Francisco, Washington, D.C., and Chicago (the three cities included in the "Art against AIDS on the Road" tour), *Kissing Doesn't Kill* was thus displayed in an incomplete fashion, although viewers in those cities had no sense of what they were missing (figure 5.12).[27] Without its rejoinder text, *Kissing Doesn't Kill* addressed the AIDS crisis rather more loosely than Gran Fury had intended.[28] Some viewers concluded that the graphic was chiefly about the right of gay men and lesbians to kiss in public.[29] In Chicago, this misreading propelled a legislative effort to prohibit the poster's exhibition on public transit. City alderman Robert Shaw, for example, criticized *Kissing Doesn't Kill* as irrelevant to the AIDS crisis. "I don't have any objection to campaigning against AIDS," he told the *Chicago Tribune*, "but what does kissing have to do with the fight against the AIDS virus?"[30] Shaw, who went on to propose a citywide ban on the poster, argued that *Kissing Doesn't Kill* "has nothing to do with the cure for AIDS. It has something to do with a particular lifestyle, and I don't think that is what the CTA

[Chicago Transit Authority] should be [in] the business of promoting."[31] Shaw further claimed, without citing any evidence beyond the graphic itself, that Gran Fury's "advertisement seems to be directed at children for the purposes of recruitment."[32] The charge that gay and lesbian people aim to "recruit" children to homosexuality has often been used as a means of fomenting public support for antigay legislation.[33] What we might note here is how that accusation is being lodged not against gay people but against an image produced by them. In charging that *Kissing Doesn't Kill* aimed to "recruit" children to the cause of homosexuality, Shaw both misunderstood and (unwittingly) exemplified the poster's core concern: the irrational fear of homosexuality in the context of the AIDS crisis.

Although the Chicago City Council voted down Shaw's resolution banning *Kissing Doesn't Kill*, a similar proposal was taken up by the state legislature. On June 22, 1990, the Illinois State Senate approved a measure preventing the Chicago Transit Authority "from displaying any poster showing or simulating physical contact or embrace within a homosexual or lesbian context where persons under 21 can view it."[34] Since people of all ages take Chicago city buses, ride city trains, and walk down city streets, there would be no way to display *Kissing Doesn't Kill* on public transit so as to ensure that "persons under 21" would not see it. And this, of course, was precisely the logic structuring the wording of the bill. If passed into law, the bill would have effectively prohibited the public display of Gran Fury's work in Chicago.

Both the American Civil Liberties Union and the local gay and lesbian community protested the bill as unconstitutional. Participants in the 1990 Chicago lesbian and gay pride parade and rally carried a banner of *Kissing Doesn't Kill* to protest what they viewed as public intolerance and legislative censorship (figure 5.13). And, as the *Windy City Times* reported, "immediately following the Gay and Lesbian Pride Rally in Lincoln Park scores of people marched to the CTA bus maintenance facility . . . to hold a 'kiss-in' to protest the bill."[35] In a strategy of what might be called mimetic protest, the Chicago marchers enacted a version of the image that the state legislature was seeking to censor. They kissed to protest the prohibition of *Kissing Doesn't Kill*.

Later that summer, the "no physical embrace" bill was defeated by the Illinois House of Representatives. Following the bill's defeat, Chicago mayor Richard Daley encouraged Gran Fury to produce a "less offensive" image for display in the city, a proposal the collective "unequivocally refused."[36] In August 1990, forty-five *Kissing Doesn't Kill* billboards were belatedly exhibited on city bus shelters and subway platforms. Within two days of their installation, however, most of the billboards were defaced by vandals (figure 5.14). In defacing the posters, the vandals were making good on a prior threat that Alderman Shaw, among others, had made to the press: "This is a poster that advertises the homosexual and lesbian lifestyle. People are outraged. If the system fails us, I'm afraid people will take matters into their own hands and paint over this homo-erotic art."[37] As legislative attempts on both the local and state level had indeed failed to prohibit the display of *Kissing Doesn't Kill*, a more "hands-on" approach was apparently deemed necessary, at least by the most aggressive opponents of the poster.

Yet the vandalism of *Kissing Doesn't Kill* was itself reported by both the local and national press, thus exposing Gran Fury's poster (as well as its defacement) to a far wider audience than that which might have seen it on Chicago's buses and

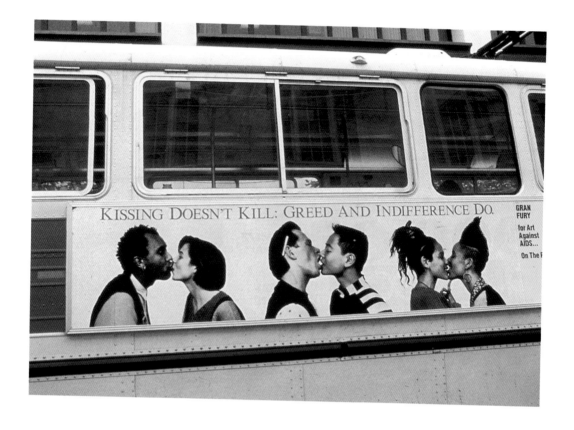

KISSING DOESN'T KILL: GREED AND INDIFFERENCE DO.

GRAN FURY

for Art Against AIDS...

On The

subway platforms.[38] The August 17 issue of the *Chicago Tribune*, for example, included a story on *Kissing Doesn't Kill* accompanied by an image of a policeman investigating the defacement of the poster on an elevated train platform. Entitled "Experts Cast Doubt on AIDS poster," the story reported not on the vandalism of *Kissing Doesn't Kill* but, rather, on whether the poster had anything productive to contribute to the battle against AIDS. The article cited comments from a range of Chicago health professionals and AIDS counselors, almost all of whom felt that *Kissing Doesn't Kill* was too vague to be of much value in terms of AIDS prevention. Departing from this consensus, the director of youth services for a local AIDS prevention project emphasized the value of the public dialogue that *Kissing Doesn't Kill* had provoked in Chicago: "I was listening to all the people calling in on the radio talk shows this morning and I thought, 'In opening up discussion on what this poster means and how we react to these three couples, it is far more successful than anything that would have just given facts.'"[39] This educator highlights something about *Kissing Doesn't Kill* that the other "experts" cited by the *Tribune* overlook: Gran Fury's poster is not seeking to instruct people about the proper use of condoms, the necessity of clean needles, or any other specific HIV prevention measure. Instead, *Kissing Doesn't Kill* aims to affirm the value of eroticism, especially homoeroticism, in light of the prevailing image of homosexuality as deadly threat and contagion.

Within the context of "Art against AIDS on the Road," *Kissing Doesn't Kill* faced several different forms of external constraint: AmFAR's rejection of the rejoin-

Figure 5.12. Gran Fury, *Kissing Doesn't Kill*, 1989. Bus panel installed on San Francisco MUNI as part of "Art against AIDS on the Road," 136" × 28". Photo by Gran Fury.

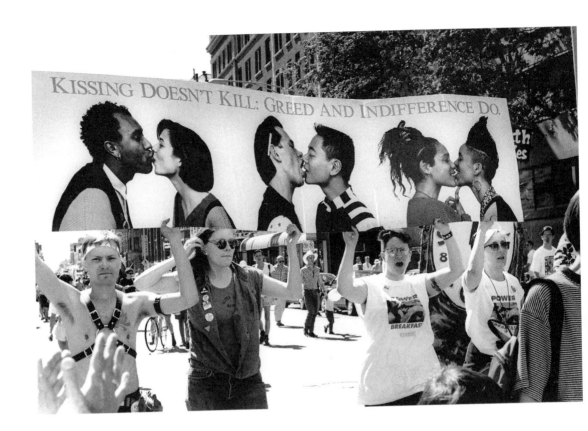

der text, the attempt of a Chicago city alderman to ban the image, the Illinois State Senate's bill outlawing "any poster showing or simulating physical contact or embrace within a homosexual or lesbian context," and the material defacement of the work once it was finally displayed in Chicago. These forms of constraint were linked to one another in various ways. The refusal of AmFAR to run the rejoinder text, for example, removed the work's explicit reference to the AIDS crisis and "softened" its activist message. This revision, in turn, enabled critics of the work to attack *Kissing Doesn't Kill* as a "recruiting" poster for homosexuality that had "nothing to do with AIDS."

As we have seen, the attempted suppression and actual defacement of *Kissing Doesn't Kill* in Chicago provoked a public dialogue about homosexuality, AIDS, and visual representation. Such dialogues formed a strategic part of Gran Fury's activism, extending the reach of their graphic production by tapping into the power of the mass media to spark and sustain public debate. The "work" of Gran Fury's art thus occurred as much in its reproduction as in its initial creation, as much in its coverage by the press as in its original display by the collective. Following its contested display in Chicago, *Kissing Doesn't Kill* would go on to become Gran Fury's most popular graphic, one that was widely reproduced in both the mainstream and alternative presses, exhibited in museums (figure 5.15), reprinted several thousand times as a poster, and even restaged by Gran Fury as a music video and broadcast on European MTV and American public television. When Gran Fury revived *Kissing Doesn't Kill*, the collective restored the work's rejoinder text.

I want to conclude this section with a particular example of the way *Kissing Doesn't Kill* circulated within the public sphere long after the poster's defacement in Chicago. In May 1991, the *New Art Examiner* published an article that recounted the Chicago controversy over *Kissing Doesn't Kill*. A footnote to the article mentions that "in a nice study in contrast with Chicago, the San Francisco Department of Public Health requested a copy of the 'kissing' poster from Art Against AIDS, which it had framed to hang in its public lobby."[40] In May 1999, I phoned the Department of Public Health in San Francisco to see whether *Kissing Doesn't Kill* was still on display there. After speaking to several employees who could not recall ever having seen a poster of three interracial couples kissing, I was instructed to phone the HIV Research Section, a division of the Department of Public Health housed in a different building from the main offices. I spoke with Paul O'Malley, a program manager in HIV Research who told me that the poster was "hanging in the hall right outside my office. I'm looking at it as I talk to you."[41] According to O'Malley, the poster's display was the work of a public health care staffer named Torsten Weld Bodecker who had admired *Kissing Doesn't Kill* when it was shown on San Francisco public transit in 1989. Following the poster's month-long display on city buses and trains, Bodecker decided that it should continue to be seen in San Francisco, at least by the clients and employees of the city's health department. After requesting and receiving a copy of *Kissing Doesn't Kill* from Art against AIDS, Bodecker hung the poster in the department's waiting area.

Bodecker died as a result of AIDS in 1992. The poster he installed at the Department of Public Health now hangs in a hallway that leads to rooms devoted to AIDS counseling, testing, and community-based studies (figure 5.16). The

FACING PAGE

Figure 5.13. TOP ACT-UP Chicago members carrying *Kissing Doesn't Kill* banner in Gay Pride Parade, June 1990. Photo by Lisa Ebright, originally published in *Windy City Times*, June 28, 1990. © Lisa Ebright, Chicago.

Figure 5.14. BOTTOM Defaced *Kissing Doesn't Kill* on Chicago train platform, August 1990. © Bill Stamets/ Impact Visuals.

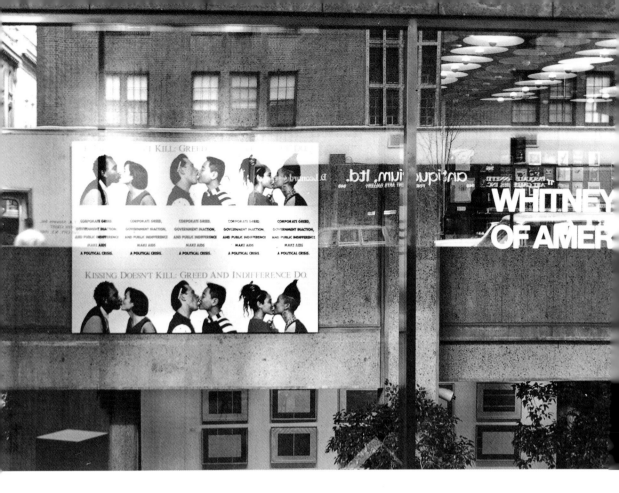

version of *Kissing Doesn't Kill* hanging in San Francisco is one of the original bus-board posters fabricated for "Art against AIDS on the Road." It does not, therefore, include Gran Fury's rejoinder text about AIDS. But the display of the poster in the HIV Research Section of the city's health department makes something of the same connection. Torsten Weld Bodecker's copy of *Kissing Doesn't Kill* continues to declare the importance of affection and desire in the face of a health crisis that, while dramatically changed since Bodecker's death, remains ongoing.

THE CONFLICT over *Kissing Doesn't Kill* in the summer of 1990 began less than a year after the cancellation of *The Perfect Moment* in June 1989. In the course of that same year, the National Endowment for the Arts would attempt to rescind an already-awarded grant to an art exhibition in New York City on the theme of AIDS and survival. A catalog essay by the artist and writer David Wojnarowicz lay at the core of the NEA's decision to defund the exhibition. The next section of this chapter considers this episode of attempted defunding as well as a subsequent attack on Wojnarowicz's work by a fundamentalist Christian organization.

This chapter pairs Wojnarowicz and Gran Fury in part because the controversies in which these artists became embroiled occurred at roughly the same (immediately post-Mapplethorpe) moment. The historical coincidence of these controversies should not, however, be taken as entirely coincidental. Following the passage of the Helms amendment in the summer of 1989, religious leaders and conservative politicians stepped up their offensive on "homosexual art." Both Gran Fury and Wojnarowicz understood the attacks on their work as part of a more far-reaching effort to suppress gay and lesbian expression. By way of introducing Wojnarowicz's critical voice, I cite a 1990 essay he published in *Outweek*, a gay and lesbian newspaper published in New York:

> For each grant rescinded in the name of politics and homophobia, public works can be made in response and in anticipation. If they want to make our bodies and minds invisible, let's create more spontaneous public works and glue them on to the walls and streets of Washington and the rest of the continent. If the Gran Fury poster is stricken from the transit system in Chicago, let's put up 20 different posters on those same buses and trains. Those among us who can put together radio and TV transmission devices should do so and break into the airwaves with safer-sex information, telephone numbers and addresses where people can find access to organizations. We have all the tools of the corporate world at our disposal—Fax and Xerox machines, automatic 35mm and video cameras. We can construct a wall of reality in the form of words, sounds, and images that can transcend the state- and institution-sponsored ignorance in which most people live. We have mirrors, we have cameras, we have typewriters, and we have ourselves and our lovers and friends—we can document our bodies and minds and their functions and diversities. With our eyes and hands and mouths we can fight and transform.[42]

FACING PAGE

Figure 5.15. TOP
Gran Fury, *Kissing Doesn't Kill* displayed in the window of the Whitney Museum of American Art, New York, 1990.

Figure 5.16. BOTTOM
Gran Fury, *Kissing Doesn't Kill*, bus panel displayed at the offices of the HIV Research Section, San Francisco Department of Public Health, approximately 10' × 2⅓'. Photo by author.

With its paratactic flow and multilayered form, this passage exemplifies Wojnarowicz's voice as both a writer and a visual artist. In contrast to Gran Fury's catchy slogans and slick graphics, Wojnarowicz's work enacts a kind of sensory excess, an overload of information and ideas. Through a proliferation of textual voices and visual forms, Wojnarowicz suggests a simultaneity of psychic and physical reality, of internal sensation and external event.

In the passage cited above, Wojnarowicz calls upon his readers to interrupt the flow of the mass culture so as to counter the "state- and institution-sponsored ignorance in which most people live." He directs lesbians and gay men to document experiences that would otherwise be denied, distorted, or erased outright by the dominant culture. Even as Wojnarowicz describes such counterrepresentations as a "wall of reality," his own work insistently highlights the place and power of fantasy as a response to epidemic reality. Wojnarowicz taps into the force of individual fantasy to contest both the AIDS epidemic and the censorship of homoerotic art.

Witnesses

In the fall of 1989, the photographer Nan Goldin curated an exhibition entitled *Witnesses: Against Our Vanishing* for Artists Space, a nonprofit gallery in Lower Manhattan. The show, which was partially funded by a $10,000 grant from the NEA, focused on the themes of the AIDS crisis, survival, and self-representation. After receiving an advance copy of the *Witnesses* catalog, John Frohnmayer, then chairman of the NEA, decided to rescind the endowment's $10,000 grant to Artists Space. In a letter dated November 3, 1989, less than two weeks before the official opening of *Witnesses*, Frohnmayer demanded that Artists Space relinquish all NEA funding to the show and that it distribute a printed disclaimer which would state that "The National Endowment for the Arts has not supported this exhibition or its catalogue."[43] Artists Space refused to return the grant or to include Frohnmayer's disclaimer in any of the printed materials related to the show.

In defending his attempt to revoke the grant, Frohnmayer told the *Los Angeles Times* that,

> the show had become so politicized that it no longer met artistic criteria. There is a certain amount of sexually explicit material, but the primary problem is the political nature. It essentially takes on the church. It takes on a number of elected officials and expresses a great deal of anger over the AIDS situation. I can understand the frustration and the huge sense of loss and abandonment that people with AIDS feel, but I don't think the appropriate place of the national endowment is to fund political statements.[44]

The "primary problem" with the exhibition, from Frohnmayer's perspective, was its "political nature." As did Christina Orr-Cahall when defending the decision to cancel *The Perfect Moment*, Frohnmayer frames political content as the

undoing of artistic value and as that which has no "appropriate place" within a federally funded art show. According to Frohnmayer, the most explicit and troubling example of this "politicization" occurred in Wojnarowicz's essay for the exhibition catalog.[45]

The face-off between the NEA and Artists Space, occurring as it did within six months of the Corcoran's cancellation of *The Perfect Moment*, attracted national attention. Leading members of the arts community voiced their support for Artists Space. The conductor Leonard Bernstein, for example, refused the National Medal of Arts (which he was to have received from then-President Bush in a White House ceremony) in protest against the defunding of *Witnesses*, and Larry McMurtry, the president of *PEN American Center*, the American branch of an international writer's congress, published an editorial in the *Washington Post* that "condemn[ed] in the strongest terms the cancellation by the National Endowment for the Arts of its grant to Artists Space for its AIDS exhibition, 'Witnesses: Against Our Vanishing.'"[46] In response to such pressures, Frohnmayer negotiated a compromise with Artists Space. The NEA chairman agreed to restore funding to the exhibition on the condition that no federal monies were used to fund the catalog.

In considering this episode, we might note that it was Wojnarowicz's written essay, rather than his visual art (some of which was also included in *Witnesses*), that was centrally at issue. In that essay, "Post Cards from America: X-Rays from Hell," Wojnarowicz launches a wide-ranging indictment of American culture and focuses with particular ferocity on the issues of AIDS policy, the Catholic Church, and the federal government. Wojnarowicz structures the essay in his characteristic stream-of-consciousness format, complete with expletives and willful mistakes of punctuation and capitalization. Although Wojnarowicz's essay is fairly long, a single passage was almost always mentioned (though never cited verbatim) in press reports about the controversy. The passage in question reads as follows:

> I'm beginning to believe that one of the last frontiers left for radical gesture is the imagination. At least in my ungoverned imagination I can fuck somebody without a rubber, or I can, in the privacy of my own skull, douse Helms with a bucket of gasoline and set his putrid ass on fire or throw rep. William Dannemeyer off the empire state building. These fantasies give me distance from my outrage for a few seconds. They give me momentary comfort.[47]

This passage is purposely obscene, strategically incendiary. Yet it also insists, and this quite explicitly, on its status as fantasmatic, as existing in the space of "my ungoverned imagination" or, again, "in the privacy of my own skull." Wojnarowicz tells us that his revenge fantasies "give me distance from my outrage for a few seconds" and thereby suggests that they fulfill a momentary psychic need, that they reside within the confines of his own imagination rather than within the space of the real.

Although situated at the epicenter of the *Witnesses* controversy in 1989, this passage was rarely discussed in relation to the larger essay of which it is part. This

is regrettable insofar as the logic and meaning of the passage are powerfully shaped by its original context. Here are the sentences that immediately precede it in "Post Cards from America: X-Rays from Hell:"

> Recently a critic/novelist had his novel reviewed by the *New York Times Book Review* and the reviewer took outrage at the novelist's descriptions of promiscuity, saying "In this age of AIDS, the writer should show more restraint . . ." Not only do we have to contend with bonehead newscasters and conservative members of the medical profession telling us to "just say no" to sexuality itself rather than talk about safer sex possibilities, but we have people from the thought police spilling out from the ranks with admonitions that we shouldn't think about anything other than monogamous or safer sex.[48]

With these sentences, Wojnarowicz frames the succeeding "bucket of gasoline" passage as a defiance of repressive attitudes concerning AIDS and sexuality. When Wojnarowicz highlights the force of his own fantasy (whether in terms of unsafe sex or political assassination), he does so as a means of contesting the "thought police" who seek to control not only sexual activities but also the very terrain of sexual fantasy and representation. Rather than a gratuitous act of provocation, then, "Post Cards from America: X-Rays from Hell" aims to counter the censorship of safer sex information and the public policing of same-sex desire and fantasy.

Even as Wojnarowicz fantasizes his lethal revenge on Jesse Helms and William Dannemeyer, he also insists on the insufficiency of language to capture his experience: "I'm a prisoner of language that doesn't have a letter or a sign or gesture that approximates what I'm sensing. Rage may be one of the few things that binds or connects me to you."[49] Throughout "Post Cards from America: X-Rays from Hell," AIDS is framed not only a medical syndrome that breaks down the body's immune system but also as a broader breakdown between internal and external worlds, between private experience and public information. "When I was told that I'd contracted the virus," Wojnarowicz writes, "it didn't take me long to realize that I'd contracted a diseased society as well."[50]

For Wojnarowicz, "the diseased society" he had contracted along with his HIV infection was nowhere more palpable than in the response to the AIDS crisis by conservative politicians such as Helms and Dannemeyer and by religious leaders such as John Cardinal O'Connor (the archbishop of New York City). Even as Wojnarowicz employed willfully offensive language, including expletives, to describe these leaders, he also made clear why he thought such language was necessary. The artist would, for example, describe O'Connor as "this creep in black skirts [who] has kept safer-sex information off the local television stations and mass transit advertising spaces for the last eight years of the AIDS epidemic thereby helping thousands and thousands to their unnecessary deaths."[51]

If Wojnarowicz's rhetoric was incendiary, so too was that of the conservative politicians and public figures he opposed. Compare Wojnarowicz's language to that employed, for example, by Patrick Buchanan at the same moment in the AIDS epidemic. In a November 1989 column denouncing the *Witnesses* exhibition, Buchanan would describe Wojnarowicz as a "AIDS victim," while making

clear that this form of "victimization" should warrant no sympathy from the reader: "The gays yearly die by the thousands of AIDS, crying out in rage for what they cannot have: respect for a lifestyle Americans simply do not respect; billions for medical research to save them from the consequences of their own suicidal self-indulgence. Truly, these are lost souls, fighting a war against the Author of human nature, a war that no man can win."[52] Although Buchanan uses no expletives or slang, his antigay rhetoric is no less aggressive than Wojnarowicz's revenge fantasies. Unlike Wojnarowicz, however, Buchanan aims to stabilize his argument as factual rather than fantasmatic, as true rather than imagined ("Truly, these are lost souls, fighting a war against the Author of human nature"). Wojnarowicz, by contrast, repeatedly underscores the status of his scenarios as fantasmatic rather than real ("These fantasies give me distance from my outrage for a few seconds").

Even after the *Witnesses* show closed, the attacks on Wojnarowicz's work by religious leaders continued. Beginning in March 1990, Reverend Donald Wildmon of the American Family Association targeted Wojnarowicz's work as exemplary of the "homosexual obscenity" that the NEA was allegedly funding. Wildmon focused not on Wojnarowicz's writing, however, but on the artist's visual production, particularly a series of photomontages entitled the *Sex Series*. Before considering the strategies Wildmon used to attack Wojnarowicz's work, I want to consider the *Sex Series* in some detail. I want, in other words, to look closely at Wojnarowicz's art before turning to the ways in which that art was restaged by Wildmon and the American Family Association.

The Sex Series

In 1988 and early 1989, Wojnarowicz created a set of eight photomontages that he aggregately entitled the *Sex Series*. In each work, negatively printed black-and-white porn shots, most featuring male couples engaged in oral or anal sex, are set within larger photographic fields that have themselves been printed in negative (figures 5.17, 5.18, 5.19, 5.20).[53] While background image and circular inset share a reversed black-and-white tonality, they otherwise belong to quite different registers of representation. Where the porn shots present couples in close-up detail, the background images offer far more expansive sweeps of land, sea, and sky: a thickly wooded forest with swampy underbrush, a residential landscape offering the upper stories of a clapboard house and watertower, a set of paratroopers descending from the skies in a tactical exercise or perhaps an outright invasion, an aerial view of New York City featuring the Manhattan and Brooklyn Bridges, a train cutting across a canyonlike terrain, a massive steamship in the midst of an ocean crossing. Whereas in the large, rectangular photographs, the camera pulls back for a wide exterior shot or aerial view, within the circular disks, it zooms in tight on bodies engaged in sexual exchange, now lopping off a face or pair of legs to focus on a penis being sucked or a pair of buttocks penetrated.

Inset images are commonly used (as, for example, in road maps or anatomical diagrams) to magnify otherwise illegible or insufficiently detailed fragments of a larger field. Perhaps the circular insets in Wojnarowicz's series fulfill a similar

Figure 5.17. David Wojnarowicz, *Untitled*, from the *Sex Series*, 1988–89. Gelatin silver print, 18" × 21½". Courtesy PPOW Gallery, New York.

Figure 5.18. David Wojnarowicz, *Untitled*, from the *Sex Series*, 1988–89. Gelatin silver print, 18″ × 21½″. Courtesy PPOW Gallery, New York.

Figure 5.19. David Wojnarowicz, *Untitled*, from the *Sex Series*, 1988–89. Gelatin silver print. Courtesy PPOW Gallery, New York.

Figure 5.20. David Wojnarowicz, *Untitled*, from the *Sex Series*, 1988–89. Gelatin silver print. Courtesy PPOW Gallery, New York.

function, serving as apertures that magnify an otherwise unseen or submerged erotics: is this what happens beneath deck or in far reaches of the wood, in the basement, under the bridge, on the piers, or in the private compartment of the train? Or is sexual fantasy itself a kind of aperture or opening in the visual field, one that disrupts the seemingly secure terrains of public space and subverts the stability of what Wojnarowicz often referred to as the "pre-invented world"? We might say that, within these photomontages, the force of sexuality is figured as that which disorients both the viewer and the visual field, as that which erupts into and undoes our relation to the larger environment. The rectangles of photographic imagery—the primary mappings—never set us securely on the ground: we are descending from the skies or in the midst of the sea, high over the Brooklyn Bridge or half a story above the earth. Perhaps the inset porn shots figure another—and more symbolic—sort of falling or groundlessness, a loss, in the face of desire, of the spatial and psychic guideposts that might otherwise situate us. On my reading, then, the circular insets are not only peepholes giving onto secret sexual exchange but also tears in the fabric of mainstream representation, tunnels of fantasy that disrupt official mappings of residential, military, and regional space.

Rather than merely reproducing pornographic images, Wojnarowicz crops and tonally distorts them. The artist's manipulation of his pornographic sources erases any sense of narrative specificity or historical detail that they might otherwise impart. While the circular insets always remain recognizable as images of sexual exchange, it is sometimes difficult to make out what, precisely, is going on in them. In creating the *Sex Series*, Wojnarowicz used as his source material not contemporary pornography but vintage, primarily amateur stills from the 1950s and 1960s.[54] The original porn shots offer highly particularized scenes of sexual exchange while capturing a (now) nostalgic sense of place and period (figure 5.21). In one, a quartet of sailors, two still sporting their white caps and hastily-ripped-open bellbottoms, engage in oral sex before a slatted screen (figure 5.22). Wojnarowicz appropriated this image for the steamship montage, but in such a way that the recognizable details of the sailor orgy were purposely lost. One must view the original porn shot to recognize the inclusion of a third man in the circular inset, the one who kneels behind, and to the left of, the standing figure. Similarly, the shadow crowning the head of the crouching figure on the right side of the inset becomes legible as a sailor cap only in the original photograph.

In producing the *Sex Series*, Wojnarowicz distanced the pornographic body from direct visual purchase by obscuring the textures of skin and hair, the contours of musculature, the specificity of facial features, and the supporting props and details of the scene (here a floral bedspread or 1950s lamp, there a sailor's cap or unbuttoned pair of trousers). Rather than conjuring specific scenarios of sexual activity (e.g., an orgy below deck, an afternoon of hotel-room sex), the porn insets signal the space of sexual fantasy itself, a space that punctures the public mappings of the visual field. The photographs seem to irradiate the sexual act and, in so doing, to override the physiognomic specificity of the participants and the period details of the original setting. Far from offering the "you are there" fiction of pornography, the inset pictures present themselves as medi-

Figure 5.21. TOP
Copy print of slide
used by David Woj-
narowicz for the *Sex
Series* (see figure 5.19).
Used with permission
of PPOW Gallery and
the Estate of David
Wojnarowicz.

Figure 5.22. BOTTOM
Copy print of slide
used by David Woj-
narowicz for the *Sex
Series* (see figure 5.20).
Used with permission
of PPOW Gallery and
the Estate of David
Wojnarowicz.

ated, patently manipulated signs of sexual exchange. They function less as explicit scenes of pornography than as generalized emblems of it.[55]

As one part of this blurring of pictorial specificity, there is an occasional slippage or indeterminacy of gender within the *Sex Series*. The receptive partner in the paratrooper inset, for example, is not immediately identifiable as the *man* we have learned he is from the original porn shot (figure 5.21). If Wojnarowicz's manipulation of this source image opens the false possibility of heterosexual exchange, it also enacts on the body of the receptive partner a certain sliding or confusion of gender codings, a confusion that may render the manipulated porn shot not less "queer" but more so. I employ the term "queer" in this context to suggest not a specifically homosexual practice but a procedure (in this case pictorial) that undoes secure distinctions between the normative and the non-normative, between acts of heterosexual and homosexual exchange or between identifiably male and female bodies.[56] Rather from framing sexual exchange as a matter of particular activities or orientations, Wojnarowicz pictures the force of sexuality as a disorientation of the visual field, as a queer disturbance of both physical and perceptual relationships. In writing on the *Sex Series*, Wojnarowicz himself noted that "by mixing variations of sexual expressions, there is the attempt to dismantle the structures formed by category,"[57] an attempt to challenge strict definitions of sexuality according to specific preferences and recognizable identities.

Yet the *Sex Series* does not simply celebrate the power of queer fantasy to disrupt the terrain of dominant culture—it also pictures the policing of sexuality by that culture. In an extended gloss he wrote on the *Sex Series* in 1990, Wojnarowicz described the work in the following terms:

> The spherical structures embedded in the series are about examination and/or surveillance. Looking through a microscope or looking through a telescope or the monitoring that takes place in looking through the lens of a set of binoculars. It's about oppression and suppression. Are you comfortable looking at these images of obvious sexual acts in a crowded room? Do you fear judgment if you pause for a long time before an image of sexual expression? Can you sense absurdity or embrace in the viewing of images?[58]

What begins as an act of monitoring by the viewing subject (an act of looking as if through a microscope or telescope) becomes, by the end of the passage, a monitoring *of* the viewing subject: "Are you comfortable looking at these images of obvious sexual acts in a crowded room? Do you fear judgment if you pause?" This shift—from the viewer as the agent of surveillance to the viewer as the object surveyed—is central to the pictorial logic of the *Sex Series*. In looking at the pornographic insets, we see both sexual activity and its surveillance from without. The *Sex Series* confuses the boundary not only between male and female bodies and between homosexual and heterosexual acts but also between sexual pleasure and social control.

When Wojnarowicz was asked about his use of pornographic imagery in the *Sex Series*, he made it clear that his intentions were hardly celebratory: "The images I use are just naked bodies, sometimes engaged in explicit sex acts. I

know they are loaded images but I'm not just putting sex pictures on a wall, I'm surrounding them with information that reverberates against whatever the image sparks in people."[59] Throughout the *Sex Series*, Wojnarowicz counters the immediate pleasure that might be "sparked" by pornographic images by embedding those images within radically discontinuous visual fields. Insofar as these larger fields mark the official spaces of public culture, they might be said to prohibit or police the sexual imagery they also contain. The *Sex Series* concerns the suppression of sexual imagery and information as much as it does the power of sexual expression.

The disciplinary theme becomes explicit in the final three works of the series, each of which includes multiple insets as well as superimposed texts. In one of these works (figure 5.23), the primary image of a long train snaking through a plateau is punctuated by four pictorial bubbles of varying sizes and formats. Scanning clockwise from the upper right, we see a tight close-up of oral sex between men, a newspaper excerpt whose partial words and sentence fragments ("Beaten," "shouting antihomosexual," "attacked two men on the Upper," "stabbing one of them") record the circumstances of a local gay-bashing, a microscopic view of blood platelets, and finally and most insistently (in terms of size) a photograph of police in riot gear and rubber gloves moving into a crowd. The photograph of the police is the only image in the work that is not tonally reversed. Because it is larger, less blurred, and less overtly manipulated than the other insets, the police photograph suggests a rather greater degree of verisimilitude. The photograph, it turns out, was taken by Wojnarowicz himself at a 1988 ACT UP demonstration at the headquarters of the Food and Drug Administration.

Once read in relation to the other insets, the image of fellatio in the upper-right-hand corner becomes linked to a number of threats arising both from within and without: the viral threat of HIV infection, but also, and inextricably, the threat of antigay violence and that of police action against public demonstrations. In contrast to the first five works in the *Sex Series*, Wojnarowicz here figures the techniques of social control and State surveillance—of riot gear and hate crimes—within the frame of the photomontage. Wojnarowicz pictures the threat of homophobia so as to contest it. Yet as we shall see, the artist's portrayal of that threat would prove an accurate forecast of the *Sex Series*'s subsequent public reception.

Cut and Paste

The *Sex Series* was first exhibited in its entirety at a 1990 retrospective of Wojnarowicz's work, entitled *Tongues of Flame*, held at the art galleries of Illinois State University in Normal, Illinois. A grant of $15,000 from the NEA covered a portion of the budget for the show's catalog. Shortly after the close of the exhibition, the Reverend Donald Wildmon and the American Family Association sent out nearly 200,000 flyers denouncing Wojnarowicz's work to church leaders, Christian radio and television stations, and the full membership of the U.S. Congress.[60] The flyer, which bore the headline "Your Tax Dollars Helped Pay for These 'Works of Art,'" was illustrated with fourteen images identified as the

Figure 5.23. David Wojnarowicz, *Untitled*, from *The Sex Series*, 1988–89. Gelatin silver print. Courtesy PPOW Gallery, New York.

work of David Wojnarowicz. Each of the images was, in fact, a detail (and in some cases a quite small detail) from a collage, montage, or photographic series by the artist (figures 5.24, 5.25). Though Wojnarowicz's art was never composed exclusively or even primarily of pornographic imagery, it was cut and pasted to appear as such by Reverend Wildmon and the American Family Association. Wildmon cropped, recombined, and rephotographed Wojnarowicz's work so as to provoke the righteous outrage of his constituents, the U.S. Congress, and the public at large.

Wildmon's appropriation of pictorial details from Wojnarowicz's art might well be said to contradict the Reverend's stated intentions. The single nonpornographic image on the back side of the flyer is a detail of Jesus Christ shooting up with a hypodermic needle and tourniquet. The detail has been ripped by Reverend Wildmon from a 1979 Wojnarowicz collage entitled *Genet* (figure 5.26) that portrayed the French author as a saint in the foreground of a vaulted cathedral with an injecting Christ at an oversized altar toward the back. In reproducing this particular detail, Wildmon was recalling (and in a sense reviving) the previous year's furor over Andres Serrano's *Piss Christ*, a furor that had itself been fueled by the efforts of the American Family Association.[61] Predictably, the juxtaposition of Jesus Christ shooting up alongside pictures of gay pornography aroused the fury of clergy and lawmakers alike. It is worth noting, however, that Christ has been inserted into a larger field of oral and anal sex *not* by Wojnarowicz but by Reverend Wildmon's ferocious reediting (and reimagining) of Wojnarowicz's work.

Wojnarowicz responded to the flyer by suing Reverend Wildmon and the American Family Association for libel and copyright infringement. Wojnarowicz's suit marked the first time that an artist had pursued legal action against a Christian Right organization. In his court affidavit, Wojnarowicz argued that "the images represented in the Pamphlet to be my work had been so severely mutilated that I could not consider them my own."[62] In a similar vein, the artist told the *Washington Post* that the members of the AFA were "creating pieces of their own. They're not even my pieces, when they've gotten through with them."[63]

And just what kind of piece is it that Reverend Wildmon and his association have created? In framing Wojnarowicz's work as nothing more than the sum of its pornographic details, the flyer produces its own pictorial orgy of drugs and sex, of shooting up and getting off. Reverend Wildmon has, in short, insistently focused upon and proliferated the imagery he claims to abhor. As I argued above, the *Sex Series* enacts a disorientation of the visual field by setting reverse-tone porn shots within larger, and quite differently ordered, mappings of public space. Wildmon's flyer attempts to undo this visual complexity, this pictorial vertigo, by grounding the *Sex Series* in its pornographic details and thereby locating it as a definitive site of obscenity. Yet Reverend Wildmon, in his fanatical overproduction of these details, enacts his own dizzying spectacle of sexual exchange and display, of what he himself termed "perversion" and "pornography."[64] As the flyer moves from the positive prints of its uppermost tier to the negative peepholes below, it seems both to close in upon (through those circular apertures) and to lose hold of (through those X-ray-like blurrings) the sexual imagery it must therefore continue, compulsively, to reproduce.[65]

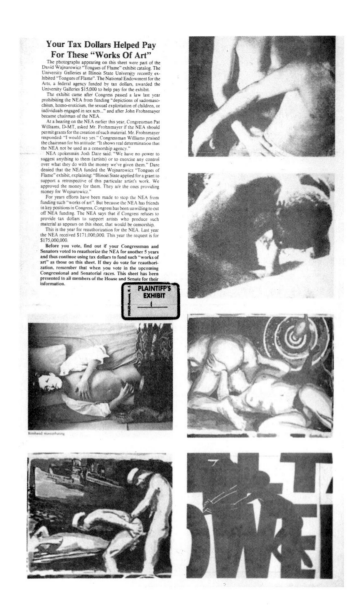

Figure 5.24. American Family Association, "Your Tax Dollars Helped Pay for These 'Works of Art,'" flyer (front). The David Wojnarowicz Papers, Fales Library/Special Collections, New York University.

Although it never came to pass, the possibility that Wildmon might be prosecuted by the postal service for sending materials that he himself had declared obscene through the U.S. mail was mentioned in the press coverage of this episode.[66] Wildmon and the American Family Association sealed each of the Wojnarowicz flyers inside an envelope marked "Caution—Contains Extremely Offensive Material."[67] Given that the AFA had gone to no small effort to cut, paste, reproduce, and distribute this "Extremely Offensive Material," its cautionary warning might also be taken as a solicitation of further interest from the reader. Like the flyer it accompanies, the warning showcases the material it simultaneously finds offense in.

On August 8, 1990, the U.S. District Court judge presiding over the case of *David Wojnarowicz v. American Family Association and Donald E. Wildmon* ruled in

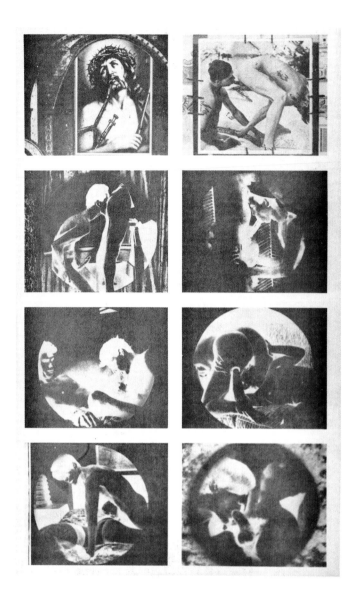

favor of Wojnarowicz. The court barred the AFA from distributing any further copies of the flyer at issue and compelled the organization to send a "corrective communication" explaining the misleading nature of the flyer to all previous recipients.[68] Because the judge found no evidence that Wojnarowicz had suffered material losses as a result of the flyer, he awarded the artist but a single, symbolic dollar in damages.[69] According to David Cole, the lawyer representing Wojnarowicz in the case, "When the suit ended, David insisted on receiving his payment in a one-dollar check signed by Wildmon. He planned to use the check in his art—back on his own turf."[70] Although Wojnarowicz never recycled the check within the space of his art ("his own turf"), neither did he cash it in. Retained by the artist until his death in 1992, the check is now housed in the Special Collections of the Fales Library at New York University (figure 5.27). In

Figure 5.25. American Family Association, "Your Tax Dollars Helped Pay for These 'Works of Art,'" flyer (back). The David Wojnarowicz Papers, Fales Library/Special Collections, New York University.

Figure 5.26.
David Wojnarow-
icz, *Genet*, 1979.
Photocopied col-
lage, 8½" × 11".
Courtesy PPOW
Gallery, NewYork.

contrast to its near worthlessness in monetary terms, the uncashed check per-
sists as a powerful symbol of Wojnarowicz's struggle against the AFA and, more
broadly, against the appropriation and attempted censorship of his art.

In the midst of his run-in with Reverend Wildmon, Wojnarowicz attempted to
figure the force of silencing within the frame of representation. For the fall 1990
cover of the magazine *High Performance*, Wojnarowicz collaborated on an image
in which his lips appear to have been sutured closed (figure 5.28). On the most
obvious level, the cover image and its accompanying caption ("Why Is Reverend
Wildmon Trying to Censor This Man?") indict Wildmon and the AFA for their
attempted censorship of Wojnarowicz. The image might also be said, however,
to depict an act of self-censorship, a refusal of the artist to speak because he now
knows the uses to which his words—and his work—will be put. Even as it
mutes the artist's voice, however, censorship is here made to perform its radical
surgery across the visible surface of the body and so to enact, in brutely pictorial
terms, its symbolic violence. While Wojnarowicz figures censorship as a form of
mutilation, he does not frame that trauma within the conventions of victim pho-
tography. The *High Performance* cover image does not solicit pathos or pity for its
sewn-up subject. Instead, the picture enacts silence so as to contest it. Like the
"Silence = Death" slogan of AIDS activism (figure 5.29), the cover photograph
offers a hyperbolized image of censorship that paradoxically functions as a form
of aggressive expression.[71]

In a somewhat similar strategy later in his career, Wojnarowicz figured the
experience of vanishing, of bodily disappearance, as a form of active confronta-
tion (figure 5.30). In a photomontage from 1992, the artist offers a pair of

filthy, heavily bandaged hands held open in a gesture of either supplication or self-inspection. A long text in red ink, superimposed over the hands, reads as follows:

Sometimes I come to hate people because they can't see where I am. I've gone empty, completely empty and all they see is the visual form; my arms and legs, my face, my height and posture, the sounds that come from my throat. But I'm fucking empty. The person I was just one year ago no longer exists; drifts spinning slowly into the ether somewhere way back there. I'm a xerox of my former self. I can't abstract my own dying any longer. I am a stranger to others and to myself and I refuse to pretend that I am familiar or that I have history attached to my heels. I am glass, clear empty glass. I see the world spinning behind and through me. I see casualness and mundane effects of gesture made by constant populations. I look familiar but I am a complete stranger being mistaken for my former selves. I am a stranger and I am moving. I am moving on two legs soon to be on all fours. I am no longer animal vegetable or mineral. I am no longer made of circuits or disks. I am no longer coded or deciphered. I am all emptiness and futility. I am an empty stranger, a carbon copy of my form. I can no longer find what I'm looking for outside of myself. It doesn't exist out there. Maybe it's only in here, inside my head. But my head is glass and my eyes have stopped being cameras, the tape has run out and nobody's words can touch me. No gesture can touch me. I've been dropped into all this from another world and I can't speak your language any longer. See the signs I try to make with my hands and fingers. See the vague movements of my lips among the sheets. I'm a blank spot in a hectic civilization. I'm a dark smudge in the air that dissipates without notice. I feel like a window, maybe a broken window. I am a glass human. I am a glass human disappearing in rain. I am standing among all of you waving my invisible arms and hands. I am shouting my invisible words. I am getting so weary. I am growing tired. I am waving to you from here. I am crawling and looking for the aperture of complete and final emptiness. I am vibrating in isolation among you. I am screaming but it comes out like pieces of clear ice. I am signalling that the volume of all this is too high. I am waving. I am waving my hands. I am disappearing. I am disappearing but not fast enough.

Figure 5.27. Check for one dollar payable to David Wojnarowicz. The David Wojnarowicz Papers, Fales Library/Special Collections, New York University.

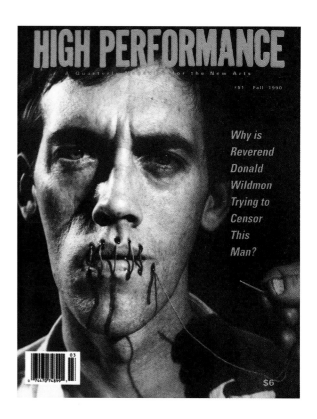

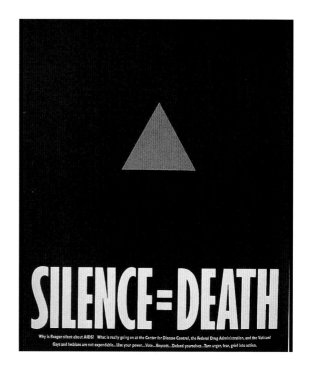

Figure 5.28. TOP
High Performance: A Quarterly Magazine for the New Arts, no. 51 (Fall 1990). Cover photograph of David Wojnarowicz by Andreas Sterzing. From the film *Silence = Death* by Phil Zwickler and Rosa Von Prauheim. Courtesy: *High Performance* and The David Wojnarowicz Papers, Fales Library/Special Collections, New York University.

Figure 5.29. BOTTOM
Silence = Death Project, *Silence = Death*, 1986. Offset lithography (poster), 24" × 29". Subsequently used as placard, T-shirt, button, and sticker. Courtesy Gran Fury.

Sometimes I come to hate people because they can't see where I am. I've gone empty, completely empty and all they see is the visual form; my arms and legs, my face, my height and posture, the sounds that come from my throat. But I'm fucking empty. The person I was just one year ago no longer exists; drifts spinning slowly into the ether somewhere way back there. I'm a xerox of my former self. I can't abstract my own dying any longer. I am a stranger to others and to myself and I refuse to pretend that I am familiar or that I have history attached to me. I am glass, clear empty glass. I see the world spinning behind and through me. I see emptiness and movement and the effects of gravity constant populations. I look familiar but I am a complete stranger being mistaken for my former selves. I am a stranger and I am moving. I am moving on two legs soon to be on all fours. I am no longer animal vegetable or mineral. I am no longer made of circuits or disks. I am no longer coded and deciphered. I am all emptiness and direction. I am an empty stranger, a carbon copy of my form. I can no longer find what I'm looking for outside of myself. It doesn't exist out there. Maybe it's only in here. Inside my head. But my head is glass and my eyes have stopped being cameras, the tape has stopped and nobody's words can touch me. Nobody's can touch me. I've been dropped into all this from another world and I can't speak your language any longer. See the signs I try to make with my hands and fingers. See the ways I move my lips among the shadows. This blank sky here is a civilization. I'm a dark smudge in the air that dissipates without notice. I feel like a window, maybe a broken window. I am a glass human. I am a glass human disappearing in the rain. I am standing among all of you waving my invisible arms and hands. I am shouting my invisible words. I am getting so weary. I am growing tired. I am waving to you from here. I am crawling and looking for the aperture of complete and final emptiness. I am vibrating in isolation among you. I am screaming but it comes out like pieces of clear ice. I am signalling that the volume of all this is too high. I am waving. I am waving my hands. I am disappearing. I am disappearing but not fast enough.

Figure 5.30. David Wojnarowicz, *Untitled*, 1992. Gelatin silver print and silkscreened text, 38" × 26". Courtesy PPOW Gallery, New York.

Wojnarowicz's sentences, most of which begin with the declarative "I am," figure a vanishing sense of self as the body undergoes disintegration. Alongside this disappearance, the text conveys the willed ignorance of a culture that refuses to acknowledge—to hear or to see—the suffering within its midst. Metaphors of sentience and bodily distress escalate as the text moves from visual experience ("I'm a blank spot," "I'm the dark smudge") to touch ("I am waving," "I am vibrating in isolation") to voice ("I am screaming," "the volume of all this is too high") to disintegration ("I am disappearing. I am disappearing but not fast enough"). Boundaries between corporeal sensation and material objects collapse into each other ("I am screaming but it comes out like pieces of clear ice") as the subject dissipates. The complexity of the text, its simultaneous sense of cognitive dissonance and physical disintegration, is reinforced by the layered visual format of the photomontage. The type, purposely difficult to read over the hands, force us to strain, to experience on the perceptual level some small measure of the confusion and dislocation it describes.

When Wojnarowicz was asked by his gallery whether this work was a self-portrait, whether the hands depicted were his own, he repeatedly refused to say.[72] Like the text of the photomontage, the artist's refusal to claim or name the bandaged hands ("mine" or "not mine") contests the boundary between internal self and external world, between the image of someone else's abjection and the experience of one's own. The fact this photomontage was the last artwork Wojnarowicz would complete before his AIDS-related death a few weeks later cannot be extricated from the history of the work itself. Neither, however, can it be made equivalent to it. The paradox at the heart of the piece is that vanishing is used to figure the presence of rage and that disappearance is made to speak through a series of insistent self-declarations. Wojnarowicz's collage offers no easy space of externality. In the portrayal of (his own) vanishing, Wojnarowicz asserts a first-person subject, a self, who cannot be fully dissociated from the viewer and, in this sense, cannot be silenced from without.

Flaming Absences

The vanishing act staged in Wojnarowicz's 1992 photomontage anticipates the artist's death as a result of AIDS, a death that occurred shortly after the work was completed. But as I have suggested above, the experience of vanishing portrayed in this work cannot be understood strictly in terms of individual tragedy or personal loss, even though the loss at issue is, on the most immediate level, that of the artist's own life. The disappearance at the core of Wojnarowicz's 1992 photomontage echoes broader shifts in the social and political terms of the AIDS crisis at the time, including the decline of ACT UP, the grassroots AIDS activist group in which Wojnarowicz had been active. The waning of radical AIDS activism in and around 1992 stemmed in part from the prior success of groups such as ACT UP in raising AIDS awareness, influencing federal policy, and forcing the development and release of new drug treatments. But it also stemmed from a mounting level of exhaustion among AIDS activists, a fatigue resulting from years of fighting the epidemic and (still) losing so many friends and colleagues to it.

In 1992, Gran Fury unofficially disbanded, which is to say, the group stopped working together a collective without formally announcing its dissolution. Gran Fury's decision was provoked by many of same factors that contributed to ACT UP's decline at the same moment. By 1992, informational projects on AIDS had appeared throughout the United States, on public transportation, billboards, television, and in mass-circulation mailings.[73] Within this expanded field of AIDS representation, much of it visually sophisticated and commercially produced, Gran Fury's work no longer constituted such a crucial intervention. The year 1992 also marked the moment of Bill Clinton's election, a moment that seemed to promise a political breakthrough in terms of the federal government's responsiveness to the epidemic and to gay and lesbian issues more generally. After four years of making AIDS activist art and agitprop, the members of Gran Fury believed that their message had, to a meaningful extent, been heard.

Alongside this guarded optimism, however, Gran Fury had to contend with the increasingly common perception of AIDS as a grim fact of everyday life, an ongoing condition rather than a temporary medical and political crisis. Writing in 1993, the critic (and former ACT UP member) Douglas Crimp observed that "there is a new kind of indifference . . . that has been called the normalization of AIDS. . . . How often do we hear the list recited?—poverty, crime, drugs, homelessness, and AIDS. AIDS is no longer an emergency. It's merely a permanent disaster."[74] How could artists and activists respond to AIDS as a "permanent disaster" rather than a state of medical and political emergency? What strategies of visual address, if any, might work within this new—and newly "normalized"—moment in the AIDS crisis?

In 1993, a group of four AIDS activists, all former members of Gran Fury, produced a small black-and-white poster that they pasted throughout the streets and storefronts of Lower Manhattan (figure 5.31). The modest format and negligible cost of the poster stood in stark contrast to the slickly produced billboards, busboards, and crack-and-peel stickers of Gran Fury's earlier work. The rhetorical tone of the poster also marked a departure from the activist work that had preceded it. Rather than grabbing the viewer's attention in a spectacular fashion, it spoke modestly, even softly. Entirely devoid of graphic imagery, the poster presented a series of questions in small, typewritten print: "Do you resent people with AIDS?" "Do you trust HIV-negatives?" "Have you given up hope for a cure?" and "When was the last time you cried?" Rather than making a demand, the poster asked its viewers to reflect on the emotional stakes of the AIDS crisis. Rather than speaking in the collective voice of outrage that characterized Gran Fury's earlier work (e.g., "The Government Has Blood on Its Hands," "All People with AIDS Are Innocent") the poster touched upon issues of individual subjectivity and response, of personal despondency and defeat ("Have you given up hope for a cure?" "When was the last time you cried?").

With its miniature black text against a field of white space, the poster suggests not only a sense of intimacy and individual address but also of disappearance. It is as though Gran Fury's once-bold slogans and full-color graphics had all but withered away, leaving behind just these four small sentences. The 1993 poster did not bear the Gran Fury logo, and its relation to the larger collective remained unclear. The four creators of the poster considered it a Gran Fury project; sev-

Figure 5.31. Gran Fury (ad hoc committee of four members), *Untitled*, 1993. Poster, 20" × 24". Courtesy Loring McAlpin.

eral other members of the larger, but now defunct, collective did not. The inde-terminate status of the "four questions" poster (is it by Gran Fury or isn't it?) bespeaks something of confusion and ambivalence that marked the waning of AIDS activism at the time.

Like the "four questions" poster, the public billboards of Felix Gonzalez-Torres characterize a move away from activist instrumentality and toward more allusive and ambiguous interventions in the epidemic. A dramatic shift in repre-sentational strategy separates the artist's 1990 billboard demanding universal health care (figure 5.32) from a 1991 project that spoke, in far less explicit terms, of both comfort and vanishing within the public sphere (figure 5.33). In the earlier work, the bold typography of the slogan "Health Care Is a Right" and blaring white-on-red color scheme arrest our vision, forcibly compelling us to "get the message." The billboard is a kind of visual alarm, the sounding of a state of medical and political emergency.[75]

The 1991 work, by contrast, depicts a space of comfort—but also of bodily absence and longing—within the commercial sphere. The near-monochrome image, entirely devoid of text, offers a bed that bears the visible impression but not the physical presence of two reclining bodies. Rather than a surface to be quickly scanned, the billboard opens up a space that viewers might "fall into" on the visual and fantasmatic level. Far from the immediate legibility that advertis-ing images and agitprop posters typically extend, the bed billboard sets up a more complex dialogue between desire and its frustration. Gonzalez-Torres placed the bed billboard at twenty-four sites throughout Manhattan, Brooklyn, the Bronx, and Queens (figures 5.34, 5.35, 5.36). The proliferation of the bill-boards opened up multiple spaces of private loss within the public sphere of New York City.

From a museum brochure on the bed billboards, I learned that Gonzalez-Torres had lost his lover, Ross Laycock, to AIDS in 1991 and that the project might therefore be seen as an individual memorial or tribute to the artist's absent partner.[76] Once offered, this biographical information becomes inextri-cable from any experience of the work's meaning. Yet in its willful ambiguity and open appeal to individual fantasy, the billboard project cannot be confined to any one message about the epidemic or to any single act of memorialization. The bed billboards open up a space within the public sphere for the registration of absence and exhaustion. In this project, Gonzalez-Torres conveys an experience of individual loss and bodily vanishing without confining his work to the explicit production of "art about AIDS".[77] Rather than reconstituting the artist's lost lover as a pictorial presence, the bed billboards offer the visual trace of two bod-ies that have, as it were, disappeared before our very eyes.

In addition to the double disappearance portrayed in the bed billboards, Gonzalez-Torres would couple commercially produced objects (electric clocks, lightbulbs, mirrors) as a metaphor for same-sex pairing. Gonzalez-Torres de-scribed works such as *Perfect Lovers* (figure 5.37) as a partial response to the con-troversies surrounding homoerotic art in the wake of the Mapplethorpe and Wojnarowicz affairs: "It going to be very difficult for members of Congress to tell their constituents that money is being expended for the promotion of homo-sexual art when all they have to show are two plugs side by side, or two mirrors

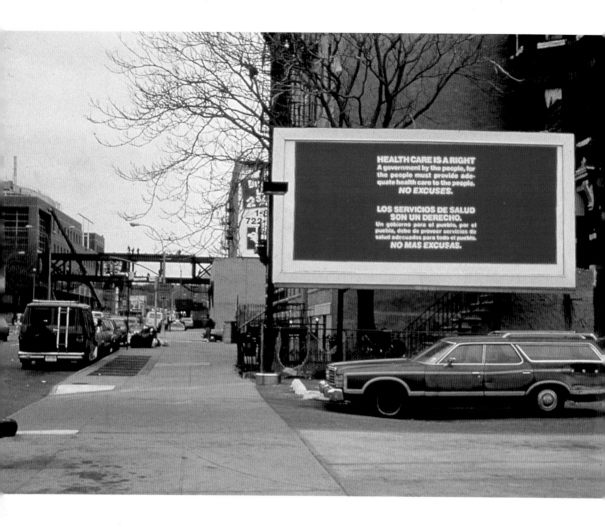

HEALTH CARE IS A RIGHT
A government by the people, for
the people must provide ade-
quate health care to the people.
NO EXCUSES.

LOS SERVICIOS DE SALUD
SON UN DERECHO.
Un gobierno para el pueblo, por el
pueblo, debe de proveer servicios de
salud adecuados para todo el pueblo.
NO MAS EXCUSAS.

Figure 5.32.
Felix Gonzalez-
Torres, *Untitled*,
1990. Billboard.
Location: 144th
Street/Grand
Concourse, Mott
Haven, The Bronx.
Photo by Peter
Muscato. Courtesy
Andrea Rosen
Gallery, New York.

side by side, or two light bulbs side by side."[78] Gonzalez-Torres responded to the threat of censorship by refusing to offer the expected (and, for would-be censors, indispensable) image of homosexuality. The absence that structures both the bed billboard and *Perfect Lovers* is not only that of the human figure but also that of any content that might arouse censorship. Such strategies of erasure may, however, court a different kind of danger, namely, that they mimic invisibility so well as to enact the very suppressions they seek to elude. To put the problem another way, we might ask whether works such as *Perfect Lovers* or the bed billboards reinforce, however unintentionally, the external threat of censorship to which gay artists are subjected.

Consider, as a partial response to this question, one last artwork by Wojnarowicz, a self-portrait of the artist, partially buried beneath the Chaco Canyon in California (figure 5.38). Wojnarowicz's face and bright white front teeth protrude through the surface of the earth. It is as though the remains of his body, uncannily well preserved, have just been dug up. Or perhaps the burial of the body has only just begun. Much of the image's power derives from the way it

Figure 5.33. Felix Gonzalez-Torres, *Untitled*, 1991. Billboard, as installed for the Museum of Modern Art, New York, "Projects 34: Felix Gonzalez-Torres," May 16–June 30, 1992, in twenty-four locations throughout New York City. Location #24: 31–11 Twenty-first Street, Long Island City. Photo by Peter Muscato. Courtesy Andrea Rosen Gallery, New York.

Figure 5.34. TOP
Felix Gonzalez-Torres, *Untitled*, 1991. Billboard, as installed for the Museum of Modern Art, New York, "Projects 34: Felix Gonzalez-Torres," May 16–June 30, 1992, in twenty-four locations throughout New York City. Location #6: 47–53 South Fifth Street/Berry Street, Brooklyn. Photo by Peter Muscato. Courtesy Andrea Rosen Gallery, New York.

Figure 5.35. MIDDLE
Felix Gonzalez-Torres, *Untitled*, 1991. Billboard, as installed for the Museum of Modern Art, New York, "Projects 34: Felix Gonzalez-Torres," May 16–June 30, 1992, in twenty-four locations throughout New York City. Location #11: 31–33 Second Avenue at East Second Street, Manhattan. Photo by Peter Muscato. Courtesy Andrea Rosen Gallery, New York.

Figure 5.36. BOTTOM
Felix Gonzalez-Torres, *Untitled*, 1991. Billboard, as installed for the Museum of Modern Art, New York, "Projects 34: Felix Gonzalez-Torres," May 16–June 30, 1992, in twenty-four locations throughout New York City. Location #18: 365 West Fiftieth Street, between Eighth and Ninth Avenues, Manhattan. Photo by Peter Muscato. Courtesy Andrea Rosen Gallery, New York.

suggests both excavation and entombment, both burial and disinterment. The photograph was shot in 1991, the year before Wojnarowicz's death, but it was not printed until 1993, the year after. The experience of disappearance that the photograph figures thus resonates with the history of its material production. The image stages a burial that has yet to take place even as it memorializes a death that has, from the moment the photograph is printed, always already occurred.

The theatricalized staging of his own burial is something Wojnarowicz enacted not only as an individual artist but also as an AIDS activist. The artist participated, for example, in a 1988 "die-in" held at the headquarters of the Food and Drug Administration in Rockville, Maryland. The die-in was one part of a massive ACT UP demonstration that closed down the offices of the FDA and successfully applied pressure on the agency to accelerate the pace of clinical drug trials and quicken the release of experimental AIDS drugs. Within the terms of ACT UP's die-in, death is enacted as a form not of individual disappearance but of collective protest, one in which the mock epitaph or grave marker stands as both political indictment and call to arms: "Never Had a Chance," "AZT Wasn't Enough," "I Died for the Sins of the FDA," "I Got the Placebo, R.I.P.," "Dead, I Needed Aerosol Pentamadine," "Dead: As a Person of Color I Was Exempt from Drug Trials." This last epitaph was inscribed on a mock gravestone held by Wojnarowicz, who clipped a photograph of the demonstration from the *Washington Post* and sent it along with an identifying notation ("me") to some friends in Europe (figure 5.39).

As in ACT UP's 1988 die-in, Wojnarowicz's self-portrait in the Chaco Canyon stages a mock death, a false burial that both defies and redoubles the disappearance of the person with AIDS, including (but not limited to) the disappearance of the artist himself. Like the bed billboards of Gonzalez-Torres and the "four questions" poster of Gran Fury, Wojnarowicz's self-portrait uses the thematics of vanishing to make the disintegration of the subject into something insistent and

Figure 5.37. Felix Gonzalez-Torres, *Untitled (Perfect Lovers)*, 1987–90. Clocks, 14" × 28" × 2¾" overall, two parts each 14" diameter, edition of 3. Photo by Peter Muscato. Courtesy Andrea Rosen Gallery, New York.

Figure 5.38. David Wojnarowicz, *Untitled*, 1993. Gelatin silver print, 28½" × 28½". Courtesy PPOW Gallery, New York.

present. Wojnarowicz solicits not a liberal response of concern about the AIDS crisis but a questioning, on the part of each viewer, as to his or her own psychic and corporeal vulnerability. The AIDS epidemic and the losses it has wrought hover near the scene of his later work, ever present but never explicitly named or pictured. "Somewhere in me," said Wojnarowicz in 1990, "I feel that I don't want to be polite. I don't want that pressure of dying in a very clean way, making it easy for people. Somewhere, I want the world to have my rage and reactions."[79] By staging his own disappearance while refusing the role of either tragic victim or heroic survivor, Wojnarowicz made "somewhere" the space of his work.

David Wojnarowicz died on July 22, 1992. One week later, a "political funeral" procession devoted to the artist was held on the streets of Manhattan's East Village. The procession was adapted from one of AIDS activism's most dramatic strategies of protest: the public presentation of corpses at political sites such as the White House or New York City Hall. Wojnarowicz himself wrote about the symbolic force of political funerals in "Post Cards from America: X-Rays from Hell."

Figure 5.39. Photocopy of personal clipping by David Wojnarowicz of *Washington Post* photograph of ACT-UP's 1988 die-in at the offices of the Food and Drug Administration in Rockville, Md. Used with permission of PPOW Gallery and the Estate of David Wojnarowicz.

ters demonstrate for faster approval of the more than 80 potential AIDS treatments that the FDA is testing.

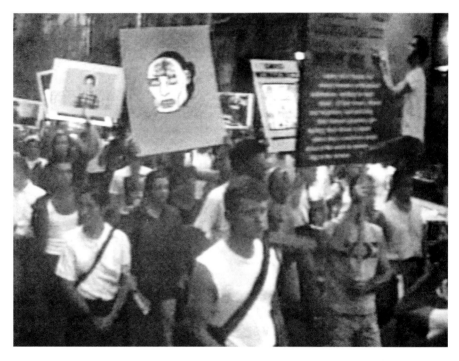

Figure 5.40. TOP Still from "David Wojnarowicz: Political Funeral, July 29, 1992," video-tape. Courtesy James Wentzy, DIVA (Damned Interfering Video Activists) TV.

Figure 5.41. BOTTOM Still from "David Wojnarowicz: Political Funeral, July 29, 1992," videotape. Courtesy James Wentzy, DIVA (Damned Interfering Video Activists) TV.

I imagine what it would be like if, each time a lover or friend or stranger died of this disease, their friends, lovers or neighbors would take the dead body and drive with it in a car a hundred miles an hour to washington d.c. and blast through the gates of the white house and come to a screeching halt before the entrance and dump their lifeless form on the front steps. It would be comforting to see those friends, neighbors, lovers, and strangers mark time and place and history in such a public way.[80]

In this passage, Wojnarowicz recasts the ritual of mourning as a collective act of rage, as a "blast through the gates of the white house" that would finally make visible the death and disappearance of people with AIDS. Wojnarowicz's own "political funeral" featured the presentation not of the artist's body but, rather, of his body of work. Behind a banner reading "David Wojnarowicz / 1954–1992 / Died of AIDS / Due to Government Neglect," participants carried placards with reproductions of Wojnarowicz drawings, photographs, collages, and performances as well as quotations from the artist's writings (figures 5.40, 5.41). At the conclusion of the march, the banner and placards were set on fire to create a kind of funeral pyre (figure 5.42). Even as they went up in smoke, Wojnarowicz's words and pictures did not simply disappear. They created a combustible image fully in keeping with this artist's life and work, an image of private loss flaming into public protest.

Afterword

Unrespectable

How, then, is it possible to build up art history as a respectable scholarly discipline, if its very objects come into being by an irrational and subjective process?

—Erwin Panofsky, *The History of Art as a Humanistic Discipline*

For as long as I have been writing about homosexuality and art history, I have wondered—and sometimes worried—about the discomfort my work might arouse in various audiences. I have worried that teachers, colleagues, students, readers, even family members would not consider my work fully professional, that, on some level, all it would signify to them would be sex, and, more especially, gay male sex. At scholarly conferences, I have secretly suspected that the slides I was projecting on screen (of, say, Mapplethorpe's bullwhip *Self-Portrait* or Warhol's *Decorated Penis*) were displacing the intellectual seriousness and interpretive nuance I sought to sustain. In this sense, the respectability of my own practice as an art historian has been an ongoing—if, until now, unspoken—concern, one that has shaped the research and writing of this book.

That an insistence upon homosexuality might jeopardize one's professional standing is a risk that each of the artists discussed in this book has also taken, and in ways far more audacious and profound than my own. David Wojnarowicz performed this risk quite explicitly when, in the midst of giving an artist's talk in 1990, he asked his audience: "If I say I am homosexual, or 'queer,' does it make you nervous? I have experienced various reactions to that simple disclosure in the course of life. I often wonder whether my being a queer who asserts his sexual identity publicly makes some people see the word 'QUEER' somehow written across my forehead in capital letters. And I wonder whether or not it automatically *discounts* anything else I might say" (Wojnarowicz's emphasis).[1]

Wojnarowicz conjures the audience's discomfort with his homosexual difference ("does it make you nervous?") as a kind of corporeal inscription, a tattoo imprinted on his forehead. Yet even as he imagines himself being branded with the word "queer" by others, Wojnarowicz simultaneously invokes that branding as a form of self-identification. The artist's "queer" tattoo stands, then, as both a mark of denigration and a means of self-description, as both a stigma imposed from without and a sense of difference perceived from within.

Since the early 1990s, the term "queer" has increasingly been reclaimed by gay men, lesbians, and other sexual minorities as a defiant form of self-naming.[2] Calling oneself "queer" necessarily means confronting the homophobic uses to which that word has been put in the past. "'Queer' derives its force," writes Judith Butler, "precisely through the repeated invocation by which it has been linked to accusation, pathologization, insult."[3] If "queer" cannot but echo a history of denigration and external attack, its more recent use (as, for example, by Wojnarowicz) insists on a difference from that history, on a gap between where the word has been and where it is going.[4] When spoken in the first person, "queer" announces one's own commitment to sexual nonconformity.

Many of the artworks reproduced in this book might be thought of as queer in that they take the stigmatized image of homosexuality (as crime or obscenity, as sickness or stereotype) and force it into a different register of visibility. Rather than countering homophobia with "positive" images of assimilation or dignity, artists from Cadmus to Wojnarowicz have drawn upon (and often drawn out) the deviant force of homosexuality. Whether through the use of satire, stereotype, camp, mug-shot photography, sadomasochism, or appropriated pornography, these artists pictured homosexuality as something that could never be fully disciplined by the dominant culture. Their various strategies of outlaw representation remain significant today, not least because of the normalizing pressures now applied both to federally funded art and to gay and lesbian culture. In this afterword, I aim to sketch out some of these pressures as well as the strategies that one queer-identified artist, Holly Hughes, has crafted for responding to them.

IN NOVEMBER 1990, the U.S. Congress imposed the so-called decency clause on the funding procedures of the National Endowment for the Arts. The clause decreed that the NEA must ensure that "artistic excellence and artistic merit are the criteria by which applications are judged, taking into consideration general standards of decency and respect for the diverse beliefs and values of the American public."[5] The clause might seem relatively toothless insofar as both "general standards of decency" and the act of taking them into consideration sound so vague as to be negligible. As I have argued throughout this book, however, the regulation of art is often most effective where it is least visible and explicit.

In this context, it is instructive to recall that the decency clause was designed as an alternative to (but hardly an undoing of) the Helms amendment of 1989, whose original wording prohibited the NEA from funding "obscene or indecent materials, including but not limited to depictions of sadomasochism, homoeroticism, the exploitation of children, or individuals engaged in sex acts."[6] When read in tandem with the original text of the Helms amendment, an insistence upon "general standards of decency" begins to sound much more pointed

as a means of restricting certain kinds of art—and of artists—from receiving NEA support. If "general standards of decency" still sounds a bit vague, consider that in August 1989, Senator Helms sent photocopies of four Mapplethorpe pictures to every member of the House and Senate after labeling them with the word "indecent."[7]

The passage of the decency clause in 1990 could not but recall (and in a sense revive) Helms's prior use of the term "indecent" to describe Mapplethorpe's work. In contrast to Helms's often vivid denunciations, however, the decency clause derives restrictive power from the very looseness of its wording, from the fact that terms such as "homoeroticism," "sadomasochism," and "individuals engaged in sex acts" are no longer spelled out as specifically prohibited. The concept of "general standards of decency" allows for a more subtle restriction on federally funded art, one that can be used to regulate not only gay and lesbian imagery but any form of oppositional art.[8] Just a few weeks after the decency clause was adopted, for example, Mel Chin's *Revival Field*, an environmental art project designed to clean up a land mass contaminated with toxic waste, was defunded by the NEA as a result of its perceived "political tone."[9] Although funding was later restored to Chin's project, this incident reveals just how far the restrictive language of "decency" may be made to extend.

The defunding controversy most closely associated with the decency clause started several months before the clause was even adopted by Congress. In June 1990, NEA chairman John Frohnmayer overturned four solo performance grants that had been unanimously recommended by the NEA's panel of peer reviewers. All of the performance artists whose grants were rescinded—Karen Finley, John Fleck, Holly Hughes, and Tim Miller—dealt explicitly with issues of sexuality in their work, and three of them were openly gay or lesbian. Although he provided little justification for his actions at the time, Frohnmayer would later explain his decision as a response to political pressures applied by then-President George Bush. In his 1993 memoir, Frohnmayer recalls that:

> On June 19, [1990] the President wrote saying . . . he didn't want
> censorship, but he didn't want a dime of taxpayers' money going to art that
> was 'clearly and visibly filth.' He said he was shocked by the examples in a
> recent *Washington Times* story (describing, among others, Fleck, Finley,
> Hughes, and Miller) and that we had to find a way to preserve
> independence and creativity in the arts and at the same time see that
> taxpayers' money would not subsidize 'filth and patently blasphemous
> material.'[10]

Frohnmayer never saw firsthand the work of the four performance artists whose grants he rescinded. His decision to defund was based, at least in part, on second-hand accounts of that work as "filth."

In September 1990, Fleck, Finley, Hughes, and Miller (by now known as the "NEA Four") sued Frohnmayer and the federal government for violating their First Amendment rights.[11] The artists later amended their case so as to challenge the constitutionality of the decency clause.[12] In 1993, each of the plaintiffs accepted an out-of-court cash settlement from the federal government. Even as they did so, however, the NEA Four pushed ahead with their legal challenge to

the decency clause. Their case, officially known as *Finley v. NEA,* ultimately reached the U.S. Supreme Court which in June 1998 ruled that the decency clause was constitutional.

Less than one year later, Holly Hughes created a solo performance piece entitled *Preaching to the Perverted.* The piece focuses on censorship, queer art (including Hughes' own), and the Supreme Court's hearing of *Finley v. NEA.* The title of the piece echoes both the denunciation of Hughes's work by evangelical preachers and the charges of perversion to which she was subjected in the wake of her 1990 defunding. But Hughes's title (like her performance) also insists on the creative and political power of identifying with "the perverted" and of directing one's art toward—or "preaching to"—an avowedly queer audience.

The announcement postcard for *Preaching to the Perverted* offers a wide-eyed Hughes holding an American flag at chest level (figure 6.1). The flag drops, garmentlike, in front of her body. Although Hughes appears at first glance to be naked beneath the flag, she is in fact wearing a black bra and panties, undergarments that become increasingly noticeable the longer one looks at the image. Shortly after Hughes was defunded in 1990, several press accounts mistakenly described her performances as featuring nudity and masturbatory sex acts.[14] In the postcard for *Preaching to the Perverted,* Hughes revisits the image of her naked body on stage but on terms which reveal that image to be a misrecognition by others, a mistaken perception of sexual exposure and activity. Hughes's appropriation of the U.S. flag as a mock dress also recalls (and wittily responds to) the public accusation that her performance art—along with that of Finley, Fleck, and Miller—constituted an assault on American values.[15]

Throughout the course of *Preaching to the Perverted,* Hughes cites the descriptions (and distortions) of her work by Jesse Helms, John Frohnmayer, Hilton Kramer, Patrick Buchanan, and *U.S. News and World Report,* among others. But she also interweaves these descriptions with her own experience of hearing them for the first time and with the jokes, fears, fantasies, and personal associations they provoked. *Preaching to the Perverted* restages the story of Hughes's federal defunding through the lens of her own and often hilarious reception of it:

> June 30, 1990 . . . Responding to a Congressional statute forbidding the funding of obscenity, the National Endowment for the Arts strips four performance artists—Karen Finley, John Fleck, Tim Miller, and Holly Hughes—of their funding. Some people called us the NEA Four. Others called us "Karen Finley and the Three Homosexuals." You remember us. We played your middle school prom. You were hoping for Duran Duran but you got us instead. Later we became "Karen Finley and the three Non-Mainstream Artists."[16]

After opening her description of the NEA Four in the dispassionate voice of a television or radio newscaster, Hughes slides ever further away from that voice and into her own. With terrific irreverence, she demonstrates how the fact of homosexuality may displace any other information about an artist's life and work, including, in this case, her very name. Even as Hughes was targeted for defunding as a result of her work's lesbian content, she was often marginalized, for that same reason, in the media coverage of the NEA Four.

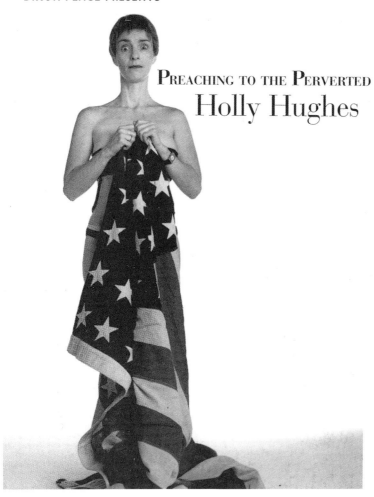

Preaching to the Perverted
Holly Hughes

Later in *Preaching to the Perverted*, Hughes returns to the ways in which the differences among artists may be flattened or denied outright within the context of public controversy. Standing silently on stage, Hughes listens to the recorded voice of a man as he spits out the following harangue:

Hello, is this the ACLU?
I'm outraged at your representing Holly Hughes.
The woman needs to be shot for her lewdness.
You need to be shot for representing her.
I have just one question.
Which one is Holly Hughes?
Is she the one with the chocolate?
Is she the big nigger lover?
Is she the one with the piss?
Is she the one who wants to kill the Pope?

Figure 6.1.
Holly Hughes,
Preaching to the Perverted announcement postcard,
Dixon Place, New York, summer 1999. Photo: Kelly Campbell; design: Frances White.

Didn't she die already?
She's dead, she died of AIDS
Like all the other fags.[17]

In leveling his threat against Hughes, the anonymous speaker slips furiously from one controversial artist to the next or, rather, from one epithet describing a controversial artist to the next. The instability of the speaker's attack ("Which one is Holly Hughes?") seems only to fuel the rage through which he collapses different artists, artworks, and bodies such that they all, in the end, become "fags" who have "died of AIDS." By citing this hate speech in her performance, Hughes demonstrates how homophobia may fuel the attacks on controversial art regardless of the "actual" sexual identity of the artists at issue.

Early in *Preaching to the Perverted*, Hughes succinctly reviews the legal history of *Finley v. NEA*, from the initial filing of the suit through lower court rulings and later appeals:

So we sued the government . . .
We won.
They appealed.
We won again!
They appealed again
This time "they" means Bill Clinton
And the appeal is to the Supreme Court.
And well . . .
Did you hear the one about the lesbian, the feminist, and a couple of fags go
 to the
Supreme Court . . . [18]

By describing the Supreme Court's hearing of *Finley v. NEA* as a joke—or more precisely, as the set-up to a joke whose punchline we never hear—Hughes suggests the absurdity of the proceeding. Hughes renders this absurdity visible on stage by presenting the nine Supreme Court Justices as nine tiny yellow rubber duckies, each of which she pins to the top of a lectern. The rubber duckies then hear the oral arguments in the case of *Finley v. NEA*, arguments which Hughes recounts as follows:

The government's lawyer is up first.
He's trying to explain how the NEA can take into consideration
General standards of decency without violating the first amendment.
I guess the reason this lawsuit got this far
Is that everyone is pretending that the definition of decency isn't clear
Everyone is acting as though that word
Weren't a big pink neon sign flashing:
"No Queers! No Queers!"

And the way the NEA insures decency, we are told,
Is by asking people who are certified to be decent to sit on the panels
Decent people, says the lawyer, can only make decent decisions.

The other defense that is offered by the government
Is that the law doesn't really mean anything
It hasn't hurt anyone
But it's a nice little law and we shouldn't get rid of it.

But the obvious question doesn't get asked:
How does the government decide someone is decent?
Perhaps it's not asked because we're talking about
"general standards of decency"
and it's no mystery how that is determined.
They no doubt use my mother's method:
They check your underwear.
First, it has to exist; no drip-dry advocates need apply
It must be all natural fibers, preferably white
No holes, stains, sagging waistband, safety pins!
Maybe a simple pattern but no slogans, please!
No "I can't believe I ate the whole thing"
And it's got to be appropriate:
No boxer shorts on women
No lacey thongs on men.[19]

Hughes recasts the NEA's insistence on "general standards of decency" as an exercise in discipline no less literal-minded and infantilizing than an "underwear check" by her mother. Like an underwear check, the decency clause insists on cleanliness, appropriate gender roles, traditional styles—in a word, respectability. By drawing out this analogy within the space of her performance, Hughes punctures the demand for respectability made by the NEA. She likens the decency clause not only to an underwear check but also (and relatedly) to a "big pink neon sign flashing 'No Queers! No Queers!'" At such moments, Hughes forces the rhetoric of decency to speak its own fear of queer artists.

An hour before the official hearing of *Finley v. NEA* is to begin, a member of the Secret Service informs Hughes and the rest of the courtroom audience that "there is absolutely no talking in the U.S. Supreme Court!" In *Preaching to the Perverted*, Hughes recalls this instruction as well as the compulsory hour of silence that followed it. She uses this concrete example of silence to symbolize the broader, if more subtle, silencing of expression imposed by the Court's ruling in *Finley v. NEA*. Throughout her performance, Hughes reenacts the terms under which her art has been denounced, defunded, and dismissed as indecent. But in reenacting those terms, Hughes works them over into something else, something far more compelling and uproarious than any Supreme Court hearing or NEA funding clause. And that something is *Preaching to the Perverted*.

I have seen *Preaching to the Perverted* four times since the Spring of 1999: in Los Angeles at the University of Southern California, in San Francisco at the New Conservatory Theater, in Montreal at the annual meeting of the American Studies Association, and in New York City at P.S. 122, a not-for-profit performance space. I first attended Hughes' performance not because I planned to write about it but because I knew it would be laugh-out-loud funny. But as I sat in the audience, something else happened as well. Hughes extended the narrative of

her defunding into that of the culture wars more generally and from there into a free-wheeling story of the ways in which private memory rubs up against public controversy. She responded not only to Jesse Helms and John Frohnmayer but also to the wider set of prohibitions and restrictions that are imposed upon queer culture and the people who make it. In so doing, however, Hughes created an alternative to those prohibitions, a space apart from the hushed precincts of the Supreme Court and the legislated decency of the National Endowment for the Arts. Each time I see *Preaching to the Perverted*, whether in a university class-room, a conference hotel ballroom, or a community-based theatre, I visit this "space apart." In reenacting the history of her own censorship, Hughes defies the silencing of art and sexuality that history sought to enforce. And she invites me, along with everyone else in her audience, to do the same.

The artists discussed in this book, from Paul Cadmus to Holly Hughes, could not transcend the homophobic constraints imposed upon their work. They could, however, restage and resist those constraints within the space of their art. Rather than defending their work as proper or decent, these artists drew upon the force of the improper and the indecent, the force of fairies, most wanted men, sadomasochists, AIDS activists, and flaming queers. They used the outlaw status of homosexuality both to contest the threat of censorship and to propose other visions of social, sexual, and creative life. These artists offer a record of resistance within the history of twentieth-century American culture. But they also do something more. In the face of ongoing demands for decent art, they urge us to recognize the value, and to take the risk, of unrespectability.

Notes

Chapter 1

1. According to Robertson's letter, the Christian Coalition would "register God-fearing Americans to vote and insist that candidates for every office tell us their views on religious freedom, abortion, prayers in schools, sex education, pornography, and other issues important to the moral fiber of our nation." Rev. Pat Robertson, Christian Coalition direct mail letter, October 25, 1989. Copy housed in the archives of People for the American Way, Washington, D.C. An excerpted version of the letter is reproduced in Richard Bolton, *Culture Wars: Documents from the Recent Controversies in the Arts* (New York: New Press, 1992), 123–25.

2. That controversy had begun in April 1989, when the Reverend Donald Wildmon, the director of the American Family Association, contacted members of the U.S. Senate to protest the federal funding of an art exhibit in North Carolina that included a photograph entitled *Piss Christ* by Andres Serrano. On the controversy over *Piss Christ*, which I discuss briefly in chapter 4, see Bolton, *Culture Wars*, especially the following texts reprinted therein: "Rev. Donald Wildmon, letter concerning Serrano's *Piss Christ*, April 5, 1989," p. 27; "Debate in Senate over the NEA," May 18, 1989, pp. 28–31; and Patrick Buchanan, "Losing the War for America's Culture?," pp. 31–32.

3. Number 1, for example, describes Mapplethorpe's 1978 *Self-Portrait*, which had been denounced on the floor of the Senate by Jesse Helms in July 1989. I discuss this photograph at length in chapter 4.

4. Jean Laplanche and J. B. Pontalis, *The Language of Psycho-Analysis* (New York: Norton, 1973), 314–15. On the subject of fantasy, Laplanche and Pontalis write, "The use of the term phantasy cannot fail to evoke the distinction between imagination and reality (perception). If this distinction is made into a major psycho-analytic axis of reference, we are brought to define phantasy as a purely illusory production which cannot be sustained when it is confronted with the correct apprehension of reality" (315). On the distinction between "phantasy" and "fantasy," Laplanche and Pontalis direct the reader to Charles Rycroft's *Critical Dictionary of Psychoanalysis* (New York: Penguin, 1968 [55–56]), which in turn relies upon the *Oxford English Dictionary*. Here is Rycroft's entry for "fantasy and phantasy": "According to the O.E.D., 'In modern usage, *fantasy* and *phantasy*, in spite of their identity in sound and in ultimate etymology, tend to be apprehended as separate words, the predominant sense of the former being "caprice, whim, fanciful invention," while that of the latter is "imagination, visionary notion."' Since the psychoanalytical concept is more akin to imagination than to whimsy, English psychoanalytical writers use *phantasy* not *fantasy*, but few, if any, American writers have followed them in doing so."

Following American usage, I opt for the term "fantasy" throughout this book. I want the term to carry the psychoanalytic meaning of an imaginary scene while also suggesting the sense of pleasure that attends to such notions as fancifulness and whimsy. I stress the importance of pleasure because the fantasies at issue in this book are almost always sexual, and more specifically homosexual. The pleasure produced by these fantasies is typically, and often ferociously, disavowed within the context of censorship. On this issue, see Judith Butler's analysis of Senator Jesse Helms's response to the work of Robert Mapplethorpe in her essay "The

Force of Fantasy: Feminism, Mapplethorpe, and Discursive Excess," *Differences* 2, no. 2 (Summer 1990): 105–25, esp. 108. My own work on Mapplethorpe is indebted to Butler's essay.

5. Butler, "The Force of Fantasy," 108.

6. Elsewhere in the mailing, we all told that all nine entries on the list are "descriptions of photographs funded by taxpayer dollars and displayed in galleries and art museums receiving Federal Funding." We are also informed that "these photographs have been exhibited and available for children of any age when visiting these galleries." Rev. Pat Robertson, Christian Coalition direct mail letter, October 25, 1989.

7. Ibid.

8. Carol S. Vance, "Negotiating Sex and Gender in the Attorney General's Commission on Pornography," in *Sex Exposed: Sexuality and the Pornography Debate* (ed. Lynne Segal and Mary McIntosh, London: Virgago, 1992), 40–41. This essay is a reprinted, and lightly revised, version of Vance's "The Pleasures of Looking: The Attorney General's Commission on Pornography versus Visual Images," in *The Critical Image: Essays on Contemporary Photography*, ed. Carol Squiers (Seattle: Bay Press, 1990), 38–58. "The Pleasures of Looking" has itself been reprinted in Carol Squiers, *Overexposed: Essays on Contemporary Photography* (New York: New Press, 1999), 305–26. In what follows, I draw upon both versions of Vance's essay.

9. Vance points out that "the Attorney General's Commission on Pornography, a federal investigatory commission appointed in May 1985 by then–Attorney General Edwin Meese III, orchestrated an imaginative attack on pornography and obscenity, The chief targets of its campaign appeared to be sexually explicit images. These were dangerous, according to the logic of the commission, because they might encourage sexual desire or acts. The commission's public hearings in six U.S. cities during 1985 and 1986, lengthy executive sessions, and an almost 2,000-page report constitute an extended rumination on pornography and power. Its ninety-two recommendations for strict legislation and law enforcement, backed by a substantial federal, state, and local apparatus already in place, pose a serious threat to free expression." *Sex Exposed*,

30. In the revised version of this essay, Vance writes, "The goal of the Meese Commission was to implement a repressive agenda on sexually explicit images and texts: vigorous enforcement of existing obscenity laws coupled with the passage of draconian new legislation." "The Pleasures of Looking," 40.

10. See Vance, *Sex Exposed*, 45.

11. See ibid., 46.

12. Vance, *The Critical Image*, 46–47.

13. The work of several other artists (e.g., Thomas Hart Benton, Jared French, George Platt Lynes, Cecil Beaton, Mark Chester, Peter Hujar, and Felix Gonzalez-Torres) will be also be discussed, albeit more briefly, in the course of these chapters.

14. Michel Foucault, *The History of Sexuality, Volume 1: An Introduction*, trans. Robert Hurley (New York: Random House, 1980), 101–2. Within a specifically American context, Jonathan Ned Katz has similarly argued that "by the 1880s, in the United States, sexually 'abnormal' individuals were beginning to perceive themselves, and to be seen, as members of a group. The mutual association and new visibility of such persons in American cities, and their naming by the medical profession, made their group existence manifest in a way that it had not been earlier. By way of contrast, in the early colonies, isolated enactors of sodomy did not perceive themselves, and were not seen, as members of a sodomitical collective." Jonathan Ned Katz, *Gay/Lesbian Almanac: A New Documentary* (New York: Carroll and Graf, 1983), 157.

15. For an excellent elaboration of "reverse discourse," see David Halperin, *Saint Foucault: Towards a Gay Hagiography* (New York: Oxford University Press, 1995), 52–62. As Halperin argues, "A reverse discourse, as Foucault describes it, does not simply produce a mirror reversal—a pure, one-to-one inversion of the existing terms of the discourse it reverses. . . . Gay politics is not a politics of pure reactivity, then, even though its conditions of possibility are admittedly rooted in an oppressive regime of power/knowledge. It is a reversal that takes us in a new direction" (60).

16. Weegee, *Naked City* (1945; reprint, New York: Da Capo Press, 1975), 170. Of the male transvestites (including the "gay deceiver") whose photographs appear in

Naked City, Weegee would note, "These are men arrested for dressing as girls. . . . The cops, old meanies, broke up their dance . . . and took them to the Pokey" (174).

17. The artist and critic John Coplans describes how Weegee "exposed and exploited the involuntary, naked emotions of people he photographed without their permission, often by deliberately spying. . . . People shocked, in terror, convulsed with pain, or blown out of their minds were his special target." John Coplans, "Weegee—The Famous," in *Weegee: Naked New York* (New York: te Neues Publishing Company, 1997), 12. Far from evincing the "involuntary, naked emotions" of someone photographed at the worst possible moment, the drag queen in *The Gay Deceiver* self-consciously poses for Weegee's camera.

18. I am indebted to David Halperin for this Foucault reference and for its translation into English. For a fuller discussion of this passage, see Halperin, *Saint Foucault*, 58–60.

19. The term "compulsory heterosexuality" was coined by Adrienne Rich to describe the historical prohibition and forced invisibility of lesbianism within dominant cultures that insist on—and sometimes quite literally compel—female heterosexuality. I am adapting Rich's use of the term to suggest that the compulsory nature of heterosexuality has held repercussions for the history and representation of both male and female homosexuality. See Adrienne Rich, "Compulsory Heterosexuality and Lesbian Existence," in *Powers of Desire: The Politics of Sexuality*, ed. Ann Snitow, Christine Stansell, and Sharon Thompson (New York: Monthly Review Press, 1983), 177–205.

20. Henry Campbell Black, *Black's Law Dictionary*, 5th ed. (St. Paul, Minn.: West Publishing, 1979), s.v. "censorship."

21. Elizabeth Childs, introduction to *Suspended License: Censorship and the Visual Arts* (Seattle: University of Washington Press, 1997), 4. Childs's definition, like that of *Black's Law Dictionary*, carries significant ambiguities. Who, for example, counts as a representative of political, moral, or religious authority? Can such authorities be self-designated (e.g., the Christian Coalition) or must they carry some form of official State power (e.g., the Meese Commission)?

22. Leo Steinberg, *The Sexuality of Christ in Renaissance Art and in Modern Oblivion*, 2d ed. (Chicago: University of Chicago Press, 1996), 185.

23. Tom Kalin, "Parting a Sea of Ink," *Outweek*, August 8, 1990: 62. Kalin's piece appeared in a special "arts and censorship" issue of *Outweek*, a grassroots gay and lesbian newspaper published in New York City.

24. Sigmund Freud, *The Interpretation of Dreams* (1900), vol. 4 of *The Standard Edition of the Complete Psychological Works of Sigmund Freud*, trans. and ed. James Strachey (London: Hogarth Press, 1953), 141.

25. Ibid., 141–42.

26. Immediately after the passage cited above, Freud asserts that "the fact that the phenomena of censorship and of dream distortion correspond down to their smallest details justifies us in presuming that they are similarly determined" (ibid., 143). And in a footnote added to *The Interpretation of Dreams* in 1909, Freud affirms that "the kernel of my theory of dreams lies in my derivation of dream-distortion from the censorship" (ibid., 308, n. 2). Freud's use of the term "censorship" both describes the process of dream distortion and stands, by way of analogy, as a counterpart to it within the social world. Censorship thus seems to oscillate between the psychic and social spheres, between internal and external forms of regulation.

On Freud's formulation of dream censorship, see Michael Levine, *Writing through Repression: Literature, Censorship, Psychoanalysis* (Baltimore: Johns Hopkins University Press, 1994). My understanding of Freud's theory of psychic censorship is much indebted to Levine's book.

27. Freud, *Interpretation of Dreams*, 142–43.

28. Freud writes, for example, that "if we adopt the method of interpreting dreams which I have indicated here, we shall find that dreams really have a meaning and are far from being the expression of a fragmentary activity of the brain, as the authorities have claimed. *When the work of interpretation has been completed, we perceive that a dream is the fulfilment of a wish*" (Freud's emphasis). Ibid., 121.

29. Annette Kuhn, *Cinema, Censorship, and Sexuality, 1909–1925* (London: Routledge, 1988), 2.

30. Ibid., 9.

31. Ibid., 7.

32. Ibid., 128.

33. Judith Butler, "Ruled Out: Vocabularies of the Censor," in *Censorship and Silencing: Practices of Cultural Regulation*, ed. Robert C. Post (Los Angeles: Getty Research Institute for the History of Art and the Humanities, 1998), 251–52.

34. This paradox should not be taken to suggest, however, that the damages wrought by censorship are easily reversible or exclusively symbolic. Even as censorship provokes unpredictable responses and counter-representations, this does not mean that its deleterious effects (on an individual career or reputation, on public or private sources of funding, on creative freedom) have been overturned or undone.

35. Michel Foucault, "Truth and Power: Interview with Alessandro Fontano and Pasquale Paquino," in *Michel Foucault: Power, Truth, Strategy*, trans. Paul Patton and Meaghan Morris (Sydney: Feral Publications, 1979), 36.

36. For Foucault, the individual subject is always already an effect of power: "The individual is not to be conceived as a sort of elementary nucleus, a primitive atom . . . on which power comes to fasten or against which it happens to strike, and in so doing subdues or crushes individuals. In fact, it is already one of the prime effects of power that certain bodies, certain gestures, certain discourses, certain desires, come to be identified and constituted as individuals. The individual, that is, is not the *vis-à-vis* of power: it is, I believe, one of its prime effects. The individual is an effect of power, and at the same time, or precisely to the extent to which it is that effect, it is the element of its articulation. The individual which power has constituted is at the same time its vehicle." "Lecture One, 7 January 1976," in Michel Foucault, *Power/Knowledge: Selected Interviews and Other Writings, 1972–1977*, ed. Colin Gordon (New York: Pantheon Books, 1980), 98. While I hardly wish to resurrect the individual subject as the "elementary nucleus" on which power acts, I would argue that the category of the individual (including that of the individual artist) cannot always or only be understood as a vehicle of power.

37. See David Halperin, *One Hundred*

Years of Homosexuality and Other Essays on Greek Love (New York: Routledge, 1990); David F. Greenberg, *The Construction of Homosexuality* (Chicago: University of Chicago Press, 1988); Jonathan Ned Katz, *The Invention of Heterosexuality* (New York: Plume, 1996); and Jeffrey Weeks, *Against Nature: Essays on History, Sexuality, and Identity* (London: Rivers Oram Press, 1991). Each of these authors draws, more or less explicitly, on Foucault's argument about the "invention" of the homosexual in the nineteenth century:

"As defined by the ancient civil or canonical codes, sodomy was a category of forbidden acts; their perpetrator was nothing more than the juridical subject of them. The nineteenth-century homosexual became a personage, a past, a case history, and a childhood, in addition to being a type of life, a life form, and a morphology, with an indiscreet anatomy and possibly a mysterious physiology. . . . The sodomite had been a temporary aberration; the homosexual was now a species." *The History of Sexuality*, 43.

Foucault's descriptive list draws out the multiple meanings that homosexuality was forced to carry once it entered into medical language, and then into more broadly social and cultural discourse.

38. Writing in 1990, David M. Halperin put the point most succinctly: "Although there have been, in many different times and places (including classical Greece), persons who sought sexual contact with other persons of the same sex as themselves, it is only within the last hundred years or so that such persons (or some portion of them, at any rate) have been homosexuals." *One Hundred Years of Homosexuality*, 29.

39. In a helpful paraphrase of Michel Foucault, Anne Goldstein argues that

although illicit sexual acts were seen as sinful, immoral, criminal, or all three, before the 1870s illicit sexual acts between men, or between women, were not seen as fundamentally different from, or even necessarily worse than, illicit acts between a man and a woman. What was new, then, was an understanding of sex not merely as behavior, some of which

might be criminal or sinful, but as *sexuality*: pervasive throughout a person's entire life, character, and being. Sexual acts might be mere incidents within a life, but sexuality was constitutive of identity.

This idea, new in the 1870s, is today our dominant assumption. Indeed, it is so dominant that it inflects our interpretation of the much older notions that sex between men or between women is a sin or a crime. Those ideas certainly persist, but not quite in their original form. Originally ideas about acts, they now often elide into ideas about the people who do those acts. No longer is the doer of such acts merely the "juridical subject" of them; he or she has become, at least in some eyes, the quintessential sinner or criminal, whose very existence is wrong.

Anne B. Goldstein, "Homosexual Identity and Gay Rights," in *A QueerWorld: The Center for Lesbian and Gay Studies Reader*, ed. Martin Duberman (New York: New York University Press, 1997), 402. On the complexities of Foucault's account of the history of homosexuality and their flattening by subsequent scholars, see David M. Halperin, "Forgetting Foucault: Acts, Identities, and the History of Sexuality," *Representations* 63 (Summer 1998): 93–120.

40. Jonathan Dollimore, *Sexual Dissidence: Augustine to Wilde, Freud to Foucault* (Oxford: Clarendon Press, 1991), 30.

41. Diana Fuss, introduction to *Inside/Out: Lesbian Theories, Gay Theories* (New York: Routledge, 1991), 5.

42. Slogan quoted by gay activist Jim Fouratt in *Outrage '69: A Question of Equality* (Part 1), documentary film directed by Arthur Dong and produced by Testing the Limits Collective (New York, 1995).

43. Guy Hocquenghem, *Homosexual Desire*, trans. Daniella Dangoor, 2nd edition (Durham, N.C.: Duke University Press, 1993), 50. Originally published as *Le Désir Homosexuel* (Paris: Editions Universitaires, 1972).

44. Naomi Spinrad, line producer, *NBC Nightly News*, phone interview by author, March 21, 1993.

45. As Judith Butler has argued, "The regulation [of gays in the military] must conjure one who defines himself or herself as a homosexual in order to make plain that no such self-definition is permissible within the military." *Excitable Speech: A Politics of Performance* (New York: Routledge, 1997), 104.

46. On the greater likelihood of female dismissal from the military on the grounds of homosexuality, see Judith Hicks Stiehm, "The Military Ban on Homosexuals and the Cyclops Effect," in *Gays and Lesbians in the Military: Issues, Concerns, and Contrasts*, ed. Wilbur J. Scott and Sandra Carson Stanley (New York: Aldine De Gruyter, 1994), 149–62. Stiehm observes that "the bottom line is that women are dismissed from the services for homosexuality at a rate far higher than that of men. Between 1980 and 1990, women constituted 23 percent of discharges for homosexuality although they were only 10 percent of military personnel" (158). See also Virginia Solms, "Purity, Honor, Country: If You're Straight," in *It's Our Military Too!: Women and the U.S. Military*, ed. Judith Hicks Stiehm (Philadelphia: Temple University Press, 1996), 33.

47. As Jan Zita Grover has observed, "When lesbianism was represented visually [in the nineteenth and early twentieth centuries], it was largely from without, by men speaking from and for dominant culture: one thinks immediately of the pornographic films, peeps shows, and photographic card sets of commerce, the lesbian masquerade of classical Hollywood film, the Parisian photographs of Brassai." "Dykes in Context: Some Problem in Minority Representation," in *The Contest of Meaning: Critical Histories of Photography*, ed. Richard Bolton (Cambridge: MIT Press, 1989), 166.

Deborah Bright has described the asymmetry between gay and lesbian visibility within the history of photography in the following terms:

From the anonymous tintypes, cartes-de-visite and snapshots found in thrift shops and flea markets . . . to the beefcake "pin-ups" in physique magazines, images suggesting eroticized male-male relations from photography's beginnings to gay liberation have been lovingly excavated, published, and written about.

On the other hand, lesbian or "sapphic" photographs were almost exclusively produced by men as a staple of straight porn. As "normal women" were not believed (permitted) to be interested

in sex outside of marriage and reproduction, no self-identified erotic image commerces by and for women developed until the 1970s, within the context of feminism.

Introduction to *The Passionate Camera: Photography and Bodies of Desire* (New York: Routledge, 1998), 10–11. On the discontinuity between gay and lesbian visibility, see also Sarah E. Murray, "Dragon Ladies, Draggin' Men: Some Reflections on Gender, Drag, and Homosexual Communities," *Public Culture* 6 no. 2 (Winter 1994): 343–63.

48. If homoerotic images of men have been relatively unsusceptible to heterosexual appropriation, it is in part because of the prevailing assumption that any man who would take pleasure in such images must himself be gay (or closeted) and in part because of the assumption (however inaccurate) that sexually suggestive images—whether artistic, popular, or pornographic—address a male viewer.

49. Teresa de Lauretis makes a similar point about the distinctness of lesbian and gay subcultures when she writes, "The fact of the matter is, most of us, lesbians and gay men, do not know much about one another's sexual history, experience, fantasies, desire, or modes of theorizing." "Queer Theory: Lesbian and Gay Sexualities, an Introduction," *Differences* 3, no. 2 (Summer 1991): viii. Lee Edelman has argued that lesbian experience is all but erased when it is viewed through the lens of male homosexuality: "Although lesbianism, when it finally achieves a public articulation, comes to be read in terms of male homosexuality, that reading is itself a masculinist appropriation of a relationship with a distinct history and sociology. While lesbians and gay men often have been, and for the most part remain, allies in struggling for their civil rights, the fact of their common participation in same-sex relationships should not obscure the differences of experience that result from the differences in their social positioning within a culture that divides human beings into separate categories of male and female." *Homographesis: Essays in Gay Literary and Cultural Theory* (New York: Routledge, 1994), 244, n. 17.

50. Writing in 1989, Jan Zita Grover observed that "lesbian visual self-representation in the early twentieth century was limited largely to noncommercial artwork undertaken and distributed informally, from hand to hand, within lesbian subcultures. . . . So far as I know, there were few commercial enterprises involving production, distribution, and exhibition of images from within lesbian communities until very recently. In this sense, what self-generated images we do have from the first sixty-odd years of this century exist not as commercial commodities but as personal mementos, private or collective expressions of regard and friendship. They existed, in other words, outside the standard practices of commercial production and circulation, and, as such, their content was not determined by the dominant culture's market values and methods." "Dykes in Context," 166.

51. Writing in 1990 on the controversies over federal funding for the arts, Peggy Phelan argued that "lesbians are not as overtly hated [as gay men] because they are so locked out of the visible, so far from the minds of the NEA and the New Right, that they are not acknowledged as a threat." "Money Talks: Serrano, Mapplethorpe, the NEA, and You," *The Drama Review* 33, no. 4 (Spring 1990): 14.

Shortly after Phelan's essay appeared, NEA chairman John Frohnmayer defunded Holly Hughes, a lesbian performance artist. In so doing, Frohnmayer sought to keep Hughes "locked out of the visible." But the controversy provoked by Hughes's defunding in 1990 indicated that lesbian art could no longer be confined (at least not completely or seamlessly) to the register of public invisibility. The defunding of Hughes—and of feminist performance artist Karen Finley and gay male performers John Fleck and Tim Miller—is discussed in the afterword to this book.

Although visual art by and about lesbians has not, until recently, provoked public controversy in the United States, various films, theatrical productions and literary texts about lesbianism aroused censorship controversies at earlier moments in the twentieth century. In chapter 5, I discuss one such example: the 1927 police raid on *The Captive*, the first Broadway play to focus on the topic of lesbianism. On theatrical censorship in relation to both male and female homosexuality, see Kaier Curtin, *We Can*

Always Call Them Bulgarians: The Emergence of Lesbians and Gay Men on the American Stage (Boston: Alyson Publications, 1987), and Joseph Lieberman, "The Emergence of Lesbians and Gay Men as Characters in Plays Produced on the American Stage from 1922 to 1954" (Ph.D. diss., City University of New York, 1981).

On the censorship of lesbian-themed films, see Patricia White, *Uninvited: Classical Hollywood Cinema and Lesbian Representability* (Bloomington and Indianapolis: Indiana University Press, 1999), especially chapter 1, "Reading the Code" (1–28), and Vito Russo, *The Celluloid Closet: Homosexuality in the Movies* (New York: Harper and Row, 1987). See also Rhona J. Berenstein, "Adaptation, Censorship, and Audiences of Questionable Type: Lesbian Sightings in *Rebecca* (1940) and *The Uninvited* (1944)," *Cinema Journal* 37, no. 2 (Spring 1998): 6–37.

The most significant case of literary censorship involving lesbian content involves the suppression, in both England and the United States, of *The Well of Loneliness*, a 1928 novel by the British author Radclyffe Hall. Although Hall was brought up on obscenity charges in England as a result of the book, it went on to enjoy a strong (if often underground) following among American and English lesbians for many decades afterward. On Radclyffe Hall and *The Well of Loneliness*, see Diana Souhami, *The Trials of Radclyffe Hall* (New York: Doubleday, 1999), and Sally Cline, *Radclyffe Hall: A Woman Called John* (Woodstock, N.Y.: Overlook Press, 1998).

52. The concept of the "structuring absence" was introduced by Pierre Macherey to describe how literary texts are shaped by their own absences and avoidances: "The speech of the book comes from a certain silence, a matter which it endows with form, a ground on which it traces a figure. Thus the book is not self-sufficient; it is necessarily accompanied by a *certain absence*, without which it would not exist. A knowledge of the book must include a consideration of this absence." *A Theory of Literary Production* (London: Routledge and Kegan Paul, 1978), 85. I am adapting Macherey's concept to discuss the cultural and material absence of lesbian art within the public sphere, an absence I read as crucial to the "presence" of gay male art (and its censor-

ship) within twentieth-century American culture.

53. See, for example, Jonathan Weinberg, *Speaking for Vice: Homosexuality in the Art of Marsden Hartley, Charles Demuth, and the First American Avant-Garde* (New Haven, Conn.: Yale University Press, 1993), and James M. Saslow, *Ganymede in the Renaissance: Homosexuality in Art and Society* (New Haven, Conn.: Yale University Press, 1986). The related concept of a "homosexual aesthetic" is proposed by Allen Ellenzweig in "The Homosexual Aesthetic," *American Photographer* 5 (August 1980): 60–63.

54. These questions are posed in Weinberg, *Speaking for Vice*, 126.

55. See, for example, "The Art and Politics of the Male Image—A Conversation between Sam Hardison and George Stambolian," *Christopher Street*, 4:7 March 1980: 14–22. This conversation between Hardison, the owner of a New York gallery that specialized in "male image" art, and Stambolian, a professor of French and comparative literature who was among the first in his field to publish on homosexuality as a literary issue, touches on the importance of visual representation to post-Stonewall gay culture. At one point, Stambolian describes the new "male image" galleries (in which both the paintings of both Paul Cadmus and the photographs of Robert Mapplethorpe were exhibited) as being not "about cruising or therapy, but about sharing a culture by looking at works that tell us something, whether positive or negative, about our identity and purpose" (18). Later in the interview, Hardison discusses the ways in which gay artists of the late 1970s attempted to find an expressly homosexual iconography that drew both upon the classical tradition of the male nude and the contemporary influence of gay pornography. "I think that many artists working with the male image today find themselves between two traditions—the classic, going back to Greece and strongly modified by the Renaissance, and the pornographic. Somewhere in between these two extreme poles we are witnessing the beginnings of a new tradition that hasn't been defined as yet, and that's what make this such an exciting time" (20). The new "tradition" for which gay artists of the late 1970s (such as Mapplethorpe) searched was inseparable from the new forms of homo-

sexual embodiment and visibility (e.g. the gay clone, the prominence of leather and s/m) that marked gay subcultures of the 1970s.

56. Mark Thompson, "To the Limits and Beyond: Folsom Street," *The Advocate*, July 8, 1982: 30.

57. Quoted in ibid.

58. For Cadmus's influence on the work of Tom of Finland, see F. Valentine Hooven III, *Tom of Finland: His Life and Times* (New York: St. Martin's Press, 1993), 85–86, and Micha Ramakers, *Dirty Pictures: Tom of Finland, Masculinity, and Homosexuality* (New York: St. Martin's Press, 2000), 45–47, 149–51.

59. Jacqueline Rose, "Sexuality in the Field of Vision," in *Sexuality in the Field of Vision* (London: Verso, 1986), 231.

60. In triumphalist rhetoric not uncommon to the art-historical literature on postwar American art, Joshua Taylor observed in 1976 that

> critics and art historians will never cease to debate the causes and nature of the extraordinary flowering in the late 1940s of an art in America so vigorous and moving that, for the first time in history, the United States was looked to as a source of vital artistic expression, as an artistic avant-garde. America finally had its place in art not because of its wilderness, its engineers, or its promising skylines, but because of the creations of its artists.
>
> Significantly, the art that in the early 1950s began to be recognized as American paid little heed to what had previously been considered American traits or the local scene.

America as Art (Washington: National Collection of Fine Arts, 1976), 265.

Recent art-historical scholarship has not, as a rule, attempted to track the continuities and dialogues between pre- and postwar American art. Erika Doss's study of Thomas Hart Benton and (his one-time student) Jackson Pollock marks a significant exception to this rule. See Erika Doss, *Benton, Pollock, and the Politics of Modernism: From Regionalism to Abstract Expressionism* (Chicago: University of Chicago Press, 1991).

61. According to Elizabeth Johns, the 1950s mark the disciplinary moment in which "new historians of American art became either 'modernists' or 'Americanists'; if they became Americanists, they wrote on art before 1900, or, at the latest, before 1940. . . . There entered into the study of American art a distrust for contemporary art and culture that has not yet been totally dispelled: reversing the action of the historians of the late nineteenth century who pushed away a past they considered dismal in order to concentrate on a present that excited them, scholars of American art turned their backs on a chaotic present in favor of an interpretable past." "Histories of American Art: The Changing Quest," *Art Journal* 44, no. 4 (Winter 1984): 342.

62. Jules Prown, "Editor's Statement: Art History vs. the History of Art," *Art Journal* 44, no. 4 (Winter 1984): 313.

63. Wanda Corn, "Coming of Age: Historical Scholarship in American Art," *Art Bulletin* vol. 70, no. 2 (June 1988), reprinted with a new afterword by the author in *Critical Issues in American Art: A Book of Readings*, ed. Mary Ann Calo (Boulder, Colo.: Westview Press, 1997), 3.

64. Wanda Corn, afterword to "Coming of Age," in *Critical Issues in American Art*, 25.

65. Corn neglects to mention that the history of modern European art has itself been revised, particularly by feminist and Marxist scholars, so as to address the complex relations among commodity culture, popular images, and the production of high art. No art historian has mapped these relations with more descriptive brilliance and archival rigor than T. J. Clark in *The Painting of Modern Life: Paris in the Art of Manet and His Followers* (New York: Knopf, 1985).

66. See Linda Nochlin, *Women, Art, and Power and Other Essays* (New York: Harper and Row, 1988), and *Representing Women* (London: Thames and Hudson, 1999); Anne Wagner, *Three Artists (Three Women): Modernism and the Art of Hesse, Krasner, and O'Keeffe* (Berkeley and Los Angeles: University of California Press, 1996); and Lisa Tickner, "Feminism, Art History, and Sexual Difference," *Genders* 3 (Fall 1988): 92–128.

67. Wagner, for example, describes her book on O'Keeffe, Krasner, and Hesse as one which "demonstrates the conviction that just as images are not transparent to social identity (or anything else), neither are people." *Three Artists (Three Women)*, 26. Fol-

lowing Wagner, I insist on the non-equivalence—and sometimes, the outright mismatch—between visual images and sexual identity.

68. The links tying this book to feminism recall an earlier—and to my mind, signal—moment within the art-historical study of homosexuality. In 1979, James Saslow published an essay entitled "Closets in the Museum," which criticized official practices of art history for the ways in which they suppressed or silenced questions of homosexuality. Even as Saslow helped to inaugurate (what he called) "gay scholarship" within the field of art history, he made explicit the debt of such scholarship to the feminist movement: "The predominance of women has helped art history become a pioneering field in feminist scholarship; the impact of the women's movement has provided at least the beginnings of a similar openness to gay scholarship. . . . The issues raised by feminist art historians have begun to 'clear the ground' for a more sympathetic understanding of concepts important to developing a theoretical justification for gay art. Prominent critics like Linda Nochlin and Lucy Lippard bring to their analysis a concern for gender roles and androgyny as well as psychological and sociological understanding of oppression, both of which clearly overlap with gay concerns" (224). If feminist art history of the 1970s helped "clear the ground" for Saslow's scholarship, then Saslow's scholarship has in turn enabled subsequent work on homosexuality within the history of art. It is worth noting, however, that "Closets in the Museum" was originally published in neither a feminist nor an art-historical context. Instead, the essay appeared in *Lavender Culture*, a 1979 volume that sought to "demonstrate that the struggle for social change that has become known as the gay liberation movement is a vital cultural and political force" by drawing together essays on gay and lesbian art, fashion, fiction, poetry, dance, and music as well as writings on the social and cultural significance of camp, Judy Garland, leather and s/m, lesbian separatism, and the history of the gay bar scene in Cleveland, Ohio. As Saslow makes clear in his essay, his scholarly work owed as much to the gay and lesbian liberation movement (and to the publications underwritten by it, such as *Lavender*

Culture) as to feminist art history. *Outlaw Representation* is similarly indebted to the gay and lesbian movement of the 1970s and to the space it opened for the cultural and historical study of homosexuality. See James Saslow, "Closets in the Museum," in *Lavender Culture*, ed. Karla Jay and Allen Young (New York: Jove/HBJ, 1979), 215–27.

69. Jonathan Weinberg, "Speaking for Vice: Homosexuality in the Art of Charles Demuth, Marsden Hartley, and the Early American Avant-Garde" (Ph.D. diss., Harvard University, 1990), 14. Weinberg subsequently revised his dissertation and published it as *Speaking for Vice* (see n. 53 above). The sentence cited from Weinberg's dissertation does not appear in his book.

Weinberg is part of a small group of pioneering scholars whose work has focused on the relation between male homosexuality and twentieth-century American art. In addition to Weinberg, this group includes Kenneth E. Silver and Jonathan D. Katz. See Kenneth E. Silver, "Modes of Disclosure: The Construction of Gay Identity and the Rise of Pop Art," in *Hand-Painted Pop: American Art in Transition, 1955–1962*, ed. Russell Ferguson (Los Angeles and New York: Museum of Contemporary Art and Rizzoli International Publications, 1992), 178–203; Jonathan D. Katz, "The Art of Code: Jasper Johns and Robert Rauschenberg," in *Significant Others: Creativity and Intimate Partnership*, ed. Whitney Chadwick and Isabelle de Courtivron (London: Thames and Hudson, 1993), 189–207. In addition to Weinberg's *Speaking for Vice*, see also his essays "It's in the Can: Jasper Johns and the Anal Society," *Genders* 1 (1988): 40–56, and "Cruising with Paul Cadmus," *Art in America* 80 (November 1992): 102–209.

70. Carol Armstrong, response to "Visual Culture Questionnaire," *October* 77 (Summer 1996): 27.

The introduction of a wider range of objects and images into the field of art history has provoked something of a backlash against what is now called "visual culture" or "visual studies." Within the terms of this backlash, the study of popular, non-canonical, and interactive art has been dismissed as a mindless embrace of new technologies on the one hand and a failure to attend to the visual and material specificity of artworks on the other. Thus, for example, does Arm-

strong claim that a "predilection for the dis-embodied image" and "a distrust of the material dimension of cultural objects" characterize "new interdisciplinary models such as that of visual culture." She further insists that "[w]ithin this model, paintings and such are to be viewed not as particular-ized *things* made for particular historical uses, but as exchanges in some great, boundless, and often curiously ahistorical economy of images, subjects, and other rep-resentations." [27]. *Outlaw Representation* is committed to the close visual analysis of art-works ("paintings and such") as well as other forms of pictorial production (e.g. activist posters, physique photographs, popular press images). It refutes the suggestion that studying visual culture necessarily entails a sacrifice of careful looking or sustained for-mal description.

71. By attending to particular forms of invisibility within modern art, *Outlaw Repre-sentation* attempts to fulfill something of the agenda proposed for the "social history of art" by T. J. Clark in 1973, an agenda attentive to the social constraints and con-tradictions under which artists and critics necessarily labor. Although Clark did not have questions of homosexuality in mind when he wrote the following passage, his words have informed and inspired the mis-sion of this book: "Finally there is the old familiar question of art history. What use did the artist make of pictorial tradition; what forms, what schemata, enabled the painter to see and to depict? It is often seen as the only question. It is certainly a crucial one, but when one writes the social history of art one is bound to see it in a different light; one is concerned with what prevents representation as much as what allows it; one studies blindness as much as vision." T. J. Clark, "On the Social History of Art," in *Image of the People: Gustave Courbet and the Second French Republic 1848–1851* (1973; Grenwich, CT: New York Graphic Society, 1973), 15. Adapting Clark's argument a bit, I would suggest that the place of homosexu-ality within the history of art can only be understood by attending to "what prevents representation as much as what allows it."

Clark's emphasis on the role of social and ideological constraint within the history of art would later be echoed by Linda Nochlin: "A social history of art cannot be con-structed out of what is visible, nor can it be created merely by adding additional objects—items of popular culture or other assorted documentation—to the space in which art works are shown. The function of a social history of art is precisely to reveal what is *invisible*—repressed, deleted, unrep-resentable, scandalous, forgotten." Nochlin's remarks were published within a 1988 dossier on the recently opened Musée d'Orsay, a controversial museum of nine-teenth-century art that seeks (and, in Nochlin's view, largely fails) to convey a social history of post-1848 French culture. "Successes and Failures at the Orsay Museum, or Whatever Happened to the Social History of Art," in "The Musée D'Or-say: A Symposium," *Art in America* 76, no. 1 (January 1988): 88.

72. The image of the effeminate gay man (the "fairy" or "pansy") appears with some regularity in pre–Hays Code Hollywood films and depression-era tabloid cartoons. The figure of the "fairy" is discussed in chapter 2.

73. Although the concept of the "case study" is adapted from medical, and espe-cially psychiatric, discourses of pathology, I mean to use it in a quite different sense, namely, as an index of social and art-histori-cal meaning. Nevertheless, the clinical con-notation of the term "case study" (or its vari-ant, "case history") could hardly be irrelevant to a history of censorship within which particular works of art, and the artists who made them, have been construed as obscene, dangerous, or "sick."

Patricia Juliana Smith, the editor of an anthology entitled *The Queer Sixties*, notes in that book's introductory essay that "each essay in this volume is, in a sense, a 'case study'—a term ironically appropriate for the decade in which homosexuals were still regarded as 'cases' requiring psychoanalytic study—of a particular cultural phenome-non or figure that, since manifesting in the context of the 1960s, has taken on iconic status among queer audiences." Introduction to *The Queer Sixties*, ed. Patricia Juliana Smith (New York: Routledge, 1999), xv. Following Smith, I understand the "case study" as an "ironically appropriate" method for studying the relationship between homosexuality and censorship within modern art.

On the history of the "case study," see

John Forrester, "If *p*, then what?: Thinking in Cases," *History of the Human Sciences* 9, no. 3 (1996): 1–25.

74. Chapter 5 departs from this format by focusing on both an individual artist, David Wojnarowicz, and on an art collective, Gran Fury. The logic of making this chapter into a "double case study" is addressed within the body of the chapter.

75. Donna Penn, "The Present and Future of Recuperating the Past: A Review Essay," *GLQ* 2, no. 3 (1995): 282.

76. Freud, *Interpretation of Dreams*, 142–43, n. 3.

77. Although Freud includes a transcription of the dream of the love services in the 1919 footnote to *The Interpretation of Dreams*, he does not analyze the dream in that text. Freud does, however, remark at some length on the *Liebesdienste* dream in his lecture "The Censorship of Dreams," which is included in *The Introductory Lectures* (1916–17), vol. 15 of the *Standard Edition*. He writes, for example, that "what is remarkable and interesting from our point of view is that the dream shows several gaps—gaps not in the dreamer's memory but in the content of the dream itself. At three points the content was, as it were, extinguished; the speeches in which these gaps occurred were interrupted by a mumble. As no analysis was carried out, we have, strictly speaking, no right to say anything about the sense of the dream. Nevertheless, there are hints on which conclusions can be based (for instance, in the phrase 'love services'); but above all, the portions of the speeches immediately preceding the mumbles call for the gaps to be filled in, and in an unambiguous manner. If we make the insertions, the content of the phantasy turns out to be that the dreamer is prepared, by way of fulfilling a patriotic duty, to put herself at the disposal of the troops, both officers and other ranks, for the satisfaction of their erotic needs. This is, of course, highly objectionable, the model of a shameless libidinal phantasy—but it does not appear in the dream at all. Precisely at the points at which the context would call for this admission, the manifest dream contains an indistinct mumble: something has been lost or suppressed." *Introductory Lectures*, 138.

78. Ibid., 138–39.

79. Gay Treasures has since become Creative Visions, a contemporary fiction and nonfiction bookstore whose back room includes some of the materials formerly sold at Gay Treasures. As Richard Goldstein has pointed out, "The adult merch[andise] is protected by a more traditional collection of books and periodicals." The marginalization of the physique magazines and homoerotica to the rearmost section of Creative Visions (along with the loss of Gay Treasures as an independent shop) reflects New York City mayor Rudolph Giuliani's increasingly restrictive policy toward the sale of pornography and the commercial sex industry in general. See Richard Goldstein, "The Little Shop of Hornies," *Village Voice*, December 31, 1996: 45.

Chapter 2

1. *Encyclopaedia Britannica* (14th ed.), vol. 17, pl. 24.

2. The term "Regionalism" is a shorthand description of the shared thematic and pictorial concerns of antiurbanist painters of the 1930s, especially Benton, Curry, and Wood. The agrarian nostalgia of Regionalist paintings offered an escape, however regressive, from the perceived failures of modernity during the Great Depression. From a historical point of view, however, Regionalism is a problematic category insofar as no unified set of artists would have described themselves as belonging to such a movement at the time. As Mathew Baigell argues, "The term Regionalism was applied to certain painters of the American Scene with increasing frequency after the appearance of an article on Regionalist painters in *Time* magazine in December 1934. It created (and still creates) a good deal of confusion, for try as they might, critics never succeeded in finding truly Regionalist painting in America during the 1930s. They saw plenty of localized subject matter, but they never discovered styles typical of particular sections of the country. . . . Nevertheless, the term 'Regionalism' unfortunately stuck, and in the eyes of both the critics and the public it became identified with three Middle Western painters—[Thomas Hart] Benton, Grant Wood, and John Steuart Curry—even though Benton did not meet Curry until 1929 and Wood until 1934, after each had developed separate styles and aims. . . .

Because of this linkage, Regionalist painting came to stand for an art of rural and country views, apolitical in content, often nostalgic in spirit, and usually unmindful of the effects of the Depression." According to Baigell, Regionalism was initially known as the American Scene movement. This term was soon applied, however, not only to painters of small-town American life such as Benton, Curry, and Wood but also to politically engaged social realists such as Ben Shahn, Philip Evergood, and Raphael Soyer. In this chapter, I follow Baigell's commodious definition of American Scene painters as "those who found their subject matter in various aspects of American life and who formed their mature styles around 1930." [16]. The title "A Different American Scene" means to suggest the distinctive character of Cadmus's pictorial approach to contemporary American life in the 1930s. Mathew Baigell, *The American Scene: American Painting of the 1930s* (New York: Praeger Publishers, 1974), 55. On Regionalism, see also Wanda M. Corn, *Grant Wood: The Regionalist Vision* (New Haven, Conn.: Yale University Press, 1983).

3. "Spotlight: Paul Cadmus," *Life*, March 14, 1937: 51.

4. Alone among the pictures in the spread, *Gilding the Acrobats* includes a black figure, although the terms on which it does so are patently stereotypical, an issue to which I shall return later in this chapter.

5. On the uses of "queer," see Eve Kosofsky Sedgwick, "Queer and Now," in *Tendencies* (Durham, N.C.: Duke University Press, 1993), 1–22; Michael Warner, introduction to *Fear of a Queer Planet: Queer Politics and Social Theory* (Minneapolis: University of Minnesota Press, 1993), vii–xxxi.

6. I am indebted to a series of conversations with Jonathan Weinberg for this formulation. For a somewhat different take on the homoeroticism of Cadmus's early paintings, see Weinberg's "Cruising with Paul Cadmus," *Art in America* vol. 80, no. 11 (November 1992): 101–108.

7. See M. H. Abrams, *A Glossary of Literary Terms*, 3d ed. (New York: Holt, Rinehart, and Winston, 1971): "Satire differs from the comic in that comedy evokes laughter as an end in itself, while satire 'derides'; that is, it uses laughter as a weapon, and against a butt existing outside the work itself. . . . Satire has usually been justified by those who prac-

tice it as a corrective of human vice and folly. Its claim (not always borne out in the practice) has been to ridicule the failing rather than the individual, and to limit its ridicule to corrigible faults, excluding those for which a man is not responsible" (153). Abrams's last point, about the supposed correctability of the satirized fault, is especially provocative in the context of Cadmus's work, since homosexual desire is so often the "failing" in question.

8. This claim concerns Cadmus's representation of homosexuality within the public sphere of art exhibition and reproduction. Several other artists (e.g., Charles Demuth, Jared French, George Platt Lynes, Marsden Hartley, and Pavel Tchelitchew) created expressly homoerotic images during the 1930s. These works were not, however, publicly exhibited. One salient exception to this privatizing rule is Demuth's 1930 watercolor *Distinguished Air*. On the exhibition of this work at the Whitney Museum, see Jonathan Weinberg, *Speaking for Vice: Homosexuality in the Art of Charles Demuth, Marsden Hartley, and the First American Avant-Garde* (New Haven, Conn.: Yale University Press, 1993), 196–200. On the private circulation of homoerotic imagery during the interwar period, see Weinberg's exhibition brochure titled "Male Desire: Homoerotic Images in Twentieth-Century American Art" (New York: Mary Ryan Gallery, 1995) and his *Speaking for Vice*.

9. Note that the single image selected for reproduction in the exhibition checklist is *Gilding the Acrobats*. Like the *Encyclopaedia Britannica* spread, the Midtown checklist takes the picture as representative of Cadmus's early career.

10. Edward Alden Jewell, "Cadmus Canvases Hung at Midtown," *New York Times*, March 27, 1937: 12. Jewell further comments, "'Gilding the Acrobats' (1935) seems constructed with flawless skill."

11. "Cadmus, Satirist of Modern Civilization," *Art Digest*, April 1, 1937: 17. The notice was accompanied by a reproduction of *Gilding the Acrobats*, a painting the review described as "luminous."

12. "Cadmus' Tars under Fire at the San Francisco Fair," *Newsweek*, August 19, 1940: 51.

13. Clement Greenberg, "Avant-Garde and Kitsch" (1939), reprinted in *Clement*

Greenberg: The Collected Essays and Criticism, Volume 1: Perceptions and Judgments, 1939–1944, ed. John O'Brian (Chicago: University of Chicago Press, 1986), 12.

14. Cited in William Grimes, "The Charge? Depraved. The Verdict? Out of the Show," *New York Times*, March 8, 1992: sec. 2, pp. 1, 35. As Cadmus's career demonstrates, critical attention cannot be taken as an index of artistic productivity. Cadmus created some of his most accomplished work, including some of his most ambitious and painstaking egg tempera paintings, during periods of relative obscurity.

15. See Philip Eliasoph, "Paul Cadmus: Life and Work" (Ph.D. diss., State University of New York at Binghamton, 1979); Philip Eliasoph, *Paul Cadmus: Yesterday and Today* (Miami, Ohio: Miami University Art Museum, 1981); Lincoln Kirstein, *Paul Cadmus* (Petaluma, Calif.: Pomegranate Art Books, 1984; rev. ed., New York: Chameleon Books, 1992); David Sutherland, *Paul Cadmus: Enfant Terrible at Eighty* (documentary film distributed by Home Vision, 1984); Weinberg, "Cruising with Paul Cadmus"; and Weinberg, "Paul Cadmus: Visionary Realist" (New Haven, Conn.: Yale University Art Gallery, 1997).

16. On the occasion of this award, I published a short essay profiling Cadmus's artistic career and achievement in *Art Journal* (a publication of the College Art Association devoted to modern art). See Richard Meyer, "Profile: Paul Cadmus," *Art Journal* 57, no. 3 (Fall 1998): 80–84.

17. Writing in 1985, Harriet Fowler observed that "the 1970s and 80s show a flourishing of studies, exhibitions, and articles [on American art of the 1930s] and there is every indication that the resurgence of interest in New Deal art is growing daily. The renewed interest coincides with a number of social and cultural factors: the recent economic recession and our general tendency to compare it with previous historical examples, a continuing re-evaluation of American art which, of course, constantly reflects changes of taste and, very importantly, the revitalized tradition of figurative painting in contemporary art. The solid, heroic representationalism of the 1930s no longer looks as dated, awkward, or jarring as it did at the height of 1950s or 1960s abstraction." *New Deal Art: WPA Works at the University of Kentucky* (Lexington: University of Kentucky Art Museum, 1985), 15.

18. See, for example, Robert G. Boylan, "This Is America's Greatest Gay Artist," *Vector*, January/February 1976: 19–23; Donnell Stoneman, "A Very Special Interview: Painter Paul Cadmus," *The Advocate* 191 (June 2, 1976): 25–29; Brant Mewborn, "Paul Cadmus: Portrait of the Artist as a Gentle Man," *After Dark*, March 1978: 46–53.

19. See Boylan, "This Is America's Greatest Gay Artist."

20. One reflection of the renewed interest in Cadmus's early work has been that work's reproduction on the covers of recent books related to homosexuality. The second edition of *Intimate Matters: A History of Sexuality in America*, for example, features a detail from Cadmus's 1933 painting *Shore Leave*; *Queer Forster*, a 1997 anthology of essays on sexuality in the work of E. M. Forster, offers a detail of Cadmus's *What I Believe* (1947–48); and the cover of *Take the Young Stranger by the Hand: Same-Sex Relations and the YMCA* features a reproduction of Cadmus's 1933 painting *YMCA Locker Room*. All of these titles were published by the University of Chicago Press. In addition, the paperback edition of Frank Browning's *A Queer Geography* (New York: Noonday Press, 1998) features a reproduction of Cadmus's 1935 painting *Horseplay*. See John D'Emilio and Estelle B. Freedman, *Intimate Matters: A History of Sexuality in America*, 2d ed. (Chicago: University of Chicago Press, 1997); Robert K. Martin and George Piggford, eds., *Queer Forster* (Chicago: University of Chicago Press, 1997); and John Donald Gustav-Wrathall, *Take the Young Stranger by the Hand: Same-Sex Relations and the YMCA* (Chicago: University of Chicago Press, 1998). Cadmus's work is also reproduced (though not on the cover) and briefly discussed in both George Chauncey's indispensable *Gay New York: Gender, Urban Culture, and the Making of the Gay Male World, 1890–1940* (New York: Basic Books, 1994), 54, 64, 78, and in Charles Kaiser's *The Gay Metropolis, 1940–1996* (Boston: Houghton Mifflin, 1997), 116–17.

21. See, for example, Weinberg, "Cruising with Paul Cadmus" and *Speaking for Vice*, 32–42; James M. Saslow, *Pictures and Passions: A History of Homosexuality in the Visual*

Arts (New York: Viking, 1999), 238–40;
Jeff Weinstein, "Out for Art's Sake: Paul
Cadmus," *Village Voice*, June 1, 1982; Meyer,
"Profile: Paul Cadmus" and "Collection in
Context: Paul Cadmus: The Sailor Trilogy"
(New York: Whitney Museum of American
Art, 1996); Steve Hogan and Lee Hudson,
*Completely Queer: The Gay and Lesbian Encyclo-
pedia* (New York: Henry Holt, 1998),
115–16; Grace Glueck, "Paul Cadmus: A
Mapplethorpe for His Times," *New York Times*,
June 7, 1996: C28. Cadmus's death on
December 12, 1999, at the age of ninety-four
occasioned obituaries and published memo-
rials that likewise addressed the historical
significance of the artist's homoerotic work
in the 1930s. See Holland Cotter, "Paul Cad-
mus Dies at 94; Virtuosic American Painter,"
New York Times, December 15, 1999: A22;
Myrna Oliver, "Paul Cadmus; Artist
Shocked Many with Homoerotic Themes,"
Los Angeles Times, December 16, 1999: A48;
Justin Spring, "Scout's Honor," *Artforum* 38,
no. 7 (March 2000): 21–22; David Ebony,
"Paul Cadmus (1904–1999)," *Art in America*
88, no. 2 (February 2000): 150.

Several months before his death, Cadmus
received the first international arts award
from Pridefest America, an annual gay and
lesbian cultural festival held in Philadelphia.
According to the official Pridefest Web site
(www.pridefest.org), the award honors "a
contemporary gay or lesbian artist who has
greatly impacted gay culture and visibility in
the visual, performing or literary arts."

22. On those rare occasions when
homosexuality was alluded to within Ameri-
can art criticism of the 1930s, it was by way
of an attack on male effeminacy, French cul-
ture, and the elite precincts of the modern
art museum. See, for example, Thomas
Craven, "Effeminacy," *Art Digest*, October 1,
1935: 10; Thomas Craven, *Modern Art:
The Men, the Movements* (New York: Simon
and Schuster, 1934), 369; and Thomas Hart
Benton, *An Artist in America*, 4th rev. ed.
(Columbia: University of Missouri Press,
1983), 265.

23. This claim is based on my review of
some forty articles on the episode (all
extant materials that I could find) and is con-
firmed by the similar findings of Elizabeth
Armstrong, "Paul Cadmus: American Scene
as Satire" (master's thesis, University of Cal-
ifornia, Berkeley, 1982), and Weinberg,

Speaking for Vice, 32–42. As Weinberg notes,
"None of the attacks that Cadmus's painting
elicited mentions homosexuality—in fact,
from reading the many newspaper descrip-
tions of the picture one would not even
know the work includes a male civilian. The
criticism of the picture simply characterized
the work as portraying the Navy in an unflat-
tering light" (37).

24. As we shall see, Cadmus's public
identity was similarly inflected, if never
explicitly framed, by the half-open, half-
secret knowledge of his homosexuality.

25. Although the Public Works of Art
Project was relatively short-lived (incorpo-
rated in November 1933, the agency
was dissolved in June 1934), the PWAP
preceded and prepared the foundation
for the arts employment programs of the
Works Progress Administration (WPA).
According to a 1936 report delivered at the
First American Artist's Congress, the PWAP
"marked the first attempt of any American
administration to support unemployed
artists in socially productive work. Over a
period of six months, 3,749 artist were
employed for periods ranging from one to
six months at wages running from $27 to
$38.25 for a thirty hour week. The govern-
ment expenditure was $1,185,000.00."
Arnold Friedman, "Government in Art"
(1936), in *Artists against War and Fascism:
Papers of the First American Artists' Congress*
(New Brunswick, N.J.: Rutgers University
Press, 1986). On the founding of the PWAP,
see Richard McKinzie, *The New Deal for
Artists* (Princeton, N.J.: Princeton Univer-
sity Press, 1973), 3–19, and "Introduction:
New Deal for Public Art," in Marlene Park
and Gerald E. Markowitz, *Democratic Vistas:
Post Offices and Public Art in the New Deal*
(Philadelphia: Temple University Press,
1984), 3–11.

26. "Artist Defends Fleet Picture," *New
York Sun*, April 19, 1934: 3.

27. Satires of the New York scene were
not, even at this early moment in Cadmus's
career, without precedent in his work. The
artist had just returned from an extended
stay in Mallorca, where, in addition to por-
traits, landscapes, and genre scenes, he
painted two satirical accounts of New York:
Shore Leave (1933) and *YMCA Locker Room*
(1933). While each depicted a specific locale
(Riverside Drive and the Sixty-third Street

YMCA, respectively), they were painted entirely from memory.

28. "The works in the exhibition are supposed to be the best produced by government-hired artists. Each regional director chose from his field what he regarded as the best done there and forwarded them [to the central office in Washington]." "Bans CWA Picture as Insult to Navy," *New York Times*, April 19, 1934: 1. Juliana Force, the director of the Whitney Museum of American Art, also served as the New York regional director of the PWAP. Force, together with Whitney Museum curator Forbes Watson, was largely responsible for the selection of *The Fleet's In!* and *Greenwich Village Cafeteria* for the Corcoran exhibit.

29. "I trust," wrote Rodman in an outraged letter to the secretary of the navy, "that it [*The Fleet's In!*] will not be allowed to be hung in the Corcoran Art Gallery or any other [gallery], but that it will be immediately destroyed. [9]" Rodman's power to make such a demand derived from the prestige of his rank and reputation. The admiral, as the *New York Times* reminded its readers, "commanded the American battleship force in British Waters during the World War." See "Bans CWA Picture as Insult to Navy," 1, 9.

30. According to Cadmus, Roosevelt personally removed the painting from the Corcoran under cover of night, less than one week before the official opening of the exhibit. See Jerry Talmer, "'Fleet' Was Out, Now It's In," *New York Post*, March 27, 1992: 32. Philip Eliasoph has confirmed Cadmus's account of the episode. Eliasoph, interview by author, Fairfield, Conn., June 12, 1995.

31. On the Alibi Club's illicit custody of *The Fleet's In!* and the battle to return the painting to public view, see Eliasoph, "Paul Cadmus," 62–64; Eliasoph, "That Other Time Censorship Stormed into the Corcoran Gallery" (letter to the editor), *New York Times*, November 26, 1989: 42; and Judd Tully, "The Painting the Navy Shipped Out," *Washington Post*, March 16, 1992: C1, C4.

32. *Time, Newsweek, Esquire, Life*, the *New Yorker*, and the *New Republic*, as well as all the major New York, Washington, and Boston dailies (among many other newspapers), ran substantive stories on the episode, many of which were accompanied by reproductions of the censored painting. Before shipping *The Fleet's In!* and *Greenwich Village Cafeteria* to the Corcoran, Cadmus had both paintings professionally photographed. When the former work was confiscated, he was thus able to provide the press with good reproductions of it. Paul Cadmus, interview by author, New York, N.Y., July 12, 1995.

33. Quoted in "Gobs Brawl Ashore?— Never! Navy Guns Sink CWA Art," *New York Daily News*, April 19, 1934.

34. Harry Salpeter, "Paul Cadmus: Enfant Terrible," *Esquire*, July 1937: 106. The Corcoran exhibit, which included nearly five hundred works by PWAP artists, received rather less attention than did the single painting censored from it. Richard McKinzie has summarized the bland reception of the show as follows: "Critics noted the absence of nudes, night-club subjects, pretty women, aristocratic-looking men, and genteel houses. They noted a predominance of machinery, locomotives, steamships, workers, and common subjects of village and farm life. One reporter calculated that at least 192 of the 498 subjects were of labor and industrial character. Most critics seemed surprised that the canvases displayed so little rebellion or despair. They agreed with the President that the art revealed 'hope and courage,' was 'robust and American,' and lacked 'both slavery to classical standards and decadence common to much European art.' No major critic suggested the government's money had been ill spent. Most agreed that government had provided new impetus for American art." *The New Deal for Artists*, 31.

35. Cited in "Art Row in Navy Surprised Painter," *New York Times*, April 20, 1934.

36. It did so, of course, through its black-and-white reproduction. The acidic brilliance of the painting's palette thus dropped out of public visibility altogether.

37. Cited in Sutherland's film *Paul Cadmus: Enfant Terrible at Eighty*.

38. Naval spokesmen, government officials, newspaper commentators, contemporary artists (including Cadmus), cartoonists, and sundry private citizens all aired their views on the topic. See, for example, "Navy Scuttles CWA Art on Gobs and Gals," *New York Post*, April 18, 1934: 1; "Painting Called Insult to Navy," *New York Sun*, April 18, 1934: 1; "Admiral on Art, Pain to Painter," *New York World Telegram*, April 19,

1934: 1, "His Art Piques Navy, and So —,"
New York Evening Journal, April 19, 1934: 5;
"Village Backs CWA Artist in Navy Row,"
New York Evening Journal, April 19, 1934: 5;
"Art Row in Navy Surprises Painter," *New
York Times*, April 20, 1934: 1; "The Inquiring
Photographer," *New York Daily News*, April 24,
1934: 28; "Removals," *Time*, April 30, 1934:
21; "Picture of Sailors with 'Colors Flying'
Annoys Navy," *Newsweek*, April 28, 1934: 25;
"Unwarranted Insult to Navy Enlisted Men
by PWA Artist Arouses Deep Resentment,"
Our Navy, mid-May 1934: 26–28.

39. According to Cadmus, illustrated
cartoons were not a direct source of inspira-
tion for *The Fleet's In!*. Paul Cadmus, inter-
view by author, New York, N.Y., July 12,
1995.

40. For example, the viewer of *The Fleet's
In!* looks up the nose of the splayed-out
sailor on the left-hand side of the composi-
tion, as though we were crouching down to
see him from below.

41. "Cadmus, Satirist of Modern Civi-
lization," 17.

42. Madelin Blitzstein, "It May Be Hard
to Take but It's Art," *Minneapolis Journal*, Feb-
ruary 24, 1935 (unpaginated clipping
included in personal scrapbook of Paul Cad-
mus; photocopy of clipping provided to the
author by D. C. Moore Galleries, New York,
with permission of the artist). Notice how
the descriptive phrase "carousing in queer
postures" emphasizes the depicted body,
rather than the face, as a vehicle of expres-
sion in *The Fleet's In!*.

43. Reading from left to right, the three
sailors are aligned as follows: the buttocks of
the (back-turned) sailor in blue are angled
toward the crotch of the sailor in white. The
buttocks of the sailor in white are, in turn,
angled toward the crotch of the sailor in
blue behind him. In contrast to these
homosocial intimacies, the sailor (in blue)
on the far right turns away from the female
figure behind him. This moment offers the
only back-to-back juxtaposition in the
painting.

44. As Weinberg points out of this
grouping, "It is significant that the two men
carry on their conversation over the prone
body of a second drunken sailor. As if to save
that fellow from a possible homosexual
adventure, a woman dressed in a tight
pleated skirt grabs one of his arms with both

of her hands and tries to pull him up, while
his other arm falls across the lap of the man
reaching for a cigarette." *Speaking for Vice*,
35–36. I would push this interpretation fur-
ther by suggesting that the woman is
attempting (without success) to "rouse" the
sleeping sailor not only into consciousness
but into heterosexuality. Like the sailor in
The Fleet's In!, Cadmus's male figures often
remove themselves from active participa-
tion in the scene that surrounds them, opt-
ing instead for sleep, intoxication, semicon-
sciousness, solitude, or reverie. Such
refusals constitute a kind of tear in the fabric
of representation, a moment of difference in
which alternatives to the scene depicted are
marked but never fully described. The
strongest example of this occurs in *Sailors
and Floosies* (1938), Cadmus's sequel paint-
ing of shore leave in Riverside Park.
Although the sailors have been paired with
floosies in this composition, sleep binds the
men together in a state of parallel uncon-
sciousness and suggests the possibility that
they are dreaming an alternative erotics to
the one depicted—that they are, in effect,
dreaming of each other. In *Sailors and
Floosies*, as in *The Fleet's In!*, sleep provides
both an access route to the homoerotic and
an escape hatch from the harshly satiric
world of the painting.

45. On the period appearance and cul-
tural significance of the fairy in urban cul-
ture, see Chauncey, *Gay New York*. Chauncey
quotes a 1933 study of "sexual abnormali-
ties" that lists the characteristic features of
the male homosexual as including "plucked
eyebrows, rouged cheeks, powdered face,
and marcelled, blondined hair" (64). The
male civilian in *The Fleet's In!* also resembles
caricatures of the fairy that appeared in
Broadway Brevities, a period scandal sheet. A
sampling of these caricatures is reprinted in
Chauncey, *Gay New York*, 46, 150, 178, and in
Jonathan Ned Katz, *The Gay/Lesbian
Almanac: A New Documentary* (New York:
Routledge, 1989), 486–87.

46. Novelty songs such as "Masculine
Women, Feminine Men" (1926), "The Right
Kind of Man" (1929), "He's So Unusual"
(1929), "Gay Love" (1929), and "Come Up
and See Me Sometime" (1933) described
male homosexuals as "inverted" women. See
Can't Help Lovin' That Man (compilation
recording), liner notes by Michael Musto

(Art Deco/Columbia, 1993). On the representation of the fairy in Hollywood films of the 1920s and early 1930s, see Vito Russo, "Who's a Sissy?," in *The Celluloid Closet* (New York: Harper and Row, 1987), 3–60. The Hays Code, which took effect in 1934, effectively prohibited all representations of homosexuality, no matter how stereotypical or derogatory. Period films featuring the fairy (e.g., *Call Her Savage* [1932] and *The Broadway Melody* [1929]) thus predate both the implementation of the code and the creation of *The Fleet's In!*.

47. Chauncey, *Gay New York*, 47–48. Chauncey's analysis of the fairy in early-twentieth-century New York is worth citing in some detail because it pinpoints the symbolic role (and surprising centrality) of this figure within the larger social and sexual cultures of Cadmus's day. Chauncey argues that fairies

> were not the only homosexually active men in New York, but they constituted the primary image of the "invert" in popular and elite discourse and stood at the center of the cultural system by which male-male sexual relations were interpreted. As the dominant pejorative category in opposition to which male sexual "normality" was defined, the fairy influenced the culture and self-understanding of *all* sexually active men.
>
> The determinative criterion in the identification of men as fairies was not the extent of their same-sex desire or activity (their "sexuality"), but rather the gender persona and status they assumed.
> (47–48)

48. The vernacular meaning of "Pickled Corned Beef" was explained to me by Jonathan Ned Katz, the editor of *The Gay/Lesbian Almanac*, the first scholarly volume to reproduce the cartoon in question. Katz, phone interview by author, March 3, 1994.

49. See, for example, the cartoons published in *Broadway Brevities* and reprinted in Katz, *The Gay/Lesbian Almanac*, 486–87.

50. In addition to using the term "floosie" to describe the female figures in *The Fleet's In!*, Cadmus incorporated it into his follow-up painting of shore leave, *Sailors and Floosies* (1938).

51. The historical construction of a mean-spirited rivalry between fairies and floosies confirms Eve Kosofsky Sedgwick's assertion that "homophobia directed by men against men is misogynistic," not only because "it is oppressive of the so-called feminine in men" but also because "it is oppressive of women." *Between Men: English Literature and Male Homosocial Desire* (New York: Columbia University Press, 1985), 20.

52. The specific location depicted in the painting was mentioned in period coverage and confirmed by Cadmus in conversation with the author. Paul Cadmus, interview by author, New York, N.Y., July 12, 1995.

53. In the context of a larger discussion of *The Fleet's In!*, Cadmus has recalled his interest in Riverside Park: "We were always trying to see what was going on behind the bushes." Paul Cadmus, interview by author, New York, N.Y., July 12, 1995. On Riverside Park (and the adjacent Riverside Drive) as a sexual cruising ground during the interwar period, see Chauncey, *Gay New York*, 52, 68, 142, 146, 181–82. Under the entry for Riverside Park, the 1939 *WPA Guide to New York City* discreetly notes that "when the fleet's in, battleships line the Hudson from the Battery to Spuyten Duyvil. At night the crisscrossing beams of their searchlights fill the sky over the whole city with a strange and shifting brilliance, while sailors on leave and their friends congregate in the park." *The WPA Guide to New York City (Federal Writer's Project Guide to 1930s New York)*, intro. by William H. Whyte (1939; reprint, New York: Pantheon Books, 1982), 285.

54. The fairy in *Broadway Brevities*, by contrast, saunters proudly down the promenade with sailor in tow and thus embodies the public flamboyance discussed in Chauncey, *Gay New York*, 46–63.

55. Cadmus's pictorial sabotage of heterosexuality becomes even more apparent when we compare *The Fleet's In!* to other images of military men on leave by period artists. *United States Marine*, Reginald Marsh's tempera of 1934, offers a nocturnal scene of a New York City park (either Central or Riverside) in which military men have paired off with female civilians to pursue erotic pleasure. The featured couple, a marine and his date in the left foreground, lean against a stone monument whose struc-

ture provides a measure of privacy within the public space of the park. This couple may well be en route to an exchange like those depicted in the background: military men necking with women in the densely packed woods of the park. While the marine looks down at the woman and reaches toward her waist, she gazes out, rather seductively, at the viewer. The eroticized relation between the marine and his date is thus "triangulated" (across the body and gaze of the woman) to include the viewer of the painting. Like *United States Marine*, Marsh's 1932 tempera, *George Tilyou's Steeplechase* offers an account of military leisure that pivots around opposite-sex pairing. Marsh depicts four figures (a sailor and his date as well as two other female civilians) astride the mechanized horses at Tilyou's Steeplechase, a period attraction at Coney Island. The central pair are pressed tightly against each other in a pose that mimes sexual contact. What is more: the sailor is literally surrounded by female civilians, including not only his date but also the two women on either margin of the painting. As in *United States Marine*, the pictorial energies of the painting turn on heterosexual possibility.

56. Writing some forty years after Cadmus painted *The Fleet's In!*, Adrienne Rich would liken compulsory heterosexuality to "a queasy strobelight which creates, specifically, a profound falseness, hypocrisy, and hysteria in the heterosexual dialogue. . . . However we choose to identify ourselves, however we find ourselves labeled, it flickers across and distorts our lives." *The Fleet's In!* might be called Cadmus's response to— and satirical revenge on—the "queasy strobelight" of compulsory heterosexuality. See Adrienne Rich, "Compulsory Heterosexuality and Lesbian Existence," in *Powers of Desire: The Politics of Sexuality*, ed. Ann Snitow, Christine Stansell, and Sharon Thompson (New York: Monthly Review Press, 1983), 199.

57. Sections of Rodman's letter were widely cited in the press coverage of the censorship episode. The *New York Times* reprinted the letter in its entirety, as did the mid-May issue of *Our Navy*. In *Our Navy*, the letter was accompanied by a military portrait of the admiral and a reproduction of *The Fleet's In!* with a caption identifying it as an "untrue, unjust, and insulting painting" by

"an obscure Greenwich Village artist." See "Unwarranted Insult to Navy Enlisted Men by PWA Artist Arouses Deep Resentment," *Our Navy*, mid-May 1934: 26–28, 46.

58. Quoted in "Bans CWA Picture as Insult to Navy," 8.

59. Ibid.

60. Ibid.

61. Quoted in "Village Backs CWA Artist in Navy Row," *New York Evening Journal*, April 19, 1934: 4. Later in the same article, Cadmus would continue his tone of swaggering defiance: "Those admirals can throw me in the brig, put me in irons, and feed me bread and water. But from now on I'm painting the truth. I used to paint pretty things. The ugliness of life hasn't been painted nearly so much."

62. Quoted in "Admiral on Art, Pain to Painter," *New York World Telegram*, April 19, 1934: 5.

63. Carl Gardner, "Our Navy Challenges Paul Cadmus and His Portrayal of the Navy," *Our Navy*, mid-May 1934: 28.

64. "Sailors, Beware Artist with Camera," *Literary Digest*, May 5, 1934: 24.

65. Quoted in (among other sources) "Is It Art—Or Is It Truth?—Let's Ask the Navy Boys," *New York Evening Journal*, April 19, 1934: 4.

66. Quoted in multiple sources, including "Denied Anchorage," *Art Digest*, May 1, 1934: 14.

67. "Y.M.C.A. Defends Sailors: Better Than College Boys, Head Asserts," *Boston Daily Record*, undated clipping in scrapbook of Paul Cadmus. Given that the article from the *Boston Daily Record* responds so directly to the controversy over *The Fleet's In!*, it can be dated with some confidence to late April or May 1934.

68. Ibid.

69. Ibid.

70. The Soldiers' and Sailors' Memorial, located in Riverside Park near Eighty-ninth Street, honors Union men lost in the Civil War. A well-known landmark within the city, the monument recurs in several period cartoons on *The Fleet's In!*. Though not depicted in Cadmus's painting, the memorial provided an easy way for cartoonists to specify the venue of Riverside Park.

71. This cartoon accompanied an article entitled "Sailor, Behave! Artists Hold He But Rarely Does," *New York Daily News*, April 20,

1934 (unpaginated clipping in scrapbook of Paul Cadmus).

72. A newspaper editorial on the controversy argued that "the fact that a competent artist has painted some sailors, under the urge of spring, in dalliance with lassies on Riverside Drive when the fleet's in, is no reflection upon the enlisted men. In fact it is quite in keeping with the seagoing tradition." "The Fleet's In," *Washington Post* (?), May 21, 1934 (clipping in Cadmus's private scrapbook). A newspaper clipping of this editorial is identified in Cadmus's scrapbook as "Washington Post"(?) May 21, 1934." The editorial did not, however, appear in the *Washington Post* on May 21, 1934 nor on any other date in April, May, or June of 1934. I have not, as yet, succeeded in locating the newspaper that ran the editorial.

73. "Should Sailors Be Sissies?," *New York Daily News*, April 20, 1934: 39.

74. The opposition between Cadmus's (masculine) bravado and Rodman's (feminine) delicacy was rehearsed both during and after the censorship episode. As late as 1937, a newspaper article would describe Cadmus as "the young man whose painting *The Fleet's In!* made the admirals quiver in their sea joints a few years back." Paul Cadmus: Who Is Through with Navy Now," *Brooklyn Daily Eagle*, April 24, 1937: 12.

75. "Picture of Sailors with 'Colors Flying' Annoys Navy," *Newsweek*, April 28, 1934: 25.

76. As discussed in chapter 1, the term "reverse discourse" was coined by Michel Foucault to describe the way in which discourses furnish the means of their own subversion. Foucault, *The History of Sexuality, Volume 1: An Introduction*, trans. Robert Hurley (New York: Random House, 1980), 101.

77. See Eve Kosofsky Sedgwick, *The Epistemology of the Closet* (Berkeley and Los Angeles: University of California Press, 1990), especially 1–90.

78. Foucault, *History of Sexuality*, 27. Sedgwick cites a portion of this same passage and then adds her own gloss to it: "'Closetedness' itself is a performance initiated as such by a speech act of a silence— not a particular silence, but a silence that accrues particularity by fits and starts, in relation to the discourse that surrounds and differentially constitutes it." *Epistemology of the Closet*, 3.

79. Quoted in "Admiral on Art, Pain to Painter," *New York World Telegram*, April 19, 1934: 1, 5.

80. Quoted in "Sailor Behave! Artists Hold He But Rarely Does," *New York Daily News*, April 20, 1934.

81. "Paul Cadmus: Who Is Through with Navy Now," *Brooklyn Daily Eagle*, April 24, 1937: 12.

82. These references are taken, respectively, from "Roiled by Navy: Admiral on Art, Pain to Painter," *New York World Telegram*, April 19, 1934: 1; ". . . Claims His Picture Is True to Life" (unattributed clipping, dated April 19, 1934, Cadmus's private scrapbook), "Cadmus' Tars Under Fire at the San Francisco Fair," *Newsweek*, August 19, 1940: 51.

83. "Roiled by Navy," 5.

84. Weinberg, *Speaking for Vice*, 43.

85. D. A. Miller's analysis of homosexuality and connotation, though launched within a discussion of Alfred Hitchcock's 1948 film *Rope*, is no less relevant to the popular discourse surrounding Cadmus in 1934: "Until recently, homosexuality offered not just the most prominent, it offered the only subject matter in American mass culture appertained exclusively to the shadow kingdom of connotation, where insinuations could be at once developed and denied, where (as with the Mafioso who alleged he wasn't there and if he was, was asleep) one couldn't be sure whether homosexuality was being meant at all, but on the chance it was, one also learned, along with the codes that might be conveying it, the silence necessary to keep about their deployment. . . . The cultural work performed by *Rope*, toiling alongside other films, . . . consists in helping construct a homosexuality held definitionally in suspense on no less a question than that of its own existence— and in helping produce in the process homosexual subjects doubtful of the validity and even the reality of their desire, which *may only be*, *does not necessarily mean*, and all the rest" (Miller's emphasis). "Anal *Rope*," *Representations* 32 (Fall 1990): 119–20.

86. See, for example, the period caricatures of the fairy in *Broadway Brevities*.

87. Philip Eliasoph, phone interview by author, May 18, 2000. See also Eliasoph, "The Other Time Censorship Stormed into

the Corcoran Gallery," *New York Times*, November 26, 1989: 42; "Controversial Painting 'Revealed' as Cadmus Art Tours," *Bridgeport (Conn.) Sunday Post*, August 16, 1981: E15.

88. The government official who effected the retrieval of *The Fleet's In!* from the Alibi Club and its subsequent transfer to the navy was Karel Yasco, Counsellor for Fine Arts and Historic Preservation, General Services Administration (GSA). See Eliasoph, "The Other Time Censorship Stormed into the Corcoran Gallery," 42.

Eliasoph's account is confirmed by a memorandum on file at the Naval Historical Center in Washington, D.C. My thanks to Gale Munro, curator of the Navy Art Collection, for providing me with a copy of this document. Memorandum from Gale Munro, curator, Navy Art Collection, to the file, on the story of the recovery of "The Fleet's In!" by Paul Cadmus, November 17, 1998 (updated May 19, 2000).

In the "updated" version of the document I received, Munro blocked out the names of several individuals who wished (according to Munro) to remain anonymous. The memo begins, for example, with the following entry: "1. I spoke with XXXXX and XXXXX this morning (Nov. 17, 1998) about the story behind the Naval Historical Center getting custody of Paul Cadmus's *The Fleet's In!*." The X's that blot out the names of Munro's sources echo (however faintly, however distantly) the censorship of Cadmus's painting in 1934.

89. The Web site for the Naval Historical Center (accessed May 14, 2000) www.history-navy.mil/nhc1.htm describes it as "the official history program of the Department of the Navy."

90. Gale Munro, curator, Navy Art Collection, Naval Historical Society, Washington, D.C. Phone interview by author, May 19, 2000.

91. For the mission statement of the Naval Historical Center, see n. 89 above.

92. In *Flight Deck at Dawn*, an undated watercolor by Mitchell Jamieson, a set of silver fighter planes is prepared for battle against an early morning sky. *Bullets and Barbed Wire*, a charcoal drawing by Kerr Eby from 1944, depicts a troop of U.S. Marines advancing through waters that have been strewn with barbed wire. In William F.

Draper's 1944 painting *A Warrior Homeward Bound*, a wounded marine is lifted to safety by a group of muscular, mostly shirtless military men. All three works are in the Navy Art Collection.

93. Munro interview. Munro based this judgment on the number of "hits" *The Fleet's In!* has received on the Naval Historical Center's Web site as well as on the number of visitors to the Navy Art Collection who comment on, admire, or expressly seek out the painting.

94. In 1996, I curated an exhibition at the Whitney Museum of American Art that reunited Cadmus's three sailor paintings of the 1930s: *Shore Leave* (1933), *The Fleet's In!* (1934), and *Sailors and Floosies* (1938). See Richard Meyer, "Collection in Context: Paul Cadmus—The Sailor Trilogy" (New York: Whitney Museum of American Art, 1996). Predating all three of these works is a much smaller (8½" × 11") gouache of a pair of sailors pursuing a couple of female civilians, which Cadmus painted in 1929. The work, entitled *Sailor #1*, is reproduced in Thomas W. Sokolowski, *The Sailor 1930–45: The Image of an American Demigod* (Norfolk, Va.: Chrysler Museum, 1983), 71.

95. Cited in Kirstein, *Paul Cadmus*, 25.

96. According to the artist's own account, the interior space of *Self-Portrait Mallorca* is based directly on the apartment house in which Cadmus and French resided during their extended visit to Mallorca in 1932–33. The layout of the apartment is particularly difficult to map, however, given the spatial ambiguities of the painting. According to Cadmus, the veranda continues past the low ledge on which the shaving mirror rests. In other words, the artist is standing on the same veranda that the woman has just entered, though his space is separated from hers by the dividing ledge. Paul Cadmus, interview by author, New York, N.Y., July 12, 1995.

97. T. J. Clark, "Gross David with the Swoln Cheek: An Essay on Self-Portraiture," in *Rediscovering History: Culture, Politics, and the Psyche*, ed. Michael S. Roth (Stanford, Calif.: Stanford University Press, 1994), 296.

98. While in Mallorca, Cadmus owned a small shaving mirror with silver insets. According to the artist, he both depicted this mirror in, and used it to make, *Self-Portrait Mallorca*. Paul Cadmus,

interview by author, New York, N.Y., July 12, 1995.

99. On the constraints placed on the public representation of homosexuality in the 1930s, see James Crump, "Iconography of Desire: George Platt Lynes and Gay Male Visual Culture in Postwar New York," in *George Platt Lynes: Photographs from the Kinsey Institute* (Boston: Bulfinch Press, 1993), 137–48. See also Weinberg, *Speaking for Vice*, xv–xx, 32–33, 35–36, 89–90.

100. According to Kirstein's interpretation of the painting, "In the casual schedule of a neutral billet, a naked guest on her way to bathe is astonished to encounter an artist working at his open window and more engrossed in his own character than in her buxom display." Kirstein suggests (though he does not state) that the female guest is surprised by Cadmus's self-absorption because it constitutes a lack of interest in her "buxom display." *Paul Cadmus*, 12.

101. French's turn away from the camera could also be read, however, as yet another marker of self-absorption. Insofar as he is oblivious to (or uninterested in) the camera, French seems rather more removed from the beholder than does Crevel in the Lynes portrait.

102. Sigmund Freud, "A Case of Hysteria," "Three Essays on Sexuality," and Other Works (1901–1905) vol. 7 of *The Standard Edition of the Complete Psychological Works of Sigmund Freud*, trans. and ed. James Strachey (London: Hogarth Press, 1953), 145, n. 1.

103. See Kaja Silverman, *Male Subjectivity at the Margins* (New York: Routledge, 1992), 339–89; Michael Warner, "Homo-narcissism; or, Heterosexuality," in *Engendering Men: The Question of Male Feminist Criticism*, ed. Joseph A. Boone and Michael Cadden (New York: Routledge, 1990), 190–206, 313–15; Earl Jackson Jr., *Strategies of Deviance: Studies in Gay Male Representation* (Bloomington and Indianapolis: Indiana University Press, 1995), 1–52, 267–74. As Warner in particular argues, the conflation of narcissism and male homosexuality has as much to do with the reduction of Freudian theory into popular belief systems (and stereotypes) as with the theory itself.

104. Silverman, *Male Subjectivity*, 363. My reading of *Self-Portrait Mallorca* and the larger understanding of narcissism on which

it depends are much indebted to Silverman's work.

105. Ibid., 388.

106. Henry Adams, *Thomas Hart Benton: An American Original* (New York: Alfred A. Knopf, 1989), 209.

107. In his 1937 autobiography *An Artist in America*, Benton launches an attack against what he calls the "concentrated flow of aesthetic-minded homosexuals into the various fields of artistic practice." The following passage captures the contemptuous—if always colorful—tone of Benton's homophobia:

In the homosexual circles of artistic New York there are a few who, like the gentleman in the Klondike poem, are ready to jump anything from a steer to a kitchen mechanic. Our New York aberrants are, for the most part, of the gentle feminine type with predilections for the curving wrist and the outthrust hip.

Far be it from me to raise my hands in any moral horror over the ways and taste of individuals. If young gentlemen, or old ones either, wish to wear women's underwear and cultivate extraordinary manners it is all right with me. But it is not all right when, by ingratiation or subtle connivance, precious fairies get in positions of power and judge, buy and exhibit American pictures on a base of nervous whim under the sway of those overdelicate refinements of taste characteristic of their kind. (*An Artist in America*, 265)

On Benton's homophobia, see Erika Doss, *Benton, Pollock, and the Politics of Modernism: From Regionalism to Abstract Expressionism* (Chicago: University of Chicago Press, 1995), 36–37, 280–81.

For all of his antagonism toward "precious fairies," Benton would write a note of support to Paul Cadmus (whom he had never met) during the controversy over *The Fleet's In!*. The handwritten note reads as follows:

Mr. Paul Cadmus
54 Morton Street
I've seen a reproduction of the picture the old navy boys are kicking about. If I can be of any service to you in its defense, call on me.
Sincerely yours,
Thomas H. Benton

Crowning the upper-left-hand corner of Benton's letter to Cadmus is the printed figure of a man in coveralls playing the fiddle. The figure, quite obviously a Benton drawing, may have been meant to stand in for the artist himself. Letter from Thomas Hart Benton to Paul Cadmus, undated but c. May 1934. I am grateful to Paul Cadmus for sharing Benton's letter with me and for granting me permission to cite it.

108. Cadmus told me that his inclusion of the female neighbor in *Self-Portrait Mallorca* was a "silly idea" that had no particular relation to his homosexuality. While my interpretation of *Self-Portrait Mallorca* departs from that of its creator, we both agree that self-portraits are highly mediated representations of identity rather than reliable revelations of it. Cadmus interview, July 12, 1995.

109. Unlike Cadmus's *Self-Portrait Mallorca*, French's self-portrait is not a full-scale painting but a watercolor on paper. Its dimensions are approximately 5" × 7".

110. Clark, "Gross David with the Swoln Cheek," 276.

111. There are, of course, any number of other ways to "travel" through *Self-Portrait Mallorca*. Regardless of how we do so, Cadmus's mirror image will always be situated "between" the (ontological) viewer and the female figure looking back (at that viewer) from within the space of the painting.

112. According to Cadmus, this was the intended effect of *Self-Portrait Mallorca*— namely, to show the artist looking at himself while also catching sight of the woman in the background. Cadmus interview, July 12, 1995.

113. Chauncey, *Gay New York*, 207.

114. Kirstein, *Paul Cadmus*, 11.

115. Cited in Judd Tully "Oral History Interview with Paul Cadmus," Oral History Program, Archives of American Art, Washington D.C., and New York, N.Y., typed transcript, Interview 2, April 7, 1988: 60.

116. "The touchable body" is a phrase coined by the writer and filmmaker Charles Boultenhouse and used by him in conversation with the historian Catrina Neiman. Drawing in part of her interviews with Boultenhouse, Neiman delivered a paper at the 1993 conference of the College Art Association in which she discussed "the aesthetic of 'the touchable body'" in the paintings of Paul Cadmus, Jared French, and Pavel Tchelitchew. My thanks to Neiman for introducing me to Boultenhouse's wonderful phrase and for permitting me to cite it here. Catrina Neiman, "Parker Tyler, Towards Charting a Gay Criticism," lecture, College Art Association, annual meeting, February 1993, Seattle.

117. Cadmus interview with the author, August 25, 1994.

118. Lewis Mumford, "Art Galleries," *New Yorker*, April 10, 1937: 66–67.

119. Male homosexual (or "fairy") figures appear in several Cadmus paintings, including *The Fleet's In!* and *Greenwich Village Cafeteria*, both from 1934. The function of these figures in Cadmus's early work is discussed in detail above.

120. "Cadmus states that while gilding was usually done with sponges, he preferred to show the process using brushes instead." Interdepartmental memorandum from Kay Bearman, February 9, 1987, archival files, Department of Twentieth-Century Art, Metropolitan Museum of Art, New York, N.Y.

121. "Jerry posed for everything, including the little black boy. . . . I didn't work on the painting [directly] from anybody posing. . . . I made drawings [from Jerry's posing] and turned these drawings into the people I wanted." cited in Judd Tully "Oral History Interview with Paul Cadmus," Interview 2, April 7, 1988: 62. Cadmus drew the features of the black youth from period stereotype rather than from the description of a specific person. The appearance of the white figures in the composition, while satirical, is not stereotypical.

122. *Ulysses* was banned from publication, sale, or import into the United States from the date of its initial publication (in Paris) in 1922 until December 1933, at which time U.S. District Court judge John M. Woolsey ruled that the novel was neither obscene nor libelous. In refuting the U.S. Attorney's case against *Ulysses*, the judge ruled that

> The words which are criticized as dirty are old Saxon words known to almost all men, and, I venture, to many women, and are such words as would be naturally and habitually used, I believe, by the types of folk whose life, physical and mental, Joyce is seeking to describe. In respect of

the recurrent emergence of the theme of sex in the minds of his characters, it must always be remembered that his locale was Celtic and his season Spring.

. . .

I am quite aware that owing to some of its scenes, *Ulysses* is rather strong draught to ask some sensitive, though normal, persons to take. But my considered opinion, after long reflection, is that whilst in many places the effect of *Ulysses* on the reader undoubtedly is somewhat emetic, nowhere does it tend to be an aphrodisiac.

Ulysses may, therefore, be admitted into the United States.

The United States of America v. One Book Entitled Ulysses by James Joyce: Documents and Commentary—A 50-Year Retrospective, ed. Michael Moscato and Leslie LeBlanc (Frederick, MD: University Publications of America, 1984), 310–312.

123. In response to a question about the inclusion of *Ulysses* in the 1931 portrait of Jared French, Cadmus recalled that the book depicted in the portrait was "one of the early copies. Yes. Somebody had smuggled it over and given it to me. In fact, I think it was Luigi Lucioni who brought it to me from Europe." This response leads to the following exchange between Cadmus and Tully:

J.T.: This was a book that was obviously banned.

P.C.: Oh, you couldn't buy it, no.

J.T.: Before the Supreme Court decision.

P.C.: Oh no. Banned for quite a while I think.

. . .

J.T.: What kind of impression did *Ulysses* make on you when you read it? Do you remember?

P.C.: Well, I really don't remember, except that of course I was impressed to be reading *Ulysses*.

J.T.: You knew it was contraband . . .

P.C.: And knowing I understood quite a lot of it.

Judd Tully, "Oral History Interviews with Paul Cadmus," Interview 1 March 22, 1988: 27–29.

124. On the "living statues," see Jack W. McCullough, "Living Pictures on the New York Stage," *Theater and Dramatic Studies*, no. 13 (Ann Arbor, Mich.: UMI Research Press, 1983), and Fred D. Pfening Jr., "The Living Statues," *Bandwagon*, July–August 1969: 20–21. My thanks to Fred Dahlinger Jr., director of collections and research at the Circus World Museum and Library in Baraboo, Wisconsin, for providing these references and a good deal of other information about "living statues." Fred Dahlinger Jr., phone interview by author, March 3, 1994.

125. Kirstein, *Paul Cadmus*, 28.

126. "Anthony J. Sansone," in *Modern Classics* (Brooklyn, New York, 1932). A copy of *Modern Classics* is housed in the archives of the Gay and Lesbian Historical Society of Northern California. My thanks to archivist Willie Walker for bringing it to my attention.

127. Cited in Grace Pagano, *The Encyclopaedia Britannica Collection of Contemporary American Painting* (Chicago: Encyclopaedia Britannica Company, 1946), 18.

128. On race and the history of the circus, see Janet Marie Davis, "Instruct the Minds of All Classes: Circus and American Culture at the Turn of the Century" (Ph.D. diss., University of Wisconsin, Madison, 1998). For information on the history of black employees within both American and European circuses, I once again thank Fred Dahlinger Jr., director of collections and research at the Circus World Museum and Library in Baraboo, Wisconsin. Dahlinger interview, March 3, 1994. According to a *New York Times* article on the Universoul Circus (a black-owned and operated circus troupe founded in 1994), "Although there was a black-owned circus that toured the country in the early 1900's, a strong circus-performing tradition never developed in black American communities." Julian Barnes, "Circus Act for the Streetwise: Universoul Aims to Inspire Urban Audiences," *New York Times*, April 27, 2000, A25.

129. Insofar as the postcard situates the "familiar figure" of the black delivery boy on "the campus" (rather than on any particular campus), it frames him as a laboring "type" common to the culture of the private university in the 1930s. The faux-gothic architecture in the background could well be that of Yale University.

130. In an important essay on stereotype and colonialist fantasy, Homi K. Bhabha writes, "[Stereotype] provides a colonial identity that is played out . . . in the face and space of the disruption and threat from the heterogeneity of other positions. As a form of splitting and multiple belief, the stereotype requires, for its successful signification, a chain of other stereotypes. This is the process by which the metaphoric 'masking' is inscribed on a lack which must then be concealed, that gives stereotype both its fixity and its phantasmatic quality—the same old stories of the negro's animality, the coolie's inscrutability, or the stupidity of the Irish which must be told (compulsively) again and afresh and is differently gratifying and terrifying each time." "The Other Question: Difference, Discrimination, and the Discourse of Colonialism," in *Out There: Marginalization and Contemporary Cultures*, ed. Russell Ferguson, Martha Gever, Trinh T. Minh-ha, and Cornel West (New York: New Museum, 1990), 82.

131. On the stereotypical representation of the black body in American and European popular culture of the period, see Jan Nederveen Pieterse, *White on Black: Images of Africa and Blacks in Western Popular Culture* (New Haven, Conn.: Yale University Press, 1992), 124–212. Pieterse discusses the minstrel show as an occasion in which a stereotypical—and broadly theatricalized— blackness was "painted" onto the white body. Minstrelsy offered not just a simulation of racial stereotype but, more specifically, "a white imitation of a black imitation of a contented slave" (132). The trope of the white subject painting his body to "perform" a (happily enslaved) blackness is, I think, relevant to *Gilding the Acrobats*. Insofar as Jared French posed for the figure of the black youth, and insofar as that figure appears as a white boy in both preliminary sketches, we could say that Cadmus painted a stereotypical—and superficial—blackness onto the foreground youth in *Gilding the Acrobats*.

132. The depiction of racial difference in American Scene painting of the 1930s has not, as yet, been considered in depth by art historians. When the black body does appear in the work of white artists of the day, it is typically rendered in stereotypical terms similar to those of *Gilding the Acrobats*. See Guy C. McElroy, *Facing History: The Black Image in American Art, 1710–1940* (Washington, D.C.: Bedford Arts, 1990).

133. Cadmus interview, August 24, 1994. In a 1988 interview, Cadmus likewise recalled of *Gilding the Acrobats*, "I made it up entirely. I think they use sponges [to gild themselves]. I just wanted a composition of figures and again with a nude or near-nude in it." Judd Tully, "Oral History Interview with Paul Cadmus," Interview 2, April 7, 1988: 78.

134. Of his interest in depicting the nude, Cadmus has recalled: "I often wished that I had done what John Sloan did. He did paintings of nudes in the subway, nudes in the butcher shops, nudes in everyday life walking the streets. I've often thought of these people I saw—how I would love to undress them and do them in the nude." Cited in Judd Tully, "Oral History Interview with Paul Cadmus," Interview #4, May 5, 1988: 147. Though he does not acknowledge it in this passage, Cadmus devoted himself to the male nude, while Sloan almost always painted the female. One reason that Cadmus could not do "what John Sloan did" was because the male nude required a narrative context or justification (e.g., the beach, the changing room, the swimming hole) in ways that the female nude did not. As I have argued, Cadmus was drawn to the theme of acrobatic gilding less for its theatrical appeal than for the justification of the male nude it provided.

135. One might argue that it was precisely when Cadmus lost any powerful sense of constraint that the pictorial interest and social engagement of his work declined. Beginning in the late 1930s, Cadmus vacationed on, and increasingly painted scenes of, Fire Island. These works (with titles such as *Two Boys on the Beach* and *The Shower*) combine magic realism, swirling pastel colors, and openly homoerotic content. They mark a shift in Cadmus's work away from urban satire and toward the representation of Fire Island as an idyllic space of homosexual contact and mystical pleasure. To my mind, Cadmus's magic realist work of the 1940s reveals far less about its historical moment than do his satirical paintings of the 1930s. Fire Island functions as a metaphor of sexual and social escape; it removes Cadmus's figures from the rough-and-tumble pace of urban life and situates them, all too magically, on the sands of

erotic fantasy. Rather than confronting the social world of the modern city, these paintings "vacation" from it.

136. Paul Cadmus, "Credo" (broadside, 1937), reprinted in Kirstein, *Paul Cadmus*, 142. This credo, although signed by (and still widely attributed to) Cadmus, was written for the artist by Jared French. Cadmus interview, July 15, 1995.

137. Brian A. Connery and Kirk Combe, *Theorizing Satire: Essays in Literary Criticism* (New York: St. Martin's Press, 1995): 2.

138. In our 1994 interview, Cadmus confirmed that the torn T-shirt was indeed a studio prop and not something he would ever have worn ("been caught dead in") in public. The erotic motif of the torn T-shirt does appear, however, in Cadmus's contemporaneous prints and paintings, notably in *Idle Afternoon* (1937) and *Two Boys on a Beach* (1938). Cadmus interview, August 25, 1994.

139. See the exhibition brochure "George Platt Lynes" (New York: Pierre Matisse Gallery, 1941); "Paul Cadmus," *Life*, October 25, 1943; "SeeSaw Season," *Town and Country*, January 1938. In addition, a Lynes portrait of Cadmus wearing work clothes, holding a drafting triangle, and turning away from the camera appeared in the October 1941 issue of *Minicam Photography* (clipping in Cadmus's scrapbook), and another from the same series was published in "Paul Cadmus," *Current Biography*, July 1942: 12.

140. Glenway Wescott, *Continual Lessons: The Journals of Glenway Wescott*, ed. Robert Phelps with Jerry Rosco (New York: Farrar, Straus, and Giroux, 1990), 11. Wescott, a novelist and critic, served as the first director of publications at the Museum of Modern Art in New York and was active in the same artistic circle as Cadmus. Wescott was also one-third of a longtime ménage à trois whose other members were George Platt Lynes and Monroe Wheeler. The three men lived together for several years on a farm in New Jersey and were, in 1940, the subject of an extraordinary group portrait by Cadmus entitled *Conversation Piece*. *Conversation Piece* is representative of Cadmus's turn away from satire—and toward a more direct representation of gay life and domesticity—in the early 1940s. For a reproduction of the portrait, see Kirstein, *Paul Cadmus*, 72.

141. The Midtown Payson Galleries (formerly the Midtown Gallery) represented Cadmus from 1937, when his first one-man show was staged, until October 1995, when the gallery closed. From November 1995 until the artist's death in December 1999, Cadmus was represented by the D. C. Moore Gallery, a concern that now represents the artist's estate. The president and director of the D. C. Moore Gallery (Bridget Moore and Edward De Luca, respectively) were formerly the director and associate director of the Midtown Payson Galleries.

142. These constitute all of the extant negatives of the series in the Kinsey Institute. Apart from the cropped portrait of Cadmus (which is in the artist's own collection), I have located no other images that belong to the series.

143. Christian Metz, "Photography and Fetish," in *The Critical Image: Essays on Contemporary Photography*, ed. Carol Squiers (Seattle: Bay Press, 1990), 161.

144. The Midtown Payson Galleries selected this individual portrait to illustrate both the invitation and the small brochure for *The Artist as Subject*. As the exhibit included over sixty portraits of Cadmus from different moments in his life, it seems significant that this especially erotic photograph should have been chosen (i.e., constructed) by Cadmus's gallery as representative of his career. See *The Artist as Subject* (New York: Midtown Payson Galleries, 1993).

145. These terms belong, respectively, to Kirstein (*Paul Cadmus*) and to Eliasoph ("Paul Cadmus").

Chapter 3

1. Philip Pearlstein, cited in Jean Stein (with George Plimpton), *Edie* (New York: Knopf, 1982), 157.

2. No other images of "boys kissing boys" appear in any of the published books on Warhol's earliest work, and no such images are included in the extensive holdings of the Andy Warhol Museum in Pittsburgh. Margery King, chief curator at the Warhol museum, told me that she knew of no other Warhol drawing from the 1950s of same-sex male kissing. Margery King, interview by author, Pittsburgh, January 8, 1996.

3. In addition to Stein's interview with Pearlstein cited above, see Pearlstein segment in "Andy Warhol 1928–87," *Art in America* 75 no. 5 (May 1987): 138; Victor Bockris, *The Life and Death of Andy Warhol* (New York: Bantam, 1989); and Trevor Fairbrother, "Tomorrow's Man," in *Success Is a Job in New York: The Early Art and Business of Andy Warhol*, ed. Donna de Salvo (New York and Pittsburgh: Grey Art Gallery and the Carnegie Museum of Art, 1989), 72. The question also remains as to whether Pearlstein rejected Warhol's work unilaterally (as is implied in certain versions of the episode) or showed them to the other members of the Tanager collective.

4. Donna De Salvo, interview with Philip Pearlstein, October 13, 1987, New York City, typescript (unpaginated). My thanks to Trevor Fairbrother for furnishing me with a copy of this typescript and to Donna De Salvo for permission to cite from it. Fairbrother cites excerpts from the interview in "Tomorrow's Man," 72.

The last line of Pearlstein's advice to Warhol ("the more neutral the subject the better") raises more questions than it resolves, particularly in relation to the prominence of de Kooning as the "big dog" in the Tanager Cooperative. Whatever Pearlstein might have thought of de Kooning's work in the 1950s, the word "neutral" could hardly be applied to the slashing abstractions and ferocious female nudes de Kooning painted in the early years of that decade. Within the logic of Pearlstein's anecdote, the word "neutral" seems to function less as a synonym for "dispassionate" or "objective" than as a euphemism for "not homosexual."

5. Pearlstein segment in "Andy Warhol 1928–87," 138. *Art in America* describes its dossier on Warhol as a "collage of appreciations from the artist's colleagues, critics, and friends." (137) Along with Pearlstein's contribution, the memorial "collage" featured nine other tributes, all written by men.

6. In considering this version of the Tanager story, we should take into account the memorial context in which it appears. That the subject of "boys kissing boys" should go unmentioned in this (and only this) version suggests Pearlstein's need, whether conscious or not, to avoid homoeroticism within the context of public tribute.

7. In both *Warhol* (New York: Da Capo Press, 1997) and *The Life and Death of Andy Warhol*, Victor Bockris dates the Tanager episode to 1955. The three editors of the volume *Pop Out: Queer Warhol* assign the date 1957 to the Tanager rejection and cite David Bourdon as their source. Bourdon, in turn, dates the episode to 1956 (as does art historian Jonathan Katz), while Trevor Fairbrother writes that it occurred "during the 1959/60 season."

Part of this confusion stems from Pearlstein's failure to assign a specific date to the Tanager episode in either of his published retellings of it (in *Edie* in 1982 and *Art in America* in 1987). Pearlstein's oversight has not prevented writers on Warhol from dating the Tanager episode with apparent confidence. The various datings mentioned above appear in Bockris, *The Life and Death of Andy Warhol*, 84; Bockris, *Warhol*, 119; Jennifer Doyle, Jonathan Flatley, and José Esteban Munoz, *Pop Out: Queer Warhol* (Durham, N.C.: Duke University Press, 1996), 3; David Bourdon, *Warhol* (New York: Harry N. Abrams, 1989), 51; Jonathan Katz, "Andy Warhol," in *Gay Histories and Cultures: An Encyclopedia*, ed. George Haggerty (New York: Garland Publishing, 2000), 943; and Fairbrother, "Tomorrow's Man," 72.

8. In the last fifteen years, a handful of art historians and museum curators have analyzed Warhol's commercial work from the 1950s in some detail. In part, this scholarship is a reaction against the prior dismissal of Warhol's 1950s work as irrelevant to the terms of his later Pop art. The best scholarship on Warhol's commercial design appears in De Salvo, *Success Is a Job in New York*. Warhol's commercial and artistic projects of the 1950s are also examined in Jesse Kornbluth, *Pre-Pop Warhol* (New York: Random House, 1988), and Rainer Crone, *Andy Warhol: A Picture Show by the Artist* (New York: Rizzoli, 1987). For more information on Warhol's professional clients and ad campaigns in the 1950s, see Ellen Lupton and J. Abbott Miller, "Line Art: Observations on the Early Work of Andy Warhol," 28–43 and "The Art Directors" 44–53 in *Success Is a Job in New York*, 44–53.

9. Bourdon, *Warhol*, 42.

10. Kornbluth, *Pre-Pop Warhol*, 132.

11. Bourdon, *Warhol*, 42.

12. Frankfurt's description of Warhol as

having "a good feel for the delicate, the femi-
nine" is part of a longer account of the lat-
ter's work on the Modess campaign that
appears in De Salvo, *Success Is a Job in New
York*, 46–49. Two of Warhol's rejected
designs, including the dove drawing dis-
cussed above, are reproduced in that catalog
as figures 47A and 47B.

13. I am indebted to Trevor Fairbrother
for this information. See Fairbrother,
"Tomorrow's Man," 72.

14. In an e-mail to the author, Warhol
Museum archivist Matt Wrbican explains his
attribution of the inscription to Warhol's
mother: "I believe that the handwriting is
Julia's based on simply having seen so much
of it, as well as Warhol's handwriting (I've
been looking at them almost daily for about
8 yrs now). I haven't done a direct compari-
son that I recall, so that may well be the next
step. The note on the envelope is the kind of
florid handwriting that Julia did for Warhol's
commercial work (although since its done in
pencil there isn't the characteristic thick-
and-thin), and that Warhol probably wished
he could do himself. It also is very similar (in
my memory at least) to other notes we have
which are clearly written by Julia." E-mail to
the author, April 26, 2000.

15. Michael Bronski, *Culture Clash: The
Making of Gay Sensibility* (Boston: South End
Press, 1984), 43.

16. Fairbrother, "Tomorrow's Man," 70.

17. Bronski, *Culture Clash*, 43.

18. Warhol's personalized style of adver-
tising would later be inverted by a produc-
tion of fine art modeled upon mass culture
and mechanical reproduction. Where
Warhol's advertising designs mimicked the
handmade appearance of traditional art, his
subsequent fine-art work mimed the com-
mercial. One of Warhol's most often cited
quotations plays on the imbrication, if not
reversibility, of fine art, commercial art, and
commerce more broadly conceived: "Busi-
ness art is the step that comes after Art. I
started as a commercial artist, and I want to
finish as a business artist. After I did the
thing called 'art' or whatever it's called, I
went into business art. I wanted to be an Art
Businessman or a Business Artist. Being
good in Business in the most fascinating kind
of art." Cited in Benjamin H. D. Buchloh,
"Andy Warhol's One-Dimensional Art:
1955–1966," in *Andy Warhol: A Retrospective*

(New York: Museum of Modern Art, 1989),
60.

19. Ibid., 43.

20. My descriptions of I. Miller shoes are
taken from the copy of an ad drawn by
Warhol and reproduced in Buchloh's essay
as figure 4. Ibid., 42.

21. Buchloh persuasively links Warhol's
commercial work of the 1950s to his Pop art
of the early 1960s. "It frequently has been
argued that there is very little continuity
between Warhol's commercial art and his
fine art but a more extensive study of
Warhol's advertisement design would, in
fact, suggest that the key features of his work
of the early sixties are prefigured: extreme
close-up fragments and details, stark
graphic contrasts and silhouetting of forms,
schematic simplification, and, most impor-
tant, rigorous serial compositions." Ibid.,
42–43. While I agree with Buchloh's argu-
ment on formal grounds, I am trying in this
chapter to draw out the importance of other
sources for Warhol's commercial art of the
1950s, namely homosexual culture, the
codes of femininity, and the ways in which
both were linked to advertising and design
at the time.

22. Mathew J. Tinkcom describes
Serendipity as "a combination
restaurant/general store that displayed
some of [Warhol's] earliest works, [and]
immersed him in New York's young gay set."
Tinkcom, "Camp and the Question of Value"
(Ph.D. diss., University of Pittsburgh,
1995), 122. Jesse Kornbluth notes that
Serendipity was "the favorite haunt of maga-
zine editors, art directors, and theater per-
sonalities" in the mid-1950s, a group of
patrons that overlapped rather extensively
with the "young gay set" described by Tin-
kcom. Kornbluth, *Pre-Pop Warhol*, 158.

23. John Coplans, "Crazy Golden Slip-
pers," *Life*, vol. 42, no. 3 January 21, 1957:
12–13.

24. The December 1956 *Art News* lists
the following prices for various shows that
ran during the same month as Warhol's Bod-
ley exhibit: "Semi-Abstractions at Burr"
($25–$200), "Women Artists at Roerich"
($75–$350), "John Laurent at Krashaar"
($50–$500), "Henry Regis at Stairway"
($15–$200). *Art News* (December 1956):
54, 55.

25. "A Birth Under Water," *Life*, vol. 41,

no. 23 (December 3, 1956): 24–25; "Hurdles from on High," *Life*, vol. 41, no. 21 (November 19, 1956), 18–19; "Rhythmic Colors of a Symphony," *Life*, vol. 41, no. 22 (November 26, 1956), 24–25.

26. P.T. [Parker Tyler], "Andy Warhol [Bodley; Dec 3–22]," *Art News* vol. 55, no. 8 (December 1956): 59.

27. George Chauncey, *Gay New York: Gender, Urban Culture, and the Making of the Gay Male World, 1890–1940* (New York: Basic-Books, 1994), 290.

28. In her 1964 "Notes on 'Camp,'" Susan Sontag draws a distinction between the trashiness of camp and the affectations of "old-style" dandy-ism. "The old-style dandy hated vulgarity. The new-style dandy, the lover of Camp, appreciates vulgarity. Where the dandy would be continually offended or bored, the connoisseur of Camp is continually amused, delighted. The dandy held a perfumed handkerchief to his nostrils and was liable to swoon; the connoisseur of Camp sniffs the stink and prides himself on his strong nerves." For Sontag, both the "old-style dandy" (with his perfume and swooning) and the "lover of Camp" (with his stylized delight in vulgarity) are paradigmatically homosexual. "The peculiar relation between Camp taste and homosexuality has to be explained. While it's not true that Camp taste *is* homosexual taste, there is no doubt a peculiar affinity and overlap . . . So, not all homosexuals have camp taste. But homosexuals, by and large, constitute the vanguard—and the most articulate audience—of Camp." Sontag, "Notes on 'Camp,'" (1964), reprinted in *Against Interpretation*, First Anchor Books edition (New York: Anchor Books, 1990), 289–290.

29. Bérubé, *Coming Out under Fire*, 86.

30. Mark Booth, *Camp* (London: Quartet Books, 1983), 17–18.

31. Charles Lisanby, interview by author, Los Angeles, June 15, 1999.

32. "Camp art," according to Sontag, "is often decorative art, emphasizing texture, sensuous surface, and style at the expense of content." Sontag, "Notes on 'Camp,'" 278.

33. As Sontag observes, "There is a sense in which it is correct to say: 'It's too good to be Camp.' Or 'too important,' not marginal enough. . . . Many examples of Camp are things which, from a 'serious' point of view, are either bad art or kitsch." Ibid.

34. Ibid.

35. J. F. [James Fitzsimmons], "Irving Sherman, Andy Warhol," *Art Digest*, vol 26, no. 18 July 1952: 19. The only other review I have been able to find of the show is Barbara Guest's brief comment in the September 1952 issue of *Art News*. To Warhol's work, she devotes a single sentence: "Andy Warhol's drawings are montage sequences of the activities to be found in the novels of Truman Capote—young boys' heads, women dressed in the style of the twenties, float airily across the paper." B. G. [Barbara Guest], "Warhol and Sherman," *Art News* vol 51, no. 5 (September 1952): 47.

36. In *The Philosophy of Andy Warhol*, Warhol writes, "I admire people who do well with words . . . and I thought Truman Capote filled up space with words so well that when I first got to New York I began writing short fan letters to him and calling him on the phone every day until his mother told me to quit it." *The Philosophy of Andy Warhol: From A to B and Back Again* (New York: Harcourt Brace Jovanovich, 1975), 148. Two of the postcards Warhol sent Capote in the early 1950s are reproduced as figures 2a–b and 3a–b in *Andy Warhol: A Factory*, ed. Germano Celant, Veit Görner, and Gerard Hadders (Ostfildern, Germany: G. Hatje, 1998). On Warhol's fixation on Capote, see also Reva Wolf, *Andy Warhol, Poetry, and Gossip in the 1960s* (Chicago: University of Chicago Press, 1997), 10; Bob Colacello, *Holy Terror: Andy Warhol Close Up* (New York: Harper-Collins, 1990), 24; and Bockris, *The Life and Death of Andy Warhol*, 45, 60–61.

In a 1973 interview with Jann Wenner, Capote recalled the terms under which he became acquainted with Warhol:

JW: When did you first meet Andy Warhol?

TC: I don't remember it. He used to write me these letters all the time. They were just admiring letters. He liked my work, etc.

JW: Did you take any note?

TC: Well I got so many of them, of course, I remember them.

JW: What? Every day?

TC: Yes. For quite a long time. He used to send me lots of pictures and draw-

ings and things. But I don't remember when we first met.

Jann Wenner, "Coda: Another Round With Mister C.," *Rolling Stone* 182 (April 12, 1973): 50.

37. B. G. [Barbara Guest], "Clarke, Rager, Warhol [Loft]," *Art News* 53, no. 4 (Summer 1954): 75. Victor Bockris describes the show as "devoted to drawings of the dancer John Butler" in *The Life and Death of Andy Warhol*, 79.

38. Coplans, "Crazy Golden Slippers," 12–13.

39. In a chapter of *Popism* devoted to the years 1960–63, Warhol describes his identity as an effeminate gay man in the following terms: "And as for the 'swish' thing, I'd always had a lot of fun with that—just watching the expressions on people's faces. You'd have to have seen the way all the Abstract Expressionist painters carried themselves and the kinds of images they cultivated, to understand how shocked people were to see a painter coming on swish. I certainly wasn't a butch kind of guy by nature, but I must admit, I went out of my way to play up the other extreme." Andy Warhol and Pat Hackett, *Popism: The Warhol '60s* (New York: Harper and Row, 1980), 12–13.

40. Art historian Joanna Woodall has defined the traditional portrait as "a physiognomic likeness which is seen to refer to the identity of the living or once-living person depicted." As Woodall suggests, the authority of the traditional or "naturalistic" portrait to represent the person portrayed depends above all on the perceived likeness of the face. Clearly, no one would mistake Warhol's celebrity shoes for naturalistic portraits. Yet Woodall also mentions other pictorial practices that rely on symbolic association, rather than physical resemblance, to represent identity (e.g., coats of arms). In displacing attention from the face to the shoe, from a physiognomic likeness to a symbolic image, Warhol's shoe collages might be seen as emblematic portraits. The problem here, however, is that the collages do not function, as would a coat of arms, as a pictorial claim for an authentic or particularized identity. The assignment of shoes to celebrity names is not based on any consistent or conventional system of correspondence: the shoes pictured were not, for example, ones associated with the star's persona or most famous roles (e.g., Garland's ruby slippers, Elvis's blue suede shoes). "Introduction: Facing the Subject," in *Portraiture: Facing the Subject*, ed. Joanne Woodall (Manchester, England: Manchester University Press, 1997), 1.

41. Patrick S. Smith, "Interview with Nathan Gluck, 20 November 1978," in *Andy Warhol's Art and Films* (Ann Arbor, Mich.: UMI Research Press, 1986), 336–37.

42. Charles Lisanby, interview by author, Los Angeles, June 11, 1999.

43. In this sense, Warhol's celebrity shoes look forward to his far more celebrated portraits of Elvis and Marilyn, of Jackie and Liz, in the early 1960s. Rather than underscoring the uniqueness of particular celebrities, Warhol's pop portraits reveal the star as an effect of visual repetition and recognition.

44. Describing the *Elvis Presley* boot, Margery King writes, "The drawing was inscribed 'Elvis Presely' and signed 'Andy Warhol' by Warhol's mother, Julia, who contributed her charming Old-World penmanship, complete with misspellings, to her son's work." "Starstruck: Andy Warhol's Marilyn and Elvis," *Carnegie Magazine*, July/August 1995: 10. For more on the issue of Mrs. Warhola's collaboration with her son in the 1950s, see the following note.

45. According to Jesse Kornbluth, "Warhol liked his mother's distinctive and loopy handwriting so much that he had her sign his name on his drawings and write out any text in his commercial assignments as well as his private books. When she made a mistake—as she did in the title of *25 Cats* [*name Sam and one Blue Pussy*] with the omission of the final 'd' in *named*, her son applauded yet another accidental improvement." *Pre-Pop Warhol* (New York: Random House, 1988), 143. Nathan Gluck similarly recalls that "for the *Cat Book*, Mrs. Warhola did all the calligraphy, and Warhol would leave in her mistakes, such as 'Name' instead of 'Named' on the title page." Cited in Patrick S. Smith, *Warhol: Conversations about the Artist* (Ann Arbor, Mich.: UMI Press, 1988), 63.

46. Cited in Smith, *Warhol*, 56.

47. Fairbrother, "Tomorrow's Man," 64.

48. Smith, "Interview with Nathan Gluck, 20 November 1978," 336–37.

49. Cited in ibid., 32.

50. Lisanby interview, June 11, 1999. For other "pear" works devoted to Lisanby by Warhol, see *A Pear for Mr. Charles, 1956,* reproduced in Crone, *Andy Warhol: A Picture Show,* 202, and *Two Pears, c. 1957,* reproduced in *Andy Warhol Drawings 1942–1987* (Boston: Bulfinch Press, 1999), plate 94.

51. Cited in Bockris, *The Life and Death of Andy Warhol,* 89–90.

52. The agent and filmmaker Emile De Antonio informed Warhol in the late 1950s that Robert Rauschenberg and Jasper Johns disliked him (Warhol) both because of his openly homosexual (or "swish") sensibility and because "you're a commercial artist, which really bugs them because when *they* do commercial art—windows and other jobs I find them—they do it just 'to survive.' They won't even use their real names. Whereas *you've* won *prizes!* You're *famous* for it!" See Warhol and Hackett, *Popism,* 12. In an extended analysis of this passage from *Popism,* Kenneth Silver has argued that "Andy Warhol *was* proud of his commercial work, and with good reason: he was one of New York's best-known and highest paid commercial artists of the fifties. But there is special pleading in 'Jasper and Bob's' objections to Warhol's willingness to 'own' his commercial reputation: as 'De' recounts, they also did commercial assignments. Specifically, they designed windows for Gene Moore at Tiffany and Bonwit Teller, both working under the same pseudonym: Matson Jones. There is a parallelism, then, between Warhol's willingness to wear his 'swishness' as a sign and to wear his 'commercialism' as a sign, just as there is a symmetry in 'Jasper and Bob's' twin refusals to do either. Moreover, these two buttoned-down guys were surely aware that moonlighting as a window dresser was not quite the same thing as moonlighting as a security guard: to dress Tiffany's windows was, and often still is, a typically gay pursuit." "Modes of Disclosure: The Construction of Gay Identity and the Rise of Pop Art," in *Hand-Painted Pop: American Art in Transition, 1955–1962,* ed. Russell Ferguson (Los Angeles: Museum of Contemporary Art, 1992), 194–95.

53. Wallowitch is identified as Warhol's boyfriend in several sources, including Judith Keller, "Andy Warhol's Photo-Biogra-phy," in *Nadar / Warhol, Paris / New York: Photography and Fame* (Los Angeles: J. Paul Getty Museum, 1999), 34, and Bockris, *The Life and Death of Andy Warhol,* 90–91. According to John Wallowitch, Edward was romantically involved with Warhol from 1955–1959. John Wallowitch, telephone conversation with the author, October 18, 2000.

54. John Wallowitch, telephone interview by author, January 25, 2000.

55. Patrick S. Smith, "Interview with Nathan Gluck, 17 October 1978," in *Andy Warhol's Art and Films,* 317–18.

56. This drawing, now in the collection of the Andy Warhol Museum, is among several hundred that, while definitely produced in the 1950s, have not been, and probably cannot be, more precisely dated.

57. Recall, in this context, Booth's observation that camp "is escapist in the sense of escaping from the realities of life—work, material want, and above all sex. Camp wants to escape from rather than to have sex" Booth, *Camp,* 54.

58. Fairbrother, "Tomorrow's Man," 63.

59. Ronald Vance, "Andy Warhol at Bodley," *Art News* vol. 55, no. 1 (March 1956): 55.

60. Warhol first exhibited his Campbell Soup Can paintings at the Ferus Gallery in Los Angeles in 1962.

61. In so doing, Warhol also abandoned the social and professional milieu in which he had circulated throughout the 1950s. In 1960, according to Victor Bockris, "although Andy continued to work with Nathan Gluck every day, his commercial art friends were gradually excluded from his new world." *The Life and Death of Andy Warhol,* 100. According to Gluck, Warhol continued to do commercial assignments (and to employ Gluck as his assistant) until 1963. During the early 1960s, Warhol grew increasingly secretive about the fact that he was continuing to do commercial work. According to Gluck, Warhol "worried that people wouldn't think he was 'a real artist' if they knew [about the commercial projects]." Gluck, interview by author, New York, N.Y., November 28, 1999. A 1964 interview of Warhol by Gerard Malanga (Warhol's studio assistant at the time) refers quite explicitly to this professional secret:

Q. Where were you last employed?

A. I. Miller Shoe Salon.

Q. What is your profession?

A. Factory owner.

Q. Do you have a secret profession?

A. Commercial artist.

"Andy Warhol: Interviewed by Gerard Malanga," *Kulchur* 16 (Winter 1964–65): 37.

62. In *The Warhol Look: Glamour, Style, Fashion*, an exhibition organized by the Andy Warhol Museum to explore the relation between art and fashion in every decade of Warhol's artistic production (the 1950s through the 1980s), the section on the 1950s was introduced with the following wall text:

In 1950s New York, Warhol found himself both as an artist and as an individual. He moved in an apparently carefree, success-ful gay milieu with other young illustra-tors, artists, photographers, and per-formers. He and his friends frequented the ballet, the opera, and the rococo Serendipity café.

Warhol created the first of a number of distinctive personal styles in the 1950s, a "How to Succeed in Business Look" with a touch of the gay dandy. Photographs often show him with illustrator's portfo-lio in hand in neat suits or jackets and khakis, button-down shirts, and ties or bow ties.

Wall text, *The Warhol Look: Glamour, Style, Fashion*, Whitney Museum of American Art, New York, November 8, 1997–January 18, 1998.

63. On the Factory, see Nat Finkelstein, *Andy Warhol: The Factory Years, 1964–1967* (New York : St. Martin's Press) 1989, Stephen Shore and Lynne Tillman, *The Velvet Years: Warhol's Factory, 1965–1967*, (London: Pavil-ion, 1995), Debra Miller, *Billy Name, Stills from the Warhol Films*, (New York: Prestel, 1994), Caroline A. Jones, "Andy Warhol's Factory, 'Commonism,' and the Business Art Business," chapter 4, *Machine in the Studio: Constructing the Postwar American Artist* (Chicago: University of Chicago Press, 1996), 189–267, 420–444, and, most espe-cially, Warhol and Hackett, *Popism: The Warhol '60s*. A marvelous trove of Billy Name photo-graphs of the Factory is reproduced in *Andy Warhol*, exhibition catalog (Stockholm: Moderna Museet, 1968).

64. David Bourdon segment in "Andy Warhol 1928–87," *Art in America* 75 no. 5 (May 1987): 139.

65. In the mid- to late 1960s, Warhol shot a number of films (e.g., *Blow Job, Bike Boy, My Hustler, Camp*) that revived (but also reinvented) the high camp and overtly homoerotic content of his pre-Pop art. As film historian Peter Wollen has pointed out, "There is a sense in which Warhol's fine-art phase [of the early 1960s] was bracketed by the much more obviously gay affiliation of both his earlier work (personal and com-mercial) and by his subsequent film work." "Raiding the Icebox," in *Andy Warhol: Film Factory*, ed. Michael O'Pary (London: BFI Publishing, 1989), 27, n. 45.

66. Sontag, "Notes on Camp," in *Against Interpretation*, 291–292. On Sontag's distinc-tion between Camp taste and Pop art, see Andrew Ross, "Uses of Camp" in *Camp Grounds: Style and Homosexuality*, ed. David Bergman (Amherst: University of Massa-chusetts Press, 1993): 68. My thinking about Warhol's use of camp is indebted to both Sontag and Ross.

67. Caroline A. Jones, *Machine in the Stu-dio: Constructing the Postwar American Artist* (Chicago, University of Chicago Press, 1996), 244.

68. Paradoxically, the term "camp" was applied by critics (in part as a code word for "homosexual") to Warhol's Pop art of the 1960s but not to his far campier drawings and collages of the 1950s. For an important account of the critical use of camp to frame Warhol's Pop art, see Cécile Whiting, "Warhol, the Public Star and the Private Self," in *A Taste for Pop: Pop Art, Gender, and Consumer Culture* (Cambridge: Cambridge University Press, 1997), 146–86, especially 177–186.

69. The *Journal American*'s picture accompanied an article by Richard Barr and Cyril Egan Jr. entitled "Some Not-So-Fair Faces: Mural Is Something Yegg-stra," *New York Journal American*, April 15, 1964.

70. Milton Esterow, "Spain's Paintings to Arrive Today," *New York Times*, April 17, 1964: 22. Esterow went on to report that "in the latter category [Pop art] will be John Chamberlain's crushed automobile fender

mounted on a truck chassis on a wall outside the New York State Pavilion. Not far away will be Andrew Warhol's front and side views of the Federal Bureau of Investigation's 13 most wanted men."

71. Ibid.

72. Martin Tolchin, "World's Fair Guards Increased to Curb Pilferage at Pavilions," *New York Times*, April 18, 1964: 16.

73. Mel Juffe, "Fair's 'Most Wanted' Mural Becomes 'Least Desirable,'" *New York Journal American*, April 18, 1964: 4.

74. Emily Genauer, "Fair Mural Taken Off, Artist to Do Another," *New York Herald-Tribune*, April 18, 1964.

75. Grace Glueck, "In Britain, What's a Government Budget without Art," *New York Times*, July 19, 1964: sec. 2, p. 12.

76. Through the passive construction of this sentence, Glueck suggests a potential inconsistency between the initial story of the mural's overpainting ("said to have been painted out") and the more recent information she has received ("it is understood that he received legal threats"). Ibid.

77. Ibid.

78. As mentioned above, no replacement mural was ever created by Warhol, no other "inspiration" ever found. Warhol did, however, propose an idea for a replacement mural—a portrait of Fair president Robert Moses—but that idea was immediately nixed by Johnson. The Moses proposal and the fact of its rejection are discussed in some detail later in this chapter.

79. Cited in Rainer Crone, *Andy Warhol* (New York: Praeger, 1970), 30.

80. Cited in ibid.

81. Warhol and Hackett, *Popism*, 71–72. In 1978, Gerard Malanga would recall "all sorts of trouble with the Most Wanted Men" in an interview with Patrick Smith: "We had to paint over some of the Most Wanted Men series because, it turned out, that they were no longer wanted, or, they had served their terms in prison, or, whatever. So, we had to paint over some of the images, and then, again, the esthetic decision occurred—it was just to leave them blank and do it over." Cited in Smith, "Interview with Gerard Malanga, 1 November 1978" *Andy Warhol's Art and Films*, 399.

82. Even the document that would seem to provide the most reliable evidence regarding *Thirteen Most Wanted Men* turns out

to be far from stable. Here is the entire text of a brief letter Warhol sent to the New York State Department of Public Works on April 17, 1964:

Gentlemen:
This serves to confirm that you are hereby authorized to paint over my mural in the New York State Pavilion in a color suitable to the Architect.
Very Truly Yours,
Andrew Warhol

Warhol's letter "confirms" the State's right to cover his mural with paint. Such a confirmation does not mean, however, that Warhol either requested or desired the State to take such an action. The decision to cover over *Thirteen Most Wanted Men* seems already to have been made by the time Warhol sent this letter to the New York State Department of Public Works. Letter from Andrew Warhol to New York State Department of Public Works, April 17, 1964, copy housed in the Archives of the Andy Warhol Museum (folder P-19). My thanks to Matt Wrbican for bringing this letter to my attention.

83. *New York World's Fair 1964–1965*, no. 1, January 15, 1961: 2; cited in Mark H. Miller, "Something for Everyone: Robert Moses and the World's Fair," in *Remembering the Future: The New York World's Fair from 1939 to 1964* (New York: Queens Museum and Rizzoli, 1989), 57.

84. The 1964 World's Fair emphasized both the technological achievements of today and their even greater promise for tomorrow. The General Motors pavilion, for example, featured a forward-looking "trip to the moon." On futurism at the 1964 World's Fair, see Rosemarie Haag Bletter, "The 'Laissez-Fair,' Good Taste, and Money Trees: Architecture at the Fair," in *Remembering the Future*, 105–35.

85. Warhol's mural was not the only public critique of the World's Fair in 1964. Several antiwar and antidiscrimination groups staged demonstrations at the exposition: "On opening day, three hundred civil rights demonstrators were arrested for protesting the racist nature of the fair's employment policy, which excluded minorities from all positions of power; [in addition,] a group called Women's Strike for Peace, chanting 'No More Hiroshimas,' called for the imme-

diate end to America's involvement in Vietnam." Elizabeth Bigham and Andrew Perchuk, "American Identity / American Art," in *Constructing American Identity* (New York: Whitney Museum of American Art, 1991), 16. For more on political protests at the Fair, see Morris Dickstein, "From the Thirties to the Sixties: The New York World's Fair in Its Own Time," in *Remembering the Future*, 32–35.

86. Sidra Stich, "The American Dream / The American Dilemma," in *Made in U.S.A.: An Americanization in Modern Art, the '50s and '60s* (Berkeley, Calif.: University Art Museum, 1987), 177.

87. See Thomas Crow, "Saturday Disasters: Trace and Reference in Early Warhol," in *Reconstructing Modernism: Art in New York, Paris, Montreal, 1945–1964* ed. Serge Guilbaut (Cambridge: MIT Press, 1990): 311–331. On this subject, see also King, "Starstruck: Andy Warhol's Marilyn and Elvis" (as in n. 44), 10–14. King's essay includes an illustration of a Warhol drawing of James Dean from the mid-1950s. The image closely resembles the *Boy Book* drawings of the same moment (the upturned head, the profile view, the simplified line), with one significant difference: the inclusion of an overturned car and brick wall in the background. The reference, of course, is to Dean's 1956 death from an automobile crash. In the context of this chapter, the drawing is significant because it reveals that Warhol's interest in both celebrity and death (and in celebrity death) was already apparent in his openly homoerotic work of the 1950s. In her essay, King observes that "like his James Dean drawings of the 1950s, the *Marilyn* paintings are in part a response to the star's death. In a 1963 *Artnews* interview, the artist related them to his death and disaster paintings of the same period: 'I was also painting the *Marilyns*. I realized that everything I was doing must have been death'" (13). In the context of an essay on Warhol's early films, Juan A. Suárez argues that "Warhol's fascination with his movie stars had Hollywood as a constant point of reference. Acutely aware of the institution's decline at the time, his approach to celebrity and glamour is ridden with self-consciousness and nostalgia. He noted that the Marilyns and Liz Taylors were homages to a star system that was both figuratively and liter-

ally dying—he undertook the Marilyn silkscreen right after her death, and while he executed the first of Liz Taylor's portraits ('Liz Taylor as Cleopatra'), the actress was gravely ill and there were rumors about her possible demise." *Bike Boys, Drag Queens, and Superstars: Avant-Garde, Mass Culture, and Gay Identities in the 1960s Underground Cinema* (Bloomington: Indiana University Press, 1996), 227–28.

88. Thomas Crow, "Saturday Disasters," 324.

89. Warhol, *The Philosophy of Andy Warhol*, 85.

90. Crow, "Saturday Disasters," 323. See also Cécile Whiting's analysis of Warhol's pictorial treatment of stardom (and of Marilyn in particular) in the early 1960s in *A Taste for Pop*, 146–86.

91. Crow, "Saturday Disasters," 317. In comparing Warhol's representations of Jackie and Marilyn, Crow argues that the former's "slim, dark, aristocratic standard of beauty had made Monroe's style, and thus her power as a symbol, seem out of date even before her death. . . . Warhol reinforced that passé quality by choosing for his series a photograph of Monroe from the early 1950s" (316–317).

92. Ibid., 324.

93. Philip Johnson cited in Crone, *Andy Warhol*, 30.

94. Kenneth Silver and Neil Printz are the exceptions here. See Silver, "Modes of Disclosure," 178–203. Printz's discussion of the mural appears in *Andy Warhol: Death and Disasters* (Houston: Houston Fine Arts Press, 1988). On Silver's essay, see also n. 96.

95. See, for example, Bourdon, *Warhol*, 181, and Andrew Kagan, "Most Wanted Men: Andy Warhol and the Culture of Punk," *Arts Magazine* 53 (September 1978): 119–22.

96. In 1992, Kenneth Silver published an important essay that focused on the work of Warhol and Jasper Johns in relation to questions of homosexuality. In the course of that essay, Silver interprets *Thirteen Most Wanted Men* as an allusion to same-sex desire: "The *Thirteen Most Wanted Men* mural which Warhol created for Philip Johnson's New York State Pavilion at the 1964 World's Fair . . . was— for those who could decipher it— a punning reference not only to the FBI's desire, but to Warhol's own. That 'wanting

men' was here synonymous with criminal activity must have made the joke all the better to Warhol. As local post offices across America offered, if unintentionally, male pinups to the American public, Warhol can be said to have collaborated with the U.S. government in cultivating gay sensibility. Inasmuch as Warhol was asked to hide his mural from public view before the Fair opened (which he did by painting over his 'most wanted men' with silver paint), it may be that some of his 'inside' jokes were, at least subliminally, too close to the surface." "Modes of Disclosure," 194.

Silver's description of *Thirteen Most Wanted Men* closely resembles my own, albeit with slightly different shadings and emphases. While I admire Silver's essay, I would also like to note that I initiated research on *Thirteen Most Wanted Men* as a graduate student at U.C. Berkeley in the fall of 1990, and my paper "Warhol's Clones" was delivered at the Fifth Annual Conference on Lesbian and Gay Studies at Rutgers University in November 1991 and again at the annual conference of the College Art Association in Chicago in February 1992. That paper was subsequently published as "Warhol's Clones," *Yale Journal of Criticism* 7, no. 1 (Spring 1994): 79–110.

97. John Tagg, *The Burden of Representation: Essays on Photographies and Histories* (Amherst: University of Massachusetts Press, 1988), 85.

98. Kenneth Silver has argued that "during the early Pop art years, 1960–65, as distinct from the periods both before and after, representations of frank sexuality are almost completely displaced from the realm of the pictorial to the filmic. . . . In contrast to the relatively direct 'boy drawings' of the 1950s, full appreciation of Warhol's early Pop paintings and silkscreens required at least a certain gay-attuned sensibility and sense of humor." "Modes of Disclosure," 194. As Silver argues, Warhol's early films do address sexuality, and especially homosexuality, with far greater explicitness than does his contemporaneous Pop art. In addition to *Thirteen Most Beautiful Boys*, several of Warhol's early films (e.g., *Blow Job, Bike Boy*, and *My Hustler*) focus on issues of same-sex desire and, in the case of *My Hustler*, male prostitution. The interest in homosexual camp that marked Warhol's pre-Pop art of

the 1950s also extends into such films of the 1960s as *Camp, Mario Banana*, and *Chelsea Girls*.

99. Barr and Egan, "Some Not-So-Fair Faces."

100. Juffe, "Fair's 'Most Wanted' Mural Becomes 'Least Desirable,'" 4. Compare the jokiness of Juffe's tone to the humorlessness of Philip Johnson, whose opinion on the mural is quoted in the same article: "The picture is a comment on the sociological factor in American life." Johnson refuses to acknowledge any double-coding or Warholian wit in *Thirteen Most Wanted Men*. Against all odds, Johnson attempts a diplomatic, hopelessly neutral interpretation of Warhol's highly charged work.

101. Barr and Egan, "Some Not-So-Fair Faces."

102. A thermofax copy of this booklet is now in the holdings of the Andy Warhol Museum Archives in Pittsburgh, Time Capsule #11.

103. Barr and Egan, "Some Not-So-Fair Faces."

104. Ibid., 8.

105. John Giorno, "Andy Warhol's Movie *Sleep*," in *You Got to Burn to Shine: New and Selected Writings* (London and New York: High Risk Books/Serpent's Tail, 1994), 127–29.

106. John Giorno, phone interview by author, February 20, 1996. Wynn Chamberlain, who now lives abroad, maintains little contact with the United States, and I could not reach him. O'Neill and Keely are both deceased.

107. My thanks to Matt Wrbican, archivist at the Andy Warhol Museum, for helping me locate some of these mug-shot posters among the extensive (and terrifically eclectic) contents of Warhol's "time capsules."

108. Letter from Frank O'Hara to John Ashbery, January 21, 1964, cited in Brad Gooch, *City Poet: The Life and Times of Frank O'Hara* (New York: Alfred A. Knopf, 1993), 424. My thanks to Marc Siegel for bringing this letter to my attention. I am also indebted to Siegel's essay on *Flaming Creatures*, which includes a discussion of both O'Hara's letter and the police crackdown on queer culture in 1964. See Marc Siegel, "Documentary That Dare/Not Speak Its Name: Jack Smith's *Flaming Creatures*," in

Between the Sheets, in the Streets: Queer, Lesbian, Gay Documentary, ed. Chris Holmund and Cynthia Fuchs (Minneapolis: University of Minnesota Press, 1997), 95.

109. I am grateful to Douglas Crimp for urging me, both in print and in person, to link the censorship of *Most Wanted Men* to broader attacks on the queer culture of New York City in the months leading up to the 1964 World's Fair. See Douglas Crimp, "Getting the Warhol We Deserve," *Social Text* 59, vol. 17, no. 2 (Summer 1999): 49–66.

110. Buchloh, "Andy Warhol's One-Dimensional Art," 54.

111. Eve Kosofsky Sedgwick, *Epistemology of the Closet* (Berkeley and Los Angeles: University of California Press, 1990), 3.

112. Paul Morrison, "Coffee Table Sex: Robert Mapplethorpe and the Sado-masochism of Everyday Life," *Genders* 11 (Fall 1991): 29.

113. Philip Johnson, interview by Rainer Crone, January 1970, cited in Crone, *Andy Warhol*, 30.

114. See Patrick Smith's interview of Ivan Karp in *Andy Warhol's Art and Films*, 362.

115. *The American Man — Watson Powell* was commissioned by Powell's son, Watson Powell Jr., who was then president of the American Insurance Republic Company. The younger Powell was so pleased with the portrait that he wrote a personal letter of gratitude to Warhol: "I might say that I share the thought of everyone who has seen the wonderful portrait [of Dad] that Andy Warhol is indeed a great artist! I hope everything is going along very well with you, Andy. Thanks for the beautiful job which you did and which will mean so much to so many people." Letter from Watson Powell Jr. to Andy Warhol, January 11, 1965, Andy Warhol Museum Archives, Time Capsule #5.

In its review of the American Republic Insurance Company's "magnificent collection of paintings," the *Des Moines Register* offered a similarly positive assessment of Warhol's portrait: "The picture is a wall-to-ceiling 32-portrait repeat, done from a single photograph of the retired insurance executive which was taken several years ago. The unusual but highly pleasing picture will be in the company's lobby. The 32-repeat portraits symbolize the elder Powell's 32 years as company president." George Shane,

"The Visual Arts," *Des Moines Sunday Register*, January 10, 1965: 2L, photocopy in Andy Warhol Museum Archives, Time Capsule #5. Warhol's treatment of Watson Powell was not seen as ironic (or in any way critical) by these viewers. That George Shane, the local arts reporter for the Des Moines paper, and Watson Powell Jr., the patron of the portrait and the son of the subject portrayed, should so heartily approve of the painting testifies both to the subtlety of Warhol's wit and to the ability of viewers to find in his work that which they wished to see.

116. Bourdon, *Warhol*, 87. The creation of *Ethel Scull Thirty-six Times* furnishes one of the great camp moments in Warhol's career. Here is Bourdon's version of the story: "Instead of basing the [Scull] portrait on pre-existing 'official' photographs supplied to him by the sitter, Warhol chose to make his own candid pictures, but he did not shoot them himself. He taxied with Mrs. Scull, who was ready to face posterity in an Yves Saint Laurent for Christian Dior suit, to a Times Square amusement arcade and installed her in an automatic, four-for-a-quarter photo-booth. 'Now start smiling and talking, this is costing me money,' he told her, as he dropped quarters into the machine, setting off the photofloods. With and without her sunglasses, Ethel preened, mugged, bared her teeth, patted her chin, stroked her hair, and clutched her throat. She posed for more than one hundred shots, presenting herself in a wide gamut of moods—pensive, exuberant, seductive, cheerful, laughing" (158, 160). In the context of this anecdote, we might recall Mark Booth's definition of camp: "To be camp is to present oneself as being committed to the marginal with a commitment greater than the marginal merits" (*Camp*, 17–18). The brilliance of *Ethel Scull Thirty-six Times* owes a great deal to such a commitment (on Warhol's part and, in a different sense, on Mrs. Scull's) to the "four-for-a-quarter photo-booth" photograph as a form of fine-art portraiture.

117. Roland Barthes, "That Old Thing Art . . . ," in *The Responsibility of Forms*, translated by Richard Howard (New York: Hill and Wang, 1985), 205.

118. *Double Elvis* conforms to what Mathew Tinkcom has described as a ten-

dency within Warhol's pop art that "'per-
verts' the conditions under which cinematic
representation, particularly that of Holly-
wood, is said to always be in control of a
fully realized heterosexuality." "Camp and
the Question of Value," 42.

119. I have elsewhere discussed the ways
in which homosexuality shapes the codes of
Hollywood representation even as it is dis-
avowed by those same codes. See Richard
Meyer, "Rock Hudson's Body," in *Inside/Out:
Lesbian Theories, Gay Theories*, ed. Diana Fuss
(New York: Routledge, 1991), 258–88.

120. Irving Blum, interview by Patrick
S. Smith in Smith, *Warhol*, 197. Blum's rec-
ollection of the episode is worth quoting at
length: "Andy sent a roll of printed Presley
images, an enormous roll, and sent a box of
assorted size stretcher bars, and I called him
and said, 'Will you come?' And he said, 'I
can't. I'm very busy. Will you do it?' I said,
'You mean, you want me to cut them? Virtu-
ally as I think they should be cut and placed
around the wall?' And he said, 'Yes, cut them
any way that you think they should be cut. I
leave it to you. The only thing I really want is
that they should be hung edge to edge,
densely—around the gallery. So long as you
can manage that, do the best you can'"
(196–97).

121. Warhol, *The Philosophy of Andy
Warhol*, 53.

122. Shortly after Warhol's death in
1987, the artist Margia Kramer requested
the FBI file on Warhol. She published the
file, along with her own introductory analy-
sis and overview, in 1988. I am deeply
indebted to Kramer's research and publica-
tion. See Margia Kramer, *Andy Warhol et Al.:
The FBI File on Andy Warhol* (New York: UnSub
Press, 1988).

123. *Lonesome Cowboys* was shot on loca-
tion at the Rancho Linda Vista Guest Ranch
near Tucson, Arizona, in January 1968. Here
is Paul Morrisey (Warhol's assistant on *Lone-
some Cowboys*) describing the film in 1969:
"The new film *Lonesome Cowboys*—it's the
first one to really tell a story. It's about a
group of brothers in the West. . . . They
aren't really brothers, they're well, sleeping
together, or whatever, but they say they're
brothers so people won't talk. There was
supposed to be some lines about that—but
the way we work—well, they forgot to say
it, so you sort of don't know whether

they're brothers or not." Cited in Neal
Weaver, "The Warhol Phenomenon: Trying
to Understand It," *After Dark*, January 1969:
30.

124. Kramer, *Andy Warhol et Al.*, 35–37.

125. Susan Stewart, "The Marquis de
Meese," in *Crimes of Writing: Problems in the
Containment of Representation* (Durham,
N.C.: Duke University Press, 1994), 236.

126. Warhol and Hackett, *Popism*, 72.

Chapter 4

1. On Stonewall and the founding of the
gay liberation movement, see Martin
Duberman, *Stonewall* (New York: Dutton,
1993); Dick Leitsch, "Acting Up at the
Stonewall Riots," *The Advocate* (July 1969),
reprinted in *Long Road to Freedom: The* Advo-
cate *History of the Gay and Lesbian Movement*,
ed. Mark Thompson (New York: St. Martin's
Press, 1994), 28–29; Donn Teal, *The Gay
Militants* (New York: Stein and Day, 1971).

2. *Gay Power* has a rather complicated his-
tory. During the first fifteen months of its
publication run (September 1969–Decem-
ber 1970), the newspaper was a commu-
nity-based, collectively run, activist-ori-
ented publication. In 1971, *Gay Power* was
purchased by a commercial publisher and
became increasingly devoted to male pin-
ups, soft-core pornography, and ads for sex-
ual paraphernalia (which, even in the pages
of *Gay Power*, were referred to as "marital
aids"). By 1972, *Gay Power* was no longer
reporting on the gay liberation movement
nor, for that matter, on any political struggle
or contemporary social issue. According to
Rodger Streitmatter, the commercial ver-
sion of *Gay Power* "was published by a straight
entrepreneur interested only in exploiting
the gay community for financial gain." What
had once been an explicitly activist publica-
tion featuring stories on gay and lesbian pol-
itics and current events became, by 1972, an
almost entirely pictorial—as well as an all-
male—publication. While Streitmatter's
accusations of economic exploitation may
well be justified, I would suggest that the
changes in *Gay Power* should also be seen as
part of the wider commodification of gay
male culture in the 1970s. On the earlier
incarnation of *Gay Power*, see Teal, *The Gay
Militants*, 81. For Streitmatter's criticism of
the later *Gay Power*, see Rodger Streitmatter,

Unspeakable: The Rise of the Gay and Lesbian Press in America (Boston: Faber and Faber, 1995), xi.

3. This moment was dependent, in part, upon the judicial relaxation of obscenity laws and the concomitant proliferation of commercially produced soft-core pornography (both gay and straight) in the late 1960s and early 1970s. On the birth of a radical gay press in the immediate aftermath of Stonewall, see Streitmatter, *Unspeakable*, chap. 5 (116–53).

4. The cover appears in Binder #0 of the Mapplethorpe clippings housed at the Robert Mapplethorpe Foundation in New York. As with virtually all the clippings in these binders, the *Gay Power* cover has been cut out or otherwise removed from the larger issue in which it appeared.

5. Critical and biographical accounts of Mapplethorpe typically present him as an insistently apolitical figure, one who betrayed no interest in activism of any stripe. Ingrid Sischy has noted that "there's irony in Mapplethorpe's becoming such a political cause celebre. He may have been political in terms of whom to talk to at a dinner party, but he didn't give a hoot about real politics. Still, real politics found him when his work was about to appear in the capital." Sischy, "White and Black," *New Yorker* vol. 65, no. 39 (November 13, 1989), 138. According to Allen Ellenzweig, "It is an irony of the present culture debate that Robert Mapplethorpe, of all people, should come to symbolize 'gay photography,' for he was the least involved in any realpolitick, gay or otherwise." *The Homoerotic Photograph: From Durieu/Delacroix to Mapplethorpe* (New York: Columbia University Press, 1992), 140. Similarly, Edmund White writes that "Mapplethorpe was singularly apolitical and obsessed with his own career, with a degree of self-absorption friends might have called anarchic individualism and enemies might have labeled narcissism." "Altars: The Radicalism of Simplicity," in *Mapplethorpe: Altars* (New York: Random House, 1995), 128. Arthur Danto has similarly argued that "it is difficult to suppose that Mapplethorpe had any particularly well-formed political views. He was not an activist. His interests in sex were somehow more aesthetic and in a sense metaphysical and—despite the tautology—*sexual*. Danto, Arthur C., *Playing*

with the Edge: The Photographic Acheivement of Robert Mapplethorpe* (Berkeley: University of California Press, 1996), 75.

6. The expression "Gay Is Good" was not invented by the gay liberation movement. In the summer of 1968, the North American Conference of Homophile Organizations adopted the slogan as its official motto. Franklin Kameny, the most vocal proponent of "Gay Is Good" and the person most responsible for its adoption within the homophile movement, subsequently wrote an essay explaining the significance of the phrase. In strong contrast to Shelley's identically titled manifesto of 1970, Kameny's 1969 "Gay Is Good" stresses the similarity of homosexuality to heterosexuality. "To the heterosexual community, I say that we are full human beings—children of God, no less than you—with the same feelings, needs, sensitivities, desires, and aspirations. We are not the monsters that so many of you have been led to believe we are. We differ not at all from you except in our choice of those whom we love and with whom we relate intimately—in those ways, in their narrowest sense, but in no other ways." "Gay Is Good," cited in Toby Marotta, *The Politics of Homosexuality* (Boston: Houghton Mifflin, 1981), 67.

7. Martha Shelley, "Gay Is Good," in *Out of the Closets: Voices of Gay Liberation*, [1972] ed. Karla Jay and Allen Young (New York: New York University Press, Twentieth Anniversary Edition, 1992), 31–32.

8. Allen Young, "Out of the Closet: A Gay Manifesto," *Ramparts Magazine*, November 1971: 8, reprinted as a pamphlet by New England Free Press.

9. The *San Francisco Free Press* was a bimonthly, alternative newspaper published from 1969 to 1972. In late 1970, the newspaper officially changed its name to the *San Francisco Gay Free Press*.

10. Jill Johnston, "Of This Pure but Irregular Passion," *Village Voice*, July 2, 1970: 29.

11. On the rhetorical strategies of the homophile movement, see Toby Marotta, *The Politics of Homosexuality* (Boston: Houghton Mifflin, 1981), 3–68.

12. According to Martin Duberman, it was at the insistence of Frank Kameny, a primary organizer of the demonstration, that "a strict dress code was enforced on all par-

ticipants. 'If we want to be employed by the Federal Government,' Kameny intoned, 'we have to look employable to the Federal Government.'" *Stonewall*, 112.

13. The picket was sponsored by ECHO, a coalition of members of the Mattachine Society and the Daughters of Bilitis in Washington, New York, Philadelphia, and Boston.

14. Duberman, *Stonewall*, 111.

15. Duberman explains the disappointing turnout for the photo shoot—and Hujar's clever response to it—in the following terms: "Appearing on the poster would be tantamount to publicly coming out, and in 1970 that was still a terrifying prospect for most people. Many of the phone messages [asking people to attend Hujar's shoot] went unanswered, and many others called back to stammer invented regrets or to express real fears. Ultimately, some fifteen people showed up to be photographed. And Hujar had them run back and forth, back and forth, down the deserted street, shouting and laughing in triumph. . . . In the final poster, the fifteen marchers crowd the center, and it only gradually becomes clear that the sidewalks behind them are empty; these ebullient troops seem to have no backup forces. What also becomes apparent is the nearly equal number of women and women—though in GLF itself the women were far outnumbered" (ibid., 273–74).

16. Tensions between male and female GLF members eventually led a core group of women to leave the GLF and found Radicalesbians, a lesbian separatist organization. According to John D'Emilio, "Lesbians were active in both early gay liberation groups and feminist organizations. Frustrated and angered by the chauvinism they experienced in gay groups and the hostility they found in the women's movement, many lesbians opted to crate their own separatist organizations. Groups such as Radicalesbians in New York, the Furies Collective in Washington, and Gay Women's Liberation in San Francisco carved out a distinctive lesbian-feminist poetics." *Sexual Politics, Sexual Communities: The Making of a Homosexual Minority in the United States, 1940–1970* (Chicago: University of Chicago Press, 1983), 236. This split was indicative of larger divisions between gay male and lesbian subcultures at the time, divisions that would become deeper and more ingrained throughout the course of the 1970s.

17. "No longer," wrote Dennis Altman in 1971, "is the claim made that gay people can fit into American society, that they are as decent, as patriotic, as clean-living as anyone else. Rather, it is argued, it is American society that needs to change." *Homosexual: Oppression and Liberation* (New York, Discus Books, 1973, originally published in 1971), 118–19. Historian Neil Miller has likewise noted that "to young radicals [in gay lib], there was no need to create a 'favorable' public image, as the homophiles had tried so hard to do. Now, Blatant was Beautiful." *Out of the Past: Gay and Lesbian History from 1869 to the Present* (New York: Vintage Books, 1995), 369.

18. Eve Kosofsky Sedgwick, *Epistemology of the Closet* (Berkeley and Los Angeles: University of California Press, 1990), 47.

19. Ibid., 47.

20. The most salient difference between the original collage and its reproduction on the cover of *Gay Power* is this central circle. As reproduced in *Gay Power*, the image lacks the white band that wraps around the central red circle. Instead, a larger circle of red marks the bull's-eye on the cover of *Gay Power*. It has been suggested to me that this change probably had less to do with any aesthetic or symbolic preference on the part of the newspaper's editorial staff than with financial and practical constraints of color printing at the time.

21. According to historian Thomas Waugh, "Full frontal nudes only became systematically available over the counter around 1966, after a set of crucial court decisions. Prior to that you took your chances: some sets [of male nude photographs] were distributed with inked-in posing straps which the customer was supposed to have enough ingenuity to sponge off." "Photography, Passion, and Power," *Body Politic* (March 1984): 30. On the relaxation of obscenity laws in the late 1960s, see also F. Valentine Hooven III, *Beefcake: The Muscle Magazines of America, 1950–1970* (Berlin: Benedikt Taschen, 1995), 123–25. On the rise of gay pornography in the 1970s, see Michael Bronski, "Gay Publishing: Pornography," in *Culture Clash: The Making of a Gay Sensibility* (Boston: South End Press, 1984), 160–74.

22. As Maria Wyke has pointed out, "After the Second World War, a new form of

physique magazine began to be produced for wide circulation among the gay community of the United States. During a period of growing demand for cultural legitimacy, it was nonetheless necessary to employ clever circumventions for any representations of homoeroticism if they were to remain above ground and be distributed through the legitimate market. For, during the fifties and early sixties, the so-called 'beefcake' photographers were frequently prosecuted and convicted in the American courts if they were felt to have exceeded the strict requirements of state censorship. The rhetoric of classicism was then one of several such circumventions employed to safeguard mass-produced but privately consumed visualizations of gay desire." "Herculean Muscle!: The Classicizing Rhetoric of Bodybuilding," *Arion* 4, no. 3 (1997): 59–60.

23. "Homosexuality and Citizenship in Florida" (Tallahassee: Florida Legislative Investigation Committee, 1964; reprint, New York: Guild Press, 1965).

24. Notice, as well, that the bar through the eyes, in shielding the identity of the man in the photograph, also makes him into a kind of everyman, one who could be patronizing any public restroom in the country.

25. In an essay on the pornographic logic of the Meese Commission report, Susan Stewart argues that glory holes "are particularly threatening to the bourgeoisie's standards of sexual contact. For the glory hole permits a particular form of anonymity— an anonymity of the body in pieces. Sex is detached from the whole or organic body, [and] from . . . all accoutrements of the proper name." The glory holes with which the Meese Commission was concerned were those drilled into the partition walls between adjacent peep show booths. As a means of policing the activity of the men in such booths, the Meese Commission insisted that "individual [peep show] booths . . . should not be equipped with doors. The occupant of the booth should be clearly visible." In response to this recommendation, Stewart remarks: "It does not occur to the commissioners that the removal of doors— as is the case with the removal of doors from high school toilets—results in its own voyeuristic, and thereby pleasurable, possibilities." "The Marquis de Meese," in *Crimes of Writing: Problems in the Containment of Rep-*

resentation (Durham, N.C.: Duke University Press, 1994), 263.

26. On the Guild Press, see Jackie Hatton, "The Pornography Empire of H. Lynn Womack," *Thresholds: Viewing Culture* 7 (Spring 1993): 9–32.

27. Guild Press advertisement for "Homosexuality and Citizenship in Florida." A clipping of the advertisement is included in the Tim Wood Erotica Collection at the Gay, Lesbian, Bisexual, and Transgender Historical Society of Northern California, San Francisco.

28. Thomas Waugh, *Hard to Imagine: Gay Male Eroticism in Photography and Film from Their Beginnings to Stonewall* (New York: Columbia University Press, 1996), 375–76. Of the Guild Press reprint of "Homosexuality and Citizenship in Florida," Waugh further argues that "gay sexual culture achieved a new visibility if not legitimacy with these images recycled for pleasure, pride, and profit. That this was all brought to pass with impunity ensured by the state's imprimatur was deliciously savored by all subversives and deviates of the period" (375).

29. "This is the most amazing book we have ever seen come from any public body. This is a facsimile reproduction; purple cover, glory hole scene, and all." Guild Press advertisement for "Homosexuality and Citizenship in Florida."

My formulation of the Guild Press reprint strongly recalls Michel Foucault's concept of reverse discourse, wherein the medical and legal surveillance of homosexuality unwittingly provides the means through which homosexual counteridentification can be forged. See my discussion of Foucault's concept of reverse discourse in chapter 1. Foucault, *The History of Sexuality, Volume 1: An Introduction*, trans. Robert Hurley (New York: Random House, 1980), 100–101. On the strategic use of reverse discourse to counter homophobia, see David M. Halperin, *Saint Foucault: Toward a Gay Hagiography* (New York: Oxford University Press, 1995), 52–62. According to Halperin, "The most radical reversal of homophobic discourses consists not in asserting . . . that "gay is good" (on the analogy with "black is beautiful") but in assuming and empowering a marginal positionality—not in rehabilitating an already demarcated, if devalued, identity but in tak-

ing advantage of the purely oppositional location homosexuality has been made to occupy . . ." (61).

30. Foucault, *The History of Sexuality*, 95.

31. Mapplethorpe, cited in Carol Squiers, "With Robert Mapplethorpe," *The Hamptons Newsletter*, August 27, 1981, photocopy in archives of the Robert Mapplethorpe Foundation (Clippings Binder #2). No record of the show Mapplethorpe describes or of its announcement survives.

32. The process Mapplethorpe used to create this and several other similar works has been described as follows: "Mapplethorpe applied a synthetic emulsion to [the cover] pages from a male physique magazine in order to lift the image and its color. He then transferred the dried emulsion onto the canvas, adding color and stretching and distorting the image as he arranged it." Richard Marshall, "Mapplethorpe's Vision," in *Robert Mapplethorpe* exhibition catalog (New York: Whitney Museum of American Art, 1988), 9.

33. "Creed of the Grecian Guild," *Grecian Guild Pictorial*, no. 54 (January 1966): 2. The remainder of the creed continues in the same vein:

Our goal is the development of a sound mind in a sound body that we may best serve our God, our fellow man and our country.

34. Richard Marshall has observed, "The masked and unpainted area over the kissing mouths is the same area usually masked by a black rectangle for censorship purposes." In fact, it is not the mouths that would typically be blocked out but the genitals or, occasionally, the eyes. Such a misreading of the collage is telling, I think, insofar as it emphasizes how Mapplethorpe has used the visual coding of censorship to restage the viewer's relation to the pornographic image. "Mapplethorpe's Vision," 8.

35. According to the chronology assembled by the Robert Mapplethorpe Foundation, "An exhibition of Mapplethorpe's collages and constructions [was] mounted at the Chelsea Hotel on November 4, 1971." "Chronology," in *Mapplethorpe*, prepared in collaboration with the Robert Mapplethorpe Foundation (New York: Random House, 1992), 342.

36. Patricia Morrisroe, *Mapplethorpe: A Biography* (New York: Random House, 1995), 78.

37. White, "Altars," 128. According to White, "In 1973 the Supreme Court decided [in *Miller v. California*] that communities could censor works of art which might offend local standards of morality—which led, for instance, to a raid in New Jersey on six allegedly obscene movies, including Warhol's *Flesh* and *Lonesome Cowboys*. The continuing closetedness this persecution brought about even in the gay artistic community in New York had a direct effect on Mapplethorpe's career" (128).

38. Also noticeable is the division of labor this quote suggests—Smith going to dealers on Mapplethorpe's behalf as a kind of intermediary or agent.

39. In 1970, the same year that he created *Bull's Eye* and *Leatherman III*, Mapplethorpe starred in Sandy Daley's film *Robert Having His Nipple Pierced*. The film, which documented Mapplethorpe's own nipple-piercing as a kind of live "happening" in his studio, was shown at the Museum of Modern Art on November 24, 1971, and it provided Mapplethorpe with his first modicum of recognition by the New York art world. See Morrisroe, *Mapplethorpe*, 86–87, 106–7.

40. Mapplethorpe also made occasional forays into color photography, furniture design, and mixed-media objects.

41. Gayle Rubin, writing in 1981, noted that "gay men have developed an elaborate technology for building public institutions for sexual outlaws. . . . The first gay male leather bar opened in New York in 1955. The first one in San Francisco opened five years later. There was a population explosion of leather bars along with gay bars in general (including lesbian bars) around 1970. In San Francisco today, there are five to ten leather bars and about five baths or sex clubs that cater to the gay male leather community. There are also several social or charitable organizations, motorcycle clubs, a performance space, assorted shops, and a couple of restaurants for the South of Market crowd." "The Leather Menace: Comments on Politics and S/M," in *Coming to Power: Writings and Graphics on Lesbian S/M*, ed. members of SAMOIS (Palo Alto: Up Press, 1981), 219.

42. In 1973, Mapplethorpe's Polaroids

had been the subject of a one-person show at the Light Gallery in New York.

43. Bob Colacello, "Robert Mapplethorpe: Photographer," *Andy Warhol's Interview*, vol. 7, no. 2 (February 1977), 31.

44. The material contrivance of Mapplethorpe's photographs was something for which the artist was pointedly criticized in the late 1970s. The critic Ben Lifson, for example, would argue that "at Robert Miller Gallery [Mapplethorpe's dealer], people are buying art the way interior decorators sometimes buy books—by the foot. Mapplethorpe's presentation encourages the comparison. His frames are made of stained and polished wood, his overmattes are wrapped in silk. He puts ebony frames inside oak frames; his silken mattes sometimes open onto edges of yet another matte before giving way to the print. In some of his diptychs, amber, pink, or watery brown Plexiglas covers one of the panels: often the second panel isn't a photograph but a mirror. It's easy to imagine a customer asking if the color of Plexiglas, silk, or wood mightn't be changed for better color-coordination with his or her apartment." "The Philistine Photographer: Reassessing Mapplethorpe," *Village Voice*, April 9, 1979: 80.

45. Cited in Inge Bondi, "The Yin and Yang of Robert Mapplethorpe," *Print Letter* (Switzerland) vol. 4, no. 1 (January/February 1979):1.

46. David Bourdon, "Robert Mapplethorpe," *Arts Magazine* vol. 51, no. 8 (April 1977): 7.

47. Pat Califia, *Sensuous Magic: A Guide for Adventurous Couples* (New York: Masquerade Books, 1998), 223.

48. Jeffrey Weeks, *Sexuality and Its Discontents: Meanings, Myths, and Modern Sexualities* (London: Routledge and Kegan Paul, 1986), 236.

49. Paul H. Gebhard, *Sex Offenders: An Analysis of Types* (New York: Harper and Row, 1965). As the title of his book might suggest, Gebhard sets sadomasochism within a clinical framework of sexual pathology and psychological "offense." I cite Gebhard to reveal how, even within the terms of such a pathologizing discourse, the theatricality of s/m was recognized and described.

As the attacks on Mapplethorpe's s/m photographs in 1989–90 demonstrate, the notion of s/m as a "sex offense" has yet to be retired. On the ways in which leather and s/m cultures have been construed as symbolic "folk devils" see Rubin, "The Leather Menace," 192–225; and Gayle Rubin, "The Valley of the Kings: Leathermen in San Francisco, 1960–1990" (Ph.D. diss., University of Michigan, 1994).

50. On the theatricality of sadomasochism, see Lynda Hart, *Between the Body and the Flesh: Performing Sadomasochism* (New York: Columbia University Press, 1998). In introducing her study, Hart writes that "what unites this book above all is a persistent focus on the ways in which s/m sexual practices have been variously caught up in theatrical discourse. Throughout the book I return again and again to the vexed distinctions (and lack of them) between fantasy and reality, the 'real' and the 'performative'" (6). As I will argue, Mapplethorpe's photographs of gay s/m similarly trouble the boundary between fantasy and reality.

51. Toward the end of his career, Mapplethorpe would, in fact, photograph neoclassical busts and statues in much the same way as he here portrays Helmut.

52. Parker Hodges, "Robert Mapplethorpe: Photographer," *Manhattan Gaze*, December 10, 1979–January 6, 1980.

53. On the occasion of the publication of the X and Y portfolios in 1979, the Robert Miller Gallery mounted an exhibition of Mapplethorpe's recent black-and-white photography. The press release for the show framed the issue of subject matter as relatively insignificant while describing the visual and material form of the photographs in intricate detail:

Portraits, landscapes, floral still-lifes, and images of sexuality are the subject of Mapplethorpe's latest black and white photographs. In these works the framing is made an integral part of the composition. Several images are combined sculpturally with the color and texture of an eccentric mat and frame and sometimes mirrors to create a "piece" rather than merely a framed picture. Mapplethorpe (like photographers Baron de Meyer and F. Holland Day in their time) considers the presentation of the photograph an essential element.

Concurrently with this exhibition, two portfolios of Robert Mapplethorpe's

photographs will be published. Called "X" and "Y," the portfolios each contain 13 unbound prints. Each is an edition of 25. "X" contains prints whose subject matter is male sexuality. "Y" contains floral still-lifes. "X" will be boxed in black silk with an introductory essay by writer Paul Schmidt. "Y" comes boxed in grey silk with an introductory essay by artist/poet/singer Patti Smith. Each 8 × 10 inch photograph is archivally mounted. The dimensions of the portfolios are 13 × 13½ inches.

The press release makes no reference whatever to the most distinctive feature of the X portfolio—the sadomasochistic content of its thirteen pictures. Press release by Robert Miller Gallery, February 22, 1979, Robert Miller Gallery Archives.

54. It has become nearly a cliché of the art-critical writing on Mapplethorpe to note that his still lifes emphasize the fact and metaphor of flowers as sexual organs. See, for example, Alan Hollinghurst's 1983 catalog essay for the London retrospective of Mapplethorpe's work: "Mapplethorpe's flowers are subjected to a scrutiny which discovers their tense sensuality. Their staring eyes, their extended fingers, their drooping or thrusting penile leaves complement the concentrated postures of Mapplethorpe's men. Flowers, which are the sexual organs of plants, are brilliantly deployed as a subject both abstract and heavily metaphorical at the same time." Alan Holinghurst, "Robert Mapplethorpe," in *Robert Mapplethorpe 1970–1983* (London: Institute of Contemporary Arts, 1983), 17. Gary Indiana similarly claims that within the vocabulary of Mapplethorpe's oeuvre, "a white man's fist clutching his enormous, stiff, bent dick has the same harsh elegance as the numerous, voluptuous studies of flowers (which are, lest we forget, sexual organs)." "Mapplethorpe," *Village Voice*, May 14, 1985: 97.

55. Cited in Janis Bultman, "Bad Boy Makes Good," *Darkroom Photography*, July 1988: 26.

56. Roland Barthes, *Camera Lucida: Reflections on Photography*, trans. Richard Howard (New York: Farrar, Straus, Giroux, 1981), 59.

57. On the photograph's capacity to serve as fetish see Christian Metz, "Photography and Fetish," in *The Critical Image: Essays on Contemporary Photography*, ed. Carol Squiers (Seattle: Bay Press, 1990), 155–64.

58. Mapplethorpe cited in David Hershkovits, "The Shock of the Black and Blue," *Soho News*, May 20, 1981: 10.

59. Cited in Gary Indiana, "Robert Mapplethorpe," (interview) *Bomb* 22 (Winter 1988), 22.

60. Mark Thompson, "To the Limits and Beyond: Folsom Street, a Neighborhood Changes," *The Advocate* 346 (July 8, 1982): 28–31, 57–58. I would like to thank Mark I. Chester for granting permission to reproduce this image and for sharing with me his thoughts on Mapplethorpe's s/m project. A selection of Chester's striking portraits of San Francisco leather, fetish, and s/m enthusiasts appears in Mark Chester, *Diary of a Thought Criminal*, afterword by Pat Califia (Liberty, Tenn.: RFD Press, 1996).

61. It also recalls the centrality of interior decoration to gay male culture, especially in the decades before Stonewall. In a paper entitled "Walk-In Closet: Gay Men and Interior Decoration," I have begun to map the historical and symbolic associations between male homosexuality and interior decoration. The paper, delivered at the Parsons School of Design in 1997 and at the annual conference of the Society for Architectural Historians in 1998, will be revised for publication.

62. These contradictions also point, of course, to the intrinsic theatricality of gay sadomasochism. As Edmund White, describing urban gay culture in 1977, argued, "The adoration of machismo is intermittent, interchangeable, between parentheses. Tonight's top is tomorrow's bottom. Like characters in a Genet play, we're all more interested that the ritual be enacted than concerned about the particular role we assume. The sadist barking commands at his slave in bed is, ten minutes after climax, thoughtfully drawing him a bubble bath or giving him hints about how to keep those ankle restraints brightly polished." "Fantasia on the Seventies" (1977), reprinted in *The Burning Library: Essays by Edmund White*, ed. David Bergman (New York: Alfred A. Knopf, 1994), 41.

63. Richard Mohr observes of both *Eliot and Dominick* and *Brian Ridley and Lyle Heeter*

that "whatever is stern in these pictures . . . is exactly the stiffness and intensity that one expects from the overly posed nature of marriage portraiture: no one looks natural, no one looks relaxed, friendly, or themselves in such photos. So too here. Marriage portraits are public renewals of vows, renewals of the public sanctifications that constitute wedding ceremonies." *Gay Ideas: Outing and Other Controversies* (Boston: Beacon Press, 1992), 185, 188.

64. As Paul Morrison has dryly observed: "It is perfectly obvious, of course, who wears the chaps in Ridley's and Heeter's relationship: They both do." For Morrison's incisive account of this double portrait and of Mapplethorpe's larger s/m project, see Morrison, "Coffee Table Sex: Robert Mapplethorpe and the Sadomasochism of Everyday Life," *Genders* 11 (Fall 1991): 26.

65. Mapplethorpe interviewed in the documentary film *Robert Mapplethorpe* (London: Arena Films, 1988).

66. On Mapplethorpe's sexual pleasures and pursuits, see Morrisroe, *Mapplethorpe*, and Jack Fritscher, *Robert Mapplethorpe: Assault with a Deadly Camera* (Mamaroneck, N.Y.: Hastings House, 1994). Virtually every account of Mapplethorpe's sexual activity stresses his multiple partners, albeit with varying degrees of envy and disapproval. Combining both these attitudes is Edmund White, who writes: "For Mapplethorpe, gay life began and ended with sexual opportunity, always of the most urgent importance to him. As he explained in 1988 without a trace of irony, referring to the late 1970s: 'I had many affairs during that period, but I was never into quickie sex. I've only slept with maybe a thousand men.' Even today older gays have trouble understanding what 'gay culture' means and what 'gay identity' might represent, since for them gayness was only a matter of sexual necessity best forgotten once desire was sated.'"Altars," 128. Mapplethorpe's claim to have "slept with maybe a thousand men" hardly implies, as White would have it, that "for Mapplethorpe gay life began and ended with sexual opportunity." Gay life, as I have argued throughout this chapter, shaped Mapplethorpe's artistic output as well as the marketing and reception of his work. Indeed, Mapplethorpe insisted throughout his career on the inextricability of his professional and sexual identities.

White's combination of envy and condescension toward Mapplethorpe's sexual life is also conveyed (however unintentionally) in the public eulogy White delivered at Mapplethorpe's memorial service in 1989: "If his sexual tastes sometimes led Robert into the poorest sections of the city, his success carried him to the richest. I never knew whether I'd see him skulking off at two in the morning with his leather or catch him in black tie in Paris or Gstaad or London. His manner never changed, because it worked equally well wherever he found himself. With his rich friends his simplicity came off as a form of sophistication; with his poor friends it seemed like simplicity, which it was." "Two Eulogies," in *The Burning Library*, 343.

67. Sontag uses the term "supertourist" to criticize the work of Diane Arbus: "'Photography was a license to go wherever I wanted and to do what I wanted to do,' Arbus wrote. The camera is a kind of passport that annihilates moral boundaries and social inhibitions, freeing the photographer from any responsibility toward the people photographed. The whole point of photographing people is that you are not intervening in their lives, only visiting them. The photographer is supertourist, an extension of the anthropologist, visiting natives and bringing back news of their exotic doings and strange gear." *On Photography* (New York: Dell Publishing, 1977), 41–42.

68. See Eve Kosofsky Sedgwick, "A Poem Is Being Written," in *Tendencies* (Durham, N.C.: Duke University Press, 1993), 199. Sedgwick's comment occurs within the context of a complex rumination on anality and childhood sexuality. For Sedgwick, the anus signifies both "the place that is signally not under one's own ocular control and also the site, by 'no accident,' of the memorializing outerworks of an earliest struggle, bowel training, over private excitations, adopted controls, the uses of shame, and the rhythms of productivity" (199).

69. Hocquenghem argues that both the social order and the Freudian subject are governed by an economy of phallic power and anal sublimation: "Ours is a phallocratic society, inasmuch as social relationships as a whole are constructed according to a hierar-

chy which reveals the transcendence of the great signifier. . . . Whereas the phallus is essentially social, the anus is essentially private. . . . The analytic case history presupposes that the anal stage is transcended so that the genital stage may be reached. But the anal stage is necessary if detachment from the phallus is to take place. In fact sublimation is exercised on the anus as on no other organ, in the sense that the anus is made to progress from the lowest to the highest point: anality is the very movement of sublimation." Guy Hocquenghem, *Homosexual Desire*, trans. Daniella Dangoor (London: Allison and Busby, 1978), 83.

70. Richard Dyer, "Coming to Terms," *Jump Cut*, no. 30 (March 1985): 28.

71. Susan Sontag, "Certain Mapplethorpes," preface to *Certain People* (Pasadena, Calif.: Twelvetrees Press, 1985), unpaginated.

72. Quoted in a transcript of a public discussion of the "Censored" exhibition held at 80 Langton Street, April 1978 and subsequently cited (in part) by Robert McDonald, "Censored," *The Advocate* 244 (June 28, 1978): 21 (Second Section). The transcript is housed in the archival files of New Langton Arts (formerly 80 Langton Street) in San Francisco.

73. Cited in Mark Thompson, "Portfolio: Nikonoclast Robert Mapplethorpe," *The Advocate* 297 (July 24, 1980): 22 (second section).

74. In a 1979 interview, Mapplethorpe recalled: "I did a show in San Francisco, I went out with a bunch of pictures supposedly for Si Lowinsky. When I was out there initially I showed him some pictures, like the cock on the slab, and I said, this is the area I'm interested in working in, doing a show out here—San Francisco is very gay-oriented. I wanted to do a show out there on male sexuality and I also wanted to have an objective to doing those pictures, [an] incentive—So he said fine and I worked in that direction for the next six months—I brought the pictures out there and—well, he didn't have as many objections as his partner did. I'd never met him [the partner], anyway, they said no, you can't do it." Elsa Bulgari, "Robert Mapplethorpe" (interview), *Fire Island Newsmagazine*, July 3, 1979: 7. Mapplethorpe's reference to Lowinsky's "partner" is confusing because Lowinsky had no

professional partner at the time. According to the *San Francisco Chronicle*, it was Lowinsky's wife who repudiated Mapplethorpe's photographs and convinced her husband to do the same. If this is the case, then either Mapplethorpe knowingly misrepresented the person who most vigorously "objected" to his s/m photographs in the 1979 interview or Lowinsky conjured (and conveyed to Mapplethorpe) the story of a "male partner" who disliked the s/m work so as to shield his wife from recriminations.

75. "Edited out" was Lowinsky's term for his rejection of the s/m photographs. "Censored" was the term ascribed to Lowinsky's act by Mapplethorpe and 80 Langton Street.

76. Bulgari, "Robert Mapplethorpe," 7.

77. The single review the show received, Thomas Albright's notice in the *San Francisco Chronicle*, was not positive: "Mapplethorpe's photography is pedestrianly conventional: Rigidly posed, crisply focused, somewhat melodramatically illuminated in the cliché style one might find in the commercial photography of the slick glamour magazines. The message is the message. It is, at any rate, consistent—but then artificiality is the essence of decadence, which is really just another form of conspicuous consumption." "Realism, Romanticism, and Leather," *San Francisco Chronicle*, February 24, 1978: 64.

78. As Mapplethorpe would recall in a 1987 interview, "When I've exhibited pictures, particularly at Robert Miller Gallery [his New York dealer since 1979], I've tried to juxtapose a flower, then a picture of a cock, then a portrait, so that you could see they were the same." Janet Kardon, "Robert Mapplethorpe Interview," in *Robert Mapplethorpe: The Perfect Moment*, exhibition catalog (Philadelphia: Institute of Contemporary Art, 1988), 25. Kardon notes that the interview occurred on July 2 and August 13, 1987.

79. Bulgari, "Robert Mapplethorpe," 7. In the Bulgari interview, Mapplethorpe attributes the resuscitation of his s/m pictures to Jim Elliot and suggests that it was Elliot's idea to exhibit the photographs at 80 Langton Street. According to Mapplethorpe's biographer, however, it was Mapplethorpe who approached Elliot and "asked his help in finding an exhibition space for his 'censored' pictures." See Morrisroe, *Mapplethorpe*, 205.

80. Mapplethorpe's remark suggests the significance of the NEA's support for what he calls "free spaces" (i.e., alternative and not-for-profit galleries) at the time. Such spaces were relatively "free" from both the commercial art world's entrepreneurial concerns and its regulatory control of artistic imagery.

81. According to anthropologist Gayle Rubin, the SoMA (South of Market) District first became associated with the gay leather and s/m scenes in the early 1960s, when the Tool Box, a gay leather bar, opened at Fourth and Harrison. The Tool Box was followed by the Stud in 1966, the Ramrod in 1968, and then a wave of bars (including the Ambush, the Arena, the Black and Blue, the Boot-camp, Chaps, the Eagle, the Stables, and the Trench) in the 1970s and early 1980s. By the late 1970s, Rubin writes,

> the South of Market served gay men well as the headquarters of the leather com-munity. It was centrally located, rents were low and buildings cheap, and night-time parking was plentiful. The economy of the area was based on low-rent com-mercial and light industrial use. Since images of working class masculinity are central to leather iconography, the area's blue collar labor force was the stuff of fantasy. At night when local businesses closed the streets were fairly deserted. The empty streets gave privacy and safety to men whose sexual activities drew hos-tility and sometimes physical attacks in more populated areas.
>
> As more gay and leather businesses located along the Folsom corridor, the Miracle Mile (as it was known) became a recognizably specialized zone of gay nightlife. . . . By the late 70s, "the Valley of the Kings" [Folsom Street] was a world capital of gay male leather. It even attracted heterosexual and lesbian sado-masochists and fetishists, who began to occupy the margins of the more estab-lished gay male leather world. They felt safe there.

Gayle Rubin, "Requiem for the Valley of the Kings," *Southern Oracle* (Fall 1989): 14–15. See also Rubin, "Valley of the Kings," *Sentinel*, September 13, 1984: 10–11, and Rubin, "The Catacombs: A Temple of the Butthole," in *Leatherfolk: Radical Sex, People, Politics, and Practice*, ed. Mark Thompson (Boston: Alyson Publications, 1991), 119–41.

82. Rita Brooks, "Censored," *San Fran-cisco Art Dealer's Associated Newsletter*, May/June 1978. A copy of the newsletter is housed in the archives of the New Langton Art Gallery (formerly 80 Langton Street) in San Francisco.

83. In fairness to Mapplethorpe it should be noted that according to Rink, the photog-rapher who documented the *Censored* open-ing at 80 Langton, it was art dealer Edward de Celle who was most responsible for stag-ing the opening as an avant-garde event in which the worlds of art and leather would meet. According to Rink, "De Celle kept dragging people over to be photographed with Mapplethorpe, who was really pretty shy about the whole thing." Rink, phone interview by author, November 11, 1989.

84. The Lowinsky Gallery's exhibit of Mapplethorpe photographs opened in late February 1978. Less than four weeks later, the *Censored* show opened at 80 Langton Street. Because *Censored* was not part of 80 Langton's exhibition schedule for the year, it could remain on display for only two weeks. During this brief period, the Lowinsky show was on view across town.

85. According to Robert McDonald, "The San Francisco exhibition, entitled 'Censored' because of Mapplethorpe's ear-lier frustrations in trying to place the work, lasted less than two weeks at the end of March because of 80 Langton Street's crowded schedule and a very short lead-time. While there in S.F. it aroused some bitter controversy within the art commu-nity, strangely enough on the part of artists whose own works probably, albeit for differ-ent reasons, would outrage ordinary citi-zens. San Francisco art press either ignored it or, as rumor had it, boycotted it." "Robert Mapplethorpe," *LAICA Journal* (Los Angeles Institute for Contemporary Art), Octo-ber/November 1978: 53.

86. Lowinsky maintains that far from "censoring Mapplethorpe's work," his deci-sion to "edit out" the explicit s/m photo-graphs was part of "a series of ongoing nego-tiations" between himself and the photographer. Simon Lowinsky, phone interview by author, August 12, 1998.

87. Ibid.

88. Jack Fritscher, "The Robert Mapplethorpe Gallery," *Son of Drummer* (special issue of *Drummer* 1978). Mapplethorpe's claim that he was a participant in, rather than a voyeur of, gay sadomasochism is repeated in virtually every interview in which the subject of the s/m photographs was raised. In 1983, for example, when Mapplethorpe was asked to discuss the cool formalism of his sex pictures, he said, "I have that cool because for the most part I've experienced it . . . so I can abstract and compose it. I'm not a voyeur." "Not Just a Technical Hitch," *City Limits* (London), November 4–10, 1983: 12. In a 1980 interview, Mapplethorpe similarly observed of the s/m pictures that "I didn't feel like a voyeur. I felt I was directly *there*." Cited in Thompson, "Robert Mapplethorpe," 22.

89. Fritscher, "The Robert Mapplethorpe Gallery," 15.

90. Ibid. On the Mineshaft, see Jack Fritscher, "Men's Barscene: Mineshaft," *Drummer* 3, no. 19 (1977): 82–83. As Fritscher described it,

The 'Shaft is an amazing maze of rooms, stairways, toilets, closets, hallways, bathtubs, gloryholes, and sex equipment. Light varies [from] shadows to darkness. Men sit, stand, kneel, hang, crawl, drink, and eat. . . . The music is truly weird, but played low enough not to cover the slurps, moans, whippings, and piss scenes.

Anything you can fantasize is available somewhere in the Mine Shaft. The Mine Shaft is the pits. In the best sense. The 'Shaft is no place to take your daytime identity. The 'Shaft is the place of the night-time ID. Abandon inhibition all ye who enter here.

91. One Fifth Avenue was an exclusive downtown restaurant popular within the New York art world at the time. In 1979, a publication called *Manhattan Gaze* ran a feature on Mapplethorpe that emphasized his social and sexual world in terms strongly reminiscent of *Son of Drummer*: "He lunches casually at One/Fifth with a trustee of the Museum of Modern Art; he goes to Harlem with Lord Snowdon; he is able to help Tom

of Finland get a show in a New York gallery; at big gay events like last year's Sleaze Ball he has easy access to the VIP section." Hodges, "Robert Mapplethorpe" (see n. 52).

92. John D'Emilio, foreword to *Out of the Closets: Voices of Gay Liberation*, Twentieth Anniversary Edition (New York: New York University Press, 1992), xxvii.

93. See poster for "Rites Part II: A Two-Night Black Party," The Saint, New York City, March 20–22, 1981. A copy of the poster is housed in the archives of Leslie-Lohman Gay Art Foundation, New York City.

94. Thomas Crow, "Modernism and Mass Culture in the Visual Arts," in *Pollock and After: The Critical Debate*, ed. Francis Frascina (New York: Harper and Row, 1985), 257.

95. Cited in Hodges, "Robert Mapplethorpe." (See note 52.)

96. The energy around "faggot art" to which Mapplethorpe refers was most evident in the growth of gay male-owned and -oriented galleries in the late 1970s. "By 1980," notes George Stambolian, "there were four galleries [in New York City] specializing in the display of homoerotic art: Leslie-Lohman, Rob of Amsterdam (which showed the works of European artists), Stompers (which concentrated on high-quality pornographic drawings), and Sam Hardison's Robert Samuel Gallery (later Hardison Fine Arts), which quickly became the most active and influential of the group." George Stambolian, "Foreword," in Ellenzweig, *The Homoerotic Photograph* (New York: Columbia University Press, 1992): xv. Mapplethorpe was the subject of a one-man show at the Robert Samuel Gallery in 1979. That same year, the gallery exhibited work by Paul Cadmus, Jared French, and George Platt Lynes. See "The Art and Poltics of the Male Image: A Conversation between Sam Hardison and George Stambolian," *Christopher Street* 4:7 (March 1980): 14–22.

97. Edmund White has written of gay male culture of the 1970s as a moment "of virilization; as gay men rejected other people's definitions, they embraced a new vision of themselves as hypermasculine—the famous 'clone' look. Soldier, cop, construction worker—these were the new gay images, rather than dancer or decorator or

ribbon clerk." "Altars," 132. On the masculinism of gay culture in the 1970, see also Richard Meyer, "Warhol's Clones," *Yale Journal of Criticism* 7, no. 1 (Spring 1994): 79–110.

98. Thompson, "Robert Mapplethorpe," 22. As art critic Arthur Danto has pointed out, "The photographs [of s/m] were not accepted at first by the straight art world, for all its proclaimed liberality." "Playing with the Edge: The Photographic Achievement of Robert Mapplethorpe," in *Robert Mapplethorpe* (see n. 35), 332. By 1980, Mapplethorpe had ceased taking photographs of gay s/m and increasingly directed his attention, both sexual and photographic, to black men. Although the racial and sexual politics of these photographs (many of which were later collected in Mapplethorpe's *Black Book*) would make them quite controversial, the pictures were never as sexually explicit—or as subculturally specific—as Mapplethorpe's s/m photographs.

As Kobena Mercer and Isaac Julien have argued, Mapplethorpe's black male nudes are portraits not so much of individual black men but of Mapplethorpe's desire for an idealized black male body, a desire that he works and reworks across the surface of these pictures: "Because the aesthetic and erotic idealisation is so total in effect, the images reveal more about what the eye/I behind the lens wants to see than they do about the relatively anonymous black male bodies whose beautiful bodies we see." Mercer and Julien, "Race, Sexual Politics, and Black Masculinity: A Dossier," in *Male Order: Unwrapping Masculinity*, ed. Rowena Chapman and Jonathan Rutherford (London: Lawrence and Wishart, 1988), 143–44.

The black men in Mapplethorpe's photography, insofar as they are always muscular, youthful, and well-endowed, are cut to the very pattern of the photographer's desire. The white men in the s/m project, by contrast, are granted their own sexual costumes and paraphernalia, not to mention their own physical eccentricities and imperfections. There is one other structuring difference between the s/m project and the black male nudes that must be taken into account. Where the s/m photographs alternately portray individuals, couples, and (very occasionally) threesomes, the black

male nudes always feature a lone subject. As Mercer and Julien argue, Mapplethorpe "imposes an isolation-effect whereby it is only ever *one* black man in the field of vision at any one time. This is a crucial component of the process of objectification, not only because it preempts the depiction of a collective black male body and instead homogenises the plurality of socialised black male bodies into an ideal-type (young, healthy, dark-complexioned) but also because this is the precondition for the fetishistic work of representation in which an absence is made present. Like the function of the solo-frame in pornography, this promotes the fantasy of an unmediated, unilateral, relation between seer and seen" (145). For Mercer and Julien, Mapplethorpe's isolation of the black male body within the photographic frame enables a spectatorial fantasy of free and exclusive access to that body. Mercer and Julien elsewhere describe this "isolation effect" in terms of Mapplethorpe's "emphasis on mastery" and his "authority over his subjects" (145). Such a descriptive vocabulary foregrounds the relations of mastery and subordination, of obedience and authority, that are everywhere implicit in Mapplethorpe's photographs of the black male nude.

Mercer, a black gay critic, would later write an essay that dramatically revised his interpretation of Mapplethorpe's black male nudes by stressing the ambivalence they provoke on aesthetic, erotic, and political grounds. As Mercer makes clear, part of his intention in writing the later essay was to distance his critique of Mapplethorpe from the then current attacks on the photographer's work by Jesse Helms and the Christian Right. See Kobena Mercer, "Skin Head Sex Thing: Racial Difference and the Homoerotic Imaginary," in *How Do I Look?: Queer Film and Video*, ed. Bad Object Choices Collective (Seattle: Bay Press, 1991), 169–222.

99. Cited in Hershkovits, "Shock of the Black and Blue" (see n. 58), 10.

100. Ingrid Sischy, "A Society Artist," in *Robert Mapplethorpe* (New York: Whitney Museum of American Art, 1988), 84.

101. Cited in Elizabeth Kastor, "Corcoran Decision Provokes Outcry; Cancellation of Photo Exhibit Shocks Some in Arts Community," *Washington Post*, June 14, 1989: B1.

102. See Barbara Gamarekian, "A Call for Corcoran Resignation," *New York Times*, September 30, 1989: 15; Elizabeth Kastor, "Damage Control at the Corcoran: Trustees Panel Will Decide Director's Fate," *Washington Post*, September 26, 1989: D1.

103. See Elizabeth Kastor, "Corcoran's Orr-Cahall Resigns after Six-Month Arts Battle," *Washington Post*, December 19, 1989: A1.

104. Senator Helms, *Congressional Record*, May 18, 1989: S5595.

105. Representative Dornan, *Congressional Record*, September 21, 1989: H5819.

106. Senator Helms, *Congressional Record*, September 28, 1989: S12111.

107. Mapplethorpe's 1979 photograph of the flag was projected in reverse at the protest, though I do not know whether this was accidental or intentional.

108. On the projection protest, see Anne V. Hull, "The Art of Protest: Cancelled Photography Exhibit Brings Rally Cry," *St. Petersburg Times*, July 3, 1989: 1D. Hull provides a rather dramatic account of the event:

When the first of Mapplethorpe's 50-by-50-foot images is flashed on the wall of the gallery, it is a self-portrait, the one of the artist staring down the camera like a ruffian, dressed in a leather jacket and shirt, a cigarette dangling from the corner of his mouth. The occasional red strobe of a police car siren flashes on the artist's face. Mapplethorpe's eyes seem to be looking out over the crowd. It is an eerie moment, some say the perfect moment. The crowd falls silent.

When the final image is projected—Mapplethorpe's 1977 photo titled *American Flag*, a tattered and threadbare flag, whipping in the wind, with a brilliant, round sun shining through the frail cloth—without pause, almost before they can even think about it, the protesters burst into thunderous applause.

109. Recall, in this context, the Christian Coalition's (mis)attribution to Mapplethorpe of a "photo of naked children in bed with a naked man," discussed in chapter 1. Within the field of psychoanalysis, the term "projection" denotes a psychic operation whereby "the subject sends out into the external world an image of something that exists in him in an unconscious way. Projection is defined here as a mode of *refusal to recognise (méconnaissance)* which has as its counterpart the subject's ability to recognise in others precisely what he refuses to acknowledge in himself." Emphasis in original, Jean Laplanche and J. B. Pontalis, *The Language of Psycho-Analysis*, trans. Donald Nicholson-Smith (New York: W. W. Norton and Company, 1973), 354.

110. The phrase "like insistent ghosts" is borrowed, in slightly modified form, from Judith Butler. In an essay on Helms and Mapplethorpe, Butler writes that "certain efforts to restrict practices of representation in the hopes of reigning in the imaginary, controlling the phantasmatic, end up reproducing and proliferating the phantasmatic in inadvertent ways, indeed, in ways that contradict the intended purposes of the restriction itself. The effort to limit representations of homoeroticism within the federally funded art world—an effort to censor the phantasmatic—always and only leads to its production; and the effort to produce and regulate it [homoeroticism] in politically sanctioned forms ends up effecting certain forms of exclusion that return, like insistent ghosts, to undermine those very efforts." "The Force of Fantasy: Feminism, Mapplethorpe, and Discursive Excess," *Differences* 2, no. 2 (Summer 1990): 108.

111. Although Hollier has the work of the artist Krzysztof Wodiczko in mind here, his description of Wodiczko's public projections as a means by which "the excluded ones come back as ghosts to haunt the places that expelled them" seems especially germane to the Corcoran protest. Denis Hollier, "While the City Sleeps: Mene, Tequel, Parsin," in *Krzysztof Wodiczko: Instruments, Projections, Vehicles* (Barcelona: Fundació Antoni Tapies, 1992), 27.

112. In a 1990 analysis of the Mapplethorpe controversy, the photographer and critic Allan Sekula argued that "what terrifies conservatives . . . is a truly popular, open homosexual culture, a culture capable of forging alliances and bonds with dissident and mainstream groups in American society. They fear the sort of politicized gay and lesbian culture that emerged with the Stonewall Rebellion of 1969 and gathers force now in response to the AIDS crisis."

"Some American Notes," *Art in America* vol. 78, no. 2 (February 1990): 43.

113. Patrick Buchanan, "How Can We Clean Up Our Art Act?," *Washington Times*, June 19, 1989: D1.

114. American Family Association, "Is This How You Want Your Tax Dollars Spent?" (fundraising advertisement), *Washington Times*, February 13, 1990, reprinted in *Culture Wars: Documents from the Recent Controversies in the Arts*, ed. Richard Bolton (New York: New Press, 1992), 150.

115. On legal issues concerning photographs of naked children, including the contested definition of child pornography, see Edward De Grazia, "The Big Chill: Censorship and the Law," *Aperture* 121 (Fall 1990): 50; Carole S. Vance, "Photography, Pornography, and Sexual Politics," *Aperture* 121 (Fall 1990): 52–53, 64; and Allen Ginsberg and Joseph Richey, "The Right to Depict Children in the Nude," *Aperture* 121 (Fall 1990): 42–49.

116. Shortly after this book had gone into production, I was notified that the English office of Oxford University Press had been advised by counsel that the reproduction of Mapplethorpe's *Jesse McBride* would likely constitute a violation of the British "Protection of Children Act" of 1978 and the "Criminal Justice Act" of 1988. In response to this legal opinion and to my subsequent refusal to remove *Jesse McBride* from the manuscript, the press decided not to distribute this book in England or any other foreign market. I have further been informed that the English arm of Oxford University Press wishes, to whatever extent possible, to sever all formal and legal ties to *Outlaw Representation*.

117. Helms amendment reprinted in Philip Brookman and Debra Singer, "Chronology," in Bolton, *Culture Wars*, 347. Although approved by the Senate, the Helms amendment was rejected by the House of Representatives (264–53) on September 13, 1989. See William Honan, "House Shuns Bill on 'Obscene' Art," *New York Times*, September 14, 1989: A1, C22. Although it did not include all the restrictions that Helms had sought, the Senate-House compromise appropriations bill that eventually passed into law did stipulate that artworks in any media may be denied support if they include "depictions of sadomasochism, homoeroticism, the sexual exploitation of children or

individuals engaged in sex acts which, when taken as a whole, do not have serious literary, artistic, political or scientific value." The compromise bill, which was signed into law by President Bush, marked the first content restrictions Congress had ever imposed on the NEA, a federal arts funding agency established in 1965. On this episode, see Philip Brookman and Debra Singer, "Chronology," in Bolton, *Culture Wars*, 348.

118. Carole S. Vance, "Misunderstanding Obscenity," *Art in America* (May 1990): 49–55.

119. At 3 P.M. on April 7, 1990, "police officers ejected about 500 viewers [from the Contemporary Art Center], shut the museum for 90 minutes, videotaped Mapplethorpe's work as evidence, and indicted Barrie." Robin Cembalest, "Cincinnati: Imperfect Moment," *Art News* vol. 89, no. 6 (Summer 1990): 51.

120. Quoted in Bolton, *Culture Wars*, 333.

121. *State of Ohio v. Contemporary Arts Center and Dennis Barrie* (1990) 57 Ohio Misc. 2d 15.

122. Janet Kardon, "The Perfect Moment," in *Robert Mapplethorpe* (see n. 78), 13.

123. Ibid., 9.

124. Both Mapplethorpe's nudes (including the Z portfolio of black male nudes) and his sex photographs (including the entire X portfolio of s/m pictures) are identified by Kardon as "figure studies" in the exhibition catalog (ibid., 118). Kardon's testimony at the trial likewise described *The Perfect Moment* as an exploration of the ways in which Mapplethorpe "treated [the] three classical subjects, three traditional subjects of still life, portraiture, and of figure studies." *State of Ohio v. Contemporary Arts Center and Dennis Barrie, Excerpt of Proceedings*, 18.

125. Eric Harrison, "Banish Pornography, Mapplethorpe Jury Told," *Los Angeles Times*, September 29, 1990: A2.

126. *State of Ohio v. Contemporary Arts Center and Dennis Barrie, Transcript of Proceedings*, 2:19. I am grateful to Mark Jarzombek for providing me with the following materials, which are extremely difficult to find: *State of Ohio v. Contemporary Arts Center and Dennis Barrie, Transcript of Proceedings*, 2:1–45 (afternoon session, August 20, 1990: direct and cross-examination of Martin Fried-

man); *Transcript of Proceedings*, 3:1–44
(afternoon session, August 20, 1990: direct
and cross-examination of Evan Turner); and
Excerpt of Proceedings: 1–30 (morning session,
October 1, 1990: cross-examination of
Janet Kardon). Robert Sobieszek, an expert
witness for the defense, kindly allowed me
to transcribe an audiotape recording of his
trial testimony. When citing sections of trial
testimony to which I did not otherwise have
access, I have relied on contemporary press
coverage in the *New York Times*, the *Washing-
ton Post*, the *Los Angeles Times*, *Art in America*,
and *Artnews*.

127. Kardon as cited in Kim Masters,
"Obscenity Trial Asks: 'Is It Art?'; Jurors
Examine Mapplethorpe Works," *Washington
Post*, October 2, 1990: E1.

128. Kardon as cited in Robin Cem-
balest, "The Obscenity Trial: How They
Voted to Acquit," *Artnews* vol. 89, no. 10
(December 1990): 138.

129. Kardon as cited in Jayne Merkel,
"Art on Trial," *Art in America* 78, no. 12
(December 1990): 47. On cross-examina-
tion, the prosecuting lawyer would seek to
confront Kardon with the explicitly sexual
nature of the five s/m photographs at issue.
Kardon rebuffed his effort in the following
manner:

Q: [prosecution] . . . Some of his photo-
graphs did have sexual expressions, is
that correct?

A: [Kardon] Yes.

Q. And is it fair to say the five pictures
there are sexual expressions. Is that
correct?

A. I would call them figure studies.

Q. Figure studies. So in other words, you
call them figure studies, I might call
them sexual acts or expressions. Any-
body else could say what they are,
too?

A. Well, there is freedom of speech, so
anybody can say anything they want.

*State of Ohio v. Contemporary Arts Center and
Dennis Barrie*, *Excerpt of Proceedings*, 8–9
(morning session, October 1, 1990: cross-
examination of Janet Kardon).

130. *State of Ohio v. Contemporary Arts Cen-
ter and Dennis Barrie*, *Transcript of Proceedings*,

3:36 (testimony of Evan Hopkins
Turner).

131. *State of Ohio vs. Contemporary Arts
Center and Dennis Barrie*, author's transcrip-
tion of audiotape recording (testimony of
Robert A. Sobieszek).

132. Ibid.

133. Douglas Crimp, *On the Museum's
Ruins* (Cambridge: MIT Press, 1993), 11.

134. Cited in Eric Harrison, "Gallery
Photos Compared to Child Porn," *Los Angeles
Times*, October 5, 1990: A27.

135. Ibid.

136. Although Reisman had little to say
about the s/m pictures, she spoke at some
length about the two portraits of children at
issue during the Cincinnati trial, *Rosie* and
Jesse McBride. A *Washington Post* article
describes this part of Reisman's testimony in
detail:

Reisman, who did a controversial study
on the links between child abuse and the
portrayal of children in *Playboy*, *Penthouse*
and *Hustler* magazines, offered her analy-
ses of two children's portraits that led to
indictments for displaying depictions of
nude minors.

One depicts a little girl crouching,
her dress falling in such a manner that her
genitals are visible. "If you follow the lines
of the little girl's leg going down . . . the
foot is flat [and] the genitals are extremely
visible. The foot points to the genitalia,"
she said.

" . . . You have to look at the photo-
graph very carefully. You have to look at
the child's face, the way it's tucked into
the shirt. And when you look very care-
fully and just relax and pay attention, [you
see] the child should be centered over the
vaginal area."

Instead, she observed, the child
appears to lean slightly to one side. "It
indicates some degree of real strain
because children do not sit in that man-
ner," she said.

Turning to a picture of a naked little
boy perched on the back of a couch, Reis-
man said the photograph "is much more
clear-cut."

"Is there a contrast of light and dark
there?" Prouty [the prosecuting attorney]
asked.

"Exactly," Reisman said.

She resumed: "The lines focus on the child's genitals because the entire background is white, he is white, the lower body is on a horizontal line." She added that an "electrical cord coming in from a diagonal on the side … is a very disturbing" feature.

The defense has submitted depositions from the mothers of both children stating that they gave Mapplethorpe permission to photograph their children and display the portraits.

But Reisman said frequently, "the use of the child in pornography comes through the consent [of the parent] unless they're kidnapped."

Again, Reisman said that showing the photographs in a museum doesn't diminish the damage. "We are, I think, putting at risk additional children, because many people see themselves as photographers and many people do use the technique of telling children this is appropriate because it's in a museum or a book. That happens to be a . . . standardized, codified technique that child sex abusers use to seduce vulnerable kids. These photographs can be used to blackmail these children into other kinds of services.

Kim Masters, "Controversial Witness Says 5 Mapplethorpe Works Are Not Art," *The Washington Post*, October 5, 1990, D1.

137. Lew Moores, "Witness at Obscenity Trial Rebuts Testimony on Mapplethorpe Photos," *Louisville Courier-Journal*, October 5, 1990, 1B.

138. Kim Masters, "Art Gallery Not Guilty of Obscenity," *Washington Post*, October 6, 1990, A1.

139. This quote, from juror Anthony Eckstein, is cited in Isabel Wilkerson, "Obscenity Jurors Were Pulled Two Ways," *New York Times*, October 10, 1990: A12.

While the jurors felt confident in the credentials and expertise of the defense witnesses (four museum curators, two local art critics, and a member of the board of trustees of the CAC), they did not find Judith Reisman a similarly credible witness. On the jurors' perception of Reisman, see Cembalest, "The Obscenity Trial," 140. According to one of the jurors quoted by Cembalest, Reisman "did not make a big impression," whereas in the view of the same juror, all of the expert witnesses for the defense were "excellent. . . . They were very well prepared." Another juror added, "When the experts said this is why it's art, they were very convincing."

140. Cited in Andy Grundberg, "Critic's Notebook: Cincinnati Trial's Unanswered Question," *New York Times*, October 18, 1990: C3. See also Stuart Culver, "Whistler v. Ruskin: The Courts, The Public, and Modern Art," in *The Administration of Aesthetics: Censorship, Political Criticism, and the Public Sphere*, ed. Richard Burt (Minneapolis: University of Minnesota Press, 1994), 151.

141. Carol S. Vance, "The War on Culture," in *Art in America* vol. 77, no. 9 (September 1989), 43.

142. Cited in Harrison, "Gallery Photos Compared to Child Porn," 27.

143. This association had been drawn by Reisman herself in an editorial she published the preceding year in the *Washington Times*, a conservative newspaper. After framing Mapplethorpe's portraits of nude and semi-nude children as criminal acts of "photographic molestation," Reisman puts the following (somewhat incoherent) question about Mapplethorpe to the reader: "Would his own death from AIDS (commonly an 'anal recipient' disease) not preclude (in a national museum) 'encouraging' the sadistic acts which, on the evidence, facilitate AIDS?" Later in the same editorial, Reisman describes Mapplethorpe as a photographer who "instruct[ed] in the joy of AIDS-efficient anal-sadism" and encouraged "adult sexual access to small children."

See Reisman, "Promoting Child Abuse as Art," *Washington Times*, July 7, 1989, reprinted in Bolton, *Culture Wars*, 56–58.

144. In the larger context of the passage in which this quote appears, Helms frames the Corcoran controversy in explicitly adversarial terms, with himself as the ultimate victor:

"'Old Helms will win every time' on cutting Federal money for art projects with homosexual themes. 'This Mapplethorpe fellow,' said Mr. Helms, who pronounces the artist's name several ways, 'was an acknowledged homosexual. He's dead now, but the homosexual theme goes throughout his work.'" Maureen Dowd, "Unruffled Helms

Basks in Eye of Arts Storm," *New York Times*, July 27, 1989: 1.

145. Charles Babington, "Jesse Riles Again," *Museum and Arts: Washington*, November/December 1989: 59.

146. *Proceedings and Debates of the 101st Congress*, 1st sess., July 26, 1989: S8807.

147. See "Helms Says AIDS Quarantines a Must," *San Diego Union-Tribune*, June 15, 1987: A2. In November 1987, ACT UP (the AIDS Coalition to Unleash Power) created an installation entitled *Let the Record Show . . .* for the front window of the New Museum of Contemporary Art in New York City. The work, which will be discussed in detail in chapter 5, included a cardboard cutout of Helms's face along with an inscription citing his proposal for an AIDS quarantine.

148. On the 1987 Helms amendment, see "AIDS Booklet Stirs Senate to Halt Funds," *Los Angeles Times*, October 14, 1987: 1; "Limit Voted on AIDS Funds," *New York Times*, October 15, 1987: B12.

149. See *Congressional Record*, October 14, 1987: S14200–S14210: "Discussion of AMENDMENT NO. 956—'To prohibit the use of any funds provided under this Act to the Centers for Disease Control from being used to provide AIDS education, information, or prevention materials and activities that promote, encourage, or condone homosexual sexual activities or the intravenous use of illegal drugs.'"

Helms's logic for making the assertion that "every case of AIDS can be traced back to a homosexual act" is as follows:

A hemophiliac who contracts AIDS from a blood bank has gotten it from a homosexual with AIDS who contributed blood or a heterosexual infected by an infected bisexual. For the prostitute, she got it from an infected man who had had sexual relations with a bisexual or a homosexual. For the drug addict, somewhere along the line the needle has been used by a homosexual or a bisexual man or a heterosexual woman infected by a bisexual or homosexual. Heterosexuals are infected only from bisexuals or other heterosexuals who have had sexual relations with bisexuals.

So it seems quite elementary that until we make up our minds to start insisting on distributing educational

materials which emphasize abstinence outside of a sexually monogamous marriage—including abstinence from homosexual activity and abstinence from intravenous use of illegal drugs—and discourage the types of behavior which brought on the AIDS epidemic in the first place, we will be simply be adding fuel to a raging fire which is killing a lot of people. And, as with so many other things, Mr. President, this will take courage. It will force this country to slam the door on the wayward, warped sexual revolution which has ravaged this Nation for the past quarter of a century. (*Congressional Record* Ibid.)

150. Dominick Dunne, "Robert Mapplethorpe's Proud Finale," *Vanity Fair*, February 1989: 126.

151. Susan Weiley, "Prince of Darkness, Angel of Light," *Artnews* 87, no. 10 (December 1988): 109.

152. Carol S. Vance, "The War on Culture," 41.

153. Patrick Buchanan, "How Can We Clean Up Our Art Act?," *Washington Times*, June 19, 1989: D1. For Vance's discussion of this passage, see "The War on Culture," 41.

154. Ingrid Sischy, "White and Black," *New Yorker*, November 13, 1989: 139–40.

155. The concept of "victim photography" is discussed by Martha Rosler in her essay "in, around, and afterthoughts (on documentary photography)," in *The Contest of Meaning: Critical Histories of Photography*, ed. Richard Bolton (Cambridge: MIT Press, 1992), 303–41.

156. Douglas Crimp, "Portraits of People with AIDS," in *Cultural Studies*, ed. Lawrence Grossbert, Cary Nelson, and Paula A. Treichler (New York: Routledge, 1992), 117–33.

157. Ibid., 120.

158. Ibid., 132.

Chapter 5

1. William F. Buckley, "Crucial Steps in Combating the AIDS Epidemic: Identify All the Carriers," *New York Times*, March 18, 1986: A27.

2. The differentiation at issue is not only between the ailing and the healthy homosexual, or between the infected and the

"common needle-user," but also between the person with AIDS and the so-called general public (e.g., nonhomosexuals, non–IV drug users, non–people with AIDS).

3. On this work, *Let the Record Show ...*, see Douglas Crimp, "AIDS: Cultural Analysis/Cultural Activism," in *AIDS: Cultural Analysis/Cultural Activism*, ed. Douglas Crimp (Cambridge: MIT Press, 1988): 7–13.

4. As Simon Watney points out, "The last time people were forcibly tattooed was under Nazi rule, when millions were slaughtered because their politics or race or sexuality, or combinations of these, did not conform to the master plan of a totalitarian state. Such prescriptions remain unthinkable in relation to any other category of American citizen. But Buckley clearly regards gay men [and IV drug users] as so far 'outside' the body politic that no measure is too extreme to contemplate. What is so very remarkable about such pronouncements, however, is that they are announced *on behalf* of gay men [and IV drug users]" (Watney's emphasis). *Policing Desire: Pornography, AIDS, and the Media*, 2d ed. (Minneapolis: University of Minnesota Press, 1989), 44.

5. On the visual representation of people with AIDS in the late 1980s, see Jan Zita Grover, "Visible Lesions: Images of People with AIDS," *Afterimage* 17, no. 1 (Summer 1989): 10–15; Watney, *Policing Desire*; and Timothy Landers, "Bodies and Anti-Bodies: A Crisis in Representation," *The Independent* 11, no. 1 (January/February 1988): 18–24, reprinted in *Global Television*, ed. Cynthia Schneider and Brian Wallis (New York and Cambridge: Wedge Press and MIT Press, 1988): 281–99.

6. David Román, *Acts of Intervention: Performance, Gay Culture, and AIDS* (Bloomington and Indianapolis: Indiana University Press, 1998), xxii. Román continues, "The encapsulation of AIDS as 'homosexual,' despite the knowledge that HIV and AIDS surfaced simultaneously in other populations not contained within the category of 'homosexual'—IV drug users, 'Haitians,' and hemophiliacs, for example—locked in the linkage between homosexuals and AIDS as a foundational logic in the cultural understanding of AIDS."

7. In *Let the Record Show ...*, the fourth

figure represented is the televangelist Jerry Falwell. The quote inscribed on his slab reads "AIDS is God's judgment of a society that does not live by His rules." Falwell thus situates AIDS as divine retribution for such "rule-breaking" activities as homosexuality and IV drug use.

8. Román, *Acts of Intervention*, xxii.

9. Gran Fury fact sheet and exhibition history (unpublished). Personal archives of Loring McAlpin, New York, N.Y.

10. Douglas Crimp with Adam Rolston, *AIDS Demo/Graphics* (Seattle: Bay Press, 1990), 16.

11. *The Captive* was one of three plays raided by the New York City police on the evening of February 9, 1927; the others were *Sex* (a Mae West vehicle) and *The Virgin Man* (a comedy about a woman who attempts to seduce her young brother-in-law, a sexually inexperienced college student). Various cast members, including Mae West, and producers from *Sex* and *The Virgin Man* were also arrested that night. The police crackdown on these three "dirt plays" (as *Variety* called them) is described in detail in Kaier Curtin, *We Can Always Call Them Bulgarians: The Emergence of Lesbians and Gay Men on the American Stage* (Boston: Alyson Publications, 1987), 43–67.

12. See Abe Laufe, *The Wicked Stage: A History of Theater Censorship and Harassment in the United States* (New York: Frederick Ungar, 1978), 60. On *The Captive*, see Curtin, *We Can Always Call Them Bulgarians*, 43–67. According to the February 15, 1927, edition of the *Baltimore Daily Post*, "The company and producer [of *The Captive*] were arrested" by New York City police. The star of the production, Helen Menken, "was released on $1,000 bail by a night court pending trial Monday." *Baltimore Daily Post* clipping reprinted in Steve Hogan and Lee Hudson, *Completely Queer: The Gay and Lesbian Encyclopedia* (New York: Henry Holt and Company, 1998), 539.

13. On this law, see Jonathan Ned Katz, *Gay/Lesbian Almanac: A New Documentary* First Carol & Graf Edition (New York: Carroll & Graf, 1994), 426–28.

14. *Read My Lips* would acquire an extra layer of significance (and irony) a few months later when George Bush made his notorious vow "Read My Lips: No New Taxes" during his acceptance speech at the

Republican National Convention. On Bush's use of the phrase, see William Safire, "On Language: Read My Lips," *New York Times*, September 4, 1988: sec. 6, p. 22.

15. The "day of protest" against homophobia was one of nine such days (each devoted to a different issue related to the AIDS crisis) that ACT UP chapters throughout the United States organized in April 1988. For more on the "nine days of protest," see Crimp and Rolston, *AIDS Demo/Graphics*, 52–69.

16. ACT UP fact sheet on the New York kiss-in (April 29, 1988), cited in ibid., 55.

17. Philip Brian Harper, *Private Affairs: Critical Ventures in the Culture of Social Relations* (New York: New York University Press, 1999), 22.

18. Max Kozloff, in an article on photographic representations of the kiss, observed that "to be made witness of a kiss or embrace at close range is generally to be given a spectacle whose good cheer, tenderness, or erotic vitality intimates a positive value from which all beholders are instantly excluded. Such personal binding brings home the fact that we the watchers are not at this moment in the same kind of solidarity with anyone— are not being attended to, comforted, or fussed over in like measure." "Passion Play," *Artforum* 27, no. 4 (December 1988): 80.

19. The cropping of the source image was, among other things, a savvy design decision on the part of Gran Fury. In the original photograph, the sailors' kiss, however passionate, is somewhat trumped by the visibility of their exposed penises. By removing the most explicitly sexual part of the image, Gran Fury showcases (or "zooms in on") the sailors' kiss, a focus then redoubled by the slogan "Read My Lips."

20. Cindy Patton, *Sex and Germs: The Politics of AIDS* (Boston: South End Press, 1985), 142.

21. In a 1989 interview, Tom Kalin argued that such works as *Kissing Doesn't Kill* were both politically adversarial and sexually affirmative: "Speaking personally, I think that along with being enraged and wanting to engage in direct action . . . we should also be giving ourselves something to look forward to. The media and information that we make doesn't have to be only adversarial. It can also be affirmative at a certain level and necessarily should be that way." Avram

Finkelstein, another collective member, responded, "Of course, in the given context being affirmative about sex is being adversarial." David Deitcher, "Gran Fury" (interview), *Discourses: Conversations in Postmodern Art and Culture* ed., Russell Ferguson, William Olander, Marcia Tucker, and Karen Fiss (New York: New Museum, 1989), 201.

22. Quoted in Karrie Jacobs, "Night Discourse," in *Angry Graphics: Protest Posters of the Reagan/Bush Era*, ed. Steven Heller and Karrie Jacobs (Salt Lake City: Peregrine Smith Books, 1991), 12.

23. Quoted in Deitcher, "Gran Fury," 198.

24. According to the joint catalog for *Art against AIDS: San Francisco/Art against AIDS: On the Road*, "The primary objectives of AMFAR's Art Against AIDS campaign are to raise urgently needed money for medical research, patient services, and public education, and to open the doors to significant corporate and philanthropic giving for AIDS organizations." Introduction to *Art against AIDS: San Francisco/Art against AIDS: On the Road* (San Francisco and New York: American Foundation for AIDS Research, 1989), 4. On the relation between AMFAR, "Art against AIDS on the Road," and Gran Fury, see Kristen Engberg, "Marketing the (Ad)Just(ed) Cause," *New Art Examiner*, vol. 18, no. 9 (May 1991): 27.

25. This according to McAlpin (interview by author, April 20, 1993) and Engberg, "Marketing the (Ad)Just(ed) Cause," 27. AMFAR has steadfastly refused to comment on the episode.

26. McAlpin interview.

27. In 1990, Gran Fury raised funds, with the assistance of Creative Time, Inc., to exhibit *Kissing Doesn't Kill* in its complete format on New York City mass transit. That episode was also marked by forms of institutional resistance in this case from AMNI America Inc., which sells ad space on New York City buses. According to *New York Newsday*, AMNI initially claimed that *Kissing Doesn't Kill* was "unacceptable" for public display on city buses and asked Creative Time to make the work "more palatable." Both Creative Time and Gran Fury refused to change the work, and AMNI eventually relented and agreed to install *Kissing Doesn't Kill* as submitted. See Michael Fleming and Karen Freifeld, "Inside New York: Telling

'Kiss' Ads Debatable for Buses," *New York Newsday*, June 22, 1990. *Kissing Doesn't Kill* was also exhibited, from November 1989 to February 1990, in the front window of the Whitney Museum of American Art as part of the *Image World* exhibition. This dual exposure (on New York buses, in the Whitney) underscores Gran Fury's status as both an activist collective committed to the public sphere and a high-profile presence within the New York art world of the late 1980s and early 1990s. See Marvin Heiferman and Lisa Phillips, *Image World: Art and Media Culture* (New York: Whitney Museum of American Art, 1990).

28. Like every other graphic in the campaign, *Kissing Doesn't Kill* was accompanied by an *Art against AIDS on the Road* logo.

29. See, for example, the Chicago residents and aldermen quoted in Gary Washburn, "AIDS 'Kiss' Posters Going Up on CTA," *Chicago Tribune*, August 15, 1990: C1, C8.

30. Cited in Robert Davis, "Council to Join Fray over Bus AIDS Ad," *Chicago Tribune*, June 6, 1990: C2.

31. Quoted in Washburn, "AIDS 'Kiss' Posters," 8.

32. Quoted in Rick Pearson and Paul Wagner, "Senate Votes to Ban AIDS Posters from CTA," *Chicago Tribune*, June 23, 1990: C1.

33. The rhetoric of "homosexual recruitment" was deployed with particular ferocity by Anita Bryant during her 1977 "Save Our Children" campaign in Dade County, Florida. Bryant was especially effective at exploiting the image of the homosexual as someone who cannot (or wishes not to) reproduce. "As a mother," Bryant told Florida voters in 1977, "I know that homosexuals, biologically, cannot reproduce children; therefore they must recruit our children." See Frank Rose, "Trouble in Paradise," *New Times*, vol. 8, no. 8 (April 15, 1977): 48.

34. Cited in Pearson and Wagner, "Senate Votes to Ban AIDS Posters," 1.

35. David Olson, "State Senate Denounces Art against AIDS," *Windy City Times*, June 28, 1990: 8.

36. On the exchange between Mayor Daley and Gran Fury, see Engberg, "Marketing the (Ad)Just(ed) Cause," 27.

37. Cited in Fran Spielman and Ray Hannai, "AIDS Posters Need New Look, Daley Tells CTA," *Chicago Sun-Times*, August 16, 1990: 12. The *Chicago Tribune* likewise reported that "Ald. Robert Shaw . . . said he has been contacted by several black clergyman [sic] who plan either to paint out the ads or tear them down. 'I don't encourage this, but I have been told that a campaign of civil disobedience will begin soon,' Shaw said at a City Hall press conference. 'There are people in this town who are furious.'" Notice the way in which Shaw simultaneously announces the threat of vandalism and attributes that threat to others, to unnamed "black clergy." Gary Washburn and Robert Davis, "AIDS Poster Debuts, Fans Controversy," *Chicago Tribune*, August 16, 1990.

38. An Associated Press photograph of a defaced *Kissing Doesn't Kill* billboard on a Chicago train platform was reproduced in "AIDS Poster's Same-Sex Couples Raise an Outcry in Chicago," *Philadelphia Inquirer*, August 17, 1990: 20, as well as "AIDS Awareness Poster Stirs Free Speech Debate," *San Juan Star*, August 17, 1990: 14. The same picture was also published as a stand-alone photograph (with caption) in the August 17, 1990, edition of the *Louisville Courier-Journal*. A similar photograph was published (again as a stand-alone picture with caption) in the August 17, 1990, edition of *USA Today* (News section).

39. Jean Latz Griffin and Gary Washburn, "Experts Cast Doubts on AIDS Poster," *Chicago Tribune*, August 17, 1990: sec. 2, p. 2.

40. Engberg, "Marketing the (Ad)Just(ed) Cause," 28.

41. Paul O'Malley, phone interview by author, May 20, 1999.

42. David Wojnarowicz, "With Our Eyes and Hands and Mouths," *Outweek*, August 8, 1990: 61–62.

43. John Frohnmayer, "Letter to Susan Wyatt," November 3, 1989, reprinted in *Culture Wars: Documents from the Recent Controversies in the Arts*, ed. Richard Bolton (New York: New Press, 1992), 126.

44. Cited in Allan Parachini, "Arts Groups Say NEA Future at Risk," *Los Angeles Times*, November 10, 1989: F1.

45. "Mr. Frohnmayer said that while he considered some of the images in the [*Witnesses*] show in 'questionable taste,' his principal objection to the grant was to the

catalogue." William H. Honan, "The Endowment vs. the Arts: Anger and Concern," *New York Times*, November 10, 1989: C33.

Speaking in reference to Wojnarowicz's essay in the *Witnesses* catalog, Frohnmayer would assert that "I strongly believe in the ability of people to speak their minds under the First Amendment, but the endowment should not be funding that discourse." Cited in "Front Page: NEA Chairman Does Turnabout on AIDS Exhibition," *Art in America* vol. 78, no. 1 (January 1990): 31.

46. See Larry McMurtry, "When Art Is 'Too Political,'" *Washington Post*, November 10, 1989: A27. On Bernstein's rejection of the National Medal of Arts, see Elizabeth Kastor, "Bernstein Rejects Medal in Arts Controversy; Composer Acts as Clash over Canceled NEA Grant Escalates," *Washington Post*, November 16, 1989: A1.

47. David Wojnarowicz, "Post Cards from America: X-Rays from Hell," in *Witnesses: Against Our Vanishing* exhibition catalog (New York: Artists Space, 1989), 10.

48. Ibid.

49. Ibid., 8–9.

50. Ibid., 7.

51. Ibid.

52. Patrick Buchanan, "Where a Wall Is Needed," *Washington Times*, November 22, 1989, reprinted in Bolton, *Culture Wars*, 137–38.

53. The method by which Wojnarowicz created the *Sex Series* is rather more complex than a simple printing of negative imagery. According to critic John Carlin, Wojnarowicz produced the series by "putting color slides in an enlarger and exposing them directly onto black and white photographic paper, which gives them an eerie negative quality like an X-ray. The basic image is then combined with various elements made by exposing areas of the paper which were masked in the earlier development process. Some of these images were then given an overlay of text made of white letters which drop out of the black background." John Carlin, "David Wojnarowicz: As the World Turns," in *David Wojnarowicz: Tongues of Flame*, exhibition catalog (Normal, IL: University Galleries of Illinois State University, 1990).

54. These two source images were among Wojnarowicz's personal effects at the time of his death, along with several hundred other pornographic prints (both amateur and professional) from the 1950s and 1960s. According to Wojnarowicz, the pornographic images on which he based the *Sex Series* insets came from "a box of photographs that Peter [Hujar] was throwing out, and I took the original photographs, which had no reference to authorship, or anything else and I . . . photographed with color film a section of the work, a section of the photo source, I photographed it on to color slide film and then had that developed; and in the darkroom I put the color slide film in a black and white enlarger and put light through the color slide, so that when it appeared on the photographic paper, it greatly changed the image that was the source image, and it created what was like a weird negative which you can see here [in the *Sex Series*]. Trial transcript, *David Wojnarowicz, Plaintiff v. American Family Association and Donald E. Wildmon, Defendants*, United States District Court, Southern District of New York, June 25, 1990, 71.

55. According to Wojnarowicz, "The images of sexuality in my works are not meant to titillate the viewer—whether heterosexual or homosexual—but are part of a broad comment on many aspects of human experience." Affidavit of David Wojnarowicz, United States District Court, Southern District of New York, *David Wojnarowicz, Plaintiff, v. American Family Association and Donald E. Wildmon, Defendants*, Civil Action No. 90 Civ. 2457 (WCC), notarized, May 18, 1990, 7.

56. The significance of "queer" lies in the way the term (like Wojnarowicz's montage) muddies structural binarisms of sex (male/female) and sexual practice (homo/hetero) and thereby throws into relief what cannot be assimilated about them. This is not to claim that a mere linguistic term can override the sexual definition of subjects along hetero/homo and male/female binaries. It is, however, to point out the descriptive usefulness of "queer" (as opposed to "gay") in this context. On the significance of the term "queer," see Michael Warner, "From Queer to Eternity: An Army of Theorists Cannot Fail," *Village Voice Literary Supplement*, June 1992: 18; Judith Butler, "Critically Queer," in *Bodies That Matter* (New York: Routledge, 1993), 223–42, 281–84.

57. David Wojnarowicz, *In the Shadow of*

Forward Motion (New York: privately printed, 1990), unpaginated. A photocopy of this booklet is housed in the files of PPOW Gallery, New York. Quoted with permission of PPOW.

58. Ibid.

59. Quoted in Adam Kuby, "The Art of David Wojnarowicz," *Outlook* vol. 4, no. 3 (Winter 1992): 59–60.

60. The AFA, formerly known as the National Federation for Decency, is a multi-million-dollar agency that organizes public boycotts and national censorship campaigns against films, television shows, magazines, and works of art it deems indecent. On Reverend Wildmon and the AFA, see Bruce Selcraig, "Reverend Wildmon's War on the Arts," *New York Times Magazine*, September 2, 1990: 22–25, 43, 52–53.

On the AFA's campaign against Wojnarowicz, see Brian Wallis, "Wojnarowicz Show Riles Right-Wingers," *Art in America* 78, no. 6 (June 1990): 45. According to Wallis, Wildmon "sent a mid-April mailing to every member of Congress denouncing the work of N.Y. artist David Wojnarowicz and criticizing the NEA for funding a museum exhibition of it. In the letter (also sent to 3,200 Christian leaders, 1,000 Christian radio stations, 100 Christian television stations, and 178,000 pastors), Wildmon implied that the NEA grant violates the so-called Helms amendment, which bans NEA funding for obscene art."

61. In April 1989, the AFA sent out over 1 million letters of protest against Serrano's *Piss Christ* and the NEA. On this and other censorship campaigns organized by Reverend Wildmon, see Selcraig, "Reverend Wildmon's War on the Arts."

62. Affidavit of David Wojnarowicz, *David Wojnarowicz, Plaintiff, v. American Family Association and Donald E. Wildmon, Defendants* (see n. 55).

63. Kim Masters, "NEA-Funded Art Exhibit Protested; Wildmon Mails Sexual Images to Congress," *Washington Post*, April 21, 1990: C1.

64. William H. Honan, "Multi-Media Artist Sues Political Action Group," *New York Times*, May 22, 1990: C14.

65. In a slightly different reading of Wildmon's brochure, Caroline Jones writes that Wildmon's "composition evokes paired filmstrips or a bank of video monitors,

returning Wojnarowicz's images to an imagined (and titillating) source in the pornography industry. The bodies in Wildmon's image no longer read as negatives or counterweights to a dominant and suppressive reality, but as reality itself: a dark reality in which sex *is* a kind of aggression, not its radical alternative." "Greenberg's Politics and Postmodernism's Account" (unpublished ms., 1993), 25. Jones has published a French translation of this essay as "La Politique de Greenberg et le Discours Posmoderniste." *Cahiers du Musée National d'Art Moderne*, no. 45–46 (Autumn-Winter 1993), 105–137. My thanks to Caroline Jones for graciously sharing this work with me.

66. See Joe Jarrell, "God Is in the Details: Wojnarowicz Is in the Courts," *High Performance* 51, vol. 13, no. 3 (Fall 1990): 20. As Jarrell points out, "In trying to make Wojnarowicz's art look as offensive as possible, Wildmon ironically ended up creating what some might consider a pornographic pamphlet, fueled entirely by his own aggressive imagination. If the government deems Wildmon's flyer porno (and Wildmon himself calls the images he is sending obscene), Wildmon makes himself eligible for federal prosecution for sending such a flyer over state lines."

An article in the *Washington Post* cited Wildmon to the effect that the flyer in question, although mailed to nearly 200,000 people, was not intended for the mainstream public: "'It's not the kind of mailing you can send to the general public,' Wildmon said. 'I could be prosecuted by the U.S. Postal Service for that mailing. What I'm trying to do is put it into the hands of key leaders.'" Cited in Kim Masters, "NEA-Funded Art Exhibit Protested; Wildmon Mails Sexual Images to Congress," *Washington Post*, April 21, 1990: C1.

Underscoring a similar paradox concerning the Christian Coalition's attack on Mapplethorpe's photography, the November 5, 1990, edition of the *Columbus (Ga.) Ledger-Enquirer* carried an article entitled "Pat Robertson: Porn Distributor?" The article opened with the question "Is evangelist Pat Robertson a pornography distributor?" and then reported:

Robertson's group, [The] Christian Coalition, mailed photographs that

Robertson calls pornographic to more than 10,000 homes in Atlanta's 4th Congressional District. He hopes to help Republican challenger John Linder unseat Democratic U.S. Rep. Ben Jones.

The photos by Robert Mapplethorpe depict a young boy and girl with their genitals exposed, a man urinating in another man's mouth, and a painting [sic] of Christ injecting heroin into his arm. . . .

If Robertson deems Mapplethorpe's work pornographic, how can he justify an unsolicited mailing of it to thousands of unsuspecting families. He is distributing pornography, by his definition.

Frankie Abourjalie, a spokeswoman for Robertson, said the evangelist does not consider this to be pornography distribution. He considers it voter education, she said.

"Pat Robertson: Porn Distributor?," *Columbus (Ga.) Ledger-Enquirer*, November 5, 1990, unpaginated clipping in the archives of People for the American Way, Washington, D.C. (clippings file on the Christian Coalition). Even as the *Columbus (Ga.) Ledger-Enquirer* reveals the contradiction through which Pat Robertson distributes the very images he also denounces, the article makes its own set of factual errors and symbolic slippages, first by conflating the work of Mapplethorpe with that of Wojnarowicz (the artist responsible for the photocollage from which the image of the injecting Christ has been appropriated) and then by characterizing that image as a painting.

67. Envelope for "Your Tax Dollars. . ." flyer, accompanied direct mail letter signed by the Reverend Donald Wildmon, dated April 12, 1990, printed on American Family Association letterhead. Copies of the letter, flyer, and envelope are on file in the archives of People for the American Way. My thanks to them for providing access to their extensive files on the censorship campaigns of the AFA and the Christian Coalition.

68. See "Judge Orders a Correction," *New York Times*, August 9, 1990: C14.

69. "The court allowed that the artist's reputation had probably suffered as a result of the AFA mailing, but it found no evidence that any museum or gallery exhibitions had been canceled as a result. Wojnarowicz was awarded only a symbolic $1 in damages." Christopher Phillips, "Wojnarowicz Bags Buck," *Art in America* 78, no. 10 (October 1990): 240.

70. David Cole quoted in *David Wojnarowicz: Brush Fires in the Social Landscape*, *Aperture* 137 (special issue, Fall 1994): 37. When asked by the press what he would do with the dollar, Wojnarowicz responded, "I'll use it to buy either an ice-cream cone or a condom, depending [on] how hot I feel." Cited in Phillips, "Wojnarowicz Bags Buck," 240. The comment wryly underscores the negligible amount of the check. But it also suggests Wojnarowicz's continued insistence on sexuality, including and especially his own, in response to the Christian Right.

71. The photograph of Wojnarowicz on the cover of *High Performance* was, in fact, drawn from an AIDS activist film entitled "Silence = Death" in which the artist appeared. In a 1990 photomontage entitled *Silence Thu Economics*, Wojnarowicz included a similar, though more tightly cropped, picture of a mouth sutured closed. On the motif of forcible silencing in Wojnarwoicz' work, see Mysoon Rizk, "Nature, Death, and Spirituality in the Work of David Wojnarowicz," Ph.D. diss., University of Illinois at Urbana-Champaign, 1997, 175–176.

In this context, we might note that the slogan "Silence = Death" calls for action by linking the absence of speech to the eradication of the self. As Lee Edelman has argued, "What is striking about 'Silence = Death' as the most widely publicized, gay-articulated language of response to the 'AIDS' epidemic is its insistence upon the therapeutic property of discourse without specifying in any way what should or must be said. Indeed, as a text produced in response to a medical and political emergency, 'Silence = Death' is a stunningly self-reflexive slogan. It takes the form of a rallying cry, but its call for resistance is no call to arms; rather, it calls for the production of discourse, the production, that is, of more text, as a mode of defense against the opportunism of mainstream medical and legislative responses to the continuing epidemic." *Homographesis: Essays in Gay Literary and Cultural Theory* (New York: Routledge, 1994), 87.

72. Scott Catto, gallery director of PPOW, interview by author, October 2, 1995.

73. These projects were produced not only by AIDS activist groups such as Gran Fury but also by AIDS service organizations (the Gay Men's Health Crisis in New York, the San Francisco AIDS Foundation) as well as local and state health departments.

74. Douglas Crimp, "Right on Girlfriend," in *Fear of a Queer Planet*, ed. Michael Warner (Minneapolis: University of Minnesota Press, 1993), 304.

75. In its entirety, Gonzalez-Torres's billboard reads:

HEALTH CARE IS A RIGHT, a government by the people, for the people must provide adequate healthcare to the people. NO EXCUSES.

LOS SERVICIOS DE SALUD SON UN DERECHO. Un gobierno para el pueblo, por el pueblo, debe de provear servicios de salud adecuados para todo el pueblo. NO MAS EXCUSAS.

This billboard is a "registered nonwork" of Felix Gonzalez-Torres. Registered nonworks are those that the artist "removed" from his official oeuvre prior to his death in 1995. A complete list of the artist's registered nonworks appears in Dietmar Elgar, *Felix Gonzalez-Torres, Catalogue Raisonné* (Ostfildern-Ruit: Cantz Verlag, 1997), 146–48.

76. See Anne Umland, "Museum of Modern Art," *Projects* 34 (May 16–June 30, 1992): unpaginated; Amei Wallach, "Two Artists in Conflict," *New York Newsday*, March 10, 1985.

77. Gonzalez-Torres was quite explicit about the problem of visibility posed by the AIDS crisis: "When people think about AIDS, they think of images of hospital beds, medicine, needles, and all such garish things. That's not AIDS. That part of it, but AIDS also, unfortunately, includes discrimination, fear, shame, desperation, and political repression. The fact that gays still cannot serve openly in the military, because people still want to believe it's just a gay disease— that's AIDS too. I don't need to see an image of someone dying in a hospital bed to understand AIDS. No one needs to see that; we've seen it before, and we'll see more." Cited in Nancy Spector, *Felix Gonzalez-Torres* (New York: Guggenheim Museum, 1995), 166.

78. Cited in Ibid., 73.

79. Wojnarowicz, quoted in David

Hirsh, "Courage and Censorship: A Conversation with David Wojnarowicz," *New York Native*, May 7, 1990: 19.

80. Wojnarowicz, "Post Cards from America," 122.

Afterword

1. David Wojnarowicz, "Do Not Doubt the Dangerousness of the 12-Inch Politician" (1990), in *Close to the Knives: A Memoir of Disintegration* (New York: Vintage Books, 1991), 150.

2. On the reclamation of the term "queer" in the 1990s and the conflicts aroused by it, see David J. Thomas, "The 'Q' Word," *Socialist Review* 25, no. 1 (Special 25th Anniversary Issue 1995): 69–94.

3. Judith Butler, *Bodies That Matter: On the Discursive Limits of "Sex"* (New York: Routledge, 1993), 226.

4. While a public reclamation of the term "queer" may be a product of the early 1990s, the antinormative strategy behind that reclamation most certainly is not. Attempts to trouble the conventional codes of gender and sexuality, to highlight the performative aspects of identity, and to oppose the tyranny of "the normal" are woven into the historical fabric of homosexuality and its representation.

5. Cited in *National Endowment for the Arts, et al., v. Karen Finley, et al.*, Supreme Court of the United States (October Term, 1997), Brief for Claes Oldenburg, Arthur Miller, Jasper Johns, Hans Haacke, et al. (Amici Curae), 4.

6. *Congressional Record*, "Helms Amendment No. 420," July 26, 1989: S8862. In October 1989, the Helms amendment was rejected by the Senate in favor of "compromise legislation" that included much of Helms's original wording as well as language drawn from the Supreme Court's 1973 ruling (in *Miller v. California*) on obscenity. The compromise legislation prohibited the use of federal funds "to promote, disseminate or produce materials which in the judgment of the National Endowment for the Arts or the National Endowment for the Humanities may be considered obscene, including but not limited to depictions of sadomasochism, homoeroticism, the sexual exploitation of children or individuals engaged in sex acts and which, when taken as a whole, do not

have serious literary, artistic, political or scientific value." See Elizabeth Kastor, "Congress Bars Funding for 'Obscene' Art: Senate Vote Sends Measure to Bush," *Washington Post*, October 8, 1989: A21.

7. Kara Swisher, "Helms's 'Indecent' Sampler: Senator Sends Photos to Sway Conferees," *Washington Post*, August 8, 1989: B1. See also "Helms Mails Photos He Calls Obscene," *St. Louis Post-Dispatch*, August 9, 1989: 11A.

8. I am referring here to the wide range of artists and not-for-profit art institutions that were defunded by the NEA after the decency clause was adopted. A partial list of these artists and agencies, some of whose grants were later restored, includes Mel Chin (defunded in 1990); Mike Kelley (1990); the Franklin Furnace, New York, N.Y. (1992); Highways Performance Space, Santa Monica, Calif. (1992); the List Visual Arts Center, Cambridge, Mass. (1992); the Gay and Lesbian Media Coalition, Los Angeles (1992); the New Festival (a gay and lesbian film festival), New York, N.Y. (1992); the Pittsburgh International Lesbian and Gay Film Festival (1992); the photographers Merry Alpern, Barbara DeGenevieve, and Andres Serrano (1994); and the African American dance troupe Urban Bush Women (1995). On the Kelley episode, see Paul Gardner, "The NEA's Slippery Slope," *Artnews* 89, no. 10 (December 1990): 57. On the List Center, see Stephen Burd, "Rejection of Two Proposals by Acting Head of Arts Endowment Spawns Protests, Questions about Accepting Agency Support," *Chronicle of Higher Education*, May 27, 1992: A21–A23. On the defunding of the three gay and lesbian film festivals, see Eric Brace, "More NEA Grant Woes," *Washington Post*, November 23, 1992: B7, and Stephan Salisbury, "NEA Rejects Three Grants for Gay Film Festivals," *Philadelphia Enquirer*, November 21, 1992: A1. On the history of recent NEA defunding controversies, see *"Finley v. NEA: The Supreme Court Decides,"* special supplement to the *NCFE (National Campaign for Freedom of Expression) Quarterly* and the *NAAO (National Association of Artists' Organizations) Bulletin*, July 1998: S1–S4.

9. Just after the passage of the decency clause, Chin's already awarded grant to make a "sculpture of plants that cleanse heavy metal deposits at toxic waste sites" was rejected by John Frohnmayer. In announcing his decision, Frohnmayer cited the views of one member of the NEA council who felt that Chin's work "had a 'political tone' and should not be federally funded." Cited in Kim Masters, "Art Chief Ignores Advice, Vetoes Grant. Environmental Project Criticized as Political," *Washington Post*, November 20, 1990: C1. On this episode, see also Patti Hartigan, "Another Controversial NEA Grant Rejection," *Boston Globe*, November 28, 1990: 72.

10. John Frohnmayer, *Leaving Town Alive: Confessions of an Arts Warrior* (Boston: Houghton Mifflin, 1993), 161.

11. Elizabeth Kastor, "Four Artists Sue Endowment; Grant Denial Triggers Lawsuit," *Washington Post*, September 28, 1990: C1.

12. As a result of the decency clause, the plaintiffs argued, "artists will be inhibited in creating or proposing work for NEA funding because they will be unable to determine what artistic ideas violate NEA perceptions of general decency standards." Cited in Allan Parachini, "Repeal of NEA Decency Law Sought," *Los Angeles Times*, March 19, 1991: F4.

13. Jacqueline Trescott, "NEA to Pay Four Denied Arts Grants but Decency Rule Challenge Unresolved," *Washington Post*, June 5, 1993: D1.

14. The most egregious examples of these misrepresentations occurred in the *Washington Times* and *U.S. News and World Report*. The *Washington Times* erroneously reported on June 12, 1990, that Hughes's performance piece *World without End* featured the artist "displaying her body and placing her hand up her vagina." In a July 30 editorial in *U.S. News and World Report*, David Gergen, drawing on the *Washington Times* as source material, described Hughes as "a playwright who wants to advance lesbianism and whose performance on stage includes a scene in which she places her hand up her vagina." In its August 13 issue, *U.S. News and World Report* printed a retraction of Gergen's description: "Correction. David Gergen's July 30 editorial described one segment of Holly Hughes's performance as including 'a scene in which she places her hand up her vagina.' That was incorrect. David Gergen regrets the error." Cited in Edward de

Grazia, *Girls Lean Back Everywhere: The Law of Obscenity and the Assault on Genius* (Random House: New York, 1992), 663.

15. Among those launching this accusation was David Gergen who, in the pages of *U.S. News and World Report*, argued that the NEA 4 "believe they can have it both ways: They want to engage in wanton destruction of a nation's values and they expect that same nation to pay their bills. Grow up friends. No society, even one as tolerant as this one, is willingly going to pay for its own demise. . . . To argue that in the name of freedom they [the American people] must send in money for smut perverts the idea of freedom itself." "Who Should Pay for Porn?," *U.S. News and World Report*, July 30, 1990, reprinted in *Culture Wars: Documents from the Recent Controversies in the Arts*, ed. Richard Bolton (New York: New Press, 1992), 256.

16. Holly Hughes, *Preaching to the Perverted*, performance typescript, p. 4. My thanks to Holly Hughes for kindly providing me with a copy of her script.

17. Ibid., 17.

18. Ibid., 4.

19. Ibid., 23.

Selected Bibliography

Published Sources

Abelove, Henry, "The Queering of Lesbian / Gay History," *Radical History Review* 62 (Spring 1995): 44–57.

Adam, Barry. *The Rise of a Gay and Lesbian Movement*. Boston: Twayne Publishers, 1987.

Adams, Henry. *Thomas Hart Benton: An American Original*. New York: Alfred A. Knopf, 1989.

Albright, Thomas. "Realism, Romanticism, and Leather." *San Francisco Chronicle*, February 24, 1978: 64.

Alloway, Lawrence. *American Pop Art*. New York: Collier Books, 1974.

Altman, Dennis. *The Homosexualization of America, the Americanization of the Homosexual*. New York: St. Martin's Press, 1982.

Andy Warhol: His Early Works 1947–1959 exhibition catalog, compiled by Andreas Brown. New York: Gotham Book Mart Gallery, 1971.

Aperture 137, Special Issue: *David Wojnarowicz: Brush Fires in the Social Landscape*. Fall 1994.

Apter, Emily, and William Pietz, eds. *Fetishism as Cultural Discourse*. Ithaca, N.Y.: Cornell University Press, 1993.

Armstrong, Elizabeth. "Paul Cadmus: American Scene as Satire." Master's thesis, University of California, Berkeley, 1982.

"The Art and Politics of the Male Image: A Conversation between Sam Hardison and George Stambolian." *Christopher Street*, 4:7 March 1980: 14–22.

Bad Object-Choices, eds. *How Do I Look?: Queer Film and Video*, Seattle: Bay Press, 1991.

Baigell, Mathew. *The American Scene: American Painting of the 1930s*. New York: Praeger Publishers, 1974.

Barthes, Roland. *Camera Lucida: Reflections on Photography*, trans. Richard Howard. New York: Farrar, Straus, and Giroux, 1981.

———. "That Old Thing Art. . . ." In *The Responsibility of Forms*, translated by Richard Howard. New York: Hill and Wang, 1985, 198–206.

Baume, Nicholas. ed. *About Face: Andy Warhol Portraits*, exhibition catalogue. Hartford, CT: Wadsworth Atheneum, 1999.

Bergman, David, ed. *Camp Grounds: Style and Homosexuality*. Amherst: University of Massachusetts Press, 1993.

Bernstein, Mathew, ed. *Controlling Hollywood: Censorship and Regulation in the Studio Era*. New Brunswick, New Jersey: Rutgers University Press, 1999.

Bersani, Leo. *Homos*. Cambridge: Harvard University Press, 1995.

———. "Is the Rectum a Grave?" *October* 43 (Winter 1987): 197–222.

Bérubé, Allan. *Coming Out under Fire: The History of Gay Men and Women in World War II*. New York: Plume Books, 1990.

Bhabha, Homi. *The Location of Culture*. (London and New York: Routledge, 1994).

Bigham, Elizabeth, and Andrew Perchuk. "American Identity / American Art." In *Constructing American Identity*, exhibition catalog. New York: Whitney Museum of American Art, 1991.

Bletter, Rosemarie Haag. "The 'Laissez-Fair,' Good Taste, and Money Trees: Architecture at the Fair." In *Remembering the Future: The New York World's Fair from 1939 to 1964*, 105–35. New York: Rizzoli, 1989.

Blinderman, Barry. *David Wojnarowicz: Tongues of Flame*. Exhibition catalog. Normal, IL: University Galleries of Illinois State University, 1990.

Blitzstein, Madelin. "It May Be Hard to Take but It's Art." *Minneapolis Journal*, February 24, 1935.

Bockris, Victor. *The Life and Death of Andy Warhol*. New York: Bantam, 1989.

———. *Warhol*. London: Frederick Muller, 1989.

Boffin, Tessa, and Sunil Gupta, eds. *Ecstatic Antibodies: Resisting the AIDS Mythology*. London: Rivers Oram Press, 1990.

Boffin, Tessa and Jean Fraser, eds. *Stolen Glances: Lesbians Take Photographs*. London: Pandora Press, 1991.

Bolton, Richard. "The Cultural Contradictions of Conservatism." *New Art Examiner* vol. 17, no. 10 (June 1990): 24–29, 72 .

———, ed. *The Contest of Meaning: Critical Histories of Photography*. Cambridge, MA: MIT Press, 1992, first paperback edition (hardcover edition first published in 1989).

———, ed. *Culture Wars: Documents from the Recent Controversies in the Arts*. New York: New Press, 1992.

Boone, Joseph A., Martin Dupuis, Martin Meeker, Karin Quimby, Cindy Sarver, Debra Silverman, and Rosemary Weatherston, eds. *Queer Frontiers: Millennial Geographies, Genders, and Generations*. Madison: The University of Wisconsin Press, 2000.

Booth, Mark. *Camp*. London: Quartet Books, 1983.

Bourdon, David. "Andy Warhol 1928–87." *Art in America* 75, no. 5 (May 1987): 137–143.

———. "Eroticism Comes in Many Colors." *Village Voice*, May 10, 1976.

Boylan, Robert G. "This Is America's Greatest Gay Artist." *Vector*, January/February 1976: 19–23.

Bravmann, Scott. *Queer Fictions of the Past: History, Culture, and Difference* (Cambridge: Cambidge University Press, 1997).

Bray, Alan. *Homosexuality in Renaissance England*. London: Gay Men's Press, 1982.

Bronski, Michael. *Culture Clash: The Making of a Gay Sensibility*. Boston: South End Press, 1984.

Brooks, Rita. "Censored." *San Francisco Art Dealer's Associated Newsletter*, May/June 1978.

Buchanan, Patrick. "How Can We Clean Up Our Art Act?" *Washington Times*, June 19, 1989: D1.

Buchloh, Benjamin H. D. "Andy Warhol's One-Dimensional Art: 1955–1966." In *Andy Warhol: A Retrospective*. New York: Museum of Modern Art, 1989, 39–61.

Bulgari, Elsa. "Robert Mapplethorpe" (interview). *Fire Island Newsmagazine*, July 3, 1979.

Butler, Judith. *Bodies That Matter*. New York: Routledge, 1993.

———. *Excitable Speech: A Politics of the Performative*. New York: Routledge, 1997.

———. "The Force of Fantasy: Feminism, Mapplethorpe, and Discursive Excess." *Differences* 2, no. 2 (Summer 1990): 105–25.

———. *Gender Trouble: Feminism and the Subversion of Identity*. New York: Routledge, 1990.

———. "Imitation and Gender Insubordination." In *Inside/Out: Lesbian Theories, Gay Theories*, ed. Diana Fuss, 13–31. New York: Routledge, 1991.

———. "Sexual Inversions." In *Feminist Interpretations of Michel Foucault*, ed. Susan J. Hakman, 59–75. University Park: Penn State University Press, 1996.

Cadmus, Paul. "Credo" (1937 broadside). Reprinted in Lincoln Kirstein, *Paul Cadmus*, 142. Petaluma, Calif.: Pomegranate Art Books, 1992.

"Cadmus, Satirist of Modern Civilization." *Art Digest*, April 1, 1937: 17.

"Cadmus Tars under Fire at the San Francisco Fair." *Newsweek*, August 19, 1940: 51.

Califia, Pat. *Public Sex: The Culture of Radical Sex*. Pittsburgh: Cleis Press, 1994.

Cameron, Dan, et al. *Fever: The Art of David Wojnarowicz*, exhibition catalog. New York: New Museum of Contemporary Art and Rizzoli, 1999.

Carr, C. (Cynthia). "David Wojnarowicz, 1954–1992." *Village Voice*, August 4, 1992: 3, 23.

———. *On Edge: Performance at the End of the Twentieth Century*. Hanover, NH: University Press of New England, Wesleyan University Press, 1993.

———. "The Robert Mapplethorpe Trial: Cincinnati: A City Cross-Examined," *L.A. Weekly* (October 26–November 1, 1990), 20–28.

Can't Help Lovin' That Man. Audio recording, liner notes by Michael Musto. Art Deco/Columbia: 1993.

Cembalest, Robin. "Cincinatti: Imperfect Moment." *Artnews* vol. 89, no. 6 (Summer 1990): 51–52.

———. "The Obscenity Trial: How They Voted to Acquit." *Artnews* vol. 89, no. 10 (December 1990): 136–41.

Center Ring—The Artist: Two Centuries of Circus Art. Exhibition catalog. Milwaukee: Milwaukee Art Museum, 1981.

Chauncey, George. *Gay New York: Gender, Urban Culture, and the Making of the Gay Male World, 1890–1940.* New York: Basic Books, 1994.

Chester, Mark I. *Diary of a Thought Criminal.* Liberty, Tenn.: RFD Press, 1996.

Childs, Elizabeth C., ed. *Suspended License: Censorship and the Visual Arts.* Seattle: University of Washington Press, 1997.

Clark, T. J. "Gross David with the Swoln Cheek: An Essay on Self-Portraiture." In *Rediscovering History: Culture, Politics, and the Psyche,* ed. Michael S. Roth, 243–307. Stanford, Calif.: Stanford University Press, 1994.

———. *Image of the People: Gustave Courbet and the Second French Republic, 1848–1851.* Greenwich, Conn.: New York Graphic Society, Ltd., 1973.

Colacello, Bob. *Holy Terror: Andy Warhol Close Up.* New York: Harper Collins, 1990.

Collins, Bradford. "The Metaphysical Nose-job: The Remaking of Warhola, 1960–1968." *Arts Magazine* vol. 62, no. 6 (February 1988): 47–59.

Connery, Brian A., and Kirk Combe. *Theorizing Satire: Essays in Literary Criticism.* New York: St. Martin's Press, 1995.

Contreras, Belisario R. *Tradition and Innovation in New Deal Art.* Lewisburg, Pa.: Bucknell University Press, 1983.

Cooper, Emmanuel. *The Sexual Perspective: Homosexuality and Art in the Last 100 Years in the West.* London: Routledge and Kegan Paul, 1986.

Coplans, John. "Crazy Golden Slippers." *Life,* January 21, 1957: 12–13.

Corn, Wanda "Coming of Age: Historical Scholarship in American Art," *Art Bulletin,* vol 70, no 2 (June 1988), reprinted, with a new afterword by the author in Mary Ann Calo, ed., *Critical Issues in American Art: A Book of Readings* (Boulder, CO: Westview Press, 1997): 1–34.

Cotter, Holland. "After Stonewall: Twelve Artists Interviewed," *Art in America,* vol. 82, no. 6 (June 1994), 56–65.

Couvares, Francis G., ed. *Movie Censorship and American Culture.* Washington: Smithsonian Institution Press, 1996.

Crimp, Douglas. *On the Museum's Ruins.* Cambridge: MIT Press, 1993.

———. "Portraits of People with AIDS." In *Cultural Studies,* ed. Lawrence Grossbert, Cary Nelson, and Paula A. Treichler, 117–33. New York: Routledge, 1992.

———. "Right on Girlfriend." In *Fear of a Queer Planet: Queer Politics and Social Theory,* ed. Michael Warner, 300–320. Minneapolis: University of Minnesota Press, 1993.

———, ed. *AIDS: Cultural Analysis, Cultural Activism.* Cambridge: MIT Press, 1988.

Crimp, Douglas, with Adam Rolston. *AIDS Demo/Graphics.* Seattle: Bay Press, 1990.

Crone, Rainer. *Andy Warhol.* New York: Praeger, 1970.

———. *Andy Warhol: A Picture Show by the Artist.* New York: Rizzoli, 1987.

Crow, Thomas. "Modernism and Mass Culture in the Visual Arts." In *Pollock and After: The Critical Debates,* ed. Francis Frascina, 233–266. New York: Harper and Row, 1985.

———. *The Rise of the Sixties: American and European Art in the Era of Dissent.* New York: Harry N. Abrams, 1996.

———. "Saturday Disasters: Trace and Reference in Early Warhol." In *Reconstructing Modernism: Art in New York, Paris, Montreal, 1945–1964,* ed. Serge Guilbaut, 311–331. Cambridge: MIT Press, 1990.

Crump, James. *George Platt Lynes: Photographs from the Kinsey Institute.* Exhibition catalog. Boston: Bulfinch Press, 1993.

Culver, Stuart. "Whistler v. Ruskin: The Courts, The Public, and Modern Art." In *The Administration of Aesthetics: Censorship, Political Criticism, and the Public Sphere,* ed. Richard Burt, 149–165. Minneapolis: University of Minnesota Press, 1994.

Danto, Arthur C. *Playing with the Edge: The Photographic Achievement of Robert Mapplethorpe.* Berkeley: University of California Press, 1996.

Davenport, Guy. *The Drawings of Paul Cadmus.* New York: Rizzoli, 1989.

Davis, Whitney, ed. *Gay and Lesbian Studies in Art History.* New York: Harrington Park Press, 1994.

Davis, Whitney, "'Homosexualism,' Gay and Lesbian Studies, and Queer Theory in Art History." In *The Subjects of Art History: Historical Objects in Contemporary Perspective*, ed. Mark A. Cheetham, Michael Ann Holly, Keith Moxey. (Cambridge: Cambridge University Press, 1998), 115–142.

Davy, Kate. "From Lady Dick to Ladylike: The Work of Holly Hughes." In *Acting Out: Feminist Performance*, ed. Lynda Hart and Peggy Phelan, 55–84. Ann Arbor: University of Michigan Press, 1993.

D'Emilio, John. *Making Trouble: Essays on Gay History, Politics, and the University*. New York: Routledge, 1992.

———. *Sexual Politics, Sexual Communities: The Making of a Homosexual Minority in the United States, 1940–1970*. Chicago: University of Chicago Press, 1983.

D'Emilio, John, and Estelle B. Friedman. *Intimate Matters: A History of Sexuality in America*. New York: Harper and Row, 1988.

Deitcher, David. "Gran Fury." Interview in *Discourses: Conversations in Postmodern Art and Culture*, ed. Russell Ferguson, William Olander, Marcia Tucker, and Karen Fiss. New York: New Museum, 1989, 196–208.

———. "Ideas and Emotions." *Artforum* 27, no. 9 (May 1989): 122–127.

———, ed. *The Question of Equality: Lesbian and Gay Politics in America since Stonewall*. New York: Scribner, 1995.

De Grazia, Edward. *Girls Lean Back Everywhere: The Law of Obscenity and the Assault on Genius*. New York: Vintage, 1993.

De Lauretis, Teresa. *Technologies of Gender*. Bloomington: Indiana University Press, 1987.

De Salvo, Donna. *Success Is a Job in New York: The Early Art and Business of Andy Warhol*. Exhibition catalog. New York and Pittsburgh: Grey Art Gallery and the Carnegie Museum of Art, 1989.

Dickstein, Morris. "From the Thirties to the Sixties: The New York World's Fair in Its Own Time." In *Remembering the Future: The New York World's Fair from 1939 to 1964*. New York: Queens Museum and Rizzoli, 1989.

Doezema, Marianne and Elizabeth Milroy, ed *Reading American Art*. New Haven and London: Yale University Press, 1998.

Dollimore, Jonathan. *Sexual Dissidence: Augustine to Wilde, Freud to Foucault*. Oxford: Clarendon Press, 1991.

Dong, Arthur, director. *Outrage '69: A Question of Equality, Part 1*. Documentary film produced by Testing the Limits Collective. New York, 1995.

Doss, Erika. *Benton, Pollock, and the Politics of Modernism: From Regionalism to Abstract Expressionism*. Chicago: University of Chicago Press, 1991.

Dowd, Maureen. "Jesse Helms Takes No-Lose Position on Art." *New York Times*, July 28, 1989: B6.

Duberman, Martin. *Midlife Queer: Autobiography of a Decade*. New York: Dutton, 1986.

———. *Stonewall*. New York: Dutton, 1993.

Dubin, Steven. *Arresting Images: Impolitic Art and Uncivil Actions*. London and New York: Routledge, 1992.

Dunne, Dominick. "Robert Mapplethorpe's Proud Finale." *Vanity Fair*, February 1989: 121–26.

Dyer, Richard. "Don't Look Now." *Screen* 23, nos. 3–4 (September/October 1982): 61–73.

———. *Stars*. New York: Routledge, 1990.

Edelman, Lee. *Homographesis: Essays in Gay Literary and Cultural Theory*. New York: Routledge, 1994.

———. "Seeing Things: Representation, the Scene of Surveillance, and the Spectacle of Gay Male Sex." In *Inside/Out: Lesbian Theories, Gay Theories*, ed. Diana Fuss, 93–118. New York: Routledge, 1991.

Edwards, Tim. *Erotics and Politics: Gay Male Sexuality, Masculinity, and Feminism*. London: Routledge, 1994.

Elgar, Dietmar. *Felix Gonzalez-Torres: Catalogue Raisonné*. Ostfildern, Germany: Cantz Verlag, 1997.

Eliasoph, Philip. "Paul Cadmus: Life and Work." Ph.D. diss., State University of New York at Binghamton, 1979.

———. "That Other Time Censorship Stormed into the Corcoran Gallery." Letter to the editor. *New York Times*, November 26, 1989: 42.

Ellenzweig, Allen. *The Homoerotic Photograph: From Durieu/Delacroix to Mapplethorpe*. New York: Columbia University Press, 1992.

———. "The Homosexual Aesthetic."

American Photographer 5 (August 1980): 60–63.

Engberg, Kristen. "Art, AIDS, and the New Altruism: Marketing the (ad)just(ed) Cause." *New Art Examiner* 18, no. 9 (May 1991): 19–24.

Fairbrother, Trevor. "Tommorrow's Man." In *Success Is a Job in New York: The Early Art and Business of Andy Warhol*, ed. Donna De Salvo, 54–74. New York and Pittsburgh: Grey Art Gallery and the Carnegie Museum of Art, 1989.

Fischer, Hal. *Gay Semiotics*. San Francisco: NFS Press, 1977.

———. "The New Commercialism." *Camera Arts*, January 1981: 9–10.

Fletcher, John. "Freud and His Uses: Psychoanalysis and Gay Theory." In *Coming On Strong: Gay Politics and Culture*, ed. Simon Shepherd and Mick Wallis, 90–118. London: Unwin Hyman, 1989.

Foster, Alasdair. *Behold the Man: The Male Nude in Photography*. Exhibition catalog. London: Stills Gallery, 1988.

Foucault, Michel. *Discipline and Punish: The Birth of the Prison*. Trans. Alan Sheridan. New York: Pantheon, 1978.

———. *The History of Sexuality, Volume 1: An Introduction*. Trans. Robert Hurley. New York: Random House, 1980.

———. "An Interview: Sex, Power, and the Politics of Identity." *The Advocate* 400 (August 7, 1984): 26–30, 58.

———. "Sexual Choice, Sexual Act: An Interview with Michel Foucault." In *Foucault Live (Interviews, 1966–84)*, ed. Sylvère Lotringer, 211–32. New York: Semiotext(e), 1989.

Fowler, Harriet. *New Deal Art: WPA Works at the University of Kentucky*. Lexington: University of Kentucky Art Museum, 1985.

Francis, Mark, and Margery King. *The Warhol Look: Glamour, Style, Fashion*. Exhibition catalog. New York: Whitney Museum of American Art, 1997.

Freud, Sigmund. *The Interpretation of Dreams*. Trans. James Strachey. 1900. Reprint, New York: Avon Books, 1965.

———. *Leonardo DaVinci and a Memory of His Childhood*. Trans. Alan Tyson. 1910. Reprint, New York: W. W. Norton, 1964.

———. *Sexuality and the Psychology of Love*. In *Collected Papers*, ed. Philip Rieff. New York: Collier, 1963.

———. *Three Essays on the Theory of Sexuality*. Trans. and ed. James Strachey, intro. Steven Marcus. 1905. Reprint, New York: Basic Books, 1975.

Fried, Michael, "New York Letter: Warhol, December 25, 1962." Reprinted in *Art and Objecthood*, 287–88. Chicago: University of Chicago Press, 1998.

Friedman, Arnold. "Government in Art." 1936. Reprinted in *Artists against War and Fascism: Papers of the First American Artists' Congress*. New Brunswick, N.J.: Rutgers University Press, 1986.

Friedman, David. "ACT-UP's Second Act." *New York Newsday*, August 24, 1990: sec. 2, pp. 42–44.

Frischter, Jack. *Mapplethorpe: Assault with a Deadly Camera*. Mamaroneck, N.Y.: Hastings House, 1994.

———. "The Robert Mapplethorpe Gallery." In *Son of Drummer* (special issue of *Drummer* magazine). San Francisco: 1978.

Frohnmayer, John. *Leaving Town Alive: Confessions of an Art Warrior*. Boston, Houghton Mifflin, 1993.

Fung, Richard. "Looking for My Penis: The Eroticized Asian in Gay Video Porn." In *How Do I Look?: Queer Film and Video*, ed. Bad Object-Choices. Seattle: Bay Press, 1991.

Fuss, Diana. *Inside / Out: Lesbian Theories, Gay Theories*. New York: Routledge, 1991.

"Gag Order: Gay and Lesbian Art, Censorship, and the NEA." Dossier of articles. *Outweek*, August 8, 1990: 50–66.

Gardner, Carl. "Our Navy Challenges Paul Cadmus and His Portrayal of the Navy." *Our Navy*, mid-May 1934.

Giorno, John. *You Got to Burn to Shine: New and Selected Writings*. London and New York: High Risk Books / Serpent's Tail, 1994.

Glueck, Grace. "Publicity Is Enriching Mapplethorpe Estate." *New York Times*, April 16, 1990: B1.

Gott, Ted, ed. *Don't Leave Me This Way: Art in the Age of AIDS*. Melbourne: National Gallery of Australia, 1992.

Greenberg, Clement. "Avant-Garde and Kitsch." 1939. Reprinted in *Clement Greenberg: The Collected Essays and Criticism*, vol. 1: *Perceptions and Judgments, 1939–1944*, ed. John O'Brian, 5–22. Chicago: University of Chicago Press, 1986.

Greenberg, David F. *The Construction of*

Homosexuality. Chicago: University of Chicago Press, 1988.

Grimes, William. "The Charge? Depraved. The Verdict? Out of the Show." *New York Times*. March 8, 1992: sec. 2, pp. 1, 35.

Grover, Jan Zita. "AIDS: Public Issues, Public Art." *Public Art Issues* (1992): 6–8.

———. "Dykes in Context: Some Problems in Minority Representation." In *The Contest of Meaning: Critical Histories of Photography*, ed. Richard Bolton. Cambridge, MA: MIT Press, 1989, 1992, 162–197.

Guthmann, Edward. "Stars." *San Francisco Sentinel*. June 2, 1978: 11.

Hall, Stuart, and Tony Jefferson, eds. *Resistance through Rituals*. London: Hutchinson, 1976.

Halperin, David M. "Forgetting Foucault: Acts, Identities, and the History of Sexuality. *Representations* 63 (Summer 1998), 93–120.

———. "Military Secrets." In *Doug Ischar: Orderly*, exhibition catalog, 3:10–3:13. Cambridge, MA: MIT List Visual Arts Center, 1993.

———. *One Hundred Years of Homosexuality and Other Essays on Greek Love*. New York: Routledge, 1990.

———. *Saint Foucault: Towards a Gay Hagiography*. New York: Oxford University Press, 1995.

Harris, Ann Sutherland and Linda Nochlin. *Women Artists, 1550–1950*. Exhibition catalog. Los Angeles: Los Angeles County Museum of Art, 1976.

Harris, William. "Demonized and Struggling with His Demons." *New York Times*, October 23, 1994: H31.

Hart, Lynda. *Between the Body and the Flesh: Performing Sadomasochism*. New York: Columbia University Press, 1998.

———. *Fatal Women: Lesbian Sexuality and the Mark of Aggression*. Princeton, N.J.: Princeton University Press, 1994.

Heath, Stephen. "Men in Feminism: Men and Feminist Theory." In *Men in Feminism*, ed. Alice Jardine and Paul Smith, 41–46. New York: Methuen, 1987.

Hebdige, Dick. *Subculture, the Meaning of Style*. London: Methuen, 1979.

Heiferman, Marvin, and Lisa Phillips. *Image World*. Exhibition catalog. New York: Whitney Museum of American Art, 1990.

Heller, Steven, and Karrie Jacobs, eds. *Angry Graphics: Protest Posters of the Reagan / Bush Era*. Salt Lake City: Peregrine Smith Books, 1991.

Hershkovits, David. "The Shock of the Black and Blue." *Soho News*, May 20, 1981.

Hess, Elizabeth. "Jesse Helms's Nightmare." *Village Voice*, November 28, 1989: 117.

———. "NEA Shoots Itself: Frohnmayer Targets 'Political' Art." *Village Voice*, Novembe 28, 1989: 117.

———. "Queer in Normal." *Village Voice*, February 13, 1990, 97–99.

Hocquenghem, Guy. *Homosexual Desire*. Trans. Daniella Dangoor. Durham, N.C.: Duke University Press, 1993.

Hoffman, Barbara, and Robert Storr, eds. "Censorship 1" (special issue). *Art Journal* 50, no. 3. (Fall 1991).

———. "Censorship 2" (special issue). *Art Journal* 50, no. 4 (Winter 1991).

Holinghurst, Alan. "Robert Mapplethorpe." In *Robert Mapplethorpe: 1970–1983*, 8–17. London: Institute of Contemporary Arts, 1983.

Honan, William H. "House Shuns Bill on 'Obscene' Art." *New York Times*, September 14, 1989: A1, C22.

———. "Multi-Media Artist Sues Political Action Group." *New York Times*, May 22, 1990: C14.

Hooven, F. Valentine, III. *Beefcake: The Muscle Magazines of America, 1950–1970*. Berlin: Benedikt Taschen, 1995.

———. *Tom of Finland: His Life and Times*. New York: St. Martin's, 1993.

Horton, Anne. "Robert Mapplethorpe." Interview. In *Robert Mapplethorpe 1986*. Berlin: Raab Galerie; Cologne: Kicken-Pauseback, 1986.

Hostile Climate: A State by State Report on Anti-Gay Activity, 1994. Washington D.C.: People for the American Way, 1994.

Hostile Climate: A State by State Report on Anti-Gay Activity, 1995. Washington D.C.: People for the American Way, 1995.

Hughes, Holly. *Clit Notes: A Sapphic Sampler*. New York: Grove Press, 1996.

———. "Headless Dyke in Topless Bar: A Personal History of Lesbian Comedy" (special section). *Village Voice*, June 21, 1994: 7–9, 33.

———. "Reverberations of 'The NEA Four' Affair." Reprinted *in The Best of the Harvard Gay and Lesbian Review*, ed.

Richard Schneider. Philadelphia: 1997, 56–58.

Hughes, Holly, and David Román. *O Solo Homo: The New Queer Performance*. New York: Grove Press, 1998.

Indiana, Gary. "Mapplethorpe." *Village Voice*, May 14, 1985: 97.

———. "Robert Mapplethorpe" (interview). *Bomb* 22 (Winter 1988): 18–23.

Ischar, Doug. "Endangered Alibis." *Afterimage*, vol. 17, no. 10 (May 1990), 8–11.

———. "Parallel Oppressions: The Ideal and the Abject in Gay Representation." *Afterimage*, vol. 16, no. 7 (February 1989) 10–11.

Jacobsen, Carol. "Redefining Censorship: A Feminist View." *Art Journal*, vol. 50, no. 4 (Winter 1991), 42–55.

Jarzombek, Mark. "The Mapplethorpe Trial and the Paradox of its Formalist and Liberal Defense: Sights of Contention." *Appendx: Culture / Theory / Praxis* 2 (1994): 59–79.

Jay, Karla, and Allen Young, eds. *Lavender Culture*. New York: Jove / HBJ publications, 1979.

———. *Out of the Closets: Voices of Gay Liberation*. 1972. Reprint, New York: New York University Press, 1992.

Jewell, Edward Alden. "Cadmus Canvases Hung at Midtown." *New York Times*, March 27, 1937: 12.

Johns, Elizabeth. "Histories of American Art: The Changing Quest." *Art Journal* 44, no. 4 (Winter 1984): 338–45.

Jones, Amelia. "Lari Pittman's Queer Feminism." *Art and Text*, no. 50. (Jan. 1995): 36–42.

Jones, Caroline A. *Machine in the Studio: Constructing the Postwar American Artist*. Chicago, University of Chicago Press, 1996.

———. "La Politique de Greenberg et le Discours Postmoderniste." *Cahiers du Musée National d'Art Moderne* no. 45–46. (Autumn-Winter 1993), 105–37.

Joselit, David. "Robert Mapplethorpe's Poses." In *Robert Mapplethorpe: The Perfect Moment*, exhibition catalog. Philadelphia: Institute of Contemporary Art, 1988, 19–21.

Juffe, Mel. "Fair's 'Most Wanted' Mural Becomes 'Least Desirable.'" *New York Journal American*, April 18, 1964: 4.

Juhasz, Alexandra. *AIDS TV: Identity, Community, and Alternative Television*. Durham, N.C.: Duke University Press, 1995.

Kagan, Andrew. "Most Wanted Men: Andy Warhol and the Culture of Punk." *Arts Magazine* 53 (September 1978): 119–22.

Kaiser, Charles. *The Gay Metropolis: 1940–1996*. New York: Houghton Mifflin Company, 1997.

Katz, Jonathan D. "The Art of Code: Jasper Johns and Robert Rauschenberg." In *Significant Others: Creativity and Intimate Partnership*, ed. Whitney Chadwick and Isabelle de Courtivron, 189–208. London: Thames and Hudson, 1993.

———. "Dismembership: Jasper Johns and the Body Politic." In *Performing the Body, Performing the Text*, ed. Amelia Jones and Andrew Stephenson, 170–85. London: Routledge, 1999.

———. "Opposition, Inc: The Homosexualization of Postwar American Art." Ph.D. diss., Northwestern University. 1995.

Katz, Jonathan Ned. *Gay American History: Lesbians and Gay Men in the U.S.A.* 1976. Reprint, New York: Meridian, 1992.

———. *Gay / Lesbian Almanac: A New Documentary*. New York: Carroll and Graf Publishers, 1983.

———. *The Invention of Heterosexuality*. New York: Plume, 1996.

King, Margery. "Starstruck: Andy Warhol's Marilyn and Elvis." *Carnegie Magazine*, July / August 1995: 10–15.

Kirstein, Lincoln. *Paul Cadmus*. 1984. Reprint, Petaluma, Calif.: Pomegranate Art Books, 1992.

Klusacek, Allan, and Ken Morrison. *A Leap in the Dark: AIDS, Art, and Contemporary Cultures*. Montreal: Véhicule Press, 1993.

Koestenbaum, Wayne. "Wilde's Hard Labor and the Birth of Gay Reading." In *Engendering Men: The Question of Male Feminist Criticism*, ed. Joseph A. Boone and Michael Cadden, 176–189, 311–313. New York: Routledge, 1990.

Kornbluth, Jesse. *Pre-Pop Warhol*. New York: Random House, 1988.

Kramer, Margia. *Andy Warhol et al.: The FBI File on Andy Warhol*. New York: UnSub Press, 1988.

Kuhn, Annette. *Cinema, Censorship, and Sexuality, 1909–1925*. London: Routledge, 1988.

Kunzle, David. *Posters of Protest: The Posters of*

Political Satire in the U.S., 1966–1970. Goleta, CA: Triple R Press, 1971.

Laplanche, Jean and J.B. Pontalis, *The Language of Psycho-Analysis*. New York: Norton, 1973.

Lauretis, Teresa de. "Queer Theory: Lesbian and Gay Sexualities, an Introduction." *Differences* 3, no. 2 (Summer 1991): iii–xviii.

Leddick, David. *Intimate Companions: A Triography of George Platt Lynes, Paul Cadmus, Lincoln Kirstein, and Their Circle*. New York: St. Martin's Press, 2000.

Leitsch, Dick. "Acting Up at the Stonewall Riots." *The Advocate* (July 1969). Reprinted in *Long Road to Freedom: The Advocate History of the Gay and Lesbian Movement*, ed. Mark Thompson, 28–29. New York: St. Martin's Press, 1994.

Levine, Martin P. "The Life and Death of Gay Clones." In *Gay Culture in America*, ed. Gilbert Herdt, 68–88. Boston: Beacon Press, 1992.

Lewes, Kenneth. *The Psychoanalytic Theory of Male Homosexuality*. London: Quartet Books, 1988.

Lewin, Ellen. *Inventing Lesbian Cultures in America*. Boston: Beacon Press, 1996.

Lippard, Lucy R. *Pop Art*. New York: Praeger, 1966.

Lipson, Benjamin. "Celebration and Crisis." *New York Newsday*, August 1, 1988: 8.

MacCabe, Colin, with Mark Francis and Peter Wollen, ed. *Who is Andy Warhol?*. London and Pittsburgh: British Film Institute and The Andy Warhol Museum, 1997.

Mamiya, Christin J. *Pop Art and Consumer Culture: American Super Market*. Austin: University of Texas Press, 1992.

Manegold, C. S. "Robert Mapplethorpe, 1970–1983: On the 1983–84 Retrospective." *Arts Magazine* vol. 58 no. 6 (February 1984): 96–99.

Marling, Karal Ann. *Wall-to-Wall America: A Cultural History of Post-Office Murals in the Great Depression*. Minneapolis: University of Minnesota Press, 1982.

Marshall, Richard. "Mapplethorpe's Vision." In *Robert Mapplethorpe* (exhibition catalog) 8–15. New York: Whitney Museum of American Art in association with New York Graphic Society Books, 1988.

Masters, Kim. "NEA-Funded Art Exhibit Protested, Wildmon Mails Sexual Images to Congress." *Washington Post*, April 21, 1990: C1.

McClintock, Anne. *Imperial Leather: Race, Gender, and Sexuality in the Colonial Contest*. New York: Routledge, 1995.

McDonald, Robert. "Censored." *The Advocate* 244, June 28, 1978: 21 (second section).

McElroy, Guy C. *Facing History: The Black Image in American Art, 1710–1940*. Washington, D.C.: Bedford Arts, 1990.

McKinzie, Richard. *The New Deal For Artists*. Princeton, N.J.: Princeton University Press, 1973.

McQuiston, Liz. *Graphic Agitation: Social and Political Graphics since the Sixties*. London: Phaidon Press, 1993.

Melosh, Barbara. *Engendering Culture: Manhood and Womanhood in New Deal Public Art and Theater*. Washington: Smithsonian Institution Press, 1991.

Mercer, Kobena. "Imaging the Black Man's Sex." In *Photography/Politics Two*, ed. Pat Holland, Jo Spence, and Simon Watney, 61–69. London: Comedia/Methuen, 1986.

———. "Skin Head Sex Thing: Racial Difference and the Homoerotic Imaginary." In *How Do I Look?: Queer Film and Video*, edited by Bad Object-Choices, 169–210. Seattle: Bay Press, 1991.

Merck, Mandy. "Difference and Its Discontents." *Screen* 28, no. 1 (Winter 1987): 2–9.

Merck, Mandy, Naomi Segal, and Elizabeth Wright, eds. *Coming Out of Feminism?* Oxford: Blackwell, 1999.

Merkel, Jayne. "Art on Trial." *Art in America* 78, no. 12 (December 1990): 47–51.

Merryman, John Henry, and Albert E. Elsen. *Law, Ethics, and the Visual Arts*, 3d ed. London, The Hague, Boston: Kluwer Law International, 1998.

Metz, Christian. "Photography and Fetish." Reprinted in *The Critical Image: Essays on Contemporary Photography*, ed. Carol Squiers, 155–164. Seattle: Bay Press, 1990.

Mewborn, Brant. "Paul Cadmus: Portrait of the Artist as a Gentle Man." *After Dark*, March 1978: 46–53.

Meyer, Moe, ed. *The Politics and Poetics of Camp*. London: Routledge, 1994.

Meyer, Richard. "Gran Fury and the Graphics of AIDS Activism." In *But Is It Art?: The*

Spirit of Art as Activism, ed. Nina Felshin, 51–83. Seattle: Bay Press, 1995.

———. "Rock Hudson's Body." In *Inside/Out: Lesbian Theories, Gay Theories*, ed. Diana Fuss, 258–88. New York: Routledge, 1991.

———. "At Home in Marginal Domains," *Documents* 18 (Summer 2000), 19–32.

———. "Profile: Paul Cadmus," *Art Journal*, vol. 57, no. 3 (Fall 1998): 80–84.

Miller, D. A. "Anal *Rope*." In *Inside/Out: Lesbian Theories, Gay Theories*, ed. Diana Fuss, 119–41. New York: Routledge, 1991.

———. *Bringing Out Roland Barthes*. Berkeley: University of California Press, 1992.

———. *The Novel and the Police*. Berkeley: University of California Press, 1988.

Miller, Tim, and David Román. "Preaching to the Converted." *Theatre Journal* 47 no. 2 (May 1995): 169–88.

Miller, Marc H. "Something for Everyone: Robert Moses and the World's Fair." In *Remembering the Future: The New York World's Fair from 1939 to 1964*, 45–73. New York: Queens Museum and Rizzoli, 1989.

Mohr, Richard. *Gay Ideas: Outing and Other Controversies*. Boston: Beacon Press, 1992.

Mookas, Ioannis. "Culture in Contest: Public TV, Queer Expression, and the Radical Right." *Afterimage*, April 1992: 8–9.

Moon, Michael. "Outlaw Sex and the 'Search for America': Representing Prostitution and Perverse Desire in Sixties Film (*My Hustler* and *Midnight Cowboy*)." *Quarterly Review of Film and Video* 14, no. 1 (1993): 27–40.

Morrison, Paul. "Coffee Table Sex: Robert Mapplethorpe and the Sadomasochism of Everyday Life." *Genders* 11 (Fall 1991): 17–36.

Morrisroe, Patricia. *Mapplethorpe: A Biography*. New York: Random House, 1995.

Moscato, Michael and Leslie LeBlanc, ed., *The United States of America v. One Book Entitled Ulysses by James Joyce*. Frederick, MD: University Publications of America, Inc, 1984.

Mulcahy, Kevin V., and C. Richard Swaim. *Public Policy and the Arts*. Boulder, Colo.: Westview Press, 1982.

Mullins, Greg. "Nudes, Prudes, and Pigmies: The Desirability of Disavowal in Physical Culture," *Discourse* 15, no. 1. (Fall 1992): 28–48.

Mulvey, Laura. *Visual and Other Pleasures*. Bloomington: Indiana University Press, 1989.

Mumford, Lewis. "Art Galleries." *New Yorker*, April 10, 1937: 66–67.

Muñoz, José Esteban. *Disidentifications: Queers of Color and the Performance of Politics*. Minneapolis: University of Minnesota Press, 1999.

Neale, Steven. "Masculinity as Spectacle: Reflectons on Men and Mainstream Cinema." *Screen* 24, no. 6 (November/December 1983): 2–16.

Newton, Esther. *Mother Camp: Female Impersonators in America*. Chicago: University of Chicago Press, 1972.

Nochlin, Linda. "'Sex Is So Abstract': The Nudes of Andy Warhol." In *Andy Warhol's Nudes*, unpaginated. New York: Robert Miller Gallery, 1995.

———. *Representing Women*. New York: Thames and Hudson, 1999.

Owens, Craig. *Beyond Recognition: Representation, Power, and Culture*. Ed. Scott Bryson et al. Berkeley: University of California Press, 1992.

———. "The Discourse of Others: Feminism and Postmodernism." In *The Anti-Aesthetic*, ed. Hal Foster, 57–82. Seattle: Bay Press, 1983.

———. "Outlaws: Gay Men in Feminism." In *Men in Feminism*, ed. Alice Jardine and Paul Smith, 219–32. New York: Methuen, 1987.

Padgug, Robert. "Sexual Matters: On Conceptualizing Sexuality in History." *Radical History Review* 20 (Spring/Summer 1979): 3–23.

Pagano, Grace. *The Encyclopaedia Britannica Collection of Contemporary American Painting*. Chicago: Encyclopaedia Britannica Company, 1946.

Panofksy, Erwin. *Meaning in the Visual Arts*. Garden City, N.Y.: Doubleday Anchor Books, 1955.

Parachini, Allan. "Artist Sues the Rev. Wildmon over Mailing." *Los Angeles Times*, May 22, 1990: calendar section, p. 1.

Park, Marlene, and Gerald E. Markowitz. *Democratic Vistas: Post Offices and Public Art in the New Deal*. Philadelphia: Temple University Press, 1984.

———. *The New Deal for Art*. Hamilton, N.Y.: Gallery Association of New York State, 1977.

Parker, Rozsika, and Griselda Pollock. *Old*

Mistresses: Women, Art, and Ideology. London: Routledge and Kegan Paul, 1981.

Patton, Cindy. *Sex and Germs: The Politics of AIDS*. Boston: South End Press, 1985.

Pearson, Rick, and Paul Wagner. "Senate Votes to Ban AIDS Posters from CTA." *Chicago Tribune*, June 23, 1990: 1.

Phelan, Peggy. *Unmarked: The Politics of Performance*. New York: Routledge, 1993.

Philippe, Robert. *Political Graphics: Art as a Weapon*. Oxford: Oxford University Press, 1982.

Phillips, Christopher. "Wojnarowicz Bags Buck." *Art in America* 78, no. 10 (October 1990): 235.

"Picture of Sailors with 'Colors Flying' Annoys Navy." *Newsweek*, April 28, 1934: 25.

Pieterse, Jan Nederveen. *White on Black: Images of Africa and Blacks in Western Popular Culture*. New Haven, Conn.: Yale University Press, 1992.

Pollock, Griselda. *Differencing the Canon: Feminist Desire and the Writing of Art's Histories*. London and New York: Routledge, 1999.

———. *Vision and Difference: Femininity, Feminism, and the Histories of Art*. New York: Routledge, 1988.

Post, Robert C., ed. *Censorship and Silencing: Practices of Cultural Regulation*. Los Angeles: Getty Research Institute for the History of Art and the Humanities, 1998.

Preston, John. "The New York Galleries: Non-Competitive Exposure." *The Alternate* 2, no. 12 (March/April 1980): 14–19.

Printz, Neil. *Death and Disasters*. Houston: De Menil Foundation, 1989.

Raimondo, Justin. *In Praise of Outlaws: Rebuilding Gay Liberation*. San Francisco: Students for a Libertarian Society, 1979.

Reed, Christopher. "Postmodernism and the Art of Identity." In *Concepts of Modern Art: From Fauvism to Postmodernism*, ed. Nikos Stangos, 3rd edition 271–293. New York: Thames and Hudson, 1994.

"Removals." *Time*, April 30, 1934: 21.

Rich, Adrienne. "Compulsory Heterosexuality and Lesbian Existence." Reprinted in *The Lesbian and Gay Studies Reader*, ed. Henry Abelove, Michele Aina Barale, and David Halperin, 227–54. New York: Routledge, 1993.

Rizk, Mysoon. "Nature, Death, and Spirituality in the Work of David Wojnarowicz." Ph.D. diss., University of Illinois at Urbana-Champaign, 1997.

———. "Reinventing the Pre-Invented World." In *Fever: The Art of David Wojnarowicz*, exhibition catalog. New York: New Museum of Contemporary Art and Rizzoli, 1999, 45–67.

Robert Mapplethorpe. Documentary film. London: Arena Films, 1988.

Román, David. *Acts of Intervention: Performance, Gay Culture, and AIDS*. Bloomington: Indiana University Press, 1998.

———. "Not about AIDS." *GLQ: A Journal of Gay and Lesbian Studies* 6, no. 1 (March 2000): 1–28.

Rose, Frank. "Trouble in Paradise." *New Times*, vol 8, no. 8 (April 15, 1977): 45–51.

Rose, Jacqueline. *Sexuality in the Field of Vision*. London and New York: Verso, 1986.

Rosler, Martha. *3 Works*. Halifax, Nova Scotia, Canada: Press of the Nova Scotia College of Art and Design, 1981.

Ross, Andrew. "Uses of Camp." In *Camp Grounds: Style and Homosexuality*, ed. David Bergman. Amherst: University of Massachusetts Press, 1993, 54–77.

Rubin, Gayle S. "The Catacombs: A Temple of the Butthole." In *Leatherfolk: Radical Sex, People, Politics, and Practice*, ed. Mark Thompson, 119–41. Boston: Alyson Publications, 1991.

———. "Requiem for the Valley of the Kings." *Southern Oracle* (Fall 1989): 14–15.

———. "Valley of the Kings." *Sentinel*, September 13, 1984: 10–11.

———. "The Valley of the Kings: Leathermen in San Francisco, 1960–1990." Ph.D. diss, University of Michigan, 1995.

Russo, Vito. *The Celluloid Closet*. Harper and Row: New York, 1987.

"Sailors, Beware Artist with Camera." *Literary Digest*, May 5, 1934: 24.

Salpeter, Harry. "Paul Cadmus: Enfant Terrible." *Esquire*, July 1937: 106.

Saslow, James M. *Ganymede in the Renaissance, Homosexuality in Art and Society*. New Haven, Conn.: Yale University Press, 1986.

———. *Pictures and Passions: A History of Homosexuality in the Visual Arts*. New York: Viking, 1999.

Scott, Joan. "Experience." In *Feminists Theorize the Political*, ed. Judith Butler and Joan Scott. New York and London: Routledge, 1992, 22–40.

Sedgwick, Eve Kosofsky. *Between Men: English Literature and Male Homosocial Desire*. New York: Columbia University Press, 1985.

———. *Epistemology of the Closet*. Berkeley: University of California Press, 1990.

———. *Tendencies*. Durham, N.C.: Duke University Press, 1993.

Seidman, Steven. *Romantic Longings: Love in America, 1830–1980*. New York: Routledge, 1991.

Sekula, Allan. "The Body and the Archive." *October* 39 (Winter 1986), 3–64.

———. "Some American Notes." *Art in America* vol 78, no. 2 (February 1990): 39–45.

Selcraig, Bruce. "Reverend Wildmon's War on the Arts." *New York Times Magazine*, September 2, 1990, 22–25, 43, 52–53.

Shane, George. "The Visual Arts." *Des Moines Sunday Register*, January 10, 1965: 2L.

"Should Sailors be Sissies?" (editorial). *New York Daily News*, April 20, 1934: 39.

Showalter, Elaine. "Critical Cross-Dressing: Male Feminists and the Woman of the Year." In *Men in Feminism*, ed. Alice Jardine and Paul Smith, 116–32. New York: Methuen, 1987.

Siegel, Marc. "Documentary That Dare / Not Speak Its Name: Jack Smith's Flaming Creatures." In *Between the Sheets, in the Streets: Queer, Lesbian, Gay Documentary*, ed. Chris Holmund and Cynthia Fuchs, 91–106. Minneapolis: University of Minnesota Press, 1997.

Silver, Kenneth E. "Modes of Disclosure: The Construction of Gay Identity and the Rise of Pop Art." In *Hand-Painted Pop: American Art in Transition, 1955–1962*, ed. Russell Ferguson, 178–203. Los Angeles: Museum of Contemporary Art, 1992.

Silverman, Kaja. *Male Subjectivity at the Margins*. New York: Routledge, 1992.

Sischy, Ingrid. "A Society Artist." In *Robert Mapplethorpe*, exhibition catalog, 76–88. New York: Whitney Museum of American Art, 1988.

———. "White and Black." *New Yorker*, vol. 65, no. 39 November 13, 1989: 124–146.

Smith, Patricia, ed. *The Queer Sixties*. New York: Routledge, 1990.

Smith, Patrick. *Andy Warhol's Art and Films*. Ann Arbor, Mich.: UMI Research Press, 1986.

Smith, Roberta. "Warhol before the Soup." *New York Times*, April 16, 1989: 33, 37.

Sontag, Susan. "Certain Mapplethorpes." Preface to *Certain People*. Pasadena, Calif.: Twelvetrees Press, 1985.

———. "Notes on 'Camp.'" 1964. Reprinted in *Against Interpretation*, 275–292. New York: First Anchor Books Edition, Anchor Books, 1990.

———. *On Photography*. New York: Dell Publishing, 1977.

———. "The Pornographic Imagination." 1967. Reprinted in *Styles of Radical Will*, 35–73. New York: Farrar, Straus, and Giroux, 1969.

Spector, Nancy. *Felix Gonzalez-Torres*, exhibition catalog. New York: Solomon R. Guggenheim Museum, 1995.

"Spotlight: Paul Cadmus." *Life*, March 14, 1937: 51.

Spurier, Jeff. "Blood of a Poet." *Details*, February 1995: 106–11, 140.

Squiers, Carol, ed. *The Critical Image: Essays on Contemporary Photography*. Seattle: Bay Press, 1990.

———. "With Robert Mapplethorpe." *Hamptons Newsletter*, August 27, 1981.

Stein, Jean, edited with George Plimpton. *Edie: An American Biography*. New York: Knopf, 1982.

Steiner, Wendy. *The Scandal of Pleasure: Art in the Age of Fundamentalism*. Chicago and London: University of Chicago Press, 1995.

Stewart, Susan. *Crimes of Writing: Problems in the Containment of Representation*. Durham and London: Duke University Press, 1994.

Stich, Sidra. *Made in U.S.A.: An Americanization in Modern Art, the '50s and '60s*. Berkeley: University Art Museum, 1987.

Stoneman, Donnell. "A Very Special Interview: Painter Paul Cadmus." *The Advocate* 191 (June 2, 1976): 25–29.

Streitmatter, Rodger. *Unspeakable: The Rise of the Gay and Lesbian Press in America*. Boston: Faber and Faber, 1995.

Suárez, Juan A. *Bike Boys, Drag Queens, and Superstars: Avant-Garde, Mass Culture, and Gay Identities in the 1960s Underground Cinema*. Bloomington: Indiana University Press, 1996.

"Survey on Terror and Terrorism." *Documents 2*, no. 4/5 (Spring 1994): 113–169.

Sutherland, David. *Paul Cadmus: Enfant Terrible at Eighty*. Documentary film. Distributed by Home Vision, 1984.

Tagg, John. *The Burden of Representation: Essays on Photographies and Histories*. Amherst: University of Massachusetts Press, 1988.

Talmer, Jerry. "'Fleet' Was Out, Now It's In." *New York Post*, March 27, 1992: 32.

Teal, Donn. *The Gay Militants*. New York: Stein and Day, 1971.

Terry, Jennifer. "Theorizing Deviant Historiography." *Differences* 3, no. 2 (Summer 1991): 55–74.

Thompson, Mark. "To The Limits and Beyond: Folsom Street, a Neighborhood Changes." *The Advocate* 346 (July 8, 1982): 28–31, 57–58.

———. "Portfolio: Nikonoclast Robert Mapplethorpe," *The Advocate* 297 (July 24, 1980): 20–22 (second section).

———, ed. *Leatherfolk: Radical Sex, People, Politics, and Practice*. Boston: Alyson Publications, 1991.

Tickner, Lisa. "Feminism, Art History, and Sexual Difference." *Genders* 3 (Fall 1988): 92–128.

Tinkcom, Mathew J. "Camp and the Question of Value." Ph.D. diss. Pittsburgh: University of Pittsburgh, 1995.

Tully, Judd. "Oral History Interviews with Paul Cadmus," transcript dated March 22–May 5, 1988. *Oral History Program*, Archives of American Art, Smithsonian Institution, Washington D.C.

Tyler, Parker [P.T.]. "Andy Warhol [Bodley; Dec. 3–22]." *Art News* 55, no. 8 (December 1956): 59.

Vance, Carole S. "Misunderstanding Obscenity." *Art in America* vol. 78, no. 5 (May 1990): 49–55.

———. "Negotiating Sex and Gender in the Attorney General's Commission on Pornography." In *Sex Exposed: Sexuality and the Pornography Debate*, ed. Lynne Segal and Mary McIntosh. London: Virago, 1992.

———. "The New Censorship." *Art in America* vol. 77, no. 5 (September 1989): 40–46.

———. "The Pleasures of Looking: The Attorney General's Commission on Pornography versus Visual Images." In *The Critical Image: Essays on Contemporary Photography*, ed. Carol Squiers. Seattle: Bay Press, 1990: 38–58.

———. "The War on Culture." *Art in America* vol. 77, no. 9 (September 1989): 39–45.

Vance, Ronald. "Andy Warhol at Bodley." *Art News* vol. 55, no. 1 (March 1956): 55.

Vanderham, Paul, *James Joyce and Censorship: The Trials of Ulysses*. New York: New York University Press, 1998.

"Village Backs CWA Artist in Navy Row." *New York Evening Journal*, April 19, 1934: 4–5.

Wagner, Anne Middleton. "Lee Krasner as L.K." *Representations* 25 (Winter 1989): 42–57.

———. *Three Artists, (Three Women): Modernism and the Art of Hesse, Krasner, and O'Keeffe*. Berkeley and Los Angeles: University of California Press, 1996.

Wallach, Alan. *Exhibiting Contradiction: Essays on the Art Museum in the United States*. Amherst: University of Massachusetts Press, 1997.

Wallis, Brian, Marianne Weems, and Philip Yenawine. *Art Matters: How the Culture Wars Changed America*. New York: New York University Press, 1999.

Warhol, Andy. *The Philosophy of Andy Warhol: From A to B and Back Again*. New York: Harcourt Brace Jovanovich, 1975.

———. "Sunday with Mr. C." (interview with Truman Capote). *Rolling Stone* 132 (April 12, 1973): 36–43.

Warhol, Andy, and Pat Hackett. *Popism: The Warhol '60s*. New York: Harcourt Brace Jovanovich, 1980.

Warner, Michael. "From Queer to Eternity: An Army of Theorists Cannot Fail." *Village Voice Literary Supplement*, June 1992: 18.

———. ed. *Fear of a Queer Planet: Queer Politics and Social Theory*. Minneapolis: University of Minnesota Press, 1993.

———. "Homo-narcissism, or, Heterosexuality." In *Engendering Men: The Question of Male Feminist Criticism*, ed. Joseph A. Boone and Michael Cadden, 190–206, 313–315. New York: Routledge, 1990.

———. *The Trouble with Normal: Sex, Politics, and the Ethics of Queer Life*. New York: Free Press, 1999.

Washburn, Gary. "AIDS 'Kiss' Posters Going Up on CTA." *Chicago Tribune*, August 15, 1990: 1, 8.

Watney, Simon. *Policing Desire: Pornography, AIDS, and the Media*. 2d ed. Minneapolis: University of Minnesota Press, 1989.

Waugh, Thomas. *Hard to Imagine: Gay Male Eroticism in Photography and Film from Their Beginnings to Stonewall*. New York: Columbia University Press, 1996.

———. "A Heritage of Pornography: Tom Waugh on the Gay Film Collection of the Kinsey Institute." *Body Politic*, no. 90 (January 1984): 29–33.

———. "Photography, Passion, and Power: Tom Waugh on the Gay Still Photo Collection of the Kinsey Insititute." *Body Politic*, no. 101 (March 1984): 29–33.

Weeks, Jeffrey. *Against Nature: Essays on History, Sexuality, and Identity*. London: Rivers Oram Press, 1991.

———. "Discourse, Desire, and Sexual Deviance: Some Problems in a History of Homosexuality." In *The Making of the Modern Homosexual*, ed. Kenneth Plummer, 76–111. London: Hutchinson, 1981.

———. *Sexuality and Its Discontents: Meanings, Myths, and Modern Sexualities*. London: Routledge and Kegan Paul, 1985.

Weiley, Susan. "Prince of Darkness, Angel of Light." *Artnews* 87 no. 10 (December 1988): 108–13.

Weinberg, Jonathan. "Cruising with Paul Cadmus." *Art in America* vol. 80, no. 11 (November 1992): 101–8.

———. *Speaking for Vice: Homosexuality in the Art of Marsden Hartley, Charles Demuth, and the First American Avant-Garde*. New Haven, Conn.: Yale University Press, 1993.

Weinstein, Jeff. "Out for Art's Sake: Paul Cadmus." *Village Voice*, June 1, 1982: 42–43.

Wescott, Glenway. *Continual Lessons: The Journals of Glenway Wescott*, ed. Robert Phelps with Jerry Rosco. New York: Farrar, Straus, and Giroux, 1990.

What's Wrong with this Picture? Artists Respond to Censorship, exhibition catalog (San Francisco: San Francisco Arts Commission Gallery, 1989).

Whelan, Richard. "Robert Mapplethorpe: Hard Sell, Slick Image." *Christopher Street*, June 1979: 17–18.

White, Edmund. *The Burning Library*. New York: Alfred A. Knopf, 1994.

———. "The Political Vocabulary of Homosexuality." In *The State of the Language*, ed. Leonard Michaels and Christopher Ricks, . Berkeley: University of California Press, 1980.

White, Patricia. *Uninvited: Classical Hollywood Cinema and Lesbian Representability*. (Bloomington and Indianapolis: Indiana University Press, 1999).

Wojnarowicz, David. *In the Shadow of Forward Motion*. New York: Privately printed, 1990.

———. "Post Cards from America: X-Rays from Hell." In *Witnesses: Against Our Vanishing*, exhibition catalog. New York: Artists Space, 1989.

WPA Guide to New York City: Federal Writer's Project Guide to 1930s New York. Intro. by William H. Whyte. 1939. Reprint, New York: Pantheon Books, 1982.

Wye, Deborah. *Committed to Print: Social and Political Themes in Recent American Printed Art*. Exhibition catalog. New York: Museum of Modern Art, 1988.

Yingling, Thomas. "How The Eye Is Caste: Robert Mapplethorpe and the Limits of Controversy." *Discourse* 12, no. 2 (Spring–Summer 1990): 3–28.

Archives and Collections

The Andy Warhol Foundation, New York, N.Y.

The Andy Warhol Museum, Pittsburgh, Pa.

Archives of American Art, Smithsonian Institution, main office, Washington, D.C., district offices New York, N.Y., San Marino, Calif.

D. C. Moore Gallery, New York, N.Y.

The David Wojnarowicz Papers, The Downtown Collection, The Fales Library and Special Collections, Bobst Library, New York University.

Department of Twentieth-Century Art, Metropolitan Museum of Art, New York, N.Y.

Estate of David Wojnarowicz, New York, N.Y.

Gay, Lesbian, Bisexual, Transgender Historical Society of Northern California, San Francisco, Calif.

Getty Research Institute for the History of Art and the Humanities, Special Collections, Los Angeles, Calif.

International Gay Information Center (IGIC) Papers, New York Public Library, Special Collections, New York, N.Y.

Leslie Lohman Gallery, New York, N.Y.
Midtown Payson Galleries, New York, N.Y.
Museum of Modern Art, New York, N.Y.
National Archives, Washington, D.C.
National Coalition against Censorship, New York, N.Y.
National Gay and Lesbian Museum, New York, N.Y.
National Museum of American Art, Washington, D.C.
New Langton Arts, San Francisco, Calif.
One Institute and Archives, Los Angeles, Calif.
People for the American Way, Washington, D.C.
PPOW Gallery, New York, N.Y.
Robert Mapplethorpe Foundation, New York, N.Y.
Robert Miller Gallery, New York, N.Y.
Whitney Museum of American Art, New York, N.Y.

Interviews by the Author

Blinderman, Barry (curator, *David Wojnarowicz: Tongues of Flame*), October 6, 1995, by phone.

Cadmus, Paul (artist): August 25, 1994, Weston, Conn.; July 12, 1995, New York, N.Y.; March 6, 1996, New York, N.Y.; May 10, 1996, New York, N.Y.; June 11, 1996, New York, N.Y.; May 22, 1997, Weston, Conn.

Cardinale, Marisa (director, Robert Mapplethorpe Foundation), June 1, 1996, New York, N.Y.

Catto, Scott (director, PPOW Gallery, New York, N.Y.), October 2, 1995, by phone.

Dahlinger, Fred Jr. (head curator/archivist, Circus World Museum and Library, Baraboo, Wis.), March 3, 1994, by phone.

Eliasoph, Philip (art historian), June 12, 1995, Fairfield, Conn.

Fritscher, Jack (former editor, *Drummer* magazine), April 3, 1997, by phone.

Giorno, John (poet), February 10, 1996, by phone; March 23, 1997, New York, N.Y.

Gluck, Nathan (studio assistant to Andy Warhol), November 28, 1999, New York, N.Y.

Guthmann, Edward (journalist, *San Francisco Chronicle*), March 24, 1993, by phone.

Hughes, Holly (performance artist), September 8, 1999, San Francisco, December 2, 1999, New York, N.Y.

King, Margery (curator, Andy Warhol Museum), January 8, 1996, Pittsburgh, Pa.

Lindell, John (member, Gran Fury), May 4, 1994, New York, N.Y.

Lisanby, Charles (set designer): August 22, 1999, Los Angeles; August 25, 1999, Los Angeles; September 3, 1999, by phone.

Lowinsky, Simon (art dealer), August 12, 1998, by phone.

McAlpin, Loring (member, Gran Fury): April 20, 1994, New York, N.Y.; May 8, 1994, New York, N.Y.

McCarty, Marlene (member, Gran Fury), May 19, 1994, New York, N.Y.

McDonald, Robert (former board member of 80 Langton Street), November 14, 1989, by phone.

Moffett, Donald (member, Gran Fury), May 19, 1994, New York, N.Y.

Munro, Gale (curator, Navy Art Collection, Washington, D.C.), May 19, 2000, by phone.

Pritikin, Renny (former director, New Langton Arts), November 11, 1989, San Francisco.

Rink (photographer, San Francisco), November 11, 1989, by phone.

Simpson, Mark (member, Gran Fury), May 13, 1994, New York, N.Y.

Sobieszek, Robert A. (curator), October 22, 1997, Los Angeles.

Wallowitch, John (musician), January 21, 2000, by phone.

Index

Page numbers in *italics* indicate illustrations.